NUYORICAN & DIASPORICAN
VISUAL ART

NUYORICAN & DIASPORICAN VISUAL ART

A CRITICAL ANTHOLOGY

Edited by Arlene Dávila
and Yasmin Ramirez

with Néstor David Pastor, Gabriel Magraner,
and Nikki Myers

DUKE UNIVERSITY PRESS
Durham and London
2025

Project Editor: Lisa Lawley
Designed by A. Mattson Gallagher
Typeset in Warnock Pro and Degular
by Westchester Publishing Services

Library of Congress Cataloging-in-Publication Data
Names: Dávila, Arlene M., [date] editor. | Ramirez, Yasmin, editor. |
Pastor, Néstor David, editor. | Magraner, Gabriel, editor. | Myers, Nikki,
editor.
Title: Nuyorican and diasporican visual art : a critical anthology /
edited by Arlene Dávila and Yasmin Ramirez ; with Néstor David Pastor,
Gabriel Magraner, and Nikki Myers.
Description: Durham : Duke University Press, 2025. | Includes
bibliographical references and index.
Identifiers:
LCCN 2024017407 (print)
LCCN 2024017408 (ebook)
ISBN 9781478031215 (paperback)
ISBN 9781478026952 (hardcover)
ISBN 9781478060208 (ebook)
Subjects: LCSH: Art, Puerto Rican—New York (State)—New York. |
Art, Puerto Rican—United States. | Art, Puerto Rican—Themes,
motives. | Group identity in art. | Hispanic American artists. | BISAC:
ART / American / Hispanic & Latino | SOCIAL SCIENCE / Ethnic Studies /
American / Hispanic American Studies
Classification: LCC N6612.2 .N89 2025 (print) | LCC N6612.2 (ebook) |
DDC 709.7295—dc23/eng/20240722
LC record available at https://lccn.loc.gov/2024017407
LC ebook record available at https://lccn.loc.gov/2024017408

Cover art: Fernando Salicrup, *Una vez más, Colón* (detail), 1978.
Acrylic on linen, 54 × 44 in. (137.2 × 111.8 cm). Collection of
El Museo del Barrio. Museum purchase with a grant from the
National Endowment for the Arts and a gift from George
Aguirre. Photo courtesy of El Museo del Barrio, New York.
Artist estate's permission courtesy of Zoraida Salicrup.

CONTENTS

ix Acknowledgments

1 **Introduction**

Arlene Dávila and Yasmin Ramirez

PART I. FROM PUERTO RICAN TO NUYORICAN
FORGING DIASPORICAN ART IN NEW YORK

27 1 **The Way Out = Left Out?**
Paradoxes of Puerto Rican Avant-Garde Art

Melissa M. Ramos Borges

45 2 **Nuyorican Vanguards**
The Puerto Rican Alternative Art Space
Movement in New York

Yasmin Ramirez

70 3 **The Construction of Nuyorican Identity
in the Art of Taller Boricua**

Taína Caragol

90 4 **The Politics and Poetics of Máximo Colón's
 Activist Photography**

 Elizabeth Ferrer

104 5 **Artistic Decoloniality as Aesthetic Praxis**
 Making and Transforming Imaginations
 and Communities in NYC

 Wilson Valentín-Escobar

131 6 **The Art of Survival**
 The Visual Art Activism of Maria Dominguez

 Al Hoyos-Twomey

149 7 **The Parallel Aesthetics of Nilda Peraza**

 Néstor David Pastor

167 8 **Creative Camaraderie**
 Puerto Rican/Nuyorican Artists and
 Robert Blackburn's Printmaking Workshop

 Deborah Cullen-Morales

 PART II. DIASPORICAN SITES
 REPORTS FROM THE FIELD

189 9 **Unpacking the Portmanteau**
 Locating Diasporican Art

 Teréz Iacovino

212 10 **Puerto Rican Arts in Philadelphia**
 Una Perla Boricua en Filadelfia

 Johnny Irizarry

233 11 **"A pesar de todo"**
 The Survival of an Afro–Puerto Rican Family
 in Frank Espada's Puerto Rican Diaspora Project

 Yomaira C. Figueroa-Vásquez

250 12 **The Fight to Make Art in Borilando**

 Raquel Reichard

270 13 **Abstractions between Puerto Rico and Chicago**
 An Ongoing Conversation about Nationalism
 and Nonrepresentational Art

 Abdiel D. Segarra Ríos

 PART III. ALL OF THE ABOVE
 DIASPORICAN AESTHETICS

291 14 **Nuyorican Poets' Art of Making Books**

 Urayoán Noel

311 15 **Visual Artists, Surrealist Communions**
 Lois Elaine Griffith and Jorge Soto Sánchez
 at the Nuyorican Poets Café

 Joseph Anthony Cáceres

329 **16** **"SAMO© ... AS AN EPIC POEM WITH FLAMES"**
Al Díaz's Poetics of Disruption

Rojo Robles

352 **17** *¡No te luzcas!*
Nuyorican Performance and Spectacularity
in the Visual Art of Adál, David Antonio Cruz,
and Luis Carle

Arnaldo M. Cruz-Malavé

372 **18** **"Bridging Gaps and Building Communities"**
Wanda Raimundi-Ortiz's *Ask Chuleta* and
Afro-Latinx Identity beyond the "White Box"

Kerry Doran

393 **19** **A Modernist Nuyorican Casita and the
Aesthetics of Gentrification**

Johana Londoño

407 **Conclusion**
The Spatial Politics of Shellyne Rodriguez,
Rigoberto Torres, Lee Quiñones, and
Danielle De Jesus—With Some Concluding
Comments

Arlene Dávila

427 Contributors

435 Index

ACKNOWLEDGMENTS

The editors of this book recognize that it was a collaborative effort, made possible by the dedication of numerous colleagues, friends, and collaborators. We are immensely grateful to everyone at The Latinx Project at New York University who contributed to the Nuyorican/Diasporican Art conference in the fall of 2022 as well as the contributors and participants who enriched our volume with their involvement.

A special thanks goes to Jessica Enriquez for her exceptional management of logistics and Orlando Ochoa for their invaluable contributions in organizing the conference and other publication logistics. The conference and this book were made possible by generous funding from the Ford Foundation, and we acknowledge its pivotal role in bringing this project to fruition.

Our appreciation extends to Rocío Aranda-Alvarado for her vision and commitment to uplifting Latinx art. We are deeply grateful for her support. A heartfelt thank you to the peer reviewers whose wise and insightful comments enhanced our work. At Duke University Press, Ken Wissoker's encouragement was crucial; he recognized the unique contribution of our volume and consistently supported it as a friend and ally. Thanks also to the Duke University Press team, including Kate Mullen and Lisa Lawley.

Lastly, we extend our gratitude to all the artists, curators, scholars, and friends who share our vision to amplify the voices of marginalized artists everywhere.

Introduction

Arlene Dávila and Yasmin Ramirez

The objective of *Nuyorican & Diasporican Visual Art: A Critical Anthology* is to anchor our understanding of the historical importance of the first Puerto Rican art movement in New York, aka the Nuyorican art movement, and to introduce new scholarship that centers the work, innovation, and worldmaking of Puerto Rican artists across the United States—that is, Diasporican artists. In particular, the chapters in the anthology call for us to reassess the presence of Puerto Rican artists living and working in the United States within the broader mainstream context of the US and international art world. Not accepted as either fully "Puerto Rican" or "American," Puerto Ricans in the United States defy restrictive boundaries

of ethnicity and national identification, and they have yet to receive substantive attention in museums, exhibitions, and contemporary scholarship. Puerto Rican artists remain generally missing from art historical scholarship, but even more overlooked are those who were born and/or raised and primarily live and work outside the archipelago.

As a result, we know little about visual artists who were generative to creating new visual vocabularies, such as Jorge Soto Sánchez and his urban Afro-Taino aesthetics (see figure I.1); or about pioneers in street and mural art, such as muralist Maria Dominguez or graffiti artist Lee Quiñones; or about artists who innovated interdisciplinary approaches in performance and visual art, such as Adál Maldonado and Wanda Raimundi-Ortiz, among others. When Pablo Delano's *The Museum of the Old Colony* was featured in the Venice Biennale 2024, joining the ranks of many Diasporican artists finally receiving the recognition they deserve, it came as no shock to scholars of Puerto Rican studies who have long acknowledged his contributions. In other words, the fate and experiences of Nuyorican/Diasporican artists in the United States are generative for learning about the difficulties of Latinx artists at large and for obtaining a fuller understanding of American art history.

The scope of the anthology spans from an examination of Nuyorican participation in the alternative and multicultural art movements of the late twentieth century to the roles of Diasporican artists in creating new artistic communities under the constraints of massive debt, displacement, and natural disasters that have beset Puerto Ricans in the twenty-first century. Altogether, these chapters help explain the reasons underlying Nuyorican art invisibility—among them, the nationalist tendencies of art history to relegate these artists to the "American" and Latin American art canon, the racism that has tended to limit our understanding of the rich history of Puerto Ricans in the United States, and the disciplinary boundaries that limit assessment of alternative vanguardist art practices.[1]

Puerto Rico's colonial status has rendered all Puerto Rican artists invisible to art scholars and institutions worldwide. Nevertheless, for generations Puerto Rican artists, as well as scholars and curators, have migrated to the United States, especially to New York, to pursue advanced arts degrees while often continuing to center archipelago and Latin American art in their work and curatorial approaches. As a result, many Puerto Rican art initiatives have failed to explore, uplift, learn from, or make connections with Nuyorican/Diasporican artists in the United States in ways that would also elevate these artists in the art world. This is despite the increasingly popular

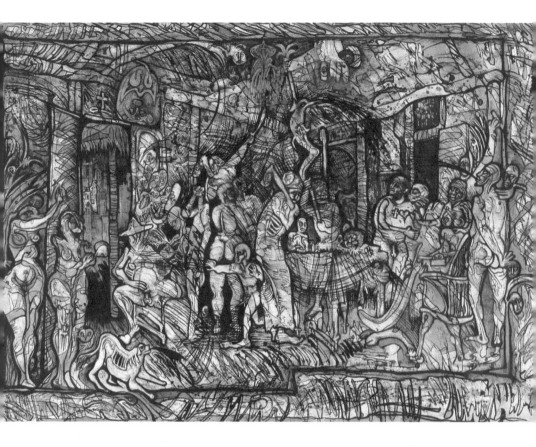

I.1 Jorge Soto Sánchez, *El Velorio de Oller en Nueva York*, 1974 (revised
 1984). Hand-colored screenprint, 25⅞ × 39⅞ in. Collection of Smith-
 sonian American Art Museum.

declaration that we are all part of the same community and "equally Puerto
Rican." In this way, centering Nuyorican/Diasporican artists who live and
work primarily in the United States is crucial to addressing the historical
disinvestment in Latinx art within art history, visual arts scholarship, mu-
seums, archives, and arts and cultural institutions at large.

 We also invite readers to see this volume as a personal intervention in
the spirit of the work we have been doing at The Latinx Project at New York
University (NYU). We offer this book as a call to action for scholars, cura-
tors, and fellow artists to be attentive to hierarchies of race, class, gender,
and sexuality that are often reproduced, veiled, and erased by public asser-
tions of Puerto Ricanness that fail to pay attention to the historical patterns

of exclusion of Diasporican artists in the art world. Our goal is to create the dialogue necessary to produce more equitable exchanges and relationships among all Puerto Rican artists within the archipelago and across the United States.

The editors have been working to uplift and document the work of Nuyorican and Latinx creatives in their individual work for decades: Arlene Dávila through her work on cultural politics and the Latinization of New York, Yasmin Ramirez through her foundational research and curatorial work on Nuyorican art, and our editorial team—Néstor David Pastor, Gabriel Magraner, and Nikki Myers—through their extensive background in Puerto Rican and Latinx arts and cultural institutions and their work with The Latinx Project. We came together to make a public call to identify contributors across the United States that led first to a virtual conference organized by The Latinx Project in the fall of 2022 and then to this volume in the spirit of artivism that pervades the current Latinx movement—where we see a rise of scholarly and institutional interest in and attention to Latinx artists. In this regard, we are in solidarity with so many members of our scholarly and activist community intent on creating and addressing the existing voids in the art history and scholarship cannon.

Our initial call for the conference and book sought contributors exploring the creative work and practices of Nuyorican/Diasporican artists from the 1960s onward and in all genres of visual art, such as street art, muralism, printmaking, painting, photography, performance art, conceptualism, architecture, advertising, and more, with a special appeal for topics focusing on historical perspectives, decolonial aesthetics, queer identities, aesthetics and movements, arts activism and art historical revisions, underground genres, fashion and design, and unknown figures. The submissions came from all fields, and while the final program and content of this book are not a comprehensive or accurate portrayal of the current state of research, they are nonetheless highly informative.

First, our premise that Nuyorican art has been studied primarily through poetry and performance studies and that Diasporican art is understudied was confirmed by the general lack of submissions focusing on diverse forms of visual culture and on Diasporican art beyond New York City. While the Nuyorican movement is celebrated for its legacy of sociopolitical activism, poetry, and music, there has been a notable lag in critical awareness and scholarship regarding Nuyorican visual art. In particular, many of the topics identified by our initial call remain generally untapped and understudied, and we urge students to heed our initial public call. We

encountered an even greater dearth of submissions on key diaspora cities, such as Chicago and Orlando. We realized that our inability to identify contributors in states where Diasporican populations are numerous was linked to a void in institutional structures to support and sustain art worlds and networks, driving our call for more robust art resources across the United States that promote arts and educational opportunities and serve as catalysts of creativity for diverse communities.

Interestingly, and not surprisingly, the submissions of art historians in part I of this book focus primarily on NYC, which is the most established and somewhat documented art scene, while interdisciplinary, independent, and younger writers and scholars in parts II and III look at scenes beyond New York. We feel this speaks to the key role that interdisciplinary scholars have historically played in opening up fields of study before the traditional disciplines. On this point, it is worth quoting Adriana Zavala's observation of the field of art history at large. As she explains, "An informal survey reveals that out of approximately 72 *current* PhD students in art history with a declared focus in Latin American or Latinx visual art, and including PhD students in the ethnic studies fields of Chicano/a/x and Latino/a/x studies, who are focusing on the visual arts, only one is currently writing a dissertation focused on Nuyorican/Diasporican visual art."[2] As she notes, most of the current Latinx art historical scholarly work focuses on Latinx or Chicanx art, a trend that points to the need for more art historical research on the diversity of Latinx artists at large, from Diasporican art to Central American and Dominican artists in the diaspora, and the like. Then there are structural issues in academia, such as the lack of archives available to scholars, and how this contributes to the absence of research on Nuyorican/Diasporican art. For instance, NYU houses the Downtown Collection at Fales Library—an important archive that has contributed to the art historical canon of late twentieth-century New York art history. However, this collection contains virtually no works by Nuyorican visual artists beyond Papo Colo, the founder of Exit Art. This is despite the fact that Downtown Manhattan was a central hub of the Nuyorican art and poetry movement. A researcher would need to know they should comb through the Exit Art Archives to find catalogs from the Museum of Contemporary Hispanic Art (MoCHA) featuring Nuyorican and Latinx artists to reconstruct some of the living art history captured in chapters by contributors Al Hoyos-Twomey, Joseph Anthony Cáceres, Pastor, and Ramirez.[3] In this way, another key takeaway from this book is the importance of Latinx-specific archives in filling the void in art history. We extend a special shout-out to the efforts of

the Center for Puerto Rican Studies Library and Archive; the Latin American and Latino Art Documents at the International Center for the Arts of the Americas at the Museum of Fine Arts, Houston; and Latinx archivist and curator Josh T. Franco at the Smithsonian's Archives of American Art. We are also excited about the digitization, of the Museum of Contemporary Hispanic Art archives, launched in 2024 at Hostos College in New York City, which has finally made this important collection accessible to the public. These archives have played a crucial role in documenting Nuyorican art, which, in turn, greatly assisted the work of several of our contributors.

In summary, our book seeks to address sedimented erasures in academia, art history, archives, and museums through interdisciplinary examinations of the evolution and impact of Puerto Rican visual culture in the United States. The collection provides a critical (re)evaluation and historical overview of Nuyorican and Diasporican visual art production with the aim of asserting its importance and contemporaneity alongside the vanguardist movements that emerged in New York City from the 1960s onward. Moreover, the chapters included here, while not intended to be comprehensive, develop a more intersectional and inclusive understanding of Nuyorican/Diasporican art as it pertains to a specific community-based visual aesthetic aligned with the Nuyorican movement and manifest in a wide array of artistic mediums. As such, there is a particular emphasis on the undervalued contributions and radical aesthetics of female, Black, and queer Puerto Rican artists. In addition, this volume addresses the expansion and decentralization of the Puerto Rican diaspora by the turn of the twenty-first century and explores Diasporican art as expressive of Puerto Rican communities in cities such as Chicago, Philadelphia, and Orlando.

Altogether, the chapters in this book fill the current void of knowledge and appreciation of Nuyorican and Diasporican artists by showing that the Nuyorican/Diasporican art movement has always been global and vanguardist in scope. The printmaking, painting, muralism, photography, and performance-based art practices that arose from the Nuyorican art movement in the 1970s were not only significant to the Puerto Rican community at that time. Rather, the politically engaged, global cultural sensibility of Nuyorican art anticipated the contemporary interest in Afro-diasporic expressivity, artivism, social practice art, and decolonial aesthetics. It also innovated across genres, formats, and mediums, from printmaking to graffiti arts.

We also recognize that the visual arts were always produced in conversation with music, performance, and poetry, and we encourage readers to consult several scholars who take interdisciplinary perspectives and

who have provided a larger context of this movement.[4] In this regard, our work is in conversation with a growing literature on Latinx art—including new or forthcoming works by Rocío Aranda-Alvarado, Deborah Cullen-Morales, and E. Carmen Ramos, among others—as well as with the growing archives of the US Latinx Art forum and The Latinx Project's digital publication *Intervenxions*, where readers can find original interviews and oral histories and new criticism of Nuyorican and Latinx artists. This being said, our volume is far from comprehensive, as there are many gaps and areas in need of further research. We hope this anthology inspires others to fill these gaps and to carve new paths of study. Our goal is that this interdisciplinary and collaborative project helps bring about the necessary change that allows these fantastic artists to get the attention and appreciation they legitimately deserve.

Part I of our anthology, "From Puerto Rican to Nuyorican: Forging Diasporican Art in New York," offers chapters on the history of the Puerto Rican art movement in New York, aka the Nuyorican movement. In particular, many of these chapters focus on underexamined art spaces that provided artists with communal platforms from which to address the long-standing ethnic, gender, and racial discrimination that Puerto Ricans and other Black and Latinx groups faced in New York.

Puerto Ricans artists have been migrating to the United States since the late nineteenth century; however, the effervescence of Puerto Rican activism in the visual arts occurred after the postwar migration of Puerto Ricans to New York, also known as the Great Migration. Subject to ethnoracial discrimination, Puerto Rican artists were practically invisible in New York until the late 1960s when a new generation of artists who were born and/or raised in the city became activists in civil rights struggles and affiliated themselves with radical groups such as The Young Lords Organization, the Puerto Rican Student Union, the Black and Puerto Rican Art Workers' Coalition, El Comité, the Puerto Rican Socialist Party, and the Puerto Rican Independence Party. Their rebellion evolved into a movement to establish alternative art spaces in their communities, transforming the politics of race, space, and representation in New York's cultural landscape.

Puerto Rican artists formed their own movement within the larger New York alternative art space movement. From the mid-1960s to late 1980s, artists from diverse backgrounds began operating nonprofit "alternative" galleries that enabled women, African American, LGBTQ, and Puerto Rican/Latin American artists to gain a measure of visibility and validation in the New York art world, whose hierarchical institutions were governed by Eurocentric,

patriarchal, and market-driven values.[5] The concentration of artists' lofts and galleries in SoHo made Lower Manhattan the alternative art space epicenter. Puerto Rican alternative galleries in SoHo were few in number since most of these artists were invested in rebuilding New York's barrios and operating in community-based art spaces in the neighborhoods in which they were raised.

Between 1969 and 1993, interlinked circles of Puerto Rican artists and poets formed collectives and founded an array of multidisciplinary art spaces in East Harlem/El Barrio, the Lower East Side/Loisaida, Lower Manhattan more generally, and in the South Bronx. Some of the notable groups and spaces that emerged during this era include the Real Great Society Urban Planning Studio (1968), Black and Puerto Rican Artworkers (1969), El Museo del Barrio (1969), Taller Boricua (1970), CHARAS (1970), United Graffiti Artists (1972), Institute of Contemporary Hispanic Art (1973), Nuyorican Poets Café (1973), En Foco (1974), Galería Tito/Moriviví (1974), Cayman Gallery (1975), The Alternative Museum (1975), Foto Gallery (1975), New Rican Village (1976), CHARAS/El Bohío (1979), Association of Hispanic Arts (1975), Caribbean Cultural Center (1976), Longwood Arts Project (1981), Exit Art (1982), Museum of Contemporary Hispanic Art (1985), Eventos: Space for Living Arts (1987), and the Clemente Soto Vélez Cultural and Educational Center (1993).

It is at this juncture that some discussion of the different terms that authors use to describe the movement and the art that arose within these spaces is needed. The visual artists who established the first alternative art spaces in East Harlem identified themselves as Puerto Rican and saw their spaces as serving the needs of the Puerto Rican artistic community in New York and beyond. In deference to these artists, Ramirez has termed their collective efforts the "Puerto Rican alternative art space movement." The founding of the Nuyorican Poets Café in 1973, along with the subsequent publication of the anthology *Nuyorican Poetry* by Miguel Algarín and Miguel Piñero in 1975, made the term *Nuyorican* widespread as an "alternative" name for Puerto Rican New Yorkers and a descriptor of the rebirth of Puerto Rican culture in the city, a hybridity that Nuyorican poets celebrated.[6] Although visual artists did not always apply the term *Nuyorican* to themselves or their work—some rejected the term outright—the decision of scholars in this anthology to use the terms *Nuyorican art* and *Nuyorican movement* is intended to uplift and validate the work of artists and poets who invented visual/verbal languages that portrayed the Puerto Rican identity as transnational, transhistorical, racially mixed, culturally hybrid, and unapologetically queer.[7]

Despite the significant number of collectives and alternative spaces that Puerto Rican artists operated, and the hundreds of exhibits, happenings, festivals, and demonstrations that occurred during the twenty-year span of the alternative art movement in New York, Puerto Rican alternative art spaces and the Nuyorican art movement remain largely absent from historical surveys of art movements in New York. Whereas mainstream dealers, curators, and critics are now inclined to visit shows of emerging artists at El Museo del Barrio and the *Artist in the Marketplace* at the Bronx Museum, Puerto Rican alternative art spaces were infrequently reviewed in the 1970s and 1980s, a fact that suggests that New York art critics foreclosed the possibility that vanguard work could be found in galleries that identified themselves as "community-based" or "Puerto Rican/Latino" (see figure I.2). Ironically, the interdisciplinary structure of Puerto Rican alternative spaces may have also contributed to their invisibility in the New York art world; one of the most important revelations in this anthology is that spaces renowned for poetry and theater like the Nuyorican Poets Café, the New Rican Village, and CHARAS/El Bohío were important venues for visual artists.

Scholarship on the alternative art movement has grown since 2000, but the underrepresentation of alternative spaces led by Puerto Rican artists remains the same in surveys such as *Alternative Art, New York, 1965–1985* (2002) and *Alternative Histories: New York Art Spaces, 1960–2010* (2012).[8] In what may be a once-in-a-decade tradition at this point, chapters by Ramirez, Hoyos-Twomey, Wilson Valentín-Escobar, and Pastor in this anthology further revise the history of the alternative art movement. Namely, this volume shows that Puerto Rican alternative art spaces comprised a movement within a movement that had specifically anti-racist foundations and aims where the focus was not only about achieving creative equity and accessibility, as is largely associated with the alternative space movement, but also about challenging the elitism and binary assumptions that marginalized artists of color more generally. As we will see, the vanguardist perspective of these artists and artivists echoes the Afro-diasporic positionality espoused by diaspora thinkers such as Arturo Schomburg, the Young Lords, and Marta Moreno Vega. This foreshadows the current attention to Black expressivity in Puerto Rican culture, both on the archipelago and beyond, that we're finally witnessing as part of larger movements toward equity and inclusion in the art world. One example is the exhibition *Puerto Rico Negrx* at the Museum of Contemporary Art in Puerto Rico (October 20, 2023–September 1, 2024), the largest institutional

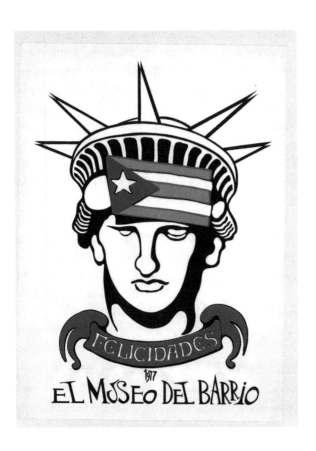

I.2 Domingo García, *Felicidades-El Museo del Barrio*,
 1977. Serigraph. Collection of El Museo del Barrio,
 New York.

exhibition of Black Puerto Rican artists (including Diasporican artists) in a major art museum on the archipelago.[9]

Chapters by Melissa M. Ramos Borges and Taína Caragol document the trajectories of two pioneering artist collectives that emerged in the mid to late 1960s. Ramos Borges focuses on Carlos Irizarry and Domingo López de Victoria, two New York–trained artists/*impresarios* who organized a series of exhibitions in New York and Puerto Rico that promoted Pop Art, hard-edge abstraction, and installation-based works. While this duo and their peers were working in styles that should have earned them international acclaim, Ramos Borges notes that Irizarry and López de Victoria were met with condescension from New York critics like Jay Jacobs, who dubbed their efforts

as outdated, and rejection from established artists on the archipelago that regarded them as foreigners. Determined to be accepted as Puerto Rican artists, Irizarry and López de Victoria remained on the archipelago for most of their lives, yet as Ramos Borges reminds us, they remain stigmatized as examples of "way out" artists in Puerto Rican history.

Caragol examines the early work of the printmaking collective Taller Boricua. Founded in 1969, incorporated as the Puerto Rican Workshop Inc. in 1970, and still operating today, Taller Boricua together with El Museo del Barrio hold pride of place as the first artist-run spaces in East Harlem, the cradle of the Puerto Rican diaspora. In contrast to scholarship that foregrounds the heroic agit prop posters that Taller members produced, Caragol draws attention to works of art by Marcos Dimas, Fernando Salicrup, Jorge Soto Sánchez, and Nitza Tufiño to explore the unique perspectives, experiences, and identities that emerge from their diasporic subjectivity. The breakthrough that Caragol credits these artists with making is to transform figures of historic rupture—the Indigenous Taino peoples as signifiers of colonial genocide—into polyvalent "figures of connection" (see figure I.3).

In their chapters, Ramirez, Valentín-Escobar, Hoyos-Twomey, Elizabeth Ferrer, and Pastor describe some of the collaborative relationships and overlapping agendas of alternative spaces that broke ground for the outpouring of art, activism, photography, poetry, and performance from the Puerto Rican artistic community in New York and beyond. They demonstrate that the artistic innovation and political interventions that occurred in these spaces was unprecedented and transformative. Within the alternative art world circuit, the boundaries between curators and artists and activists were blurred, enabling the display and validation of artistic practices and forms of expression that were new and radical at the time. Barrio-based alternative galleries became havens for artists whose aesthetic practices, political beliefs, race, ethnicity, gender, class, and sexual orientation positioned them as outsiders; within the liminal alternative art world circuit, a plurality of styles and conceptual approaches coexisted and became visible and viable to the public at large. In particular, Ramirez's chapter highlights that Nuyorican artists in the 1970s represent a vanguard because their innovation in several key elements is recognized as vanguardist artistic practices broadly. Specifically, she documents how these artists helped introduce new elements into New York's visual culture, in particular Afro-Taino iconography, as well as new content directed to an oppressed working-class minority that had not been prioritized as consumers and audiences for contemporary art. Finally, these artists also helped reshape

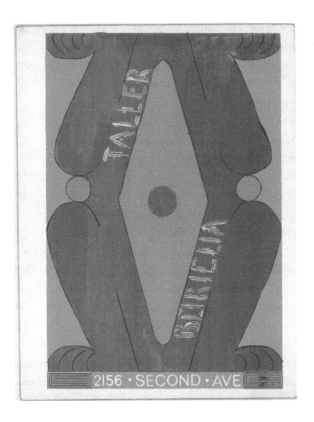

I.3 *Taller Boricua*, 1971. Silkscreen, 21 × 14⅝ in.
Collection of Marcos Dimas.

the production and distribution of art through the creation of alternative
spaces that valued underserved audiences and artists.

The proliferation of Nuyorican alternative art spaces detached the New
York art world from its moorings in wealthy districts on the Upper East
Side. Artist-run alternative galleries became sites for experiments and in-
terventions that destabilized hierarchical structures. Within the alternative
art world circuit, the boundaries between curators and artists and activists
were blurred, enabling artists to display and validate art forms and practices
that were unconventional and critical of societal and institutional norms.
Alternative art spaces thus became a support system for artists whose aes-
thetic practices, political beliefs, race, ethnicity, gender, class, and sexual
orientation positioned them as outsiders; within the liminal alternative art

world circuit, conceptual, feminist, political, performance, and identity-based art became visible and viable to the public at large.

The effervescence of these spaces is evident in chapters by Ramirez, Valentín-Escobar, Pastor, and Hoyos-Twomey, who delve into the wide-ranging artistic exchanges that occurred at MoCHA, Taller Boricua, the Nuyorican Café, the New Rican Village, and CHARAS/El Bohío. The emergence of these multidisciplinary alternative art spaces positioned artists and poets in the trenches of numerous battles waged by Puerto Rican, African American, and Asian community activists on behalf of the city's growing population of ethnoracial minorities to gain visibility in the civic sphere and assume community control of New York's public schools, universities, libraries, housing stock, health facilities, and cultural institutions.

As many of the chapters argue, a unique and unappreciated aspect of the Puerto Rican alternative art space movement, particularly at spaces like the Alternative Museum, Exit Art, and MoCHA, is that the artists not only shouldered the responsibility for creating the infrastructures to exhibit their own work—they also exhibited work by Latin American, Caribbean, Latino, African American, and Asian artists who faced similar discrimination in New York City. One must consider that Puerto Rican alternative spaces served diverse constituencies in the 1970s and 1980s and continue to do so today. In addition, while the local community was a primary audience, these galleries also served the mainstream art world by providing places for emerging artists of color to exhibit in New York and emerging curators of color to organize exhibits, including several authors in our anthology such as Caragol, Ferrer, Cullen-Morales, Ramirez, and Valentín-Escobar.

Cullen-Morales's chapter on the camaraderie that existed at Robert Blackburn's Printmaking Workshop makes an important intervention in the exclusionary practice of segregating "African American" and "Nuyorican/Puerto Rican" artistic circles in New York. Blackburn was trained in printmaking by Harlem Renaissance artists; his studio is renowned for nurturing African American artists. As Cullen-Morales demonstrates, he was equally invested in mentoring Nuyorican artists. Notably, Marcos Dimas and Fernando Salicrup, cofounders of Taller Boricua, studied with Blackburn at the School of Visual Arts. Blackburn's workshop was the site where artists such as Nitza Tufiño and Juan Sánchez created some of their best works in the 1980s and 1990s. Cullen-Morales notes that the inclusion of Blackburn, who was honored at the XLL Printmaking Biennial of San Juan, in Puerto Rico's printmaking lineage, affirms his role as overlooked but "crucial to the development of Nuyorican art."

Part II, "Diasporican Sites: Reports from the Field," champions some of the artists making a difference in the diaspora. This section demonstrates that Nuyorican is no longer adequate for a survey of the Puerto Rican diaspora and its art production. For decades the diaspora has expanded geographically and now doubles the population of the archipelago. Whereas Nuyorican could once adequately serve as a signifier for all Puerto Ricans in the diaspora, given the prominence and sheer concentration of the New York population, that is simply no longer the case as outmigration, gentrification, and other factors have led to the displacement and migration of Puerto Rican communities throughout the United States. In particular, activism around displacement and colonialism was fundamental to this conception of "the diaspora." We note here the importance of the Vieques movement to oust the US Navy from the island in the late 1990s, which coincided with the one-hundredth anniversary of the 1898 US invasion and followed the five-hundred-year anniversary of Christopher Columbus's arrival in the Caribbean. This movement provoked a broader reckoning with the colonial history of Puerto Rico, the oldest colony in the world. Likewise, Diasporican activism around the release of political prisoners and contemporary activism around Hurricane Maria has marked a growing transition to the development of a broader consciousness in which the Puerto Rican diaspora became less centered around New York City and the Northeast in general. These mobilizations appeal to a broader consciousness and recognize the diaspora at-large as a political force. *Nuyorican* is therefore a term in need of revision, even as we attempt to expand its resonance within the world of art. As such, in our anthology, we limit the term *Nuyorican* to describe New York Puerto Rican artists who came of age in New York during the post–civil rights era and to those artists who claim this identification today. Otherwise, we use *Diasporican*, a term inaugurated by poet Mariposa Fernández at the turn of the twenty-first century, to account for the sizable Puerto Rican communities that have emerged in new areas of the United States.

In geographical terms, Philadelphia, Chicago, and Florida are necessary areas of research and documentation, not only to combat erasure but to showcase a new generation of artists—some in transit via the *vaivén* (back and forth) that exists between Puerto Rico and the mainland, and others establishing art practices and participating in broader movements. At the same time, we remind readers that this was also the section that received fewer submissions and is unfortunately the least represented in our volume. To our surprise and alarm, we did not find published surveys about

Puerto Rican artists beyond NYC that could provide more background to supplement this section. However, it is important to acknowledge that while art historical sources on the art worlds of regions beyond NYC may be generally missing, Puerto Rican cultural activism has been long in the making in cities such as Chicago, Philadelphia and beyond.

We encourage readers to learn about the origins and development of the Puerto Rican Chicago community and the Young Lords in Chicago.[10] There are also scholars such as Ivis García and Nilda Flores-Gonzalez documenting the community activism that led to the institution of Paseo Boricua and the National Museum of Puerto Rican Art and Culture in Chicago.[11] Artists are also filling the void, as is the case of Edra Soto's The Franklin—a home garage she turned into a gallery and collaborative artists' space. By the time this volume is published, we will have also seen foundational exhibitions on Chicago diasporic artists at the Museum of Contemporary Art Chicago via the work of Puerto Rican curator Carla Acevedo-Yates.

For our anthology, we were grateful to receive Yomaira C. Figueroa-Vásquez's close readings of photographs by Frank Espada of an Afro–Puerto Rican family in Chicago. Noting that Black Puerto Ricans are marginalized by racism on the island and in the continental United States, Figueroa-Vásquez argues that Espada's photographs and taped interviews with the family have much to show us about ethical approaches to documenting the lived experience of overlooked populations. Additionally, in dialogue with the curatorial investigations that Carla Acevedo Yates is initiating at the Museum of Contemporary Art Chicago, Abdiel D. Segarra Ríos's chapter explores a network of Puerto Rican abstract artists who migrate between the island, New York, and Chicago to expose the theme of diaspora and abstraction and how artists perform and expand notions of Puerto Rican identity through their work.

Philadelphia is home to one of the most established Diasporican institutions, Taller Puertorriqueño, which is also one of the few local organizations that owns its building and has achieved a level of institutional sustainability that has been impossible for most organizations in New York City. In his chapter, Johnny Irizarry covers institution building in Philadelphia and discusses the diverse networks of artists who have been feeding community-based work in the region.

Raquel Reichard's chapter examines emergent artists and cultural organizations in Orlando, Florida, one of the fastest-growing Diasporican cities in the world. Orlando's first Puerto Rican boom came in the early 1990s and 2000s, when Boricuas on the archipelago fled financial crises

and Diasporicans in New York, Chicago, Philadelphia, and New Jersey left gentrifying neighborhoods to start over in Central Florida. Reichard observes that akin to how Nuyoricans in the 1960s introduced a culture of diasporic art and activism nearly three decades after Puerto Ricans began migrating to New York, the youth of the families who found refuge in Orlando and Kissimmee are beginning to create visual art that speaks to the struggles and joys in their homelands and their new homes. From the street art of locals like Don Rimx, public art initiatives by Mariah Román, photography by Nancy Rosado, and political illustrations by Ricky Rodriguez and Vanessa Flores, a new generation of Diasporican art is taking shape.

While we did not receive more submissions from other regional areas and cities across the United States, we are excited about emerging scholarship on Latinos in the Midwest, where Diasporicans are discussed alongside multiethnic communities across the region.[12] Consider, for instance, the *Latino Art Midwest* initiative by Alex E. Chávez and Gilberto Cardenas, specifically geared to uplifting knowledge of Latinx artists in the region, many of whom are Diasporican. In this volume, contributor Teréz Iacovino examines the placemaking practices of artists working in Minneapolis, Miami, and Philadelphia to explore how social, regional, and demographic considerations, among other variables, affect their Diasporican identities and art practices.

We also acknowledge a number of important university-based projects foregrounding Diasporican artists, such as La Estación Gallery, founded by the scholar Sandra Ruiz along with a group of queer women of color and feminists of color across the University of Illinois at Urbana-Champaign. In Austin, Texas, Diasporican scholar Ramón Rivera-Servera has been advancing Diasporican art through his Puerto Rican Arts Initiative (PRAI) since 2017. Initially founded to help artists rebuild after hurricanes Maria and Irma devastated the island, it has grown into a foundational project creating networks of exchange and collaboration between artists and scholars in the archipelago and the diaspora.

The chapters in part III, "All of the Above: Diasporican Aesthetics," provide close readings of the aesthetic practices and formal innovations of underrecognized artists. They also offer new proposals for documenting and reconceptualizing Puerto Rican identity, illustrating how artists expanded notions of art through their work. For instance, Urayoán Noel argues that self-published chapbooks and zines created by Nuyorican poets expand the field of what is considered "Nuyorican art." He argues against the disciplinary silos that obfuscate the significant intersections between

literary, visual, and performance arts across the Puerto Rican diaspora in the United States and traces an alternative history rooted in these intersections through avant-garde book art and performance.

Joseph Anthony Cáceres highlights the importance of Surrealism in the works of many Nuyorican artists. This section also reveals the power of oral histories and interviews with key founding figures in the movement and speaks to a general trend in alternative art history where it is people's memories, stories, and archives (rather than in official sources, museums, and libraries) where scholars must search to reconstruct the missing pieces of American art histories. In particular, Cáceres draws from interviews and conversations with Lois Elaine Griffith, an Afro-Caribbean diasporic artist of Barbadian descent and one of the founders of the Nuyorican Poets Café, to establish linkages between the movement's connection to surrealism, Yoruba religious practices, and the work of Nuyorican visual artist Jorge Soto Sánchez.

Rojo Robles examines SAMO© (1978–80), the conceptual art intervention by Jean-Michel Basquiat and Al Díaz. Presented simultaneously as a tag and a corporate entity, SAMO©'s messages, spray-painted on Manhattan walls, used cryptic ironic tones that questioned our dependency on products and artificial brainwashed lifestyles. While Basquiat left the project in 1980 and declared that SAMO© was dead, Díaz resuscitated the text-based graffiti in 2016. Robles's chapter examines how Díaz has actualized the conceptual project by tackling current neoliberal political issues, notably with the processes of commodification and co-option of Afro-Boricua aesthetics and hip-hop culture.

In addition, Arnaldo M. Cruz-Malavé and Kerry Doran examine the spectacularity of Nuyorican art. Doran focuses on the class-hierarchy breaking and critical perspective of artist Wanda Raimundi-Ortiz, who performs as an avatar-like version of herself to challenge the racism and elitism of the art world. Cruz-Malavé, in turn, focuses on David Antonio Cruz and Luis Carle to make an argument about how Nuyorican artists have long challenged socially enforced respectability through the performative aesthetics of their work. Queer and performance studies take center stage in these analyses into alternative ways to read the visual work and contributions of these artists.

This section shows how Nuyorican visual art in this period manifests in images the concepts and feelings that were revolutionary and beyond words at the time. Nuyorican poetry invented language to convey a consciousness that Puerto Rican nationhood transcends, authenticating boundaries that limited nationality and identity to geographical boundaries. Visual artists

did the same, drawing from and uplifting the most marginalized components of Puerto Rican identity—such as Afro-Taino iconography and urban vernacular culture, as this volume evinces. Arguably the most impactful work of this movement results from cross-disciplinary collaborations between Nuyorican poets and visual artists who prefigure our century's concerns with diasporic aesthetics and decolonial praxis.

Finally, Johana Londoño and Rojo Robles look at Nuyorican interventions in public spaces—from street art to the Nuyorican casitas—to explore the role of Nuyorican art in graffiti arts, architecture, and design history more broadly. In particular, Londoño centers Nuyorican history within design history to point scholars to pay more careful attention to the work and value of vernacular architecture and to its transformative impact on urban space. Her chapter not only delves into the aesthetics of gentrification but also underscores the crucial importance of recognizing and evaluating Nuyorican/Diasporican aesthetics as a subject deserving serious study and consideration.

The conclusion by Arlene Dávila explores the spatial politics involved in the work of four artists whose practices show how much political/economic considerations have come to bear in their art practices. Just like Nuyorican artists fought for real estate in the arts/cultural ecosystem, challenging the racism and elitism of the New York City art establishment to establish alternative spaces, artists today continue to struggle for space, especially amid the rapid neoliberal gentrification of contemporary cities. They do so on behalf of multidiverse communities of color in New York City and beyond, as is evident in the work of activist artists Shellyne Rodriguez, Rigoberto Torres, Lee Quiñones, and Danielle De Jesus.

Finally, in the spirit of encouraging more work on this topic, we humbly note the shortcomings that surfaced through our call. We are excited that women artists such as Sophie Rivera and Nitza Tufiño have received some attention through recent exhibitions, such as in the Brooklyn version of the traveling exhibition *Radical Women: Latin American Art 1960–1985* (2018) and *Domesticanx* at El Museo del Barrio (2023) (see figure I.4). Yet we recognize that women artists remain undocumented relative to their male counterparts. Likewise, there is a dearth of substantive scholarly research on foundational Puerto Rican artists. Take, for example, Jorge Luis Rodriguez, who exhibited at MoCHA and JAM gallery and internationally, artists who worked on abstraction such as Evelyn López de Guzmán, or even Juan Sánchez, who is one of the most well-known Nuyorican artists and subject of important scholarship yet is seldom known in the archipelago.[13] Likewise,

I.4 Sophie Rivera, *Untitled*, 1978 (printed in 2006). Gelatin silver print, sheet, and image, 48 × 48 in. Smithsonian American Art Museum, Washington, DC. Museum purchase through the Luisita L. and Franz H. Denghausen Endowment, 2011.24.1, © 1978, Sophie Rivera.

we need more work on experimental film, architecture, and design as well as documentation and criticism of both foundational pioneers and contemporary artists to halt their historical erasure in the scholarly literature.

Most of all, there is a huge void of research on Diasporican artists and artistic communities beyond New York City more generally. A key takeaway of our public call was the difficulty of finding contributors who explored Diasporican artists beyond the major city centers of Philadelphia, Chicago, and Orlando. As mentioned, we feel this gap in the literature reveals the significance of having access to institutional infrastructures for artistic communities to develop and thrive, underscoring the need for

more equitable arts/cultural policies that make artistic and cultural opportunities and resources more freely accessible across the United States.

Together, the chapters in this collection make clear and bold statements. First, the history of Nuyorican and Diasporican artists is rich and complex, and any project, exhibition, or art history of the Americas that does not center or engage with the evolving community of Nuyorican/Diasporican artists and interdisciplinary scholars will remain forever uninformed and incomplete. Second, we have a clear foundation for appreciating Nuyorican/Diasporican art history; although, we are barely getting started. We need and hope that more scholars and writers continue the work, among the areas we've identified as well as others we may not have even imagined.

NOTES

1 See Dávila, *Latinx Art*, particularly chapter 3, "Nationalism and the Currency of Categories," on the nationalist dimensions of the global contemporary art market; and Zavala, "Latin@ Art at the Intersection." These works show how distinctions are sustained by the nationalist biases that influence the organization of art history, exhibitions, and collections, and by the lack of institutional spaces devoted to the study, archiving, and exhibition of Latinx artists in the United States.

2 Conversation with art historian Adriana Zavala, director of the US Latinx Art Forum (http://uslaf.org), October 19, 2023.

3 Thanks to Al Hoyos-Twomey for this insight, corroborated through interviews with librarians of the special collections for NYU's Fales Library on November 6, 2023.

4 Some key examples include Cahan, *Mounting Frustration*; Cardalda Sánchez and Tirado Avilés, "Ambiguous Identities!"; Fernandez, *Young Lords*; Fusco, *English Is Broken Here*; Jaime, *Queer Nuyorican*; Jones, *Basquiat*; Indych, "Nuyorican Baroque"; Londoño, *Abstract Barrios*; Morales; Negrón-Muntaner, "Look of Sovereignty"; Noel, *In Visible Movement*; Noriega, "Sacred Contingencies"; Ramirez, "Place for Us"; Ramirez, "Activist Legacy"; Rivera, *New York Ricans*; and Ruiz, *Ricanness*. We also acknowledge Tatiana Reinoza's 2023 study of the Taller Boricua Print Workshop, which she appraises in relation to a larger history of print workshops across the Americas, as the type of art historical comparative work that is needed for this movement. Reinoza, *Reclaiming the Americas*.

5 Ault, *Alternative Art*.

6 Algarín and Piñero, *Nuyorican Poetry*.

7 On the queer aesthetics of the Nuyorican movement, see Jaime, *Queer Nuyorican*.

8 Ault, *Alternative Art*; Rosati and Stanieszewski, *Alternative Histories*. These chronological surveys exclude some of the most important alternative Puerto Rican institutions at the time, such as CHARAS/El Bohío, the New Rican Village, and the Nuyorican Poets Café.

9 Vargas Rodriguez, "'Puerto Rico Negrx.'"

10 See Pérez, *Near Northwest Side Story*; and Fernandez, *Young Lords*, as examples.

11 See García, "No Se Vende"; Flores-Gonzalez, "Paseo Boricua"; and Pallares and Flores-González, *¡Marcha!*

12 See Delgadillo et al., *Building Sustainable Worlds*, which compiles work by key scholars working on Latinos in the Midwest.

13 Zavala, "Juan Sanchez's Counter-Archive."

BIBLIOGRAPHY

Algarín, Miguel, and Miguel Piñero. *Nuyorican Poetry: An Anthology of Puerto Rican Worlds and Feelings*. New York: Morrow, 1975.

Aranda-Alvarado, Rocío, and Deborah Cullen-Morales, eds. *A Handbook of Latinx Art*. Documents in Art. Berkeley: University of California Press. Forthcoming.

Aranda-Alvarado, Rocío, Raymond Hernández-Durán, and E. Carmen Ramos, eds. *The Routledge Companion to Latinx Art*. New York: Routledge. Forthcoming.

Ault, Julie. *Alternative Art, New York, 1965–1985: A Cultural Politics Book for the Social Text Collective*. Minneapolis: University of Minnesota Press, 2002.

Cahan, Susan E. *Mounting Frustration: The Art Museum in the Age of Black Power*. Durham, NC: Duke University Press, 2016.

Cardalda Sánchez, Elsa B., and Almícar Tirado Avilés. "Ambiguous Identities! The Affirmation of Puertorriqueñidad in the Community Murals of New York City." In *Mambo Montage: The Latinization of New York City*, edited by Arlene M. Dávila and Agustín Laó-Montes, 288–315. New York: Columbia University Press, 2001.

Dávila, Arlene M. *Latinx Art: Artists, Markets, and Politics*. Durham, NC: Duke University Press, 2020.

Delgadillo, Theresa, Ramón H. Rivera-Servera, Geraldo L. Cadava, and Claire F. Fox. *Building Sustainable Worlds: Latinx Placemaking in the Midwest*. Urbana: University of Illinois Press, 2022.

Fernandez, Johanna. *The Young Lords: A Radical History*. Chapel Hill: University of North Carolina Press, 2020.

Flores-Gonzalez, Nilda. "Paseo Boricua: Claiming a Puerto Rican Space in Chicago." CENTRO *Journal* 13, no. 2 (2001): 7–23.

Fusco, Coco. *English Is Broken Here: Notes on Cultural Fusion in the Americas.* New York: New Press, 1997.

García, Ivis. "No Se Vende (Not for Sale): An Anti-gentrification Grassroots Campaign of Puerto Ricans in Chicago." *América Crítica* 3, no. 2 (2019): 35–61.

Indych, Anna. "Nuyorican Baroque: Pepón Osorio's Chucherías." *Art Journal* 60, no. 1 (2001): 72–83.

Jaime, Karen. *The Queer Nuyorican: Racialized Sexualities and Aesthetics in Loisaida.* New York: New York University Press, 2021.

Jones, Kellie. *Basquiat.* Brooklyn, NY: Brooklyn Museum, 2005.

Londoño, Johana. *Abstract Barrios: The Crises of Latinx Visibility in Cities.* Durham, NC: Duke University Press, 2020.

Morales, Ed. *Latinx: The New Force in American Politics and Culture.* London: Verso, 2019.

Negrón-Muntaner, Frances. "The Look of Sovereignty: Style and Politics in the Young Lords." In *Sovereign Acts*, 254–82. Tucson: University of Arizona Press, 2015.

Noel, Urayoán. *In Visible Movement: Nuyorican Poetry from the Sixties to Slam.* Iowa City: University of Iowa Press, 2014.

Noriega, Chon A. "Sacred Contingencies: The Digital Deconstructions of Raphael Montanez Ortiz." *Art Journal* 54, no. 4 (1995): 36–40.

Pallares, Amalia, and Nilda Flores-González, eds. *¡Marcha! Latino Chicago and the Immigrant Rights Movement.* Urbana: University of Illinois Press, 2010.

Pérez, Gina M. *The Near Northwest Side Story: Migration, Displacement, and Puerto Rican Families.* Berkeley: University of California Press, 2004.

Ramirez, Yasmin. "The Activist Legacy of Puerto Rican Artists in New York and *The Art and Heritage of Puerto Rico*." ICAA *Documents Project Working Papers* 1, no. 1 (2007): 46–53.

Ramirez, Yasmin. "'. . . A Place for Us': The Puerto Rican Alternative Art Space Movement in New York." In *A Companion to Modern and Contemporary Latin American and Latina/o Art*, edited by Alejandro Anreus, Robin Adèle Greeley, and Megan A. Sullivan, 281–95. Hoboken, NJ: Wiley-Blackwell, 2022.

Reinoza, Tatiana. *Reclaiming the Americas: Latin Art and the Politics of Territory.* Austin: University of Texas Press, 2023

Rivera, Raquel Z. *New York Ricans from the Hip Hop Zone.* New York: Palgrave Macmillan, 2003.

Rosati, Lauren, and Mary Anne Staniszewski. *Alternative Histories: New York Art Spaces, 1960 to 2010.* Cambridge, MA: MIT Press, 2012.

Ruiz, Sandra. *Ricanness: Enduring Time in Anticolonial Performance.* New York: New York University Press, 2019.

Vargas Rodriguez, Shakira. "'Puerto Rico Negrx,' la primera exhibición institucional en el país que presenta a artistas negros en un contexto histórico." *El*

Nuevo Día, October 20, 2023. https://www.elnuevodia.com/entretenimiento
/cultura/notas/puerto-rico-negrx-la-primera-exhibicion-institucional-en-el
-pais-que-presenta-a-artistas-negros-en-un-contexto-historico/.

Zavala, Adriana. "Juan Sanchez's Counter-Archive." *American Art* 37, no. 2
(2023): 54–81.

Zavala, Adriana. "Latin@ Art at the Intersection." *Aztlán: A Journal of Chicano
Studies* 40, no. 1 (Spring 2015): 127–42.

FROM PUERTO RICAN
TO NUYORICAN

FORGING DIASPORICAN ART
IN NEW YORK

1

The Way Out = Left Out?

Paradoxes of Puerto Rican Avant-Garde Art

Melissa M. Ramos Borges

Included in "the way-out group," a term coined by the US art critic Jay Jacobs in 1967, Carlos Irizarry (1938–2017) and Domingo López de Victoria (1942–2024), among others, produced works that were divergent from their Puerto Rican contemporaries, setting them apart from artists of the same generation brought up on the archipelago.[1] Their ability to come and go from New York to Puerto Rico produced a network of exchange with three art scenes: the Puerto Rican, New York, and diasporic Puerto Rican communities. Although they exhibited their works in all these scenes, their efforts and works have been overlooked.[2] In turn, Puerto Rican

and Diasporican art history has focused on prioritizing artists whose works reflect their cultural experience, reinforcing the constructed "national" discourse whose intent was to create a monolithic cultural and visual identity. This chapter analyses the art criticism discourse, the art market, and the role that national privilege plays in the construction of said identity.

Although the term *avant-garde* began to be employed in Puerto Rico by the mid-1960s, its genesis can be traced to exiled Spanish intellectual Eugenio Granell, who taught in the Department of Fine Arts at the Universidad de Puerto Rico, Río Piedras (UPRRP, by its Spanish initials) from 1950 to 1957. Granell instilled the Surrealist approach to all aspects of life in his disciples, who organically created Mirador Azul, the first avant-garde front documented in Puerto Rican art historiography.[3] Out of this group of disciples, Rafael Ferrer (b. 1933) and Roberto "El Boquio" Alberty (1930–1985) would come to exemplify the first facet of avant-garde art in Puerto Rico, one rooted in Surrealist and Dadaist thought.[4]

This new approach to art making broke the foundations of Puerto Rican art and was confronted with resistance from established local artists, known as the Generación del 50.[5] Their "nationalistic school" philosophy defended the figurative, political, and socially committed ideologies of Mexican muralists' social realism school, which in turn created images that constructed and affirmed *a* Puerto Rican identity. The ideological dissonance between the groups was palpable, as artist José Antonio Torres Martinó expressed: "La polémica, más inventada que real, era encarnizada, al punto de que algunos de acá se consideraban enemigos irreconciliables de algunos de los de allá y viceversa" (The controversy, more invented than real, was fierce, to the point that some people here considered themselves irreconcilable enemies of some people there, and vice versa).[6]

Unsurprisingly, the second wave of avant-garde artists on the island was also confronted with the same opposition. By the mid-1960s, art critics in Puerto Rican newspapers used avant-garde as an umbrella term that encompassed works of Op art, Kinetic art, Pop art, Conceptual art, shaped-canvas, Hard-edge, Experimental art, happenings, Junk art, Neo-Dada, and installation. The main goal of this chapter is to reintroduce the work of the groundbreaking Puerto Rican–born New York–raised second-wave avant-garde artists and their agency in bridging the San Juan and New York art scenes.

"Jes an'now from Noo Jork"

Roberto Alberty arrived in New York City in 1961 and, along with Dia-
sporican artists Domingo López de Victoria, Jorge Mendoza (1944–2021),
and Juan Spinet, opened in 1965 what art historian Sandra Cintrón Goitía
identified as the first exhibition space for Puerto Rican artists in New York.[7]
Galería El Morro was located in the West Village, which at the time was the
hub of the counterculture in New York, undergoing a vibrant art, music,
literary and political revival. The exhibition space was outside the East Har-
lem/El Barrio Puerto Rican community, which might point out the artists'
concerns with inserting Puerto Rican artists in the dominantly white-Anglo
art scene in New York. Alberty stated: "El Morro Gallery también es una
citadela, en este caso sitio de albergue y de defensa para nuestros artistas,
ya que en parte por prejuicio, en parte por ser su situación económica pre-
caria le es muy difícil encontrar donde exponer sus obras: anhelo y deber de
todo pintor" (El Morro Gallery is also a citadel, in this case a place of shelter
and defense for our artists, because, partly due to prejudice and partly due
to their precarious economic situation, it is very difficult for them to find a
place to exhibit their works: the aspiration and duty of every painter).[8] Al-
though almost no information about the short-lived Galería El Morro has
been found, it can be considered as the genesis of the Diasporican avant-
garde artists' efforts to visibilize an otherwise invisible artistic community.
Furthermore, its entrepreneurial spirit to establish artist-run spaces became
the standard for the diasporic avant-gardes in Manhattan and Puerto Rico.

Galería El Morro was succeeded by Puerto Rico Gallery (APRAG, Aspira
Puerto Rico Art Guild) in 1966, under the Puerto Rican organization ASPIRA,
and was located at 1974 Broadway.[9] Puerto Rico Gallery's inauguration was a
collective exhibit by the previously mentioned Mendoza and López de Vic-
toria as well as by Joaquín Mercado (1940–2003) and displayed works "de
tipo representativo, unas, y abstractas modernistas, otras, reflejan la capa-
cidad e inquietud juvenil de sus autores" (some are representational, while
others are abstract modernist, reflecting the talent and youthful restlessness
of their creators).[10] The name of the gallery, as well as the artists identify-
ing as *borincanos*, emphasizes the artists' cultural identity as the diasporic
desire to connect to the motherland and reaffirms that the diasporic com-
munity infrastructure was not yet articulated formally. Whichever the
reason, national identity was not tied to an aesthetic discourse, like it had
been argued in Puerto Rico, where social realism would be the vessel of the
nationalistic discourse of visual arts like the Generación del 50 had laid out.

The issue of identifying as Puerto Rican in a host community outside the archipelago constituted an identity crisis of the Diasporican avant-gardes. On the one hand, within the Puerto Rican community in New York, they were considered Puerto Rican; yet in other circles they were not, as it can be understood in López de Victoria's remarks on the complexities of the Diasporican experience:

> At the beginning of 1966, when we were both in New York, we founded, together with Joaquín Mercado and Jorge Mendoza a gallery named Aspira, in order to have a place where the Puerto Rican artists then living in New York, as well as those coming to New York, would/could exhibited [sic] their works. After a couple of shows there we decided to come back home, because *we wanted to be known as Puerto Rican artists, and not New Yorkers, the way people who came to visit Aspira Gallery wrongly considered us.*[11]

This group of artists wanted to showcase the work of Diasporican artists but also bridge the two communities by providing an exhibition space for artists living and working in Puerto Rico. What is not clear is *who* considered the APRAG artists as New Yorkers; was it Puerto Ricans on the archipelago? This could be the case, since it is notoriously known that homeland Puerto Ricans at that time met with estrangement those living outside the archipelago because they were wrongly considered as culturally assimilated, losing their ethnic identity, among other social class-based issues.

"Me hacía falta algo y yo sabía que ese algo era sentirme que era un artista puertorriqueño"

After almost twenty years of living in New York, Carlos Irizarry relocated to San Juan in 1966, along with his wife, Monina. Irizarry's motivation for returning to Puerto Rico was clear: "'Yo quiero ser conocido como un artista de Puerto Rico. Quiero identificarme con mi gente y con mi tierra'" (I want to be known as an artist from Puerto Rico. I want to identify with my people and my land).[12] Two months after his return, Irizarry established Galería 63 in Old San Juan, which promoted Op art, shaped-canvas, and Hard-edge paintings produced in Puerto Rico, proving avant-garde artists' interest in inserting themselves within the island's art scene.[13]

Galería 63's inaugural exhibition was a monographic show by Irizarry, where he presented the diversity of retinal explorations in Op art: black and

white lines or curved shapes creating uniform geometric patterns on a flat background (see figure 1.3). Irizarry's exhibit was followed by López de Victoria's second solo show in Puerto Rico, where he exhibited drawings, collages, preparatory work, and shaped-canvas paintings. Even though the show was scantly reviewed by media outlets in Puerto Rico, the *San Juan Star* published photographs that documented the works exhibited: trapezoids, diamonds, and triangles, among other geometric forms, in which the artist explored concepts related to the fourth dimension of space-time and Newton's Law of Opposites, creating a visual language in which López de Victoria attributes physical concepts of space-time to geometric shapes and flat colors.[14]

The group show *La nueva plástica* (1966) rallied up avant-gardes active in San Juan, such as Jesse Liss (1939–2003), Richard Pritts, Elí Barreto (b. 1945), Domingo García (1932–2022), Irizarry, and López de Victoria. The exhibition's threefold opuscule, a recent discovery, includes a list of the nineteen works exhibited and photos of the artists alongside their Op art, Hard-edge, or abstract geometric artworks.[15] Galería 63's role in the advancement of avant-garde art generated opposition, as Irizarry stated: "It created controversy with figures like Lorenzo Homar and Tufiño because at that time they were very traditional. But after a while, the tradition was broken. It all began with Gallery 63 the gallery I founded when I first returned to Puerto Rico."[16]

The older generation's aversion could also be rooted in the nuance of the title itself, which could be interpreted as an act of defiance. In Spanish, *plástica* is also a synonym for art. Was the group declaring a shift from the figurative style of the previous generation to a new visual language with *foreign* references?[17] Was it a case of "out with the old, in with the new"? Or were they suggesting the literal use of the word *plástica*, pointing to the contemporary materials—Plexiglass, as was the case with Barreto's sculptures—used to create their works, influenced by the new styles arising internationally?

"Estábamos buscando entrar a una dimensión internacional. Aquí todo el arte era figurativo en ese momento"

In April 1967, Irizarry visited Tibor de Nagy gallery, renowned for exhibiting young progressive artists in New York, where he spoke to the gallery's then director, John Bernard Myers.[18] Myers offered to present the collective *La nueva abstracción*, with works by Irizarry, López de Victoria, and

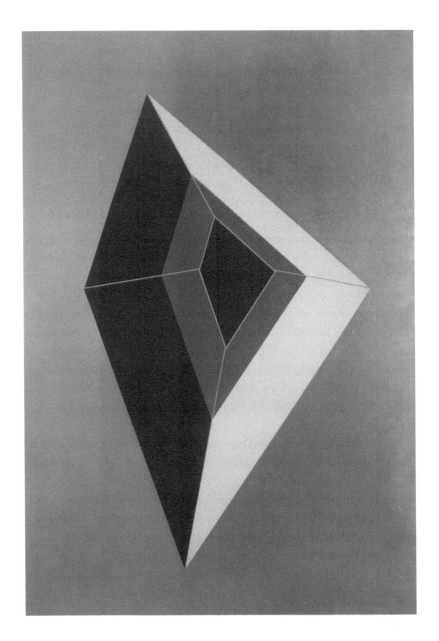

1.1 Carlos Irizarry, *Etcetera*, 1969. Silkscreen on aluminum sheet, 30 × 22 in. Private collection.

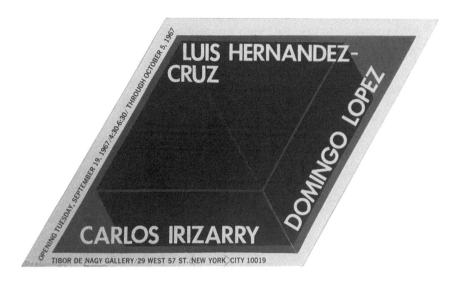

1.2 *La nueva abstracción invitation*, 1967. Collection of the Art Museum of the Americas Archive, Washington, DC.

Luis Hernández Cruz (b. 1936), in September 1967.[19] Again, the title can be interpreted as another act of defiance: prioritizing the use of the Spanish language to differentiate and highlight their cultural "otherness" from other artists exhibiting in the Lower East Side gallery. Through Hernández Cruz's connections with the cultural "establishment" in Puerto Rico, the artists received sponsorship from the Instituto de Cultura Puertorriqueña (ICP): shipping costs and advertising funds in *theARTgallery Magazine*, *ARTnews*, *ArtForum*, and *Art International*.[20] The show was reviewed by Charlotte Willard of the *New York Post* and in *Art in America* by art critic Grace Glueck, who commented: "The trio . . . might be called canvas shapers who work with hard-edge imagery. Lopez' thrusting wing-like forms, some on acrylic panels, evoke the speed of outer-space flight; Cruz's dots and grids give his work a slightly op quality; Irizarry's curved cut-out and repetitive bars seem to hark back to the *art moderne* forms of 1930s architecture."[21]

Both Irizarry and López de Victoria presented shaped-canvas paintings using Plexiglas panels as support, cutting them into dynamic geometric forms and later painting them with enamel spray paint (see figure 1.2). Irizarry's five pieces were informed by geometric shapes and mathematical theories, as can be appreciated in *Homage to Albers* (1967). In it, the artist used

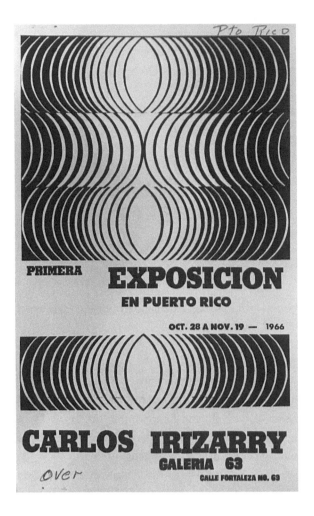

Pto Rico

PRIMERA **EXPOSICION**

EN PUERTO RICO

OCT. 28 A NOV. 19 — 1966

CARLOS IRIZARRY

over GALERIA 63

CALLE FORTALEZA NO. 63

1.3 Invitation for Carlos Irizarry's one-man exhibition at Galería 63, San Juan, Puerto Rico, 1966. 5 × 7 in. Art Museum of the Americas Archive, Washington, DC. Photo by Melissa M. Ramos Borges.

two Penrose triangles joined at their base to create a parallelogram-shaped painting surface and used tints and tones of a coral orange hue delimited by thin black lines. Unfortunately, no information has been uncovered about López de Victoria's triptych *Changes of Time I* and diptych *Changes of Time II*. Hernández Cruz exhibited five mixed-media works: integrating wood pegs and gesso stamped with mosquito netting or chicken wire mesh, creating two grid patterns, and exploring materiality and texture.

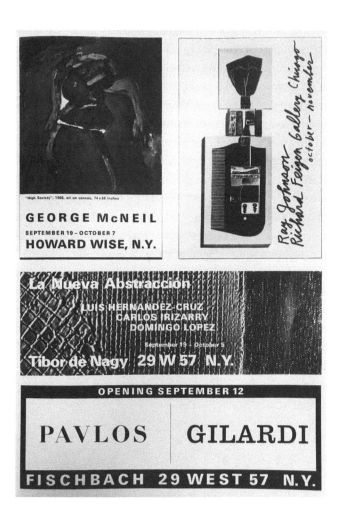

1.4 *La nueva abstracción* advertisement published in *Art in America*, 1967. Newspaper and Magazine Collection, Biblioteca Francisco Oller, Escuela de Artes Plásticas y Diseño, San Juan, Puerto Rico.

Although the exhibition received media coverage and I found the exhibition's invitation (see figure 1.2), a *New York Times* "In the Art World" section mention, and the advertisements published in art magazines previously mentioned in this chapter (see figure 1.4), very little is known about the exhibition. The Puerto Rican collective has been removed from history, and no further proof is needed than the catalog celebrating the gallery's fifty-year trajectory: there is no mention of the exhibition in this chronology

of exhibitions.[22] However, in the gallery's historical archives, housed at the Archives of American Art in Washington, DC, I discovered that the communications between the artists and the gallery, photographs of the exhibited works, and other documentation were erroneously archived.[23]

Tibor de Nagy's exhibit almost coincided with the now infamous "Art in Puerto Rico" article published in *theARTgallery Magazine* Puerto Rico edition of December 1967, where the term *way-out group* was originally coined. Jay Jacobs's essay became a controversial issue in the local art scene: it is a stark and sometimes heartbreaking view of the art scene of the day.[24] Jacobs criticized the artists of Generación del 50 for being out of tune with contemporary art styles and offered a glimpse of the public's reception to the new avant-garde generation, stating: "Those painters and sculptors working in the prevailing modes of the late 1940s consider themselves (and are considered) avant-garde artists, while the very few who are only two or three seasons off the pace are, as far as most Puerto Rican aficionados are concerned, lost in outer space."[25] Although he considered these artists to be a few "seasons off the pace," Jacobs noted that the work of Carlos Irizarry, Domingo López de Victoria, Luis Hernández Cruz, and Domingo García was truly contemporary art on the island. He labeled them as *way-out*, another nuanced term that can be interpreted as either an exit or as unconventional. The author saw them as a departure from the realist socialist aesthetic that dominated the visual arts and as the closest thing to the international avant-garde due to their experimental nature. However, being part of the *way-out group* brought its own concerns, as Irizarry eloquently expressed in Jacob's article: "The Puerto Ricans won't accept us yet. The Latin Americans think we're not ready for *them* yet they tell us to show with the *North* Americans. We're always told by the people down here to paint like Puerto Ricans, but nobody knows what Puerto Ricans paint like."[26] Irizarry expressed the displacement he and his peers felt on three fronts: Puerto Rico, Latin America, and the United States. Where were they intended to fit in, if they were not considered "enough" in any of the three art scenes associated with Puerto Rico and its artists?

Two years after the controversial Jacobs article, Irizarry relocated once again to New York City, where he was adamant about bridging the avant-garde art scene of New York with San Juan; yet his work as a cultural agent would confront him with the reality of the Puerto Rican experience in New York.[27] After signing a two-year lease on March 1969, he opened Puerto Rican Art, a gallery located at 43 East Eightieth Street in Manhattan, with "planes para mostrar la producción creativa de artistas puertorriqueños tanto de la

isla como de los que residen en esta enorme metrópolis" (plans to showcase the creative output of Puerto Rican artists, both from the island and those residing in this vast metropolis).[28] As happened with other exhibitions discussed in this chapter, there is very little information; the only surviving documentation I found was a catalog/magazine publication titled *Puerto Rican Art Program May 1969*.[29]

What did produce considerable media coverage were the events that transpired after opening day: Irizarry received a letter from Ms. Esther Rosen, the real estate broker, requesting the gallery's street sign be removed and altered, "que solo pusiera en el mismo 'Galería de Arte' o 'Galería Carlos Irizarry,' eliminando el nombre 'Puerto Rican' . . . le indicó a él que si no quitaba el rótulo de la marquesina 'lo vamos a echar del edificio con galería y todo'" (that he should just put 'Art Gallery' or 'Carlos Irizarry Gallery,' removing the name 'Puerto Rican' . . . he was told that if he didn't remove the sign from the marquee, 'we're going to kick him out of the building, gallery and all).[30] Although the Puerto Rican press expressed their rejection of the landlord's racist actions, a recently found letter from artist Lorenzo Homar to Bill Lieberman reveals that the Generación del 50 artist was skeptical of the incident.[31] Homar wrote:

> He must have some very good backing on [*sic*] he could not have the location he now has. This is about as much as I know about the project although I did give him a couple of my things for the opening show. Perhaps you have heard that he now faces eviction even if the next two months rent has been paid. Apparently his landlord does not like the huge, (not in very good taste) sign that reads Puertorrican [*sic*] Art. I say not in very good taste because I like good signs ans [*sic*] his is not. However he came to see me this week, as well as Marín who opens the next exhibition of drawing this week. I only write hoping you can give him some sound advice, that is all. Personally I do not like all the touristic balony in the opening program but it is none of my business.[32]

In this letter, Homar dismissed the racist and xenophobic attitude denounced by Irizarry and seemed to side with the landlord's plea to alter the sign because of "aesthetic" reasons. Homar's stance is complicated to understand. On the one hand, Homar supports Irizarry and the project, participating in the inaugural exhibition and reaching out to an important figure in the New York art scene. On the other hand, he resorts to backhanded

compliments that minimize Irizarry's struggle, criticize his work, and diminish his effort. Furthermore, Homar spoke under the protected mantle of national privilege: his intentions were never questioned or challenged, whereas Irizarry's, as a Diasporican, were.

Irizarry filed a complaint stating a case of discrimination at the New York State Division of Human Rights, which determined the sign should remain as it was until a preliminary hearing was held. In the meantime, Irizarry flew to Puerto Rico to ask for funding from then governor Luis A. Ferré when he received an eviction notice on the grounds that the rent was allegedly two weeks behind. With the help of the entity Rescate, Irizarry sent a payment for May and June.

Puerto Rican associations on the island and in New York expressed their rejection of the discriminatory actions against Irizarry.[33] Concurrently, the Puerto Rican community in New York was also facing similar biases and was filing discrimination cases against real estate firms for their unwillingness to rent on account of "there were already too many Puerto Ricans in the building."[34] Lester Properties Inc. was ordered to apologize at Irizarry's preliminary hearing.[35] Alas, although the court ruled in his favor, no other exhibition was presented in Puerto Rican Art, or at least no further information has been found, which can indicate that the gallery closed its doors soon after the ruling.[36]

Irizarry returned to Puerto Rico in late 1969 but continued his relationship with the New York art scene, participating in collective exhibitions at Hundred Acre Gallery and Rosa Esman Gallery as well as in the *Artist as Adversary* exhibition organized by Betsy Jones for the Museum of Modern Art. The 1970s would prove to be a pivotal decade for avant-garde art in Puerto Rico. López de Victoria, Irizarry, Joaquín Mercado, and Suzi Ferrer, among others, produced works ranging from Pop art to conceptual installations in Puerto Rico omitted from the "official" art historical narrative discourse, seeing as how the avant-garde was condemned as cultural assimilation. This belief was rooted in Generación del 50 and their disciples' aesthetic and ideological resistance to adopting avant-garde styles as a pro-independence strategy.[37]

"We were highly criticized . . . for doing art that was *not Puerto Rican*"

The efforts of avant-garde diasporic Puerto Rican artists in managing artist-run spaces or participating in exhibitions in mainstream galleries in New York City during the mid to late 1960s could suggest that their attempts

were short-lived in part due to the lack of community infrastructure—which was developed years later thanks in part to the Nuyorican movement of 1969.[38] Consequently, these artists returned to Puerto Rico, probably thinking that the island's art scene would provide the support needed to prosper as an artist. Nonetheless, they were surprised by the prejudice and pushback from the public and from fellow artists working on the island, who thought of them as "non-Puerto Ricans" due to their avant-garde works.

As mentioned previously, the Puerto Rican school was defined as imaging Puerto Rican subjects through figurative art; therefore, the avant-garde conjured polemics of what was, in fact, the Puerto Rican identity. Irizarry and López de Victoria addressed and confirmed just that, back in 1968 when they candidly spoke about the public's reaction to their work:

> Irizarry We were highly criticized, though, by the general public and some artists, for doing art that was *not Puerto Rican.*
>
> López de Victoria We are being *labeled non-Puerto Ricans because of our non-figurative art, shaped canvases, hard-edge painting style, and constructions.*[39]

This statement raises some flags; both Irizarry and López de Victoria were born in Puerto Rico but raised in New York City. When they returned to the island by the mid-1960s, their experience as diaspora invalidated their *puertorriqueñidad.* It was therefore insinuated that the only Puerto Rican experience was that of those living on the archipelago and of those who produced artworks within the aesthetic ideology favored by the Generación del 50.

NOTES

1 Jacobs arrived on the Island in October 1967 as a correspondent for *theART-gallery Magazine*, through Galería Colibri director Luigi Marozzini's contacts. Irizarry was born in Santa Isabel and moved to New York in 1946 with his parents. López de Victoria was born in Gurabo and relocated to New York with his parents in 1959. A year later, he returned to Puerto Rico, where he enrolled at the University of Puerto Rico, Río Piedras, and was a disciple of Domingo García at Galería Campeche. In 1965, he returned to New York City, where he met Irizarry and Joaquín Mercado. In 1966, the three of them returned to the Island, where López de Victoria lived until 1973. During the

seventies, he was actively exhibiting in Galería Colibrí, Instituto de Cultura Puertorriqueña, and Cayman Gallery in New York.

2 Puerto Rican artist Luis Quero Chiesa, Haitian-born Juan De'Prey, and Rafael Palacios left Puerto Rico for New York in the mid-1920s and were exhibiting alongside avant-garde Latin American, US, and Harlem Renaissance artists, as historian María Elba Torres Muñoz's research posts. As this chapter discusses, the avant-garde sixties generation met a destiny like those artists who relocated to New York thirty years before them: exclusion from the Puerto Rican narratives. See Torres Muñoz, "El arte como resistencia."

3 Hartrup, "Ocho mil espejos oscuros." His disciples included Roberto "El Boquio" Alberty, Rubén Bras, Otto Néstor Bravo, Carlos Crespo, Hilton Cummings, Frances del Valle, Rafael Ferrer, Jorge Luis García, Pedro Gispert, Gloria Gómez, José Lima, Félix López, Gustavo López Muñoz, Luis A. Maisonet, Ethel Ríos, Julio Rosado del Valle, Ernesto Jaime Ruiz de la Mata, Víctor Sánchez, Luz Santos, Nieves Serrano, J. L. Soya, Virginia Vidich, and Cossette Zeno.

4 Puerto Rican artists and art historians agree in that Ferrer was *the* pioneer avant-garde artist on the island.

5 Generación del 50 was a group of artists with a populist agenda who created images of Puerto Rican national affirmation, showcasing the autochthonous: its people, landscape, popular festivals, and the explicit condemnation of the US regime over Puerto Rico.

6 Torres Martinó, "Roberto Alberty," 3–4. Translation mine.

7 *Quotation source*: Jaime Carrero, *Jet Neorriqueño/Neo-Rican Jetliner* (San Germán: Universidad Interamericana de Puerto Rico, 1964), 2. Mendoza was born in Salinas and was a disciple of Domingo García at Galería Campeche, where he had his first exhibition in 1963. By the mid-1960s, he moved to New York and eventually returned to Puerto Rico in the 1970s. Sandra Cintrón Goitía's master's thesis, "Aproximaciones a Roberto Alberty (Boquio)," and the catalog of Alberty's 1999 retrospective at the Museo de Historia, Antropología y Arte (MHAA), which she organized, have incongruencies on the dates of Galería El Morro's inauguration. In chapter 3, the artist's biography, Cintrón Goitía dates the opening to 1965, whereas in the artist's chronology it is given as 1964. Cintrón Goitía, *Roberto Alberty: El Boquio*.

8 Alberty quoted in Cintrón Goitía, *Roberto Alberty: El Boquio*, 22. Translation mine.

9 Founded by Antonia Pantoja in 1961, the educational program ASPIRA was part of an effort from the Puerto Rican community in New York to counteract the negative image that has been created of the Diasporican community. See "Puerto Rican Here Set Up Youth Aid," *New York Times*, March 21, 1962, 42.

10 Alonso, "ASPIRA auspicia muestra," 39. Translation mine. The press article lists the titles of the works and includes a photograph of the artists in the

exhibition hall, yet very little is known about the works. Joaquín Mercado was born in San Juan and moved to New York with his parents when he was eight years old. He studied at the School of Visual Arts in New York. In the mid-1960s, he relocated to Puerto Rico, where he worked as a graphic designer, an art director of *Revista Avance*, a professor at the Escuela de Artes Plásticas, and a gallery director. It must be noted that Irizarry, Mercado, and López de Victoria frequented exhibitions of the New York avant-gardes in the West Village, visited Andy Warhol's The Factory, and even participated in Robert Rauschenberg happenings. I found no evidence of their exhibiting in collective exhibitions with New York artists during the sixties, which can speak to exclusive practice in the Anglo art scene.

11 Ruiz de la Mata, "Newest Abstraction," 8. Emphasis mine.

12 *Quotation source*: Estela Ruaño, "Carlos Irizarry abre galería de pintura en SJ," *El Mundo*, December 8, 1966, 60. Irizarry, quoted in "Pintores boricuas exponen obras en NY," *El Mundo*, September 15, 1967, 38. Translation mine.

13 Irizarry had previously opened an artist-run gallery in the Bronx called Galería 22, but I have not located any information about this gallery. Galería 63 also presented a solo show by Elí Barreto; although not discussed in this chapter, it was briefly mentioned in my dissertation, "Omisión o censura."

14 "Domingo Lopez," *San Juan Star*, March 6, 1967, 10.

15 Both Jesse Liss and Elí Barreto presented some of the works in *La nueva plástica* at their solo exhibits at the Ateneo Puertorriqueño, in 1967 and 1968, respectively. Their inclusion in the "traditional" institution's exhibition calendar speaks of the institution's disposition with avant-garde art, thanks to artist Luis Hernández Cruz's tenure as director of the Cátedra de Artes Plásticas (1966–71) of the Ateneo Puertorriqueño.

16 Carlos Irizarry, telephone interview by Yasmin Ramirez, 2000, shared via email.

17 The word *foreign* is used with intent, alluding to Torres Martinó's essay "El arte puertorriqueño de principios de siglo XX," in which he employs derogatory language when discussing works by artists whose work did not "fit" with the editorial line.

18 *Quotation source*: Mercedes Trelles Hernández, "Entrevista: Luis Hernández Cruz, el abstracto por excelencia," in *Luis Hernández Cruz* (San Juan: Museo de Arte de Puerto Rico, 2003), 71–76. Wilkin, "First Fifty Years," 17.

19 Carlos Irizarry, "Letter to Mr. Myers," April 25, 1967, Archives of American Art, Tibor de Nagy Gallery Records, 1941–1993. A namesake exhibit was concurrently displayed at the UPRRP museum (September 1967), which later traveled to La Casa del Arte gallery in Old San Juan (October 1967) as *Pintura estructural*; and as *Arte estructural* to the Galería de Arte at UPR's Mayagüez campus (February 1968), which incorporated works by Arturo Bourasseau (1946–2020). Hernández Cruz has been an arduous defender of

abstract and avant-garde art. He was assistant to the executive director of the Instituto de Cultura Puertorriqueña (ICP) (1964–68), and therefore was a key player in the advancement of avant-garde and abstract art exhibitions that were promoted by these "traditional" institutions.

20 Luis Hernández Cruz, "Letter to Mr. Myers," June 1, 1967, Tibor de Nagy Gallery Records, 1941–1993, Archives of American Art.

21 Glueck, "New York Gallery Notes," 111. See also Willard, "In the Art Galleries,"

22 Wilkin, "First Fifty Years," 17.

23 Documents were found in the *Homage to Antonio Machado* exhibition folder. See Grau Tello, "Homage to Machado."

24 Jacobs's essay was reprinted in the local newspaper under the same title.

25 Jacobs, "Art in Puerto Rico," 16.

26 Carlos Irrizarry, quoted in Jacobs, "Art in Puerto Rico," 19.

27 In New York, Irizarry produced the photo-silkscreen series *The New York School versus the Metropolitan Museum of Art* (1970) in the basketball court of an old Catholic school. The series references Henry Geldzahelr's *New York Painting and Sculpture: 1940–1970* (1969), a controversial exhibition at the Metropolitan Museum of Art. As part of the Met's centennial celebration, Geldzahelr "modernized" thirty-five galleries of the institution with works that traced the ascendency of Abstract Expressionism, Hard-edge abstraction, and Pop art. According to Irizarry, these were exhibited as a collective exhibit at Hundred Acre gallery.

28 "Puerto Rican Art: Inauguran galería Nueva York para artistas puertorriqueños," *El Mundo*, March 24, 1969, 14A. Translation mine.

29 Similar in content to the Puerto Rico issue of *theARTmagainze* of 1967, the catalog includes advertisements for galleries in Puerto Rico, an essay about Museo de Arte de Ponce, a short text by ICP director Ricardo Alegría about Puerto Rican art, a letter by then governor Luis A. Ferré, and promotional material about Puerto Rico's booming economy and setup as a tax haven, alternated with black-and-white images of the works on display. Participating artists were all mostly living and working in the archipelago: Olga Albizu, José R. Alicea, Alfonso Arana, Ángel Botello, Arturo Bourasseau, Luis Hernández Cruz, Suzi Ferrer, Domingo García, Lorenzo Homar, Carlos Irizarry, Marcos Irizarry, Domingo López, Joaquín Mercado, José Luis Rochet, Juan Antonio Roda, José Rosa, and Rafael Tufiño.

30 Berenguer, "'Afecta Diginidad del Sector,'" 19A. Translation mine.

31 Then curator of prints and drawings at MoMA as well as a consultant of the Bienal de San Juan del Grabado Latinoamericano, Lieberman helped Puerto Rican art strengthen its relationship with museums in New York. Silkscreens by avant-garde artists were incorporated into the permanent collection of MoMA and Brooklyn Museum, the latter through an anonymous donation that research indicates was, in fact, Lieberman.

32 Lorenzo Homar, "Letter to William Lieberman," May 26, 1969, WSL Collection, Museum of Modern Art Archives, NY.

33 In Puerto Rico, Senator María Arroyo de Colón, for the Partido Popular Democrático (PPD), presented a motion that was approved by the Senate in solidarity with the artist. In New York, Irizarry had the support of Hernán Badillo, president of the Bronx borough; Gilberto Gerena Valentín, president of the Segunda Conferencia Puertorriqueña de Nueva York; artist Luis Quero Chiesa, president of the Instituto de Puerto Rico; Ángel M. Arroyo, president of the New York chapter of Sociedad Puertorriqueña de Escritores; Juan Martínez, president of Puerto Rican Day Parade; and Amelia Betanzos, president of Asociación Nacional Puertorriqueña de Derechos Civiles.

34 Berenguer, "En alquiler vivienda," 3A.

35 "Le ordenan pedir perdón," *El Mundo*, April 2, 1969, 2A.

36 Lester Properties Inc. was allegedly interested in countersuing, since it argued that the contract had a clause about sign specifications.

37 Bazzano-Nelson, "Cambios de margen." The term *resistance* references Argentine art critic Marta Traba's "theory of resistance," whose genesis was articulated during her residence in Puerto Rico from 1969 to 1971.

38 *Quotation source*: Ernesto Jaime Ruiz de la Mata, "The Newest Abstraction: Total Environment," *San Juan Star*, January 21, 1968, 8.

39 Ruiz de la Mata, "Newest Abstraction," 8. Emphasis mine.

BIBLIOGRAPHY

Alonso, Alberto. "ASPIRA auspicia muestra de pintores puertorriqueños." *El Diario*, June 5, 1966.

Bazzano-Nelson, Florencia. "Cambios de margen: Las teorías estéticas de Marta Traba." In Marta Traba, *Dos décadas vulnerables en las artes plásticas latinoamericanas, 1950–1970*, 9–32. Buenos Aires: Siglo XXI, 2005.

Berenguer, Jerónimo. "'Afecta Diginidad del Sector': No permiten en NY identificar como puertorriqueña Galería de Arte." *El Mundo*, March 27, 1969.

Berenguer, Jerónimo. "En alquiler vivienda Boricua somete en NY querella por discrimen." *El Mundo*, March 27, 1969, 3A.

Carrero, Jaime. *Jet neorriqueño/Neo-Rican Jetliner*. San Germán: Universidad Interamericana de Puerto Rico, 1964.

Cintrón Goitía, Sandra. "Aproximaciones a Roberto Alberty (Boquio): Un artista con vida." Master's thesis, Centro de Estudios Avanzados de Puerto Rico y el Caribe, 1996.

Cintrón Goitía, Sandra. *Roberto Alberty: El Boquio*. San Juan, Museo de Historia, Antropología y Arte, 1999.

Glueck, Grace. "New York Gallery Notes: Think Up a New Brand Name." *Art in America* 55, no. 5 (1967): 108–11.

Grau Tello, María Luisa. "Homage to Machado, John Bernard Myers y la Spanish Refugee Aid: Historias de un homenaje en Nueva York." ACAA *Digital*, no. 48 (September 2019). http://www.aacadigital.com/contenido.php?idarticulo =1575&idrevista=56.

Hartrup, Cheryl. "Ocho mil espejos oscuros." *Visión doble*, February 15, 2014. http://humanidades.uprrp.edu/visiondoble/?p=3398.

Jacobs, Jay. "Art in Puerto Rico." *theARTgallery Magazine* 11, no. 3 (1967): 12–17.

Jacobs, Jay. "Art in Puerto Rico." *San Juan Star*, December 17, 1967, E8, 36, 38.

Ramos Borges, Melissa M. "Omisión o censura: Una revisión de la vanguardia artística en Puerto Rico, 1960–1970." PhD diss., Universidad Autónoma de Madrid, 2020.

Ruaño, Estela. "Carlos Irizarry abre galería de pintura en SJ." *El Mundo*, December 8, 1966.

Ruiz de la Mata, Ernesto Jaime. "The Newest Abstraction: Total Environment." *San Juan Star*, January 21, 1968.

Torres Martinó, José Antonio. "El arte puertorriqueño de principios de siglo XX." In *Puerto Rico: Arte e Identidad*, 63–81. San Juan: Editorial de la Universidad de Puerto Rico, 2004.

Torres Martinó, José Antonio. "Roberto Alberty." In *Mirar y ver: Texto sobre arte y artistas en Puerto Rico*, 3–11. San Juan: Editorial Instituto de Cultura Puertorriqueña, 2001.

Torres Muñoz, María Elba. "El arte como resistencia: Lo afropuertorriqueño." In *The Future Is Now: A New Look at African Diaspora Studies*, edited by Vanessa K. Valdés, 43–65. Newcastle: Cambridge Scholars, 2012.

Trelles Hernández, Mercedes. "Entrevista: Luis Hernández Cruz, el abstracto por excelencia." In *Luis Hernández Cruz*, 71–76. San Juan: Museo de Arte de Puerto Rico, 2003.

Wilkin, Karen. "The First Fifty Years." In *Tibor de Nagy Gallery: The First Fifty Years*, edited by Eric Brown, 17–40. New York: Tibor de Nagy, 2000.

Willard, Charlotte. "In the Art Galleries: Balancing the Books." *New York Post*, September 30, 1967.

2

Nuyorican Vanguards

The Puerto Rican Alternative Art Space Movement in New York

Yasmin Ramirez

In the late sixties and seventies our communities duplicated what the *cimarrones* [runaway enslaved people] did during colonization. . . . We empowered our communities while establishing locations for resisting Euro-centric cultural oppression. The ancient societies of our ancestors, the *quilombos* of Brazil, the *palenques* of Colombia and Cuba—became the Puerto Rican Traveling Theater, El Museo del Barrio, Taller Boricua, The Caribbean Cultural Center. Collectively, we defined, articulated and insisted upon our fair share of resources, our right to our own culture and right to self-determination.

Marta Moreno Vega, "The Purposeful Underdevelopment of Latino and Other Communities of Color" (1993)

Puerto Rican alternative art spaces arose within the larger movement known as the New York alternative art space movement. From the late 1960s to the late 1980s, artists from diverse backgrounds began operating nonprofit "alternative" galleries that stood in opposition to mainstream institutions governed by Eurocentric, patriarchal, and market-driven values. The concentration of artist lofts and galleries in the Lower Manhattan manufacturing district known as SoHo was the alternative art space epicenter. While there were some Puerto Rican alternative spaces in SoHo, the central hubs of artistic activity for Puerto Rican artists were concentrated in El Barrio (East Harlem) and Loisaida (Lower East Side).[1] The emergence of Puerto Rican alternative art spaces evolved into an art movement that challenged and changed the politics of race, space, and representation in New York's cultural landscape.

1969

Year zero in the history of the Puerto Rican alternative art space movement in New York, aka the Nuyorican art movement, was 1969. During this pivotal year, disenfranchised Puerto Rican artists met each other at exhibitions and rallies on behalf of Puerto Rican civil rights.

January 1969 was a hot month in the New York art world. On January 3, the artist Takis removed his sculpture from the galleries of the Museum of Modern Art to protest that the museum had not obtained his permission to display it, an incident that galvanized artists to demand greater control over the way museums and galleries handle their work. On January 12, the Black Emergency Cultural Coalition (BECC) began picketing the Metropolitan Museum of Art for the lopsided portrayal of Black history in *Harlem on My Mind*, a multimedia exhibition that did not display works of art by African Americans.[2] Last but not least, on January 14, Puerto Ricans gathered at the Brooklyn Museum to celebrate the opening of *Contemporary Puerto Rican Artists*, the first exhibition of Puerto Rican art to occur in a New York City museum since 1957.[3]

Organized by African American curator and BECC member Henry Gent, *Contemporary Puerto Rican Artists* was a showcase for emerging artists who were enrolled in the city's fine art schools such as the Pratt Institute, Cooper Union, and the School of Visual Arts.[4] What did Puerto Rican art look like in 1969? Surprisingly conventional. Installation photos in the Brooklyn Museum archive demonstrate that these artists were working in modernist styles promoted by their instructors: Surrealism, Expressionism, Hard-edge

abstraction, and Pop art. Marcos Dimas's surreal painting of an unseen being wearing a suit, provocatively titled *Self Portrait as an Invisible Man* (1968), conveyed his generation's sense of alienation: "We could all agree that there existed a cultural void in the Puerto Rican community."[5]

Dimas credits participating in the Brooklyn Museum show with spurring him and fellow art students Adrian Garcia, Martin Rubio, and Armando Soto to continue working together on increasing the visibility of Puerto Rican artists. "Myself, Adrian, Armando, and Martin, we were like white on rice after the Brooklyn show," recalled Dimas. "Anything that was happening, we were there." Nicknaming themselves "the four horsemen," Dimas, Garcia, Rubio, and Soto charged into the widespread rebellion that was going on in New York. Dimas joined the pickets of the *Harlem on My Mind* exhibit at the Metropolitan Museum of Art, and Garcia took part in demonstrations to support the Black and Puerto Rican student takeover of City College in April 1969. In May the four artists participated in the inaugural exhibition for Galería Hoy at the Society of the Friends of Puerto Rico Cultural Center, a short-lived multi-arts space located in a defunct Catholic school on Twenty-Ninth Street and Third Avenue. Interviews with Dimas and Garcia confirm that they did not pursue taking studio spaces at the center because of their growing commitment to student activism and attending meetings of the Art Workers' Coalition (AWC)—an umbrella organization composed of artists involved in civil rights and anti-war activism, causes that artists began to tie into demands for institutional reforms in the New York art world.[6]

Carle Andre, Robert Morris, Hans Haacke, and Lucy Lippard were prominent figures in the AWC. Faith Ringgold and Tom Lloyd were point persons for artists whose involvement in the AWC was connected to the BECC demands that museums exhibit works by women and artists of color. Ringgold, Lloyd, and Raphael Montañez Ortiz formed the Black and Puerto Rican Art Workers' Coalition (see figure 2.3). Montañez Ortiz, a renowned figure in the downtown scene for his destruction art performances, was the sole representative of the Puerto Rican community at the AWC until Dimas, Garcia, Rubio, and Soto began attending meetings in the summer of 1969. Ortiz welcomed working with the younger artists on AWC actions and offered them a place on the artist advisory board in the community-based museum he was developing in West Harlem for the Board of Education that was set to open in the Fall: El Museo del Barrio.

A fresh surge of Puerto Rican activism gushed into East Harlem during the summer of 1969 when the newly formed New York chapter of the

Young Lords Organization (YLO) barricaded Third Avenue and 110th Street with mountains of trash that the Department of Sanitation had failed to pick up. Known as the Garbage Offensive, this takeover was the first of many waged by the YLO that inspired New York–born Puerto Ricans to reclaim East Harlem, popularly referred to as *la cuna* of the Puerto Rican diaspora. The YLO galvanized its peers to realize that this historic neighborhood needed to be salvaged by community activism and investment to counteract decades of willful neglect by the city's power brokers.[7]

The number of posters, news stories, films, photos, and paraphernalia produced by and about the YLO during the early 1970s is staggering.[8] What made the YLO's way of mobilizing such a successful social movement? According to T. V. Reed, it was its ability to generate a repertoire of strategies, tactics, expressions, behaviors, and material objects to create cohesion among participants and disseminate their ideas to the wider public. Reed calls this matrix of actions and objects "movement culture" and observes that the most impactful movement cultures use the arts to alter or transgress dominant cultural codes.[9]

Orchestrators of spectacular demonstrations, the YLO's leadership deployed its collective talents to portray Puerto Rican culture as resilient and to reframe Puerto Rican youth in New York—pejoratively associated with delinquency and gangsterism—as composed of organized troops of socially conscious young adults who were unafraid to defy authority in defense of their rights.[10] As numerous photographs of the group attest, the YLO was an army of beautiful rebels who could disarm their critics by flashing smiles as they marched in formation down the city's streets. The YLP paramilitary dress code—purple berets, leather jackets, dark clothing, combat boots, and buttons emblazoned with a rifle superimposed on the Puerto Rican flag—flaunted its affiliation with the Black Panthers and other leftist organizations. The YLP's ability to look good while doing "bad" deeds contributed to its notoriety in the barrios and broadcast studios.[11]

In addition to coding their bodies with signs of their political solidarities, YLP cadres flooded their surroundings with images that conveyed the main principles of its "13 Point Program and Platform," which included the following demands:

> (1) We want self-determination for Puerto Ricans, liberation on the island and inside the United States. . . . (3) We want liberation of all third world people. (4) We are revolutionary nationalists and oppose racism. (5) We want equality for women. (6) We want community

2.1 Miguel Luciano, *Re-creation of the Original Storefront Office Window of the Young Lords Party in East Harlem* (based on Hiram Maristany's *Photograph of Juan González, Minister of Education, at the Office Storefront Headquarters of the Young Lords*, 1969), Hunter East Harlem Gallery, New York, 2015. Photo by Miguel Luciano.

control of our institutions and land. (7) We want a true education of our Afro-Indio culture and Spanish language. . . . (9) We oppose the Amerikkkan military. (10) We want freedom for all political prisoners and prisoners of war. (11) We are internationalists. (12) We believe armed self-defense and armed struggle are the only means to liberation. (13) We want a socialist society.[12]

Photographs of the YLO's storefront offices demonstrate that the windows were covered in posters that put the underground history of Puerto Rican printmaking on public display (see figure 2.1). Indeed, prior to the founding of El Museo del Barrio and Taller Boricua, the YLP offices in East Harlem, the South Bronx, and the Lower East Side were the only spaces where posters produced by the YLO and the Black Panthers could be seen alongside posters from leftist printmakers from Puerto Rico, Cuba, Asia, Africa, and Latin America. Even posters rendered during the 1950s that nostalgically portrayed Puerto Rico's caramel-colored farmers and Black

folk singers as happy with their lots in life were recoded as portraits of the island's revolutionary proletariat when seen within the context of the YLO's politically charged window displays,

The YLO clarion call to take over the streets and structures of El Barrio strengthened the resolve of Dimas and his colleagues to open a space for Puerto Rican artists in the heart of East Harlem rather than in Downtown Manhattan, where artists associated with AWC and BECC were forming collectives and opening galleries like 112 Greene Street and Cinque Gallery. They found support for their vision from Manuel "Neco" Otero, an architect in the Real Great Society Uptown Urban Planning Institute (RGS/UPS), the organization that helped the Young Lords Organization get started in East Harlem.[13] Manuel "Neco" Otero and Hiram Maristany of the Young Lords Party began joining meetings and demonstrations waged by the Black and Puerto Rican Art Workers' Coalition around the spring of 1970. The voices of Puerto Rican artists in the AWC are reflected in three out of thirteen demands the AWC issued to the city's art museums:

2 Admission to all museums should be free at all times, and they should be open evenings to accommodate working people.

3 All museums should decentralize to the extent that their activities and services enter Black, Puerto Rican, and all other communities. They should support events with which these communities can identify and control. They should convert existing structures all over the city into relatively cheap, flexible branch museums or cultural centers that do not carry the stigma of catering only to the wealthier sections of society.

4 A section of all museums under the direction of Black and Puerto Rican artists should be devoted to showing the accomplishments of Black and Puerto Rican artists.[14]

The peak period of AWC activism (1969–71) was concurrent with the Young Lords' biggest mobilizations. During the spring and summer of 1970, the Young Lords were seizing tuberculosis (TB)-testing trucks in East Harlem and taking over Lincoln Hospital in the Bronx while the Black and Puerto Rican Art Workers were picketing MOMA and occupying Thomas Hoving's office at the Metropolitan Museum of Art.[15] Months after the occupation, the Metropolitan Museum hired a Puerto Rican community liaison, Irvine MacManus, who facilitated resource sharing and loans

between the Metropolitan Museum of Art and El Museo del Barrio. The Museum of Modern Art, on the other hand, never complied with the AWC's demand to create a Martin Luther King Jr./Pedro Albizu Campos wing for Black and Puerto Rican art.

East Harlem Renaissance: Taller Boricua and El Museo del Barrio

The Puerto Rican Art Workers' construction of El Museo del Barrio and Taller Boricua offset the institutional shortcomings of the New York art world. Although, the founders of both organizations date their origins to 1969, El Museo del Barrio did not have a space of its own in East Harlem until 1971. Taller Boricua, on the other hand, began operating in the storefront offices of RGS/UPS on 1673 Madison Avenue in the fall of 1970.

Taller Boricua/the Puerto Rican Workshop was initially started by Marcos Dimas, Adrian Garcia, Martin Rubio, Armando Soto, and Manuel "Neco" Otero. Looking for more members, the artists recruited two major artists from Puerto Rico who had studios in the Friends of Puerto Rican Cultural Center: Rafael Tufiño and Carlos Osorio. Tufiño's daughter, Nitza, joined Taller Boricua soon after her father. The addition of Osorio and the Tufiños brought credibility and experience to the group. Taller Boricua became a magnet site that drew artists from the diaspora and the island through its doors. The workshop's collaborators included artists and poets who went on to open their own alternative spaces, notably Sandra María Esteves, Jesús Papoleto Meléndez, and Pedro Pietri, cofounders of the New Rican Village and Nuyorican Poets Café; Néstor Otero Rodriguez, founder of Eventos: Space for Living Artists; Geno Rodriguez, cofounder of the Alternative Museum; and Papo Colo, cofounder of Exit Art.[16]

Taller Boricua's public outreach was complemented by a dedicated studio practice. The artists exceeded the Young Lords' demand for a true education in Puerto Rico's African and Indigenous Taino heritages by creating a visual vocabulary that combined forms from both cultures. The visual aesthetic developed by artists at Taller Boricua embedded signifiers of Puerto Rican history and culture, especially its Indigenous and African heritages, into New York's urban landscape. Artworks by Jorge Soto Sánchez and his colleagues at Taller Boricua anticipated the intersectional perspectives of contemporary artists like Juan Sánchez (see figures I.1 and 2.2). The cultural syncretisms and ethnoracial hybridity seen in work by Taller artists do not necessarily celebrate Puerto Rican *mestizaje*. Rather,

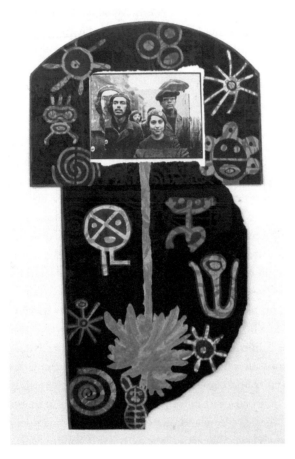

2.2 Juan Sánchez, *Once We Were Warriors*, 1999. Litho-
graph, photolithograph, pulp painting, chine-collé,
and hand color on paper, 34½ × 60 in. Courtesy
of the artist and Hutchinson Modern and Con-
temporary, New York.

like the mixing of Spanish and English in Nuyorican poetry, the hybrid
ethnoracial subjects in Nuyorican art were critical responses to the ten-
sions of straddling multiple and sometimes oppositional affiliations with
oppressed peoples of color during an era in US history that witnessed a
short-lived progressive agenda to dismantle institutional racism and sys-
temic poverty within its borders while forging war and neocolonial occu-
pations across Africa, Asia, and Latin America.

Following a mission to disseminate Puerto Rican art and culture in the
city's barrios, Taller Boricua organized traveling and outdoor exhibitions,

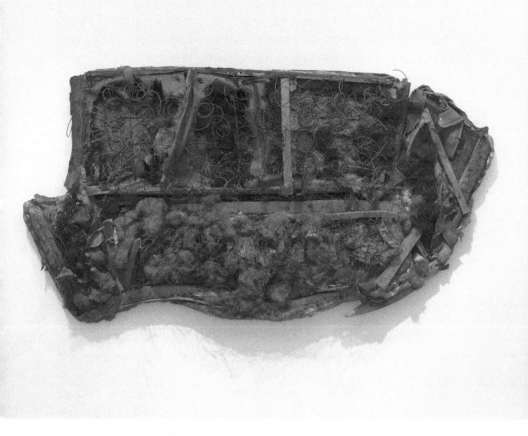

2.3 Raphael Montañez Ortiz, *Archeological Find # 22: The Aftermath*, 1961. Deconstructed sofa (wood, cotton, wire, fiber, and glue), 54 × 110 × 24 in. Collection of El Museo del Barrio, New York.

art classes, poetry readings, and political meetings in its workshop. Taller Boricua's visual impact went beyond El Barrio via posters that members designed for causes like Puerto Rican independence and events at affiliate spaces like El Museo del Barrio, Cayman Gallery, the Caribbean Cultural Center, the Association of Hispanic Art, the New Rican Village, and the Museum of Contemporary Hispanic Art. Among the workshop's most important achievements are: (1) resurrecting Puerto Rico's printmaking tradition in New York, (2) developing an identifiable New York Puerto Rican visual vocabulary, and (3) promulgating a community-based ethos

that anticipated contemporary social practice art. Discussing Taller Boricua's historical importance, muralist Manny Vega once explained to *New York Times* art critic Holland Cotter that Taller Boricua comprised a school that he and others followed. "They're the East Harlem School," said Vega. "Eventually historians will get it" (see figure I.3).[17]

The separation between the Young Lords, Taller Boricua, and El Museo del Barrio practically vanished once Marta Moreno Vega became director of El Museo del Barrio in 1971. During her extraordinary five-year tenure, she transformed the museum from being an educational project in a public school classroom to functioning independently as a storefront museum in East Harlem. Hiring Young Lords photographer Hiram Maristany, together with Adrian Garcia, Manuel "Neco" Otero, and Nitza Tufiño from Taller Boricua, Morena Vega oversaw a radical dream team. Together they organized trailblazing exhibitions and museum education programs whose themes fulfilled the demands for cultural equity voiced by the YLO and the Puerto Rican Art Workers: *Homage to Our Painters* (1972), *Taino* (1972), *The Art Heritage of Puerto Rico: Pre-Columbian to Present* (1973), *The History of Puerto Rican Posters* (1973), *Aspectos de la Esclavitud en Puerto Rico* (1974), and *Art as Survival* (1974).[18]

In retrospect, it is apparent that the Puerto Rican Art Workers, the Young Lords, Taller Boricua, and El Museo del Barrio mutually benefited from each other's activism and catalyzed a Puerto Rican Renaissance in East Harlem that spread throughout New York. The demands for cultural equity that Puerto Rican artists were voicing in front of museums would have rung hollow without the uproar that the Young Lords were causing in other parts of the city. Likewise, Puerto Rican alternative art spaces provided safe havens for Young Lords ex-cadres to evolve and disseminate their utopian ideas though creative mediums like poetry, photography, and filmmaking, especially after government infiltrations and internal conflicts began dismantling the YLO in the early 1970s.

Claiming the City: En Foco and United Graffiti Artists

Hiram Maristany's documentary photographs, reproduced in the YLO newspaper *Palante*, made space in the public domain for the emergence of a socially conscious photographic practice among Puerto Rican artists who distributed their photos to local newspapers and leftist presses like *Claridad* and *Ramparts Magazine*. In 1973, photographer Geno Rodriguez organized *Dos Mundos: Worlds of the Puerto Rican*, which gathered an

extraordinary group of twelve photographers who, independent of each other, were documenting their lives in New York and the island: Charles Biasiny-Rivera, Roger Cabán, Gustavo Candelas, Máximo Colón, Phil Dante, Ángel Franco, Benedict J. Fernandez, Martin Gonzalez, George Malave, Adál Maldonado, Geno Rodriguez, and Denis Velez. *Dos Mundos* led to the formation of the photography collective En Foco in 1974.[19]

Similar to the Kamoinge Workshop, the African American photography collective that was active in New York during the 1960s and 1970s, En Foco began as a member-driven organization of professional photographers who came together to develop their craft and think about how their documentary work could effect social change for Puerto Ricans in New York. Initially, photographers met in each other's studios to share work and concentrated on organizing group shows. In 1978, En Foco established an office in the South Bronx and initiated a series of outreach programs that included holding photography classes in public schools and managing an outdoor portrait studio known as the En Foco Street Gallery that traveled to neighborhoods in Upper Manhattan and the South Bronx. Notable Puerto Rican photographers who joined En Foco in the 1970s and early 1980s include David Gonzalez, Perla de Leon, Sophie Rivera, and Frank Gimpaya. By 1985, En Foco had evolved into a not-for-profit organization to support contemporary photographers of color via grants, exhibitions, and publications such as *Nueva Luz*, its annual photographic journal with a production quality rivaling *Aperture*. Still in publication today, *Nueva Luz* has been instrumental in promoting the work of emerging and mid-career photographers such as Elia Alba, Dawoud Bey, Albert Chong, Jamal Shabazz, and Coreen Simpson, among many others.

Muralism and graffiti blossomed in New York's barrios during the 1970s. The movement's major muralists, Maria Dominguez, Alfredo "Freddy" Hernandez, Nitza Tufiño, and Manny Vega, were linked to alternative art spaces like Taller Boricua and CHARAS/El Bohio and worked on commissions from the city and community groups.

Graffiti artists whose masterpieces on the subway system were criminalized as vandalism formed their own collective, United Graffiti Artists (UGA), to promote their work as legitimate art. The director of UGA, Hugo Martinez, was New York's first graffiti impresario. A junior at the City College of New York, Martinez organized a show of UGA members' works on canvas for the CCNY art department in October 1972. The exhibition received favorable word of mouth and a review in the *New York Times* that led to more opportunities in the art world.[20] In 1973, Twyla

Tharp commissioned UGA to paint backdrops for her ballet *Deuce Coupe*, and UGA had a show at the Razor Gallery in SoHo that Peter Schjeldahl reviewed in the *New York Times*. Norman Mailer's interviews with UGA members informed his manifesto validating the artform, published in *Faith of Graffiti*.[21] After its final show at Artist Space in 1975 UGA disbanded.[22] Although Martinez continued organizing exhibits with former UGA members including Coco 144, he was unable to establish a connection with the post-UGA graffiti artists such as Jean-Michel Basquiat, Al Diaz, Futura 2000, Fab Five Freddy, Lady Pink, Rammelzee, Lee Quiñones, and John "Crash" Matos who dominated the art world in the 1980s.

El Downtown: Loisaida and SoHo

During the mid-1970s, Puerto Rican alternative art spaces began opening in the Lower Manhattan barrio popularly known as Loisaida (a phonetic spelling of the Spanish-speaking residents' pronunciation of the neighborhood's English name: "Lower East Side"). Although Loisaida's streets were crumbling, a vibrant cultural scene was emerging from the rubble. In the manifesto-like introduction to *Nuyorican Poetry: An Anthology of Puerto Rican Words and Feelings* (1975), Miguel Algarín underscored that building alternative spaces went hand in hand with cultivating alternative behaviors capable of fighting against institutional oppression. "To be free is not theoretical," writes Algarín. "It is to take over your immediate environment."[23] Rather than discuss the poets in the anthology as rarefied individuals, Algarín's introductory essay related stories of coalition building between poets, residents, and former gang members to rehabilitate tenements and improve public services on the Lower East Side. The effect of these vignettes demonstrated that the poets' unique contribution to this grassroots movement was facilitating communication between English-speaking officials and a predominantly Spanish-speaking Puerto Rican population. For Algarín, the poet is an intermediary, a troubadour of the people's struggles, a translator of their ideas into words. "There are no 'alternatives' without a vocabulary in which to express them," he writes. "The poet has to invent a new language, a new tradition of communication.[24] Algarín calls this new language "Nuyorican" and specifies that its structure derives from the innovative speech patterns of Puerto Rican New Yorkers whose employment of bilingualism and slang were mistakenly denigrated as proof of this group's ignorance and incorrigibility. The term *Nuyorican* stands for several things at once: it is the name of the school of bilingual

poetry that he and the poets in the anthology represent and a somewhat Anglicized, "alternative" name for Puerto Rican New Yorkers who were referred to as *Neorriqueños* and *Nuyorriqueños* in the Spanish-language press. Lastly and most significantly, the Nuyorican moniker rebrands Puerto Rican New Yorkers as a transnational community whose language and lifestyles defied essentialist constructions of national identity, language, and culture in the United States and Puerto Rico.

Run by writers and performers affiliated with the Nuyorican poetry movement, three alternative spaces opened in quick succession: the Nuyorican Poets Café (which outgrew its East Village apartment home and moved into a rented pub in 1975), the New Rican Village (1976), and CHARAS/El Bohío (1979). These spaces had congruent programming that served different sectors of Loisaida's multiethnic creative community. Founded by Algarín and Pedro Pietri, among others, the Nuyorican Poets Café was the main venue for spoken-word performances and short plays. The New Rican Village, cofounded by YLO ex-cadre Eddie Figueroa, operated as a multi-arts learning center during the day and hosted experimental theater, dance, and Latin jazz performances at night.

CHARAS/El Bohío was the largest and most eclectic alternative space in Loisaida—if not all of New York City. Housed in a block-long defunct public school PS 64 on East Ninth Street and Avenue B, CHARAS/El Bohío was overseen by Chino García and Armando Perez, community artivists who worked in the early 1970s on experimental housing projects like building domes with Buckminster Fuller on vacant lots in Lower Manhattan.[25] Gordon Matta-Clark was similarly drawn to collaborating with García and Perez in 1976 to build an amphitheater in a vacant lot on Avenue C and East Ninth Street but did not live to see its completion as the CHARAS/El Bohio community garden, La Plaza Cultural.[26] In addition to maintaining public programs and a soup kitchen at La Plaza Cutural, CHARAS/El Bohío sponsored an artist-in-residence program; independent film screenings; art exhibitions; after-school programs in music, dance, theater, and writing; and it was the home base for Nuyorican poet Bimbo Rivas's performance troupe, Teatro Ambulante. Adding to the building's hub of activities were organizations that rented office space: Interfaith Adopt a Building, the Bread and Puppet Theater, Ninth Street Theater, the Seven Loaves Community Arts Coalition, and the New Aché Dance Company. Two local newspapers were published in the building: *Quality of Life in Loisaida* and the *East Village Eye.*[27]

The wide range of programming and late hours that alternative spaces kept in Loisaida made this area a nightlife epicenter for Puerto Rican

creatives across the city. Moreover, unlike in Harlem, where Puerto Rican art spaces were concentrated on the East Side and African American art spaces on the West, in Loisaida African American spaces like Kenkeleba House and Tribes were located near Nuyorican art spaces, which facilitated social exchange between Puerto Rican, Black, and Asian artists (who were forming art collectives like the Basement Workshop in nearby Chinatown). The open mic policies and queer friendly atmosphere at the New Rican Village and Nuyorican Café made those venues havens for writers and artists of color to find support for their work.[28] Once Collaborative Projects (Colab) opened its gallery, ABC No Rio Dinero, on Rivington Street in 1980, a crew of young, left-leaning, mostly white artists who were eager to work with the surrounding community also inhabited Loisaida.[29] The extraordinary intercultural collaborations that occurred in Loisaida during the early 1980s include Martin Wong's series of paintings inspired by the writings of his muse, Nuyorican poet Miguel Piñero, and Charlie Ahearn's promotion of Loisaida resident Lee Quiñones's graffiti art in *Wild Style*. The iconic film concluded with the unveiling of Lee's new mural at a rousing hip-hop jam at the East River Park Amphitheater south of Delancey Street.[30]

The Alternative Museum on East Fourth Street and Bowery stood several blocks west of the Loisaida art scene. Geno Rodriguez, the former curator of *Dos Mundos: Worlds of the Puerto Rican*, cofounded the Alternative Museum in 1975 with the intention of breaking free from ethnic-specific/identity-based curatorial practices, which he found limited. For Rodriguez, authentic alternative spaces were those that offered freedom of expression to artists regardless of their race, ethnicity, gender, or sexual orientation.

> At one point in 1975, I had to divorce myself from the Puerto Rican community because it was killing me. I had to move on and find out who I was on my own and not rely on anyone else's definition about my identity. I saw myself as an outsider, somebody who was going to fight on his own because the reality was that I wanted to fight for equality. My job was to open a place in the belly of the beast, in SoHo and before that in Tribeca and the East Village, where we would put on exhibitions of artists that merited exhibitions whether they were Black, Brown, Asian, Gay, Women. . . . We were showing good artists and what made us different was that we were not excluding people of color and we became a gateway.[31]

The Alternative Museum presented exhibitions around issues of identity politics, (post)feminist explorations of gender, and group shows devoted to national and international political causes, notably, US interventions in Central America and the Middle East. Rodriguez also began to focus on organizing retrospectives of midcareer artists such as Adrian Piper, whose conceptual works and performances examined racial stereotyping; Michael Lebron, a Nuyorican photographer who created subversive ad campaigns in the 1980s and 1990s; and Alfredo Jaar, a conceptual photographer from Latin America.

In 1976, Nuyorican poet Jack Agüeros and Nilda Peraza, a former arts administrator at the defunct Society of the Friends of Puerto Rico Cultural Center, opened Cayman Gallery in SoHo. Agüeros's decision to christen the gallery after a man-eating amphibian that is found in tropical areas around the world draws on the legacy of vanguard poets such as Oswaldo de Andrade of Brazil, who proposed in the "Manifesto antropófago" (1928) that Latin American artists should adopt the fearless attitude of cannibals and devour Euro-American modernism: "The reason I picked the name was that Puerto Ricans in those days were into little animals like the *coqui*, but I said I wanted a fierce animal with teeth, so I called the gallery Cayman."[32]

Although Cayman Gallery became known as a "Latin American" alternative art gallery, it did not shed its Puerto Rican identity. Domingo García, an abstract artist from the island, had a live-in studio at Cayman Gallery and designed many of its invitations in the late 1970s. Cayman Gallery's core advisors were drawn from the Nuyorican arts community. As Nilda Peraza explained, they saw themselves as complementing the community-based focus of alternative art spaces in El Barrio and Loisaida: "We were working on a parallel level with spaces like El Museo del Barrio. We knew that El Museo del Barrio had a mission to serve that particular community and we did not need to duplicate that. Basically, we went another route and decided to infiltrate the mainstream in SoHo. We opened our doors to the Latin American community because those artists could not get shows at other galleries and they were coming to us."[33]

Agüeros and Peraza were successful at creating a space that welcomed Puerto Rican, Latino/a, and Latin American artists who were working in styles that ran the gamut of traditional landscapes to abstract and conceptual modes. The pluralistic curatorial vision of Cayman Gallery arose from inviting artists and emerging curators to organize exhibitions. More by default than design, Cayman Gallery became the training center for Latinx arts professionals in New York. In 1977, for example, Jack Agüeros

left Cayman Gallery to become director of El Museo del Barrio. Artist Luis Cancel took over the management of Cayman after Agüeros departed and was later named director of the Bronx Museum in 1978. Art historian and curator Susana Torruella Leval worked at Cayman Gallery in the 1980s, after which she became chief curator of El Museo del Barrio in 1990 and director of El Museo del Barrio in 1993.

The opening of Exit Art in 1982 marks the apex of the Puerto Rican alternative art movement. Founded by Jeanette Ingberman and Papo Colo, Exit Art encompassed the best practices of prior Puerto Rican alternative art spaces. Colo, who was born and raised in Puerto Rico, moved to New York in the mid-1970s. He integrated his concerns about Puerto Rican independence, colonialism, racism, and transnational identity into endurance-based performances and a politically engaged curatorial praxis (see figure 2.4). Exit Art earned a solid reputation in the New York art world for its curatorial innovation, global perspective, and large thematic group shows that brought activist artists from different generations and mediums together. Located in SoHo from 1984 to 2002 and Chelsea from 2003 to 2012, Exit Art was one of the few alternative spaces that thrived in the 1990s and 2000s. Exit Art's closure was a consequence of Jeanette Ingberman's untimely death from cancer in 2011.[34]

The Denouement of the Puerto Rican Alternative Art Space Movement, ca. 1985

Little more than a decade after Puerto Rican artists in New York began claiming places for themselves in the city, a formidable network of alternative art spaces spanned across Manhattan. But the boom that Puerto Rican artists and art spaces experienced in New York during the 1970s was succeeded by a lean period in the late 1980s, one that was driven by gentrification and backlashes against artist-run and ethnic-specific institutions. The period of the Ronald Reagan and George H. W. Bush administrations (1981–93) marks the beginning of a long era of social and cultural conservatism in the United States. During Reagan's second term in office (1985–89), the administration pushed forward its agenda to dismantle the social gains of the 1960s. Legislative actions during that time included challenging the legitimacy of affirmative action, reducing government aid to poor and working-class families, and cutting aid and programs to visual artists and visual art institutions granted through the National Endowment for the Arts (NEA). Under the George H. W. Bush administration (1989–93), censorship of artists by the

2.4 Papo Colo, *Superman 51*, 1977. VHS transferred to digital video. Courtesy
of the artist.

religious right became acute; the NEA's individual artists grants program was shut down and the agency was threatened with closure.

The Association for Hispanic Arts (AHA) played a crucial role in advocating on behalf of Puerto Rican and Latino arts organizations during the late 1970s and 1980s. Cofounded in 1975 by Moreno Vega, the former director of El Museo del Barrio, AHA offered workshops in Spanish and English to nonprofit cultural groups and to individual artists on grant writing, funding opportunities, professional development, and audience development. The composition of AHA's Board of Trustees from the mid-1970s to early 1980s was largely but not exclusively composed of Puerto Ricans artists who were active in the struggles of the late 1960s and early 1970s, such as Miguel Algarín, founder of the Nuyorican Poets Café; Míriam Colón, founder of the Puerto Rican Traveling Theater; and Jack Agüeros, who succeeded Moreno Vega as director of El Museo del Barrio in 1977. The visual arts organizations that belonged to AHA were likewise predominantly Puerto Rican/Nuyorican artists' spaces such as Cayman Gallery/ Friends of Puerto Rico, El Museo del Barrio, En Foco, Galería Morivivi, Taller Boricua, and the Bronx Museum.

Artist-run alternative galleries and community-based museums that survived the conservative corporate-driven era of the 1980s and 1990s had to submit to greater administrative oversight, produce long-range planning goals, invite elites to their boards of trustees, and turn to corporate funders and private donors who instilled their own aspirations and expectations into the missions of cultural institutions.[35] The NYC Department of Cultural Affairs' near closure of El Museo del Barrio in the mid-1980s due to unsubstantiated claims that Agüeros misappropriated funds was a warning to the community that alternative spaces had to adopt mainstream management models or face extinction. Cayman Gallery, which rebranded itself as the Museum of Contemporary Hispanic Art (MoCHA) in 1985, was forced to close in 1990 under similar charges that poor recordkeeping made it ineligible to receive public funding.

Agüeros returned to writing after resigning as director of El Museo del Barrio in 1986. On streets once enlivened by salsa, hip-hop, and wild-style graffiti, one now heard bomba played as a death knell and saw RIP murals in honor of those who were passing away from the AIDS and crack-cocaine epidemics of the late 1980s. Agüeros's poem "Sonnet Substantially Like the Words of Fulano Rodríguez One Position Ahead of Me on the Unemployment Line" captures the sense of suspended animation that he and other members of the Nuyorican arts movement experienced:

It happens to me all the time—business
goes up and down but I am the yo-yo spun
into the high speed trick called sleeping
such as I am fast standing in this line now.
Maybe I am also a top: they too sleep
while standing, tightly twirling in place.
I wish I could step out and listen for
the sort of music that I must make.

But this is where the state celebrates its sport.
From cushioned chairs the agents turn your ample
time against you through a box of lines.
The faster you spin, the stiller you look.
There is something to learn in that, but what?[36]

Taking stock of the complex sociopolitical and economic factors that maintain Puerto Rican artists spinning in place is soul crushing. At this point, it appears easier to list the reasons the Puerto Rican alternative art movement will continue to be overlooked in the United States than to propose a strategy for inclusion. Our invisibility in the annals of US art history is the result of a constellation of forces that includes a backlash against populism, pluralism, and multiculturalism in the arts launched by conservative critics on the grounds that the heterogeneity in the arts reflects a decline in aesthetic/moral standards; the promotion of Pop, Minimalism, and Conceptual art as the definitive vanguard movements in the postwar United States, arguments that reduce other forms of expression as rearguard status; and resistance toward incorporating Puerto Ricans and other artists of Latin American descent into the annals of "American" art on mistaken assumptions that they are foreigners.

Certainly, a factor that has contributed to underrecognition of the Puerto Rican alternative space movement is that it conformed more to the structure of vanguard movements in Latin America than to vanguard movements in the United States. As Vicky Unruh maintains in *Latin American Vanguards: The Art of Contentious Encounters*, vanguardism is a field of activity that fostered particular forms of organization and cultural production in Latin American countries. Among the most notable differences between Euro-American and Latin American vanguardists is their imagined audience. Whereas it is common for Latin American vanguardists to regard the "oppressed masses" as a target audience, Euro-American

vanguardists tend to position themselves as creating work for an elite sector. The majority of artist-run alternative spaces in the 1970s and 1980 saw their audience composed of other artists and aficionados of vanguard art. Given the community-based orientation of the Puerto Rican alternative space movement, it is easier to understand why it has been overlooked by US art historians interested in this period.[37]

Notwithstanding these biases, the Puerto Rican alternative art movement is too important in New York's art history to be ignored. In her sociological study *The Transformation of the Avant Garde: The New York Art World, 1940–1985*, Diane Crane asserts that critics, art historians, and artists in the United States have relied on a diverse set of criteria to judge whether an art movement merits being classified as vanguardist. Her analysis of several classic theoretical texts on vanguardism, such as Renato Poggioli's *Theory of the Avant-Garde* (1968) and Peter Bürger's *Theory of the Avant-Garde* (1984), found that scholars have classified movements as vanguardist if they redefine any one of the following categories: the aesthetic content of art, the social content of art, or the norms surrounding the production and distribution of artworks.[38] The Puerto Rican alternative art space movement accomplished all the above.

The next question that begs answering is who benefited from this movement? If one measures the success of an art movement by the fame and fortune that the artists derived from their work, then it was a failure. Puerto Ricans artists from this pioneering generation were not "discovered" by art dealers or patronized by rich collectors or championed by critics in tony magazines like *Artforum*. Moreover, the Nuyorican arts community did not develop its own for-profit counterpart. Of course, the objective of this movement was to create spaces where artists were free to make art in and for their communities—not for the marketplace, not for rich collectors. Therefore, if you evaluate this movement by the value these art spaces provided for generations of artists that were denied a place in the New York art world, then the Puerto Rican alternative art space movement succeeded against all odds.

One must take into account that Puerto Rican alternative art spaces served diverse constituencies in the 1970s and continue to do so today; the local community is a primary audience, but these galleries have also served the art world at large by providing places for emerging artists (of color) to exhibit in New York and emerging curators to organize exhibits. The Longwood Arts Center (1982), cofounded by arts administrator Bill Aguado in the South Bronx, can boast of nurturing two artists who won MacArthur Fellowships: Pepón Osorio and Fred Wilson.[39] Whereas mainstream dealers,

curators, and critics are now more inclined to attend exhibitions at El Museo del Barrio, Taller Boricua, and the Caribbean Culture Center, the founders of those spaces, many of whom are still living, have suffered neglect in part because of the art world's attraction to young and new or the newly dead.

Given the speed at which countercultural and subcultural art forms are either co-opted by the marketplace or censured by the state, and that "not-for profit' artist-run galleries are practically unsustainable in today's economy, the anti-capitalist principles and barrio-based practices adopted by artists in the Puerto Rican alternative art space movement may appear outdated. However, we must remember that conditions were different in the past. Nuyorican artists seized a small window of opportunity brought about by the mass rebellions of the late 1960s to create alternatives to functioning within the commercial mainstream. They created art, poetry, and artist-run galleries and museums that are testaments to the progressive collective consciousness of the New York Puerto Rican creative community. The inter-linked networks alternative spaces founded by Puerto Rican artists in New York throughout the 1970s and 1980s deserve recognition in US art history as a vanguard socio-aesthetic movement—the Puerto Rican/Nuyorican al-ternative art space movement—that bridged the gaps between the island and the mainland, the margin and the center, art and life. "Alternative spaces are alternative societies constructing parallel histories," writes Papo Colo. "Al-ternatives have been associated with the young, new or unusual, but as the concept has gown older, they have also become wise and prophetic. Art is the action of consuming the self and the supreme manifestation of humans. Agitate the art and power shakes. Alter your life and the world will change."[40]

NOTES

Epigraph: Marta Moreno Vega, "The Purposeful Underdevelopment of Latino and Other Communities of Color," in *Voices from the Battlefront: Achieving Cultural Equity*, edited by Marta Moreno Vega (Trenton, NJ: Africa World Press, 1993), 104.

1 Ault, *Alternative Art.*

2 See Cahan, "Harlem on My Mind at the Metropolitan Museum of Art."

3 *Contemporary Puerto Rican Art*, Riverside Museum, New York, January 1957. Organized by the Institute for Puerto Rican Culture, the exhibition featured work by twenty-five artists from the island.

4 *Contemporary Puerto Rican Artists*, Brooklyn Museum of Art, New York, January 1969. With the exception of Hector Alvarez, a midcareer artist, the

other participants were art students: Adrian Garcia, Armando Soto, Antonio Bechara, Jaime Yamin, James Jacobo Gross, Juan Fernandez Jr., Marcos Dimas Ramirez, Martin Rubio, and Rafael Rodriguez.

5 See Dimas, "Reflecting on Twenty Years of the Puerto Rican Workshop."

6 Marcos Dimas and Adrian Garcia, interview by the author, 2001.

7 See Fernandez, *Young Lords*.

8 See Ramirez, "Young Lords Way."

9 See Reed, *Art of Protest*, 297.

10 While some former members of the YLO have expressed misgivings to me about being labeled "artists," its leadership team was extraordinarily gifted. Felipe Luciano, chairman, was a member of the Last Poets, a Black Power performance poetry troupe; Denise Oliver, minister of economic development and revolutionary artist, designed many of the posters and illustrations that appeared in the YLO's weekly newspaper, *Palante*; Hiram Maristany, who conducted photography workshops in East Harlem prior to joining the group, was the YLO's in-house photographer. Juan Gonzalez, minister of education, led the Columbia University student strikes of 1968 and was an aspiring journalist. He wrote numerous articles examining the impact of US interventions in Latin America for the YLO newspaper, *Palante*, that later became the basis for his award-winning book documentary series, *The Harvest of Empire*. The YLO also recognized Nuyorican poet and playwright Pedro Pietri as its poet laureate.

11 See Negrón-Muntaner, "Look of Sovereignty."

12 "Young Lords Party 13 Point Program and Platform."

13 See Aponte Pares, "Lessons from El Barrio."

14 See Art Workers' Coalition, "Statement of Demands." Lippard reproduced the 1970 demands of the Art Workers' Coalition in *Get the Message? A Decade of Art for Social Change* and later updated her foundational short essays in the 2002 book *Alternative Art*.

15 See Hendricks and Toche, *Guerrilla Art Action Group*. Section 10 of this unpaginated artist book contains descriptions, letters, handouts, and photos related to the Black and Puerto Rican Art Workers demonstration at MoMA on May 2, 1970.

16 See Dimas, "Reflecting on Twenty Years."

17 Cotter, "Neighborhood Nurtures Its Vibrant Culture."

18 See Ramirez, "Activism Legacy."

19 Essays on the history of En Foco can be found in Biasiny-Rivera et al., *Nueva Luz*.

20 The *New York Times* covered the first graffiti art show at City College in 1972. See David L. Shirey, "Semi-retired Graffiti Scrawlers Paint Mural at C.C.N.Y.

133," *New York Times*, December 8, 1972, https://www.nytimes.com/1972/12/08/archives/semiretired-graffiti-scrawlers-paint-mural-at-ccny-133.html.

21 See Norman Mailer's text in Kurlansky, *Faith of Grafitti*.
22 Martinez, *United Graffiti Artists*.
23 Algarín, "Introduction," 11.
24 Algarín, "Introduction," 9.
25 See Syeus Mottel, *Charas, the Improbable Dome Builders*.
26 Jody Graf, "Life between Buildings."
27 For an analysis of alternative spaces as sites of resistance in Loisaida, see Bagchee, "Communitarian Estates of Loisaida."
28 For discussions of the early history of the Nuyorican Poets Café, see Noel, *In Visible Movement*; Jaime, *Queer Nuyorican*.
29 See Moore and Miller, "The ABCs of No Rio."
30 See Ramirez, "La Vida."
31 Geno Rodriguez, interview by the author, 2003.
32 Jack Agüeros, interview by the author, 2001.
33 Nilda Peraza, interview by the author, 2001.
34 Rosati and Staniszewski, *Alternative Histories*.
35 Wallis, "Public Funding and Alternative Spaces."
36 Agüeros, "Sonnet Substantially Like the Words," 36.
37 Unrah, *Latin American Vanguards*.
38 Crane, *Transformation of the Avant Garde*.
39 Pepón Osorio and Fred Wilson won MacArthur Fellowships in 1999.
40 Colo, "Alter the Native," 15.

BIBLIOGRAPHY

Agüeros, Jack. "Sonnet Substantially Like the Words of F Rodríguez One Position Ahead of Me on the Unemployment Line." In *Correspondence between the Stonehaulers*, 36. Brooklyn, NY: Hanging Loose Press, 1991.
Algarín, Miguel. "Introduction: Nuyorican Language." In *Nuyorican Poetry: An Anthology of Puerto Rican Words and Feelings*, 9–19. New York: William Morrow, 1975.
Andrade, Oswald de. "Manifesto antropófago." *Revista de Antropofagia*, no. 1 (1928): 3, 7.
Aponte Pares, Luis. "Lessons from El Barrio—The East Harlem Real Great Society/Urban Planning Studio: A Puerto Rican Chapter in the Fight for Self-Determination." *New Political Science* 20, no. 4 (1998): 399–420.
Art Workers' Coalition. "Statement of Demands." In Lucy R. Lippard, *Get the Message? A Decade of Art for Social Change*, 12. New York: E. P. Dutton, 1984.

Ault, Julie, ed. *Alternative Art, New York, 1965–1985: A Cultural Politics Book for the Social Text Collective*. New York: The Drawing Center; Minneapolis: University of Minnesota Press. 2002. Exhibition catalog.

Bagchee, Nandini. "The Communitarian Estates of Loisaida: 1967–2001." In *Counter Institution: Activist Estates of the Lower East Side*, 101–52. New York: Fordham University Press, 2018.

Biasiny-Rivera, Charles. Commemorative issue, *Nueva Luz: Photographic Journal* 7, no. 2 (2001).

Bürger, Peter. *Theory of the Avant Garde*. Minneapolis: University of Minnesota Press, 1984.

Cahan, Susan E. "Harlem on My Mind at the Metropolitan Museum of Art." In *Mounting Frustration: The Art Museum in the Age of Black Power*, 31–107. Durham, NC: Duke University Press, 2016.

Colo, Papo. "Alter the Native." In *Alternative Histories, New York Art Spaces: 1960 to 2010*, edited by Lauren Rosati and Mary Anne Staniszewski, 15. Cambridge, MA: Exit Art and MIT Press, 2012.

Cotter, Holland. "A Neighborhood Nurtures Its Vibrant Culture; Pride of Place for Art and Artists in El Barrio." *New York Times*, May 16, 1998, sec. E, p. 1.

Crane, Diane. *The Transformation of the Avant Garde: The New York Art World, 1940–1985*. Chicago: University of Chicago Press, 1987.

Dimas, Marcos. "Reflecting on Twenty Years of the Puerto Rican Workshop." In *Taller Alma Boricua 1969–1989*, 10–16. New York: El Museo del Barrio, 1990.

Fernandez, Johanna. *The Young Lords: A Radical History*. Chapel Hill: University of North Carolina Press, 2020.

Graf, Jody. "Life between Buildings." MoMA PS1, May 2022. https://www.momaps1.org/post/162-life-between-buildings-curatorial-essay.

Hendricks, John, and Jean Toche. *GAAG: The Guerrilla Art Action Group, 1969–1976: A Selection*. New York: Printed Matter, 2011.

Jaime, Karen. *The Queer Nuyorican: Racialized Sexualities and Aesthetics in Loisaida*. New York: New York University Press, 2021.

Kurlansky, Mervyn. *Faith of Grafitti*. New York: Praeger, 1974.

Lippard, Lucy. "Biting the Hand: Artists and Museums in New York since 1969." In *Alternative Art, New York, 1964–1985*, edited by Julie Ault, 79–114. Minneapolis: University of Minnesota Press, 2002.

Lippard, Lucy. "The Art Workers' Coalition: Not a History." *Studio International* 180, no. 927 (1970): 171–174.

Martinez, Hugo. *United Grafitti Artists*. New York: Artists Space, 1975.

Moore, Alan, and Marc H. Miller. "The ABCs of No Rio in Its Time." In *ABC No Rio Dinero: The Story of a Lower East Side Art Gallery*, edited by Alan Moore and Marc H. Miller, 1–7. New York: ABC No Rio with Collaborative Projects, 1985.

Moreno Vega, Marta. "The Purposeful Underdevelopment of Latino and Other Communities of Color." In *Voices from the Battlefront: Achieving Cultural*

Equity, edited by Marta Moreno Vega, 103–108. Trenton, NJ: Africa World Press, 1993.

Mottel, Syeus. Charas, the Improbable Dome Builders. New York: Drake, 1973.

Negrón-Muntaner, Frances. "The Look of Sovereignty: Style and Politics in the Young Lords." In *Sovereign Acts*, 254–82. Tucson: University of Arizona Press, 2017.

Noel, Urayoán. *In Visible Movement: Nuyorican Poetry from the Sixties to Slam.* Iowa: University of Iowa Press, 2014.

Poggioli, Renato. *The Theory of the Avant Garde.* Cambridge, MA: Belnap Press of Harvard University Press, 1968.

Ramirez, Yasmin. "The Activist Legacy of Puerto Rican Artists in New York and The Art and Heritage of Puerto Rico." ICAA Documents Project Working Papers No. 1. International Center for the Arts of the Americas, Museum of Fine Arts, Houston, Texas, September, 2007.

Ramirez, Yasmin. "La Vida: The Life and Writings of Miguel Piñero in the Art of Martin Wong." In Martin Wong, *Sweet Oblivion: The Urban Landscape of Martin Wong*, edited by Amy Scholder, 33–47. New York: New Museum Books, 1998.

Ramirez, Yasmin. "The Young Lords Way." In Johanna Fernandez, Frances Negrón-Muntaner, Yasmin Ramirez, Rocío Arando-Alvarado, Wilson Valentín-Escobar, and Libertad O. Guerra, *¡Presente! The Young Lords in New York*, 39–56. New York: Bronx Museum of the Arts, 2015. https://www.yasminramirezphd.com/_files/ugd/73ee56_c665bc4c539041fa96611b8a63f4971b.pdf.

Reed, T. V. *The Art of Protest: Culture and Activism from the Civil Rights Movement to the Streets of Seattle.* Minneapolis: University of Minnesota Press, 2005.

Rosati, Lauren, and Mary Anne Staniszewski, eds. *Alternative Histories: New York Art Spaces, 1960 to 2010.* Cambridge, MA: MIT Press, 2012.

Unrah, Vicky. *Latin American Vanguards: The Art of Contentious Encounters.* Berkeley: University of California Press, 1994.

Wallis, Brian. "Public Funding and Alternative Spaces." In *Alternative Art, New York: 1964–1985*, edited by Julie Ault, 161–82. Minneapolis: University of Minnesota Press, 2002.

"Young Lords Party 13 Point Program and Platform." *Palante* 2, no. 16 (1970): 22.

3

The Construction of Nuyorican Identity in the Art of Taller Boricua

Taína Caragol

Art and social activism were inseparable in the sociocultural movement that blossomed in the late 1960s at the hands of diasporic Puerto Ricans. Almost two decades after the massive migration that brought approximately half a million Puerto Ricans to the continental United States, stateside Puerto Ricans mobilized to assert their presence and civil rights. As its name suggests, the Nuyorican movement was rooted in New York City, the epicenter of the Puerto Rican diaspora. In a quest to create workshops and exhibition spaces for themselves and other artists of color who were absent from the cultural mainstream, and to foster a sense of place and

belonging, Puerto Rican artists founded institutions such as El Taller Alma Boricua (most often known as Taller Boricua or El Taller).[1]

Although El Taller did not prescribe a specific aesthetic program for its members, artists Marcos Dimas (b. 1943), Fernando Salicrup (1946–2015), Jorge Soto Sánchez (1947–1987), and Nitza Tufiño (b. 1949), all members of the organization, shared an intent to assert their culture and lived experience as Puerto Ricans in the United States through their artwork.[2] This chapter examines their visual vocabulary and conceptual strategies, employing as a framework the theories of Edward Said, Homi K. Bhabha, and Michael Seidel that describe the psychological and cultural condition of migrants. It also revisits and expands my essay "Aesthetics of Exile." Two decades later, I reprise and refine the theoretical framework and analysis of artworks in the original version. While I still find the sociocultural condition of exile helpful to understand the work of these artists, now I prefer to call their aesthetics "diasporic" rather than "exile aesthetics."[3]

Today, as Nuyorican and Diasporican art seem more sustainable in academia and museums, and as Puerto Rico faces a new historic migration wave since 2015, the opportunity is ripe to revisit the work of the diaspora's artistic forebears, understanding the sense of grounding it may provide to a community in movement.[4]

The "Unhomely" in Said's Exile and the Puerto Rican Émigré

The twentieth century saw historically unprecedented movement of peoples between countries and continents. As journalist Juan Gonzalez established in his crucial *Harvest of Empire: A History of Latinos in America*, many of these migrations from the Global South to the West are the outcome of colonial relations from past centuries. The social, political, and economic hierarchies established by empires such as the Spanish, the French, the English, and the US American in the lands where they claimed sovereignty have engendered long-lasting social disparities. These have often continued to reverberate, sometimes outlasting colonial bonds, creating a permanent movement of people from the (former) colonies to the (former) metropolises in search of economic opportunity.[5] These massive human translocations and their cultural impact have called for a reexamination of diasporic movements and of the exile's condition in fields like sociology,

cultural criticism, and literature. Said, Seidel, and Bhabha are some of the scholars concerned with the condition of exiles and diasporic people in relation to their literary production. In this chapter, I employ their theories as a loose framework for discussing the work of artists at Taller Boricua.

In my original essay, I applied to the Puerto Rican diaspora Said's broader definition of the exile as "anyone who is prevented from returning home."[6] For Said, exiles, expatriates, and émigrés share the condition of uprooted-ness. But while expatriates and émigrés have the choice to go back to their land, exiles do not, either because they have been banned or because their land has been taken away from them. The involuntary nature of the exile's displacement carries a unique feeling of solitude. While acknowledging the unique pain of ostracism and forced migration of the exile, this chapter focuses on that condition of uprootedness as the common denominator of mass migrations, particularly the Puerto Rican post–World War II migra-tion, and examines its impact on Nuyorican art.

Due to the nature of the first massive Puerto Rican diaspora, which occurred as a consequence of the archipelago's transition from an agrar-ian to an industrial economy in the 1940s and 1950s, Puerto Ricans in the United States should be considered as émigrés.[7] In Said's terms, it should be stressed that diasporic Puerto Ricans were not expelled from their coun-try. Nevertheless, the high unemployment among rural workers caused by the dramatic modernization of the Puerto Rican archipelago through Operation Bootstrap determined the lives of hundreds of thousands of islanders who, starting in the mid-1940s, relocated to the continent in the world's first airborne diaspora. They came to fulfill the demands for cheap labor of the growing US economy. During the 1950s, an annual average of 41,200 arrived in the continental United States in search of the elusive American Dream.[8] By 1960, they comprised more than one million. They were most numerous in New York, where by 1970 they made up 12 percent of the population, but others settled in New England, the mid-Atlantic, and the Midwest, working in the service sector as well as in manufacturing and farming.[9] The precarious living conditions, labor exploitation, forced cultural assimilation, and institutional racism to which these Puerto Ricans were subject as one of the first US migrations from Latin America and the Caribbean have been extensively documented.[10]

With this geographic and social displacement, diasporic Puerto Ri-cans, or Diasporicans, came to be situated between two temporalities and cultures—the past, related to the archipelago they or their parents had left; and the present, related to their new continental context—but

not fully inserted in either. Such displacement is defined by Bhabha as "unhomeliness"—a condition of extraterritorial and cross-cultural initiations, common to (post)colonial subjects.[11] I would argue that unhomeliness is a useful paradigm for the so-called second generation of Puerto Ricans in the United States (the children of the 1940s and 1950s émigrés) who grew up in a marginalizing US society that forced their assimilation to white hegemonic culture. The unhomely second generation shared the exile's discontinuous state of being. What Said describes as the "sadness of been denied of a land, an identity, and a past" became the ferment of their art.[12]

Inspired by the activist energy of the late 1960s, this young generation of Diasporicans rose to empower their communities socially and culturally. Their status as outsiders from their native Puerto Rico as well as from their new homeland triggered their urgent need to articulate and express their identities through the Nuyorican movement of the 1960s–1980s. El Taller Boricua/the Puerto Rican Workshop came into existence in 1970, bringing together visual artists and poets in the service of valuing the diasporic Puerto Rican experience, of improving the community's social conditions, and of instilling cultural pride. The pain and trauma of displacement became generative forces to articulate and value their diasporic identity and experience. In the words of Jorge Soto Sánchez, one of El Taller's cofounders: "We did not come here on an 'artistic sojourn,' we were traumatically transplanted or should we say up-rooted from our native soil, just like the masses of our people."[13] To borrow the words of literary critic Michael Seidel, Marcos Dimas, Nitza Tufiño, Fernando Salicrup, and Jorge Soto Sánchez transformed through their art the figure of historic rupture back into a "figure of connection."[14]

Reconstructing a Fragmented Identity: Rescuing Taino and African Roots

In their work reconstructing a cultural identity fragmented by migration and formulating a new Diasporican identity through their art, Marcos Dimas, Nitza Tufiño, Fernando Salicrup, and Jorge Soto Sánchez all share some iconographic and formal traits. This identity incorporates the traditional repertoire of collective myths, memories, and icons that have come to be associated with national identity in the Puerto Rican archipelago. It is also strongly informed by their cultural and social displacement in New York and their close contact with other communities with a relatable social experience, particularly African Americans. Analyzing their art is essential

to understanding the duality of the émigré's identity as one that flows between a past and a present culture, as described by Seidel.[15]

References to Taino culture drawn from ancient petroglyphs found in Puerto Rico are a foundational element in El Taller's visual vocabulary.[16] As the original preconquest inhabitants of Puerto Rico, the recovery of the Taino legacy in the archipelago has occurred under a nationalist framework that positions these first inhabitants as "the first root" and a cornerstone of Puerto Rican identity.[17] One of the clichés that modern archaeologists and historians of Taino culture had to contend with was the notion that the docility of these First Peoples facilitated the Spanish colonial enterprise.[18] Puerto Rican anthropologist Ricardo Alegría attributed this pervasive historiographic construct to the impact of Christopher Columbus's description of Amerindians in his February 15, 1493, letter to Ferdinand and Isabella, his voyage financiers.[19] In his letter he says:

> The inhabitants . . . are all, as I said before, unprovided with any sort of iron, and they are destitute of arms, which are entirely unknown to them, and for which they are not adapted; not on account of any bodily deformity, for they are well made, but because they are timid and full of terror. . . . But when they see that they are safe, and all fear is banished, they are very guileless and honest, and very liberal of all they have. . . . I gave them many beautiful and pleasing things, which I had brought with me, for no return whatever, in order to win their affection, and that they might become Christians and inclined to love our King and Queen and Princes and all the people of Spain; and that they might be eager to search for and gather and give to us what they abound in and we greatly need.[20]

The artists of the Puerto Rican diaspora presented Taino culture as the most legitimate link of Puerto Ricans to their land.[21] According to El Taller's founding member Marcos Dimas: "As a gesture of solidarity and union, we adapted and personalized Taino images, which became insignias that symbolically linked us with our ancestral root culture."[22] Taller Boricua's rescuing of Taino culture is present in part of the organization's name, Boricua—derived from the Taino name for Puerto Rico, Borikén—as a Puerto Rican cultural identifier and mark of belonging in its diasporic context.[23] Yet in a move to decolonize history, to rid Tainos of their docility and victimhood, the artists of El Taller foregrounded Taino culture as a symbol of Puerto Ricanness that preceded the never-ending political

domination of the archipelago by foreign powers, and its cultural impact. According to Nitza Tufiño, in addition to studying Taino iconography through trips to archaeological sites in Puerto Rico and bibliographic research, the artists of El Taller also created their own new designs following the schematic style of Taino icons with the intent of projecting Taino culture into the future and giving it a new Nuyorican spin.[24]

Diasporicans identified their social and cultural marginality in the United States as a continuum of the systemic oppression brought about by the colonization of Puerto Rico by Spain, starting in 1508, and later by the US takeover of the archipelago during the War of 1898, commonly known in US history as the Spanish-American War.[25] For this reason, the unmasking of historical narratives that traditionally erased the violence against and decimation of Indigenous people at the hands of Spanish conquistadors, and the affirmation of the active role of Tainos as historical subjects before and during colonization, was paramount in the art of El Taller.

Fernando Salicrup is one of the artists who revisits Puerto Rican colonial history, as seen in his 1978 painting *Una vez más, Colón* (*Once Again, Columbus*; see figure 3.1). In this work, Salicrup depicts dozens of eyes of Taino Indigenous people suspiciously staring through thick tropical foliage at an entity outside the picture plane. By omitting the conquistador from the composition, Salicrup upsets the primacy of the Genovese sailor in Puerto Rico's historical narrative. Inverting the traditional scheme that situates the colonized as the Other, Salicrup positions Tainos as subjects instead of objects of history who seem to discover the real intentions of exploitation and extermination of the colonizers. The reiteration implied in the title *Una vez más, Colón* offers a new take on Puerto Rico's colonial history, where Tainos are on guard and ready to rebel. Simultaneously, Salicrup positions the viewer where the conquistadors would be, implying museum goers in the power dynamic of colonization and its historical legacy of ongoing social oppression.

In contrast to Salicrup's averting Tainos, Nitza Tufiño's 1972 painting *Pareja Taína* (*Taino Couple*; see figure 3.2) presents us with a frontal, disarming portrait of a woman and a man depicted as anthropomorphic and reinterpreted Taino icons. The closely cropped painting monumentalizes the figures. At the same time, the loose brushwork and bright colors give the artwork a playful and informal Pop aesthetic. The male figure, on the right, is painted pink, with pectoral and abdominal muscles delineated by a coqui frog icon and a face that resembles a Taino sun icon. His arm is placed around the woman, whose face is outlined in black in a more ambiguous shape. The

3.1 Fernando Salicrup, *Una vez más, Colón*, 1978. Acrylic on linen, 54 × 44 in. Collection of El Museo del Barrio. Museum purchase with a grant from the National Endowment for the Arts and a gift from George Aguirre. Photo courtesy of El Museo del Barrio, New York.

3.2 Nitza Tufiño, *Pareja Taína*, 1972. Acrylic, charcoal, and polyurethane on Masonite, 48¾ × 48¼ in. Collection of El Museo del Barrio. Museum purchase through the support of George Aguirre, National Endowment for the Arts, Boricua College, the Reader's Digest Foundation and individual contributions. Photo courtesy of El Museo del Barrio, New York.

ovoid form and schematic ears, eyes, and hair not only resemble Taino petroglyphs; together these shapes also evoke the image of a wartime gas mask such as the M17 manufactured in 1959 and used during the Vietnam War to protect US troops from toxic chemical and biological agents. This could be interpreted as a critique of the Vietnam War, ongoing at the time this work was painted, and where many Puerto Rican male colleagues of Tufiño fought—including Dimas, Salicrup, and Soto Sánchez. The military service of these artists, coming from humble backgrounds, opened the

doors to higher education and thus to becoming professionally trained artists through the GI Bill.[26]

A reference to war in *Pareja Taína* would not be fortuitous, as for Puerto Ricans colonization and military service have been intertwined since 1917, when the United States recognized Puerto Ricans as citizens a month before its entry into World War I. Although Puerto Ricans were eligible for US military service before, once they were granted citizenship, they were required to register, which resulted in the immediate drafting of 17,855 of them.[27] Ever since, Puerto Ricans have participated in all the wars fought by the United States. As many as 200,000 of them have served in the military. The island is a leading recruitment station for the US armed forces, particularly among the working class, underscoring the ties between colonialism and militarism at the service of the metropolis.[28]

By masking the face of the female, traditionally portrayed as the keeper of culture, Tufiño is perhaps also denouncing US cultural imposition over Puerto Rico. The phallic shape replacing the nose of the female figure, trying to penetrate the protection mask, acquires a polysemic value, referring to a multiple violation that takes place on political, cultural, and sexual levels. The placement of the phallus in the female figure could also suggest the absence of that organ in the male, leading us to ponder the possibility that the future of Puerto Ricans as a culture and a people might be uncertain and at risk, under the threat of war and assimilation to US culture.

In literary correlation, the Nuyorican poet Miguel Algarín uses a similar masculinist metaphor—a flaccid phallus—to characterize the perennial colonial dependence and political disempowerment of Puerto Ricans. His poem "Mongo Affair," published in the 1975 landmark publication *Nuyorican Poetry: An Anthology of Puerto Rican Words and Feelings*, reads:

> that even the fucking a man does
> on a government mattress draws the blood from his cock
> cockless, *sin espina dorsal,*
> mongo—that's it!
> A welfare fuck is a mongo affair!
> Mongo means *flojo*
>
> mongo can only tease
> but it can't tickle
> the juice of the earth-vagina
> *mongo es el bicho Taíno*

porque murió
mongo es el borinqueño.[29]

Both Tufiño and Algarín relate the colonial status of Puerto Rico to sexual impotence. In the case of Tufiño, a chain of relations is built through the iconography, starting at the Taino genocide, passing through the Puerto Rican participation in US wars, and ending in the menaced future of Puerto Rican culture under colonial rule. It is worth mentioning that in the rest of the poem, Algarín also denounces the use of Puerto Rican soldiers as cannon fodder in US wars. Compared to Miguel Algarín's poem, and considered within the context of the vehement praise of Taino culture among the members of El Taller, Tufiño's work is a wake-up call against the cultural risks of colonialism rather than the condemnatory stance on the passivity and subjugation of the Taino people in colonial history that Algarín adopts in his poem.

The painting *Pariah* (1971–72) (see figure 3.3), by Marcos Dimas, founder and current artistic director of El Taller, furthers the rescuing of Puerto Rico's Indigenous culture, while also alluding to the recovery of the Afro–Puerto Rican ancestry. *Pariah* is a large-scale painting, measuring more than five by four feet, and portrays an unidentified person with curly hair, thick lips, and dark skin.[30] The figure's uneven haircut, nude neck, and rustic necklace, apparently made from a sea shell, go against the conventions of Western portraiture, where formal dress, coiffure, and elaborate jewelry are markers of distinction. For Dimas, *Pariah* is a person of mixed race from the Caribbean, someone of Indigenous and Afro-diasporic background. In addressing how he titled the artwork, Dimas said: "Originally, I wanted to title the artwork *Obatalá*, the name of an androgynous Orisha or deity of Yoruba and Santería religions. The idea of having an individual who could be a female or a male, but who was outside society, like we were, was important to me."[31] Ultimately, Dimas decided to be more direct and accessible by naming it *Pariah*. The tension between the monumental scale of the artwork and the marginality implied in the title overrides the outcast status of the subject. Far from being victimized, the figure gazes at the viewer with dignity, fearlessly affirming their presence and mixed racial identity. Thus, Dimas transgresses the tradition of Western portraiture, which for centuries has cemented the power of white elites.

It should be noted that the portrait's three-quarter profile and self-assurance are reminiscent of Diego Velázquez's portrait of Juan de Pareja at the Metropolitan Museum of Art. Since 1650, when Velázquez painted this work, the portrait of Juan de Pareja (ca. 1610–70) shocked the art world

3.3 Marcos Dimas, *Pariah*, 1971–72. Oil on canvas, 65 × 54 in. Collection of Smithsonian American Art Museum, Washingon, DC. Museum purchase through the Luisita L. and Franz H. Denghausen Endowment. Photo by Marcos Dimas.

for its technical bravura, and for being a dignified, unsubmissive portrayal of the Spanish painter's enslaved apprentice and studio assistant, who became a painter in his own right.[32] While this was not a conscious quote by Dimas, he does agree that Pareja and *Pariah* carry themselves in a way that is similar, and that it might have been a subconscious reference.[33]

As an attempt to articulate a Diasporican identity, this painting operates as a critique of Black and Brown marginality in both Puerto Rico

and the United States. For Puerto Rican audiences, the painting counters the mainstream national discourse that supports the notion of a harmonious *mestizaje* or miscegenation where the Spanish root prevailed over the Indigenous and African roots. In the 1970s, Puerto Rican artists from the archipelago and the United States questioned the racist foundations of this narrative.[34]

In relation to the United States, through the signifier of its title and the complexion of the figured portrayed, *Pariah* evokes the close ties between Puerto Ricans and African Americans. The contiguities between Puerto Rican and Black communities in New York in neighborhoods like El Barrio and Harlem or Williamsburg and Bedford-Stuyvesant, the migratory patterns of both populations, their cultural and racial similarities, and their common history as marginalized populations in the United States fostered strong ties and a sense of solidarity between them.[35] In more personal terms, concurrent with his work in El Taller, Marcos Dimas was also a member of the Art Workers' Coalition, which fought for the decentralization of the New York art world in the 1970s and the representation of African Americans and Puerto Ricans (among other underrepresented groups) in the city's art establishment. In other words, in *Pariah* Dimas also introduces his lived experience as a Nuyorican fighting alongside African Americans for equality in the art world.

A Sarcastic Response to Estrangement and Alienation

Although Jorge Soto Sánchez was one of the main Nuyorican artists who reclaimed Taino and African roots as constitutive of the Diasporican identity, here I will address another salient aspect of his work: his frontal attack on the conditions of socioeconomic marginality of Nuyoricans through biting sarcasm. In his 1982 artwork *Anonymous Americans*, Soto Sánchez transgresses the tradition of sculpture through the assemblage of urban waste to construct a metaphor for the disempowerment of the Puerto Ricans in New York.

Like Nitza Tufiño's *Pareja Taína*, Soto Sánchez's *Anonymous Americans* symbolically portrays a heterosexual couple, but in sculptural form.[36] The man and woman are mutilated mannequins: both have only one arm, and the woman also lacks one leg. His genitals are covered with the head of a doll. Hers are occluded by a black mass that resembles asphalt. The abject state of the couple is amplified by aggressive expressionist brushstrokes

over their silver bodies, suggesting images of violence, abandonment, and impurity. The woman wears a party hat, adding perhaps a note of decadent celebration or apathy amid crisis. The title *Anonymous Americans* suggests people who are nameless. Their damage and lost identity signal a subordinate position as Americans. Much like Marcos Dimas's *Pariah*, Soto Sánchez's assemblage *Anonymous Americans* subverts the tradition of portrait sculpture, and in this case also the myth of the American Dream, to confront us with the image of two broken and unrecognized individuals, standing by each other, against the odds of an oppressive society.

Soto Sánchez's biting sarcasm in conjuring the social marginality of Puerto Ricans echoes a similar gesture by writer Miguel Piñero in his poem "The Book of Genesis According to Saint Miguelito," also published in the anthology *Nuyorican Poetry*. Appropriating the biblical narrative of "The Book of Genesis," Piñero narrates the creation of the underserved neighborhoods inhabited by Puerto Ricans in New York City. He writes:

> In the beginning
> God created the ghettos and slums
> and God saw this was good
> .
> to decorate it
> God created lead-based paint
> and then
> God commanded the rivers of garbage and filth
> to flow gracefully through the ghettos.[37]

With bitter irony, Piñero makes an inventory of the social ills that define the living spaces that Puerto Ricans inhabit. He inverts the idea of perfection in the divine creation of the universe, exchanging it for the crude reality of the slum, its unhealthy nature, and the indifference of God, here referring to the US government as a generator of social differences. Likewise, through the rescuing and assemblage of discarded materials and an aesthetics of abjection, Jorge Soto Sánchez creates a metaphor of social displacement and abandonment. In his work, the strong images of disenfranchisement and mutilation mirror some of the painful events and experiences that shaped Soto Sánchez, as described in the "Biographical Sketch" for his solo exhibition at El Museo del Barrio in 1979.

Some of these events are: "1951 Playing in abandoned lots, rusty cans, broken bricks, dead cats being devoured by hundreds of worms, dead rats,

olor de podrido, decaying matter. 1957 Find aesthetic pleasure in the form and shapes of boilers and steam pipes on roof tops. . . . Would experience/witness, Puerto Ricans that I have known from early childhood turn into human parasites, sculptural forms in deep sleep (and pain). Heroin addicts."[38]

Despite the initial crudeness of his proposal, the dirty, injured, nameless figures are still standing. This suggests at least the spirit of survival of the Puerto Rican community in the face of the pervasive adversity of their everyday. Likewise, in "The Book of Genesis," Piñero, for a brief moment, gives the disempowered subjects of his poem the possibility of becoming politically conscious and understanding the roots of their oppression. The vehicle for this sociopolitical awakening would be Satan, according to the poem's last stanza, which reads:

> On the seventh day God was tired
> So he called in sick
> Collected his overtime pay
> A paid vacation included
> But before God got on that t.w.a.
> For the sunny beaches of Puerto Rico
> He noticed his main man satan
> Planting the learning trees of consciousness
> Around his ghetto edens
> So God called a news conference on a state of the heavens
> address
>
> and God told the people to be
> COOL
>
> and the people stayed cool.

Instead of going back to the Taino and African roots that serve as a cultural referent of the past to Puerto Ricans on the island, in *Anonymous Americans* and "The Book of Genesis According to San Miguelito" the images chosen by Jorge Soto Sánchez and Miguel Piñero constitute the everyday life, the present of the Diasporican's fragmented history. This historic moment is filled with uncertainties and marked by the experience of social displacement, approachable only through a bitter and tragic humor. A profound frustration emanates from the poem and the sculptural assemblage, the frustration of being uprooted and transplanted from their

homeland into an urban slum, where marginality is chronic and systemic—almost inescapable.

A Symbolic Portraiture to Represent Themselves

To summarize, the artistic production of the Puerto Ricans Nitza Tufiño, Marcos Dimas, Jorge Soto Sánchez, and Fernando Salicrup is part of the project of forging and valuing the particular and unique identity and culture of Puerto Ricans in New York City. The persistent questioning of colonial history, the rescuing of the devalued Taino and African cultural elements, and the reference to marginalization and émigré displacement define this cultural identity as one that bridges their ancestral homeland and with their present experience in the continental United States. Whether in painting or assemblages, the portrayal of imagined individuals is key as a way to articulate that identity and its different aspects. In the case of the artists of El Taller Boricua, we have seen the border between the two temporalities and cultural poles—the past in Puerto Rico and the present in New York—transforming itself into a place of creation. The result is a highly complex and unique artistic expression that simultaneously evokes humiliation and self-pride; profound sadness and sardonic humor; chaos and anarchy; and finally the hope for a dignified future.

NOTES

Acknowledgments: I am grateful to Nitza Tufiño, Fernando Salicrup, and Marcos Dimas for their generosity in sharing their practice when I was a graduate student and lived in El Barrio, and for their continued trust and friendship today. I dedicate this chapter to the memory of Fernando Salicrup (1946–2015).

1 Yasmin Ramirez has written the most expansive scholarly account of the Nuyorican art movement in her dissertation, "Nuyorican Vanguards, Political Actions, Poetic Visions."

2 The founding members of El Taller in 1970 included Marcos Dimas, Adrián García, Armando Soto, and Carlos Osorio. By 1971–72, Olga Alemán, Jimmy Jiménez, Manuel "Neco" Otero, Jorge Soto Sánchez, Nitza Tufiño, and Rafael Tufiño, among others, joined. Between 1972 and 1978, Fernando Salicrup also joined. In numerous publications and public programs, 1969 has been cited as the founding year of El Taller; however, Ramirez restates and emphasizes in this anthology what Diógenes Ballester established in his "Annotated Chronology" of Taller Boricua. Formative meetings between what would become the

original members of El Taller happened in 1969 at the Centro Puertorriqueño de Relaciones Culturales de la Sociedad de Puerto Rico, located at 432 Third Avenue, New York City; but El Taller itself only comes into being in 1970. See Ballester, "Annotated Chronology"; and Ramirez, "Nuyorican Vanguards."

3 This choice is due to a deeper awareness of the pain caused by the impossibility of returning to one's home country.

4 This sustainability has been tied to several factors, including a critique from scholars such as Arlene Dávila and Jorge Duany to Puerto Rican nationalist paradigms of the second half of the twentieth century that defined the culture of the island in relation to Spain and in opposition to the United States. Slowly but surely, this incisive criticism has led to more openness within academia, museums, and other cultural institutions to studying Puerto Rican art as a transnational phenomenon. The field's newfound viability is also due to the establishment of Latinx art as a field of study through dedicated curatorial positions at the Smithsonian American Art Museum, the National Portrait Gallery, and through the hiring of curators who are Latinx art experts at places like the Whitney Museum of American Art. Groundbreaking studies such as Ramirez's dissertation, "Nuyorican Vanguards," and Dávila's *Latinx Art*, as well as the digitization of primary and secondary sources related to Latin American and Latinx art led by the International Center for the Art of the Americas (ICAA) at the Museum of Fine Arts Houston; and the creation of the US Latinx Art Forum have been game changers for the art of Nuyoricans, Diasporicans, and Latinx artists in general.

5 Gonzalez, *Harvest of Empire*, xii.

6 Said, "Reflections on Exile," 181.

7 The presence of Puerto Ricans in the United States dates back to the mid to late nineteenth century, when many of the diaspora settled in New York and worked alongside Cubans to organize the overthrow of the Spanish colonial government in their islands. Puerto Rican migration to the United States increased after 1898, when the island became a US colony.

8 Gonzalez, *Harvest of Empire*, 81; López, *Puerto Ricans*, 317–20.

9 Domestic work in well-to-do homes was a substantial form of employment among women. Some men also worked in farms and food-processing plants in New Jersey, Pennsylvania, New York, Connecticut, and other states. Ayala and Bernabe, *Puerto Rico in the American Century*, 180.

10 Similar to the Puerto Rican diaspora, the Mexican diaspora in the United States is the product of the long-standing social and cultural relationship between the two countries before the signing of the Treaty of Guadalupe Hidalgo in 1848, when the northern half of Mexico became the southwest of the United States. The colonization of northern Mexico by the United States implied the dispossession of landholdings, proletarization, and the occupational and racial segregation of Mexicans, as documented by anthropologist

Patricia Zavella. I am grateful to Arlene Dávila for suggesting this parallel. Zavella, *I'm Neither Here nor There*, 25–27.

11 Bhabha, *Location of Culture*, 13.

12 Said, "Reflections on Exile," 173–77.

13 Jorge Soto Sánchez, "The Possible Role of the Caribbean Artist in an Urban Setting," *Caribe* (New York), 1981, 21–23. Source digitized by the International Center of the Art of the Americas, Museum of Fine Arts Houston, record ID ICAA 841643.

14 Seidel, *Exile and the Narrative Imagination*, 10.

15 Seidel, *Exile and the Narrative Imagination*, 13.

16 Whereas the Tainos lived throughout all the Greater Antilles, Puerto Rico has the most surviving petroglyphs.

17 El Taller's rescue of Taino iconography in New York City is in alignment with the same process in Puerto Rico. In the archipelago since the late 1940s, the recovery of Taino history was part of a state-sponsored agenda of cultural nationalism and led by anthropologist and archaeologist Ricardo Alegría, founder of the Center for Archaeological Research and of the Instituto de Cultura Puertorriqueña. Duany, *Puerto Rican Nation*, 264–65.

18 On the signification of Indigenous people of the Americas from noble savages to fierce barbarians in the narrative discourse of the Spanish conquest, see Bravo, "Las formas de la arcilla," 113–44. On the use of the phrase "the Taíno" in the fields of history, archaeology, and anthropology, see Curet, "Taíno," 467–95.

19 Columbus addressed this letter to Luis de Santángel, royal treasurer and scribe, but it was destined for the king and queen, in order to share with them his findings upon his return from his first trip to Spain. The letter was originally published in April 1493 in Barcelona and subsequently translated into Latin and published in multiple editions throughout Europe. (See Alegría, *Las primeras representaciones gráficas*, 12–13; see also Emanuel Bravo, "Las formas de la arcilla," 118.) The original version of "Aesthetics of Exile" cited Duany in attributing to Ricardo Alegría the characterization of Tainos as a people whose docility facilitated the colonial enterprise. Duany based this judgment on Alegría's *Historia de nuestros indios* (Duany, *Puerto Rican Nation*, 264–65.) However, in text published in 1969, Alegría adds nuance to his description of Tainos as a peaceful people by expounding on their rebellions against the Spanish *encomienda* system (Alegría, *Descubrimiento*, 34–37, 61–70).

20 Christopher Columbus, letter to Ferdinand and Isabella of Spain, February 15, 1493, Gilder Lehrman Collection, no. GLC01427, https://www.gilderlehrman .org/collection/glc01427.

21 Ramirez has also analyzed the Afro-Taino aesthetics of the artists of El Taller Boricua in an essay that addresses Soto Sánchez's foundational role in de-

veloping this visual language, and looking back at the work of artist Rafael Tufiño, who had strong ties to El Taller. See Ramirez, "Nuyorican Visionary."

22 Marcos Dimas, dir., *Taller Boricua: Art for All*, documentary, 1969, released in 2020.

23 Even before joining El Taller, artist Nitza Tufiño was invested in learning about and recovering Taino culture. In Puerto Rico, she visited archaeological sites with Walter Murray Chiesa, director of arts and crafts at the Institute of Puerto Rican Culture in 1970, and created rubbings of numerous petroglyphs. Separately, in 1972 Marcos Dimas traveled to Puerto Rico and along with fellow artist and art administrator Luis Cancel also created rubbings of petroglyphs at Taino archaeological sites. Dimas and Cancel visited five sites, of which Dimas remembers El Centro Ceremonial Indígena de Tibes in Ponce, La piedra escrita in Jayuya, and La cueva del indio in Arecibo. Phone interview with Nitza Tufiño, August 12, 2023; phone interview with Marcos Dimas, August, 1, 2023; Marcos Dimas, "Autobiography," accessed December 23, 2022, http://marcosdimas.com. El Taller's Boricua logo, designed by Dimas, also employs Taino iconography.

24 Phone interview with Nitza Tufiño, August 12, 2023.

25 I prefer to use the War of 1898 to refer to this conflict because it neutralizes the imperial powers underscored in the nomenclature "Spanish-American War," opening the way to question which of the countries involved were sovereign and nonsovereign. See Caragol and Lemay, *1898*, 12.

26 Interview by the author with Fernando Salicrup and Marcos Dimas, March 2000.

27 Duany, *Puerto Rico*, 48.

28 Duany, *Puerto Rico*, 77.

29 Algarín, "A Mongo Affair," in Algarín and Piñero, *Nuyorican Poetry*, 52–57. To facilitate the understanding of English readers, I have translated the Spanish words in this stanza:

> That even the fucking a man does
> on a government mattress draws the blood from his cock
> cockless, without a spinal cord
> numb—that's it!
> A welfare fuck is a numb affair!
> Numb means weak
>
> Numb can only tease
> but it can't tickle
> the juice of the earth-vagina;
> the Taino's dick is numb
> because he died
> the borinqueño is numb.

30 The monumental scale was a decision informed by the scale of Chuck Close's portraits. Dimas took several courses with him during his artistic training at the School of Visual Arts. Phone interview with Marcos Dimas, August, 1, 2023.

31 Phone interview with Marcos Dimas, August, 1, 2023.

32 Lugo-Ortiz and Rosenthal, *Slave Portraiture in the Atlantic World*, 15.

33 Author's phone interview with Marcos Dimas, August, 1, 2023.

34 Dávila, *Sponsored Identities*, 64–65.

35 Flores, "'Qué Asimilated, Brother, Yo Soy Asimilao.'"

36 In the original version of this chapter, Jorge Soto Sánchez's work is referenced with the title *Tom and Jill*, as it had been identified in *Taller Alma Boricua*. However, per conversations with El Museo del Barrio, this artwork in its collection is cataloged under the title *Anonymous Americans*.

37 Piñero, "The Book of Genesis According to Saint Miguelito," in Algarín and Piñero, *Nuyorican Poetry*, 62–64.

38 Soto Sánchez, "Biographical Sketch," 6.

BIBLIOGRAPHY

Alegría, Ricardo. *Descubrimiento, conquista y colonización de Puerto Rico, 1493–1599*. San Juan: Colección de Estudios Puertorriqueños, 1992.

Alegría, Ricardo. *Historia de nuestros indios: version elemental*. San Juan: Departamento de Instrucción de Puerto Rico, 1950.

Alegría, Ricardo. *Las primeras representaciones gráficas del indio americano 1493–1523*. Barcelona: Centro de Estudios Avanzados y de Puerto Rico y el Caribe, 1986.

Algarín, Miguel, and Miguel Piñero, eds. *Nuyorican Poetry: An Anthology of Puerto Rican Words and Feelings*. New York: William Morrow, 1975.

Ayala, César, and Rafael Bernabe. *Puerto Rico in the American Century: A History Since 1898*. Chapel Hill: University of North Carolina Press, 2007.

Ballester, Diógenes. "Annotated Chronology." In *Taller Alma Boricua: Reflecting on Twenty Years of the Puerto Rican Workshop, 1969–1989*, 63–77. New York: Museo del Barrio, 1990. Exhibition catalog.

Bhabha, Homi K. *The Location of Culture*. New York: Routledge Classics, 2004.

Bravo, Emanuel. "Las formas de la arcilla: Significaciones sobre el aborigen en el discurso de la conquista de América y sus repercusiones hasta hoy." *Revista de Estudios Hispánicos* 7, no. 2 (2020): 113–44.

Caragol, Taína. "Aesthetics of Exile: The Construction of Nuyorican Identity in the Art of El Taller Boricua." *centro Journal* 17, no. 2 (Fall 2005): 6–19.

Caragol, Taína, and Kate Clarke Lemay. *1898: Visual Culture and U.S. Imperialism in the Caribbean and the Pacific*. Princeton, NJ: Princeton University Press, 2023.

Curet, L. Antonio. "The Taíno: Phenomena, Concepts, and Terms." *Ethnohistory* 61, no. 3 (2014): 467–95.

Dávila, Arlene. *Latinx Art: Artists, Markets, and Politics.* Durham, NC: Duke University Press, 2020.

Dávila, Arlene. *Sponsored Identities: Cultural Politics in Puerto Rico.* Philadelphia: Temple University Press, 1997.

Duany, Jorge. *The Puerto Rican Nation on the Move: Identities on the Island and in the United States.* Chapel Hill: University of North Carolina Press, 2002.

Duany, Jorge. *Puerto Rico: What Everyone Should Know.* Oxford: Oxford University Press, 2017.

Flores, Juan. "'Que Asimilated, Brother, Yo Soy Asimilao': The Structuring of Puerto Rican Identity in the U.S." In *Divided Borders: Essays on Puerto Rican Identity*, 182–95. Houston: Arte Público Press, 1993.

Gonzalez, Juan. *Harvest of Empire: A History of Latinos in America.* New York: Penguin, 2022.

Lopez, Adalberto. *Puerto Ricans: Their History, Culture and Society.* Cambridge, MA: Schenkman, 1980.

Lugo-Ortiz, Agnes, and Angela Rosenthal. *Slave Portraiture in the Atlantic World.* New York: Cambridge University Press, 2013.

Ramirez, Yasmin. "Nuyorican Vanguards, Political Actions, Poetic Visions: A History of Puerto Rican Artists in New York, 1964–1984." PhD diss., City University of New York, 2004.

Ramírez, Yasmin. "Nuyorican Visionary: Jorge Soto and the Evolution of an Afro-Taíno Aesthetic at Taller Boricua." *Centro Journal* 17, no. 2 (Fall 2005): 23–41.

Said, Edward. "Reflections on Exile." In *Reflections on Exile and Other Essays*, 173–86. Cambridge, MA: Harvard University Press, 2000.

Seidel, Michael. *Exile and the Narrative Imagination.* New Haven, CT: Yale University Press, 1986.

Soto Sánchez, Jorge. "Biographical Sketch." In *Jorge Soto Sánchez: Works on Paper, 1974–1979*, 6. New York: Museo del Barrio, 1979. Exhibition catalog.

Zavella, Patricia. *I'm Neither Here nor There: Mexicans' Quotidian Struggles with Migration and Poverty.* Durham, NC: Duke University Press, 2011.

4

The Politics and Poetics of
Máximo Colón's Activist Photography

Elizabeth Ferrer

An activist and artist in equal measure, Máximo Rafael Colón has created a vast photographic archive, one that spans more than five decades, chronicling the ascendance of the Puerto Rican community in New York during a period of volatile urban development and cultural change. He has worked in many parts of the world, and his oeuvre includes portraits, landscapes, and street photography. But with his dedication to recording the Puerto Rican diaspora in New York, he has preserved the memory of a significant, if largely overlooked and often misrepresented, aspect of the city's modern history.

Born in Arecibo, Puerto Rico, in 1950, Colón came to New York in 1958, following his mother, who had arrived a few years earlier in search of steady work and a better life. His family took part in what has become known as the Great Migration, when some forty-five thousand Puerto Ricans left the island during the 1950s, attracted by the availability of jobs in the growing US postwar economy. Colón's initial years in the city, first on the Upper West Side of Manhattan and then in the Brownsville neighborhood of Brooklyn, were challenging for a young boy unable to speak a single word of English as he entered the city's unruly public school system. He frequently fought with other students and was eventually tracked—as were the majority of students of color in those days—into a vocational high school, one that would prepare him for work in an auto body shop. As a young adolescent he was introduced to photography by his stepfather, who gave him an inexpensive plastic camera and shared with him the album of photos he made during his military service in Korea. Colón began to take the camera on family excursions and learned photography, as he says, by the seat of his pants. It also provided him a creative outlet and a sense of purpose that would shape his life until the present day.

Colón became politicized at a relatively young age, amid the social tumult of the 1960s. In middle school he studied the civil rights movement and learned about the atrocities being committed against African Americans in southern states. He began participating in peace marches in Central Park during the peak years of protest against the Vietnam conflict and became well versed in leftist political philosophies. His decision to attend college was itself an act of protest against racist high school teachers and administrators who did not view Colón and his classmates as "college material." When the school principal informed Colón that he had secured a job for him in an auto body shop, Colón smugly turned down the offer, telling him he was bound for higher education.[1]

Colón entered the Borough of Manhattan Community College (BMCC) in 1968, one of the most turbulent years in twentieth-century American history. Martin Luther King Jr. and Robert F. Kennedy had been assassinated within a span of two months, war raged in Vietnam, and large-scale protests, whether in opposition to the war or in advancement of civil rights, had become increasingly militant. BMCC, opened only five years earlier, had rapidly developed a reputation for its activist student body that organized frequent demonstrations against the Vietnam War and that pressed for open admissions, lower tuition, and a more inclusive curriculum that would

recognize the interests of its large African American and Latinx populations. As a member of the school's Third World Coalition, Colón was at the center of these struggles. He participated in efforts to establish Black and Puerto Rican studies academic departments as well as in solidarity actions in support of the Panther 21, a group of Black Panthers falsely accused of conspiring to bomb police stations in New York. Colón was also becoming more serious about photography in these years; he gained access to a darkroom at BMCC and became a photographer for *Prometheus*, the school's leftist-oriented newspaper.[2] His inattention to academics in favor of political organizing and photography earned him a dismissal from the college, but his few semesters there established his lifelong commitment to participating in and documenting the struggle for social justice.

Colón turned to community-based activism on a full-time basis in 1970, beginning with his involvement with El Comité not long after its founding as a grassroots community organization on the Upper West Side. El Comité (later renamed El Comité-MINP [Movimiento de Izquierda Nacional Puertorriqueño]) initially focused its campaigns on housing justice in response to the city's northward-moving "urban renewal" campaigns in this part of Manhattan. In the late 1950s, the historically African American neighborhood known as San Juan Hill was cleared to make way for the construction of Lincoln Center, resulting in the displacement of more than seven thousand households, including a growing Puerto Rican population, and some eight hundred businesses. El Comité aimed to halt the demolition of older housing stock north of Lincoln Center, the neighborhood where Colón and his family had lived—and from which they were displaced—when he was a child. At that time, blocks along the West 80s and 90s were home to working-class Puerto Ricans and African Americans as well as to Dominicans and other immigrant households. El Comité played a key role in the fight against what became known among locals as "urban removal," supporting the efforts of squatters who aimed to remain in the neighborhood by helping them gain legal representation and advocating for their rights in meetings with city council members. Although they were unsuccessful in derailing the city's plans, their strident efforts became a model for future fights against city-sponsored gentrification.[3]

El Comité grew in scope and sophistication, developing into an avowedly leftist organization that continued to champion fair housing policies and other community needs while also acting in solidarity with broader causes, especially the Puerto Rican independence movement and the fight to end the US Navy's occupation of the island of Vieques. They collaborated with

other New York organizations, including the Young Lords, to protest the persecution of independence movement activists like Martín Tito Pérez, a musician and visual artist affiliated with the Taller Boricua who died under suspicious circumstances while in police custody after being detained for playing conga drums in the subway.[4] With his camera, Colón documented it all: the organization's day-to-day work, demonstrations and campaigns to free Puerto Rican nationalist prisoners, and the life of Puerto Ricans living in the city. It mattered little to Colón if he was documenting a workaday meeting or a major demonstration—it was all in the service of the community, all necessary in creating a record of the advancement of social justice. The large quantity of work he was producing in these years reflected an ethos that the making of the photograph was itself a political act; each image would act as a record of social struggle and honor the everyday people who took part in these efforts.

Central to membership in El Comité was participation in a rigorous process of self-education. In tandem with their organizing activities, members studied and gathered for discussions on seminal political and ideological texts of the period like Eldridge Cleaver's *Soul on Ice* and *The Autobiography of Malcolm X*, as well as writings on labor organizing, pacifism, anti-imperialism, liberation theology, and American history. Texts by the Martinican political philosopher Frantz Fanon, especially *The Wretched of the Earth*, were prominent in their consciousness-raising discussions. Fanon's theories on decolonization and on the necessity for violent resistance in the face of colonial rule sustained by violence became a valuable critical framework for those involved in the Puerto Rican independence movement. Colón states that this educational grounding "made me all that I am."[5] These texts provided him with a continuing education outside of academia as well as a moral basis for his work, whether as an organizer or with the camera.

Colón's training in photography also came largely through informal means, especially through his relationships with his peers. He is a member of a pioneering generation of Puerto Rican photographers that emerged in New York in the late 1960s and early 1970s that included figures like Charles Biasiny-Rivera (b. 1930), Roger Cabán (1942–2017), Benedict Fernandez (1936–2021), Ángel Franco (b. 1951), and Geno Rodriguez (b. 1940).[6] Prior to this period, depictions of the city's Puerto Rican communities were largely authored by outsiders, notably by the Hungarian immigrant John Albok (1894–1982), who photographed everyday life in Harlem in the 1930s, and Helen Levitt (1913–2009), who often turned her gaze on children in

East Harlem and the Lower East Side in the same period. As early as the 1960s, although their work was largely unrecognized at the time, Frank Espada (1930–2014) and Hiram Maristany (1945–2022) were actively photographing in their neighborhoods prior to the rise of the Nuyorican art movement. Their work, now the subject of increasing critical attention, represents the first significant portrayals of Puerto Ricans *by* Puerto Ricans. But by the 1970s, a confluence of factors gave rise to the initial generation of Puerto Rican photographers in New York. This decade saw the first large numbers of Latinxs (along with African Americans) receive college and graduate degrees, including masters of arts (MFAS). Members of this generation were also highly politicized, and those who decided to pursue the arts (whether as photographers or painters or writers) typically did so with the intention of affirming their culture and speaking to social justice issues. Significantly, street photography was flourishing in New York in this period, and photographers from across the city and elsewhere were often drawn to scenes of poverty, to eccentrics, and to the provocative. And while this would have included venturing into neighborhoods like East Harlem and the Lower East Side to document the more extreme examples of the city's astonishing economic and social decline, these neighborhoods were largely being represented by outsiders—mainstream journalists and photojournalists whose editors often sought sensationalized versions of conditions in places like El Barrio. This rising generation of Nuyorican photographers, in contrast, aimed to provide alternative, more balanced and nuanced views of their communities.

In 1973, many of these photographers—Colón included—exhibited together for the first time in the groundbreaking *Dos Mundos: Worlds of the Puerto Rican*, curated by Geno Rodriguez. Including images by Biasiny-Rivera, Cabán, George Malave, Franco, and others, it introduced a generation of Nuyorican photographers to a broader public for the first time.[7] This was Colón's first serious exhibition beyond informal displays in community settings, and it was the first time his work was presented in an artistic context. Among the images he exhibited was a gritty street scene depicting the stripped skeleton of a car parked along a street; a boarded-up storefront in the background has been crudely painted with the words "Que Viva Puerto R." With such work, the young Colón was singled out in a *New York Times* review for offering the only explicit note of social protest in the exhibition.[8]

It must be noted that *Dos Mundos* did not include the participation of female artists; it would be later in the 1970s that their efforts would become

more visible. Sophie Rivera (1938–2021), for example, became known for the series of black-and-white photographs she made in 1978 and 1979, when she invited passersby outside her Upper Manhattan apartment, all Puerto Ricans, to sit for formal portraits in her studio that she later printed in large scale. Also responsible for other bodies of work documenting Puerto Rican life in New York as well as more personal, feminist statements, Rivera was eventually recognized as a vanguard figure in the Nuyorican art community. Around the same time, Perla de Leon (b. 1952), a pioneering female street photographer, was venturing into the South Bronx when entire blocks had been reduced to rubble thanks to arson and neglect. Poignantly, many of these images depict children, who play amid this devastation and give life to otherwise empty streets. By the early 1980s, de Leon was also curating exhibitions and presenting her own work in the prestigious Coloquio Latinoamericano de Fotografía in Mexico City. Evelyn Collazo, a photographer in her own right, curated the first significant exhibition of female Nuyorican photographers, *Mujeres 9*, at El Museo del Barrio in 1979. It included work by Collazo, Nydza Bajandas, Sylvia Arlene Calzada, Marili Forastieri, de Leon, Carmen Mojica, Rivera, Josefa Vázquez, and Ivonne Villaquiran and was made possible thanks to Collazo's tenacity in uncovering the work of unheralded women photographers in her community.[9] As Colón states, in his nascent years as a photographer, not only was he unfamiliar with female contemporaries; he was aware of few other Puerto Rican photographers outside of Hiram Maristany and those in the orbit of the *Dos Mundos* exhibition. Photography was a solitary pursuit, and he was typically the only photographer documenting the protests and cultural events that form the basis of his oeuvre.[10]

Colón subsequently developed a friendship with *Dos Mundos* curator Geno Rodriguez, a gifted street photographer who went on to found the Alternative Museum, one of the first institutions in the city to regularly exhibit political art and artists of color. Another photographer who took part in *Dos Mundos*, Ángel Franco (later a celebrated *New York Times* photojournalist), encouraged Colón to assemble a portfolio of his photographs and apply to the School of Visual Arts to gain additional training. Colón enrolled for a few semesters but rather than take on debt once his scholarship ended, Colón, then with a family to support, left after a few semesters. In part he was following the advice of a teacher, the Cuban street photographer Julio Mitchel, that the best education for a working photographer would be found not in school but on the streets shooting pictures. And at that point, as Colón has stated, "I didn't need anyone to tell me I was an

artist."[11] He did, however, gain technical skills. In addition to his classes with Mitchel, he studied under Sid Kaplan (b. 1938), well known for the fine quality prints he made for such leading figures as Cornell Capa, Robert Frank, and Duane Michals. Through Kaplan, Colón had the opportunity to study their work firsthand and gain an appreciation for the artistry of the black-and-white silver gelatin print. This became an enduring influence for the photographer, who has worked exclusively with black-and-white film and analog technology throughout his career. Color, he believes, acts as its own subject matter and can detract from the impact of a composition.

As he progressed, Colón developed a rigorous set of technical values that he brought to his craft. He worked frequently with 35 mm lenses, which he says "force him to get in close." Being part of the action, especially when photographing protests and public gatherings, also meant working quickly, spontaneously, and bringing one's full self—one's values as much as technical expertise—to the realization of each image. Moreover, the image Colón shows us is precisely what he saw framed through his viewfinder. He never cropped (or what he calls "making a photograph from a photograph"), printing all his negatives full frame.[12]

Early on, Colón seems to have internalized a mode of working in the moment articulated by Henri Cartier-Bresson, who wrote, "In order to 'give a meaning' to the world, one has to feel oneself involved in what one frames through the viewfinder. This attitude requires concentration, a discipline of mind, sensitivity, and a sense of geometry."[13] For someone whose work as a social activist and as a photographer could be understood almost interchangeably, this meant the ability to transform haphazard moments into meaningful statements. In the 1970s, Colón was working extensively in the public sphere, often, in heated moments, among crowds of people, and in environments where he could control neither the action nor the lighting. In *Operation Move-In Demonstration*, ca. 1971 (see figure 4.1), he captured a dense scene of marchers demanding housing rights amid flags and signs. Through Colón's lens, the protest appears almost regal, becoming an emblem of collective strength and determination. And although he may have not been conscious of it at the time, his composition bears reminders of an iconic image of insurgent rebellion, Eugène Delacroix's *Liberty Leading the People* (1830). In both the painting and the photograph, the central female figure and the upward raised flags signal a triumphant body politic. In *Grito de Lares, Plaza Borinquen* (1974), Colón photographed three children taking part in a demonstration in the South Bronx (see figure 4.2).[14] Seen from his position below, the children appear heroic, standing amid flags

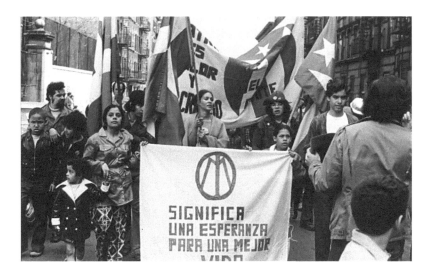

4.1 Máximo Rafael Colón, *Operation Move-In Demonstration*, ca. 1971. Gelatin silver print. Courtesy of the artist.

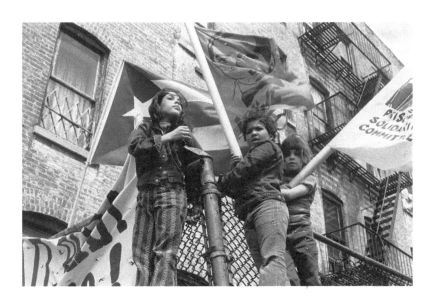

4.2 Máximo Rafael Colón, *Grito de Lares, Plaza Borinquen*, 1974. Gelatin silver print. Courtesy of the artist.

and banners that radiate outward. By framing the image this way, the photographer underscored his subjects' agency and makes a symbolic claim to public space—in this case, of an empty lot that would later become an affordable housing complex.

Colón also used his camera to explore New York's music scene in the 1970s and 1980s. Clubs like the Village Gate and the Copacabana had become important places to hear Latin jazz, and Colón photographed such prominent figures as the percussionist Ray Barretto and salsa musicians Rubén Blades and Eddie Palmieri. Significantly, he also gravitated to music making in the street, and some of his most powerful images portray the Brown and Black musicians who gathered regularly in Central Park on summer weekends for drum circles and jam sessions.[15] Here, we witness the assertion of the city park as a kind of Third Space for members of the Puerto Rican diaspora who gathered and performed in the very center of a city that frequently felt unwelcoming, if not hostile at times. Many lived in substandard housing in neighborhoods lacking amenities, including well-maintained parks, but Central Park offered ample space, greenery, and an environment of pan-Latino solidarity fostered by music making and an enthusiastic audience. Colón was also a ubiquitous presence at parades and festivals, where he photographed musicians and dancers on stages and in the streets (see figure 4.3). Among the most joyful and exuberant images in his oeuvre, for Colón, these subjects were essential propagators of cultural affirmation and pride. Their performance of identity in the public sphere demonstrates a powerful sense of belonging, within a diasporic urban space that is wholly distinct from the Puerto Rican homeland but where Nuyoricans extended and evolved culture. Moreover, their participation in events like festivals and parades linked them to traditions on the island, where celebrations of saint's days (*fiestas patronales*), historic commemorations, and *carnaval* are ubiquitous elements of culture in San Juan and in small towns alike. These performers drew power by coming together as a collective voice, not unlike the political demonstrators who were also his frequent subjects.

Especially in his documentation of creative expression, Colón understood the complexity of Boricua identity and the vitality of its Afro-Caribbean legacy. Key in this regard is his extensive documentation of the Festival Santiago Apóstol de Loíza, an event that originated in Loíza, Puerto Rico, a town with a significant population of people with African ancestry, to preserve and celebrate Afro-Boricua traditions.[16] Colón's 1975 photograph (see figure 4.4) of children gathered around a costumed man, one boy trying on his traditional *vejigante* mask, reflects a multiracial,

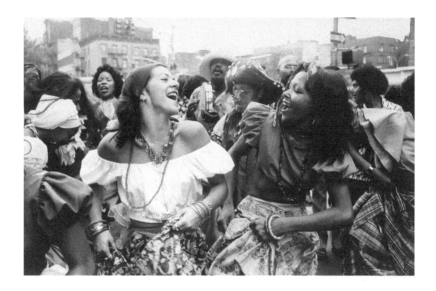

4.3 Máximo Rafael Colón, *Las Caras Lindas*, 1975. Gelatin silver print. Courtesy of the artist.

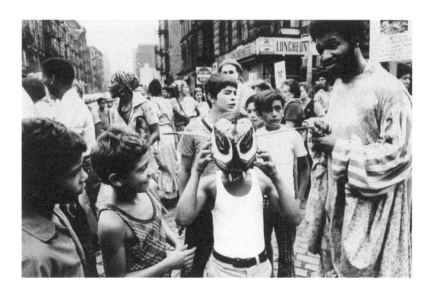

4.4 Máximo Rafael Colón, *Fiesta de Loíza*, 1975. Gelatin silver print. Courtesy of the artist.

multigenerational community on the Lower East Side in these years.[17] Images like these also act as valuable historic records, especially in light of the neighborhood's conversion over the past two decades from an immigrant enclave into one now largely populated by boutiques, expensive restaurants, and "creatives." Indeed, Colón's photographs of the neighborhood preserve the memory of its populist roots, documenting its final phase as a magnet for generations of immigrants since the mid-nineteenth century.

Across his work, Colón was motivated by the desire to use the camera as a tool for self-representation, to provide his subjects with a platform to depict their own narratives, and to rebuke the stereotyped, negative portrayals of Puerto Ricans in New York that abounded in the 1970s and in previous decades. As he once noted, "We were not all stickup artists or dealers. That is the most important thing for the generation I belong to. We are now able to state our own story and picture it through our own eyes."[18]

Bruce Davidson's *East 100th Street* is perhaps the most visible example of the kind of (mis)representation that Colón aimed to counter. Just a few years before Colón began seriously photographing, Davidson spent two years documenting a single block in East Harlem, culminating in the 1970 book and Museum of Modern Art exhibition *East 100th Street*. Davidson was a serious photographer who noted that he took care to not exploit his subjects, but his series features numerous images of squalor. The poverty the Magnum photographer captured was real, but Davidson overlooked the closeness of family, the joy, and the deep sense of perseverance that Colón and his peers visualized. Colón, cognizant of the power of such images to broadly shape public perceptions, especially when disseminated in books or exhibited on walls of major museums, says that he was outraged by this outsider's emphasis on deprivation and dysfunction.[19] In contrast, he (like his colleagues) lived and worked in the neighborhoods he documented, and he understood how locals inhabited space, interacted with one another, and demonstrated their resilience in the face of hardship.

After taking part in *Dos Mundos*, Colón continued to exhibit but found this aspect of being a photographer time-consuming and expensive. From the late 1970s to 2005, he ceased exhibiting while continuing to contribute images to books and activist publications. He also held various positions, early on, as a photo and life skills instructor at a settlement house in East Harlem, and for many years, he worked in a mental health clinic in the Bronx. But he never stopped photographing and his archive now comprises some 160,000 negatives. He has scrupulously maintained this

archive; he can point to the location of prints and negatives and provide detailed information on photographs he made four or five decades earlier. In recent years he has spent more time in Puerto Rico, where he documents the frequent protests that are staged, whether for better health and education services or against the island's corrupt governor and the effects of the Commonwealth's debt crisis.

Colón has received broader recognition for this work since 2005, when he accepted an invitation to exhibit at the Center for Puerto Rican Studies at Hunter College (CENTRO). This led to other exhibitions as well as acquisitions by institutional collections. His prints are now in the collections of CENTRO, the Museum of the City of New York, the National Portrait Gallery at the Smithsonian Institution, and the Museo de Arte Contemporáneo de Puerto Rico. He has participated in exhibitions at the Museum of the City of New York, Brooklyn College, the Bronx Documentary Center, and in 2015 in ¡Presente! The Young Lords in New York, co-organized by the Bronx Museum of the Arts, El Museo del Barrio, and the Loisaida Center in Manhattan. In retrospect, Colón's diaristic approach to the medium records not so much slices of life as the advancement of a people over time and space. His archive provides the means of constructing a detailed visual history that would otherwise be unseen and of linking individuals to broader social movements. This became a hallmark of Colón's practice, envisioning the individual and the hyperlocal as part of the national and international struggle for human rights. Both a witness to and a participant in this work, he has expressed, time and again, how the collective voice gathers, gains strength, and has the power to leave an indelible imprint on history.

NOTES

1 Máximo Colón, voice message to the author, August 28, 2022.
2 *Prometheus* functioned in part as an organ of the Third World Coalition. For examples of the newspaper, see "Radicalism at BMCC: The Early Years," CUNY Digital History Archive, accessed May 14, 2024, https://cdha.cuny.edu /collections/show/91.
3 Muzio, "The Struggle against 'Urban Renewal.'"
4 Cotter, "Honoring Latinx Art."
5 Máximo Colón, voice message to the author, August 28, 2022.
6 For information on these photographers, see Ferrer, *Latinx Photography in the United States.*

7 Rodriguez curated the exhibition in collaboration with Janice Rooney under the auspices of the Institute of Contemporary Hispanic Art. See Biasiny-Rivera et al., *Dos Mundos*. Buoyed by the success of *Dos Mundos* and keenly aware of the need for platforms and resources for photographers of color who lacked access to the mainstream, some of these photographers founded the collective En Foco the following year. Disagreement among the initial members led Colón, Rodriguez, and others to part ways with the collective early on, but he remained friendly with many in the group and En Foco remains active to this day. See https://www.enfoco.org.

8 Thornton, "Puerto Rico to New York," 19.

9 The author is grateful to Perla de Leon for sharing information about this exhibition.

10 Máximo Colón, conversation with the author, June 29, 2023.

11 Máximo Colón, interview with the author, August 11, 2022.

12 Information on Colón's working method from a voice message from Colón to the author, September 22, 2022.

13 Cartier-Bresson, *Mind's Eye*.

14 The Grito de Lares (Cry of Lares) commemorates an uprising against Spanish rule in 1868, centered in the town of Lares, Puerto Rico. The revolt is commemorated annually in Lares, considered the birthplace of Puerto Rican nationalism, as well as in New York City and other locales.

15 For a fascinating account of pan-Latin music-making in Central Park in the 1960s and '70s, see Jottar, "Central Park Rumba."

16 The festival and the symbolic resonances of Santiago de Apostol (St. James the Apostle) have complex roots. In Spain, the mythic Santiago (also known as Santiago de Matamoros) was revered for slaying the Moors in a ninth-century battle. Postconquest, he was recast as Santiago Mataindios, conveying the Spanish subjugation of Indigenous populations and linking the Conquest to Catholic faith. In Loíza, Santiago evolved into a symbol of the survival of African culture. The town's annual Fiestas de Santiago draws from traditions that migrated from the African continent, including the masks and costumes used in festivals and processions. In New York, the festival was initially organized by the Puerto Rican Center for the Arts, founded in 1973 by Ana Marta Morales and located on the Lower East Side of Manhattan. It is now presented in El Barrio, by Los Hermanos Fraternos de Loíza and the Caribbean Cultural Center African Diaspora Institute.

17 The masked *vejigante*, a common figure in Puerto Rican festivals, represents the trickster and mischief maker. *Vejigantes* can also represent the battle of good over evil, the Afro-Caribbean population's struggle for survival, and resistance to colonialism and imperialism.

18 Colón quoted in Gonzalez, "Not an Objective Observer."

19 Máximo Colón, voice message to the author, August 29, 2022.

Biasiny-Rivera, Charles, et al. *Dos Mundos: Worlds of the Puerto Rican.* New York: Institute of Contemporary Hispanic Art, 1973.

Cartier-Bresson, Henri. *The Mind's Eye: Writings on Photography and Photographers.* New York: Aperture, 2005.

Cotter, Holland. "Honoring Latinx Art, Personal and Political." *New York Times,* October 15, 2020.

Davidson, Bruce. *East 100th Street.* Los Angeles: St. Ann's Press, 2003.

Fanon, Frantz. *The Wretched of the Earth.* Translated by Constance Farrington. London: Penguin Classics, 2001.

Ferrer, Elizabeth. *Latinx Photography in the United States: A Visual History.* Seattle: University of Washington Press, 2021.

Gonzalez, David. "Not an Objective Observer." *New York Times,* October 23, 2015.

Jottar, Berta. "Central Park Rumba: Nuyorican Identity and the Return to African Roots." CENTRO *Journal* 23, no. 1 (Spring 2011): 5–29.

Muzio, Rose. "The Struggle against 'Urban Renewal' in Manhattan's Upper West Side and the Emergence of El Comité." CENTRO *Journal* 21, no. 2 (2009): 109–41.

Thornton, Gene. "Puerto Rico to New York." *New York Times,* January 6, 1974.

5

Artistic Decoloniality as Aesthetic Praxis

Making and Transforming Imaginations and Communities in NYC

Wilson Valentín-Escobar

We were actually the "New Ricans." . . . We were so avant-garde . . . that we belonged in space. . . . Our place was the next space.

Dina D'Oyen

Scholars have examined the formation and significance of Latine cultural artistic expressions and institutions in many contexts.[1] Few, however, have focused on how Latine artists undertake self-directed actions to challenge both their experiences of social alienation and the dominant art institutions that ignore or overlook their subjectivity and art, rendering them invisible and insignificant according to the mainstream. Such refusal to be

unseen and disparaged has often prompted Latina/o/x artists to organize creative spaces of their own.

To explore this phenomenon, this chapter delves into the *artivist* interventions of Puerto Ricans Adál Maldonado, also known as Adál, and Sandra María Esteves at the New Rican Village (NRV), a cultural arts and education center founded in 1976 on Manhattan's Lower East Side (Loisaida) neighborhood.[2] Both Esteves and Adál were active members of this noncommercial, alternative, community-based arts venue that was home to a large, fluid community of Puerto Rican and Latina/o/x artists. Although their historical involvement with the center differs, their artworks were mutually constituted amid a liberatory, decolonial, cultural, and sociohistorical zeitgeist of sovereignty, community agency, and community making, collectively contributing to what I identify as *Bodega Surrealism*. They did so through many kinds of art, but I focus on two here: Although Esteves is primarily recognized as a poet, she is also a visual artist who designed culturally significant posters for the NRV, and I examine this lesser-known aspect of her artistic oeuvre. I also analyze some of the photographic artwork that Adál created for El Puerto Rican Embassy, which eventually morphed into performance art but was originally conceived as an integral part of the NRV.

Social and Historical Roots of the New Rican Village

In 1974, concerned about the crises that Puerto Ricans and other Latinas/os/xs confronted, Eduardo "Eddie" Figueroa sought social change from within the Latina/o/x community. His vehicle was artistic expression. A New York–born Puerto Rican activist, a New York University (NYU) theater studies student, and a former member of the New York chapter of the Puerto Rican Young Lords Party, Figueroa viewed politics as a form of theater and saw art as an important avenue for social and political intervention. Together with other Latina/o/x artists active in the Bohemian scene of New York City's Lower East Side and the neighboring East Village, Figueroa was concerned with economic impoverishment and with the social pathologies long ascribed to Puerto Rican and some Latina/o/x communities. Art became their political vehicle of choice and a conduit for the creation of new social possibilities.

In October 1976, this community of artists responded to the conditions in their community by opening the NRV at 101 Avenue A.[3] Directed by Figueroa, the cultural arts center was an aesthetic laboratory "where the concepts and dreams of a new generation of Puerto Ricans in New York

[were] given form in theater, dance, music, the visual arts and poetry."[4] In a moment marked by new social movements as strategies of resistance, Figueroa and his fellow Latina/o/x artists were unified in their quest to use art to revitalize and transform dilapidated city neighborhoods and to foster a cultural renaissance molded around new diasporic Boricua and Latine identities.[5] Originally envisioned as both an arts venue and an embassy (i.e., El Puerto Rican Embassy), the NRV served as a living laboratory for an intersectional exploration of the aesthetic and the artistic, where visual culture, music, poetry, dance, theater, and photography all shaped, informed, and advanced the artists' collective imaginary.

The NRV was the product of pioneering and visionary artists of the Puerto Rican diaspora whose socioeconomic realities and legacies stemmed from an inheritance of colonialism, extractive capitalism, generational poverty, and the compounding traumas of historical and systemic neglect and disinvestment. As a result of shifting urban policies in the 1970s, New York City was undergoing massive changes, including gentrification, racial succession, urban disinvestment, deindustrialization, and middle- and upper-class white flight; the artists at the NRV were determined to use art as a vanguard response to this neoliberal strategizing. Having directly experienced the harshness of the city's inhumane redevelopment chaos, the artists at the NRV sought to use culture and cultural practices—among them, visual art—to envision and create an alternative social world through artistic praxis. In this context, art was not an afterthought to supplement other forms of organizing; rather, it was conceived to be at the forefront of inciting alternative, decolonial, social, and imaginative realities in response to the aforementioned processes of neoliberal estrangement. A key ideological perspective that informed their artivist approaches was Surrealism.

In both my oral history interviews with NRV artists and my archival research, I found explicit and implicit parallels between the innovative perspectives of Surrealism and the artistic visions, imaginations, and generative, art-based community practices that constituted this cultural center.[6] Constructing themselves as avant-garde, and versed in avant-garde art movements like Surrealism, Impressionism, and Cubism, NRV artists went beyond the realism of the barren, gloomy, wretched "ghetto." While neo/colonial policies were shaping the "real world," artists like Esteves, Adál, Pedro Pietri, and Figueroa found decolonial freedom in their imaginations.[7]

For them, the imagination was a refuge, the source from which an artistic praxis emerged. It was not illusory, and it wasn't an escape from the neoliberal world they inhabited; rather, it became an extension of the ac-

tivist, emancipatory practices, visions, and goals that would inform their individual and collective aesthetics. In much the same way that Cuban Surrealist painter Wifredo Lam characterized his paintings as the articulation and practice of decolonization, the various NRV artists held a Surrealist *mental view* that paralleled the decolonial activism of the Young Lords, the Black Panthers, and other liberatory social movements of the post–civil rights era.[8] Surrealism, André Breton notes, "hold[s] that the liberation of humanity is the sole condition for the liberation of the mind," and draws upon the imagination to envision and create a free society and community, allowing for the realization of one's full potential.[9] The NRV members regularly practiced what Maxine Greene identified as "releasing the imagination" through their art, as the imagination is fertile ground to envision "what could be" rather than to fixate on "what is."[10]

Given their academic training, Esteves, Adál, and Figueroa were all fully aware of theories of the avant-garde.[11] Adál famously noted that Surrealists found *him*, not the other way around, explaining that many European-based avant-garde Surrealists drew their artistic ideas from ethnographic encounters while visiting countries located in what was once identified as the "Third World."[12] For NRV artists, however, the act of dreaming of possibilities, engaging in experimentation, and tapping into *their own* cultural histories—while also using humor, parody, metaphor, satire, simulation, absurdity, shock, collage, and other treatments—became an extension of their decolonial subjectivities through art as well as a strategy for disorienting hegemonic ways of being. Undertaking these approaches, they drew from a repertoire of intentional inversion from the social realities they navigated. They sought to make interventions to mentally liberate both themselves and their communities. In the process, their art and mental perspectives would become synchronized, bringing forth an unrestrained aesthetic social activism.

In the desolate landscape of 1970s Loisaida, the South Bronx, and a host of other New York City neighborhoods, such visions of decolonial emancipation, personal and collective well-being, humor, and everyday community conversations occurred in bodegas—some of the only remaining institutions that doubled as community spaces. As community-based, commercial institutions that mostly exist on street corners, bodegas are situated in places of convergence where multiple encounters between disparate community members cross and interact and make possible face-to-face socio-juxtapositions where people talk, laugh, gossip, and share "la brega" (challenges/hardships/hustles) of survival, while also disclosing future aspirations.[13] The bodega is thus a layered crossroads of intersectional elements of

possibilities that bring together spiritual, social, psychic, and cultural contact zones of nuanced realities that belie surface-level analysis. In this context, an organic, natural Surrealism—or "Bodega Surrealism"—could unfold.

Surrealism more generally was and remains an action, a viewpoint, and a series of social *and* aesthetic practices and perspectives rooted in reversal, contradiction, and revolt; it is a relentless attack on capitalism (among other ideologies) and its dehumanizing characteristics, including the shortcomings and rejections of the overlapping socially constructed philosophies working in concert with it. Surrealism intentionally defies and transcends the "logical" strategies of survival and aims to be a revolutionary movement seeking emancipation from *all* forms of subjugation, both material and ideological. The artists at the NRV converted the subjugation of the real or, in this case, of their depressed communities, and transcended above and *through* them; the "ghetto" was the material force through which their imaginations constructed a decolonial Surrealism in the everyday spaces of their community, including in the few spaces that remained after buildings were abandoned, firebombed, and/or demolished.[14]

By placing Surrealism into this context of the bodega and its barrio aesthetic, the NRV artists used the accessibility and expansiveness of the bodega to challenge a priori assumptions of Eurocentric surrealist visual language (e.g., a melting clock vs. tropical palm trees within urban landscapes). In this vein, the Surrealist, visually based practices that emerge take on a different artistic sensibility than the works of acclaimed Spanish Surrealists Pablo Picasso and Salvador Dalí, among others; instead, they draw upon, engage with, and depart from these well-known canonical artworks. Bodega Surrealism suggests that the quotidian, working-class aesthetics of this everyday space warrants reexamination, pushing us to go beyond the "real" and grasping the juxtaposition of social realities in the storefront itself and in this movement's own practices. That is, Bodega Surrealism engages everyday material aesthetics to articulate working-class ways of thinking as well as blue-collar strategies of survival.

Aesthetics in general, Janet Wolff observes, "originate and are practiced [under] particular conditions, [while also] bear[ing] the mark of those conditions."[15] These Latine artists both embodied and usurped/transcended their social conditions to advance an alternative reality, or surreality, of community and social change *through art*. This Surrealist expression and vision transcended visuality and framed the other artistic practices at the New Rican Village. The dynamic, intersectional aesthetic synergy nurtured at the NRV allowed for artistic exploration of new possibilities whereby

artists across different forms pushed each other in productive ways to develop new aesthetic frameworks.[16]

Along the visual art plane, Esteves and Adál did this work by exploring and transcending the "real" world of disparity and alienation that constituted the everyday lives of their neighborhoods; they sought instead, in the spirit of Surrealists before them, to bring a *social* Surrealism into being. They created a quotidian world that went beyond the real and understood it as a socio, spatial, and cultural arena of belonging, public debate, artistic utterances, placemaking, and on-the-ground decolonial remaking. They insisted on seeing themselves as whole, complex beings and as full participants in and agents of the world(s) they created, including those beyond this terrestrial realm.

To implement this vision, they created an artistic refuge divorced from commercialism, exploitation, and all forms of inequality. As noted by Dina D'Oyen, one of the arts administrators I interviewed for this project, "The New Rican Village was a space for the New Ricans. . . . We were so avant-garde . . . that we belonged in space."[17] Residing within this other galaxy—this other space—required a formal institutional unit of representation and political control. The various arts activities and installations that were part of the NRV, including El Puerto Rican Embassy and El Spirit Republic physical art installations, were conceived to serve that function.

Together, the shared aspirations of the NRV artists invoked socio-aesthetic practices and decolonial dreams to reenvision and transform neighborhood places through social, spatial, political, and aesthetic interventions. This cadre of organizers, cultural producers, and artists were simultaneously avant-garde aesthetic innovators, arts administrators, arts educators, grassroots activists, and artivists. Members of this vanguard generation did what came naturally to them. Their expansive imaginations and identities transcended more than just the page, the stage, and canvases: they shared a commitment to create, modify, and transform energy/space/hearts/minds, to generate a realm of new possibilities. That is, they constructed a transnational decolonized world through arts-based civic praxis and engagement.

Organizing New Avant-Garde Spaces

In the 1970s climate of civic activism and civil rights, the work of many artists became an extension of social activism, departing from the elitist practices of modernism in favor of alternative forms of aesthetic agency.

They no longer aspired to apply the paradigms and pretensions of high art and its institutions. Instead, they harnessed their organizing talent and an array of resources to build new, autonomous institutions to redefine the artistic template that had excluded their artwork and misunderstood and undervalued their vision. Together in this world they built, artists found ways to assert themselves and operate within constructed aesthetic paradigms—frameworks of their own making.

Because aesthetic practices were perceived as extensions of personal and collective identities—many of which were considered too hostile or were unwanted in dominant art spaces—these practices became synonymous with a form of political activism. Figueroa and the other artists at the NRV understood this sentiment.[18] "Artists of Puerto Rican descent were," as art scholar Yasmin Ramirez notes, "at the forefront of what is known today as the New York Alternative Art Space Movement."[19] These renegade artists were embedded in a New York City art world and cultural landscape that required them to navigate the interlocking cultural, social, economic, and political machinations of the city. Embroiled in a labyrinthine political web, they used their artistic/creative energies, visions, and grassroots know-how to embed themselves within a mise-en-scène such that, in the words of Chantal Mouffe, "there is an aesthetic dimension in the political and there is a political dimension in art."[20] This process of being innovators while navigating the overlapping bureaucracies that constituted all aspects of New York City life contributed to the emergence of a *Latina/o/x Cultural Left*.[21]

This pioneering generation opened cultural arts organizations, planned public arts activities, organized and conducted art education workshops, collaborated with others, and aesthetically amended various art forms. They understood the power of cultural organizing as part of an activism that cultivated community building, and they understood that artistic agency was consistent with the power to (re)define, (re)frame, and (re)signify themselves and their attendant communities through art and cultural practices. As such, they sought to transform and push back against dominant and alienating narratives of ethnoracial and gendered otherness and acknowledged the importance of arts-based community making to empower, liberate, and transform individuals and communities. By engaging in creative practices rooted in Puerto Rican and Latine history(ies), art had the cognitive ability to empower individuals and communities to understand their histories and challenge the fatalism and the "culture of poverty" that were forced upon them by dominant discourses and frameworks. It would

also advance cultural pride, disalienation, and self-actualization to liberate and push against an internalized, colonized mindset of individual and collective self-degradation. Said perspective would become an essential component of the zeitgeist of Latine cultural expression, including the forms that were practiced by the artists—like Sandra María Esteves and Adál Maldonado—at the New Rican Village.

Sandra María Esteves and the Making and (Re)envisioning of Community: Visual Emancipations and Disruptions

The New Rican Village pioneered a radical free space where artists could expand their individual and collective praxis. Esteves, a founding member of the NRV and long-standing leader of the Nuyorican poetry scene, drew on her visual artistic training to create some of the most prominent and iconic posters that reflected and articulated the center's radical vision. The same posters that hung from telephone booths, bodega storefronts, telephone poles, the facades of abandoned buildings, and other available surfaces became the quickest and most efficient means of advertising future events and disseminating information at a moment when Latinas/os/xs had minimal media access and when ubiquitous internet and social media use were still decades in the future. These posters offered an honest reflection of how the community viewed itself and, more importantly, offered a pointed counternarrative to the dominant culture's deficit, victim, and marginal narratives that suffocated those living in what were then deemed "blighted" urban spaces, such as the Lower East Side. Her work invokes surrealistic aesthetics as she juxtaposes disparate elements on the page, reflecting a new Surrealist world that she's envisioning and in alignment with the sociopolitical goals of the Young Lords.

As public and aesthetic interventions, her posters—rooted in a feminist perspective—centered "love in action" by transcending hyperindividuality and depicting people as central to the vibrancy of community, with images promoting holistic, inclusive social realities. These images added to a quotidian culture and the raw "aesthetic sphere" of the community, thus recasting public spaces as forums for dramatic performance, playful display, and a carnivalesque, nonlinguistic dimension of political participation in collective action.[22] Moreover, Esteves's poster art serves as an articulation of these kinds of aesthetic politics: they provide dramatic images and a kind of street performance to draw attention to the role of their culture

and history as foundational to acts of solidarity, resistance, and survival; to prefigure a possible future; and to provide a visual, feminist framing from which community members could envision a new society. In these Surrealist images, the street is the nexus of community and a performative stage: a site of festival, debate, art, decoration, and celebration. By holding space and redefining these everyday landscapes as part of the collective artistic imaginary, artivists like Esteves and others in the NRV community proactively leveraged mutuality for an inclusive, public solidarity, thereby belying the stereotypical notion of these communities as criminal, alien, and isolated. Esteves disrupts the neoliberal landscape by invoking the un-imaginable (such as palm trees and joyful Brown bodies at leisure on the streets of New York City, in contrast with the public perception that those streets are places of danger and fear) and hence decolonizes the imagination and seeks to transform on-the-ground cityscapes.

This commitment as well as aesthetic and collective sensibility is represented in some of the graphic artwork that Esteves designed. Take, for example, her "August Arts Festival, 1977" poster (see figure 5.1). Created almost a year after the center's opening, Esteves's poster highlights the reconstruction of urban community through the arts, embodying the "iconography, idealism, and imagination" of the NRV.[23] Inscribing or, more accurately, envisioning themselves within the landscape of Loisaida, Esteves's poster lays the groundwork for a community imagining its presence not only on the Lower East Side but also within the global city.

Esteves was also undeterred by the period's racial hysteria and deindustrialization in poor and working-class communities of color. For example, she uses collage as an artistic strategy to resist the exclusion of Puerto Rican and Latine artists in the diaspora. Her poster for a "Benefit Concert & Poetry Reading" (see figure 5.2) intentionally disrupts "conventional meanings by an act of recontextualization, that juxtaposes seemingly incongruent objects, images, ideas, or performative acts within a conceptual aesthetic construct."[24] This transfer of objects, or "the radical juxtaposition of meaning" in a new, distinct context, is a purposeful Surrealist intervention. Esteves's decision to use collage fostered "new possibilities of signification" for Puerto Ricans and the emergence of a distinctive working-class community of avant-garde artists. Equally significant is the insertion of "tropical" images into the northern city, a visual trope repeated by Esteves and other center artists.

Collage allows for many such insertions and resignifications. In this one, Esteves raises alternative accounts of artistic hegemony in the East Village and, specifically, the long-standing construction of that space as a

home for bohemian and avant-garde artists. Such dominant conceptions obscured the hostility that artists of color often faced in this artistic corridor. In reference to its bohemian community, as Christine Stansell reminds us, "for anyone black who sought admission, bohemia offered scant hospitality."[25] Such adversity extended to many Boricuas and Latine artists, too, as Esteves confirms. Racial and ethnic exclusion, then, contextualizes her insertion of a Latine artistic collective into the viewer's imagination, staking claim for and with the growing Latina/o/x community and its emerging artistic influence. Esteves's collage is more than an insertion of bodies into public art; it represents an extension of the NRV's social goals. Here she transcends the dominant linear narrative of avant-gardism while destabilizing a hegemonic narrative of racial exclusivity in New York City's dominant arts scene.

Collage is an aesthetic of conscious dissonance at multiple levels and as a result is often employed by Surrealists, and this collage in particular has profound implications. Through dissidence and rearticulation of dominant narratives of power, collage becomes not only a style but also a metaphoric tool with which to lay the groundwork for a Surrealist, counternarrative vision at the artistic core of the New Rican Village. Its possibilities mirror the artistic intentions of European Surrealists Georges Braque and Pablo Picasso, two globally prominent artists and masters of the genre (who, notably, were in the mainstream art world in contrast to the NRV artivists, who worked on the margins). The goal of collage is to disrupt the perspective and spatial cues of art on the page and intentionally bring about a visual revolution. This intent to disrupt operates between the real and the imagined, where Esteves seeks to counter the silence associated with invisibility. Choreographing a story within fractured spaces, the work also seeks to raise the hopes of this working-class collective.

Following the artistic direction of Cubism, in which fragments became fractured social realities, Esteves created images along artistic fault lines, identifying these cracks as spaces where the Nuyorican community could assert agency to transform collective despair. This transformation entailed uprooting a fatalistic discourse and transplanting new elements into New York's cultural geography. The uprooted palm trees placed on the city's landscape thus intentionally reverse this fatalism. But in the tradition of Cubist collage, they also resignify the city's semiotics with tropical images as markers of Puerto Rican otherness.

Representing palm trees alongside othered bodies in artistic motion signifies a semiotic reinscription of the city. Esteves's poster represents

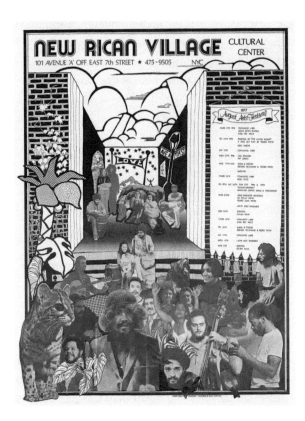

5.1 "August Arts Festival, 1977." Poster designed by Sandra María Esteves, 24 × 46 in. Collection of the artist.

community-based art making, but it also expresses "a form of art-based community making," which sought to foster a welcoming community at the New Rican Village, on the Lower East Side, and in New York City overall.[26]

Esteves's posters also transcend the property and function of a medium whose sole purpose is perceived to be disseminating information for a future event. She surpasses the poster's surface utility and imbues her designs with dramatic gaiety, action, community movement, and vitality. Equally significant are the working-class, urban, tropical aesthetics and Impressionism that emanate from her pieces. Whether intentional or not, her work markedly departs from the French, middle-class tradition, with its depiction of the city's bourgeois classes' fleeting encounters of shopping, vacationing, and strolling. Esteves instead offers instances of everyday

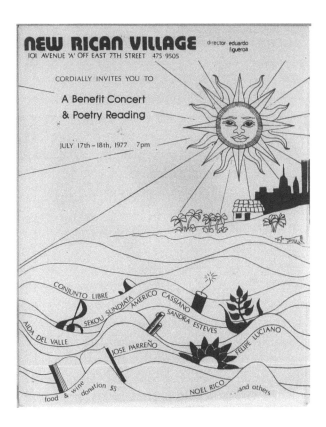

5.2 "NRV Benefit Concert and Poetry Reading," 1977. Poster designed by Sandra María Esteves. Collection of the artist.

life, thereby highlighting and reconfiguring urban cityscapes into Surrealist landscapes of leisure and joy (see figures 5.1 and 5.2). She articulates a visually based Bodega Surrealism—that is, she merges an imaginary state with the gritty world of marginalized, ostracized communities to portray possible ways of living for those who refuse to see themselves only as victims and who welcome opportunities to unleash their spirits. The visual semiotics Esteves expresses thus disrupt the "chains of social realism and rationality," transforming them into a leisure mode of exultation.[27]

The manifold realities of segregation did not deter Esteves from imagining varied dimensions and spatial possibilities in her poster art. Such social conditions called for alternative strategies to create community during a critical period of imposed neoliberal estrangement. The "arts

congregations" conceived by the NRV and artistically translated by Esteves constituted an informal, on-the-ground network as the NRV pushed for and created new aesthetic practices.²⁸ The congregations that formed at and through the New Rican Village, whose concept developed domestically was, ironically, because of the hostility that many Latine artists encountered within established arts institutions and urban neighborhoods. Despite these institutional barriers, these artists engaged a sense of both self and community to transform urban neighborhoods. As the next section will explore, Adál's auto-portraits as well as his "In and Out of Focus" Nuyorican portraits do this work as well.

Adál and El Embassy: Auto-Portraits and Out of Focus Nuyoricans

Described by *El Diario/La Prensa* newspaper as "the most brilliant art collective in all of New York City," El Puerto Rican Embassy captured considerable attention within the Puerto Rican and Latine art community.²⁹ In a communiqué issued on April 8, 1994, Adál Maldonado and El Reverendo Pedro Pietri, the acclaimed Nuyorican Surrealist poet and original member of the New Rican Village, announced its inauguration at a reception, held at the Kenkeleba Gallery. El Embassy, the letter described, "will serve as a forum for the meeting of our most creative minds. We represent a new generation of Puerto Rican artists working within the mainstream—as well as on the margin of established art movements—who take risks [to] illuminate contemporary issues and question established cultural aesthetics and dominant political issues. The Puerto Rican Embassy will spread its artistic and cultural message by appointing Ambassadors of the Arts whose achievements in their artistic fields will reflect the mission of The Puerto Rican Embassy."³⁰ El Embassy is both a name adopted for the collective that established it and a designation of an imagined sovereign space, "a forum for the meeting of our most creative minds" that would sometimes materialize in galleries, videos, and performances.³¹

Created in response to US colonialism in Puerto Rico (which started in 1898), this imagined sovereign state has accompanying state-authorized institutions, documents, symbols, proclamations, and political structures, including a national anthem, currency, secular religious iconography and saints, an aerospace program (called "Coconauts in Space"), and even underground resistance fighters known as "Bodega Bombers"—and, of course, an embassy.³²

At El Embassy's inaugural ceremony, El Reverendo Pedro Pietri and Adál issued conceptual passports, displayed the Embassy's "Manifesto," and sang its Spanglish National Anthem.[33] Years later, the circulation of El Spirit Republic's passports was accompanied by Nuyorican baptisms performed in the "Church of Our Mother of Los Tomates," the spurious religious institution sanctioned by the conceptual state.

The home of this Republic is New York City, although its management offices are specifically located on the Lower East Side of Manhattan, the New Rican Village's original neighborhood, with a central tenet of the "immediate decolonization of each citizen's brain" (figure 5.3), among other inventive political and performative culturally expansive allegories.[34] These public and interactive performance pieces, all acts of freedom and liberation, took hold of the collective imaginary among members of the Puerto Rican diaspora and their allies, within a futuristic realm: "the Hybrid State of NuYol in the Sovereign State of Mind of El Spirit Republic de Puerto Rico."

The process of decolonization, they argue, first occurs in the imagination, for "the liberation of the imagination is a precondition of revolution."[35] The pursuit of a multimedia decolonial artivist praxis thus becomes essential for this transformation because "language, representation, and perception are all means of production that must be seized if emancipation is to be won."[36] El Embassy does exactly this: Instead of waiting for the colonial US administration to declare the end of the occupation in Puerto Rico, El Embassy assumes that responsibility and declares its *own* freedom. Its actions follow the tradition of subversive mimicry, which consists of mockery, parody, resemblance, and menace, while also demonstrating the limitations of the authority of colonial discourse.[37]

The art world fashioned in El Embassy and El Spirit Republic challenges marginalization; it collectively fashions a particular form of citizenship that operates both within and outside questions of participation in political life. The public constructed by/as El Embassy is a subaltern site of belonging that contests the neocolonial Commonwealth of Puerto Rico and its imperial management by the United States.[38]

Yet engaging in the public sphere presumes a kind of political sovereignty not externally granted to El Spirit Republic. Thus, what we see developing in the work of El Embassy is an art (re)public that cultivates (an)other social imaginary through "playful dimensions."[39] It invites marginalized diasporic subjects to participate by staking claims to belonging, to a place of their own making, and within and between the various national projects (i.e., United States and Puerto Rico) that exclude or marginalize them. It calls upon the

STIMULATE PASSIVE NERVE CENTER LOISAIDA CITY, ESRPR

THINK
WAKE UP
VOMIT
UNDRESS
KICK A
POLITICIAN
WRITE A
POEM
AWAKE A
CORPSE
FALL UP
TRUST
PLAY
DOUBT
SUCK
PAINT
DRINK
SPIT
MASTURBATE
DESIRE
SHOOT
LOVE
LOOK AT
NOTHING
JUMP WITHOUT
MOVING AN INCH
REMEMBER
DON'T FORGET
LISTEN
GET MAD
WONDER
STAY TUNED

READ
DANCE
ARGUE
FUCK
DECONSTRUCT
CREATE
DISSENT
LAUGH
QUESTION
FUSE
MAKE NON-SENSE
DEBATE
DREAM
EAT BACALAO
DEFEND YOUR
FAMILY
SHIFT YOUR
ASSEMBLAGE POINT
RESPECT
REFUSE

DECOLONIZED BRAIN
AUTORETRATO ADAL 7:4:99 BRAIN DECOLONIZE PROJECT

5.3 Adál Maldonado, *La Decolonized Brain*, 2000. X-ray impression on lightbox, 9½ × 13 in. Courtesy of the Estate of Adál Maldonado and Roberto Paradise.

dominant colonial power structure of the United States to recognize them by simultaneously imitating, appropriating, and playfully mocking its signifiers of authority (i.e., embassies, ambassadors, and passports). The artists/ cultural ambassadors of El Embassy thereby conjure an imaginary nation that *would* have a place for them, a free Spirit Republic. This vision is more than Surrealist banter of a "cuchifrito" and "chevere civilization": it is an example of marginalized avant-garde artists engaging multiple publics while also constructing one (or several) of their own, despite lacking the sovereignty typically required to participate in such political discourse.[40]

Adál's account of Surrealism is one such vision; it begins in the everyday world of peripheral subjects like himself. It is an interpretation of working-

class Surrealism, of everyday magical worlds and imaginations that operate in the transnational and Nuyorican barrios and in local spaces like bodegas (corner grocery stores). Here, Bodega Surrealism deploys in art the same blue-collar strategies used to cobble together a living amid the struggles of capitalism and exploitation, thereby giving way to a Puerto Rican, Afro-Caribbean, and Latina/o/x "aesthetic sancocho," or making do with whatever is at hand.[41] Like Esteves, Adál makes these points forcefully in the artifacts of the Spirit Republic.

In another example of Bodega Surrealism, Adál's auto-portraits reverse the gaze, turning the camera's attention onto himself to mock Surrealist artists.[42] As a marginal subject who is consistently "in focus" through the surveillance camera but on the margins otherwise, Adál flips that marginality on its head, taking on a central position in the photos. "Papa not Dada" refers to Surrealism but with a différance—a difference of meaning or, in this case, a difference in the Surrealist script, as well as a deferral from the past to the transhistorical present.[43] Adál is both stepping into and displacing/replacing the central subject of the images that fall victim to his parody (in this case, Rene Magritte's *Man in a Bowler Hat*). Whereas the parodied artists are not highlighted in their own work, Adál's camera takes on a double refraction—in his work, they become *present by their absence through his presence*. That is, their absence is made visible by his presence.

Additionally, Adál's work executes a double displacement by transforming the art from image to real—that is, toward himself, a "Pre-Post Nuyorican Modern Primitive." His smirk in the Leonardo Da Vinci autoportrait suggests that he aims not to be seen as the Mona Lisa but rather to smile and say, "She is like me."[44] In all these portraits, he attempts to be modern while also engaging in jibaro existentialism, drawing upon a repertoire of signifiers that derive from Puerto Rican diasporic memories and everyday life absurdity.

Often playful, Adál's version of Surrealism plays on and usurps the public's fascination with and desire for tropical desirability onto one's body and identity. Surely, he is also cognizant of the intersections between photography, anthropology, and colonialism, where anthropologists used the advent of photography to "construct and disseminate persuasively real representations of otherness" while also using it as a technology of surveillance. Adál's pictures seem to challenge those uses and serve as an intentional departure from the exotic or demonized tropes that "transfixed difference, rendering [colonial subjects] as inert, passive, and powerless."[45]

Indeed, Adál's Surrealist photography is anything but passive, and it is grounded in the imaginative possibilities of dreams and the unconscious—an artistic mode well established within avant-garde communities. Rather than relying on realist approaches, Adál's style suggests a social utopia of possibilities "not yet won." His is a photography of Surrealist alterity; it departs from and suspends "rational" discourse. This is reflected in the "Spirit" (versus the "spirit") part of the Spirit Republic, which refers to the liberated psychic zone or utopia of a decolonial understanding of the post-colonial Boricua transnation. As claimed in the Spirit Republic Manifesto, "the imagination has always been an independent country." Essential to this utopic decolonial vision is the vision itself, the space of the mind to embark upon a noncolonized vision of possibilities. "We are not a government in exile!" claims the Manifesto. "This is where we live!"

The cultural nationalism that emerges, which El Embassy both articulates and departs from, highlights how inessential a recognized state apparatus is in generating national and transnational identity(ies). National, transnational, and even postnational visions of a Puerto Rican community exist despite the territory and its people having lived under colonial rule for more than five hundred years. El Embassy offers a different path to conceiving liberation, one that includes an opportunity to examine how the imagination remains a space of decolonial revelations and possibilities. This opportunity is attained through an ideology that parallels Surrealist principles and departs from a traditional nationalist discourse that conceives of political independence as the gateway to national and cultural distinction.

Adál's auto-portraits, as well as the other creative artwork of El Embassy, demonstrate some of the new semiotic possibilities that resist and bypass social realism through Surrealism and mimesis: whereas realism is understood to be loaded with hegemonic ideology, mimesis creatively unmasks and counters the underlying but prevailing hegemonic logics and representations of colonialism. By employing nonrealist, transcultural Surrealist aesthetics, Adál proposes an alternative political decolonial discourse of liberation that encompasses a post-Nuyorican aesthetics of resistance.

As an act of disalienation with the intention of intervening in the impact of colonial ideology on the brain and psyche (which include feelings of inferiority, insecurity, and belonging nowhere), Adál conceived of the Surrealist Spirit Republic as a decolonized space where everything is in "focus." The "Spirit" of this Republic consists of a state of mind, a conceptual, underground "schizophrenic" resistance ("of coming into and out of

5.4 Adál Maldonado, *Out of Focus* portraits, 1994–96. Courtesy of the Estate of Adál Maldonado and Roberto Paradise.

focus") that fosters a collective unity of emancipatory existence. As part of this work, Adál created the *In and Out of Focus* passport portraits.

For artists like Adál and Pietri, there is an inverse reasoning to such portraits (see figure 5.4).[46] To be "In Focus" entails existing *outside* of a subjugated/colonized state structure, while an "Out of Focus" portrait exemplifies an existence *within* a colonial state structure. In essence, Adál applies the mechanical principle that informs the optical code for cameras toward the social power dynamics that relegate one to the role of marginalized state subject.[47] The camera obscura inverts images from their natural state: an upright image is naturally horizontal, and a horizontal image is vertical. One can also conclude that a blurred portrait of a subject is naturally clear or "in focus." Adál pushes it further by perceiving the mechanical principle of a camera—through camera obscura—as socially transforming or falsely representing the natural state of its subjects. And while the camera aims to capture an accurate historical reflection of a subject, it does so under colonial conditions. And this creates the "Out of Focus Puerto Rican."

Writer, philosopher, and activist Susan Sontag asserts that photographs illustrate memories and events. While photography holds the capacity to

certify past experiences, it is also a way of refusing them.[48] Photographs can be a conduit through which one converts ephemeral experiences into a seemingly tangible image. As one actively observes, interprets, and reflects on an image, this process also allows for interventionist opportunities. In reading Adal's work, the camera can be an instrument of *future social interventions and visions*, not simply a tool that captures what happened in the past to confirm one's presence. Following the logic of camera obscura, if subjects are "out of focus" or colonized, when were they "in focus" or decolonized? For Adál, Pietri, Figueroa, Oyen, Esteves, and others involved at the NRV and El Embassy, the "in focus" decolonized Boricua is captured in a Surrealist future. And the NRV and El Embassy is where the "focused" subject comes into being, embracing the full decolonial reality of the Spirit Republic. Thus, Adál's conceptual photography imagines and projects into the future and opens a door for multiple abstract contemporary readings and interpretations. Although his blurred portraits may signify historical alienation within a specific space and time, these headshots prompt viewers to transpose them into their clear, natural, Surrealist state, and thus reenvision an imminent liberated social existence.

But to be "out" also means to be excluded, misunderstood, incomprehensible, or unintelligible; it means being on the fringes of social, economic, and political worlds, as well as of most ensconced arts institutions and artistic categories and movements. It means that one doesn't fit in; that one is shunned, without having a base from which to be located. In their liberatory praxis, one in which they adamantly defy inflexible and oppositional binaries as well as imposed boundaries—akin to queer theory—these artists pushed against mainstream ideological normativity while simultaneously aiming to subvert the idea of what it means to be in focus. In the multiverse of NRV artivists, "out" also means a coming together of a community engaging in subversive collective action and articulating speech acts of multiple kinds, recognizing in each other that they can engage in numerous activities without asking for permission. In other words, to be out is also not passive but to be sovereign, and to proactively harness their agency and right "to be" as they become transformative "subjects for the future."[49] With this understanding, they have a vision and want to aggressively work toward it, affirmatively using the arts as a medium for social action and community building. Therefore, in this self-fashioned futurism, Adál's photographs both are and become inverted articulations of a decolonial existence—past, present, and future.

Acknowledgments: All scholarship is a dialogical process, and this chapter is no different. I'm eternally grateful for the generosity and support of friends who graciously edited and proofread different versions across different moments, as it is a compilation of various excerpts from my forthcoming book, *Bodega Surrealism: Latina/o/x Artivists in New York City.* Thanks to Margaret Cerullo, Teresa I. Gonzalez, Neyda Martinez, Debra Osnowitz, Priscilla Renta, Andrew Rosa, Lauren Rubenzahl, and Michelle J. Wilkinson for their excellent feedback and editing. They read different parts of the manuscript, which made possible this final text. I am also indebted to and transformed by the dedicated artivists who shared their radical visions and stories with me.

Epigraph: From the author's interview with Dina D'Oyen, March 3, 2002.

1 Latine, Latina/o/x, and Latinx are used interchangeably in this chapter. All the terms aim to be gender neutral and inclusive of all genders. When quoting directly from a source, I employ the original language used in that source.

2 *Artivist* is a portmanteau for *artist* and *activist.* I started using terms like *artivism* and *artivist* while writing my dissertation, and at the time, such terms were not in vogue. In the early 2000s, I also began teaching a class titled "Artivism" at Hampshire College, where I was a professor. The term is employed by others to highlight how artists engage in sociopolitical issues through their art, and various nuanced meanings have evolved. Eventually, the term spread and became an accepted linguistic practice. "Artivists" is in the title of my dissertation, which I defended in December 2010 and revised and completed in the spring of 2011. See Valentín-Escobar, "Bodega Surrealism." It includes a lengthy list of publications on art and politics.

3 The official name of the center varies in the documents I've located. It ranges from the New Rican Village to the New Rican Village Cultural and Educational Center. Because the names were used interchangeably, I follow this usage. The center is also referenced in everyday usage as "the Rican," "the New Rican," or "the NRV."

4 From the New Rican Village Mission Statement, collection of the author, n.d.

5 *Boricua* is a term used to refer to someone born and raised in Puerto Rico, or a person of Puerto Rican descent who is born and raised outside the Caribbean island. It is used interchangeably with Puerto Rican. *Boricua* connotes an awareness and solidarity with Indigenous communities native to Puerto Rico. It is also a political identification, an anti-colonial standpoint, and an affirmation of ethnic and national pride that transcends birthplace and residency. It also lends itself to a shared identity of communal struggle and solidarity.

Although Eddie Figueroa was the principal director and founder of the New Rican Village, there were other artists who would eventually play instrumental roles in its development at distinct moments. They include

Americo Casiano, Sandra María Esteves, Andy Gonzalez, Jerry Gonzalez, Willie Figueroa, Brenda Feliciano, Adál Maldonado, Jesús Papoleto Meléndez, Nestor Otero, Dina D'Oyen, Pedro Pietri, Ana Ramos, Mario Rivera, Steve Turre, Papo Vázquez, Hilton Ruiz, Jorge Dalto, Dave Valentín, Aida del Valle, and Wilfredo Velez, among numerous others.

6 I conducted numerous oral history interviews with various artists active at the New Rican Village. I interviewed musicians, visual artists, poets, cultural organizers, actors, and multidisciplinary artists, among many others. Some that made direct or indirect reference to Surrealism include Dina D'Oyen, interviewed on March 3, 2002; Ana Ramos, interviewed on July 23, 2001; Sandra María Esteves, interviewed on August 1, 2001; Pedro Pietri, interviewed on July 11, 2001; and Adál Maldonado, interviewed on October 30, 2007. A more extensive engagement with their perspectives as well as with those of the numerous other artists and cultural workers active at the New Rican Village is showcased in my forthcoming book, *Bodega Surrealism.*

My discussion of Surrealism is informed by numerous sources noted here and in note 16 of this chapter. I'm highlighting a few, which include Gauss, "Theoretical Backgrounds of Surrealism"; Lefebvre, "Surreal Dream and Dreamed Reality"; Kelley, *Freedom Dreams*; Löwy, *Morning Star.*

7 The literature on Surrealism and on some of the Latinx artists active at the New Rican Village and the Lower East Side has slowly grown. See, for example, Aguilar, "Traditions and Transformations"; Ruiz, *Ricanness*; Noel, *In Visible Movement*; Herrera, *Nuyorican Feminist Performance*; Jaime, *Queer Nuyorican*; Crespy, "Nuyorican Absurdist"; Schrader, "That Special, Inevitable Mess."

8 See Lam and Mosquera, "My Painting Is an Act of Decolonization," 3.

9 Breton quoted in Löwy, *Morning Star*, 40.

10 Greene, *Releasing the Imagination.*

11 Per archival research and oral history interviews, Esteves, Adál, and Figueroa all had formal academic training. Esteves studied graphic arts at the Pratt Institute, while Adál studied photography at the San Francisco Art Institute; Figueroa was a theater student at New York University.

12 Adál Maldonado, interview by author, October 30, 2007. See also Richardson, *Refusal of the Shadow*; Sakolsky, *Surrealist Subversions*; Richardson and Krzysztof Fijalkowski, *Surrealism against the Current*; Kelley and Rosemont, *Black, Brown, and Beige*; Adamowicz, "Surrealizing Wifredo Lam?"

13 For a discussion on the historical significance of bodegas in Puerto Rican diaspora communities, see Sanchez-Korrol, *From Colonia to Community*; Pastor, "Legacy of the Puerto Rican Bodega." Note that there were numerous spaces of political and aesthetic resistance and organizing, as Aguilar

notes in her dissertation, including churches, colleges, and universities. See Aguilar, "Traditions and Transformations," 181.

14 For a discussion on Surrealism and the everyday, see Sheringham, *Everyday Life*.

15 Wolff, *Aesthetics and the Sociology of Art*, 16.

16 Bodega Surrealism goes beyond visual aesthetic. I consider it a constellation of artistic performances, styles, ideological perspectives, organizing practices, ethnoracial activities, and social class materialities. It is this assemblage, or "aesthetic sancocho," as Pietri notes, that comprise the working-class practices of Bodega Surrealism. For the aesthetic sancocho reference, see Pietri, "El Manifesto." For an elaborate discussion of Bodega Surrealism, refer to my forthcoming book, *Bodega Surrealism*.

17 Dina D'Oyen, interview by the author, March 3, 2002.

18 For an insightful discussion about the social context that spurred alternative art spaces, see Rosler, "Place, Position, Power, Politics"; Ault, *Alternative Art, New York*; Colo, "Alter the Native"; Ramirez, "'. . . A Place for Us.'"

19 Ramirez, "'. . . A Place for Us,'" 281.

20 Mouffe, "Artistic Activism and Agonistic Spaces," 4.

21 My interpretive lens of a Latina/o/x Cultural Left is inspired by Herman S. Gray's concept of the "Jazz Left" within the African American community. See Gray, *Cultural Moves*. The Latine Cultural Left is/was composed of vanguard community artists like Miguel Algarín, Papo Colo (Francisco Colón), Johnny Colón, Miriam Colón, Marcos Dimas, Maria Dominguez, Frank Espada, Sandra María Esteves, Eduardo "Eddie" Figueroa, Adrian Garcia, Jesús Abraham "Tato" Laviera, Adál Maldonado, Hiram Maristany, Raphael Montañez Ortiz, Geno Rodriguez, Armando Soto, Nitza Tufiño, and Marta Moreno Vega, among many others.

22 See Tucker, *Workers of the World, Enjoy!*, esp. chap. 4.

23 Lipsitz, "Not Just Another Social Movement," 169.

24 Harding, *Cutting Performances*, 19. For a discussion of collage aesthetics and the avant-garde, see Ulmer, "Object of Post-criticism."

25 Stansell, *American Moderns*, 68.

26 Lipsitz, "Not Just Another Social Movement," 181.

27 Kelley, *Freedom Dreams*, 192.

28 These arts congregations built on the work of scholar Earl Lewis, who observes how formal segregation still allowed African Americans to create community, or a sense of "congregation," within a hostile and unreceptive Jim Crow environment. See Lewis, *In Their Own Interests*.

29 Martinez de Pison, "Pasaporte Boricua," 7. El Puerto Rican Embassy is an ensemble of artistic installations that was conceptually conceived when Figueroa and others established the New Rican Village. Adál and Pietri

amplified El Embassy and created various related installations. Part of El Embassy is the Spirit Republic, an imaginary conceptual space of decolonial existence. Adál and Pietri also created *Blueprints for a Nation*, an installation where all the various components of El Embassy and the Spirit Republic are housed. The portraits that make up the "Out of Focus Nuyoricans" are part of this entire constellation. And all these components are intentionally modeled after state and religious institutions, which subversively and conceptually mimic and mock the shortcomings of existing colonial institutions and US imperial hegemony.

30 Letter, El Puerto Rican Embassy—The Spirit Republic of Puerto Rico, April 8, 1994, Pedro Pietri Papers, Center for Puerto Rican Studies Library and Archives, Hunter College, CUNY. There were numerous ambassadors for El Embassy. The acclaimed Diasporican poet María Teresa Fernández, aka Mariposa Fernández, is the Head of State of El New Hybrid State de Nuyol. See her 2000 statement: https://elpuertoricanembassy.msa-x.org/head-of-state.html.

31 Letter, El Puerto Rican Embassy.

32 El Puerto Rican Embassy lives virtually online. Many of the artistic references here can be found on its website, https://elpuertoricanembassy.msa-x.org/.

33 Based on interviews conducted with visual artists Nestor Otero and Rodríguez Calero (aka RoCa), the original passport design of El Embassy was conceived by them and later adapted by Adál. Interviews were conducted on June 13, 2015, and March 11, 2022. The first version of the Puerto Rican passport that circulated at the opening event at the Kenkeleba Gallery was designed by Otero and RoCa. The version that is on El Puerto Rican Embassy website and featured by the Smithsonian and elsewhere was created by Adál. See "El Puerto Rican Passport, El Spirit Republic de Puerto Rico: Adál Maldonado," 1994, https://americanart.si.edu/artwork/el-puerto-rican -passport-el-spirit-republic-de-puerto-rico-adal-maldonado-85117. The Manifesto and other aspects of the El Embassy art project can be found online. See https://elpuertoricanembassy.msa-x.org/index.html.

34 Adál Maldonado's former Lower East Side apartment was the actual location of the offices for the Spirit Republic.

35 Mercer, "Diaspora Culture and the Dialogic Imagination," 254.

36 LaCoss, "Introduction," xxvii.

37 See Bhabha, *Location of Culture*.

38 Although there are varying uses of the term *subaltern*, I am loosely using it as a process describing a historically formed community that is denied structural power.

39 Tucker, *Workers of the World, Enjoy!*, 12.

40 I'm drawing here from Parks, "Out-of-Focus Puerto Ricans." In its literal sense, cuchifrito is a general term used to describe Puerto Rican fast-food

restaurants that may closely resemble taco fast-food stands or restaurants in US Mexican/Chicano neighborhoods. When used as a signifier in every-day parlance, it may have a class connotation or quality, suggesting "cheap," "greasy," or "low quality." In the context of the argument offered here, it's related to the quotidian aspect of everyday conversations exchanged by working-class and poor communities occurring in these eating establish-ments, much like those in the barbershop scene in the Black community. The cuchifrito restaurants, coupled with bodegas, make for interesting spaces where, as argued here, one encounters more than "small talk": they are vital local institutions that bring about alternative and counter public spheres that operate below the dominant radar of public debate and popular opinion. For a discussion on the historical significance of bodegas in Puerto Rican diaspora communities, see Sanchez-Korrol, *From Colonia to Community*; and Pastor, "Legacy of the Puerto Rican Bodega."

41 Pietri, "El Manifesto"; Lévi-Strauss, *Savage Mind*; Hebdige, *Subculture*. According to Lévi-Strauss, *Savage Mind*, 21: "Bricolage entails 'the continual reconstruction from the same materials, it is always earlier ends which are called upon to play the part of means: the signified changes into the signi-fying and vice versa.' A 'sancocho' is like gumbo: it is a soup composed of various food elements, like chicken, red meat, fish, and vegetables, and then slowly stewed in a broth flavored by a range of spices."

42 There are too many auto-portrait illustrations to print here, but they can be found online. See, for example, Adál Maldonado, *Auto-portraits: Blue Ba-nanas on Fire and Blueprints for a Nation*, exhibition, David Rockefeller Cen-ter for Latin American Studies, Cambridge, MA, October 1, 2004–January 5, 2005, http://www.latinart.com/exview.cfm?start=1&id=204.

43 See Adál Maldonado, *Papa not Dada: Auto-portrait after Rene Magritte*, 1998, http://www.latinart.com/artdetail.cfm?img=pr_maldo_10_th.jpg&t =exhibit&tid=204.

44 See Adál Maldonado, *Autobiographical Art*, 1997, http://www.latinart.com /exview.cfm?start=2&id=204.

45 Gilbert, "Bodies in Focus," 17.

46 The *Out of Focus* portraits referred to here can be found virtually. See the Facebook page for Out of Focus Nuyoricans, https://www.facebook.com /people/Out-of-Focus-Nuyoricans/100069088928965/. They are pub-lished and included in an exhibition catalog, too: Maldonado, *Out of Focus Nuyoricans*.

47 Images of camera obscura can easily be found online. For a sampling, see Keener, "Lesson on the Camera Obscura."

48 Sontag, *On Photography*, 9.

49 Hall and Sealy, *Different*, 37.

Adamowicz, Elza. "Surrealizing Wifredo Lam?" *Forum for Modern Language Studies* 58, no. 1 (April 2022): 106–19.

Aguilar, Margarita J. "Traditions and Transformations in the Work of Adál: Surrealism, El Sainete, and Spanglish." PhD diss., City University of New York, 2020.

Ault, Julie, ed. *Alternative Art, New York, 1965–1985: A Cultural Politics Book for the Social Text Collective.* Minneapolis: University of Minnesota Press, 2002.

Bhabha, Homi K. *The Location of Culture.* New York: Routledge, 1994.

Colo, Papo. "Alter the Native." In *Alternative Histories: New York Art Spaces, 1960 to 2010,* edited by Lauren Rosati and Mary Anne Staniszewski, 15. Cambridge, MA: MIT Press, 2012.

Crespy, David. "A Nuyorican Absurdist: Pedro Pietri and His Plays of Happy Subversion." *Latin American Theatre Review* 45, no. 2 (Spring 2012): 25–43.

Gauss, Charles E. "The Theoretical Backgrounds of Surrealism." *Journal of Aesthetics and Art Criticism* 2, no. 8 (Autumn 1943): 37–44.

Gilbert, Helen. "Bodies in Focus: Photography and Performativity in Postcolonial Theatre." *Textual Studies in Canada* 10/11 (1998): 17–32.

Gray, Herman S. *Cultural Moves: African Americans and the Politics of Representation.* Berkeley: University of California Press, 2005.

Greene, Maxine. *Releasing the Imagination: Essays on Education, the Arts and Social Change.* San Francisco: John Wiley and Sons, 1995.

Hall, Stuart, and Mark Sealy. *Different: A Historical Context: Contemporary Photographers and Black Identity.* New York: Phaidon, 2001.

Harding, James. *Cutting Performances: Collage Events, Feminist Artists, and the American Avant-Garde.* Ann Arbor: University of Michigan Press, 2010.

Hebdige, Dick. *Subculture: The Meaning of Style.* New York: Routledge, 1979.

Herrera, Patricia. *Nuyorican Feminist Performance: From the Café to Hip Hop Theater.* Ann Arbor: University of Michigan Press, 2020.

Jaime, Karen. *The Queer Nuyorican: Racialized Sexualities and Aesthetics in Loisaida.* New York: New York University Press, 2021.

Keener, Katherine. "A Lesson on the Camera Obscura." Art Critique, March 2, 2020. https://www.art-critique.com/en/2020/03/a-lesson-on-the-camera-obscura/.

Kelley, Robin D. G. *Freedom Dreams: The Black Radical Imagination.* Boston: Beacon, 2002.

Kelley, Robin D. G., and Franklin Rosemont, eds. *Black, Brown, and Beige: Surrealist Writings from Africa and the Diaspora.* Austin: University of Texas Press, 2009.

LaCoss, Donald. "Introduction: Surrealism and Romantic Anticapitalism." In Michael Löwy, *Morning Star: Surrealism, Marxism, Anarchism, Situationism, Utopia,* vii–xxx. Austin: University of Texas Press, 2009.

Lam, Wifredo, and Gerardo Mosquera. "My Painting Is an Act of Decoloniza-
tion." *Journal of Surrealism and the Americas* 3, nos. 1–2 (2009): 1–8.

Lefebvre, Maurice-Jean. "The Surreal Dream and Dreamed Reality." *Diogenes*
11, no. 44 (1963): 81–102.

Lévi-Strauss, Claude. *The Savage Mind.* Chicago: University of Chicago Press, 1966.

Lewis, Earl. *In Their Own Interests: Race, Class and Power in Twentieth-Century
Norfolk.* Berkeley: University of California Press, 1993.

Lipsitz, George. "Not Just Another Social Movement: Poster Art and the Mov-
imiento Chicano." In *American Studies in a Moment of Danger*, 169–84.
Minneapolis: University of Minnesota Press, 2001.

Löwy, Michael. *Morning Star: Surrealism, Marxism, Anarchism, Situationism,
Utopia.* Austin: University of Texas Press, 2009.

Maldonado, Adál. *Out of Focus Nuyoricans.* Cambridge, MA: Rockefeller Center
for Latin American Studies at Harvard University, 2004. Exhibition catalog.

Martinez de Pison, Javier "Pasaporte Boricua." *El Diario/La Prensa*, July 10,
1994, 5–11.

Mercer, Kobena. "Diaspora Culture and the Dialogic Imagination: The Aes-
thetics of Black Independent Film in Britain." In *Theorizing Diaspora: A
Reader*, edited by Jana Evans Braziel and Anita Mannur, 247–60. Malden,
MA: Blackwell, 2003.

Mouffe, Chantal. "Artistic Activism and Agonistic Spaces." *Art and Research: A
Journal of Ideas, Context and Methods* 1, no. 2 (Summer 2007): 1–5.

Noel, Urayoán. *In Visible Movement: Nuyorican Poetry from the Sixties to Slam.*
Iowa City: University of Iowa Press, 2014.

Parks, Brian. "Out-of-Focus Puerto Ricans: Cuchifrito Nation." *Village Voice*,
April 2, 1996.

Pastor, Néstor David. "The Legacy of the Puerto Rican Bodega." Accessed Febru-
ary 13, 2022. https://centropr-archive.hunter.cuny.edu/centrovoices/barrios
/legacy-puerto-rican-bodega.

Pietri, Pedro. "El Manifesto: Notes on El Puerto Rican Embassy." El Puerto
Rican Embassy, 1994. https://elpuertoricanembassy.msa-x.org/index.html.

Ramirez, Yasmin. "'. . . A Place for Us': The Puerto Rican Alternative Art Space
Movement in New York." In *A Companion to Modern and Contemporary
Latin American and Latina/o Art*, edited by Alejandro Anreus, Robin Adèle
Greeley, and Megan A. Sullivan, 281–95. Hoboken, NJ: Wiley-Blackwell, 2022.

Richardson, Michael, ed. *Refusal of the Shadow: Surrealism and the Caribbean.*
New York: Verso, 1996.

Richardson, Michael, and Krzysztof Fijalkowski, eds. *Surrealism against the
Current: Tracts and Declarations.* London: Pluto Press, 2001.

Rosler, Martha. "Place, Position, Power, Politics." In *The Subversive Imagination:
Artists, Society, and Social Responsibility*, edited by Carol Becker, 55–76.
New York: Routledge, 1994.

Ruiz, Sandra. *Ricanness: Enduring Time in Anticolonial Performance*. New York: New York University Press, 2019.

Sakolsky, Ron, ed. *Surrealist Subversions: Rants, Writing and Images by the Surrealist Movement in the United States*. Brooklyn: Autonomedia, 2002.

Sanchez-Korrol, Virginia. *From Colonia to Community: The History of Puerto Ricans in New York City*. 2nd ed. Berkeley: University of California Press, 1994.

Schrader, Timo. "That Special, Inevitable Mess: El Spirit Republic de Puerto Rico and the Decolonization of the Imaginary." *Anglistica/AION* 20, no. 1 (2016): 15–30.

Sheringham, Michael. *Everyday Life: Theories and Practices from Surrealism to the Present*. New York: Oxford University Press, 2006.

Sontag, Susan. *On Photography*. New York: Picador, 1977.

Stansell, Christine. *American Moderns: Bohemian New York and the Creation of a New Century*. Princeton, NJ: Princeton University Press, 2010.

Tucker, Kenneth H., Jr. *Workers of the World, Enjoy! Aesthetic Politics and Revolutionary Syndicalism*. Philadelphia: Temple University Press, 2010.

Ulmer, Gregory L. "The Object of Post-criticism." In *The Anti-aesthetic: Essays on Postmodern Culture*, edited by Hal Foster, 83–110. Port Townsend, WA: Bay Press, 1983.

Valentín-Escobar, Wilson. "Bodega Surrealism: The Emergence of Latin@ Artivists in New York City, 1976–Present." PhD diss., University of Michigan, 2011.

Wolff, Janet. *Aesthetics and the Sociology of Art*. 2nd ed. London: Macmillan, 1993.

6

The Art of Survival

The Visual Art Activism
of Maria Dominguez

Al Hoyos-Twomey

The community muralist, painter, and arts educator Maria Dominguez was one of the most prolific artists living and working on the Nuyorican Lower East Side in the 1980s. There were very few projects—particularly those at the intersection of art and community activism—that Dominguez, a long-term resident of the neighborhood, was not involved in during the mid to late 1980s, and yet her contributions to the Nuyorican art movement of the period remain underacknowledged. The 1980s was a turbulent decade on the Lower East Side, one in which the capital disinvestment and state abandonment that had characterized the previous decade gave way to rapid reinvestment and gentrification, propelled in part by the new art

scene that developed in the first half of the 1980s in the northwestern section of the neighborhood known as the East Village. Both disinvestment and gentrification led to the isolation, marginalization, and displacement of the most precarious residents of what was by then a predominantly Puerto Rican neighborhood. What distinguished disinvestment from gentrification, however, was that the latter process also involved social and cultural *substitution*, gradually transforming a multiethnic, multiracial, working-class, immigrant neighborhood with a long history of cultural and political resistance to marginalization into an area that was much more homogenous, middle class, and white.[1]

In this chapter, I examine three projects undertaken by Dominguez on the Nuyorican Lower East Side between 1983 and 1987: the mural project *Baile Bomba* (1983), painted onto two abandoned buildings on Clinton Street; a relief sculpture titled *Gentrification* (1985), included in a show at Kenkeleba House; and *Contemporaneos* (1987), an exhibition of Latinx artists cocurated with the artist Carmelo Diaz. These projects built on the work of an earlier generation of Nuyorican activists, artists, and residents. In the face of state abandonment and capital disinvestment in the 1970s, grassroots community groups like CHARAS and Pueblo Nuevo worked to transform empty buildings and vacant lots into low-income housing, community gardens, and cultural and community centers, often collaborating with other groups such as the community mural organization Cityarts Workshop.[2] As part of this work, these activists renamed parts of the Lower East Side; the poet Bimbo Rivas and CHARAS cofounder Carlos "Chino" García rechristened the section north of East Houston Street (between Avenues A and D) as "Loisaida," while the section just south of East Houston Street was renamed "Pueblo Nuevo" (New Town) after a community group working to build affordable housing in the area.[3] The projects examined here were undertaken in collaboration with these long-running groups, and yet I argue that they offered fresh challenges to the multilayered effects of gentrification in the 1980s, a process that threatened not only to physically displace low-income residents (and the small businesses and self-organized institutions that served them) but to obliterate the cultural identity and history of the Nuyorican Lower East Side.

Here I examine gentrification through the conceptual framework of what Nicholas Mirzoeff calls "visuality." For Mirzoeff, visuality is "not composed simply of visual perceptions in the physical sense but is formed by a set of relations combining information, imagination, and insight into a rendition of physical and psychic space."[4] In other words, argues Jan

Baetens, visuality "refers to a set of mechanisms that order and organize the world—and by doing so naturalize the underlying power structures that are replicated and implemented by these (violent) transformations of the real."[5] Mirzoeff insists that visuality, as "a discursive practice for rendering and regulating the real that has material effects," is made up of three interrelated operations: "First, it *classifies* by naming, categorizing, and defining. . . . Next, visuality *separates* the groups so classified as a means of social organization. Such visuality segregated those it visualized to prevent them from cohering as political subjects, such as workers, the people, or the (decolonized) nation. Finally, it makes this separated classification seem right and hence *aesthetic*."[6] Considered individually, each of the projects examined in this chapter challenged at least one of the operations of classifying, aestheticizing, and separating, through which gentrification came to establish and maintain its authority on the Lower East Side in the 1980s. Considered collectively, Dominguez's multifaceted practice articulated a powerful countervisual force, one that attempted to "dismantle the visual strategies of the hegemonic system" by insisting on the presence and agency of the communities, everyday practices, and forms of cultural expression that gentrification sought to erase.[7]

"We're Still Here": *Baile Bomba* (1983)

In 1983, while Dominguez was studying at the School of Visual Arts, she was appointed lead artist on a Cityarts Workshop mural project on the Lower East Side.[8] Across a pair of fifteen-by-twenty-five-foot walls on two abandoned buildings on Clinton Street, Dominguez painted *Baile Bomba*, a vivid celebration of the Afro–Puerto Rican tradition of bomba, a rhythmically intricate musical style that is typically performed by dancers, singers, and percussionists in communal settings. Bomba has its roots in the musical traditions of enslaved West African laborers who were brought to Puerto Rico by Spanish settlers to work in mines and on sugar plantations, and who used music as a means of spiritual and political survival and resistance to the oppressive colonial regime.[9] The style had seen a resurgence during the Nuyorican movement of the late 1960s and 1970s, as an expression of collective struggle against the racialized and classed discrimination faced by Puerto Ricans in the city.[10] On the Nuyorican Lower East Side, performances of bomba and plena (a distinct but closely related style) typically took place in public settings such as community gardens, street festivals, block parties, and mural dedication ceremonies.

In *Baile Bomba*, Dominguez connected bomba's long history of resistance to enslavement and colonialism in Puerto Rico with its significance as a tool of cultural resistance on the Nuyorican Lower East Side in the 1970s and 1980s, and used these transnational, transhistorical links to articulate a vision of the neighborhood's future. Nestor Cortijo's photographs of the *Baile Bomba* murals show them as an explosion of color and movement that stand out against the drab backdrop of the vacant tenements onto which they are painted.[11] The first mural depicts a bomba dancer midperformance (see figure 6.1). As the dancer twirls, the shape of her dress billows to resemble the shape of Puerto Rico, while its deep-red hue matches the *flamboyán* bloom (native to the island) that she holds in an outstretched palm. The second mural depicts a grinning *vejigante* mask; such masks are typically seen during festival celebrations in Puerto Rico (and, like bomba, an important symbol of Nuyorican cultural identity; see figure 6.2). One end of the ribbon tied around the *vejigante*'s horn morphs into the bomba dancer's dress, under whose skirt is visible a grim environment of burned-out tenements and shuttered storefronts set against an apocalyptic sky. The other end is connected to the landscape through which the dancer twirls, an image of the neighborhood characterized not by abandonment and poverty but by green space and affordable housing.

The vision of the transformed Nuyorican Lower East Side that *Baile Bomba* imagined was one that local activists had long been fighting for, but it was something that by the early 1980s was under threat from gentrification. Rebecca Amato insists that "displacement and dispossession—two consequences of modern-day gentrification—echo the kind of historical erasure that colonization delivered centuries before."[12] Crucially, both processes rely on the discursive and material production of "empty space" that exists to be filled. In their oft-cited critique of the East Village scene, "The Fine Art of Gentrification," Rosalyn Deutsche and Cara Gendel Ryan draw attention to representations of the Lower East Side as "empty" prior to the arrival of artists, many of whom saw themselves as urban "pioneers."[13] In his account of gentrification on the Lower East Side, Neil Smith argues that the term *urban pioneer* is "as arrogant as the original notion of 'pioneers' in that it suggests a city not yet socially inhabited."[14] For Peter Kent-Stoll, gentrification perpetuates the ongoing colonization of Black and Indigenous communities and is facilitated by the "racialized physical, cultural, and political displacement of Black, Indigenous, Asian, Latinx, and working class people."[15]

Through disinvestment in the 1970s, the Lower East Side had been designated by both state and capital as an unproductive, essentially "vacant"

6.1 Maria Dominguez, *Baile Bomba*, 1983. Mural (1 of 2). Photo by Nestor Cortijo. Collection of Maria Dominguez.

6.2 Maria Dominguez, *Baile Bomba*, 1983. Mural (2 of 2). Photo by Nestor Cortijo. Collection of Maria Dominguez.

neighborhood, a classification that required the sustained erasure of the visual and aural presence of those who lived there. In her discussion of contemporary gentrification in Oakland, California, Margaret Ramírez describes how the policing of certain types of sound—through noise complaints, ordinances, and curfews—is designed to make existing residents of a gentrifying neighborhood "feel out of place, their soundscapes offensive to new neighbors in the vicinity."[16] Black and Latinx musical forms have been especially targeted in this way. The late 1990s, for example, saw weekly confrontations in Central Park between rumba players and the New York Police Department (NYPD), which, in accordance with the "Quality of Life" initiatives of the Rudy Giuliani administration, sought to characterize the sound of the rumba drum as "unreasonable noise" in order to justify sanctions against the *rumberos*.[17] Like rumba, the ongoing presence of bomba in New York was threatened by gentrification. The community garden La Plaza Cultural, for example, was created in the mid-1970s by CHARAS out of a vacant lot in Loisaida. The garden became a key social space in the neighborhood, hosting, among many other cultural and political events, performances by Joe Bataan, Tito Puente, and the bomba and plena groups Baile Boricua and Grupo Cemi. By the early 1980s, however, as the original cohort of gardeners gradually left the neighborhood, La Plaza Cultural had once again fallen into disrepair.

By depicting a significant Puerto Rican cultural form—one that was highly visible and audible in public spaces across Loisaida and Pueblo Nuevo—and by doing so through the highly public medium of mural making, with *Baile Bomba*, Dominguez resisted the cultural erasure of the Nuyorican Lower East Side with a forceful assertion of visual and sonic agency. This agency extended to the process of getting the mural approved. *Baile Bomba* was sponsored by Pueblo Nuevo, the local grassroots housing organization. The group had been given a grant through the Department of Housing Preservation and Development (HPD) to commission a mural on the side of two of the abandoned buildings that lined Clinton Street. What Dominguez didn't realize at the time was that the project was part of an effort to "beautify" the neighborhood in a bid to attract new residents, new businesses, and new investment to the area. Pueblo Nuevo had been developing low-income housing in the neighborhood since the early 1970s, but the city had its own vision of who it sought to attract, and when HPD was shown Dominguez's design, with its vivid celebration of Afro–Puerto Rican cultures of resistance, it rejected it as being "too ethnic."[18] Cortijo (who was then Pueblo Nuevo's director of the

board) gathered representatives from the local groups that had collectively approved Dominguez's design. Together, they marched into the offices of HPD to insist that Dominguez's mural was what the community wanted. As Dominguez remembers it, "We walked into their office one morning, and when they saw all these people, they said 'Hmmm.' And after about 45 minutes it went [in our favor]." The mural was approved.[19] In its conception, design, and execution, *Baile Bomba* resisted efforts to classify the Lower East Side as an empty space, insisting, despite assumptions to the contrary, "We're here. We're still here."[20]

"Pushed East to the River": *Gentrification* (1985)

Gentrification (1985) was a relief sculpture created by Dominguez for *Dimensions in Dissent*, an exhibition of political art at Kenkeleba House gallery in December 1985. Founded by the artists Joe Overstreet and Corinne Jennings in 1978, Kenkeleba House was one of very few artist-of-color–run spaces on the Lower East Side in the 1980s, and it predominantly exhibited the work of artists of color, with an emphasis on Black artists. *Dimensions in Dissent* included work by David Hammons, Faith Ringgold, and Juan Sánchez, among others. There is very little documentation of the show (although it is notable as having been the first place that Hammons exhibited his site-specific installation *Soweto Marketplace*), so it is impossible to get a sense of what Dominguez's piece looked like displayed in Kenkeleba House.[21] However, a photograph taken by the Lower East Side documentarian Marlis Momber shows Dominguez carrying the piece down Avenue C (see figure 6.3).

The first thing one notices when looking at Momber's photograph is how busy Avenue C is. As discussed previously, gentrification on the Lower East Side relied on the classification of the neighborhood as "vacant," utterly devoid of life, and yet Momber's photograph shows a bustling thoroughfare in the heart of Loisaida. In the foreground, positioned a few steps in front of Dominguez, who is standing on the street corner with *Gentrification* slung across her back, a young man straddling a bicycle turns to stare directly at the viewer, his fists raised in a playful confrontation with the camera. At the far right of the photograph, an adult and child hold hands as they cross the street; visible just to the right of Dominguez on the opposite pavement is a child decked out in a safety helmet, riding a skateboard. Standing in front of what appears to be a shuttered storefront, two men look on with interest at the scene taking place across the street.

6.3 Maria Dominguez carrying *Gentrification* along Avenue C, New York, 1985. Photo by Marlis Momber. Collection of Maria Dominguez.

Visible a little further down Avenue C are awnings belonging to a restaurant and a *joyería* (jewelers), under which two figures stroll arm in arm.

Gentrification is large, around one meter tall by one meter wide. In Momber's photograph, the work spans from just below Dominguez's eyeline to just above her knees; with no way of seeing how it is being held up by Dominguez, the piece almost appears to float suspended in space, its bright-white hue contrasting with the darker grays and blacks that dominate the rest of the photograph. The work itself depicts a simplified face, contorted in pain, struggling to emerge from an arrangement of roughly textured rectangular shapes—made of recycled laundry detergent boxes covered in plaster gauze—that bear more than a passing resemblance to a pile of bricks. *Gentrification* is animated by a sense of movement in multiple directions. At the same time as the work's central figure struggles to break free of the jagged backdrop within which it has been confined, features on its left-hand side appear to melt back into that same space. The work articulates the struggle to maintain a sense of dignity in the face of an overwhelmingly hostile environment.

As is apparent by its title, *Gentrification* was created in response to the process that was, by 1985, well underway on the Lower East Side. More spe-

cifically, the work was a response to a quote that had been printed in a *New York* magazine article on gentrification published the year prior.[22] In "The Lower East Side: There Goes the Neighborhood," Craig Unger interviewed some of the many property speculators then flooding the Lower East Side, hoping to make a killing in the neighborhood's increasingly lucrative real estate market. One such developer, a young Aspenite turned New Yorker named Tom Pollak, made it perfectly clear what these new Lower East Siders thought of the "ethnic businesses and services" and "rent-controlled tenants" that had long populated the neighborhood: "They'll all be forced out. They'll be pushed east to the river and given life preservers. It's so clear. I wouldn't have come here if it wasn't."[23] Pollak's quote makes explicit the way in which gentrification reframed the neighborhood's boundaries in the mid-1980s. Throughout the turbulent 1970s, the borders of the Lower East Side were clearly defined by state and capital in order to siphon resources away from it as part of a program of austerity measures that were justified as the only way of stopping the neighborhood's seemingly "impossible to contain" decline spreading to wealthier neighborhoods in the vicinity.[24] By the mid-1980s, those same boundaries were being redrawn, this time to actively exclude those who had previously been isolated and marginalized but who stood in the way of the new forms of wealth extraction and profit making that the neighborhood now offered.

With its violent yet matter-of-fact imagining of the displacement of the Lower East Side's most precarious residents, Pollak's quote aestheticizes gentrification, making it seem natural, inevitable, and—for him and others like him—desirable. Although Pollak is by far the most egregious of Unger's interviewees, the rest of the article contributes to this process: through its subtitle, "There Goes the Neighborhood"; through its choice of interviewees, which include brief accounts from CHARAS' Chino García and Pueblo Nuevo director Deborah Humphreys but is otherwise dominated by the voices of gallerists, real estate brokers, and property developers; and through Steve McCurry's accompanying photographs of boutique hairdressers, upscale restaurants, and white cube galleries, in which the only image of a person of color is a photograph of a drug bust. Overall, the article constructs an image of a neighborhood whose transformation into a predominantly white, middle-class enclave is all but guaranteed.

Absent altogether in Unger's article are the faces and voices of those rent-controlled tenants whose demise Pollak so gleefully imagines. Unlike *Baile Bomba*, which actively intervened in the production of public space in Pueblo Nuevo through a highly visible celebration of Nuyorican cultural

identity, with *Gentrification*, Dominguez offered a more subtle gesture. By focusing on the figure of the displaced, depicted amid a fraught encounter with the shifting physical and conceptual borders of the gentrifying neighborhood, the work made visible the everyday spatial disempowerment and invisibility of low-income tenants that is so central to gentrification. These processes, Johana Londoño argues, "are much more difficult to bear witness to" than other, more visually conspicuous spatial interventions, but they are important to bring to light, as they can "reveal power relations that easily go unnoticed" if an understanding of the transformation of the built environment is limited "only to what we *see* in public spaces."[25] With this in mind, it feels apposite that one of the only visual documentations of *Gentrification*—Momber's photograph of Dominguez carrying the work down Avenue C—does not situate it in a traditional gallery setting. Rather, Momber captured Dominguez's ephemeral intervention into the public space of Loisaida, one that made visible those whose violent displacement from the neighborhood was, in that moment, being aestheticized and naturalized by powerful agents of gentrification.

"We Didn't See Each Other": *Contemporaneos* (1987)

In 1985, as Dominguez was finishing her bachelor of fine arts (BFA) at the School of Visual Arts, she was appointed the first visual art coordinator at El Bohío, a former public school on East Ninth Street in Loisaida that had been taken over in 1978 by CHARAS and another local group, Adopt-A-Building, and turned into a popular cultural and community center. Dominguez had first met Chino García, director of CHARAS and El Bohío, at the dedication ceremony for *Baile Bomba* back in 1983, when CHARAS had agreed to sponsor the event's bomba performers. During her four-year tenure in the role, Dominguez was involved in several significant projects, including three contemporary art auctions to benefit El Bohío, a show of political Puerto Rican art curated by Juan Sánchez, the initiation of arts workshops for young people, and the creation of a series of murals depicting life in Loisaida that was painted onto the exterior of El Bohío.[26]

A key project undertaken by Dominguez in her role as visual art coordinator was the curation of a 1987 group exhibition titled *Contemporaneos* (*Contemporaries*) in the newly renovated La Galería en El Bohío. The idea behind the show came from the fact that the 1980s had seen the opening of many new galleries as part of the booming East Village scene, and yet Dominguez recalls that Nuyorican and other Latinx artists "didn't see each other in

these galleries."[27] As early as November 1983, the critic Carlo McCormick wrote that the "dealers, collectors and critics who hesitantly venture into the East Village are looking at white artists in white galleries in an increasingly upper middle class neighborhood."[28] While McCormick's statement naturalizes both the absence of nonwhite artists in the neighborhood and the inevitability of gentrification, he acknowledges the reality that, despite the presence of certain artists of color, for the most part, the East Village scene's participants and audiences were increasingly homogenous.

The erasure of Latinx artists from the East Village scene was replicated in the so-called Latin American art boom of the late 1980s. Blockbuster exhibitions in mainstream institutions, typically curated by non-Latinx curators, such as *Art of the Fantastic* (1987) or *Hispanic Art in the United States* (1988), were critiqued for being rooted in a homogenized understanding of Latin American art and for excluding Latinx artists working in the United States.[29] Despite these erasures, Dominguez insists "we knew, as Latinos, that there are these people out there doing these wonderful works of art, and nobody is acknowledging them. So we went out."[30] Together with the curator Carmelo Diaz, who at the time was a studio assistant of the painter Julian Schnabel, Dominguez gathered together thirty-six New York–based Latinx artists to participate in the show, including Candida Alvarez, Catalina Parra, Juan Sánchez, Papo Colo, and Marina Gutierrez.

Decades of work by artists of color to both expand their representation in existing cultural institutions and create alternative spaces of their own, combined with the emergence of a new gallery district in one of New York's most ethnically and racially diverse neighborhoods, contributed to what the artist Coco Fusco describes as a "resurgent interest in otherness in the avant-garde" of the late 1980s.[31] Despite the potential for critical and commercial success that this renewed interest offered to *individual* artists of color, at a structural level, both the institutional and alternative art worlds in New York remained overwhelmingly white, dominated by what Arlene Dávila describes as an "incentive to maintain whiteness in the form of an imaginary postracial art world, because it provides resources, power, and opportunity to those who have historically most benefited from it."[32] This maintenance of whiteness facilitated, in Fusco's words, a "segregated division of labor," in which critical and commercial success for artists of color was not accessible through their collaborations and involvement with one another but remained almost entirely dependent on their uneven ability to access, typically as individuals, the power structures of predominantly white art institutions.[33]

Contemporaneos intervened in these developments at several registers. By 1987, La Galería en El Bohío was, along with Kenkeleba House, one of very few art galleries located on the Lower East Side that were run by and for artists of color.[34] With its deep roots in the Nuyorican community activism of the previous decade, and its commitment to centering the work of marginalized artists while fostering productive dialogue and collaboration between older and newer residents in the neighborhood, El Bohío was the ideal venue for an exhibition that could undermine the segregated divisions of labor and market-driven logics of New York's art worlds. The show's title insisted on a definition of those who participated as "contemporary artists," a category that, as Dávila points out, is typically used as an uncritically accepted index of whiteness and hence value within art markets, and one that is often denied to artists of color, whose work is "marked" by race.[35] The term *contemporaries* emphasizes the heterogenous collectivity of the artists, who were based in Nuyorican and Latinx neighborhoods across the city—not just Loisaida or Pueblo Nuevo but also El Barrio (East Harlem), South Bronx, Los Sures, and Bushwick. *Contemporaneos* assembled a diverse group of artists, working in myriad mediums and on myriad different themes, from across Nueva York, in defiance of the forces that would marginalize these neighborhoods and keep them separate from one another. The participation in *Contemporaneos* of Dominguez, as someone who was not trained in curation, also offered, in Dávila's words, "an important challenge to the idea that there are strict roles in the art world, each demanding unique and narrow types of expertise."[36]

Like *Dimensions in Dissent*, very little documentation of *Contemporaneos* exists today, beyond a portrait of Chino García, Bimbo Rivas, and the historian Mario Maffi by Marlis Momber, and a handful of snapshots of the exhibition opening taken by Dominguez and Diaz (see figure 6.4). Several artworks are partially visible (including a hanging sculpture by Jorge Luis Rodriguez spanning almost the length of the gallery's ceiling, and several large-scale paintings), and the photographs offer a rare glimpse at just how large La Galería en El Bohío was, especially in comparison to the tiny storefront spaces that made up the bulk of the East Village galleries. Unfortunately, no record of what work belongs to whom still exists. Gentrification is not just facilitated by the physical separation of people from their homes, neighbors, and culture; as Sarah Schulman argues, it also alienates people from their own history.[37] "We weren't thinking we were making history," recalls Dominguez. "We were surviving."[38] Although detailed documentation of *Contemporaneos* survived Dominguez's own displacement from the Lower East Side in the

6.4 Carmelo Diaz and exhibition visitors at the opening of *Contemporaneos*,
La Galería en El Bohío, New York, 1987. Photo by Maria Dominguez.
Courtesy of the photographer.

early 1990s, limited space in her studio meant that she was forced to throw out of all sorts of material related to the show in the early 2000s.[39]

Nevertheless, the photos of the opening show an incredible mix of attendees; as Dominguez puts it, the show was "a hit," attended not just by Latinx artists and audiences but by everybody in the neighborhood who "knew what was going on."[40] *Contemporaneos* created what Mirzoeff calls a "space of appearance" for Nuyorican and New York Latinx artists in an increasingly contested neighborhood in the late 1980s, a space for cultural invention and collectivity that was accessible to everyone—just like El Bohío itself—but was led by, and centered, Latinx cultural production.[41] For Mirzoeff, participation in spaces of appearance is vital to an articulation of what he calls "the right to look," a countervisual force that "claims autonomy, not individualism or voyeurism, but the claim to a political subjectivity and collectivity."[42] *Contemporaneos* paved the way for later large-scale exhibitions in La Galería that emphasized this political subjectivity even more explicitly: in 1988, Juan Sánchez curated *Huellas: Avanzada Estética por la Liberación Nacional* (*Prints: Advanced Aesthetics for National Liberation*), which brought together free and imprisoned artists on the island and in the

diaspora for a show that dealt with cultural and political struggles for Puerto Rican independence; and in 1990, Sánchez was joined by Sara Haviland, Loti Reyes, and Yong Soon Min for *Arte de Resistencia* (*Art of Resistance*), a show of political work predominantly by artists of color.

In many cultural histories of the Lower East Side in the 1980s, artists and other culture workers have been commonly understood as "shock troops of gentrification."[43] This critique is especially prevalent in discussions of the East Village art scene that developed in the first half of the decade. Although it facilitated the development of many radical new practices, the entrepreneurial, DIY spirit of the East Village scene, and its appeal to a new urban middle class, has been assessed by some observers as being in alignment (whether intentionally or not) with the entangled interests of urban capital, the institutional art world, and the neoliberal state.[44] These powerful actors had abandoned the Lower East Side and its predominantly low-income residents of color in the 1970s—in the process allowing its built environment to crumble and its population to deplete—only to return in the 1980s, when the neighborhood's changing demographics and devalued real estate guaranteed a profitable return on investment.[45]

Despite the contentious role that the new art scene played in the transformation of the Lower East Side in the 1980s, for many of those who were most at risk of gentrification, who had been living and working in the neighborhood for decades (and for the most part had no connection to the East Village scene, beyond sharing the same geographical space), art had long played a vital role in critiquing, resisting, and offering alternatives to the symbolic and material violence of displacement. Maria Dominguez is one such artist. It is impossible in a chapter of this length to fully capture Dominguez's contributions to the Nuyorican Lower East Side art and activist scene of the 1980s. I have not been able to include, for example, the work Dominguez undertook as part of the political mural collective Artmakers Inc., whose 1985 project *La Lucha Continua* remains one of the most ambitious community mural projects in New York's history.[46] Nor have I touched on Dominguez's initiation of arts workshops for young people at El Bohío, or her work as an arts educator in museums across the city, a role she moved into after the external funding for her position as visual art coordinator at El Bohío ran out.[47]

However, what I have argued is that Dominguez's multifaceted practice on the Nuyorican Lower East Side throughout the 1980s constituted an art of survival, one that responded in real time to the myriad urgent threats facing her community. Even more than this, I argue that Dominguez's work

articulated a countervisuality that challenged gentrification's strategies of displacement and was rooted in an absolute "right to the city" for marginalized people. Rejecting liberal interpretations of Henri Lefebvre's concept that have blunted its critical edge, Marcelo Lopes de Souza maintains that the right to the city is not only about better housing or lower rent—although it certainly includes these demands—but is an insistence on "the right to a very different life in the context of a very different, just society."[48] By bringing together her long-running community activism with creative practice in a range of mediums, Dominguez intervened in the production of the physical and symbolic space of the Lower East Side. In the process, she offered a glimpse of what this different and more just society might look like.

NOTES

Acknowledgments: I would like to thank Maria Dominguez for her time, patience, and generosity over the last couple of years, without which this chapter would not have been possible. The photographs included have come from the personal collection of Dominguez, whose early works and documents are in the process of being catalogued for inclusion in the archives of Centro, the Center for Puerto Rican Studies at Hunter College in New York.

1 Jukes, *Shout in the Street*, 230; Schulman, *Gentrification of the Mind*, 14.

2 Bagchee, *Counter Institution*, 104, 106–7.

3 Ševčenko, "Making Loisaida," 296–300; Momber, "Oral History Interview," 37.

4 Mirzoeff, "Right to Look," 476.

5 Baetens, "Right to Look," 95.

6 Mirzoeff, "Right to Look," 476. Emphasis mine.

7 Baetens, "Right to Look," 95.

8 *Baile Bomba* was not Dominguez's first experience working on a Cityarts Workshop mural; in 1982, she had been an assistant to lead artist Joe Stephenson on *Avenue C Storefronts*. For an account of Cityarts Workshop's formation and activities on the Lower East Side between 1968 and 1988 (when it was closed down and reestablished as CITYarts Inc.), see Braun-Reinitz and Weissman, *On the Wall*.

9 Colón-León, "Bomba," 13.

10 Rivas, "Loisaida," 8.

11 These photographs can be seen on Dominguez's website, http://mariadomin guez.com/ITWCS.html.

12 Amato, "On Empty Spaces, Silence, and the Pause," 249.

13 Deutsche and Ryan, "Fine Art of Gentrification," 103.

14 Smith, *New Urban Frontier*, xiv.

15 Kent-Stoll, "Racial and Colonial Dimensions of Gentrification," 13.

16 M. M. Ramírez, "City as Borderland," 159.

17 Jottar, "Zero Tolerance," 4.

18 Maria Dominguez, interview by the author, March 7, 2022.

19 Dominguez, interview by the author, March 7, 2022.

20 Dominguez, interview by the author, March 7, 2022.

21 Jones, "Interview," 253.

22 Maria Dominguez to Al Hoyos-Twomey, November 15, 2022.

23 Quoted in Unger, "Lower East Side," 41.

24 Amato, "On Empty Spaces, Silence, and the Pause," 255.

25 Londoño, *Abstract Barrios*, xvi.

26 Dominguez, interview by the author, March 7, 2022.

27 Dominguez, interview by the author, March 7, 2022.

28 McCormick, "Lower East Side Art Boom," 19.

29 See, for example, M. C. Ramírez, "Beyond 'The Fantastic'"; M. C. Ramírez, "Between Two Waters"; Goldman, "Looking a Gift Horse in the Mouth"; Genocchio, "Discourse of Difference."

30 Dominguez, interview by the author, March 7, 2022.

31 Fusco, "Fantasies of Oppositionality," 81.

32 Dávila, *Latinx Art*, 3.

33 Fusco, "Fantasies of Oppositionality," 82.

34 The Alternative Museum, founded by Geno Rodriguez in 1975 and initially located on East Fourth Street, had moved to Tribeca in 1980. Exit Art, cofounded by Papo Colo with Jeanette Ingberman in 1982, was based in SoHo, as was the Museum of Contemporary Hispanic Art (MoCHA), which grew out of the Cayman Gallery in 1985 and was overseen by Nilda Peraza. Linda Goode Bryant's Just Above Midtown, which had moved from Midtown to Tribeca in 1978, had closed in 1986. In Chinatown, the Asian Arts Institute became the Asian American Art Center in 1987, although Basement Workshop, the artist-run space out of which it had developed, had also closed in 1986.

35 Dávila, *Latinx Art*, 3.

36 Dávila, *Latinx Art*, 136.

37 Schulman, *Gentrification of the Mind*, 13.

38 Dominguez, interview by the author, March 7, 2022.

39 Maria Dominguez, telephone call with Al Hoyos-Twomey, November 15, 2022.

40 Dominguez, interview by the author, March 7, 2022.

41 Mirzoeff, "Empty the Museum," 8.

42 Mirzoeff, "Right to Look," 473.

43 Jukes, *Shout in the Street*, 230.

44 See, for example, Deutsche and Ryan, "Fine Art of Gentrification"; Smith, *New Urban Frontier*, 3–27; Mele, *Selling the Lower East Side*, 220–54.

45 Amato, "On Empty Spaces, Silence, and the Pause," 248.

46 For a detailed account of *La Lucha Continua*, see Weissman, *La Lucha Continua*.

47 Maria Dominguez to Al Hoyos-Twomey, November 15, 2022.

48 Souza, "Which Right to Which City?," 318.

BIBLIOGRAPHY

Amato, Rebecca. "On Empty Spaces, Silence, and the Pause." In *Aesthetics of Gentrification: Seductive Spaces and Exclusive Communities in the Neoliberal City*, edited by Christoph Lindner and Gerard Sandoval, 247–67. Amsterdam: Amsterdam University Press, 2021.

Baetens, Jan. "The Right to Look: A Counterhistory of Visuality (Review)." *Leonardo* 46, no. 1 (2013): 95.

Bagchee, Nandini. *Counter Institution: Activist Estates of the Lower East Side.* New York: Fordham University Press, 2018.

Braun-Reinitz, Janet, and Jane Weissman. *On the Wall: Four Decades of Community Murals in New York City.* Jackson: University Press of Mississippi, 2009.

Colón-León, Vimari. "Bomba: The Sound of Puerto Rico's African Heritage." *General Music Today* 34, no. 3 (April 1, 2021): 13–19.

Dávila, Arlene M. *Latinx Art: Artists, Markets, and Politics.* Durham, NC: Duke University Press, 2020.

Deutsche, Rosalyn, and Cara Gendel Ryan. "The Fine Art of Gentrification." *October* 31 (Winter 1984): 91–111.

Fusco, Coco. "Fantasies of Oppositionality: Reflections on Recent Conferences in Boston and New York." *Screen* 29, no. 4 (October 1, 1988): 80–95.

Genocchio, Ben. "The Discourse of Difference: Writing 'Latin American' Art." *Third Text* 12, no. 43 (Summer 1998): 3–12.

Goldman, Shifra M. "Looking a Gift Horse in the Mouth." In *Dimensions of the Americas: Art and Social Change in Latin America and the United States*, 317–25. Chicago: University of Chicago Press, 1994.

Jones, Kellie. "Interview with David Hammons." In *EyeMinded: Living and Writing Contemporary Art*, 247–62. Durham, NC: Duke University Press, 2011.

Jottar, Berta. "Zero Tolerance and Central Park Rumba Cabildo Politics." *Liminalities: A Journal of Performance Studies* 5, no. 4 (November 2009): 1–24.

Jukes, Peter. *A Shout in the Street: An Excursion into the Modern City.* Berkeley: University of California Press, 1991.

Kent-Stoll, Peter. "The Racial and Colonial Dimensions of Gentrification." *Sociology Compass* 14, no. 12 (2020): 1–17.

Londoño, Johana. *Abstract Barrios: The Crises of Latinx Visibility in Cities*. Durham, NC: Duke University Press, 2020.

McCormick, Carlo. "The Lower East Side Art Boom." *New York Beat*, November 1983.

Mele, Christopher. *Selling the Lower East Side: Culture, Real Estate, and Resistance in New York City*. Minneapolis: University of Minnesota Press, 2000.

Mirzoeff, Nicholas. "Empty the Museum, Decolonize the Curriculum, Open Theory." *Nordic Journal of Aesthetics*, no. 53 (2017): 6–22.

Mirzoeff, Nicholas. "The Right to Look." *Critical Inquiry* 37, no. 3 (2011): 473–96.

Member, Marlis. "Oral History Interview with Marlis Member." Interview by Liza Zapol, June 15, 2015. Greenwich Village Society for Historic Preservation. https://media.villagepreservation.org/wp-content/uploads/2020/05/15035050/Member_MarlisTranscriptFinalforWebsite-1.pdf.

Ramírez, Margaret M. "City as Borderland: Gentrification and the Policing of Black and Latinx Geographies in Oakland." *Environment and Planning D: Society and Space* 38, no. 1 (February 2020): 147–66.

Ramírez, Mari Carmen. "Between Two Waters: Image and Identity in Latino-American Art." In *Postmodernism and New Cultural Tendencies in Latin America: 500th Anniversary of the Encounter of Two Worlds*, 51–68. San Francisco, CA: New Earth Press, 1993.

Ramírez, Mari Carmen. "Beyond 'The Fantastic': Framing Identity in U.S. Exhibitions of Latin American Art." *Art Journal* 51, no. 4 (1992): 60–68.

Rivas, Bimbo. "Loisaida: The Reality Stage." *Win Magazine: Peace and Freedom through Nonviolent Action*, December 20, 1979.

Schulman, Sarah. *The Gentrification of the Mind: Witness to a Lost Imagination*. Berkeley: University of California Press, 2013.

Ševčenko, Liz. "Making Loisaida: Placing Puertorriqueñidad in Lower Manhattan." In *Mambo Montage: The Latinization of New York City*, edited by Arlene Dávila and Agustín Laó-Montes, 293–317. New York: Columbia University Press, 2001.

Smith, Neil. *The New Urban Frontier: Gentrification and the Revanchist City*. London: Routledge, 1996.

Souza, Marcelo Lopes de. "Which Right to Which City? In Defence of Political-Strategic Clarity." *Interface* 2, no. 1 (May 2010): 315–33.

Unger, Craig. "The Lower East Side: There Goes the Neighborhood." *New York*, May 28, 1984, 32–41. https://evgrieve.com/2008/06/lower-east-side-there-goes-neighborhood.html.

Weissman, Jane. *La Lucha Continua The Struggle Continues: 1985 and 2017*. New York: Artmakers Inc., 2017.

7

The Parallel Aesthetics
of Nilda Peraza

Néstor David Pastor

From the mid-1970s to the early 1990s, Nilda Peraza was a fixture of the alternative arts scene in Lower Manhattan—first, as director of Cayman Gallery, "something between a non-commercial art space and a community center"[1] that showcased a mostly emerging, underrepresented cohort of Nuyorican, Puerto Rican, Latinx, and Latin American artists; then, as the architect behind the gallery's formal transition into the Museum of Contemporary Hispanic Art (MoCHA). Among the many factors that contributed to the success and enduring relevance of these two establishments is the concept and praxis of *parallel aesthetics* or *parallel cultures*, terms coined by Peraza to express an inclusive aesthetic practice that "coexists

with the mainstream, which continues to try to exclude it."[2] It is, more-over, born from this exclusion and resulting experiences on the margins. In Peraza's words, "We have not really assimilated to the American way of life; rather, we have a parallel culture and institutions. We've kept what's good about us and added our experience of the United States."[3]

Initially articulated as a grassroots initiative "to infiltrate the main-stream in SoHo,"[4] parallel aesthetics would come to define Peraza's unique trajectory and perspective as a Puerto Rican arts administrator endeavor-ing to construct an alternative institutional model in the heart of a global arts district—that is, another world in the shadow of the old one. By De-cember of 1990, however, MoCHA was compelled to close and Peraza, unable to secure major funding or find a new location for the museum in the aftermath, retreated from the New York City art world. Consequently, there has not been a critical account of Peraza's trailblazing career.

Early Years

Born in San Juan, Puerto Rico, in 1945, Nilda Mercedes Peraza graduated from the University of Puerto Rico before leaving for New York City. She was working at a private school in Manhattan when a Puerto Rican parent suggested a nonprofit arts organization located at 432 Third Avenue where Peraza could meet other Puerto Ricans. The Society of Friends of Puerto Rico, also known as Friends of Puerto Rico, Inc. (FoPR), had been founded in 1953 by Amalia Guerrero, a well-known Puerto Rican arts patron and social-ite who married a wealthy Cuban businessman after a brief career in show business.[5] Its purpose was ostensibly to promote "cultural vibrancy" among the Puerto Rican community in New York. As a recent arrival, Peraza—now working as an education coordinator for an after-school arts program in the South Bronx's School District 7 under future US congressman José Serrano—began volunteering as a personal assistant of sorts to Guerrero, helping organize administrative files and manage after-school arts programming.

Around the same time, in the early 1970s, a group of young Puerto Rican artists and activists felt that the FoPR should utilize its resources and programming to more directly address the needs of the Puerto Rican community in New York City.[6] A grassroots effort to wrest control of the organization from Guerrero subsequently led to a contested board elec-tion. In the ensuing legal battle, George Aguirre, a "Hispanic" cultural advocate and pioneer in laser photography, was appointed president of FoPR. Peraza served as vice president.[7]

It was Aguirre, according to Peraza, who recruited Nuyorican poet, community activist, translator, and playwright Jack Agüeros to become chairman of the board shortly after the takeover was completed. Agüeros, Aguirre, and Peraza first initiated the move to the fourth floor of 853 Broadway, then to a second-floor factory loft at 381 West Broadway, where a traditional white cube-style gallery with east and west wings was inaugurated under the name Cayman Gallery on June 10, 1975 (see figures 7.1 and 7.2).[8]

Less than two years later, Agüeros would depart to become executive director of El Museo del Barrio, having established an ethos at Cayman where Latin American artists could also be exhibited. Nuyorican art historian and independent curator Yasmin Ramirez notes the early presence of Latin American artists, yet asserts the gallery maintained its Nuyorican and Puerto Rican character during this period.[9] El Museo del Barrio would initiate a similar shift during Agüeros's tenure. In a 1978 issue of *Nuestro* magazine, he would espouse this broader, seemingly prescient vision of the future for the nascent institution: "Our focus is no longer limited to Puerto Ricans . . . we are too culturally rich to force ourselves into ghettos of narrow nationalism. El Museo now wants to embody the culture of all of Latin America. New York is the fourth or fifth largest Spanish-speaking country, and El Museo must reflect everything that is Latino."[10]

Peraza, in turn, would implement and develop this radically inclusive, pan-Latino approach as the newly appointed director of Cayman Gallery. However, unlike El Museo del Barrio, which had its roots in community activism and educational initiatives, the mission of Cayman Gallery did not require a shift but rather a scaling of capacity to meet the increasing demand of its diverse constituency. In this way, Peraza began to establish the praxis that would later inform her concept of *parallel aesthetics*, building upon Agüeros' vision while establishing her own: "We were working on a parallel level with spaces like El Museo del Barrio. We knew that El Museo del Barrio had a mission to serve that particular community and we did not need to duplicate that. Basically, we went another route and decided to infiltrate the mainstream in SoHo. We opened our doors to the Latin American community because those artists could not get shows at other galleries and they were coming to us."[11]

Cayman, however, was not the only destination for the influx of Latin American artists in New York City. The OLLANTAY Gallery in Jackson Heights, Queens, was an informal storefront gallery and performance space that boasted a similarly inclusive, grassroots approach to organizing

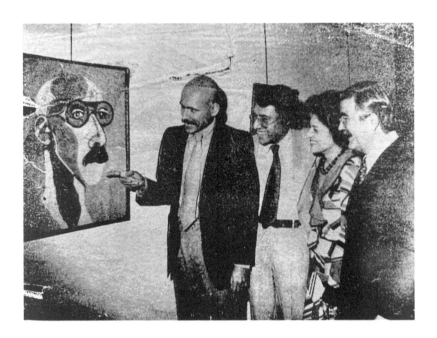

7.1 A showcase of artwork by Puerto Rican painter Domingo García was inaugurated at Cayman Gallery, 381 West Broadway, in 1975. The artist shows one of his works to members of Friends of Puerto Rico: Jack Agüeros, Nilda Peraza, and George Aguirre. Photo by Alfonso Irizarry for *El Diario/La Prensa*. Undated newspaper clipping courtesy of Nilda Peraza.

exhibitions for Latinx and Latin American artists. Many of the same underrepresented artists exhibited at Cayman were also shown at OLLANTAY, which occasionally hosted satellite exhibitions organized by Peraza and her staff. The reality is that the first noncommercial gallery of its kind in Queens barely registered within New York City's Latin American art circuit of the time, let alone the mainstream art world.[12] This highlights the relevance of parallel aesthetics in geographical terms. In other words, you could recreate the essence of Cayman outside of SoHo, but the results would not be the same, even with OLLANTAY situated in a Latin American immigrant neighborhood and therefore with access to a more immediate constituency along a commercial corridor in the epicenter of the borough.

An early example of the growing presence of Latin American artists at Cayman Gallery is an exhibition and fundraiser organized in the spring of 1977, in solidarity with the Chile Committee for Human Rights, following the assassination of Chilean economist and diplomat Orlando Letelier the

7.2　Domingo López, original floor plan sketch for Cayman Gallery, ca. 1972. Courtesy of Nilda Peraza.

previous year. Peraza was also fortunate to meet two early and important mentors around this time: renowned Paraguayan artist Laura Márquez (1929–2021) and her husband, Argentine artist and art critic Juan Carrera Buján (1926–2002). The couple had met in Argentina and participated in student protests against the Academia de Bellas Artes in the 1950s, then moved to Paraguay for a decade or so, living in Asunción under the Alfredo Stroessner dictatorship before settling in New York in the early 1970s.[13] Both completed graduate studies in Buenos Aires, with Márquez emerging as an important leader in a student-led artist movement and Buján working as an art professor. Márquez also helped found El Museo de Arte Moderno de Asunción. Together, they provided Peraza with the formal background in Latin American art that she lacked prior to assuming the role of director at Cayman in 1977. "They would come [to the gallery] when I was there in the afternoons and would sit with me. They taught me Latin American art . . . they knew more about Latin American art than anybody that I have

known," said Peraza.[14] In addition to serving on a selection committee and participating in several exhibitions, Buján worked at Cayman and served as artistic director. Márquez also exhibited at Cayman and contributed to exhibition catalogs. Peraza would undergo further training as a graduate of the Museum Management Institute in 1982—the first Puerto Rican to do so.[15]

From Alternative Space to Museum

By the mid-1980s, Cayman had exhibited hundreds of Latin American/ Latinx artists and Puerto Rican artists at an approximate 3:1 ratio, while attempting to foster a generous and open art environment, unbiased and inclusive of artists from all backgrounds, without the threat of stereotyping and pigeonholing (see figure 7.3).[16]

Peraza describes the shift to a more formal museum structure as an organic process. Cayman's reputation was growing and programming had grown increasingly ambitious.[17] This is evidenced by institutional priorities that Patricia L. Wilson Cryer outlines in her dissertation, completed just before the gallery's transformation into MoCHA. They include "the building of an archive of Latin American artists who reside in the United States, the acquisition of a viable permanent collection, and the organization of traveling exhibitions throughout the United States and Latin America."[18] To some extent, MoCHA would achieve each of these initiatives in addition to those carried over from Cayman, such as a Latin American graphic arts biennial and an annual summer showcase exhibition.

First, however, Peraza's plan for expansion required a larger, more refined space. Much like her predecessor, who facilitated El Museo del Barrio's move into its current location, Peraza took the bold step of relocating to a massive, and more importantly, cheaper space in the fifth-floor loft of a factory building at 584 Broadway. The transformation became official on March 28, 1985, with an opening ceremony attended by New York City mayor Ed Koch (see figure 7.4).[19] Since the new space accommodated four galleries, as well as artist studios,[20] the opening exhibition could feature many of the artists first exhibited and championed at Cayman Gallery. "The first show that we did was kind of a festival, and all the artists came; it was a wonderful celebration of Nilda, because it was all the people that she had worked with," says Susana Torruella Leval, director emerita of El Museo del Barrio and a former curator at MoCHA. "She put out a call and said, 'Bring your work for the opening [of MoCHA].'"[21] A citation from New York State governor Mario Cuomo and a letter of greeting from President Ronald Reagan were

FREDDY RODRIGUEZ
OCTOBER 7-30

CAYMAN GALLERY
381 W. Broadway, N.Y.C. 10012

7.3 Promotional poster for Freddy Rodríguez exhibi-
tion, Cayman Gallery, October 7–30, 1978. Cour-
tesy of Hutchinson Modern and Contemporary,
New York.

also read aloud and served as strategic, contextual examples of mainstream recognition, that is, bringing the mainstream to MoCHA to witness the birth of an institution that would exist and compete in parallel with the established legacy institutions of the city. In her inauguration letter, Peraza expressed a sense of optimism and posterity: "The Museum of Contemporary Hispanic Art is my dream come true. It is here for us today; it is our legacy for future generations; and more importantly, it exists to engender a more profound sense of cultural identity and pride among Hispanics."[22]

In hindsight, Peraza recalls one of the more difficult decisions she made during the transition involved appointing Puerto Rican art historian Torruella Leval as the museum's first curator, thereby displacing her mentors, Buján and Márquez. Peraza eventually lost touch with the pair as they stopped coming to the museum. "But I have never forgotten and I will never stop

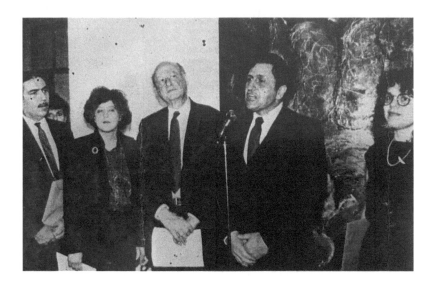

7.4 Mayor Edward Koch (*center*), alongside Nilda Peraza, director of MoCHA, and Cinque Sacarello, Esq., special advisor for Hispanic affairs, during an address by Michael Durso, vice president of Dry Dock Savings Bank, with Nelly Pagan Healy, chairperson for Friends of Puerto Rico, standing beside him at the inauguration of the Museum of Contemporary Hispanic Art, New York, on March 28, 1985. Photo by A. Paradis. Undated newspaper clipping courtesy of Nilda Peraza.

saying Laura Márquez and Juan Buján's names," says Peraza, "because they were the ones who opened my eyes, my ears, and my senses to the arts."[23]

Torruella Leval had curated exhibitions and written catalog essays for Cayman. Her first opportunity, she recalls, had been an interview with renowned Uruguayan printmaker Antonio Frasconi.[24] More opportunities and collaborations would follow. Torruella Leval remained at the museum until 1987, and later joined El Museo del Barrio as chief curator in 1990 and as executive director from 1993 to 2002. There, she oversaw a fraught process to amend the institution's mission statement to be move beyond its traditional focus on Puerto Rican art, echoing the broader curatorial and institutional mandates established by Agüeros and Peraza, respectively.[25]

During this time, Peraza, like the many students, interns, artists, family members, volunteers, and staff who sacrificed to keep MoCHA open, continued to work long hours to offset chronic understaffing and meager resources, often staying until late into the night. As a single parent, Peraza

relied on the support of her own mother, who moved from Puerto Rico to East Harlem in the 1970s after retiring from a career in teaching. "I was not socializing, I didn't go for drinks or lunches or dinners with anybody; I didn't have the time or the resources," she says.[26]

By the turn of the decade, Peraza was approaching her professional peak as a curator, writer, educator, and mentor. Her curatorial achievements include serving as one of five guest curators invited to select two artists each for the 1984 exhibition *Art and Ideology* at the New Museum, which addressed the increasing yet contested presence of identity politics in the work of artists from underrepresented communities and backgrounds— foreshadowing future exhibitions Peraza would organize with a similar intention. Peraza selected Chilean artists Alfredo Jaar and Ismael Frigerio and wrote a short essay for the catalog. Other examples include the traveling group exhibitions *Nuevos artistas colombianos en USA* and *New Directions: Mexican Women Artists*.[27] During her tenure, Peraza also served as an academic specialist for the US government, training museum and arts professionals in several Latin American countries, including on trips to Uruguay, Mexico, Guatemala, Argentina, and Venezuela. Back in New York City, Peraza says MoCHA regularly drew interest from college professors seeking to recommend students for internships, which, in turn, provided foundational experience to early career professionals, many of whom have gone on to success in the worlds of art and academia.[28]

Two of the final exhibitions organized by MoCHA speak to the historic success of parallel aesthetics as an organizing principle. *The Decade Show: Frameworks of Identity in the 1980s* (1990) was a groundbreaking and monumental collaboration with the Studio Museum in Harlem and the New Museum that conveyed the essence of the decade's alternative arts movement and the rise of multiculturalism by prioritizing content over more formal aesthetic concerns. While praised for "innovative political content," the show was criticized for "a perceived lack of formal polish"— not unlike the 1993 Whitney Biennial, which was also maligned for its emphasis on identity politics and the inclusion of women and BIPOC artists. The second noteworthy exhibition organized at this time was the 3rd International Painting Biennial, held in Cuenca, Ecuador (1991), in which MoCHA worked with the United States International Communication Agency (USICA) to send a historic delegation of six US-based Latinx artists—for the first time ever—to represent the country abroad. It was an important moment that briefly obscured the "nationalist privilege" that anthropologist Arlene Dávila ascribes to the recognition of Latin American

artists over US-based Latinx artists.[29] The participating artists were Josely Carvalho, Juan Sánchez, Candida Alvarez, Ismael Frigerio, Juan Gonzalez, and Luis Cruz Azaceta.[30]

Unfortunately, Peraza was simultaneously struggling to delay the inevitable—the SoHo arts district was rapidly gentrifying and the building where MoCHA was located had been recently sold, with most of the old factory tenants having already vacated the premises. "I knew we had until [the end of] 1990," Peraza says, in reference to the lease agreement with the previous owner.[31] Whereas Yasmin Ramirez ascribes the closure of MoCHA and other alternative arts spaces to rising rents and ongoing cuts to public funding, Taína Caragol alludes to a shift in institutional funding models that prioritized corporate sponsorship and individual philanthropy, which MoCHA had already adopted to some extent.[32] Overall, Peraza acknowledges her individual failure as director to acquire the funds needed to save the museum. "I was able to raise funds for, let's say, this exhibition, that exhibition, this project, but that will not pay the rent. . . . A lot of foundations would not give you money for that."[33] Even so, Peraza remains critical of MoCHA's Board of Trustees for continuously failing to meet its fiduciary responsibilities, a concern that dated back to at least 1987, when a letter was sent to board members giving them the option to resign in order for more active and engaged individuals to join: "If you accept to be on a board of directors and you are people who run organizations and know about the responsibilities, you should come forward and no one came forward."[34]

Any perceived mismanagement, to which some scholars have alluded, could ultimately be attributed to a persistent and overwhelming lack of capacity, as Steven D. Lavine, president emeritus of CalArts, who was working at the Rockefeller Foundation in New York City at the time, explains: "I've spent a lot of time with smaller organizations now and often they end up being sloppy in their management. . . . Almost all of it is a function of never having enough staff to actually do the job you're trying to do, never having enough money to do it in a way that is technically right and just making it happen anyway."[35] The two crossed paths after Peraza made an unsuccessful presentation to one of Lavine's colleagues, Chicano scholar and author Tomás Ybarra-Frausto, who had recently moved to New York to become associate director of arts and culture at the Rockefeller Foundation.[36]

Peraza herself seemed to anticipate the likelihood of a strong reaction to MoCHA's closing. On May 26, 1990, she participated as a panelist at a Latin American visual arts conference hosted by the OLLANTAY Center

for the Arts, the first Latin American cultural organization in Queens, NY, led by Cuban American playwright Pedro R. Monge Rafuls.[37] In her now prescient-sounding opening remarks, Peraza voiced her frustrations:

> People will say, "Se cayó MoCHA, o cerraron eso, fíjate que mal administrador, se robó todo los chavos y tienen una mala administración y el sitio está en problema porque fulanito está ganándose el sueldo'" [MoCHA fell apart or they closed, look, what a bad administrator, they stole all the money and the place was mismanaged and they're in trouble while so-and-so is making a living.] What people don't realize is that it's a constant struggle for organizations functioning without budgets, that by June we don't have a penny in the bank. We have to wait for the funding sources to start looking at our following year. You are responsible to start producing on July 1 and you don't get the checks sometimes until January or six to nine months down the road. During this time, the employees of these institutions have to work for two or three months without pay. These organizations go into debts with vendors. The institution has to juggle a $2,000 grant to pay the rent and the phone bill.[38]

Peraza has also alleged a shortsighted perception that only one major Latinx institution could be supported by the arts landscape in New York City, which, in turn, would excuse any sense of responsibility on the part of public and private institutions toward MoCHA and its broad, citywide constituency of Puerto Rican, Nuyorican, Latinx, and Latin American artists.[39]

According to Peraza, the new landlord offered a two-year lease with a significant rent increase. Unable to pay, the lease expired, and MoCHA left the premises, with all the artwork, artist files, and administrative documents associated with the museum placed in a storage unit in the Bronx. Eventually, this archival collection was placed under the care and supervision of Hostos Community College (at CUNY), where it remains today. Meanwhile, the remaining staff worked out of the offices of the Association of Hispanic Arts (AHA), holding board meetings until late 1993.[40] "At a certain point," Peraza explained, "You do all the things you know how to do and you have done, and you have knocked on all the doors you are able to knock on. . . . It was not going to happen, it's like a heartbreak."[41]

Peraza believes it was a mistake not to have sought media coverage, which likely contributed to the perceived abruptness of the museum's closure. Indeed, there does not seem to be any sort of in-depth contemporane-

ous account of MoCHA's closure, which could have served several purposes, from rallying support for the museum to attracting donors or, most importantly, providing an official version of events. Leaving New York and returning to Puerto Rico allowed rumors to circulate in Peraza's absence. But without the support of her mother, who had moved back to Puerto Rico, Peraza and her daughter could not continue living in New York City.

Peraza's career in Puerto Rico included a decade-long stint at the Instituto de Cultura Puertorriqueña (ICP), a state institution founded in 1955 to promote traditional elements of Puerto Rican culture.[42] It was far removed from the contemporary art world of SoHo. Still, Peraza was assigned various projects that utilized her unique background and experience. They included El Museo de Nuestra Raíz Africana and El Museo del Indio.[43] She also helped establish El Museo de los Próceres in Cabo Rojo and El Museo de la Masacre de Ponce, which is housed in the same building where the infamous Ponce Massacre occurred on Palm Sunday in 1937.

According to Marisol Matos Perez, a supervisor at ICP, Peraza continued to work late, just like in New York, preferring to spend time alone when the ICP building was empty.[44] She describes Peraza as a hard worker, very intense, direct, and creative, with a penchant for creating "museos vivos," or interactive exhibitions with accompanying activations, such as events and lectures.[45] The best example of this was also one of her more ambitious projects while working at the ICP—a museum dedicated to the history and culture of Puerto Rico dating back five hundred years to the Indigenous peoples who inhabited the archipelago before the arrival of the Spanish. The first phase is mentioned in a January 1997 issue of *Diálogo*, which features an interview with Peraza and describes all manner of cultural patrimony under the care and supervision of the ICP: petroglyphs, ceramics, cemis, a bohío (small hut), and the main attraction, a cavernous entrance much like the caves found throughout Puerto Rico. Had the project been fully realized, visitors would have experienced different historical periods until reaching the present.

Not all of Peraza's work in Puerto Rico was historical or educational in scope during this time. Peraza also found work with a commercial gallery and wrote catalog essays or curated exhibitions in San Juan, in many cases for artists she once exhibited in New York: Venezuelan artist Elba Damast; New York–born Puerto Rican artist Nick Quijano; Puerto Rican–born, New York–raised artist Raphael Collazo; and former Puerto Rican political prisoner and artist Elizam Escobar, among others. Outside of the

archipelago, Peraza's participation in the art world was limited to a lecture hosted by the Studio Museum in Harlem (1993) and a 1999 exhibition featuring the Institute of Puerto Rican Culture's collection of Puerto Rican santos at the William Benton Museum of Art in Connecticut.[46]

In 2003, Peraza moved back to New York City. She returned to education, working in supplemental education services despite obtaining a certificate in museum management from the University of Colorado–Boulder in 2001. Most recently, she was invited to participate in a panel on efforts to preserve and promote the legacy of Cayman Gallery and MoCHA at the 2019 Latino Art Now conference in Houston.[47] The digitization of exhibition catalogs and other archival materials at Hostos through an initiative called Digital MoCHA is one such example. The status and future of the museum's art collection, which is stored at the college, remains unclear.

A Historical Legacy

Beyond the foundation established by MoCHA, what remains is the legacy of a fierce and beloved advocate for the early Latinx arts community in New York City. Asked what could have been, Peraza imagines MoCHA as something akin to the kind of flagship Latinx museum now being developed by the Smithsonian, polemical aspects aside. That said, further institutionalization would likely have brought many of the challenges that El Museo del Barrio has faced in recent years. Collectively, according to Susan Jane Douglas and Adina Muskat, these concerns require "a delicate mediation of the local and the global, the community and the mainstream museum, progress, and an acknowledgment of its roots."[48] It would be naive to think that the parallel aesthetics championed by Peraza would not have been subject to concessions, beholden to mega donors, or held accountable to a broad and demanding constituency, not just in New York City, but nationwide, in Latin America, the Caribbean, and so on. One wonders how MoCHA would have navigated such a trajectory given the assimilationist principles of parallel aesthetics as well as its more subversive and generative outcomes. It is perhaps necessary to consider the closure of MoCHA as inherently tied to the precarity of the era in which it existed and the success of its mission as responding to a particular historical moment, or as Melissa Rachleff concludes, "There is no clear end to the alternative gallery, only an end to specific concerns." In Peraza's case, it was the reversal of the question of cultural scarcity as it related to Nuyorican, Latinx, and Latin American artists,[49] in a word, abundance.

NOTES

1 Caragol, "Boom and Dust."

2 Zolberg, Vera L. "Art on the Edge."

3 Glueck, Grace. "The Many Accents of Latino Art." *New York Times*, September 25, 1988.

4 See Ramirez, "'. . . A Place for Us.'"

5 Wilson Cryer, "Puerto Rican Art in New York."

6 Arlene Dávila elaborates on the criticism of Society of Friends of Puerto Rico as an elitist organization that rejected the African- and Indigenous-derived elements of Puerto Rican culture. See Laó-Montes and Dávila, *Mambo Montage.*

7 Aguirre was also vice president of arts and cultural activities at the Exxon Corporation. "George Aguirre, 62, Hispanic-Art Backer." *New York Times*, January 12, 1995.

8 In a taped 1981 interview with Patricia L. Wilson Cryer, Agüeros explains his reasoning for choosing the name Cayman: "The name was very important to me. The cayman is an aggressive animal. I was sick and tired of Puerto Ricans calling everything el coquí, el pirulí, la cosita . . . so—cayman. It's an amphibian. It can live on land and water, and I liked that as a duality force. We live on the mainland, and we live on an island. . . . I liked it because it could be said in English and Spanish." Wilson Cryer, "Puerto Rican Art in New York," 51. As Caragol notes, there is much confusion around the timeline of Cayman's founding. Wilson Cryer states that Puerto Rican artist Roy Kavetsky was the first to exhibit at this new location—likely in early 1974 and still under the name Friends of Puerto Rico—followed by several exhibitions also featuring Puerto Rican artists before the official name change and inauguration in the summer of 1975. Caragol, "Boom and Dust," 172.

9 See Ramirez, "'. . . A Place for Us.'"

10 Carlos V. Ortíz, "The Arts: Museo de la Gente," *Nuestro*, April (1978).

11 Nilda Peraza, interview by Yasmin Ramírez, video recording, San Juan, Puerto Rico, April 18, 2001.

12 Caragol, "Boom and Dust." The four institutions Caragol analyses as part of the Latin American art circuit of New York City included the Bronx Museum, Cayman/MoCHA, El Museo del Barrio, and CIAR/AS.

13 An additional biographical note: Márquez, along with a group of artists that included Fernando Botero, Luis Camnitzer, and Liliana Porter, founded the Museum of Latin American Art in New York in 1971. No further information appears available on this likely short-lived endeavor. Breyer, "A Desperate Pioneerism," 78.

14 Nilda Peraza, interview by the author, April 2022.

15 Founded in 1979, the Museum Management Institute, more commonly known as the Getty Leadership Institute, is now called the Museum Leadership Institute. Peraza is listed as a 1982 alumna: https://mli.cgu.edu/peraza-nilda/.

16 Tucker, Peraza, and Conwill, "Director's Introduction: A Conversation."

17 Caragol, "Boom and Dust."

18 Wilson Cryer, "Puerto Rican Art in New York," 49–52.

19 Opportunities for artists from underrepresented communities was a priority for the National Endowment of the Arts, which provided funding. At its inauguration, the Museum of Contemporary Hispanic Art was still under the auspices of Friends of Puerto Rico Inc. for the sake of convenience and expediency.

20 Cuban artists Luis Cruz Azaceta and Gladys Triana each maintained artist studios at MoCHA for several years.

21 Susana Torruella Leval, interview by the author, March 16, 2023.

22 Nilda Peraza, Museum of Contemporary Hispanic Art (MoCHA) inauguration letter, 1985. https://hutchinsonmodern.com/content/feature/667/image2079/.

23 Nilda Peraza, interview by the author, April 2022.

24 Susana Torruella Leval, interview by the author, March 16, 2023.

25 See Ramirez, "Passing on Latinidad."

26 Nilda Peraza, interview by the author, April 2022.

27 An incomplete list of participating artists in *Nuevas artistas colombianos en USA*: Esperanza Cortez, Carlos Duque, Patricia Gonzalez, Luis Monje, Gloria Ortiz, Maria Teresa Rizzi, Enrique Grau Luis Stand, Francisco Vidal. Participating artists in *New Directions: Mexican Women Artists*: Dulce Maria Nunez, Elena Villaseñor, Isabel Vazquez, Susana Sierra, Nunik Sauret, Herlinda Sanchez Laurel, Alice Rahon, Fanny Rabel, Anamario Pinto, Irma Palacios Flores, Leticia Ocharan, Monica Mayer, Ofelia Marquez, Consuelo González Salazar, Manuela Generali, Olga Dondé, Paloma Diaz Abreu, Teresa Cito, Gilda Castillo, Lilia Carrillo, Susana Campos, Maris Bustamante, Ofelia Marquez Huitzil.

28 A partial list includes University of Chicago sociology professor Nicole Marwell; Cheryl Hartup, director of El Museo de Arte de Ponce; curator Carla Stellweg; art historian and museum educator Rosa Tejada; and New York University anthropologist Arlene Dávila.

29 Dávila, *Latinx Art*, 9.

30 Both *The Decade Show* and the Cuenca Biennial were curated by Julia P. Herzberg, the final curator to work at the museum. Carla Stellweg was the second curator at MoCHA after Torruella Leval.

31 Nilda Peraza, interview by the author, April 2022.

32 Ramirez, "'. . . A Place for Us'"; Caragol, "Boom and Dust." Cuban Honduran artist Andres Serrano, who's controversial 1987 photograph *Immersion (Piss*

Christ) would result in a successful Republican-led effort to cut funding to the National Endowment for the Arts, first exhibited at MoCHA in 1985 as part of the group show *Myth and History* and held his second solo exhibition, *The Unknown Christ,* at the museum in 1986. Anecdotally, Susana Torruella Leval shares that the New York City Fire Department visited MoCHA for a fire inspection and attempted to shut down the solo exhibition due to the perceived blasphemous nature of the artwork. Susana Torruella Leval, interview by the author, March 16, 2023.

33 Nilda Peraza, interview by the author, April 2022.

34 Nilda Peraza, interview by the author, April 2022. The Board of Trustees in 1991 included Luis Miranda (chairperson), Celina Romany (vice chairperson), Jorge Luis Rodríguez (secretary), Robert A. Smith (treasurer), Elva Collazo, Elba Damast, Juan Gonzalez, Peter Mackle, Nilda Peraza, and Nitza Tufiño.

35 Steven Lavine, interview by the author, May 27, 2022.

36 The Rockefeller Foundation was among the funders of *The Decade Show.*

37 The other speakers for the conference included Charles Biasiny-Rivera, Isabel Nazario, Gladys Triana, Juan Espinos, Pedro Villarini, Julio Nazario, Heidi Sackerlotzky, Freddy Rodríguez, Pablo Schugurensky, Jorge Posada, Josely Carvalho, Nelson Colón, Francisco Vidal, Carlos Ortiz-Sueños, and Juan Boza. See also Pastor, "De Queens Pa'l Mundo."

38 Monge-Rafuls, *Visual Arts,* 25.

39 "They always thought that there should only be one Latina/o museum, not many like we wanted." Nilda Peraza, interview by Yasmin Ramirez, 2001. See also Ramirez, "'. . . A Place for Us.'"

40 Friends of Puerto Rico/Cayman Gallery was a member organization of the Association of Hispanic Arts when Dr. Marta Moreno Vega founded AHA in 1975. Other member organizations included Taller Boricua, El Museo del Barrio, the Puerto Rican Traveling Theater, INTAR, and the Nuyorican Poets Café.

41 Nilda Peraza, interview by the author, April 2022.

42 See Dávila, *Sponsored Identities.*

43 Peraza had first worked with the ICP in 1978 when she curated the exhibition *Exposición Artistas Latinoamericanos en los Estados Unidos,* which featured twenty-two artists from ten different countries. During her tenure at the ICP, Nilda worked under two executive directors: Dr. José Ramón de la Torre and Dr. Luis Díaz Hernández.

44 Marisol Matos Pérez, interview by the author, 2023.

45 MoCHA hosted similar events aimed at community engagement on Saturday mornings in the museum.

46 Santos are carved wooden statuettes depicting Catholic saints. During the 1980s, santos made by Puerto Rican artisans became popular items to collect. Uchitelle, Louis. "Shoppers World; In Search of Puerto Rican Santos." *New York Times,* May 8, 1983.

47 The other presenters included Julia P. Herzberg, Freddy Rodríguez, Susana Torruella Leval, and Luis Cancel, with Taína Caragol moderating the discussion.
48 Douglas, Susan Jane and Adina Muskat. "Whose Barrio," 92.
49 Caragol, "Boom and Dust."

BIBLIOGRAPHY

Caragol, Taína. "Boom and Dust: The Rise of Latin American and Latino Art in New York Exhibition Spaces and The Auction House Market, 1970s–1980s." PhD diss., City University of New York, 2013.
Cotter, Holland. "A Time of Danger and Pain, Two Long Decades Ago." *New York Times*, February 14, 2013.
Dávila, Arlene. *Sponsored Identities: Cultural Politics in Puerto Rico*. Philadelphia: Temple University Press, 1997.
Douglas, Susan Jane, and Adina Muskat. "Whose Barrio?: Institutional Identity and Survival Tactics of El Museo del Barrio." *International Journal of Social, Political, and Community Agendas in the Arts* 10, no. 3 (2015): 85–95.
Laó-Montes, Agustín, and Arlene Dávila. *Mambo Montage: The Latinization of New York City*. New York: Columbia University Press, 2001.
Monge-Rafuls, Pedro R., ed. *Visual Arts: A Different Approach*. Visual Arts Series 1. Queens, NY: OLLANTAY Press, 1993.
Noriega, Chon A. "Commentary: 'Presentation to Tomás Ybarra-Frausto at the Smithsonian Archives of American Art Annual Benefit.'" UCLA Chicano Studies Research Center, November 1, 2017. https://www.chicano.ucla .edu/about/news/commentary-presentation-tom%C3%A1s-ybarra-frausto -smithsonian-archives-american-art-annual.
Pastor, Néstor David. "De Queens Pa'l Mundo: A Brief History of the OLLANTAY Center for the Arts." *Intervenxions*, October 26, 2023. https://www .latinxproject.nyu.edu/intervenxions/de-queens-pal-mundo-a-brief-history -of-the-ollantay-center-for-the-artsnbsp.
Peraza, Nilda. "Art and Ideology: Alfredo Jaar and Ismael Frigerio." In *Art and Ideology*, 39–44. New York: New Museum of Contemporary Art, 1984.
Rachleff, Melissa. "Do It Yourself: A History of Alternatives." In *Alternative Histories: New York Art Spaces, 1960 to 2010*, edited by Lauren Rosati and Mary A. Staniszewski, 23–39. Cambridge, MA: MIT Press, 2012.
Ramirez, Yasmin. "Passing on Latinidad: An Analysis of Critical Responses to El Museo del Barrio's Pan Latino Mission Statements." 2003. Washington, D.C.: Smithsonian National Research Conference. 2002.
Ramirez, Yasmin. "'. . . A Place for Us': The Puerto Rican Alternative Art Space Movement in New York." In *A Companion to Modern and Contemporary Latin American and Latino/a Art*, edited by Alejandro Anreus, Robin Adèle Greeley, and Megan A. Sullivan, 281–95. Hoboken, NJ. Wiley, 2021.

Rivera, Odalis. "Despliegue de la historia puertorriqueña en ICP." Diálogo. University of Puerto Rico, January 1997. https://issuu.com/coleccionpuertorriquena/docs/dialogo19970101_60a04063e9e5df.

Tucker, Marcia, Nilda Peraza, and Kinshasha Conwill. "Director's Introduction: A Conversation." In *The Decade Show: Framework of Identity in the 1980s*, 9–17. New York, NY. Museum of Contemporary Hispanic Art, 1990.

Wilson Cryer, Patricia L. "Puerto Rican Art in New York: The Aesthetic Analysis of Eleven Painters and Their Work." PhD diss., New York University, 1984.

Zolberg, Vera L. "Art on the Edge: Political Aspects of Aestheticizing the Primitive." *Boekmancahier* 4, no. 14 (December 1992): 413–25.

Zuidervaart, Lambert. 2010. "Culture Wars." In *Art in Public: Politics, Economics, and a Democratic Culture*, 3–21. Cambridge: Cambridge University Press, 2012.

<p style="text-align:center">8</p>

Creative Camaraderie

Puerto Rican/Nuyorican Artists and Robert Blackburn's Printmaking Workshop

Deborah Cullen-Morales

Santa Barraza (b. 1951), a contemporary Chicana/Tejana artist from Kingsville, Texas, received a fellowship to work at Robert Blackburn's Printmaking Workshop (RBPMW) in 1986. Although she attended for only one summer, the heady mix of artists she met left an impression on her decades later:

> I met so many national and international artists. I don't know if you're aware, but in India, a member of parliament was a visual artist, and so I met him at Bob Blackburn's workshop. I met Faith Ringgold, Candida Alvarez, and her husband, Dawoud Bey. Of course, we were just struggling artists at that time, and we did projects

together. On Monday nights those of us with fellowships would study printmaking because we were painters, we really weren't printmakers. I learned a lot of techniques from that class but also from other artists.[1]

In addition to learning Xerox transfer and stone lithography with Blackburn's help, Barraza also mentions learning techniques from Juan Boza, the exiled, queer Afro-Cuban artist (1941–1991) who was working on Formica with sticks and leaves and "all kinds of found objects" to make a series of striking collagraphs at RBPMW that refer to Santería and the Abakuá (Leopard) secret society.[2]

Barraza highlights the creative camaraderie typical at RBPMW, and the representative sample of international creatives working there during its peak decades: the 1970s, 1980s, and early 1990s. A wide range of participants flocked to the workshop, which was open seven days per week, from early morning to midnight or later, and located on West Seventeenth Street at the time.[3] Blackburn was legendary for his welcoming and generous reputation as well as for the extensive facilities he built: a rambling loft filled with presses for intaglio/relief and lithography; worktables; paper racks; shelves and storage lockers; a plate cutter, rosin box, and at least a hundred limestones; an acid and solvent area; a darkroom; a print collection; and more. Artists who were printmakers signed up for monthly memberships to use the shared workspace and presses. Guest artists such as Faith Ringgold (1930–2024), who was there to print the panels for her *100 Pound Weight Loss Story Quilt* (1986), were invited and paid for by RBPMW. Artists with grants, galleries, or patrons, such as M. F. Hussain (1915–2011), rented private rooms that fringed the open space, where they hired master printers to produce their editioned projects. In the evenings and some weekends, classes were held. Other funded programs, such as Jerome Foundation Scholarships (for print-focused work by emerging artists under age thirty-five) and Third World Fellowships for emerging and mid-career "African-, Asian-, Native-, and Hispanic-American" artists to focus on printmaking, allowed Barraza, Alvarez, and others to learn the intricacies of the medium while working within cohorts over longer periods of time.[4] And, at any given moment, tours, school groups, and visiting artists from around the globe came through to work or simply visit. The necessity of gathering to share equipment and especially a printing press—which most artists were not able to own individually—forged unlikely meetings, intercultural friendships, collaborations, arguments, love triangles,

and more. While graphic experimentation and technical excellence were important to Blackburn, creating a creative community was also a principal goal. In the era leading up to "multiculturalism," defined by projects such as *The Decade Show* (1990), Blackburn was single-handedly cultivating a global village in his print shop. As artist Emma Amos (1937–2020) wrote, "Introductions are a major part of the Workshop's business."[5]

Candida Alvarez (b. 1955) and Dawoud Bey (b. 1953) described New York in the 1980s.[6] In an interview that is a master class that quickly maps the extremely fecund, interconnected alternative art scene of the time, Bey explains with a laugh: "It was the best of times. It was the worst of times." He goes on: "One thing happening for young artists of color, like ourselves, was that we were making work with the support of organizations and institutions that were distinctly alternative to the main scene. There was a whole other community and network of support that sustained us."[7]

They discuss, among others, Studio Museum in Harlem, El Museo del Barrio, the Alternative Museum, PS1 Contemporary Art Center, the Clocktower, Jamaica Arts Center, Cayman Gallery, Cinque Gallery, Just Above Midtown Gallery, Exit Art, INTAR Gallery, and the CETA Artist Project. Alvarez and Bey, who were married and living in Clinton Hill, Brooklyn, were deeply involved in this heady alternative scene.[8] In 1984–85, Alvarez was an artist-in-residence at the Studio Museum in Harlem, alongside Maren Hassinger (b. 1947) and Charles Burwell (b. 1955). Burwell invited Alvarez to visit RBPMW, where he was working at that time. As so many others before her have noted, Alvarez also attests, "My first experience with printmaking was with Bob Blackburn."[9] Bey elaborated:

> Bob had started the Printmaking Workshop, another important institution. The history of art and artists' communities is for me a history of institutions and studio spaces. The mid-late 1980s was when the whole race and representation conversation started to take hold, and other institutions began to selectively include the works of artists of color, but focused only on a certain kind of self-referential, identity-based work. Those institutions founded by people of color, on the other hand, had always included a broad range of work, conceptually and otherwise. There was no orthodoxy.[10]

This had been true of RBPMW since Blackburn founded it in Chelsea, New York, in 1947, where it first existed as a private, collaborative atelier and later incorporated as a nonprofit institution in 1971. Printmaking has an

important role in the history of Puerto Rican art, and Taller Boricua (the Puerto Rican Workshop) was a key workshop and convening space for some of the most important artists of Puerto Rican descent in New York. However, any account of the evolution of Nuyorican printmaking would be incomplete without discussion of RBPMW.[11] A generation older than the founders of Taller Boricua, Robert Hamilton Blackburn (1920–2003) had been running his own Black-led workshop for more than twenty years when Taller Boricua was founded in 1970. An important mentor to the Taller Boricua artists, Blackburn offered these artists encouragement throughout his life.[12] His workshop offered a conceptualization of print-making as a multifaceted medium and the workshop space as a significant, collaborative social space. More importantly, his commitment to strength-ening and bridging creative Third World communities offered a model, foreshadowing the work of the Nuyorican movement.[13]

This brief text seeks to highlight some of the Puerto Rican/Nuyori-can artists in New York who found a home at RBPMW.[14] While RBPMW has long been recognized as a space that nurtured African American and Black artists, Blackburn worked to build connections across the entirety of the African diaspora. Blackburn's own Jamaican heritage provided him a deep understanding of both the importance and neglect of Caribbean artists, and the many Puerto Rican artists living in, or regularly visiting, New York were welcomed. With RBPMW serving as a home for them and many others, Blackburn fomented an international creative camaraderie.

Blackburn was born 1920 to Black Jamaican parents who had recently immigrated to the United States. He participated in various Harlem art programs during the Harlem Renaissance period, learned printmaking at the WPA's Harlem Community Art Center, and moved to Chelsea after studying at the Art Students League with Will Barnet (1911–2012).[15] He initiated his workshop in late 1947 after obtaining his own lithographic press. He made his own work, editioned prints for others for pay, and of-fered open workshop hours for colleagues on select evenings each week. Blackburn was a master color lithographer who created an unusually ac-cessible communal space for printmaking and exchange. This was particu-larly important to nonwhite, female, and nonmainstream artists. Graphic facilities at the time were only available in universities or were costly to rent, and thus time and space for graphic experimentation was prohibitive. This gap RBPMW aimed to fill. After running the space as a private atelier and then as a membership cooperative, Blackburn registered his workshop

as a nonprofit institution in 1971, began to secure various types of grants and funding, and initiated more structured, subsidized programming.

During this same period, Blackburn taught at the School of Visual Arts (SVA), from 1967 to 1971. Blackburn taught printmaking at a number of institutions from 1948 until late in his life in order to earn a living, as he never drew a salary at RBPMW.[16] His lifelong friend Chaim Koppelman (1920–2009), who founded the printmaking department at SVA in 1959 and taught there until 2007, most likely invited him to teach at SVA. Originally called the Cartoonist and Illustrator's School, SVA was initiated in 1947 in the wake of the establishment of the GI Bill of Rights, which paid for veterans to pursue advanced education or training. In 1972, SVA was authorized to confer four-year degrees. Its central, East Twenty-Third Street New York location—easily reachable from both the Lower East Side as well as El Barrio—and the institution's legacy of serving GIs likely paved the way for numerous Puerto Rican artists to attend, including veterans returning from the Vietnam War whose tuition could be supported by the GI Bill.

Artists key to the foundation of Taller Boricua, including Adrian Garcia, Armando Soto, Marcos Dimas, and Fernando Salicrup, all attended SVA during this time. Taller Boricua was formed in El Barrio in 1970 as a collective studio and alternative space with a commitment to community and printmaking. For example, Marcos Dimas (b. 1943) attended SVA after his honorable discharge from the Vietnam War in 1967. He has noted that he met and befriended other Puerto Rican artists at SVA, who were also at the art school on the GI Bill, just as he was.[17]

Dimas has also recalled that a mutual commitment to art and social justice movements of the time brought them together in service of the predominantly Puerto Rican neighborhood of El Barrio. Dimas completed his first stint at SVA in 1970, after studying there with artists Malcom Morley, Chuck Close, Richard Artschwager, and Steve Gianakos.[18] Fernando Salicrup (1946–2015) served in Vietnam and attended SVA, where he studied from 1969 until 1973. He, too, studied painting with Chuck Close as well as printmaking with Blackburn, who had helped him get into SVA.[19] Dimas and Salicrup would long serve as codirectors of Taller Boricua, and Salicrup would be recognized particularly for digital graphic work, in which he was a pioneering figure.

Another key artist for Taller Boricua was Nitza Tufiño (b. 1949). Nitza, the daughter of master printmaker and Puerto Rico's "Painter of the People," Rafael Tufiño (1922–2008), is considered "print royalty." The senior

Tufiño used his G.I. Bill to study at Taller de Gráfica Popular (TGP, the People's Print Workshop) in Mexico after discharge from the US Army in 1946. The TGP, founded in Mexico in 1936, furthered revolutionary social ideals through large edition, widely disseminated, powerful black-and-white linoleum and woodblock prints. In fact, the TGP provided the roadmap for the United States' WPA print workshops and inspired a proliferation of didactic, black-and-white social realist lithographic images of the period. While at the TGP, the elder Tufiño met Elizabeth Catlett and Charles White, Black Americans who would become closely affiliated with the TGP. They knew Blackburn and would tell Tufiño about him.

In 1949, Tufiño and his newborn daughter, Nitza, returned to Puerto Rico from Mexico and joined the just-formed governmental project División de Educación de la Comunidad (DIVEDCO, Division of Community Education), also modeled on the TGP/WPA programs. Shortly, Tufiño and others helped establish the short-lived but influential Centro de Arte Puertorriqueño (CAP, Center of Puerto Rican Art, 1950–52) as well as the long-running Taller del Instituto de Cultura Puertorriqueño (Workshop of the Institute of Puerto Rican Culture, 1957–85). These island-based Puerto Rican print workshops, which heavily emphasized the role of the graphic arts as both an art form and a vehicle for community engagement and education, served as primary models for Taller Boricua. Art historian Yasmin Ramirez has studied the history of Taller Boricua, noting that "among the workshop's most important achievements are: (i) resurrecting Puerto Rico's populist printmaking tradition in New York and (ii) developing an identifiable New York Puerto Rican visual vocabulary, i.e., Nuyorican art."[20]

Nitza settled in New York in 1970, and both she and her father were key participants in Taller Boricua's early years. Nitza has remained a steady institutional leader, and she has created key visual icons of Nuyorican art.[21] She and her father also knew Blackburn, and they both produced work at RBPMW. Nitza has noted that Taller Boricua was space-challenged; it had only one small Martex press. There, they focused on serigraphy and, much later, digital prints. But Blackburn had a larger, more resourced studio with a range of intaglio/relief and lithography presses where the Taller Boricua artists could go to create more expansive work.

In the early 1970s, when Nitza was twenty-three or twenty-four, she first collaborated with Blackburn. She convinced a priest at St. Paul's Chapel, located on Columbia University's campus at Amsterdam Avenue, to provide her space to work and collaborate with youth. Blackburn supplied

a portable press, paper, and ink as part of RBPMW's community outreach programming.

Nitza Tufiño also produced various print editions at the RBPMW, including large relief prints related to her Metropolitan Transportation Authority (MTA) Arts and Design commission, *Neo-Boriken*, in 1990.[22] The two-part ceramic tile mural and plaque for El Museo del Barrio were created for the 103rd Street and Lexington Avenue #6 subway station stop near the museum, in the heart of El Barrio (Spanish Harlem). Inspired by Taino petroglyphs as well as other pre-Columbian iconography, they were commissioned in 1977 when El Museo moved to Fifth Avenue's Museum Mile. However, the project was not completed and installed until more than a decade later, due to station problems and contractor issues that Tufiño faced, as the first woman of color to receive such a commission. Ultimately, she had to get an individual artist grant from the New York State Council on the Arts to complete the public project. While the MTA El Barrio project was very difficult, an additional project for the MTA, *Westside Views* at the West Eighty-Sixth Street #1 station, went more smoothly.[23] This project reflected her commitment to collaborating with youth. In the 1990s, LaGuardia Community College in Long Island City commissioned a frieze of twenty-four terracotta ceramic mural *cemis* for the college's library.

Nitza worked out ideas for each of these projects, in part, at Blackburn's workshop. In addition, prints relating to the highly visible public artworks allowed the artist to have portable and affordable imagery to sell. As an Invited Minority Artist at the RBPMW in 1987, she created a linocut series of five *Neo-Boriken* prints related to the subway project.[24] Another series comprised twelve linocut *Cemis* relating to the LaGuardia library project.[25] Nitza has noted that Blackburn was always focused on the conditions of the Third World, introducing people to one another and creating collaborations. She has noted that through Blackburn and RBPMW, she met Romare Bearden, Ernest Crichlow, and Benny Andrews; was invited to show at Cinque Gallery; and became involved at the Studio Museum in Harlem. Nitza also collaborated with Peruvian artist Kukuli Velarde (on *Neo-Boriken*) and Spanish printmaker Maria Luisa Rojo (on *Cemis*), both of whom were also working at RBPMW. Blackburn introduced her to them, in order that they might assist her in working on her prints. At this time, too, as art historian Teresa Tió has documented, Rafael Tufiño re-editioned his renowned linocut portfolio *El café* at RBPMW in 1991. A re-editioned example was exhibited at La Casa del Libro, San Juan, that year.[26]

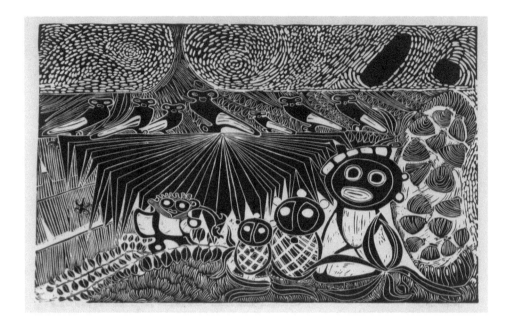

8.1 Nitza Tufiño, *The Neo-Boriquen No. 4*, 1993. Linoleum print on Japanese rice paper, 24 × 38 in. (sheet); 18 × 24 in. (image). Collection of the City University of New York.

Nitza Tufiño's intricately patterned, large black-and-white graphics incorporate Taino imagery as part of the "neo-Taino" movement (see figure 8.1).[27] With the mandate to return to Puerto Rico's Afro-Indigenous roots prompted by the Young Lords and others in the social justice movements the Taller Boricua founders admired, Taller Boricua became central to developing Nuyorican arts' visual vocabulary. The neo-Taino movement, or revival, emphasized Indigenous pre-Columbian knowledge and forms in order to reclaim the Puerto Rican diaspora's history and assert its culture, much like the Chicano movement reclaimed Aztec symbols from pre-Columbian Mexico.[28] Puerto Ricans are considered primarily a mix of Indigenous Taino people who were living on the island when the Spaniards colonized it; the Spaniards or White Europeans; and Black Africans who were enslaved and trafficked to the island against their will. The neo-Taino movement, within the context of the civil rights movement in New York, focused on Indigenous and African cultural heritage, responding to the fact that European/Spanish cultural lineage had long been emphasized. In the visual arts, this often formally meant incorporating forms and references drawn from Taino petroglyphs, *cemis*, *duhos*, and other objects, as well as

flora and fauna relevant to the pre-Columbian Caribbean worldview (all of which could be studied in books or museums, far from the Caribbean), in order to craft images for a new, equitable, and inclusive world.

Juan Sánchez (b. 1954) had also connected with the Taller Boricua artists as an undergraduate of Cooper Union, where he first did silk-screening. But he did not resume printmaking until 1984, when, at Blackburn's urging, he applied for and received a Third World Fellowship. The two had met when Blackburn taught at Rutgers in the later 1970s, but Sánchez did not do printmaking there at that time. In 1984–85 at RBPMW, he learned lithography and etching and produced the self-referential, minimal, black-and-white intaglio *Borinquen's Beginning* (1985), in which Sánchez conveys his humble new beginning as a printmaker through neo-Taino iconography. In the print, a petroglyphic face is sketched on the palm of a hand, in a manner reminiscent of Leonardo da Vinci's Vitruvian man, while leaf blades rustle and give way to a watery horizon line. Sánchez has described his hesitancy to embrace printmaking, for which he would eventually become renowned, as he struggled to learn the various complex processes in an open, collaborative environment. He was already experiencing success on his own and with the collaborative Group Material, and he has remarked on how many international artists gathered at RBPMW: "Black, Asian, Latino, some of them coming from various parts of Latin America like Peru, Ecuador, Mexico. It was quite a diversity and there was also a number of artists coming from Africa."[29]

Sánchez's printmaking breakthrough came in 1985, when he received a grant from the New York State Council for the Arts to create a suite of prints. Titled *Guariquen: Images and Words Rican/structed* (1986–87), these extremely complex color prints combine color etching, lithography, and serigraphy with photography, laser prints and Xerox, hand-coloring, tearing, and collage (see figure 8.2).[30] "Finally I was able to create prints that had the formal strength of my paintings," he remembered. "Working with people like Lorenzo Clayton and Bob Blackburn opened up a whole new world where the rules and regulations of printmaking, that I had learned earlier, were broken and reinvented in creating these pieces."[31] With *Guariquen*, Sánchez came into his own as a printmaker. He incorporated personal photography, handwriting, Taino and Christian imagery, cultural quotations, collage and tearing, and multiple colors—all the layering and complexity that he so easily marshaled in his paintings to convey his hybrid reality.

Diógenes Ballester (b. 1956) was another longtime participant at Blackburn's printshop. Born in Ponce, Puerto Rico, Ballester worked on and off

8.2 Juan Sánchez, *Un Sueño Libre*, from the portfolio *Guariquen: Images and Words Rican/structed*, 1987. Hand-colored lithograph with collage, 22⅜ × 30 in. (sheet and image). Collection of Smithsonian American Art Museum, Washington, DC. Museum purchase made possible by the Joan Mitchell Foundation. Photo by Juan Sánchez.

at RBPMW from 1981, when he arrived in New York, until Blackburn's death in 2003.[32] Ballester produced numerous works at RBPMW over the years and is affiliated with Taller Boricua and the neo-Taino and East Harlem schools as well as recognized as a digital print pioneer (see figure 8.3). He is also the person responsible for bringing Blackburn to Puerto Rico for the first time, facilitating Blackburn's only direct encounter with the Puerto Rican print community on the island. A recognized printmaker who has taught widely and served on several international juries, Ballester was a visiting artist and printmaking teacher at RBPMW from 1981 to 1983, and again in 1989 after returning from his master of fine arts (MFA) studies at the University of Wisconsin–Madison, where he received his graduate degree in 1986.

Ballester was appointed president of the XII San Juan Print Biennial of Latin American and Caribbean Printmaking, held in 1998. The San Juan Biennial is the most important graphic biennial in the world (second

8.3 Diógenes Ballester, *La dilatación del ser* (*Expansion of Being*), 1982. Etching, embossing, and relief printing, 30 × 22 in. (sheet); 23½ × 17½ in. (image). Library of Congress, Prints and Photographs Division, Washington, DC (LC-DIG-ppmsca-02394).

oldest to Ljubljana) and a crucial meeting point for the Latin American/ Caribbean art world. Founded in 1970, it is a program of the Instituto de Cultura Puertorriqueña (ICP, Institute of Puerto Rican Culture), a governmental organization. Although the format has now changed to a curated, multivenue project, from 1970 to 2000 a large, central group show, juried from mailed entries, was flanked by satellite projects that often focused on important senior figures. For the XI edition in 1995, American artist and master printer Kathy Caraccio (b. 1947) served on the jury. Caraccio had apprenticed at RBPMW for four years before founding her own studio in 1977, and she remained closely aligned with Blackburn. Thus, it is highly likely that the Biennial was seeking to gain Blackburn's participation over the years; indeed, a founder of the Biennial and Puerto Rican print promotor, Luigi Marrozzini, knew Blackburn.

Ballester secured his participation by noting that Blackburn, an intensely modest man, did not want his own work to be a point of focus in the Biennial.[33] Thus, Ballester chose instead to invite Blackburn to serve on the jury, and Blackburn consented. The jury was composed of distinguished print specialists, and in 1998, beyond Ballester and Blackburn, the other jurors were Angelica Bäumer (Austria), Ivonne Pini (Colombia), and Igor Podolchack (Ukraine). Ballester and Blackburn lobbied the jury to ensure that the Nuyorican artists they knew so well from New York were seriously considered and awarded by the jury—according to Ballester, this was the first time any Nuyorican artists won any prizes at the Biennial, despite the fact that like Puerto Rico, the Biennial was, from its inception, deeply connected to the United States, and New York specifically.[34] After complex negotiations, the 1998 Grand Prize went to Ignacio Iturria (Uruguay); the Experimental Prize went to Fernando Salicrup for his digital print *La tierra arde*, 1997; and awards also went to Belkis Ayón Manso (Cuba); Juan Sánchez for his large, complex mixed-technique print *Sol y flor para Liora*, 1997; and Rimer Cardillo (Uruguay/New York).

In addition to fully recognizing diaspora artists, the XII edition broke technical grounds as well. The Puerto Rican cultural e-zine *El cuarto del Quenepón* created the first local chat and video broadcast over the web for this Biennial, hosting a virtual symposium.[35] Participants included Yasmin Ramirez, Agustin Laó-Montes, and Ballester, who presented a version of his essay for the catalog, "Perspectives: On the XII San Juan Biennial of Latin American and Caribbean Printmaking at the Transition to the 21st Century." In this, he laid out a brief history of printmaking, print workshops, and print biennials and reviewed some evolutions. Ballester's

challenge to reconceptualize the Biennial, including international artists, works that expand beyond two dimensions and traditional definitions of the print, and account for the increasing role of technology and the graphic arts would prove to be vital suggestions for the renovation of the Biennial that occurred in 2004 with reconceptualization of the format to the *1st San Juan Poly/Graphic Triennial: Latin America and the Caribbean,* under the direction of chief curator Mari Carmen Ramírez.

The jurying in 1998 was difficult. It had been an uphill argument for Ballester and Blackburn to win the jury's majority for Black Nuyorican artists, and for a digital print, as well. After it was over, Ballester took Blackburn and others to a celebration at Daniel Lind Ramos's home in Loíza.[36] Ballester also brought Blackburn to Ponce to visit with his family in Playa de Ponce, where they visited the Museo de Arte de Ponce.[37] Importantly, the seventy-eight-year-old Blackburn was singled out for honor in the 1998 catalog with the dedication: "Bob, you must have been with the Tainos in the Coabey carving petroglyphs; surely you were. We honor Robert Blackburn at the XII Biennial of San Juan."[38]

This quote reinforces the understanding of Blackburn's standing within the history of printmaking, particularly as seen from the Puerto Rican and Nuyorican art worlds. Through the metaphor that places him with the ancestors, carving petroglyphs in the pre-Columbian, pre-Colonial world of the Tainos, the catalog effectively inserts him as a fundamental father to the island's important printmaking tradition, and that of its diaspora. Although Blackburn was among the first Black Americans to be invited and so honored by the Biennial, this insertion into Puerto Rico's legendary printmaking lineage affirms his role as crucial to the development of Nuyorican art and its creative camaraderie.

NOTES

1 Thomas, "Teaching and Creating Art." Barraza was referring to the celebrated modern Indian artist (often called "the Picasso of India") Maqbool Fida "M. F." Hussain, who worked at the Printmaking Workshop over a number of years. He was nominated to the upper house of the Indian Parliament, where he served from 1986 to 1992.

2 All the works mentioned here are part of the RBPMW Print Collection, Elizabeth Foundation for the Arts, New York. The Library of Congress also holds a collection representative of the RBPMW, and many of these can also be found there.

3 The RBPMW continues to operate as a program of the Elizabeth Foundation for the Arts in New York.

4 Xerox copy of annual report, "The Printmaking Workshop: September 1, 1983–August 31, 1984," copy in author's possession.

5 Amos, introduction to *Art in Print.*

6 The discussion of the 1980s was included in *Candida Alvarez: Here—A Visual Reader.* See Alvarez, Bey, and Schulman, "New York in the 1980s," 133–42. The book was produced in conjunction with the exhibition curated by Terry R. Myers and held at the Chicago Cultural Center, April 29–August 6, 2017.

7 Alvarez, Bey, and Schulman, "New York in the 1980s," 133.

8 For example, Alvarez took part in the group exhibition *Confrontation, Ambiente y Espacio* at El Museo del Barrio in 1977. She had a two-person exhibit in 1979 at the Brooklyn Museum with Vincent DaCosta Smith, who had worked at Blackburn's printshop since the 1960s. She participated in the New York International Studio and Workspace Program at PS1 Contemporary Art Center in 1980 and held solo exhibitions at Cayman Gallery in 1983 and Exit Art in 1985. Later, Alvarez and Blackburn would both participate in *Masters and Pupils: The Education of the Black Artist in New York: 1900–1980,* Jamaica Arts Center, 1986; and *Expression Afrikan '87,* Fashion Moda, 1987.

9 Alvarez, Bey, and Schulman, "New York in the 1980s," 138.

10 Alvarez, Bey, Schulman, "New York in the 1980s," 138.

11 Yasmin Ramirez, an expert on the Nuyorican vanguards, pointed to this connection when she curated *New Work, New Visions* for Taller Boricua in 1998 and included Blackburn's work. I have benefited from Ramirez's contributions through our interconnected work: while I worked for RBPMW, she worked for Taller Boricua. Ramirez and I worked together for several years at El Museo del Barrio, and we both attended CUNY Grad Center, where she wrote her PhD dissertation, "Nuyorican Vanguards, Political Actions, Poetic Visions: A History of Puerto Rican Artists in New York, 1964–1984" (2005), as I wrote mine, "Robert Blackburn: American Printmaker" (2002). This chapter, too, is a result of her suggestions, for which I am most grateful.

12 At the Printmaking Workshop in the mid- and late 1980s, I personally witnessed Blackburn suggest that artists and philanthropists visit and support Taller Boricua many times, and Blackburn told me about Taller Boricua when I was nineteen or twenty.

13 According to *Encyclopedia Britannica,* "Third World," a political designation dating to 1952, referred to the developing world: Africa, Asia, and Latin America, not part of either the capitalist, economically developed First World US sphere or the communist Soviet Union–led Second World. This was a common term used by Global Majority artists during the 1980s and early 1990s. For more, see Lauer, "Notes on the Art."

14 This text focuses on Marcos Dimas, Fernando Salicrup, Rafael and Nitza Tufiño, Juan Sánchez, and Diógenes Ballester. Puerto Rican artists who produced prints at RBPMW include, among others, Candida Alvarez, Analida Burgos, Luis Cancel, Rebecca Castrillo, Javier "Javi" "Vecino" Cintrón, Martiza Davila, Hector Escalante-Rivera, Rafael Ferrer, Humberto Figueroa, Martín García-Rivera, Elizabeth Grajales, Anaida Hernandez, Marcos Irizarry, Néstor Otero Rodríguez, María de Mater O'Neill, Glendalys Medina, Carlos "Sueños" Ortíz, Gloria Rodriguez Calero (ROCA), Jorge Luis Rodriguez, Liliana Rodriguez, Myrna Rodríguez Vega, Shellyne Rodriguez, Lyzette Rosado, Federico Ruiz Jr., Manuel "Manny" Vega, and Jorge Zeno.

15 The WPA (Progress Administration from 1935 to 1939, and Work Projects Administration from 1939 to 1943), created by US president Franklin Delano Roosevelt to assuage the economic difficulties presented by the Great Depression, included a robust Federal Art Project. The Graphics Division created a number of community-based print workshops, including a significant one in Harlem.

16 Blackburn has discussed how during one of his first jobs at Cooper Union, where he was hired in 1948 at Will Barnet's urging, he was titled "printer" rather than teacher, instructor, or professor, due to his race—although he has noted that they would present him as such to visitors from Africa or South America. See Robert H. Blackburn, oral history interview by Paul Cummings December 4, 1970, transcript (28), Archives of American Art, Smithsonian Institution, Washington, DC, https://sova.si.edu/record/AAA .blackb70?s=520&n=10&t=C&q=music&i=524.

17 Marcos Dimas, oral history interview by Tomás Ybarra-Frausto, June 24, 2011, Institute for Latino Studies, University of Notre Dame, Notre Dame, IN, https://curate.nd.edu/show/mp48sb41q3b.

18 Marcos Dimas would return to study film at SVA, finishing in 1973.

19 Nitza Tufiño relayed this information in a Zoom conversation on January 27, 2023, and by follow-up text messages. I am most grateful for her assistance in detailing her and her father's work in relationship to Blackburn.

20 Ramirez, "'. . . A Place for Us,'" 285.

21 As noted by Nitza Tufiño. See also Nitza Tufiño, accessed April 13, 2024, http://www.nitzatufino.com/.

22 See Nitza Tufiño, *Neo-Boriken*, at 103 St. (6), 1990. https://new.mta.info /agency/arts-design/permanent-art/neo-boriken.

23 See Nitza Tufiño, *Westside Views*, at 86 St. (1), 1990. https://new.mta.info /agency/arts-design/collection/westside-views.

24 Nitza Tufiño, *Neo-Boriken*, 1980s, portfolio of 5 linocut prints, edition of 50, printed in Charbonnel black ebony ink on Japanese paper purchased by the artist in Japan (paper 38×24 in.; image 24×14 or 24×18 in). A portfolio is

held in the collection of City College of New York and reproduced online at https://www.flickr.com/photos/26746018@N03/albums/72157605554051728 /with/3350085580 (accessed April 13, 2024).

25 *Cemis*, 1992, portfolio of 12 linocut prints, edition of 7, printed in Charbonnel terracotta color oil ink on off-white Fabriano paper (34 × 30 in.; image 24 × 19 in). A portfolio (dated 1996; overall size 42 × 36 in.) is held in the collection of City College of New York and reproduced online at https://www .flickr.com/photos/26746018@N03/albums/72157605554051728/page3 (accessed April 13, 2024).

26 Tió, "Rafael Tufiño," 237. The original version of the seven-print portfolio was produced in 1954 when Tufiño was awarded a Guggenheim Fellowship, with the help of Ricardo Alegría, in offset lithography. *El café* is considered the first individual graphic portfolio in the history of Puerto Rican printmaking. According to the checklist for the publication, "El portafolios en la gráfica puertorriqueña," in *XI Bienal de San Juan del Grabado Latinoamericano y del Caribe, 12 de noviembre de 1995 al 31 de marzo 1996* (San Juan: Instituto de Cultura Puertorriqueña, 1996), the works are between 13½ and 14 inches × 17 and 17¼ inches; the portfolio was possibly re-editioned in 1968. In 1991, Blackburn contracted Colombian printmaker Gloria Escobar (who printed and taught at RBPMW from 1989 to 1992 and later became professor of printmaking at Hartwick College, Oneonta, New York, and founding member/director of Round House Press there) to reprint the linocuts by hand on Arches paper in an edition of seventy-seven, plus ten artists' proofs. According to Nitza, the full edition was never completed. Twenty-seven portfolios were completed, printed with Charbonnel ebony black ink on Fabriano paper.

27 Torruella Leval, *Art Underground*, n.p.

28 For more on the neo-Taino movement, see Haslip-Viera, *Race, Identity and Indigenous Politics*. For more on Aztec visual symbolism in the Chicano movement, see Fields and Zamudio-Taylor, *Road to Aztlan*. For a comparison of the neo-Taino and Chicano art movements and their iconographies, see Ramirez and Estrada, *Pressing the Point*.

29 Juan Sánchez, oral history interview by Josh T. Franco, October 1–2, 2018, Archives of American Art, Smithsonian Institution, Washington, DC. Recent interest in African-US exchanges, including the touring exhibition and catalog *African Modernism in America* by the American Federation of Arts and Fisk University Galleries (2002), raises the consideration of Blackburn's Printmaking Workshop as a hub for African artists in New York. Mohammad Omar Khalil (b. 1936, Burri, Khartoum, Sudan) had printed there and was closely connected to Blackburn; Solomon Irein Wangboje (1930–1998, Sabongida Ora, Edo State, Nigeria), Alexander "Skunder" Boghossian (1937–2003, Addis Abada, Ethiopia), David Koloane (1938–2019, Johannesburg, South Africa), Zwelidumile Geelboi Mgxaji Mslaba "Dumile" Feni

(1942–1991, Cape Province, South Africa), Souleymane Keita (1947–2014, Gorée island, Senegal), and many more frequented RBPMW during this period when in New York.

30 Juan Sánchez, *Guariquen: Images and Words Rican/structed*, 1987; print portfolio of 5 mixed-media lithographic prints with an introduction by Lucy Lippard; printers Chiong-Yiao Chen and Peter F. Gross, the Robert Blackburn Printmaking Workshop, and Lorenzo Clayton, Cooper Union; published by Exit Art through an artist's-sponsored grant from the New York State Council on the Arts and presented by Exit Art, New York, March 28–April 25, 1987. The series was included in the solo exhibition at Exit Art; see Sánchez, *Rican/structed Convictions*.

31 Sánchez and Herzberg, "Conversations in the Studio," 16. Lorenzo Clayton (b. 1950, Diné/Navajo) is an artist and was professor of printmaking at Cooper Union.

32 When Blackburn was in failing health, he closed RBPMW in 2001, preparing it to become a program of the Elizabeth Foundation for the Arts. Blackburn passed in 2003, and the EFA-RBPMW reopened in 2005, continuing to operate today to further Blackburn's legacy.

33 These recollections were generously shared by Diógenes Ballester in a telephone call on November 21, 2022, and in follow-up emails. I am most grateful for his insights, especially about the jury deliberations during this momentous biennial.

34 The article "Art Biennial Opens in San Juan," *New York Times*, January 19, 1970, 33, covered the opening of the first print biennial of 700 works by 180 artists. The Museum of Modern Art's influential print specialist and curator of painting and sculpture, William S. Lieberman, served on the organizing committee and Elaine Johnson, MoMA's associate curator of drawings and prints, served on the jury.

35 Puerto Rican artist and designer Maria de Mater O'Neill (b. 1960) created the cultural e-zine *El cuarto del Quenepón* and launched it on April 15, 1995. Named after the "Spanish Lime" fruit, it was one of the first ten Spanish-language e-zines on the internet. It ran for ten years, and at the time of the XIX Biennial, it was receiving approximately twenty thousand readers a month. Efforts have been undertaken to restore it, and it can be found through the Wayback Machine.

36 Loíza, the Afro–Puerto Rican cultural center of the island, is renowned for certain mask traditions and musical forms. It is on the northeastern Atlantic coastline, just beyond the San Juan metropolitan region.

37 Playa de Ponce is a coastal neighborhood of Ponce, the second-most-populous city on the island, which faces south to the Caribbean Sea.

38 Original text by Beatriz M. Santiago-Ibarra, coordinadora general: "Bob, tú debes haber estado con los taínos en el Coabey grabando petroglifos . . .

de seguros que estuviste. Honramos a Robert Blackburn en la XII Bienal de San Juan." (Beatriz M. Santiago-Ibarra, introduction to *XII Bienal de San Juan*, by Bienal de San Juan del Grabado Latinoamericano y del Caribe and Instituto de Cultura Puertorriqueña, n.p. Translation mine.) *Coabey* refers to the spirit world.

BIBLIOGRAPHY

Alvarez, Candida, Dawoud Bey, and Daniel Schulman. "New York in the 1980s: A Discussion with Candida Alvarez and Dawoud Bey, Moderated by Daniel Schulman." In *Candida Alvarez: Here: A Visual Reader*, edited by Fulla Abdul-Jabbar and Caroline Picard, 133–42. Chicago: Green Lantern Press, 2020.

Amos, Emma. Introduction to *Art in Print: A Tribute to Robert Blackburn*, n.p. New York: Schomburg Center for Research in Black Culture, 1984. Exhibition catalog.

Bienal de San Juan del Grabado Latinoamericano y del Caribe and Instituto de Cultura Puertorriqueña. *XII Bienal de San Juan del Grabado Latinoamericano y del Caribe: 30 de abril al 30 de septiembre de 1998*. San Juan: Instituto de Cultura Puertorriqueña, 1998. Exhibition catalog.

Cullen, Deborah. "Robert Blackburn: American Printmaker." PhD diss., Graduate Center of the City University of New York, 2002.

Cullen, Deborah. *Robert Blackburn: Passages*. College Park: David C. Driskell Center for the Visual Arts and Culture of African Americans and the African Diaspora, University of Maryland, 2014. Exhibition catalog.

Fields, Virginia M., and Victor Zamudio-Taylor. *The Road to Aztlan: Art from a Mythic Homeland*. With contributions by Michele Beltrán. Los Angeles: Los Angeles County Museum of Art, 2001. Exhibition catalog.

Haslip-Viera, Gabriel. *Race, Identity and Indigenous Politics: Puerto Rican Neo-Taínos in the Diaspora and the Island*. 2nd ed. New York: Latino Studies Press, 2019.

Jamaica Arts Center and Metropolitan Life Gallery. *Masters and Pupils: The Education of the Black Artist in New York: 1900–1980*. New York: Jamaica Arts Center, 1986. Exhibition catalog.

Lauer, Mirko, "Notes on the Art, Identity, and Poverty of the Third World." In *Beyond the Fantastic: Contemporary Art Criticism from Latin America*, edited by Gerardo Mosquera, 327–36. Cambridge, MA: MIT Press; London: Institute of International Visual Arts, 1995.

Museum of Contemporary Hispanic Art, New Museum of Contemporary Art, and Studio Museum in Harlem. *The Decade Show: Frameworks of Identity in the 1980s*. New York: Museum of Contemporary Hispanic Art, New Museum of Contemporary Art, Studio Museum of Harlem, 1990. Exhibition catalog.

Ramirez, Yasmin. "Nuyorican Vanguards, Political Actions, Poetic Visions: A History of Puerto Rican Artists in New York, 1964–1984." PhD diss., Graduate Center of the City University of New York, 2005.

Ramirez, Yasmin. "'. . . A Place for Us': The Puerto Rican Alternative Art Space Movement in New York." In *A Companion to Modern and Contemporary Latin American and Latino/a Art*, edited by Alejandro Anreus, Robin Adèle Greeley, and Megan A. Sullivan, 281–94. Hoboken, NJ: Wiley, 2022.

Ramirez, Yasmin, and Henry Estrada. *Pressing the Point: Parallel Expressions in the Graphic Arts of the Chicano and Puerto Rican Movements*. New York: El Museo del Barrio, 1999. Exhibition catalog.

Sánchez, Juan. Interview with Juan Sánchez by Fernanda Espinosa. Archives of American Art, Pandemic Oral History Project, Smithsonian Institution, Washington, DC. July 30, 2020. YouTube video. https://www.youtube.com/watch?v=BnCGaowzllA.

Sánchez, Juan. *Rican/structed Convictions*. New York: Exit Art, 1989. Exhibition catalog.

Sánchez, Juan, and Julia P. Herzberg. "Conversations in the Studio: Juan Sánchez and Julia P. Herzberg." In *Juan Sánchez: Printed Convictions/Convicciones Grabadas: Prints and Related Works on Paper/Grabados y Obras en Papel*, 15–20. Jersey City: Jersey City Museum, 1998. Exhibition catalog.

Thomas, Mary. "Teaching and Creating Art in the Borderlands: A Conversation with Santa C. Barraza." *Panorama: Journal of the Association of Historians of American Art* 7, no. 2 (Fall 2021). https://journalpanorama.org/article/conversation-with-santa-c-barraza/.

Tió, Teresa. "Rafael Tufiño: Brief Chronology." In *Rafael Tufiño: Pintor del Pueblo*, 233–38. San Juan: Museo de Arte de Puerto Rico, 2001. Exhibition catalog.

Torruella Leval, Susana. *Art Underground: A Public Art Project by Nitza Tufiño*. New York: El Museo del Barrio, 1990. Exhibition brochure.

PART II

DIASPORICAN SITES

REPORTS FROM THE FIELD

9

Unpacking the Portmanteau

Locating Diasporican Art

Teréz Iacovino

The term *Diasporican* was born—like many Puerto Ricans—in the Bronx. Coined by Nuyorican poet Mariposa (María Teresa Fernández Rosario) in the summer heat of 1993, the term first appeared in the title of "Ode to the Diasporican," which would come to be recognized as Mariposa's signature work, beautifully defying what literary scholar Vanessa Pérez Rosario notes as "the boundaries of the restrictive bonds of ethnicity and national identification."[1] When the term *Diasporican* entered my orbit just a few years ago, this portmanteau opened itself up to me, and with great curiosity I began to unpack it. As an upstate New Yorker whose relationship to being Puerto Rican was primarily defined by familial estrangement,

the Nuyorican identifier never felt like something I could earnestly claim. Now, having lived in Minneapolis for more than a decade, the term *Diasporican* especially reconciles and resonates with my geographic and cultural severing to both the island of my birth (Manhattan) and the island of my kin (Puerto Rico). Claiming Diasporicanness brought with it a sense of empowerment—a rejection of legitimized authenticity, be it through language, geography, or monoethnic dominance.

On February 28, 2000, the *New York Times* published the headline "Puerto Rican Presence Wanes in New York," marking what the Department of City Planning data showed as the first decrease in the Nuyorican population since the Great Migration.[2] By 2015, Puerto Rican migration would enter what anthropologist Jorge Duany notes as its "post-Nuyorican" period: "Today, New York is no longer the dominant nucleus of the Puerto Rican diaspora in the United States. . . . As the diaspora has become more scattered, regional differences have intensified and new ethnic labels have emerged, such as Chicago-Rican, Philly-Rican, and Orlando-Rican."[3] As Duany notes, Diasporicans living outside New York City have adopted their own neologisms unique to their locations, establishing distinct communities as seen in his examples across the greater Midwest, Mid-Atlantic, and Southeast regions of the United States. We can trace the formation of these communities, and others, even prior to the Great Migration, through Diasporican history projects such as the bilingual website Neighbors: Exploring 200 Years of Puerto Rican History in Philadelphia; "Becoming SotaRicans: The Development of Diaspora, Community, and Support," a GIS story map tracing the history of Puerto Ricans in Minnesota back to 1890; and the ongoing development of the Puerto Rican Chicago Community Archive.[4] These projects just scratch the surface of Diasporican perspectives outside New York City, but they are crucial to understanding the breadth of positionalities that exist within the Puerto Rican diaspora. It is these underrepresented positionalities and the artistic practices that have come to manifest within them that I seek to bring to the forefront.

My current research investigates visual arts practices of Puerto Rico and its United States–based diaspora, extending to public art, sound, and objects activated through performance. By explicating a decentralized network of artists, I examine what voices and dialogues remain underrepresented in twenty-first-century Puerto Rican art. This chapter draws from interviews with three Diasporican artists located outside New York City: Philadelphia-based Raúl Romero, Miami-based GeoVanna Gonzalez, and Minneapolis-based Olivia Levins Holden. In the pages that fol-

low, I consider how Romero, Gonzalez, and Levins Holden engage with placemaking—"the myriad ways in which the physical, social, ecological, cultural, and even spiritual qualities of a place are intimately intertwined"—as a conduit for belonging across the multiracial, multiethnic, multiqueer communities found in Philadelphia, Miami, and Minneapolis.[5] To further expand the definition of placemaking, I look to what scholar Karen Mary Davalos terms as "the somatic effects of emplacement"—where the body becomes "the site in which placemaking occurs."[6] While Davalos specifically discusses "somatic emplacement" as a form of Latinx placemaking in the Midwest, she also regards it as "an ideal method for understanding placemaking when populations are migratory, reside in heterogeneous neighborhoods, or have not reached majority status," allowing for "flexible, porous, contested, and mysterious qualities of cultural belonging among diasporic, intersectional, and marginalized communities."[7] Using this expanded definition of placemaking as a guide, I will discuss a significant work made within the past five years by each artist and unpack how it addresses the regional context in which it is situated and, in turn, uses placemaking as a tool for refutation toward what Arlene Dávila notes as "geographically bounded definitions of authenticity."[8] By widening the scope of Diasporican artistic production to include various forms of placemaking such as a public-facing sound installation (Romero), malleable structures for gathering (Gonzalez), and multiyear-long collaborative processes for mural making (Levins Holden), the pages that follow chart a constellation of possibilities and social imaginaries that these Diasporican artists have been steadily building, bringing them into proximity with Archipelagic and Nuyorican perspectives.

Raúl Romero: Sound as a Vessel

While Raúl Romero was growing up in the predominantly white city of Valrico, Florida, his connection to a Puerto Rican community was solely through his family. Valrico in the mid-1980s was a mixture of gated cookie-cutter subdivisions and modest homes, all surrounded by farmland and grazing cows. In the late 1970s, a paternal uncle settled there; over time, abuelos, tíos, and primos would purchase adjacent properties, keeping chickens and tending to yucca and fruit trees on their acreage. Romero's parents would later join them with the purchase of a mobile home, eventually building a house on the property. I interviewed Romero over Zoom from his childhood bedroom in that very house just a few days before Christmas 2022. We spoke of his first-generation Floricua

upbringing, his path to art through music, and the life and career he has built in Philadelphia—a city with the second-largest stateside Puerto Rican population.[9]

Like many Latinx adolescents from working-class backgrounds, Romero was no stranger to "dominant manner" code-switching, attending predominantly white schools with a handful of Black students and a transient Mexican student population whose families were migrant farmworkers.[10] Throughout grade school, as people struggled to pronounce his name, Raúl José would become known as R.J. The nickname helped him assimilate, as did his light skin, but a large part of his social survival depended on compartmentalizing his Latinx identity. "I was different," he recalled. "I think about it now and . . . I'm like ethnically or culturally ambiguous because I can sometimes pass in certain areas and then have this background, or this other part of my life, that sometimes it was easier to just keep it separate."[11] Music became a site of solace for Romero, a place where this other part of him could be expressed while wailing away on the drums in his bedroom or playing in punk bands. His obsession with percussion would eventually pave the way for his sound-focused artistic practice.

Outside of school, Romero found refuge in his family and a deep involvement with their Latinx church community. With his father on bass and Romero on drums, the duo performed every Sunday at Centro De Adoración Bet-El. His father was a talented musician, playing the local music circuit and filling Romero's ears with the hits of Tito Puente, Mongo Santamaría, Rubén Blades, and Selena, among others. Musicians connected to the church would travel to Valrico to record music with Romero's father, bringing with them the rhythms of Central and South America, which reinforced the pull that sound would later have on Romero's work.

During this time, the family also traveled back and forth to Arecibo, where Romero's maternal grandparents were living. Arecibo was home to the world's largest single-unit radio telescope up until its collapse in 2020 due to environmental damage and long-term financial neglect.[12] Nicknamed "the big ear," the nineteen-acre dish was intentionally built to nestle inside a natural limestone sinkhole.[13] It was in the isolation of this rainforest-lined cradle that scientists mapped the surfaces of planets, stars, and any number of extraterrestrial objects. Through the ear of Arecibo, we could see, for the first time, the surfaces of Venus, Mercury, and Mars, as sound waves unveiled landscapes that were otherwise only speculated.[14]

The telescope's allure fascinated a nine-year-old Romero when he visited the observatory for the first time. There he learned about the Search

for Extraterrestrial Intelligence (SETI) Institute and its launch of the 1974 Arecibo Message—to date, the most powerful radio broadcast sent into space. As described on SETI's website, the message traveled up to twenty-one thousand light-years into space and was composed of binary code that created simple, pictorial representations of "the Arecibo telescope, our solar system, DNA, a stick figure of a human, and some of the biochemicals of earthly life."[15] To Romero, elements of the message resembled Taino petroglyphs found on the walls of La Cueva del Indio—a cave that opens up to the sky and out to the sea. When watching a night sky, he can't help but feel an ancestral connection to what he describes as "this obsession with looking toward the heavens for communication, and information, or answers."[16]

After going on to study communications at the University of South Florida in Tampa, Romero settled in Philadelphia in 2009, leaving the city for just two years, from 2016 to 2018, to complete his master of fine arts (MFA) at Yale University. By the time he graduated from Yale, his artistic practice encompassed a combination of sound, objects, video, and performance in service of sonic-centered participatory experiences. In his works, including musical compositions for plants, hand-drawn animations of Tito Puente's soundwaves, speakers constructed from hammered copper dishes, and a soundtrack of black holes colliding, sound serves as a vessel for connection, "fostering intercommunication among us and our environment."[17] One of Romero's works that best illustrates this ethos was presented at Taller Puertorriqueño (Taller)—Pennsylvania's most prominent Latinx arts organization, located in Philadelphia's Latinx cultural heart, "El Centro de Oro."[18]

Taller's website states that its mission is "to preserve, develop and promote Puerto Rican arts and culture, grounded in the conviction that embracing one's cultural heritage is central to community empowerment."[19] Cultural geographer Sarah De Nardi writes that "heritage is a social experiment, created and driven by community input, something that people 'feel' and 'do' as part of their everyday lives in places. The development of heritage is the development of connections."[20] Romero's multifaceted project *Onomonopoetics of a Puerto Rican Landscape* centers heritage as connection through one of Puerto Rico's most culturally significant symbols—the coqui—a tiny frog onomatopoeically named for its unique call.[21] This multimodal work consisted of indoor and outdoor soundscapes, community-recorded stories reflecting on the installation, and digitally printed spectrograms that visualized the coqui's call. While the scope of the

project is difficult to encapsulate through a singular image, Taller's short film, *Onomonopoetics of a Puerto Rican Landscape*, highlights the project's many facets and documents North Philadelphia's Latinx hub, where the work was embedded for approximately eight months during the first year of the COVID-19 pandemic.[22]

As seen in the film, Romero erected large sound sculptures featuring hammered copper dishes attached to found tripods that create forms reminiscent of the Arecibo Telescope. He placed these sculptures inside Taller's street-facing windows (see figure 9.1) and those belonging to the Hispanic Association of Contractors and Enterprises (HACE)—a Latinx-led nonprofit focused on affordable and sustainable community development.[23] In conversation with these pieces, Romero created and affixed small speakers to the facades of various Latinx storefronts and preexisting public art: a series of faux palm trees that line El Centro del Oro. As the indoor sculptures broadcasted the coqui's call, the outdoor speakers acted as receivers, creating a divaricating network of sound across Philadelphia's Latinx cultural heart. Romero reimagined the decade-old palms, created by Kansas-based designer Wendell Turner, as a networked sound habitat linking the Dominican, Mexican, and Puerto Rican communities that live and work along the corridor.[24] *Onomonopoetics of a Puerto Rican Landscape* subverts Turner's faux tropical streetscape beyond aesthetic elements of redevelopment into tools for placemaking by "paying particular attention to the physical, cultural, and social identities that define a place and support its ongoing evolution."[25] For Romero, the project marked his first foray into public art, allowing him to contribute to the arts and culture of the Latinx community through his Puerto Rican heritage.

Though the work originates in the sonic specificity of Puerto Rico, the coqui's sound transcends language, acting as a connective thread rather than a final destination. As people were able to more safely gather outside due to relaxed Centers for Disease Control and Prevention (CDC) guidelines and warmer weather during the pandemic, Romero recalls how they would listen together to the coqui on the street. For him these gatherings felt like a homecoming after a time of such deep isolation. For the community, they were especially meaningful, which you can hear in the recorded sound bites archived on the project's website in both English and Spanish. In those recordings, both Latinx and non-Latinx community members share memories not just of Puerto Rico but of spending time with Diasporican friends and family in South Jersey, Hartford, and of course Philadelphia. As one speaker shared, "the sound of the coqui reminds me

9.1 Raúl Romero, *A Vessel for Infrasound: Transmission from Arecibo* (*Ono-monopoetics of a Puerto Rican Landscape*), 2020. Copper, wooden tripod, speaker, frog exciter, *Dracaena angolensis*, *Quercus* stump, light reflection dish, water, audio components, sound, 50 × 25 × 23 in. Detail (*top*) and installation view (*bottom*), Taller Puertorriqueño, Philadelphia. Courtesy of the artist.

of family and of love," while another noted how it "brings me closer to who I am and where I come from."[26]

These community reflections reinforce how placemaking can create a sense of belonging within diasporic communities that is achieved beyond the limitations of geography and language, while lending itself to what Davalos describes as "the body as an ephemeral space of belonging."[27] While walking along North Fifth street between West Huntingdon and West Somerset, sound travels through the listener's body, offering them entry into what Romero notes as "the possibility of hidden worlds within and beyond our assumed realities."[28] Whether one is listening to the coqui with someone or listening alone, connection runs through bodies across time and space, however fleeting. Romero offers a portal to memories of family, culture, home, and Puerto Rico, creating an embodied belonging. *Onomonopoetics of a Puerto Rican Landscape* reframes the Puerto Rican expression "Soy de aquí, como el coquí" to be read loudly in diasporic terms: I'm from here, like the coqui—and I have been all along.

GeoVanna Gonzalez: Sculpture in Service of Queer Futurity

GeoVanna Gonzalez grew up in a predominantly Black and Chicanx working-class neighborhood in Inglewood, California. Her mother's side immigrated from Costa Rica to Los Angeles, while her father was a first-generation Diasporican born in New Jersey, eventually settling with his family in Los Angeles in the mid-1960s. Her relationship to a Puerto Rican community was woven through her father's extended Diasporican family. The front yard of her paternal great-grandmother's house contained a makeshift *chinchorro*, where everyone would gather on the weekend for any excuse to throw a party.[29] As we spoke over Zoom just after New Year's 2023, Gonzalez shared that leaving her Latinx community in Los Angeles to live abroad became a turning point that has dramatically shaped her artistic practice today.

After completing her bachelor of fine arts (BFA) in painting at Otis College of Art and Design in 2014, Gonzalez was hungry for an experience outside of what she knew. Los Angeles's highly commercialized art scene was difficult for any young artist to break into, let alone a young queer Latinx artist, and she felt stifled creatively by the pressure to make work in the service of sales. After much deliberation, she decided to take an opportunity to live abroad in Berlin, Germany, where she would de-

velop her studio practice over the next four years. While living in Berlin, collectivizing became an essential part of building community away from the familiarity of Los Angeles, and COVEN BERLIN—a queer art collective focused on feminism, love, gender, and sexuality—nourished new friendships and connections for Gonzalez.[30] Through her involvement with the collective, Gonzalez developed a fulfilling collaborative curatorial practice, with media outlets like *Artforum* taking notice of her projects.[31] However, at the same time, feelings of insularity and restlessness still pulled at her; while working alone in the studio, she felt like a split version of herself. "I'm building community and everything," she recalled of that time, "but then for my own individual art practice, that part wasn't present."[32] For Gonzalez, COVEN BERLIN awakened what scholar José Esteban Muñoz describes as "a structuring and educated mode of desiring"—a desire to move beyond static sculptures and gestures—but she did not yet understand how to achieve it in her own practice.[33]

Four years of living in Berlin took its toll; rising rent costs due to gentrification, the yearly and difficult intricacies of visa renewal, and the lack of a Black and Brown community compelled Gonzalez to return to the States in 2018. She reunited with her mother in Cape Coral, Florida, and shortly thereafter secured what turned into a two-year residency at Oolite Arts in Miami. What Gonzalez describes as moving to "the Caribbean in the States," both in climate and culture, was like a homecoming—the Black and Brown community she lacked in Berlin was made up tenfold in Miami. She recalled, "I very much found my family, it was really amazing to be around Brown and Black folks primarily, you know, it's just like a vastly different experience."[34] This reconnection to family, both biological and chosen, shifted Gonzalez's practice toward thinking about malleable objects that centered togetherness. Her practice was evolving into a combination of sculpture and performance that speaks to what writer Girinandini Singh notes as Gonzalez's "transition into work that was no longer confined by a static spatiality."[35] By 2019 she had exhibited and programmed her first modular sculpture, titled *PLAY, LAY, AYE: Navigating queerness, where space is always in flux | Act I* (see figure 9.2) at the Bass Museum of Art in Miami.

Miami is an important site of Caribbean and Latinx LGBTQIA history, as noted by historian Julio Capó Jr. He writes, "By the 1990s, Miami had become known as a refuge for queer exiles throughout Latin America and the Caribbean," encompassing immigration from Cuba, Haiti, Nicaragua, Colombia, Venezuela, and Brazil, among other countries.[36] The

9.2 GeoVanna Gonzalez, *PLAY, LAY, AYE: Navigating queerness, where space is always in flux | Act I*, 2019. Painted steel, expanded metal, and plexiglass, 36 × 36 × 60 in. each. Installation views, Bass Museum of Art, Miami Beach, FL. Courtesy of the artist. Photo by Vaco Studio.

Caribbean is also intertwined with the history of the Bass Museum of Art, as its founder John Bass was elected president of the Fajardo Sugar Company in 1933 following his fourteen-year term as vice president since 1919.[37] Though access to information about Bass's involvement with the company is limited, we can surmise that the initial holdings of the Bass Collection, containing more than five hundred objects, was, in part, acquired through amassed wealth from Puerto Rico's sugar industry.[38] While Gonzalez does not address these specific histories in *PLAY, LAY, AYE*, as a queer Diasporican living and working in Miami, she is uniquely tied to them geographically and culturally.

Part sculpture and part gathering, *PLAY, LAY, AYE* draws from the French Victorian furniture design known as a tête-à-tête (head-to-head)—a sofa bearing an S-shaped curve that allowed two sitters to face each other in close conversation without ever touching.[39] The form of the tête-à-tête speaks to desire, intimacy, and restraint between two bodies and represents a physical mechanism used by Victorian society to regulate impropriety. Historically, the tête-à-tête served as a site for courtship under surveillance, but it was also a place where gossip and secrets were shared. A close physical proximity was expected when seated on a tête-à-tête, no matter your sex, and this allowed it to provide one of the few public indoor sites where queer people could engage intimately without suspicion.

Gonzalez plays off this history by remixing the tête-à-tête as a modular metal sculpture without barriers between bodies, where visitors can touch and feel one another if they so desire. Unlike the tufted upholstery often seen in classic tête-à-têtes, she employs welded, expanded metal that speaks to the materiality of furniture found in public parks. In doing so, Gonzalez pays homage to what scholar Christina B. Hanhardt notes as the "unrecognized—and, more importantly, unregulated—spaces of collective gathering and exchange that have played a key role in bringing the broadest mix of LGBTQ people together."[40] In addition, the sculpture's painted pink steel frames with accents of blue translucent plexiglass employ colors historically linked with the gender binary. As light mixes the pink and blue tones reflected in the gallery space, parts of the sculpture reveal shades of lavender—a color whose long-standing associations with gender nonconforming culture can be traced back to the seventh century BC.[41] Just as the colors shift within the sculpture, depending on the way the light catches it, Gonzalez is always searching for what she terms "soft fluid possibilities."[42]

To make a new reality, you first have to dream it, and Gonzalez dreams in endless open-source modules. By engaging with the materiality of the

unrecognized and unregulated, her work asserts what Muñoz describes as "the queer aesthetic," or one that "frequently contains the blueprints and schemata of a forward dawning futurity."[43] During an afternoon gathering at the Bass museum, Gonzalez invited "artists and activists, POC, womxn, queer, trans and gender non-conforming folks—who often use their art, poetry and music as a form of self-empowerment—to sit in the structure and reflect, gather, and share their ideas of openness and outness."[44]

As documented on Gonzalez's website, during the gathering, guests read aloud from personal notebooks, laughed and drank, exchanging smiles and conversation. Their voices reverberated off the Bass's walls, queering the institutional site through their presence, as they engaged in what Davalos refers to as "a temporary but potent and corporeal political sociality referred to as 'belonging.'"[45]

Through *PLAY, LAY, AYE* Gonzalez provides a platform for gathering where BIPOC LGBTQIA people, who are often relegated to the periphery both in the kind of art we see on the walls and in the visitors we see walking in through the doors, could be together and be seen. "The purpose, and the meaning, is the people," Gonzalez told me. "It is the community. That is the only reason why the work exists."[46] In her world, the system is always in service of the people and not the other way around. While we wait for the present to catch up, Gonzalez continues to offer us endless possibilities for becoming.

Olivia Levins Holden: Mural as Public Archive

Olivia Levins Holden grew up in a family of artivists in Minneapolis.[47] The daughter of Ricardo Levins Morales, an artist and cultural worker deeply tied to the labor movement, and Paula Holden, a social worker and organizer, Levins Holden was immersed in the arts and organizing from an early age. As she spoke to me over Zoom from her desk at Studio Thalo in December 2022, I learned about the creative legacy of her Puerto Rican and Jewish family, the path to finding her own artistic voice, and her experience as a queer SotaRican.[48]

As a child, Levins Holden spent time in proximity to art in the service of social justice. Her aunt, Aurora Levins Morales, was establishing herself as a feminist poet and writer in California while her father, Ricardo, was known throughout the Twin Cities as a founding member of the Northland Poster Collective—"part activist organization, part business, and part arts group."[49] Due to the recession, after thirty years of operation, Northland

ultimately had to close its doors in 2009. Throughout her childhood, Levins Holden recalls watching her father work at the dining room table. There, he drew images to champion the causes for social justice organizations, labor unions, and musicians; these became her first art lessons.

Levins Holden found community at a young age in Solidarity Kids Theater, a Twin Cities youth theater collective that centered social justice education and was founded in 1994 by the University of Minnesota Labor Education Service and the American Postal Workers Union.[50] As she recalled in our interview, the collective was a crash course in collaboration, activist work, puppetry, and public speaking. Levins Holden fondly noted, "I think it was a foundational kind of thing for me to be part of a group where those two things were so interwoven, you know, art and speaking, and it really felt like one thing." Her interest in theater would later translate to a focus on collaboration in her artistic practice.

During the last year of her undergraduate studies, Levins Holden spent a semester abroad in Estelí, Nicaragua, working for La Fundación de Apoyo al Arte Creador Infantil (FUNARTE)—a nongovernmental organization (NGO) whose mission focuses on "social transformation and educational quality for the benefit of boy, girls, and adolescents through art."[51] It was FUNARTE that earned Estelí the nickname "'City of Murals'—with over 200 community murals promoting health, education, gender equality, and human rights."[52] Working alongside the organization's staff to implement a curriculum of political education and art, Levins Holden was inspired to seek out other muralism opportunities postgraduation. This quest would lead her to Oakland, California, to apprentice with Chicana muralist and master artist Juana Alicia Araiza.

Both Levins Holden and Araiza were raised in Jewish and Latinx families but lacked strong relationships with the Latinx populations in their communities. Araiza grew up in 1960s Detroit in a predominantly Black neighborhood where she was intertwined with what she described as "a second Harlem Renaissance happening in Detroit."[53] At that time, Araiza recalls how Detroit lacked a strong Chicanx community as compared to its Diasporican counterpart.[54] In contrast, Levins Holden grew up in 1990s Minneapolis, which had a large, newly immigrated Mexican population but lacked an equally robust Puerto Rican population.[55] While moving to California provided Araiza with a vibrant Chicanx community, Levins Holden would find connection to a larger, more visible queer community there. She would stay in the Bay Area for five years, learning technical mural skills from Araiza; but more importantly, she was most grateful

for Araiza's care and attention to community ideation, process, and long-term engagement. "She modeled how to do that really beautifully," recalled Levins Holden, "and that's something that I've emulated in many ways."[56]

After returning to Minnesota in 2013, Levins Holden would complete her most ambitious work to date: *Defend, Grow, Nurture Phillips*. This collaborative project in partnership with the Power of Vision Mural Project and Hope Community engaged a multiyear process that brought together a team of fifteen BIPOC artists, community organizers, and educators. This group, led by Levins Holden, was tasked with designing and creating a thirty-six-by-one-hundred-foot mural on the Franklin Theater Building in the Phillips neighborhood. Phillips is one of the most ethnically diverse neighborhoods in the state of Minnesota, containing the "third largest urban American Indian population in the United States," in addition to predominantly Black and East African communities that live in the neighborhood.[57] She described the community engagement process that gathered content and design feedback for the mural over the course of a year:

> We designed a community engagement process that involved interviewing people that had roots in the neighborhood, and then opening up the circle to a World Café event where we had questions and conversation and shared a meal. . . . That was the source of a lot of the kind of data that we used to find the core messages that we wanted to put in the mural. We then did a bunch of designing and ideating and sketching and had a feedback session where they tore it all up—you're not there yet! We worked it and worked it until we had something that felt good. Through one of the Native artists in the team, we had a Native elder look at it and give his blessing. And that felt really important, too.[58]

Levins Holden cultivates mural making as collaborative storytelling rather than purely transactional. It requires the union of, as she terms it, "art and speaking." In order to know one another, we must share our stories with one another.

Defend, Grow, Nurture Phillips records a community's history from the people's perspective rather than an outside observer and points to the importance of mural making as a form of public archive and storytelling. Imagery found within the mural speaks to the multiracial, multiethnic, multilingual place that is the Phillips neighborhood (see figure 9.3). Embodied in the four most prominent figures, the mural makes visible the

Black, Latinx, Indigenous, and Somali communities that anchor the area. It also brings visibility to regional and local histories as seen in the spewing oil pipeline, reminding us that Grand Rapids, Minnesota, remains the site of the "largest inland oil spill in U.S. history."[59] We see the phrase "Soul Patrol," which pays homage to the Northside group of young Black men who patrolled Minneapolis's streets, spelled out across a baseball cap. The Soul Patrol was a mediator between "potential law-breakers and law-enforcers" following the July 1967 uprising against "discrimination and mistreatment by police and Jewish business owners" of the Black community in North Minneapolis.[60] In solidarity, the mural also shows the Indigenous contemporary practices found in Miní Sóta Makhóčhe, as seen in the jingle dress worn by a young girl.[61] Scholar Brenda Child recounts the Ojibwe origins of the jingle dress tradition in an interview with the University of Minnesota College of Liberal arts:

> Ojibwe people often tell a story about a little girl who was very near death, and her father and her family became very worried about her. Her father had a dream, a vision, about a special dress and dance. He made the dress for his daughter and taught her the steps. The way folks at Mille Lacs tell the story is that there was a drum ceremony taking place that weekend, and the father brought his sick daughter to the drum ceremony. She was sort of lying on the side, taking it easy because she was so ill. And then later on in the evening, they started playing these songs, and the little girl got up and began dancing. And by the end of the evening, she had recovered.[62]

She further notes that for Ojibwe people "spiritual power moves through air," imbuing music and dance with healing properties.[63] If you are ill and hear the tinkling sound of the jingle dress, it is believed to heal you.

Through her research, Child determined that the jingle dress tradition emerged in response to the devastation of the Great Influenza epidemic from 1918 to 1920, noting that "this was also a time when the United States outlawed ritualistic dancing, making the jingle dress dance a radical tradition from its beginning."[64] At the time *Defend, Grow, Nurture Phillips* was completed in 2019, Indigenous women wore jingle dresses at protest demonstrations in the Upper Midwest and Canada such as Standing Rock (2016–17) and Idle No More (2012–present).[65] Levins Holden noted how the project "helped bring visibility to organizing that happened to be, at that moment, really coming to a head."[66] *Defend, Grow, Nurture Phillips*

9.3 Olivia Levins Holden in collaboration with James Autio, Samie Johnson, Camila Leiva, Magdalena Kaluza, Katrina Knutson, Chaka Mkali, Juliette Myers, Nell Pierce, Crystal Price, Simone Rendon, Claudia Valentino, Mattie Weiss, and Missy Whiteman, *Defend, Grow, Nurture Phillips*, 2019. Acrylic on Polytab and stucco, 36 × 100 ft. Commissioned by the Power of Vision Mural Project and Hope Community. Located at 1035 East Franklin Avenue, Minneapolis, MN. Courtesy of the artist and the Minneapolis Institute of Art.

honors the specific cultural histories and perspectives of the neighborhood's residents, while finding solidarity in shared struggles across social and environmental injustices.

Regional Contours of Placemaking

Philadelphia-based Raúl Romero, Miami-based GeoVanna Gonzalez, and Minneapolis-based Olivia Levins Holden each create objects and experiences, however permanent or temporary, as tools for connection and belonging across a vast array of materials and aesthetics. All three artists use tactics of placemaking to facilitate belonging that transcends the limitations of geographic binaries (you are either from here or you're not) and the limits of language (you either speak it or you don't). For Romero, connecting with yourself and others around you is achieved through listening,

both to your surroundings and to each other. He transmits a recording from the place of his ancestors, Puerto Rico, and within that message is a beacon that beckons us to El Centro de Oro in Philadelphia. While his use of the coqui's call might be reductively read as a nostalgic longing for Puerto Rico, I experience it as a form of reclamation—a right to claiming his Puerto Ricanness on his own terms. As Romero shared in our interview, "As much as I love being Puerto Rican and I am Puerto Rican . . . I'm not always accepted as Puerto Rican within the Puerto Rican context. 'Cause you know, I wasn't born on the island, or maybe my Spanish isn't perfect, or I don't go there enough."[67] Sound transcends the limits of language and geography, and the coqui's call rings in the ears of the diaspora as it did in the ears of Romero's ancestors.

Like Romero, Gonzalez is not interested in the rigidity of authenticity. Her sculptures guide us closer to the edge of becoming, queering systems of relegation and control. Whether occupied for a brief time by a body resting or bathed in shifting colors with the sun's passing, her work offers solace for what she terms "those constantly in an in-between space."[68] She uses the language of abstraction to allow for many things at once. For her it is a language that best encapsulates the Latinx experience:

> As Latinx people in the United States, whether you're first genera-
> tion, second generation, mixed, there isn't just one thing, and the
> way that you fit in or don't fit in, on both sides of the spectrum, is
> a constant back and forth . . . of like existence or belonging or un-
> derstanding. It's very different than if you only grew up in Puerto
> Rico versus being Puerto Rican American. Or in my instance, my
> mother being Costa Rican, it's so layered and then it's like on top
> of that for me being queer, it's endless [*laugh*]. So, I think abstrac-
> tion makes perfect sense.[69]

While Gonzalez speaks to personal experience, her work remains per-meable, like the metal mesh of her sculptures, across racial, ethnic, and cultural lines.

For Levins Holden, placemaking is seeing parts of yourself in the sto-ries of your neighbors. Unlike Romero and Gonzalez, Levins Holden is a narrative visual storyteller. For her, history belongs to the people and the artist's role is to empower communities to publicly visualize and archive their stories for years to come. Her guiding question before starting any project is this: "How [do I] use art as a community building tool . . . with

already existing threads of movements that are happening in [those] communities?"[70] We see this reflected in the specificity of imagery pertaining to Indigenous, Black, and Latinx histories of Minnesota and the ethnic and cultural ties of her collaborators. Communities that are often pushed to the margins of a Midwest white-centered narrative are pulled front and center.

Together Romero, Gonzalez, and Levins Holden demonstrate ways of working that generate platforms for belonging. Their works are monumental in the amount of distance traveled (Romero), in the number of possible architectural combinations (Gonzalez), and in sheer size (Levins Holden), yet they are also intimate in regard to memories shared (Romero), bodies touching (Gonzalez), and stories told (Levins Holden). And while their work is inherently influenced by their Diasporican positionalities, their practices reach within, between, and beyond Diasporican ties, however large or small, to encompass the multiracial, multiethnic, multiqueer voices that form their communities.

NOTES

1 Pérez Rosario, "Affirming an Afro-Latin@ Identity," 471, 469.
2 Navarro, "Puerto Rican Presence Wanes in New York."
3 Duany, "Nuyorican and Diasporican."
4 Historical Society of Pennsylvania and Taller Puertorriqueño, "Neighbors"; Cruz, "Becoming SotaRicans"; Molina, "Digital Archives Project."
5 Project for Public Spaces, "What Is Placemaking?," accessed April 20, 2024, https://www.pps.org/article/what-is-placemaking.
6 Davalos, "Festival de Las Calaveras," 163.
7 Davalos, "Festival de Las Calaveras," 163.
8 Dávila, *Latinx Art*, 25.
9 Logroño, "47."
10 Martinez, "What Is Code-Switching?"
11 Raúl Romero, interview by the author, Zoom, December 22, 2022.
12 Andrews, "Arecibo's Collapse."
13 Tobin, "Big Ear at Arecibo," 12.
14 Sobel, "Learning by Listening," 16–17.
15 SETI Institute, "Arecibo Message," accessed January 21, 2023, https://www.seti.org/seti-institute/project/details/arecibo-message.
16 Romero, interview by the author, 2022.
17 Romero, interview by the author, 2022.

18 Myers, "Centro de Oro Neighborhood Guide."

19 Taller Puertorriqueño, "About Us," accessed July 29, 2024, https://tallerpr
 .org/about-us/.

20 De Nardi, *Visualising Place*, 1.

21 US Department of Agriculture, Forest Service, "Common Coqui," accessed
 July 29, 2024. https://www.fs.usda.gov/detail/elyunque/learning/nature
 -science/?cid=fsbdev3_043003.

22 Taller Puertorriqueño, "Raúl Romero."

23 HACE, "Who We Are," accessed January 9, 2023, https://www.hacecdc.org
 /who-we-are/history.

24 Stigale, "In the Heart of Gold"; Logroño, "47."

25 Project for Public Spaces, "What Is Placemaking?"

26 Raúl Romero, "Onomonopoetics of a Puerto Rican Landscape: Stories of the
 Coquí," Onomonopoetics of a Puerto Rican Landscape (sound recordings),
 accessed April 19, 2024, https://coquicalls.com/stories-from-philadelphia.

27 Davalos, "Festival de Las Calaveras," 161.

28 Romero, interview by the author, 2022.

29 A *chinchorro* is a modest food kiosk and bar often found along the roadside
 in Puerto Rico.

30 COVEN BERLIN, "About," accessed January 9, 2023, https://www.covenberlin
 .com/about/.

31 Elderton, "UNEARTHED."

32 GeoVanna Gonzalez, interview by the author, Zoom, January 3, 2023.

33 Muñoz, "Introduction," 1.

34 Gonzalez, interview by the author, 2023.

35 Singh, "Sculptor GeoVanna Gonzalez."

36 Capó, "Locating Miami's Queer History," 91.

37 Proudfoot's Commercial Agency, Inc., to Mr. Mark, October 11, 1938, folder
 General 1939–1940 (June), item 580224, Dominican Republic Settlement
 Association (DORSA) Collection 1939–1977, JDC Archives, https://search
 .archives.jdc.org/notebook_ext.asp?item=580224&site=ideaalm&lang=EN
 G&menu=1.

38 The Bass Museum, "About," accessed July 30, 2023, https://thebass.org/about/.

39 Mitchell, "Tête-à-Têtes."

40 Hanhardt, "Making Community," 15.

41 Hastings, "How Lavender Became a Symbol."

42 Gonzalez, interview by the author, 2023.

43 Muñoz, "Introduction," 1.

44 GeoVanna Gonzalez, "PLAY, LAY, AYE: Act 1," accessed April 19, 2024, https://
 geo-vanna.com/PLAY-LAY-AYE-ACT-1.

45 Davalos, "Festival de Las Calaveras," 161.

46 Gonzalez, interview by the author, 2023.

47 Chela Sandoval and Guisela Latorre define artivism through its ties to the Chicanx movement and see it as an expression of "a consciousness aware of conflicting and meshing identities and uses these to create new angles of vision to challenge oppressive modes of thinking." Sandoval and Latorre, "Chicana/o Artivism," 83.

48 Studio Thalo is a Minneapolis-based collective creating art for social justice that includes artists Bayou Bay, Olivia Levins Holden, and Nell Pierce. See Studio Thalo (@studio.thalo), "Instagram Profile," joined November 2016, https://www.instagram.com/studio.thalo/?hl=en.

49 "Northland Poster Collective (1979–2009)," Animating Democracy, accessed January 10, 2023, http://animatingdemocracy.org/organization/northland -poster-collective-1979-2009.

50 Poferl, "Solidarity Kids."

51 Unless otherwise noted, all translations are mine. See Unidos Por La Infancia, "FUNARTE," accessed April 18, 2024, https://www.unidosporlainfancia .org/socios/funarte/#:~:text=La%20Fundaci%C3%B3n%20de%20Apoyo%20 al,adolescentes%20a%20trav%C3%A9s%20del%20arte.

52 "Nicaragua–Funarte 2," Change for Children, accessed July 27, 2023, https:// changeforchildren.org/past-projects/nicaragua-funarte-2/.

53 Araiza, "Oral History Interview."

54 Araiza, "Oral History Interview."

55 Jeff Kolnick, "Minnesotanos: Latino Journeys in Minnesota," MNopedia, accessed January 10, 2023, https://www.mnopedia.org/minnesotanos-latino -journeys-minnesota.

56 Olivia Levins Holden, interview by the author, Zoom, December 30, 2022.

57 "American Indian," Culture Care Connection, accessed January 10, 2023, https://culturecareconnection.org/cultural-responsiveness/american-indian; "Phillips Community Data," Minnesota Compass, accessed January 12, 2023, https://www.mncompass.org/profiles/city/minneapolis/phillips.

58 Levins Holden, interview by the author, 2022.

59 Kraker and Marohn, "30 Years Later."

60 Robinson, For a Moment, 81.

61 The spelling of Miní Sóta Makhóčhe is modeled after the one used by the University of Minnesota department of American Indian Studies. See "On Purpose: Portrait of American Indian Studies," American Indian Studies News, accessed April 19, 2024, https://cla.umn.edu/ais/story/purpose -portrait-american-indian-studies. As described by Dakhóta elder Chris Mato Nunpa, the word Minnesota comes from the Dakhóta phrase Miní Sóta Makhóčhe, meaning "land where the waters reflect the skies or heav-

ens." See "Mnisota Makoce: A Dakota Place," Bdote Memory Map, accessed July 31, 2023, https://bdotememorymap.org/mnisota/.

62 Child, "Jingle Dress." Ojibwe people may also identify as Anishinaabe, meaning "the original people," or as Chippewa, which is believed to have come from European settlers' mispronunciation of *ojibwe*. To learn more about the eleven tribal nations in Minnesota, see "Did You Know?," Minnesota Indian Affairs Council, accessed July, 31, 2023, https://mn.gov/indian-affairs/tribal-nations-in-minnesota/.

63 Child, "Jingle Dress."

64 Child, "Jingle Dress."

65 Child, "Jingle Dress."

66 Levins Holden, interview by the author, 2022.

67 Romero, interview by the author, 2022.

68 Gonzalez, interview by the author, 2023.

69 Gonzalez, interview by the author, 2023.

70 Levins Holden, interview by the author, 2022.

BIBLIOGRAPHY

Andrews, Robin George. "Arecibo's Collapse Sends Dire Warning to Other Aging Observatories." *Scientific American*, December 11, 2020. https://www.scientificamerican.com/article/arecibos-collapse-sends-dire-warning-to-other-aging-observatories/.

Araiza, Juana Alicia. Oral history interview by Peter Karlstrom. Archives of American Art, Smithsonian Institution, Washington, DC, May 8 and July 17, 2000. https://www.aaa.si.edu/collections/interviews/oral-history-interview-juana-alicia-13573.

Capó, Julio, Jr. "Locating Miami's Queer History." In LGBTQ *America: A Theme Study of Lesbian, Gay, Bisexual, Transgender, and Queer History*, edited by Megan E. Springate, 1–24. Washington, DC: National Park Foundation and the National Park Service, 2016. https://www.nps.gov/subjects/lgbtqheritage/upload/lgbtqtheme-miami.pdf.

Child, Brenda. "The Jingle Dress, a Modern Tradition: An Interview with Brenda Child." UMN College of Liberal Arts. Vimeo video, February 12, 2022, 16:39. https://vimeo.com/391070523.

Cruz, Tabatha. "Becoming SotaRicans: The Development of Diaspora, Community, and Support." ArcGIS Online, September 9, 2022. https://storymaps.arcgis.com/stories/5dadf38cccd64776a9da479542b30015.

Davalos, Karen Mary. "Festival de Las Calaveras and Somatic Emplacement in Minnesota." In *Building Sustainable Worlds: Latinx Placemaking in the Midwest*, edited by Theresa Deldadillo, Ramón H. Rivera-Servera, Geraldo L. Cadava, and Claire F. Fox, 161–81. Urbana: University of Illinois Press, 2022.

Dávila, Arlene M. *Latinx Art: Artists, Markets, Politics*. Durham, NC: Duke University Press, 2020.

De Nardi, Sarah. *Visualising Place, Memory and the Imagined*. New York: Routledge, 2018.

Duany, Jorge. "Nuyorican and Diasporican Literature and Culture." *Oxford Research Encyclopedia of Literature*, January 24, 2018. https://doi.org/10.1093/acrefore/9780190201098.013.387.

Elderton, Louisa. "UNEARTHED." *Artforum*, 2016. https://www.artforum.com/picks/unearthed-59663.

Hanhardt, Christina B. "Making Community: The Place and Spaces of LGBTQ Collective Identity Formation." In *LGBTQ America: A Theme Study of Lesbian, Gay, Bisexual, Transgender, and Queer History*, edited by Megan E. Springate, 1–30. Washington, DC: National Park Foundation and the National Park Service, 2016. https://www.nps.gov/subjects/lgbtqheritage/upload/lgbtqtheme-community.pdf.

Hastings, Christabel. "How Lavender Became a Symbol of LGBTQ Resistance." CNN, June 4, 2020. https://www.cnn.com/style/article/lgbtq-lavender-symbolism-pride/index.html.

Historical Society of Pennsylvania and Taller Puertorriqueño. "Neighbors: Exploring 200 Years of Puerto Rican History in Philadelphia." 2019. https://omeka.hsp.org/s/puertoricanphillyexperience/page/about.

Kraker, Dan, and Kirsti Marohn. "30 Years Later, Echoes of Largest Inland Oil Spill Remain in Line 3 Fight." Minnesota Public Radio, March 3, 2021. https://www.mprnews.org/story/2021/03/03/30-years-ago-grand-rapids-oil-spill.

Logroño, Rafael. "The 47: Historias along a Bus Route: Philly's Growing Latino Communities Reflect America's Future." WHYY, May 11, 2021. https://whyy.org/articles/phillys-growing-latino-communities-reflect-americas-future.

Martinez, Anna. "What Is Code-Switching, and What Is the Cost?" *Latinitas Magazine*, May 21, 2021. https://latinitasmagazine.org/what-is-code-switching-and-what-is-the-cost.

Mitchell, Nancy. "Tête-à-Têtes: The Answer to Awkward Conversation?" *Apartment Therapy*, April 28, 2017. https://www.apartmenttherapy.com/uses-for-a-tete-a-tete-amp-where-to-buy-them-241756.

Molina, Alejandro. "Digital Archives Project." Puerto Rican Cultural Center, September 7, 2020. https://prcc-chgo.org/blog/2020/09/07/digital-archives-project.

Muñoz, José Esteban. "Introduction: Feeling Utopia." In *Cruising Utopia: The Then and There of Queer Futurity*, 1–18. New York: New York University Press, 2009.

Myers, Michelle. "El Centro de Oro Neighborhood Guide: What to See, Eat and Do." *Philadelphia Inquirer*, September 22, 2022.

Navarro, Mireya. "Puerto Rican Presence Wanes in New York." *New York Times*, February 28, 2000.

Pérez Rosario, Vanessa. "Affirming an Afro-Latin@ Identity: An Interview with Poet María Teresa (Mariposa) Fernández." *Latino Studies* 12, no. 3 (2014): 468–75.

Poferl, Gregory, dir. "Solidarity Kids Theater and Howard Kling." YouTube, October 21, 2020. Video, 3:22. https://www.youtube.com/watch?v=HD1bIrIPg8I.

Robinson, Rolland. *For a Moment We Had the Way: The Story of The Way, 1966–1970—A Nearly Forgotten History of a Community Organization That Almost Turned Minneapolis Upside Down.* Andover, MN: Expert Publishing, Inc., 2006.

Sandoval, Chela, and Guisela Latorre. "Chicana/o Artivism: Judy Baca's Digital Work with Youth of Color." In *Learning Race and Ethnicity: Youth and Digital Media*, edited by Anna Everett, 81–108. The John D. and Catherine T. MacArthur Foundation Series on Digital Media and Learning. Cambridge, MA: MIT Press, 2008.

Singh, Girinandini. "Sculptor GeoVanna Gonzalez on Creating Perception through Her Creative Practice." *Stir World*, May 28, 2021. https://www.stirworld.com/inspire-people-sculptor-geovanna-gonzalez-on-creating-perception-through-her-creative-practice.

Sobel, Dava. "Learning by Listening." *Cornell Alumni News* 77, no. 5 (December 1974): 16–19.

Stigale, Theresa. "In the Heart of Gold." Hidden City, August 20, 2013. https://hiddencityphila.org/2013/08/in-the-heart-of-gold.

Taller Puertorriqueño, dir. "Raúl Romero: Onomonopoetics of a Puerto Rican Landscape." YouTube, August 9, 2021. Video, 3:56, https://www.youtube.com/watch?v=pM9b4M2R9Qk.

Tobin, Thomas. "Big Ear at Arecibo." *Cornell Alumni News* 66, no. 5 (December 1963): 5–14.

10

Puerto Rican Arts in Philadelphia

Una Perla Boricua en Filadelfia

Johnny Irizarry

Like other US cities where Puerto Ricans established distinct barrios during the later nineteenth century and throughout and beyond the twentieth century, the artistic and cultural expressions of Philadelphia's Puerto Rican population have served as acts of subsistence, resistance, and bearing. The city saw large numbers of Puerto Rican migrants arrive during the 1940s through the 1970s as families and individuals searched for more stable economic and social opportunities. Most Puerto Rican migrants came from rural agricultural and working-class backgrounds. Many knew via social networks that there was an emerging Puerto Rican community in Philadelphia that included cigar makers, industrial laborers, commu-

nity and political advocates, businesses, cultural clubs, and faith-based communities.[1]

They confronted challenges from racism, prejudice, and gentrification but were—and continue to be—hard workers determined to succeed. Arts and cultural programs and events became one of the crucial elements of their struggle for acceptance and survival, and one of the ways of contributing to their communities and the city overall. Neighbors helping neighbors and the establishment of speakeasies, culturally specific faith communities, hometown clubs, associations, bodegas, and social-cultural events in the city served to support Puerto Rican settlement. With the earlier Puerto Rican enclaves in Southwark, their quick growth into Spring Garden and Northern Liberties, and later consolidation into eastern North Philadelphia and the Northeast, the Puerto Rican community's population growth in the city provided for the coalescence of a permanent Philadelphia Puerto Rican community with a strong will for political, economic, artistic, and cultural engagement and impact.[2] Some examples of early Puerto Rican groups offering cultural events include the local chapter of the Republican Society of Cubans and Puerto Ricans (established 1865), La Milagrosa Spanish Chapel (opened 1912 at Nineteenth and Spring Garden Streets and closed in 2014), First Spanish Baptist Church (renamed in 1946), Comité de Mujeres Puertorriqueñas de Filadelfia, Unión Civica Puertorriqueña (1950s), and Casa del Carmen (established 1954 by the Archdiocese of Philadelphia).[3]

As the community grew, so too did its need for culturally grounded programs such as bilingual education and social services. Philadelphia's Puerto Rican community grew a forceful artistic cultural presence in the city despite the hyperstratification of the community. Soon North Philadelphia had Puerto Rican restaurants, clubs, and organizations. Backyards and basements of row homes served as additional venues where Puerto Rican music satisfied the heart of dancers, musicians, poets, and community members looking for cultural solace in urban Philadelphia (a place very different from Puerto Rico). At these events people brought instruments and sang La Décima, plena, bomba, *trova*, or a Christmas *parranda*. A celebration of Puerto Rican cultural traditions has always been an expected outcome of Boricua gatherings, whether planned or unplanned, year-round.

One element of settlement in which the Philadelphia Puerto Rican community has been especially diligent and successful has been the establishment of grassroots and community-based institution building. Today, Puerto Rican leaders are credited with the creation and development of nationally recognized social, educational, and economic development,

and arts and cultural institutions. Concilio, established in 1962, is one of many such institutions. Concilio organized the first Puerto Rican Parade and Festival in Philadelphia in 1963; its social hall was used for community cultural events. ASPIRA of Pennsylvania (1969) included arts and cultural programs as a core element of youth educational programming. Most of the organizations founded by Puerto Ricans in Philadelphia have historically integrated the arts into their services, such as the Asociación de Puertorriqueños en Marcha (APM, founded in 1970), the Congreso de Latinos Unidos (1977), and the Norris Square Senior Center (1972), led by Puerto Rican pioneer-activist Carmen Aponte. The Carmen Aponte Senior Center and apartments in Norris Square honor her legacy. Other organizations that included the arts and culture in their work are the Philadelphia Chapter of the Young Lords Party (1971), the Hispanic Association of Contractors and Enterprises (HACE, 1981), and Esperanza (1987).[4] Since its founding, Esperanza has grown into a national faith-based development organization. Esperanza recently opened state-of-the-art facilities, expanding professional arts spaces (theater, dance, visual arts) serving the growing Puerto Rican, Latinx, and diverse communities. The activist group Puerto Rican Alliance (1979) became the Philadelphia Chapter of the National Congress of Puerto Rican Rights (1983). For many years, it organized La Feria del Niño in Hunting Park, a collaborative arts/cultural festival dedicated to children in the community.

Among these, Philadelphia's premier Puerto Rican/Latinx cultural arts center Taller Puertorriqueño (1974) and the Asociación de Músicos Latino Americanos (AMLA, 1982) stand apart. Taller and AMLA have built a legacy of community-based arts and cultural-educational programs and services that have served as national models. These groups have become an essential segment of Philadelphia's rich diversity of arts and cultural organizations. The founder of AMLA, Jesse Bermudez, was the son of a cigar maker and a professional musician. He founded AMLA initially as a labor equity organization to defend the artistic economic interests of Philadelphia's Puerto Rican and Latinx musicians.[5]

Founders of Taller Puertorriqueño were activists, artists, educators, and social workers from across many spheres of the community's resources. Taller's founding executive director, Domingo Negrón, was a printmaker who painted the first major Puerto Rican/Latino–themed mural welcoming people to the Bloque de Oro (2700 block of North Fifth Street). They established the first bilingual graphic arts print shop and bookstore in the city. They implemented a performing arts program presenting visiting artists

10.1 Children's performance at Taller Puertorriqueño, Philadelphia, 2018. Photo by Senia Lopez. Courtesy of Taller Puertorriqueño Inc.

from Puerto Rico such as El Topo, Andres Jimenez, and Haciendo Punto En Otro Son. Since its beginning, Taller established a community-based nonprofit, earning income through its print shop, bookstore, and modest membership fees while expanding its multidisciplinary services to the community through cultural-educational programs and arts classes for children and youth (see figure 10.1). The organization purchased its own building and collaborated with local churches to present concerts and speaker series. During this era in Taller's history, the first oral history project of Puerto Rican migrants to the city was conducted (October 1976–December 1978).

Community youth were trained in interview, tape-recording, and photography skills to actively participate in the project. The recordings, photographs, and a final report, titled "Batiendo La Olla" (Stirring the Pot), published in March 1979, are preserved in Taller's Eugenio Maria de Hostos Resource Center.

Around 1984, Taller experienced a series of crises, including the physical deterioration of its facilities, and had to close its doors. The organization continued to offer cultural programs during this period through the volunteer labor of board and community members. In 1986, Taller opened a partially renovated building that had been granted to the organization by the city. Taller hired a brilliant Puerto Rican PhD candidate at Temple University (Luis Hernandez) as its first staff member in the new building, and then I had the honor of being selected as the organization's new executive director (1986–97). The new facilities housed the Julia de Burgos Book Store on its first floor, an unfinished second floor was used as a visual arts space, and a similarly unfinished third floor was where Taller held its classes and multidisciplinary events. Taller soon had a small dynamic staff of young artists and an active Board of Directors, and it grew its cultural educational programs, expanding its visual arts/exhibitions programs in its new space made physically functional by volunteers.

During this time, Taller built a national network with other arts organizations and with Puerto Rico. The organization established its visiting artists program, bringing to Philadelphia renowned Puerto Rican artists such as Myrna Baez, Rafael Tufiño, José Alicea, Samuel Lind, Antonio Martorell, among others. The gallery was named Lorenzo Homar-Francisco Oller. All visiting artists committed to conducting workshops with local artists and community members, especially children and youth. Taller partnered with the Institute of Puerto Rican Culture to bring master traditional artists, including *vejigante* mask makers from Loíza and Ponce, artisans using natural materials from Puerto Rico, and expert *mundillo* makers. Many donated prints and crafts, providing Taller the opportunity to start collecting art, a collection that today stands at 109 visual arts pieces plus examples of traditional artistry from Puerto Rico. Taller's visiting artists program also included poets/writers, historians, and performing artists. A priority of the organization was to support local and regional artists. Some of the regional artists were Crash, Nitza Tufiño, and Juan Sánchez. The organization adopted various public schools through the Philadelphia School District's Adopt-A-School Program. At these schools and others Taller provided cultural educational services, site-specific art, and visiting artists programs.

An important component of the visiting artists program included taking Taller's cultural education programs to local prisons, throughout both the city and the state. At these institutions, Taller offered Puerto Rican history classes, workshops, and presentations with visiting artists. The programs in prisons established lasting relationships with Puerto Rican citizens returning to the city. Among many such examples is Luis "Suave" Gonzalez.

Suave (imprisoned at age seventeen) is an accomplished painter-visual artist. While still in prison he met Maria Hinojosa of public radio fame. Upon his release Hinojosa and Gonzalez set out to create a podcast series titled *Suave*. The series won a Pulitzer Prize in 2022. Suave works at the Community College of Philadelphia, expanding the educational opportunities for returning citizens, and exhibits his artwork in galleries. His podcast continues to grow nationally, highlighting the lives of returning citizens who are making transformative contributions.[6]

Taller's national network led to several firsts, both in Philadelphia and nationally. The organization was involved in the founding of the National Association of Latino Arts and Cultures (NALAC) and through NALAC hosted the first national gathering of the Latinx cultural center Tienditas (Bookshops) at Taller's facilities. Tienditas play a critical role in supporting local visual artists through the sale of their work. The organization Taller collaborated with Teatro Pregones and initiated *La Ruta Panorámica*, an initiative between Boston (Inquilinos Boricuas en Acción), New York City (Pregones), Philadelphia (Taller and AMLA), and artist collectives from Puerto Rico, Mexico, and Chile.

Taller also physically grew during this period. The organization acquired another building a block south of its original location, significantly expanding its arts and cultural programs. In this building Taller added a performance space and initiated its Youth Artists Program, aimed at supporting community high school youth through professionally led visual arts training, portfolio building, and the pursuit of higher education in the visual arts. The organization employed dozens of local artists to teach classes of particular interest to young people in the community. These included spray/air-brush painting led by urban-artist Dan One, capoeira taught by multidisciplinary artist Lucas Rivera, traditional Puerto Rican dances led by Maribel Lozada (founder of Philareyto, intergenerational dance troupe and fearless protector of Puerto Rican folk traditions), and visual arts classes taught by Puerto Rican and diverse artists. Pottery was taught through a partnership with the Philadelphia Clay Mobile program. Taller upheld in practice its commitment to engage community members

as teachers and learners through its culturally community-grounded approach to arts programming.

Similar to other arts organizations during this time, HIV/AIDS hit the Taller community hard. The organization lost several artists and in response developed arts projects to address the AIDS crisis within its community. Taller worked in partnership with its adopted school staffs, local artists, Latinx social and health service agencies, senior centers, and HIV/AIDS activists/educators in implementing projects such as a bilingual comic book, posters, quilt making, street banners, and youth magazines. The comic book storyline was developed by children working with local Puerto Rican writer Catalina Rios. The actual storyline was inspired by the experience of an uncle of one of the children in the group who contracted HIV and became an HIV/AIDS community educator. The illustrations were created by children under the art direction of Puerto Rican visual artist Edda Santiago. The comic book was titled *Piensalo Bien, una historia sobre SIDA/Think Twice, an AIDS Story*. Despite limited funds, two editions of the comic book (3,500 of each) were printed in response to high demand from local schools and community centers. The comic book center pages listed information of local bilingual resources for young people in need of talking and obtaining support related to HIV/AIDS.

Pieces of Life: An AIDS Educational Project (quilt-making project) engaged seniors from Casa Carmen Aponte–Norris Square Senior Center and children attending the Julia de Burgos School. The Quilt Project (1989) was initiated by Juan David Acosta (Colombian-born activist and poet/writer), who approached Taller sharing the story of a member of the Senior Center who had lost a son to AIDS and was afraid of attending the center due to the many misconceptions about AIDS at the time. The National Names Project was coming to Philadelphia for the first time and Acosta/Taller saw the opportunity to engage the community through quilt making. Taller contracted renowned fiber artist Betty Leacraft to lead quilt-making sessions with participants. This multidisciplinary initiative included quilt-making workshops, HIV/AIDS educational sessions, an ecumenical candlelight vigil service, and documentation of the project by Puerto Rican filmmaker Frances Negrón-Muntaner, at the time living in Philadelphia, now in NYC. The exhibition of quilts traveled to multiple locations, including a hospital, a library, neighborhood schools, and other community locations.

Taller believed in engaging and building trust with artists, teachers, organizations, advocates, activists/change makers, and community

10.2 Taller Puertorriqueño's new 25,000 sq. ft. building in Kensington, Phila-
delphia, PA. Courtesy of Taller Puertorriqueño Inc.

members of all ages, genders, races, ethnicities, and backgrounds. These
relationships are what made these emotionally/socially challenging yet
resilience-resistance projects possible.

In 2001, Dr. Carmen Febo San Miguel, who had served as board presi-
dent (1978–79, and 1984–2001), left her practice as a respected medical
doctor to serve full-time as Taller's executive director. Febo San Miguel's
tireless dedication over the years and raising more than $11.5 million en-
abled the opening of a new multidisciplinary modern arts complex in 2016,
consolidating the previous two buildings into one 25,000—square-foot
building (see figure 10.2).[7]

The new space includes a museum-quality gallery, the Julia de Burgos
Bookstore, a performing arts theater and hall, visual arts and multiuse
classrooms, the Eugenio Maria de Hostos Resource Center, conference
areas, and space for exhibiting selections from the organization's collec-
tion. During this time, Taller established a partnership with the Inter-
American University of Puerto Rico that now offers college credit courses
from Taller's facilities. Febo San Miguel retired in 2022.[8]

Taller's next executive director, Nasheli J. Ortiz González (2022–24),
is a renowned designer, cultural activist, academic, and entrepreneur. Her
approach to cultural work is grounded in community "placekeeping," of
which a critical component is preservation of the community's Puerto

Rican/Latinx/African American historical presence facing rising gentrification. Rafael Damast serves as Taller's exhibitions program manager and curator. Under the leadership of Febo San Miguel, Ortiz González, and Damast, Taller's exhibitions have included Orlando Salgado, *Xilografías/ Woodcuts* (2002); Adál, *Coconautas in Space/Blue Prints for a Nation* (2004); Elizam Escobar, *Paisajes y Pasajes del Regreso/Views and Passages of the Return* (2005); Antonio Martorell, *A/RESTOS* (2022); traveling exhibition, *Ida y Vuelta: Experiencias de la migración en el arte puertorriqueño contemporáneo* (2023), among many more.[9]

Taller continues its commitment to exhibiting Philadelphia Puerto Rican visual artists such as Luz Selenia Salas, Sandra Andino, Marilyn Rodriguez, Daniel de Jesus, David Antonio Cruz, Roxanna J. Perez-Mendez, Raúl Romero, among others not previously mentioned.

As the largest Puerto Rican/Latinx cultural center in Pennsylvania, Taller Puertorriqueño has had a purposeful political and cultural allyship and commitment to inclusivity of Latinx staff as well as artists of color in their programs across disciplines. Latinx staff include Evelyne Laurent-Perrault, (Venezuela-Haiti), a scholar who served as director of the Julia de Burgos Bookstore. She was key in the establishment of Taller's annual Arturo Schomburg Symposium, exploring the historical cultural, social, and political experiences and artistic contributions of Afro-Latinxs (1997–present).[10] Doris Noguiera-Rogers (Brazil) is a renowned visual artist and has been a dedicated volunteer at Taller for most of the organization's history. She served as Taller's director of visual arts. Pedro Ospina (b. Colombia) came to Philadelphia as a young visual artist from New York and worked at Taller while continuing to exhibit his artwork. He has created an art garden/ community-gathering space, the Open Kitchen Sculpture Garden, in North Philly. Ospina also reconstructed his rowhouse (previously abandoned) using found and recycled materials, turning it into a live-in artwork.[11]

Taller's and AMLA's commitment to community engagement in the arts has historically served as an incubator to a treasure of Puerto Rican arts groups across all artistic disciplines. Some of these include theater and performing arts groups such as Los Pleneros del Batey. Its leader, Juaquín Rivera, was a pioneer advocate for Puerto Rican traditional music until his untimely death in 2010. Other examples include the Los Cuatro Gatos theater group, Boricuas En La Luna theater collective, La Colectiva, and Las Gallas artists collective: Puerto Rican artists and cultural workers/educators Julia Lopez (served as director of visual arts at Taller; visual artist/writer),

Magda Martinez (writer), and Michelle Angela Ortiz (painter, muralist). Other community-building women artists of Puerto Rican heritage include Marangeli Mejia Rabell (cofounder of Afro-Taino Productions and the Philadelphia Latino film festival) and Betsy Casañas (painter, muralist, founder of SEMILLAS Arts Initiative and A Seed on Diamond Street Gallery).

Michelle Angela Ortiz (b. 1978 in South Philly) is an accomplished visual artist, muralist, educator, and filmmaker who uses her art as a vehicle to represent communities whose histories are often lost or co-opted. Ortiz defines her community arts practices, paintings, documentaries, and public art installations as methods to creating a safe space for dialogue around some of the most profound issues communities and individuals may face. Her work tells stories using richly crafted and emotive imagery to claim and transform spaces into a visual affirmation that reveals the strength and spirit of the community. In the course of twenty-five years, Ortiz has created more than fifty large-scale public works in the United States and internationally. Since 2008, Ortiz has led public art-for-social-change projects in Costa Rica and Ecuador and served as a cultural envoy through the US Embassy in Fiji, Mexico, Argentina, Spain, Venezuela, Honduras, and Cuba.[12]

Ortiz has worked extensively with immigrant communities through her *Familias Separadas* project centered on stories of undocumented immigrant families affected by detention and deportations. One example is her 2015 (innovative at the time), mural/installation painted directly in front of the US Immigration and Customs Enforcement (ICE) field offices in Philadelphia. The image, a supersize legend that occupies the entire street, reads "We are human beings, risking our lives, for our families & our future." It took Ortiz more than a year to coordinate this act of resistance in collaboration with immigrant community members and allies/activists. That was the easy part. The biggest challenges were coordinating with the government, funders, and leagues of bureaucrats to accomplish this action. Speaking on this project, Ortiz said,

> I am still digesting what I feel was the strongest work I've accomplished, which was the ninety-foot-long installation *We Are Human Beings . . .* in front of the ICE building. It was a process to organize the support of immigrant community members, organizers, city officials, and the mayor to ensure the safety for the undocumented families working on the project with me. It was a big challenge and we achieved it. The project received local, national, and international coverage. It was a beautiful moment during installation to

see the families stand fearless in front of ICE building as ICE agents looked down on us. The families were empowered by seeing their allies—lawyers, artists, activists—take risks to do this work. I had to be intentional on my process and the final goal while working with allies, preserving the integrity of the work and accomplishing this through collective power.[13]

Betsy Z. Casañas (b. 1974 in North Philly) has collaborated with an impressive number of diverse communities. Some include women fighting for equity and against abuse and violence, citizens returning to our communities from incarceration, and youths, for whom she provides artistic forums to address their plight and resiliency. In my interview with Casañas, she spoke about opening her art studio to the community:

> In 2013, I opened an art studio. I had the ability to host many community groups. Teaching has always been easy for me. I grew up in one of the roughest neighborhoods in North Philadelphia, and I think that growing up with parents who were somewhat strict, gentle, very affectionate, and careful with how they spoke around us impacted how I worked with folks years later. In the fifty-three years my parents have been married I have never seen them argue in front of me or curse in front of us. I was the youngest of six children. The difference between the outside world and the environment inside was drastically different. This gave me clarity in being able to express myself honestly and directly. This was the key to the kind of environment I have always had in my classrooms or communal spaces.
>
> I had an assistant that I adored; she grew up in the same neighborhood but under circumstances that were very different. She was one of nine children, gay, and was being raised by a single mother who struggled with addiction. In the studio when she finally became comfortable, she would use humor as a coping method for what she had gone through.
>
> My assistant was sharp, super observant, and paid attention to things most people overlooked. As an assistant, she could follow a long list of instructions and be three steps ahead to make sure I had what I needed. When we first started working together, every other word out of her mouth was a curse word. This was a problem for me because I had so many community groups and members come into the studio, including many older folks as well as my seventy-

year-old father. I took her aside at the end of our first session to talk to her about it and she said, "Did I curse?" I understand that we all come from extremely different circumstances and that what may be important for me may not be for the next person. I also understand that for us to be able to work together we need to create an environment where we all feel happy, safe, and heard. For me, it was important to create an environment where anyone could walk through and feel welcomed. I worked with this assistant for years. In the end, she was still herself and still scandalized everyone she worked with but in the funniest way. She was a light in the studio, and I was so proud of how she was able to navigate in various groups without skipping a beat. She began to lead groups in the studio when I was away and began offering her own workshops.

I believe creating an environment that is neutral is important for me because it allows one to express themselves freely but also makes you a bit more self-aware in understanding how words are impacting the environment you are in.[14]

There are many legendary Puerto Rican visual artists in Philadelphia. The internationally renowned painter Rafael Ferrer (b. 1933) moved to Philadelphia in 1966, making his home and studio in the city for many years. His public sculpture at Fourth and Lehigh, *El Gran Teatro de la Luna* (1982; refurbished, then repainted by Ferrer and reinstalled in 2012), was the first permanent public artwork by a Puerto Rican/Latinx artist in Philadelphia. The piece was commissioned by the Fairmount Park Art Association (now the Association for Public Art).[15] Among his many honors, Ferrer was a recipient of the Pew Fellowship for the Arts in 2011. His artistic career embraces a wealth of approaches to art-making, including installations, sculptures, paintings, and mixed media; he is also a musician (percussionist).

Another recipient of the Pew Fellowship is Philadelphia-based artist Pepón Osorio (b. 1955). Osorio has created several public artworks in the city. One example is located at the Congreso de Latinos Unidos social services agency, titled *"I have a story to tell you . . . ,"* also commissioned by the Fairmont Park Art Association in Philadelphia. Osorio has made Philadelphia his home, along with his wife, Merián Soto. Soto is a highly recognized dancer and choreographer. Both are tenured professors at Temple University.[16]

Pepón Osorio has created several prominent Philadelphia-based projects/exhibitions/installations addressing local occurrences of notable significance and impact on the city's Puerto Rican community. One example

is *reForm*, a community-inclusive installation/exhibition project addressing the closing in 2013 of Fairhill Elementary School by the School District of Philadelphia. Fairhill was based in the Puerto Rican community of North Philadelphia. Inclusivity of the principal, teachers, and most importantly the students and their families impacted by the school's closing was Osorio's critical focus in the evolution of this collective response. Even the exhibition's catalog is handwritten by the participating students. The project's exhibition was presented in a classroom at Temple Contemporary, Tyler School of Art, where Osorio and the project participants re-created a classroom from the Fairhill school, including original furniture (desks, chairs, cubbies, cabinets) and writings/documentation from the project's process (figure 10.3). Osorio established a close relationship with the participants of this project, especially with the young people, a relationship he maintains to this day. Osorio's work, such as *reForm*, values community-engaged processes and emphasizes the voices of the silenced. In an interview with Pepón Osorio, I asked how he defines community-inclusive arts practices.

> I was a social worker, [in] NYC I used that method of reaching people via their own experience, understanding where they are— the issues they confront before addressing their case. . . .
>
> Artists must deeply engage communities, . . . take into consideration people's lives outside of ours. . . . It is always politically driven as a way to make change, there is no fiction in my work. . . .
>
> I don't go in with an agenda. . . . I do outreach with activists and teachers. . . . Others shape the project/process.[17]

The first sentence of the uniquely designed exhibition catalog for *reForm* defines the aesthetic approach of Osorio's community-grounded works: "It's time that when we speak you listen!"[18] Osorio uses a constructivist experiential methodology in his artistic process, allowing participants to visualize and interpret their experience. Using this "first-voice" process, Osorio facilitates individual experiences into collective conceptualization and manifestation of the "final" installation for public exhibition. The installation engages wider audiences into the lived experiences traveled by participants and facilitated by Osorio's artistic eye. The result serves as a sensory convener with the intention of engaging the viewer to experience the installation not only through the "voice" of the participants but also through their own personal associations made while experiencing the visual, sound, and placemaking forms in the installation. The saturated

10.3 Pepón Osorio, *reForm* (installation view), 2015. Mixed-media and video installation at Temple Contemporary, Tyler School of Art, Philadelphia. Photo by Constance Mensh.

environment of the installation stimulates and demands deeper thinking on the topics from the viewer. In the case of *reForm* those include educational inequities, systemic reform/restructuring, the politics of school resourcing, and school closings, ultimately asking the viewer to question "exclusion/inclusion" of those most affected by educational bureaucracies that ignore the humanity of students, their families, and the communities. The viewer is immersed visually, audibly, and politically and encouraged to reflect on these topics through the multiplicity of provocations within the transformed exhibition space.

In the recent 2023 "retrospective" exhibition at the New Museum in New York City, several prominent Osorio installations and individual artworks offered visitors the opportunity to appreciate his diverse approaches to Puerto Rican experiences, or "Puerto Rican vernacular."[19] The exhibition includes a reinstallation of *reForm*. Osorio describes *reForm* as "so beautifully political."[20] In "Pepón Osorio in Conversation with Margot Norton and Bernardo Mosqueira," Osorio elaborates on the political, social-cultural relevance of *reForm* for the Philadelphia Puerto Rican experience, resistance, and resiliency.[21] The New Museum exhibition also includes Osorio's critically acclaimed work *Scene of the Crime (Whose*

Crime?), originally created for the 1993 Biennial Exhibition at the Whitney Museum of American Art in New York City, and Badge of Honor (1995); these are two of his few pieces where the viewer is not allowed to freely enter the installation space. In the interview with Norton and Mosqueira, Osorio speaks to this: "I'm also interested in the spaces we can enter and the ones we can't. The space in *Scene from a Crime* is sacred, although there is no such thing as the sacred, because to remove yourself from your own environment to become exposed, is to be no longer sacred. When the installations are about specific people, the spaces are not admissible; you have to respect that."[22]

This speaks to the intimacy of art that engages with the experiences of a people, in Osorio's case, that of the Puerto Rican nation, diaspora, and the culturally identified communities they have established, such as in Philadelphia.

There are additional Puerto Rican visual artists in Philadelphia who have risen to local, national, and international recognition. Two examples are Roberto Lugo (b. 1981) and José Ortiz-Pagán (b. 1984).

Roberto Lugo grew up in the Puerto Rican community in North Philadelphia. He uses his extraordinary talents as a ceramicist, poet, and educator as processes in his work. At times he engages community members in pop-up pottery-making street workshops. His artistic multidisciplinary expressions are used as tools to reference his upbringing in North Philly and the cultural expressions of his generation. Lugo's work merges classical pottery with images of current-day culture. His striking contemporary imagery on his pottery includes hand-drawn graffiti-style writing, hip-hop social commentary, and a unique visual voice and ingenious use of mediums (see figure 10.4). Many of his works include images of those underrepresented/ left out of traditional Eurocentric representations and validations of artistic excellence. Lugo teaches at Temple University's Tyler School of Art.[23]

José Ortiz-Pagán comes to Philadelphia from Puerto Rico. After earning his master of fine arts (MFA) from Tyler School of Art, he remained in Philadelphia, working as a cultural worker, activist, and multimedia artist. His most recent awards include the Catalyst for Change Fellowship (NALAC, 2023) and the Forman Arts Initiative Grant (Philadelphia Foundation, 2021). Ortiz-Pagán connects with community members in creative experiential processes that celebrate, honor, and respond to local culture, challenges, and inspirations, a culturally interlocked art-making approach where collective engagement has equal value to the artistic resolution. He has worked with diverse communities across Philadelphia and the region

10.4 Roberto Lugo, *Put Yourself in the Picture*, 2022. Mixed media, 20 × 12 × 27 ft. Photo by Kenneth Ek. Courtesy of the artist and Grounds for Sculpture, Hamilton, NJ.

as an artist, curator, and collaborator. In an interview with Ortiz-Pagán, I also asked him how he defines community-inclusive arts practices.

> What is important to me is listening intently, building trust, and facilitating collective building while reimagining the project's possibilities, re-creating it differently with the community/participants I am working with.
>
> An artist must be ethical, uphold responsible values, earn participant trust, facilitate another capacity for thinking about issues, sustain reflection throughout, and collectively address how each participant defines community. Honesty is essential, including sharing aspects such as the project budget with participants, investing in community-based artists-creatives, caring for the environment using recycled materials, seeking to engage those in the community traditionally left out, and investing/expending project contractual services funds within the participating community. Often, this might happen by lending my creative process to serve the aesthetics of a particular community.

Artists serve as an intermediary between the expectations of sponsoring institution(s) and community interests and needs. Not always are these aligned.

I have developed a framework of operating strategies, values, and ethics for working with communities, understanding that each situation will differ. As an insider or outsider, one must manage ways to address difficult questions and sensitive topics/situations that will emerge throughout the process, working on building a safe space for participants to find freedom of expression and voice.

The artist's role is to support the process of liberation that the arts have the power to provoke.

As an artist working with communities, I hope to help communities erase geography in order to construct commonality across different communities, leading us to true liberation.[24]

Additional examples of prominent artists of Puerto Rican heritage from Philadelphia include Quiara Alegría Hudes, born and raised in Philadelphia, a Pulitzer Prize finalist in 2007 and a 2012 winner of the Pulitzer Prize for Drama for her play *Water by the Spoonful*. Alegría Hudes currently lives in NYC (since 2004) and has published a memoir titled *My Broken Language*.[25] Legendary urban artist Danny Polanco and others have maintained an enduring presence of graffiti and urban Puerto Rican artistic production in the city. Puerto Rican visual artists have significantly contributed to making Philadelphia a top Mural City globally, through the creation of independent murals and working with the Philadelphia Mural Arts Program.[26]

A leader of environmental arts in Philadelphia is Iris Brown (cofounder of Grupo Motivos). She was born in Loíza, Puerto Rico. Brown has won local and international awards for her collaborations with community members in the creation of Puerto Rican culturally grounded art/cultural gardens in the community (such as Las Parcelas, El Batey, and Villa Africana Colobó). Iris Brown is also a doll maker and grassroots educator of Afro-Boricua history, folk arts, and heritage foods (*cocina criolla*).[27]

Philadelphia's Puerto Rican community has iconic cultural spots, such as Centro Musical, a music-arts store in North Philadelphia's Centro de Oro shopping and cultural district, where palm tree sculptures stand at street corners.[28] Centro Musical, opened in the 1960s by the Gonzales family, has historically functioned as a cultural mecca of Puerto Rican/Latinx music and art. It is also where you can buy original art by Puerto Rican visual artist/muralist Danny Torres, who lived in North Philadelphia until his recent

move back to Puerto Rico. A documentary about the artist, titled *I am Danny Torres*, is successfully traveling the country's film festival circuit.[29]

Puerto Rican pioneers have also made their mark on Philadelphia's media. Dr. Diego Castellanos served as host of the TV show *Puerto Rican Panorama* from 1970 until his recent passing. It was the longest-running Puerto Rican/Latinx–focused TV talk show on a major US TV network. On every show, Castellanos invited Puerto Rican/Latinx artists to be featured, providing first-time exposure regionwide for many. In 1977, David Ortiz launched his first-of-its-kind popular Puerto Rican/Latinx music radio show *El Viaje* on local station WRTI 90.1 FM in Philadelphia.[30] Today Puerto Ricans continue to hold prominent spots on local radio and Spanish-language TV. Gilberto Gonzalez is a visual artist who has also created several film documentaries about Puerto Ricans in Spring Garden, where he grew up. He works on film projects that provide first-voice perspectives of the Puerto Rican experience in Philadelphia.[31]

Puerto Ricans also acted as pioneers in Spanish and bilingual newspapers such as *En Focus* and *La Actualidad* (1974). Both no longer exist, but there are several thriving Spanish-language newspapers in the city such as *Al Día* and *Impacto*. Historically these have reported on Puerto Rican artists, exhibitions, and cultural endeavors at the absence of mainstream media coverage.

The arts have served the Puerto Rican community in Philadelphia as a tool of empowered representation, with many Puerto Rican creators working across disciplines with racially and culturally diverse artists. Puerto Rican artists and cultural workers play music, sing, spray-paint art on walls, and jam in community playgrounds, street corners, and home-grown recording studios as well as historically hold rap and graffiti duels in rowhouse basements. Each of these creative expressions reflects a deeply set tradition of the arts in their souls. In Spanish, English, or Spanglish, the artistic voices of Puerto Rican creators generally gravitate to their Puerto Rican pride, whether in graffiti or rap.

Today, Puerto Rican artists continue to contribute to the fast-growing diversity of Latinx arts and cultural initiatives in Philadelphia. For example, Gabriela Sanchez and Erlina Ortiz, cofounders of Power Street Theatre Company, have created a multicultural company led by womxn of color, producing, directing, and starring in several powerful new plays in the heart of El Barrio.[32] Puerto Rican visual artist, musician, and educator Daniel de Jesús (b. 1982, North Philadelphia) is a gifted young visual artist, cellist, and composer with a very promising future. His music is

described as baroque pop and neo-goth. His paintings and drawings are equally entrancing.[33] Gerard Silva is another well-known Puerto Rican visual artist–cultural worker–educator who has made Philadelphia his home after working in advertising in NYC. Silva has worked at the Fleisher Art Memorial in Philadelphia for more than fifteen years; he serves as the exhibitions and community outreach director and teaches screen printing.[34]

The 2020 US Census lists the population of Philadelphia at 1,603,797. The Hispanic populations make up 15.4 percent of that total.[35] Puerto Ricans of Philadelphia are the second-largest Puerto Rican population in US mainland cities after NYC. The Puerto Rican population in Philadelphia was listed at 127,114 (7.9 percent of the 15.4 percent Hispanics in the city). The Puerto Rican/Latinx population in Philly continues to grow. Within the past decade, the Hispanic population grew 27 percent in the city.[36]

Philly-Ricans continue to play significant roles in Latinx arts in Philadelphia. New organizations, such as La Guagua 47, Ritmo Lab, and the Street College initiative, all founded by Puerto Rican lawyer, musician, and entrepreneur Alba Martinez, continue to fill the void providing Puerto Ricans in Philly connections to their heritage.[37]

Puerto Rican artists and cultural workers will continue to pay tribute to the cultural resiliency, history, creativity, and the against-all-odds contributions made by Puerto Ricans in Philadelphia. The creative spirit instilled in the Puerto Rican people is thriving in Philadelphia.

NOTES

1 Vázquez-Hernández, *Before the Wave.*

2 Vázquez-Hernández, *Before the Wave.*

3 City of Philadelphia, *Puerto Ricans in Philadelphia.*

4 Historical Society of Pennsylvania, *Latino Philadelphia*, 16–18.

5 Vázquez-Hernández, *Before the Wave,.*

6 *Suave*, hosted by Maggie Frelang, produced by Julieta Martinelli and Futuro Media, accessed February 3, 2022, https://www.futuromediagroup.org/suave/.

7 Taller Puertorriqueño, "Preserving and Promoting Puerto Rican Arts and Culture," accessed May 15, 2024, https://tallerpr.org/.

8 "Taller Puertorriqueño Announces the Retirement of Its Long-Time Executive Director, Dr. Carmen Febo San Miguel," Taller Puertorriqueño (press release), March 23, 2021, https://tallerpr.org/dr-carmen-febo-san-miguel/.

9 Taller Puertorriqueño, "Preserving and Promoting."

10 Taller Puertorriqueño, "Preserving and Promoting."

11 Nicolas Esposito, "A Row House and a Life Transformed." *Hidden City Philadelphia*, September 3, 2019, https://hiddencityphila.org/2013/02/a-row-house-and-a-life-transformed/.

12 Michelle Angela Ortiz, "Bio," accessed May 15, 2024, https://www.michelleangela.com/.

13 Michelle Angela Ortiz, interview by the author, 2023.

14 Betsy Z. Casañas, interview by the author, 2023.

15 "El Gran Teatro de la Luna (1982) by Rafael Ferrer (b. 1933)," Association for Public Art, accessed February 28, 2024, https://www.associationforpublicart.org/artwork/el-gran-teatro-de-la-luna/.

16 "Merián Soto/Performance Practice," Merián Soto (website), accessed May 17, 2024, http://www.meriansoto.com/.

17 Pepón Osorio, interview by the author, 2017.

18 Chelsey Velez, student participant in *reForm*.

19 Norton and Mosqueira, *reForm*, 17–18.

20 Norton and Mosqueira, *Pepón Osorio*, 23.

21 Norton and Mosqueira, *reForm*, 12–28.

22 Norton and Mosqueira, *Pepón Osorio*.

23 Roberto Lugo, "Bio," accessed May 17, 2024, https://www.robertolugostudio.com/bio.

24 José Ortiz-Pagán, interview by the author, 2022.

25 Quiara Alegría Hudes, "About Quiara," accessed May 17, 2024, http://www.quiara.com/.

26 Mural Arts Philadelphia, "Home," accessed May 4, 2024, https://www.muralarts.org/.

27 Norris Square Neighborhood Project, "Our Gardens," accessed May 15, 2024, https://myneighborhoodproject.org/gardens/our-gardens/.

28 Stigale, "In the Heart of Gold," *Hidden City Philadelphia*, September 10, 2019, https://hiddencityphila.org/2013/08/in-the-heart-of-gold/.

29 Torres and Melendez, *I Am Danny Torres*.

30 Vázquez-Hernández, *Before the Wave*.

31 Roa Nixon, "Gilberto González, un boricua de acciones," *Impacto*, April 5, 2024, https://www.impactomedia.com/region/vida-de-impacto/gilberto-gonzalez-un-boricua-de-acciones/.

32 Power Street Theatre, "Meet the PST Team," accessed May 15, 2024, https://www.powerstreettheatre.com/team.

33 Daniel de Jesús, "Daniel de Jesús Is a Painter, Composer, and Songwriter Versed in the Worlds of Visual and Sonic Tapestries," accessed May 15, 2024, http://www.celloeye.com/index#/about/.

34 Da Vinci Art Alliance, "Gerard Silva, Everyday Genius," October 6, 2020, https://davinciartalliance.org/everyday-genius-blog/gerard-silva.

35 U.S. Census Bureau, "Explore Census Data," 2020, accessed May 29, 2024. https://data.census.gov/table?q=2020%20philadelphia%20ethnicity.

36 U.S. Census Bureau, "U.S. Census Bureau Quickfacts: Philadelphia City, accessed May 29, 2024, https://data.census.gov/table/DECENNIALSF12010 .P9?q=philadelphia ethnicity.

37 Ritmo Lab, "About Ritmo Lab," accessed April 12, 2023, https://www.ritmolab .com/about/.

BIBLIOGRAPHY

City of Philadelphia. *Puerto Ricans in Philadelphia: A Study of Their Demographic Characteristics, Problems and Attitudes.* Philadelphia: Commission on Human Relations, 1954.

Historical Society of Pennsylvania. *Latino Philadelphia: Our Journeys, Our Communities. A Community Profile.* Philadelphia: Balch Institute for Ethnic Studies of the Historical Society of Pennsylvania, 2004. https://hsp.org/sites /default/files/legacy_files/migrated/latino_community_profile.pdf.

Norton, Margot, and Bernardo Mosqueira, eds. *Pepón Osorio: My Beating Heart/ Mi corazón latiente.* New York: New Museum, 2023.

Norton, Margot, and Bernardo Mosqueira. *reForm.* Philadelphia: Temple Contemporary, Tyler School of Art, 2015. Exhibition catalog.

Torres Melendez, Abigail, and Eric Melendez, dirs. *I Am Danny Torres.* 2023. 13 min., 52 sec. https://www.youtube.com/watch?v=m5SS17njzUM.

Vázquez-Hernández, Victor. *Before the Wave: Puerto Ricans in Philadelphia, 1910–1945.* New York: Centro Press, 2017.

11

"A pesar de todo"

The Survival of an Afro–Puerto Rican Family in Frank Espada's Puerto Rican Diaspora Project

Yomaira C. Figueroa-Vásquez

Some photos are not quiet at all.

Tina Campt, *Listening to Images* (2017)

On October 1, 1979, Frank Espada, in collaboration with Universidad Boricua/Boricua College, was awarded a three-year National Endowment for the Humanities (NEH) Grant that would allow Espada to "plan the first federally-funded documentary for the Puerto Rican community in the United States."[1] The project allowed the New York City–based Espada to travel throughout the continental United States, Hawai'i, and Puerto Rico

to document Boricua life, migration to the United States, return migration to Puerto Rico, and the establishment of communities and social life across a series of experiences and geographical locations. The immense project was the first of its kind; it combined more than four thousand photographs and interviews with more than 140 people across several cities, communities, and walks of life. These included a cross section of Puerto Rican people, such as community organizers, artists, families, gang members, children, members of the clergy, itinerant preachers and spiritual practitioners, mushroom and factory workers, students, professors, lawyers, and farmers. Espada's groundbreaking work as a documentary photographer and longtime community organizer shaped his approach to pursuing a social documentary that would bring a humanizing perspective to a group of people who had long been considered a racial and ethnic scourge in the United States. Rather than reify degrading imperial lenses that dehumanized Puerto Ricans and cast them as inferior, Espada's work traced modes of survival, collaborative community efforts, world-building practices, cultural vibrancy, joy, political consciousness, and commitments to interrelationality and solidarity. He thus created a new archive of and for Puerto Ricans in the United States, one that traces the afterlives of Spanish colonialism, US imperialism, and forced migration and that shows community formation and familial sacrifice in often inhospitable places. Puerto Rico is, after all, the world's oldest colony, having uninterrupted colonial rule since 1493; and Puerto Ricans are contemporary colonial subjects of the United States. In the face of "paperlessness"—that is, a people with lack of documentation and lack of representation in the written archive—Espada created a visual and audio archive that complemented the surge of literary and poetic cultural productions of the post-1960s era.[2]

In what follows, I first introduce Frank Espada and his work and briefly discuss the planning and execution of the project and the framing my approach to the archive and my focus on the representation of Afro–Puerto Ricans within the larger arc of the Puerto Rican diaspora project. I then examine a series of photographic images and the oral interviews of an Afro–Puerto Rican family based in Chicago, Illinois, paying close attention to themes of love, sacrifice, and hope. In doing so, I locate one of the many ways that Nuyorican visual culture, projects, and community practices offered ways to document the experiences of Afro–Puerto Ricans—an often understudied and peripheralized group of people within and beyond Puerto Rican studies.

Francisco Luis Espada Roig, known professionally as Frank Espada and colloquially as Tato, was born in Utuado, Puerto Rico, on December 21, 1930. In 1939, his family moved to New York City for reasons unknown to young Frank. He briefly attended City College of New York before joining the Air Force in 1949 and serving in the Korean War; this was a decision he regretted his entire life. He married his wife, Marilyn, in 1952 and together they had three children (Martín, Lisa, and Jason). Through the support of the GI Bill, Espada attended the New York Institute of Photography, where he fell in love with documentary photography. He was mentored by senior photographers Eugene Smith and David Heath, who remained important interlocuters for Espada throughout his career. While photography was his passion, Espada went on to work as an electrical contractor to support his young family. This was a career he did not like, and in 1967 he decided to become a community organizer for the Puerto Rican Community Development Project, where he became involved in a series of community-based action projects and support networks for New York City's most vulnerable populations. It was his work as an activist and organizer alongside his passion for documentary photography, education, and community activism that helped shape Espada's desire to illuminate unseen and misunderstood dimensions of the quotidian lives of racialized, impoverished, and oppressed populations.

Sadly, Frank felt that he had lost his most creative years without dedicating time to his creative calling and sensed that many of his ambitions had been put aside. It wasn't until 1979, at the age of forty-nine, that he was able to work toward achieving his lifelong dream of documenting the Puerto Rican diaspora. With the support of Dr. Victor Alicea, president of Boricua College in New York, Espada applied for and received an NEH grant that would support the execution of his photodocumentary project. In 1985, he moved to California with his family and began working as an arts educator, teaching photography in San Francisco and the Bay Area through the UC Berkeley Extension Program. He continued to work on other social photodocumentary projects, including the Youth Environmental Study (YES) Project that documented the impact of HIV/AIDS on youth and grassroots intervention programs, and the Chamorro Project, a photodocumentary project undertaken in Guam in collaboration with social historian Dr. Laura M. Torres Souder and sociologist Dr. Samuel Betances.

Espada passed away on February 16, 2014, and left a rich and vast archive of work that reflects a lifetime of community activism, photography, and writing rooted in an ethics of care and relationality.

Snapshot: The Puerto Rican Diaspora Project

The Puerto Rican diaspora project was a lifelong goal of Espada's, wherein he sought to photograph and interview Puerto Ricans across the United States as a way to document their living conditions, collect their stories, and learn about their arts, practices, and histories. This compendium would be the first-ever collection that documented the experiences of multiple generations of Puerto Ricans and traced the afterlives of US empire in the archipelago and the ongoing effects of dispossession, migration, racism, and labor extraction. The David M. Rubenstein Rare Book and Manuscript Library at Duke University acquired a significant number of photographs, negatives, ephemera, and publications from Espada's career. Archival documents from the late 1970s through 1980 show the preliminary outline of the project and its revisions as Espada refined his aims for the Puerto Rican diaspora project. The 1980 revised outline of the concept enumerates the following goals:

1 To document, through various means, the dispersal and present situation of the Puerto Ricans in the United States.

2 To chronicle the history of the Puerto Rican migration through the organization of a permanent collection of documents, photographs, memorabilia and interviews.

3 To assist in the development of Puerto Rican cultural and humanistic project and national networks.

4 To encourage the establishment of culturally-oriented regional and national networks.[3]

The Puerto Rican diaspora documentary project would become an expansive humanistic project that led to permanent collections, exhibitions, publications, and political action through an engagement with the Puerto Rican diaspora.[4]

Espada's work would eventually result in a dispersed archive housed in university libraries, museums, and in the Espada family collection that

would bear witness to the migration and lives of Puerto Ricans in the "entrails of the monster," the United States.[5] His focus on chronicling Puerto Rican history and building photographic collections was tied to a commitment to building, maintaining, and strengthening connections between Puerto Ricans across great distances. The "networks" he mentions in the NEH application materials are evidenced by the countless letters Espada penned (and the replies received) to local and national community organizations, universities, museums, and other potential stakeholders. These letters announced the project and gestured toward the creation of an advisory council that could serve to review and enhance the project and ultimately have a material impact on the lives of Puerto Ricans. As a work of public art, the Puerto Rican diaspora project had forty exhibits in multiple cities across the continental United States, Hawai'i, and Puerto Rico between 1981 and 1996.

For Espada, the Puerto Rican diaspora project was a labor of love and was obvious in each of the images he captured, each of the interviews he held. He dedicated years of creative and emotional labor to collect and curate it. In addition to a traveling exhibit, his hope was that within a year of the completion of the project there would be one or two books published with photographs and interviews. This would inevitably make it more accessible to a wider audience through libraries and individual purchases. While the photos were shown in various cities and institutions for more than fifteen years, it would be more than twenty years before Espada would be able to curate, design, and publish the book titled *The Puerto Rican Diaspora: Themes in the Survival of a People.* It was in 2006 that the book was finally produced in collaboration with an independent printer in Canada. A limited run of books was produced featuring photographs and select quotes from the interviews. For Espada the words and experiences shared by the subjects were as important as the images; "if there is a weakness in the work," he writes about the book, "it is the limited space we have allocated to the words." Yet the photos alone, argued Espada, were a "time machine, having the capacity to transport one to the exact time, place, and circumstances associated with the image."[6] Here Espada underscores how the photographic images were not silent but instead conjured a host of sensorial experiences. Likewise, his comment also hints at the possibility of the need not only to go back in time but to travel to a specific "place" and "circumstances" within the Puerto Rican diaspora.

As Tina Campt proffers, "some photos are not quiet at all," and by beholding and listening to these images captured by Espada, we engage in an act of bearing witness to the contours of living histories, explore the poetics of

survival, and attend to the power of the quotidian.[7] The recorded interviews offer us yet another layer of possibility, and Espada reminds us that "giving voice to our people was to be an important objective of the documentary."[8] In contexts where Puerto Ricans are silenced and are often shown through the colonial apparatus of a biased and racist media, the Puerto Rican diaspora project represents a project of self-determination, of self-reflection. It is a truly revolutionary project that allows Puerto Ricans to tell their own stories through a palimpsest of photos and oral histories. Today, the book is out of print, with many copies held in archives and libraries, and just a few in the hands of photography enthusiasts, scholars, and private collectors.

The number of photographs that constitute the Puerto Rican diaspora project is overwhelming. Thousands of images speak to the beauty, tragedy, and quotidian experiences of a population often overlooked or pathologized. My goal in approaching this rich archive was quite specific: I was searching for Afro–Puerto Ricans. What fueled my search was a desire to find visual proof, oral histories, and other documentation of Afro–Puerto Rican life in order to better conceptualize Afro–Puerto Rican experiences across generations of migration. This impetus was a necessary analytic because in many ways the lives and experiences of Black Puerto Ricans represent the "periphery of the margins."[9] This phrase, borrowed from Dominican studies scholars Silvio Torres Saillant and Ramona Hernández, allows us to capture how, within a condition of continued colonization from 1493 to the present, first under Spanish colonial rule and later under US imperial rule, Puerto Ricans have been subject to a series of dehumanizing forms of dispossession, racism, exploitation, and marginalization. Within this matrix of colonization and oppression, Puerto Ricans racialized as Black or Afro-descendant suffer extreme forms of peripheralization, exclusion, discrimination, and violence.

As I wrote in "Afro-Boricua Archives," Puerto Rico has been "long considered the 'whitest' of the Caribbean islands," and its discourses of mestizaje and racial democracy "obfuscate the race, class, and gender logics that support systematic inequality."[10] As such, a sustained study of Afro–Puerto Rican communities, families, and individuals is required to bring to the fore the unique experiences of the racialized, gendered, subjective, and phenomenological experiences faced by a population whose existence is often denied or maligned. While the interviews don't often discuss race or Blackness outright, the project provides a set of historical materials that allows for the examination of Afro–Puerto Ricans within and beyond their geospecific and temporal contexts. In other words, they are important archives for the study of Afro–Puerto Rican life and portraiture.

In what follows, I study a set of photographs and two interviews held by Espada with an Afro–Puerto Rican family in Chicago, Illinois, in 1982. I focus on the family interviews and a series of the photographs taken of the family because as Elizabeth Ferrer notes, "family narratives also point to such issues as race, class, separation, and survival."[11] By centering this interview, I trace some of the contours of everyday life for Afro–Puerto Rican families in the US Midwest and mark how, despite some of the difficult experiences they face, they are sustained by forms of sacrifice, love, and hope. Alongside the images, I offer summaries and quotes from the never-before-heard interviews between Espada and the Collazo family.[12]

Love and Struggle in a Chicago Family

Espada photographed and interviewed the Collazo family on August 1, 1982, at their family home in Chicago, Illinois. The audio interview included the husband, Luis Collazo; and his wife, Genoveva Collazo; and in the background one can sometimes hear the voices of one or more of the Collazos' children. Espada photographed the family inside and outside their home, with many of the photos focusing on the threshold of the home (the door, window) and the social spaces on the exterior (the stoop, the backyard). In figure 11.1, we see the members of the Collazo family sitting on the back stoop of their home in Chicago. Genoveva is leaning against the door, wearing a circle skirt and short-sleeve blouse. Near her, their daughter (unnamed in the interview) leans on the doorframe and wears a white screen-printed T-shirt and jeans. Luis sits in a chair to his daughter's right and wears wide-leg slacks and a pullover collared shirt in contrasting colors. There are two small dogs playing near his feet atop the stairs. Two of the Collazos' three sons sit in descending order on the stairs. Adalberto and Luis smile at the camera and wear T-shirts, jeans, and sneakers. Their skin is various shades of brown, medium and dark, and they wear their hair in Afros or short curls. The photos, taken on a sunny day, show sunlight beaming on the family's right. The sons in the center and left of the photo are engulfed in brilliant light, while the long windows of the house reflect tree branches and leaves. Affixed to the brick facade is a clothesline that stretches beyond the frame of the photo, its endpoint beyond our view. Missing from this photo is the youngest Collazo, Willie, who appears later in the photos and the interview, where his presence looms large. This is the Collazo family, whom we get to know through these captured images and the audio interview.

11.1 Frank Espada, photo of the Collazo family on the back stairs of their home in Chicago, 1982. Pictured are Genoveva and her daughter standing near the doorway, Luis seated on a chair, and two sons sitting on the stoop. Two small dogs play at the top of the steps. Courtesy of the Espada Family Archive.

As the interview begins, we hear a very soft-spoken voice; it is Luis, seemingly struggling to answer the questions being asked (such as "Where are you from in Puerto Rico?"). Genoveva steps in to answer the questions and elaborate on the family story, with her husband chiming in and providing a bit of context. The interview includes discussion of their life in Puerto Rico, their migration to the United States (first to Connecticut and then to Illinois), their struggle with illness and disabilities, their children's uncertain futures, and their conflicting desires to return to Puerto Rico after thirteen years in the United States. The Collazos were from Barrio Quebrada in Toa

Alta; Luis (thirty-seven) met Genoveva (forty-four) in 1961. He migrated from Puerto Rico to work on Connecticut tobacco farms around 1967–68 and by 1969 Genoveva came with the kids to Hartford to reunite the family; she too joined in the farm work of tobacco production.[13] The Collazos lived in Hartford for five years after which Luis went ahead to Chicago to find work and housing and later sent for his family to join him.

At the time of the interview, they had lived in Chicago for eight years. When asked why they left Hartford, Luis said that they wanted a change of scenery. He mused with a delighted lilt, "me gusta conocer" (I like exploring). This desire to move, to change, to experience new places and people highlights an important aspect of mobility in the Puerto Rican diaspora. Those who were and continue to be recruited primarily for their labor throughout Puerto Rican history were and are more than just workers; they are living, hopeful, and willing human beings, who may desire change or new experiences, including knowledge of other places and peoples. Despite their limited circumstances, the Collazo family and other Puerto Ricans were led not only by the longing to survive but also by curiosity, joy, and self-actualization.

Their arrival in Chicago, however, marked a shift for the family, when things became difficult. Luis had to have back surgery for a severe spinal injury, and later he underwent another precarious surgery in order to donate one of his kidneys to his youngest son, Willie. At this point in the interview, we hear Genoveva's lament, "De allá es que temenos los problemas" (From then on we've had problems), and she goes on to explain the family's woes and their struggle to resolve a confluence of difficulties related to health problems, structural inequality, and lack of access to resources.

In figure 11.2, we see young Willie, a fifteen-year-old boy, small for his age, sitting on the steps of the family home. Willie has brown skin and thick black hair with loose curls, and he smiles broadly toward the camera, revealing a row of gleaming white teeth with a slight overbite. With his feet spread on a step below where he is seated, he rests his elbows on his knees and slightly slouches his shoulders. His sneakers crest over the bottom step ever so slightly, showing movement. We can hear Willie's laughter as we gaze upon his face illuminated by the sunlight. Behind him is a potted plant, almost hidden behind the banister. Beyond the stairs is a chain-link fence and beyond that, a tangle of trees, bushes, leaves, and branches. If it were not for the brick facade of the building, Willie looks like he could possibly be in Puerto Rico, but instead he is in Chicago, and his family shares his story.[14]

11.2 Frank Espada, photo of Willie Collazo, age fifteen, seated on the back staircase of the Collazo home in Chicago, 1982. Willie sits with his elbows resting on his knees and smiles into the camera. Courtesy of the Espada Family Archive.

Willie had been sick since he was two years old and although he was able to be treated with limited intervention for a few years, his condition steadily worsened. At the age of eight, both of Willie's kidneys were removed, and at the time of the interview, fifteen-year-old Willie had been receiving dialysis treatment three times per week. Genoveva whispers, "Así hasta que Dios quiera" (We'll go on like this as God chooses), reflecting both her hope and her fear for Willie's life expectancy. Luis donated one of his kidneys to Willie but this only lasted two months, after which Willie's body rejected the organ. Willie, still waiting for another kidney, had issues with his heart as well as high blood pressure and hepatitis, and had undergone

seven operations. Despite this history of frail health, Willie was excited to enter high school the following year and had decided that he wanted to attend a work training program and become a chef or a computer scientist.

Of Willie, Genoveva marveled, "No se deja dominar por la enfermedad" (He is not overcome by his illness), but this hopeful disposition cuts the family both ways. According to Genoveva, at first glance neither Willie nor Luis looks particularly ill. People see them but don't think they are sick. This became a catch-22, where he would be told by the disability services officials that he looked fit to work despite medical letters indicating otherwise, and his benefits were stripped. Yet Luis would never be hired for the jobs to which he applied because his back injury and kidney donation would inevitably cause him to fail the physical exam. Thus he was too sick to be hired but not sick enough for the disability services to provide necessary aid. Luis recounted that he was denied disability three times (the last two on appeal). Genoveva wanted her husband to appeal again, but he was disillusioned and exhausted.

At the heart of the health issues of Luis and the family are the socioeconomic positions of Puerto Ricans in the diaspora, whose incorporation into the workforce as well as their housing, health care, and educational opportunities have been shaped by discrimination, exploitation, and negligence. Luis's years of hard labor and his organ donation severely impacted his health, while the scourge of asthma (the result of a confluence of environmental factors that are purposefully constructed through segregation, environmental racism, and poor housing) affected Genoveva and her daughter. The harsh Chicago winters exacerbated their asthma, and the Collazos' other two sons, Adalberto and Luis, were struggling with school. The elder, Adalberto (seventeen), had dropped out and could not find employment. The younger, Luis (sixteen), failed the ninth grade and was due to repeat it or join the Marines at age eighteen. They both were keen to return to Puerto Rico, but the Collazos were unsure if returning would be the right move for the entire family.

Their deliberation on whether to return to Puerto Rico illuminates the types of calculus that have shaped the Puerto Rican diaspora and the movement of Puerto Ricans from one space to another. One of the issues that Luis and Genoveva had to consider was whether the health of their family would improve or suffer with a move: would Willie get the support and medical treatment he needed? After conferencing with the medical team in Chicago, the doctors in Puerto Rico told the family that Willie would have better care and "comodidad" (comfort) in Chicago. This made Genoveva reconsider a return to Puerto Rico that would ease her life, her

11.3 Frank Espada, candid photo of the Collazo family in their backyard in Chicago, 1982. Luis tends to a chicken in a coop while Genoveva (*sitting*) and their daughter (*leaning*) look at the camera from atop the stoop. Courtesy of the Espada Family Archive.

husband's condition, and her daughter's asthma. She balances "la comodidad de nosotros" (our comfort) and instead thinks about Willie's life. Here, the idea of comfort is expanded beyond the physical and instead gestures toward the affective, relational, and interpersonal.

Figure 11.3 shows Luis, Genoveva, and their daughter in the backyard of their home. While Luis stands on the concrete street level, Genoveva and their daughter are at the top of the stoop, with Genoveva sitting on a chair, leaning on the banister, and the daughter standing behind her, leaning over, her arms on the banister. They are looking down at the camera and at Luis, who is also looking at the camera while opening a circular

chicken coop that holds one of the family's chickens. A wooden ladder to Luis's right leans against the brick facade of the building and a worktable, partially pictured, stands next to the coop. Behind Luis is a dark doorway, leading to a garden-level residence or basement. While the foreground of the photo is dark and shadowy, behind the family the sun brightens the trees and clotheslines in the neighboring lot. The trees and leaves, almost overexposed, seem to disappear as they reach the right side of the frame.

As the interview enters the thirty-minute mark, we can hear Genoveva sigh, exhausted from telling this story of the family's struggle. At one point she states, "Aquí nosotros los puertorriqueños están bien mal" (Here the Puerto Ricans are doing very badly), while Luis states, "Lo que mata aquí es la discriminación" (What kills us here is discrimination). He explains how workers are pitted against one another to accept the lower wages in order to work at all. He first explains how Puerto Rican, Black, and Mexican workers are usually dismissed from work while white workers are given their jobs. He also shares how Puerto Rican workers are put at odds with Mexican workers, who often accept lower wages, thereby undercutting Puerto Rican labor. While expressing this, Luis indicts the managerial class and the capitalist industries that create and exacerbate poverty and conflict amid those made most vulnerable. Here, one can see how both Luis and Genoveva give voice to different aspects of ongoing struggles faced not only by Puerto Ricans but also by the racialized underclass in Chicago. The interview documents the dispersal and "present situation" of Puerto Ricans while providing a window into how Puerto Ricans are reflecting on and narrating their own histories and lives. The situation is clear: in Chicago discrimination kills Puerto Ricans.

At the end of the interview, the family softens, and we can hear the release in the air. In sharing their story "se desahogaron" (they undrowned themselves). Espada explains more about the Puerto Rican diaspora project and invites them to the local Librería Yuquiyú for the opening of the Chicago exhibit the next evening. He offers to pick them up and give them a ride, initiating yet another space for relation that extends beyond the interview and photography. Espada ends the interview by giving them thanks: "Dándole gracias, que Dios le de fuerza" (I give you my thanks; may God give you strength). It is Genoveva's words, however, that mark the culmination of what has transpired:

> Gracias. Nosotros le damos la gracias a usted también por la entrevista. Que, a pesar de todo ha sido de nuestro agrado. Y que es bueno compartir con alguien verdad cosas, problemas que uno tiene. Y es

una oportunidad de expresar lo que sentimos y esto. Así que estamos a la orden y cuando quieras volver a repetirse aquí puedes volver.

(Thank you. We also thank you for the interview. Despite everything, this has been to our liking. And it is good to share things with someone, the problems that one has. And it is an opportunity to express what we feel. So, we are at your service and when you want to return here you are welcome.)

Let's sit with these words, "a pesar de todo" (despite everything). The Collazo family opened their home and shared intimate stories, delicate information, and topics that speak to so many facets of Puerto Rican diasporic experiences. They traversed the previous thirteen years in a forty-five-minute interview and although emotionally exhausting, they were thankful for the opportunity to share the stories, the load, the burden, despite it all. *A pesar de todo*, the Collazos exude loving sacrifice, joy, and hope for their futures.

In the final photo of the Collazo family (see figure 11.4), we see young Willie swinging a wooden bat in the backyard of the Collazo family. Genoveva watches from the top of the stairs, two children embrace on Willie's left, and clothes hanging from a clothesline swing in the breeze above them all. It is a striking photo, perhaps one of my favorites from the entire collection. Espada places Willie in the center of the photograph, an important gesture given the centrality of Willie for the family. At the same time, Willie, with baseball bat, is joyously swinging, and his "ailment," which had been central to the interview, is not present. His mother looking on with love from behind the frame and the two kids who might be friends, neighbors, cousins, or playmates demonstrate a larger network of social relations, community, and kinship. Luis, however, is not seen. Yet his absence cannot be interpreted as a missing or negligent father; perhaps he is standing behind the lens, next to the photographer, cheering on his young son, who is swinging the bat like a baseball star. The photos offer us a beautiful portrait of a family facing insurmountable odds, surrounded with love and hope, and carefully balancing the possibilities for their future. In seeing the images, we can hear the laughter, the wind, the crack of a bat, the cluck of a chicken, and the creak of the wooden stairs that have held the family throughout the day and in the preceding days. The oral interview adds yet another dimension to the sensorial portraits offered by Espada. We hear a family tending to each other with care; we bear witness to bodily sacrifice, deep love, and quests for dignity in an Afro–Puerto Rican family.

11.4 Frank Espada, photo of the Collazo family in their backyard in Chicago, 1982. Genoveva sits along a long staircase emerging from the left side. Young Willie swings a wooden baseball bat. Two children embrace nearby. Courtesy of the Espada Family Archive.

The Unending

Espada's multiyear social photodocumentary project allows us to bear witness and listen to the life of the images. Soon, the audio interviews will be accessible to the public so that the world can listen to the poetics of the Puerto Rican diasporic experience.[15] The photographs alone are an incredible contribution to the study of Puerto Rican life, and the full interviews are likewise a treasure trove. The Puerto Rican diaspora project is propelled by the commitments of a Puerto Rican–cum-Nuyorican community organizer, activist, and artist, intent on rendering visible the struggle and endurance of his people. He extended his lens beyond the islands of New York City to provide snapshots of a diasporic people intent on survival.

The ethics underpinning this project, I argue, are likewise a strategy that sought to affirm and visibilize Puerto Ricans. Love, it seems, is the unending impetus for this project, and we see it in every aspect of its iterations.

Revisiting the volume of images now, almost twenty years since its publication, tells a layered story—one of a photographer and community organizer with the goal to illuminate the struggles and dignity of his people; one of a diverse community of Boricuas sharing intimate stories of migration, cultural resistance, and love; and yet another of the same artist decades later, near the end of his life, tending to this material project, fulfilling a promise to himself and the people who let him into their homes and communities with his camera and who opened up to him and shared their stories. In many ways, we are inheritors of this project. Whether we are archipelagic or diasporic Boricuas, cultural critics, or visual studies aficionados, the Puerto Rican diaspora project has much to show us about ethical approaches to documenting lived experiences, black-and-white photography practices, and the value of listening to images. Sitting with this work that uplifts the voices of those made vulnerable by hundreds of years of colonialism, dispossession, and erasure allows us to glance at modes of survival, sacrifice, and love.

NOTES

Translations: All translations are the author's unless otherwise noted.

1 Frank Espada to Ricardo R. Fernandez, director of the Midwest national Origin Desegregation Assistance Center, February 9, 1980. The letter is for the "academic humanist" advisory council to collaborate with the project. Frank Espada Photographs and Papers, 1946–2010, David M. Rubenstein Rare Book and Manuscript Library, Duke University.

2 Sánchez-González, *Boricua Literature.*

3 Outline of revised concept, April 28, 1980, Frank Espada Photographs and Papers, 1946–2010, David M. Rubenstein Rare Book and Manuscript Library, Duke University.

4 In Espada's 1982 interview with the Collazo family in Chicago, he mentions how a possible outcome of the project would be promoting political change for Puerto Ricans. He explains the project seeks to showcase "la experiencia de nuestra gente . . . y veremos a ver, a ver si traves de esto las cosas mejoran un poquito, la gente empiezen a mover a organizer" (the experience of our people . . . and we will see, if through this things will get a little better, people will being to move and organize). See note 15 of this chapter for information about the Espada archive, which includes this interview.

5 This turn of phrase was used by José Martí in an 1895 letter. Martí, "Letter to Manuel Mercado."

6 Espada, *Puerto Rican Diaspora*, 186.

7 Campt, *Listening to Images*, 116.

8 Espada, Puerto Rican Diaspora, 186.

9 Torres-Saillant and Hernández, *Dominican Americans, 120.*

10 Figueroa, "Afro-Boricua Archives."

11 Ferrer, *Latinx Photography in the United States*, 119.

12 Interviews accessed courtesy of Frank Espada's son, Jason Espada.

13 In the interview, Espada mentioned how Hartford was one of the places where the Puerto Rican diaspora project had taken him in 1980 and how important it was to document the experience of farmworkers.

14 Espada also has a short interview with Willie, but he is very bashful. See note 15 for information on the archive.

15 This is one of the major undertakings of the Mellon Diaspora Solidarities Lab. A team of independent scholars and undergraduate and graduate students from Michigan State University, the University of Puerto Rico (Rio Piedras and Cayey), George Washington University, University of Southern California, and Arizona State University are digitizing, transcribing, translating, and creating a public archive of the Puerto Rican diaspora project interviews. See "Diaspora Solidarities Lab," Michigan State University, accessed January 31, 2023. http://www.dslprojects.org/.

BIBLIOGRAPHY

Campt, Tina M. *Listening to Images*. Durham, NC: Duke University Press, 2017.

Espada, Frank. *The Puerto Rican Diaspora: Themes in the Survival of a People.* San Francisco: printed by the author, 2006.

Ferrer, Elizabeth. *Latinx Photography in the United States: A Visual History.* Seattle: University of Washington Press, 2021.

Figueroa, Yomaira C. "Afro-Boricua Archives: Paperless People and Photo/Poetics as Resistance." *Post45*, June 4, 2021. https://post45.org/2020/01/afro-boricua-archives-paperless-people-and-photo-poetics-as-resistance/.

Martí, José. "Letter to Manuel Mercado." In *José Martí: Selected Writings*, edited and translated by Esther Allen, 347. New York: Penguin, 1999.

Sánchez-González, Lisa. *Boricua Literature: A Literary History of the Puerto Rican Diaspora*. New York: NYU Press, 2001.

Torres-Saillant, Silvio, and Ramona Hernández. *The Dominican Americans*. Westport, CT: Greenwood, 1998.

12

The Fight to Make Art
in Borilando

Raquel Reichard

Orlando is often called Puerto Rico's seventy-ninth municipality. Here, amid the Central Florida swamplands and the magic of Walt Disney World, Puerto Ricans have been able to preserve the culture, traditions, language, and way of life they led back in their motherland—probably more so than in any other city in the contiguous United States. For many, the region is seen as an extension of the archipelago rather than a distinct diaspora.

From East Orlando to Kissimmee, *puertorriqueños* can enter public spaces and be greeted in their native tongue and accent. They can have a morning café con leche at familiar franchises like Café Don Juan, a break-

fast sandwich at El Mesón, and mofongo with a side of *bomba y plena* at several local restaurants. Students at the Polytechnic University of Puerto Rico, Inter-American University of Puerto Rico, or Ana G. Mendez University can transfer to Orlando campuses. There are water parks inspired by El Yunque, buildings constructed to resemble El Morro, schools and streets named after Puerto Rican heroes, and home-front *flamboyanes*.

Here in the Sunshine State, Puerto Ricans founded Borilando, *un pedacito del archipiélago caribeño* in the US South. But you couldn't tell that Puerto Ricans carved a home for themselves from Orlando's visual art scene. Unlike Puerto Rican neighborhoods in New York, Chicago, and Philadelphia, the walls of public buildings hardly tell our stories, art galleries don't offer evidence of our presence, and local Puerto Rican artists rarely get the opportunity to contribute to beautification projects happening in our city.

As Puerto Ricans *en la Florida Central*, an area that encompasses cities like Orlando, Kissimmee, Sanford, Clermont, Oviedo, Daytona Beach, Port Orange, and more, grow in size and power, our artists have historically had to leave in order to create works that are artistically and financially rewarding. Those who stay fight to be recognized in a small but growing visual art scene built on engaging tourists rather than locals and constricted by stringent city public-art ordinances, painfully low wages, and shamefully inadequate promotion.

In the three decades since the first mass migration of Puerto Ricans to the Greater Orlando Area in the 1990s, there have been attempts to create Puerto Rican visual art spaces, but many of these movements have been short-lived. Oftentimes, these projects are halted by the socioeconomic realities of life in a Boricua refuge city where many work multiple jobs to keep roofs over their heads and struggle with untreated mental health conditions rooted in the traumatic displacements that forced them to find sanctuary in Orlando's gator-abundant wetlands.

But, in the words of Orlando-raised Puerto Rican musical artist Luis Fonsi, change comes *despacito*. In the past five years, Puerto Rican art professionals have relocated to Orlando and have worked to insert Boricua art, artists, art history, and art dialogue into university curriculums and museum exhibitions. Meanwhile, young people, often the children and grandchildren of the early migrants, have been developing a grassroots Boricua art movement centering and uplifting their distinct experiences as *puertorriqueños* in the Dirty South.

In order to understand Puerto Rican visual art culture in Central Florida, it's necessary to look at the history of Puerto Rican migration to the Greater Orlando Area, including when migration started, what precipitated this resettling, and life in Borilando.

In many ways, Puerto Rican migration to Central Florida corresponds with the transformation of the region from a small town built around cattle ranches and orange groves to a global city with world-renowned theme parks and an out-of-this-world aerospace industry. In her research on the Puerto Rican diaspora in Central Florida, anthropologist Patricia Silver found that the first known Puerto Ricans in the region arrived in the 1940s.[1] Many of those early migrants were Puerto Rican servicemen, Disney employees, and engineers who worked at the Kennedy Space Center. The first mass migration to Central Florida came in the late 1980s and early 1990s, when more than forty thousand Boricuas made the Metro Orlando Area their home.[2] At the time, Puerto Ricans were arriving in balanced numbers from both the archipelago and other diasporic communities like New York and Massachusetts, largely due to job insecurity, violence, and gentrification.

Migration from the archipelago to Central Florida hasn't slowed since. A $70 billion debt that crashed the Puerto Rican economy forced tens of thousands of Boricuas to leave for Central Florida in the early 2010s, while a devastating string of natural disasters, including the category 4 Hurricane Maria, brought in hundreds of thousands of new arrivals later in the decade.[3] Today, there are more than one million Puerto Ricans in the state and more than half of them live in Central Florida, accounting for one of the largest and the fastest-growing Puerto Rican populations in the country.

But life near the magical world of Disney hasn't exactly been idyllic. Poverty, unemployment, and homelessness is higher among Puerto Ricans in Central Florida than anywhere else in the state. According to a 2016 study by the Hispanic Federation, Boricuas in the region are more likely to work in unstable, low-paying blue-collar jobs than white-collar jobs like their counterparts in South Florida.[4] After the hurricanes, a University of Miami study found that the so-called Maria generation in Central Florida had a harder time finding jobs, housing, and transportation than in South Florida.[5] With a housing crisis in the region, hundreds of people were forced to stay months in roach-infested extended-stay motels in the shadows of Disney World.[6] Years later, the community is still reeling. While many refugees who left the archipelago have since returned, that

same report found that those who landed in Central Florida were more likely to have lost their homes and had nothing to return to. They are now among residents in the Orlando-Kissimmee-Sanford area experiencing the worst affordable housing crisis in the country.[7]

Since most Puerto Ricans came to the Greater Orlando area to escape natural, financial, political, social, and colonial upheaval in Puerto Rico and other US cities, Boricua locals often consider it a sanctuary city, a refuge where we received a second chance. But here, with traumas untreated, *la brega* (struggle) continues in new ways. Working multiple jobs to afford sharing three-bedroom apartments with other relatives and burnt out from life under the blistering Florida sun, there is often no time, money, or energy left for leisure or passion. For many, it's simply not possible for the growing diaspora to keep our heads above water—let alone cultivate a visual culture that mirrors that of other Puerto Rican barrios in the United States.

The Struggling Artist(ic Scene)

But the onus isn't on the fatigued. Doing art in Orlando is, itself, a struggle—especially for artists of color.

While Orlando has long had bustling animation and performing art scenes tied to theme parks and a music industry that bred some of the hottest acts in pop history (e.g., Backstreet Boys and NSYNC), its visual arts industry has historically been much smaller. Unlike older northeastern cities like New York, Boston, and Philadelphia, which boast highly respected cultural institutions funded by old-moneyed philanthropists, Orlando hasn't always invested in the arts.

In fact, for several years, art and music classes were not offered in every school in Orange County. Growing up in West Orlando, artists Mariah Román and Nathaly Ruiz didn't have access to art programs at their public school. "It was always short-lived," Román, whose parents are from Puerto Rico and the Virgin Islands, says. Some semesters it was active; other times it was not. "We had to go to college to really get exposed to art and to the idea that people all around the world can become artists. But we had to travel and leave Orlando to see this."[8] Currently, as Florida battles a shortage of teachers due to the state's scrutiny on classroom instruction and the second-worst average teacher's salary in the nation, art teachers are, again, hard to hold onto.[9]

Moreover, those who graduate from art programs at the University of Central Florida, Rollins College, Valencia College, or Full Sail University find

themselves applying for jobs outside the city or the state in order to land gigs with livable wages. Poinciana-raised Puerto Rican–Dominican artist Yessenia Lantigua graduated from Valencia College in 2010 with a graphic design technology degree. She started her career in the field in Chicago and New York, working with Puerto Rican cultural organizers and social justice organizations. After years of building a portfolio and Rolodex of clients, she packed her bags and headed to Orlando, where she could continue working virtually while being closer to home. But once Lantigua updated her résumé and LinkedIn page from New York to Orlando, rates for jobs dropped. Shocked that new clients wanted to pay her less, she temporarily changed the location on her vita back to New York and suddenly discovered that organizations and brands were agreeing to pay her rate again. "Artists here are so talented, but our value goes down by just being here. Orlando artists aren't respected because our city doesn't have the institutions or the money that exists in these other cities. It's unfair. We have some of the most talented artists around, across mediums, but we don't get the opportunities that others do," she says.[10] According to Indeed, the average artist in Orlando gets paid $17.23 an hour compared to a New York artist's $30.55 an hour.

Those who are unable to leave or who choose to stay often pursue unrelated careers while making art a passion side project or work for low-paying creative agencies or the massive animation and theme park industries. In Orlando, the tourism industry is the lifeblood of the economy. The theme park capital of the world, Central Florida is home to Walt Disney World, Universal Studios Orlando, SeaWorld Orlando, and a myriad of other amusement parks and entertainment options. Nearby, attractions like Port Canaveral, calm beaches, crystal-clear springs, and wetlands also bring in visitors from across the world. Orlando averages about seventy-five million visitors a year—among the highest in the nation—generating more than $75.2 billion in annual economic impact for Central Florida. Even more, this tourism supports 41 percent of the region's workforce with more than 463,000 jobs.[11]

The impact the amusement park industry has in Orlando is felt everywhere, including the art scene. The world-famous attractions are put together by teams of extremely talented and largely underpaid local artists, animators, architects, engineers, designers, producers, builders, writers, and performers. Moreover, the industry's influence informs the art programs at universities and colleges throughout Central Florida. For instance, the University of Central Florida's Center for Emerging Media features one of the largest motion-capture studios on the East Coast and has helped make Orlando a national center of video game production.

While the parks have offered employment, education, and visibility to countless Orlando artists, tourism has also dictated the kind of art that is made in Central Florida. Historically, public art in Orlando has been created for tourists rather than the people who live and work in the city. As a result, public works are overwhelmingly apolitical. This has made it difficult for artists like Ricky Rodriguez, whose work as an illustrator, graphic designer, and muralist is tied to social and political activism, to sustain in Orlando. Born and raised in West Orlando, the Puerto Rican–Mexican artist moved to Durham, North Carolina, after graduating with a bachelor of fine arts (BFA) from the University of Central Florida in 2016 in part because of the hold the tourist industry has on the art scene in the city. "It's hard to navigate as a Boricua artist in Orlando trying to get that Disney money. The commercial art industry tears your soul apart, and I didn't want that. I wanted to be able to keep my integrity," says Rodriguez, who confesses his heart remains in Orlando.[12] He continues to support local organizations, doing racial and immigration justice work with graphic design from afar.

Across the city, colorful murals of Florida's flora and fauna and delightful cartoons of mystical figures perpetuate the myth of an idyllic Southern town built on magic and entertainment. Erased is the region's history of the Seminole Wars, the Ocoee massacre, and the homeless Boricuas begging for bread and sanctuary outside Disney World. Removed are the histories of the all-Black incorporated cities in Central Florida—Eatonville and Goldsboro—as well as the narratives of the influx of Puerto Rican, Venezuelan, Colombian, Dominican, Brazilian, Haitian, Cuban, Peruvian, Mexican, and Honduran migrants who have turned Orlando into one of the fastest-growing and diverse Latine communities in the country. "This apolitical art scene is not true to Orlando and it's not sustainable. We're creating something palatable for outsiders, for profit, but it's just a mask. It's not even owned by our people," Rodriguez says. "But people are trying, and things are changing."[13]

A Fight to Be Seen and Heard

For the past decade, local government and Central Florida–based philanthropists have begun investing more deeply into the region's visual arts, creating more opportunities for artists outside of the theme park and animation industries. The city's most distinguished art museums, Orlando Museum of Art, Mennello Museum of American Art, and Rollins Museum of Art, have or are currently undergoing multimillion-dollar expansions.[14]

Art galleries are popping up across Downtown Orlando. And the city of Orlando, like other local governments in Central Florida, offers incentive programs for developers if they include public art in their projects.

Unfortunately, local artists of color haven't reaped much of the benefits of the city's investment in the arts. In the budding art scenes in Downtown Orlando, Mills 50, the Milk District, and Lake Nona, even art that is created with the intention of celebrating diversity in the city is led by non-Latine white, often male, artists from abroad. For instance, after the anti-LGBTQ shooting at Pulse nightclub in Orlando in 2016, which claimed the lives of forty-nine people, public art honoring the lives lost and affected popped up across the city. But most of them failed to represent the people who were targeted that fatal night: queer Latines, predominantly Puerto Ricans. Unsurprisingly, the most popular murals—*Inspiration Orlando* by Michael Pilato, *LOVE* by Michael Owen, and *Diversity Mural* by Jennifer Kuhns and Cherie Bosela—were all created by white artists who are not based in Central Florida.

More recently, a mural was installed in an overwhelmingly Puerto Rican neighborhood in East Orlando, aimed at celebrating the Latin American culture and cuisine available on a strip nicknamed the Gateway District. The wall located off Curry Ford Road and Semoran Boulevard reads "Bienvenido a Gateway, Orlando," with various Latin American flags and foods like tacos and Cuban bread sprawled around it. The cartoonish mural was led by two non-Latine white men, including Denver, Colorado–based artist Harry Foreman and Miami-based Cavan Koebel.

Instances like these aren't unique in Orlando. While the city is teeming with talented artists of color who are eager to create works that celebrate the nuances of their communities, including world-renowned Puerto Rican artists like muralist Don Rimx, sculptor Rigoberto Torres, and fine artist Pedro Brull, public-art opportunities are often given to outsiders with little understanding of the neighborhoods they are doing work in. "Our city is always trying to bring in international artists and talent, but they don't realize that to the world we are international. Orlando is an international city and we need to start seeing our artists this way, too," Román says.[15]

For the past three years, Roman and Ruiz, cofounders of a local arts organization called Art of Collab, have been trying to create Puerto Rican and Latine public art projects across Orlando, but those efforts have been stalled by the COVID-19 pandemic and a lack of access to funds—a problem they say impedes many Black- and Latine-run art initiatives in the city. "You see this with Black and Brown groups here all the time," Román

says.[16] "There's a learning curve because we don't have access to mentors. It's hard to grow because we don't have 501c3 status, so we don't have access to grants. We are extremely talented here, but we're all grinding in our 9-to-5s so we can maybe put out one work a year."[17]

Similar hurdles have suspended other efforts by local Puerto Rican artists and art groups, including La Diaspora, a collective of Puerto Rican fine artists in Central Florida that included heavyweights like Pedro Brull, Yasir Nieves, Carmen Rojas Ginés, and Denisse Berlingheri; as well as Arte Boríkua, a former art gallery in East Orlando that sold works by local Boricua artists and artisans and held artistic events. For muralists, another hindrance is finding businesses open to working with Black and Latine artists. Oftentimes, owners of the buildings that house Puerto Rican businesses are white and aren't willing to have their facilities represent the people and culture of the neighborhoods they profit from.

In 2020, the *Orlando Sentinel*'s arts and culture writer Matthew J. Palm started a series called "Race and Space: Making Orlando Arts More Inclusive," which looked at issues surrounding equity for people of color within Orlando's arts scene. In one report, the newspaper found that the lack of access artists of color have to art grants and opportunities in Central Florida is connected to the dearth of people of color in offices, boardrooms, and museum galleries. While more than 50 percent of residents in Orange, Seminole, Osceola, and Lake Counties identify as people of color, a survey of about twenty Central Florida arts organizations' boards of directors showed approximately 22 percent of members identified as people of color.[18]

In Winter Park, a suburb outside Orlando, Gisela Carbonell is one of a small number of women of color diversifying Central Florida's museum management. As the curator at the Rollins Museum of Art, Carbonell leads collection scholarship as well as exhibitions, acquisitions, research, and publications. In her role, the Puerto Rico–born and educated curator has been key in expanding the museum's collection to include works by Puerto Rican artists and creating programs aimed at bringing Spanish-speaking communities into the museum space. Before Carbonell arrived in 2018, Rollins Museum of Art did not have a single piece by a Puerto Rican artist in its permanent collection. Now, the institution has more than a dozen, including works by Antonio Martorell, Frances Gallardo, Carlos Dávila Rinaldo, Rafael Trelles, Elsa Meléndez, Wanda Raimundi-Ortiz, Daniel Lind-Ramos, and Myrna Báez. Many of the pieces speak to Hurricane Maria, the realities of relief under colonialism, environmental justice, and Black resilience, themes Puerto Ricans in Central Florida can relate to and see themselves in.

"The largest Puerto Rican population outside the island is here, and our artists need to be represented if we want people to come into the museum," Carbonell says. "People who are from the island come and see themselves in these works, see they are seen and validated. Museum walls are saying this is valuable, this matters, and not just because it's expensive. People who live in this area need to see that this is important."[19]

To encourage community members to engage with the works at Rollins Museum of Art, Carbonell launched Arte y Café con la Curadora, a once-a-month free event where Carbonell leads a Spanish-language tour of the museum and speaks with guests about the artists and works on display over coffee and *quesitos* sponsored by Café Don Juan, which opened its first café outside the archipelago in Winter Park in 2022. Carbonell hopes to also launch Spanish-language events that give the community access to private viewings of works by Puerto Rican and Latine artists in the Rollins collection that aren't on display. "I'm here. I have the opportunity. I have the space, the resources, the support, and the connections. I have to do this work. Not because anyone expects it of me but rather because I can't imagine not having this access and not using it in this way," she says.[20]

She's not alone in this pursuit. In 2019, former University of Central Florida associate professor Wanda Raimundi-Ortiz led a procession through Downtown Orlando called *Exodus/Pilgrimage*, calling attention to the forced migration of thousands of Puerto Ricans to Orlando after Maria and the trauma they came with and insufficient housing they received in the city. Partnering with UCF Celebrates the Arts, an annual festival showcasing the creativity, innovation, and collaboration across the University of Central Florida, she wore a gown made of debris collected from Puerto Rico after the hurricane during a mile-long journey where she was joined by community members and *pleneros* who performed folkloric Puerto Rican music (see figure 12.1). At the end, they all gathered at the Dr. Phillips Center for the Performing Arts, where Raimundi-Ortiz performed a dance to the beat of Afro–Puerto Rican bomba drummers.

"I was hearing about Puerto Rican families in single-hotel rooms being passed by all these people to get to the so-called Happiest Place on Earth, and I was mad. I wanted to refocus the attention on the people here who were struggling," says the New York–born artist and educator, who recently moved from Orlando to Virginia to teach at George Mason University.[21]

While the powerful procession is still talked about years later, the experience showed Raimundi-Ortiz why a city with a Puerto Rican population as vast as Orlando fails to have a prominent Puerto Rican visual arts scene.

12.1 Wanda Raimundi-Ortiz during her procession *Exodus/Pilgrimage* in downtown Orlando, 2019. Courtesy of the artist. Photo by Dominic DiPaolo.

Even as a professor at the largest university in the city and state, she had to fight for access and visibility. For instance, when she was planning the performance, the Dr. Phillips Center for the Performing Arts initially did not want to allow community members participating in the walk to enter the building for the *bombazo*.

"Part of why it's been slow to grow a Puerto Rican arts scene in Orlando is because it's hard for rebellious work to flourish there," she says. "It's the South. It's hostile terrain. In New York, you can throw pieces under a bridge. In Orlando, you'll get in trouble right away. And you don't want to get in trouble in Florida. There are a lot of lakes and a lot of missing people."[22]

Even more, the performance received little to no media attention, which led to a smaller crowd than expected in a largely Boricua city like Orlando.

Attendance is a common problem for Puerto Rican artistic events in the city. Unlike New York's El Barrio or Chicago's Humboldt Park, Puerto Ricans in Central Florida live in about a five- or six-county area slightly larger than the mainland of Puerto Rico, and public transportation is limited to a non-expansive Lynx bus system and the sixteen-station SunRail. In short, Puerto Ricans in Poinciana aren't driving to Downtown Orlando for an evening, and Boricuas in East Orlando are skipping the event in Kissimmee.

According to Raimundi-Ortiz, geography, red tape, and Southern intimidation are among the biggest hurdles to establishing a vibrant and sustainable visual arts scene in Borilando: "It's a vacation spot. It's a genteel Southern city. It's a land of Disney celebration, of sweetness, magic, and wonder. The city doesn't want tourists to feel bad. But there's a throbbing ache."[23]

The Rise of Grassroots Community Boricua Art

That pulsating frustration is felt by first- and second-generation Puerto Rican young people who watched their parents and grandparents struggle in a city boasting Puerto Rican people but limited power and influence, by Boricua professionals and creatives who had to leave a city they love to do work they love, and by Central Florida Boricuas who have decided it's time to be acknowledged for bringing the *magia* to the Most Magical Place on Earth.

In the past five years, grassroots Puerto Rican–led arts initiatives have sprouted up throughout Central Florida. In West Orlando, Art of Collab is a group of local artists and creatives who spark community and collaboration to create intentional visual and performing arts in places and spaces where this work is rare. Founded in 2019, Art of Collab leads pop-up events that bring Black and Latine artists together as well as mural projects that beautify neighborhoods with the stories of the people who compose them. In 2020, Art of Collab organized the "Rise" Mural Project in Eatonville, a historically Black town in Orange County. It gathered seven local artists and six poets with the community to create a mural that tells the story of one of the first self-governing all-Black municipalities in the United States. The stunning piece stretches along a wall located at a basketball court in Elizabeth Park and includes words from poets as well as a mural of author Zora Neale Hurston, a figure of the Harlem Renaissance who called Eatonville home.

"In a lot of our communities, we don't have access to museums or galleries, so we create mural projects for communities to see art that they can see themselves in," says Nathaly Ruiz, an Orlando-based Puerto Rican–Colombian artist and cofounder of Art of Collab. "By working with local

artists and people in these neighborhoods, it gives them a sense of community and ownership."[24]

Next, the group hopes to bring a community-led mural project to East Orlando that speaks to the Puerto Rican and Latine diasporas that have transformed the city. "It's about feeling represented, feeling seen, and that we are a part of the cultural landscape of this city," Román adds. "That's what we want to bring. We know that there is a strong Puerto Rican presence in East Orlando. But it's not seen in the arts. There should be sculptures and murals that honor our presence and culture in East Orlando, but there's not."[25]

Some efforts have been made, however. In 2017, New York–born, Orlando-based Puerto Rican artist and curator Caster Nova founded WestART Walls, an outdoor gallery in Downtown Orlando featuring street art from artists all over the world but predominantly from Central Florida. At the corner of Central Boulevard and North Westmoreland Drive, some of the walls speak to the Puerto Rican presence and experience in the region. One of the walls most visible to drivers passing through the area includes a giant black-and-white Puerto Rican flag painted by Orlando Boricua artist Adrian Fragoso after Hurricanes Irma and Maria devastated the archipelago and brought hundreds of thousands of Puerto Ricans to the area (see figure 12.2).

According to Nova, the goal of WestART Walls is to show locals and tourists that Central Florida is more than amusement parks. There are communities here that are vibrant and worth celebrating. "A lot of the people from around the world, they come here for the parks, but then they want to do something different. There's a lot of talent here. It's about Orlando, it's about the artists, it's about the community—giving back," Nova told local news site Click Orlando in 2018.[26]

In 2019, after the city launched a Traffic Art Box program aimed at transforming utility boxes that contain the electronics for the traffic lights as a canvas for amazing art, New York–born and Altamonte Springs–based Puerto Rican–Dominican artist Vanessa Flores applied to paint a box in Downtown Orlando's Milk District. Her mural, *Locura Lucida*, on the box at Central Boulevard and Primrose Drive, features *vejigantes*, a folkloric character in Puerto Rican festival celebrations (see figure 12.3). "The history of *vejigantes*, which come from Spain, is awful, but we turned it into rebellion, cultural pride, and joy, and that's what I think about the Puerto Rican community here," Flores says, alluding to the traumatic displacements that led Boricuas to Central Florida.[27] While she was painting the box, Puerto Ricans stopped by, asking if the figures she was sketching were *vejigantes* and thanking her for bringing *la isla* into the neighborhood.

12.2 Adrian Fragoso, mural of a black-and-
white Puerto Rican flag at WestART
Walls, Orlando, ca. 2018. Courtesy of the
artist.

A year later, in 2020, the Boricua community of Azalea Park in East Or-
lando joined Alianza for Progress, a Florida-based Puerto Rican nonprofit,
in a fight to rename a local middle school from Stonewall Jackson, the Con-
federate general, to Roberto Clemente, the Black Puerto Rican baseball
hero.[28] After the community won the crusade, Orlando Puerto Rican artist
Neysa Millán volunteered to paint a mural on the campus. The piece shows
Clemente in different aspects of his life: as a right fielder for the Pittsburgh
Pirates, a father, a husband, and a humanitarian (see figure 12.4). Sprawled
over the vignettes is one of Clemente's most popular quotes: "Anytime you

12.3 Vanessa Flores, *Locura Lucida*, a mural of *vejigantes* on a utility box in Orlando, 2019. Courtesy of the artist.

have an opportunity to make a difference in this world and you don't, then you are wasting your time on earth." The artist, Millán, says, "It's hard to be an artist in Orlando. We are truly starving artists, constantly struggling. But we want to get a good message across. We want to inspire people. We want to beautify our city. This was for the school. It was for the kids, for the community. It was for the culture, and that means a lot."[29]

As muralists fight to have public spaces in Puerto Rican neighborhoods reflect the experiences, culture, and faces of those who inhabit them, other Puerto Rican art organizations have been working to build community,

12.4 Neysa Millán, mural of Roberto Clemente in East Orlando, 2021. Photo courtesy of the artist.

showcase local talent, and inspire young people. Inside Orlando's Fashion Square Mall, Puerto Rican social entrepreneur Samí Haiman-Marrero created Casa Culture, a coworking space for Black and Latine artists, activists, and entrepreneurs that includes a meeting room with several computer stations, a studio for podcast and radio production, a wall painted green to serve as a greenscreen for video recordings, a tempered wall mirror for dance classes, an events space to host workshops for young people, and a gallery where the works of local artists are displayed. "There's so much talent in Central Florida, and so much diverse expressions of art, from sculptures, fine art, and photography to video, dance, theater, and music," says

12.5 Installation view of the multi-artist exhibition *Todos Somos Clemente* at Casa Culture in Orlando, 2023. Courtesy of Samí Haiman-Marrero.

Haiman-Marrero, a New York–born and Puerto Rico–raised media professional who also heads a communications agency and a nonprofit uplifting Puerto Rican and other marginalized communities in Orlando.[30]

Recently, Casa Culture exhibited pieces by Miguel Nicolai, a Puerto Rican painter and art teacher who migrated to Central Florida after Hurricane Maria. For years after he moved, Nicolai wasn't able to showcase his work. When Haiman-Marrero was made aware, she worked to secure a grant through her nonprofit that has allowed Nicolai to exhibit his pieces at Casa Culture, teach a workshop there to local youth, and design a parade float inspired by the municipality of Loíza at the 2023 Florida Puerto

Rican Day Parade and Festival in Downtown Orlando. Casa Culture has also hosted Puerto Rican art events, including the exhibit *Todos Somos Clemente*, which included works by local artists that embody the life, spirit, and legacy of the late athlete-humanitarian, as well as an Afro-Boricua art showcase that featured art by muralist Don Rimx and bomba performances by Tata Cepeda (see figure 12.5).

"I feel like the Puerto Rican art scene in Central Florida is like a sleeping lion. We know about it, but when the mainstream finds out, they're not going to know what hit them," Haiman-Marrero says. "When we grow in real estate, in having physical spaces where we can display the quality and magnificence of our artistic expression, it's game over. We're a sleeping lion on the brink of waking up, and we are going to roar."[31]

And the community is finding innovative ways to showcase art on the property they do have. On Orlando's Orange Blossom Trail, Angel Rivera found a creative way to display Puerto Rican art: his barbershop/art gallery, New Concept Barbershop. Rivera, who moved to Central Florida in 2012 to study art and picked up hair cutting to pay the bills, combined his passion with his skill when he cofounded the shop in 2016 with Gabriel Marrero. The barbershop has featured exhibits by Puerto Rican artists like Jose Feliciano, Joan Emanuelli Sanchez, Valentin Tirado Barreto, and more.

Borilando Is Art. Period

Making art in Central Florida is difficult. Period. Historically, the visual arts haven't been invested in here, and now that it's starting to be, many local Puerto Rican artists, like artists of color overall, are constricted by a lack of opportunities, low wages, limited art spaces, strict public-art ordinances, and a powerful tourist industry that informs the apolitical art that is propping up throughout the region.

Even still, Puerto Rican artists, art curators, art educators, and art aficionados are working to create a Borilando visual art culture. Similar to the young Nuyoricans of the 1960s and 1970s, who developed what is today recognized as Nuyorican arts and culture thirty years after the first mass migration to the city in the 1930s and 1940s, three decades after Boricuas first began arriving to Central Florida en mass in the 1990s, Borilando youth are creating works that validate the Puerto Rican experience *en el sur*—but they're doing it in a city that lacks prestigious and historic art institutions and spaces.

Through grassroots arts collectives, coworking spaces, galleries, and initiatives, Puerto Ricans *en la Florida Central* are imagining and creating

a Borilando visual art culture that is uniquely us. Under the Spanish moss and humid air, Spanish-speaking *puertorriqueños* and English-dominant Diasporicans from New York, New Jersey, Chicago, Philly, and Boston coalesce, exchanging language, style, and music while sharing space and experiences in unexpected and unfamiliar Southern terrain. Together, this merging of *la isla*, El Barrio, and the swamps gives birth to *arte boricua* with a Southern drawl. It's the vibrant *Sueños Naranja* mural by Orlando-based artist Don Rimx that merges the city of Downtown Orlando with the nature of Central Florida and the Puerto Rican spirit he brings to all his intricate pieces on the facade of the Electronic Arts building in Downtown Orlando. And it's also the bubble graffiti by Nuyorican artists at WestART Walls who bring the North to the South.

But Borilando visual art culture is also the string of food trucks off East Colonial named after different Puerto Rican municipalities. It's the Puerto Rican man wearing a gold chain necklace and thanking an injury attorney for his fat check on a billboard off Semoran. It's the "Se Vende Pasteles" posters along Dean Road and the *abuelitas* selling *limber* out of their garages in Sutton Ridge. It's the faded red mavi truck on Goldenrod. It's the mural inside the Mesón off Lee Vista that traces the franchise's first restaurant in Aguadilla to its latest three in Central Florida. It's the giant coqui next to that gator at the El Yunque Splash water park in Buenaventura Lakes. It's the Viejo San Juan–inspired interior design at Kissimmee's Plaza Del Sol. And it's the construction workers who hung the Puerto Rican flag atop the Cinderella Castle at Magic Kingdom. It's the way the Isla del Encanto and Diasporico bring magic to *Florida Central* daily.

In the words of local artist Don Rimx, "It's a new era, and it all takes time. But we're here to *mejorar*, to go *pa'lante*. I see what's happening in Orlando, y *estamos rompiendo*."[32]

NOTES

1 Silver, *Sunbelt Diaspora*.
2 Silver, "'Culture Is More than Bingo and Salsa.'"
3 Sesin, "Over 200,000 Puerto Ricans"; Gomez, Day, and Madhani, "Puerto Ricans Flee Island's Economic Mess for U.S."
4 "Latinos in Central Florida," Hispanic Federation, 2016. https://www .hispanicfederation.org/advocacy/reports/HFFloridaReport2016.pdf.
5 Scaramutti et al., "Mental Health Impact."

6 Sutter and Morris, "They Fled Maria."

7 Duerig, "Report."

8 Mariah Román, interview by the author, 2022.

9 Mueller, "Teachers Say Political Battles"; "Dozens of Orange Schools Lack Art," *Orlando Sentinel*, May 25, 2011, https://www.orlandosentinel.com/2011/05/25/dozens-of-orange-schools-lack-art-music-teachers-bvideob/.

10 Yessenia Lantigua, interview by the author, 2022.

11 "Orlando Announces Record 75 Million Visitors, Solidifies Ranking as No. 1 U.S. Travel Destination," Visit Orlando, May 9, 2019, https://www.visitorlando.com/media/press-releases/post/orlando-announces-record-75-million-visitors-solidifies-ranking-as-no-1-u-s-travel-destination/; Santana, "Visit Orlando Says Tourism Has $75.2 Billion in Economic Impact."

12 Ricky Rodriguez, interview by the author, 2022.

13 Rodriguez, interview by the author, 2022.

14 Palm, "Mennello Museum to 'Grow Up.'"

15 Román, interview by the author, 2022.

16 Román, interview by the author, 2022.

17 Román, interview by the author, 2022.

18 Palm, "It's Fear."

19 Gisela Carbonell, interview by the author, 2022.

20 Carbonell, interview by the author, 2022.

21 Wanda Raimundi-Ortiz, interview by the author, 2022.

22 Raimundi-Ortiz, interview by the author, 2022.

23 Raimundi-Ortiz, interview by the author, 2022.

24 Nathaly Ruiz, interview by the author, 2022.

25 Román, interview by the author, 2022.

26 Cardona, "This Art."

27 Vanessa Flores, interview by the author, 2022.

28 "#nameitclemente," Alianza for Progress, accessed April 26, 2024, https://alianza.org/petition/nameitclemente/.

29 Neysa Millán, interview by the author, 2022.

30 Samí Haiman-Marrero, interview by the author, 2022.

31 Haiman-Marrero, interview by the author, 2022.

32 Don Rimx, interview by the author, 2022.

BIBLIOGRAPHY

Cardona, Carolina. "This Art Is Making the City Beautiful Even More Attractive." Click Orlando, October 22, 2018. https://www.clickorlando.com/news/2018/10/22/this-art-is-making-the-city-beautiful-even-more-attractive/.

Duerig, Molly. "Report: Orlando Ties for the Country's Second-Worst Afford-able Housing Shortage." News 13, May 4, 2022. https://www.mynews13.com/fl/orlando/news/2022/05/04/orlando-suffers-from-country-s-second-worst-housing-shortage.

Gomez, Alan, Ashley Day, and Aamer Madhani. "Puerto Ricans Flee Island's Economic Mess for U.S." *USA Today*, August 25, 2015. https://www.usatoday.com/story/news/nation/2015/08/25/puerto-ricans-flee-islands-economic-mess-orlando/31301859/.

Mueller, Sarah. "Teachers Say Political Battles over Race, LGBTQ Issues, Are Driving Them out of Florida Classrooms." WFSU News, August 6, 2022. https://news.wfsu.org/wfsu-local-news/2022-08-06/teachers-say-political-battles-over-race-lgbtq-issues-are-driving-them-out-of-florida-classrooms.

Palm, Matthew J. "'It's Fear': Orlando's Arts Leadership Doesn't Reflect Region's Diversity." Orlando Sentinel, August 20, 2020. https://www.orlandosentinel.com/2020/08/19/its-fear-orlandos-arts-leadership-doesnt-reflect-regions-diversity/.

Palm, Matthew J. "Mennello Museum to 'Grow Up' with Dramatic Facelift in $20 Million Expansion." *Orlando Sentinel*, October 29, 2019.

Palm, Matthew J. "Orlando Arts Scene Needs to Get Its Diversity Act Together." *Orlando Sentinel*, December 5, 2020.

Santana, Marco. "Visit Orlando Says Tourism Has $75.2 Billion in Economic Impact." *Orlando Sentinel*, November 19, 2019.

Scaramutti, Carolina, Christopher P. Salas-Wright, Saskia R. Vos, and Seth J. Schwartz. "The Mental Health Impact of Hurricane Maria on Puerto Ricans in Puerto Rico and Florida." *Disaster Medicine and Public Health Prepared-ness* 13, no. 1 (February 2019): 24–27.

Sesin, Carmen. "Over 200,000 Puerto Ricans Have Arrived in Florida since Hur-ricane Maria." NBC News, November 30, 2017. https://www.nbcnews.com/news/latino/over-200-000-puerto-ricans-have-arrived-florida-hurricane-maria-n825111.

Silver, Patricia. "'Culture Is More Than Bingo and Salsa': Making Puertorrique-ñidad in Central Florida." CENTRO Journal 12, no. 1 (Spring 2010): 57–83.

Silver, Patricia. *Sunbelt Diaspora: Race, Class, and Latino Politics in Puerto Rican Orlando*. Austin: University of Texas Press, 2020.

Sutter, John D., and Jason Morris. "They Fled Maria in Puerto Rico; Now They're in Motels." CNN, April 20, 2018. https://www.cnn.com/2018/04/20/politics/sutter-puerto-rico-motel-misery-invs/index.html.

13

Abstractions between Puerto Rico and Chicago

An Ongoing Conversation about Nationalism and Nonrepresentational Art

Abdiel D. Segarra Ríos

Contexts and Places of Enunciation

Affirming cultural identity, understood in the sense of a static "purity," is a colonial inheritance.

Gerardo Mosquera, "Islas infinitas: Sobre arte, globalización y culturas" (2010)

The relationship of our archipelago with the city of Chicago is a decades-long bond in which we intersect with other diasporas and racialized communities with whom we have contributed to the political history of the city in various aspects.[1] At the same time, this context has provided particular

conditions for Puerto Rican and Diasporican artists to develop and convey different languages and approaches to contemporary art as Caribbean and Latinx migrants in the United States.

Given the purpose of this anthology and the task of historical reparation that involves incorporating the diaspora into the narratives of the history of art in Puerto Rico and the United States, it seems appropriate to bring abstract art into the discussion as an object of analysis in order to reflect on the place occupied by such vocabularies in the cultural imaginary and the production of national narratives in our territories and in the perception of the communities that live outside them. In the particular case of Puerto Rico, it is important to recognize that the historical narrative that has been legitimized is centered on artistic expressions of an emancipatory reclaiming that relied on figurative languages that affirmed essentialist visions of the nation. In the words of Arlene Dávila, "ideas and institutional structures geared at combating colonialism through the enhancement of Puerto Rican culture simultaneously served to reproduce some of the exclusions on which the nation was grounded."[2] As a consequence of these cultural and aesthetic parameters, a margin was created around the vocabularies embraced by institutional structures and indirectly overshadowed the contributions made from those practices and languages that were not explicit about the political struggle (pro-independence, anti-imperialist, anti-American, etc.) that for decades has circumscribed the view around the work of Puerto Rican artists and intellectuals inside and outside the archipelago.

Since then, abstract art has been inscribed in the perception of many as an art form that resists political enunciation. However, from my point of view, and that of the artists with whom I have had the opportunity to talk, there is something deeply political in abstract art that cuts across "national" codes of perception. Regarding how abstraction is perceived in the aesthetic imaginary of "Puerto Ricanness," it seems to me essential to quote the words of Nelson Rivera Rosario in response to the treatment that such languages have received: "The main thesis against Puerto Rican abstraction has been that abstraction as such is incapable of addressing issues pertinent to Puerto Rican art and society, specifically, to the definition of a national identity within the colonial context."[3]

Many artists, despite having been celebrated locally, up to a point, did not achieve sufficient visibility or recognition inside or outside Puerto Rico. Not that it is important for the conversation, but it can certainly be an invitation to reflect on how national memories are constructed and what are

the criteria that influence these processes. This exercise seeks to value the voices and experiences of artists as producers of languages that allow us to elaborate a critical framework through which to think "Puerto Ricanness" within a larger repertoire of more nuanced identities. The recognition of these nuances allows us to gain opacity, which, according to Martinican writer Édouard Glissant, goes beyond the right to difference and is, in any case, about "subsistence in a non-reducible singularity."[4]

However, from the perspective of nonwhite artists in the United States, the reclaiming of these languages is a political gesture in itself, questioning the structures that insist on promoting racist stereotypes about art made by people of color. In that sense, as Dávila states, "to do abstract art often involves battles to assert the right to produce work free of imposed expectations, constraints, or assumptions," even more so when one is part of a racialized minority.[5] To think in a situated way about the contributions made by diasporic artists is an opportunity to reflect on the distance and differences that add value and perspective regarding the places of enunciation inhabited by them, and the contrasts in terms of access, education, and challenges of circulation faced by their work. At the same time, reclaiming abstract art as a political territory implies an effort to transgress historical notions of national identification that insist on echoing outdated visions of antagonistic representations that depend on the continuity of the linear Western model of seeing and writing history as well as on circumscribing the notion of identity to the idea of nation.

The relationship between the School of the Art Institute of Chicago (SAIC) and the Puerto Rican art scene is extensive and prolific. Many Puerto Ricans have completed university degrees there as a result of a consistent transit of artists between the archipelago and the city. However, the experience of Puerto Ricans in this scenario is not exclusive to those who are pursuing a college degree. Some, like Candida Alvarez and Josué Pellot, are part of a diaspora that has grown and been formed there. Their idiosyncrasies bring a perspective that is informed by experiences of racialization very different from those shared by artists coming from Puerto Rico. This chapter highlights the contrasts between Puerto Rico and Chicago from the point of view of Nora Maité Nieves, Josué Pellot, Edra Soto, and Rafael Vega, all born in Puerto Rico. Nieves and Vega both completed master's degrees in the city and periodically migrated to New York, where they currently live and work. Pellot has lived in Chicago since the age of five. Soto arrived in the late 1990s as a student, but like Josué Pellot, she still lives and works in Chicago.

In several essays, I have referred to a series of questions that the curator Carla Acevedo-Yates posed with great eloquence in 2015 as part of the 1st Congress of Visual Arts on the occasion of the *16th National Arts Exhibit of the Puerto Rican Cultural Institute*.[6] "Where is the national frontier? How can we facilitate the dialogue between the contextual specificities of a visual production and the global scenario in which we participate? . . . How do we approach difference without essentializing it?"[7] It seems to me appropriate—and necessary—to continue reflecting on these questions as a way of positioning ourselves in the face of the erosion and crisis of nationalisms; and, at the same time, because I recognize that we cannot address the issue of making space and claiming visibility for the new diasporic and dissident identities without first questioning the structures (both material and symbolic) that reproduce the invisibility that we are trying to dismantle.

Subjectivity, Translation, Codes, and Patriotism

No identity but in hi-density proximity of buildings of bodies
more than proximity a propensity to shudder when faced with
the other in self

Urayoán Noel, *Hi-Density Politics*

Recently, Carlos Rivera Santana published an article analyzing the work of Ivelisse Jiménez, arguing for a decolonial view of her work that highlights its "opacity," physically and in terms of content. "In Jiménez's practice at large, decolonial abstraction depicts an intimate processing of colonialism and 'readability' through an oppositional view that celebrates the opacity of Puerto Rico's Caribbean, Latin American, and Latinx cultural condition."[8] Just as Rivera Santana argues about the intrinsically political relationship between abstract art and the colonial experience, others have argued precisely how the concerns of Black artists and artists of color have long charged abstract art with political content. Just as these artists are aware of the contradictions embodied in their research, both the rejection of figurativism and the blurring of the academic boundary between abstraction and realism inform their practice and the readings that derive from their work.

Even though in formal terms the work of Nieves, Pellot, Soto, and Vega are not related on a surface level, there are aspects that link them beyond the fact that they were born in Puerto Rico. As Cecilia Fajardo-Hill has stated, "It is outside of normative and pre-established (often indistinguishable)

conceptions of 'nation/identity,' 'home/house' and 'art' that it is possible for some artists to produce a work that transgresses cultural statements that are ultimately defined as binary and essential."[9] However, the exchanges in this chapter contain interesting comparisons between Chicago, New York, and Puerto Rico. In general terms, the testimonies reveal experiences of racism and cultural segregation as well as similarities and correspondences between the art circuits in San Juan and Chicago.

Some of the concepts that stood out during the conversations and the subsequent analysis of the interviews were subjectivity, translation, codes, and patriotism. Like the opacity proposed by Glissant and that Rivera Santana very lucidly evokes to comment on the work of Jiménez, these terms allow us to stop and reexamine specific aspects and instances about the relationship that each one of them approach between abstraction as a political and aesthetic path, its formalisms and the displacements of meaning that cross themselves and their work as migrants.

In the particular case of Nora Maité Nieves, the interview prompted reflection on "subjectivity" as a key piece for the development of a language of her own linking aspects of her personal life. This seemed especially relevant to me given that the validation processes faced by Puerto Ricans—other migrants and racialized people—in the United States are often mediated by voices and structures that do not recognize their contributions. To underscore the processes of identification of these artists and to insist on the relevance of their work inside and outside their territories of origin is to contemplate a crisis, not only in what we call "national aesthetics" but also about the notions of what/who is considered "other." So suggested Fajardo-Hill in her text "Mi casa no es mi casa" (My house is not my house) when she affirms: "Not belonging to the so-called ordered grid of an 'accepted' culture is an open possibility, not a closed door where the same ordering structure applies to everything called other."[10]

On that note, Nieves wonders if the expectations, imposed or inherited, that require us to fit into roles that continue to push our comments out of the mainstream are something from which we should periodically aspire to free ourselves as well. Nieves comments:

> That the work challenges these preliminary readings is a liberating act; what more political position than that of seeking freedom? . . . Which is the same thing that I feel connects me with Zilia Sánchez and Carmen Herrera. You see the work of some of them and you don't necessarily say "Cuba." It was an act of freedom to make

works that came from them, from the artist and her gaze, her way of thinking about the world we are living in, because we are more than a nation.[11]

In her work, Nieves usually invokes, both graphically and formally, decorative elements typical of the Puerto Rican urban environment in which she grew up. Glass and ornamental blocks, textures, plants, and patterns are some of the components that can be consistently identified in her paintings. Since her years as a student at the Escuela de Artes Plásticas, she has closely followed the work of painters such as Olga Albizu, Carmen Herrera, and Zilia Sánchez, all of whom migrated at some point in their careers and faced, to some extent, similar prejudices to those that Nieves has faced in the United States. Regardless of the link each of them had with their places of origin, their production, like Nieves's, approaches the experience from a path less mediated by the urgency of vindicating a fixed identity discourse. One example is the piece *Transitional Land* (2022), a large-format painting composed of three modules, two of them surrounding a smaller one that resembles the silhouette of an ornamental block very typical in Puerto Rico. The double image in high contrast suggests a tension that frames the relationship between the figures that enter and exit the background with a center piece that points from its interior to the corners; the position of the two exterior pieces conditions the reading of the center, not only by location but also by scale and proportion. This composition alludes both to the problematic relationship between the United States and Puerto Rico as well as to the position she inhabits between contexts and cultures as part of a diaspora that claims rights and visibility despite the colonial status that frames her enunciation place (see figure 13.1).

For his part, Rafael Vega reflects on the processes of translation to which he has subjected his work since he left Puerto Rico. His professional career, first in the field of science as a chemist and then in the art world as a painter, has guided him in the development of a methodology that guides his production. Throughout the interview, Vega underscored the permission—and validation—he gained for his work once he arrived in Chicago. The SAIC served as a stage for him to rehearse on a different scale the discursive independence from the conventions that frame the dialogues around art inside Puerto Rico. The distance, among other things, provided him with sufficient terrain to mature some of the pieces that would later be key in the development of his work. Tired to a certain extent of the demands for national reaffirmation, he found in this city—for a time—enough space

13.1 Nora Maité Nieves, *Transitional Land*, 2022. Acrylic, resin, gold-leaf, pigments, coarse pumice modeling paste, fiber paste, and Flashe on sintra, 3 panels: 70½ × 80 overall. Photo by Jason Haam. Courtesy of the artist.

to develop his vision without being required to prove his national identity in the academy. Vega comments on the matter: "What happens is that I come from the University of Puerto Rico, from a very formal tradition. Super craft oriented, and I found this freedom. For me it was like going back to the point when I was growing up in Yabucoa, where everything could be art. Where a cement stain on the floor could be art. Chicago offers me that opportunity."[12]

During the interview, the dialogue around his work led to a reflection on the "internal genealogy" that has followed the development of his work. We commented on the need to constantly adapt in order to avoid the intrusion of the market agenda in the development of his work. We also commented on how his production is also influenced, according to him, by instances of "invisibility, transit, camouflage, and immigration." This led us to consider "translation" as one of the tools that keep his practice in motion. "What would happen if I take the methodology as a mold and use it on another surface? I'm going to have another result. Translation is not literal. The magic of translation is in how you can take that text and bring it into this new context; and how the context works with that previous text."[13] Something similar happens in Nieves's work; both the artwork and the creative process indirectly refer to the movements that they, as part of a political minority in the United States, transit in the present. In other words, the visual language in each one of their paintings elaborates and resonates procedurally with the political negotiations that each one sustains with their physical and theoretical environment. The difference, perhaps, lies in the fact that Vega subjects the same elements to different processes, or only changes some variables in the equation in order to observe the changes that emerge in the result. Furthermore, the method can be as political as mathematics, if we take into account the place of enunciation that guides the artist and the circumstances that frame the work. We could say that Vega's aesthetics is the result of an exercise of self-determination through which the exercise of revisiting past compositions gives shape to a network of relationships that the artist wanted to reach without shortcuts (see figure 13.2). In that sense, Vega approaches his practice as an active observer seeking to make sense of that hypothetical cement stain on the floor of his childhood home in Yabucoa.

On the other hand, Josué Pellot and Edra Soto illuminate other nuances of the "Chicago-Rican" experience. Both have kept Chicago as their home and place of work, in Pellot's case since the age of five, when he migrated with his mother and brother, neither of whom knew any English.

Soto, like Nieves and Vega, came to the city to pursue a master's degree at SAIC, but her personal history led her to stay. Each in their own way has experienced segregation and racism, although unlike those who are just passing through, they have had to live with it. Both are active members of the community they live in, cultural agents who contribute with their work to transform the political and material conditions of their environment and the people with whom they share it.

Josué Pellot has made his career in Chicago in a close relationship with the art circuit in Puerto Rico. In an interview, we had the opportunity to go over some anecdotes that served to illustrate moments of breakthrough in his life that made him realize the difference between his experience as a Puerto Rican raised in the diaspora and those who grew up in the archipelago. Pellot relates how the idiosyncrasies that make up the Puerto Rican community in Chicago are deeply tied to the nationalist thinking of the Puerto Rican pro-independence left: "I feel the leaders of this community, like José López, they have strong roots on that militance era, so they continue with their education and they reflect what they lived. So then, kids tend to absorb the same energy— some 1950, right—they stay in the neighborhood because there was no other type of expression available, and on top of that, I fear that in this

13.2 (*from far left*) Rafael Vega, *Untitled*, 2011. Acrylic, spray paint on hard-board. | *Untitled*, 2015. Acrylic on wood panel. | *Untitled*, 2018. Acrylic, charcoal, canvas on wood panel. | *Untitled*, 2018. Acrylic, charcoal, canvas on wood. | *Untitled*, 2019. Acrylic, charcoal, canvas on wood panel. Each 24 × 18 in. Courtesy of the artist.

country the melting pot never melted, we just became blobs of other colors."[14] Throughout his work, Pellot interrogates assumptions of national identity through exercises that attempt to make evident the ambiguities that cut across identity codes. One of the anecdotes he shared perfectly illustrates this. He describes an encounter around his work with two Puerto Rican women from the island for whom his reference of identity did not meet the correct standards of authenticity. According to Pellot, the conversation went like this:

> —What's your art about?
> I wonder what I should talk about.
> —Do you know *malta* [malt beverage]?
> At the same time, they said: malta, mmm . . . It was such a good response. And then, one of the girls says to the other.
> —Yes, I'm Puerto Rican.
> That was mutual. I'm Puerto Rican too.
> —Yes, malta.
> —But, what do you mean?
> And the other girl said.
> —But, what *kind* of malta do you drink?

And I was, like, wait, what the hell is going on? This is a challenge now.

Then, one of them said:

—I drink Malta India [a brand of malt beverage popular in Puerto Rico]. *La India es de la isla* [Malta India is from the island].

If you drink anything besides Malta India, you're not authentic enough. You're almost *in*authentic.

—I was like, well, I like El Sol.[15]

El Sol is the brand of malt beverage that Josué drank in Chicago, a product made in the United States to be marketed and consumed by racialized populations. For his interlocutors, Malta India is the authentic brand, and its consumption is indicative of Puerto Ricanness. The misunderstanding between the two sides produces a short circuit in the code, something we would think all Puerto Ricans would share homogeneously. In this series, Pellot appropriates elements of the graphic identity of the El Sol brand and elaborates a series of geometric abstractions based on the label, alluding precisely to the ambiguity of the identity enunciated in that way in which suddenly, not drinking the right brand of malt casts doubt on the veracity of its national bond in the face of those who, because they were born in the territory, believe they have the authority on rubric to determine which experiences are, in this case, truly Puerto Rican and which are not. That stamp of ambiguity that frames their experience supposes a crisis in the "national" code. It is curious how Pellot narrates it when he recalls how he explained his intention behind the exercise of abstracting the graphic identity to his colleagues of US origin, who could not identify the reference of the label until it was shown to them. In that sense, the code is intrinsic to the experience and is only plural to the extent that it democratizes its references.

In a way, Pellot's work reminds us of the distance that exists and extends between the manifestations and contradictions within the Puerto Rican identity. An exercise of simple extraction such as the one he articulates in his pieces potentially activates a series of questions that put on the table the limits of the concept of authenticity with respect to what we understand as national identity, and consequently its adaptability. Ultimately, regardless of which brand of malt one or the other drank, drinking malt was still a Puerto Rican trait in that conversation. This echoes in a way what Fajardo-Hill states in her essay "Abstraction as a Language," "the acknowledgement that the meaning of images is not predetermined; . . . the related conviction that no image is natural, official or legible."[16] In that

sense, we could affirm that abstraction indeed is a language in itself, or at least an explicit intention of an ever-expanding crack that appears to us as fixed and determined.

Edra Soto has been based in Chicago for a little over twenty years; unlike, perhaps, the sense of Puerto Ricanness in the Chicago-Rican community that Pellot describes, Soto comes from a family in Puerto Rico that did not necessarily cultivate a national sentiment. However, her arrival and periodic integration into the diaspora brought her into contact with what she referred to as "patriotism" during the interview. When we talked about the place that Puerto Rican abstract artists occupy in the local imaginary in contrast with the recognition that some artists have achieved during the last few years in the United States, Soto affirmed that they have always been celebrated locally, as in the case of Daniel Lind Ramos. But when we commented on the work of Candida Alvarez, who was her advisor during her years at SAIC, we talked about the habits from within the island that insist on segregating and making invisible the work of those who, for one reason or another, do not live in Puerto Rico.

Soto describes herself as a conceptual artist who uses different processes and strategies to approach her production, one that often happens as a result of constant dialogue with other artists and professionals from different fields with whom she maintains dialogues that positively contaminate her practice without losing its autonomy or ceasing to be an exercise of reflection articulated from the artistic point of view. In her own words: "I think my art has activist concerns, but my voice is not a voice of protest, my voice is trying to encompass multiple voices."[17] As she tells us, a good example is the version of GRAFT (2022) that was part of the exhibition *no existe un mundo poshuracán: Puerto Rican Art in the Wake of Hurricane Maria*, presented at the Whitney Museum of American Art (see figure 13.3).[18] As part of her process, the artist invites other artists, historians, and architects to contribute to the content of the work, which in some ways imprints their voices on the piece without making it a historiographic exercise or an architectural piece. For Soto, it is important that she not be identified exclusively as a painter, nor that the perception of her work be limited to a specific style or methodology of work. That said, Soto's work can be seen through the lens that understands abstraction as a tool capable of recontextualizing the everyday, or in the words of Philip Brian Harper: "Abstractionist work invites us to question the 'naturalness' not only of aesthetic representation but also of the social facts to which it alludes, thereby opening them to active and potentially salutary revision."[19]

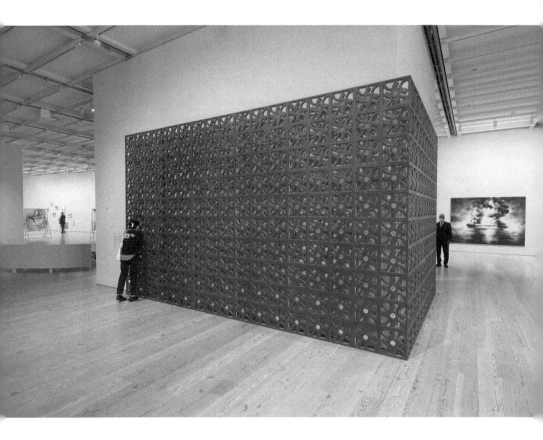

13.3 Edra Soto, *GRAFT,* 2022. Plywood, steel frames, latex enamel paint, spray paint, sand, varnish, viewfinders, inkjet prints, complementary Eng./Esp. pdf (*not visible*), dimensions variable. Installation view of *no existe un mundo poshuracán: Puerto Rican Art in the Wake of Hurricane Maria,* Whitney Museum of American Art, November 23, 2022–April 23, 2023. Collection of Whitney Museum of American Art , New York. Photo by James Prinz.

About the GRAFT project and the research, Soto articulates around the iron fence designs that are so common in Puerto Rican architecture. She narrates the particularities of the piece and why she does not present it in Puerto Rico.

> The GRAFT project is my way of representing my status as a migrant person. . . . GRAFT refers to a type of skin transplant in its literal meaning. I have been working on this project for more than a decade. In short, it is an architectural intervention, in which I cre-

ated a prompt—to take a decorative cinder block from Puerto Rico and transplant it to the US territory, with the purpose of inhabiting the space in a way that no one will doubt that I belong there. A basic feeling of "belonging" that a lot of artists talk about. It's an imaginary gesture, with a lot of physical rules. One of them is that I don't present this work in Puerto Rico. . . . Because I'm talking about something that exists in Puerto Rico, and what I'm proposing about the way we look at and understand the fencing and the decorative cinder blocks, or the vernacular architecture of Puerto Rico, is that we validate its African influence.[20]

Among the aspects that Soto highlights about her research, I find enlightening the link she draws between the designs employed in typical Puerto Rican blacksmithing with the Adinkra vocabulary of the Ghanaian region. The readings that derive from this piece reconfigure the perception of a formally abstract element in the Puerto Rican popular imaginary and politicize it, emphasizing the widespread ignorance that insists on erasing African contributions from the identity paradigm. In turn, the gesture of affirming their difference and sense of belonging through the exaltation of this root puts forth the intention of legitimizing its presence in the diaspora from a place that challenges the stereotype granted to Puerto Ricans as a subalternized population in the US racist imaginary.

Seen from here, this body of work activates a form of abstraction that Fajardo-Hill refers to in her most recent publication as "contingent abstraction" that "embodied tension and contradiction in its complex, often strange and unexpected, materiality and ideas."[21] Her approach to the subject links her to a form of abstraction that is interested in critically reviewing the relationship we have with our everyday environment, as a way of resisting invisibility and indifference by revealing the layers of political content that permeate our daily lives through the most common objects.

In 2019, Bianca Ortiz Declet, while living and working in Chicago, curated the show *Repatriation: A Cultural Exchange Project between Chicago and Puerto Rico*, an exhibition that brought together the work of ten contemporary artists of Puerto Rican origin based in the city. The show, in addition to proposing a reflection on the imaginaries that are modeled on the homeland through the migratory experience, materializes a bond of collaboration between local cultural institutions and the diaspora,

highlighting the need to make explicit in a bilateral way the exchanges that exist in this transit between cities.[22]

Thinking about the production of artists of Puerto Rican origin linked to the city of Chicago is essential, especially if we want to refer to the generations of artists who were formed between the 1980s and the present. In a way, this could help dispel the notion that automatically circumscribes—and reduces—the experience of the Puerto Rican diaspora to New York City. It seems appropriate to ask ourselves about the limits we reproduce when we insist on reducing the Puerto Rican experience to a singular totality (geography, national behavior, etc.). This demand reproduces the colonial frontier and biases the value of the contributions of the diaspora to the Puerto Rican artistic imaginary. In that sense, it would be worthwhile to approach the matter by considering the words of Ramón Grosfoguel: "From which location in the colonial divide is knowledge produced? Nationalist and colonialist discourses are thinking from a power position in the colonial divide of the modern/colonial world, while subaltern subjects are thinking from the subordinate side of the colonial difference."[23]

So, I wonder: What does abstract art enunciate? If we think about it carefully, it articulates a way of resisting identification through language; it is an accumulation of profoundly political gestures if we understand national identity—its more normative version—as a process of adaptation that seeks above all to homogenize the experience. It is important to recognize that the relationship between Puerto Rico and its diasporas, in the different cities of the United States and other territories, has never been entirely clear when it comes to valuing their contributions. The differences between one and the other, in terms of experience and with respect to the discourses they elaborate through their work, keep the idea of Puerto Rico and the conversations about identity at an honest and constant boiling point.

Geographic, demographic, and academic aspects (such as the location with respect to other major cultural centers, the scale of the city, the hegemony of SAIC, etc.) specific to the Chicago context make viable a sense of plurality with respect to the diasporic experience that diversifies the possible avenues through which the work of an artist of Puerto Rican or Latinx origin can claim a space.

In a certain way, the experiences accumulated by these artists testify to the possibility that has always existed of critically thinking the framework of identity representation and the subaltern paradox. Precisely because Chicago is not New York, perhaps the drive for affirmation, which in other

scenarios dominates the production of imaginaries, in this case allows the flourishing of approximations that, because they are abstract, do not pretend to confine or restrict reality or its perception.

NOTES

Epigraph: Mosquera, "Islas infinitas," 35.

1 For more information about the Puerto Rican diaspora in Chicago, see Velázquez, *Puerto Rican Chicago.*

2 Dávila, *Sponsored Identities,* 61.

3 Rivera Rosario, *Con urgencia,* 21.

4 Glissant, *Poética de la relación,* 221.

5 Dávila, "Nuyorican Identities," 109.

6 The *16th National Arts Exhibit* was held in the halls of the Antiguo Arsenal de la Marina Española and the Casa Blanca Museum. This edition, which was symbolically dedicated to the artists Olga Albizu and Zilia Sánchez, also included the celebration of the 1st Congress of Visual Arts that took place in the Amphitheater of the Museum of San Juan, and included the publication of the presentations in one of the issues of the *ICP* magazine, edited by Raquel Torres Arzola, who was also the organizer of the Congress.

7 Acevedo-Yates, "¿Qué nación?," 35.

8 Rivera Santana, "Puerto Rican Decolonial Abstraction."

9 Fajardo-Hill, "Mi casa no es mi casa," 59. Translation by the author.

10 Fajardo-Hill, "Mi casa no es mi casa," 60. Translation by the author.

11 Nora Maité Nieves, interview by the author, March 2022.

12 Rafael Vega, interview by the author, March 2022.

13 Vega, interview by the author, 2022.

14 Josué Pellot, interview by the author, October 2022.

15 Pellot, interview by the author, 2022.

16 Fajardo-Hill, *Remains—Tomorrow,* 159.

17 Edra Soto, interview by the author, November 2022.

18 In 2019, as part of the *Forgotten Forms* exhibition at the Chicago Cultural Center, Edra Soto presented an installation that is also part of the GRAFT series. This time, Soto shared the gallery with artist Yhelena Hall as part of a curatorial investigation that looks to everyday objects to reveal a much larger story about neighborhood identity, place making, and city life. I decided to reference the installation presented in the Whitney show and not this one since the show curated by Marcela Guerrero offers a more complete context about Puerto Rican art. See https://whitney.org/exhibitions/no-existe.

19 Harper, *Abstractionist Aesthetics*, 3.

20 Soto, interview by the author, 2022.

21 Fajardo-Hill, *Remains—Tomorrow*, 285.

22 The opening of an exhibition by curator Carla Acevedo-Yates at the Museum of Contemporary Art, Chicago, was announced as this chapter was being finalized. The exhibition *between horizons: Art Activism between Chicago and Puerto Rico* included works by Candida Alvarez, Elizam Escobar, Frank Espada, Rafael Ferrer, Carlos Flores, José Lerma, Ramón Miranda Beltrán, Nora Maité Nieves, Ángel Otero, nibia pastrana santiago and Eduardo Rosario, Marisol Plard Narváez, Edra Soto, Arnaldo Roche Rabell, Beatriz Santiago Muñoz, Bibiana Suárez, Sebastián Vallejo, and Omar Velázquez. The exhibition was open to the public from August 19, 2023, to May 5, 2024.

23 Grosfoguel, *Colonial Subjects*, 10.

BIBLIOGRAPHY

Acevedo-Yates, Carla. "¿Qué nación? La Muestra Nacional, métodos curatoriales y la producción de translocalidades en contracorriente." *Revista del ICP* 3, no. 3 (2015): 33–49.

Dávila, Arlene. "Nuyorican Abstract: Thinking through Candida Alvarez and Glendalys Medina." In *Women and Migration(s) II*, edited by Kalia Brooks, Cheryl Finley, Ellyn Toscano, and Deborah Willis, 107–116. Cambridge, UK: Open Book Publishers, 2022. https://books.openbookpublishers.com/10.11647/obp.0296.pdf.

Dávila, Arlene. *Sponsored Identities: Cultural Politics in Puerto Rico*. Philadelphia: Temple University Press, 1997.

Fajardo-Hill, Cecilia. "Mi casa no es mi casa: Imaginar lo transterritorial." In *Adiós Identidad: Arte y cultura desde América Latina*, edited by Gerardo Mosquera, 59–82. Madrid: Museo Extremaño e Iberamericano de Arte Contemporáneo, 2001.

Fajardo-Hill, Cecilia, ed. *Remains—Tomorrow: Themes in Contemporary Latin American Abstraction*. Berlin: Hatje Cantz Verlag, 2022.

Glissant, Édouard. *Poética de la relación*. Buenos Aires: Universidad Nacional de Quilmes Editorial, 2017.

Grosfoguel, Ramón. *Colonial Subjects: Puerto Ricans in a Global Perspective*. Oakland: University of California Press, 2003.

Harper, Phillip Biran. *Abstractionist Aesthetics: Artistic Form and Social Critique in African American Culture*. New York: New York University Press, 2015.

Mosquera, "Islas infinitas: Sobre arte, globalización y culturas." In *Caminar con el diablo: Textos sobre arte, internacionalismo y culturas*, 27–44. Madrid: EXIT Publicaciones, 2010.

Noel, Urayoán. *Hi-Density Politics*. New York: Blaze VOX, 2010.

Rivera Rosario, Nelson. *Con urgencia: Escritos sobre arte puertorriqueño contemporáneo*. San Juan: Editorial Universidad de Puerto Rico, 2009.

Rivera Santana, Carlos. "A Puerto Rican Decolonial Abstraction: The Right for Opacity in the Work of Ivelisse Jiménez." The Latinx Project, October 4, 2022. https://www.latinxproject.nyu.edu/intervenxions/a-puerto-rican-decolonial -abstraction-the-right-for-opacity-in-the-work-of-ivelisse-jimnez.

Velázquez, Mirelsie. *Puerto Rican Chicago: Schooling the City, 1940–1977*. Urbana: University of Illinois Press, 2022.

PART III

ALL OF THE ABOVE

DIASPORICAN AESTHETICS

14

Nuyorican Poets' Art
of Making Books

Urayoán Noel

The work of Nuyorican poets has been central to the formation of a US Latina/o/x literary corpus, yet little has been written about how these poets have, since the 1960s, challenged the category of the book through an *expanded field* of poetic practice inseparable from distinct modes of independent publishing, performance, and activism.[1] Previously, I have argued for poetry performance in and beyond spaces such as the Nuyorican Poets Café as a mode of embodied counterinstitutional critique that challenges the exclusion of diasporic Puerto Ricans from both US and Puerto Rican national imaginaries and from the institutions that shape these imaginaries.[2] What needs to be more clearly articulated is the extent

to which bookmaking of various kinds has been part of this embodied Nuyorican counterpolitics, from the 1960s to the present day.

Here, I offer a necessarily speculative and partial account of Nuyorican poets' art of making books as it complements but also expands on existing accounts of Nuyorican art within Latina/o/x art as itself marginalized within the art market and the academy and often either reduced to homogenizing 1960s social movement histories or deracinated from such histories.[3] In solidarity with the antihomogenizing analysis of Latinx studies critics, I understand Nuyorican poets' bookmaking practices as irreducible to either the formal category of the "artist book" as it has been institutionalized in art criticism or to important Puerto Rican and Latina/o/x studies criticism that has engaged Nuyorican poetry in terms of cultural identity.[4] Some of the examples I consider might fit within the institutional category of the artist book while many others probably would not, but my goal is not to simply legitimize Nuyorican poets by inserting their work into the realm of art criticism; rather, I want to honor the counterinstitutional political imagination of these poets by lingering with their books as a way of destabilizing institutional categories in both art and literary criticism. In art criticism, there is no widely agreed-upon distinction between artist's books, book art, bookworks, *libro objeto* (object book or book object), and so on, but for the purposes of this chapter, I am focusing on books (in the broad sense of the term) of Nuyorican poetry that seem to me of interest as art objects in their own right independent of the poetry, and especially those conceptualized and/or created by the author, whether solo or as part of a collaborative practice.

Following Rosalind Krauss, I am interested in reading Nuyorican poetry as an expanded field so as to emphasize the heterogeneity of a supposedly universal category (sculpture for Krauss; the artist book for me).[5] Closer to my argument is Ulises Carrión's "El arte nuevo de hacer libros," which argues for a move from writing texts that take the book for granted as sequential and full of identical pages to a new art of making books where intersubjective communication is not merely outside the book (in the poetry of the spoken or sung word) but in "un espacio concreto, real, físico—la página" (a concrete, real, physical space—the page).[6] For Carrión, the book should be approached as a structure in the context of linguistic transmission that creates specific reading conditions ("crea condiciones específicas de lectura") that the old art of making book ignores.[7] Thus, this new art of making books moves us beyond the book as a sequence of spaces and toward an engagement with how making a book enacts a parallel sequence of

signs in space and time. Carrión's relational approach to the book is key as it allows me to decenter the artist book as commodity or museum-worthy artifact and embrace instead a transversal approach to Nuyorican poets' bookmaking as it connects to performance, activism, and other modes of collaborative practice. At the same time, I value that Carrión's relational vision is not naively celebratory or democratizing; rather, it returns us to the conceptual question of what a book is or can be by highlighting how the concept of the book is necessarily historical and contextual, rooted in our differing perspectives and modes of embodiment.

The border between Nuyorican poetry and art has always been blurrier than our disciplinarily siloed criticism would have us believe, as evidenced by the figure of Jaime Carrero (1931–2013), whose work spanned painting, drawings, novels, and plays in addition to poetry. Carrero earned his undergraduate degree from the Interamerican University of Puerto Rico in San Germán and a master's degree from the Pratt Institute; he taught for decades at the former institution's art department, which he also chaired.[8] His often experimental work reflected on life between New York and Puerto Rico with a mixture of irony and social consciousness and with an ear for diasporic vernaculars that often translated into verbivocovisual explorations of the limits of the page.[9]

Carrero's short poetry book *Jet neorriqueño = Neo-Rican Jetliner*, published in San Germán in 1964, is often cited in academic histories as the first literary use and possible source of the terms *Neo-Rican* and *neorriqueño*, but for the most part, the object itself remains critically neglected. With its brevity and rustic binding, its minimal punctuation and capitalization, its street sensibility, its experiments with short, punchy poetic lines, and its embrace of the white space of the page in lieu of a more traditional layout, *Jet neorriqueño = Neo-Rican Jetliner* is arguably closer in spirit to the cheap yet irreverent and influential mimeograph poetry magazines that emerged on the Lower East Side of Manhattan in the 1960s and that Daniel Kane argues were crucial to the later development of a downtown poetry ecosystem of alternative publications and reading spaces, including the now iconic Poetry Project at Saint Mark's Church and, arguably, even the Nuyorican Poets Café in the next decade.[10] While I have no proof that Carrero was involved with this scene, the timing would have made sense, since Carrero studied art history at Columbia in 1962, around the time at least one other proto-Nuyorican poet, Jack Agüeros (later the director of El Museo del Barrio), appears to have been at least minimally involved with that scene, specifically with the readings at the coffeehouse

Les Deux Mégots and with then downtown fixture LeRoi Jones, later known as Amiri Baraka.[11]

Carrero's poetry echoes the verbivocovisual innovations of concrete poetry, yet *Jet neorriqueño = Neo-Rican Jetliner* seems less interested in the complex and contradictory strands of modernist institutionalization politics that so defined Brazilian concrete poetry in the 1950s as self-reflexive museum art, despite the book's publication being credited to Interamerican University in San Germán.[12] Instead, Carrero's book anticipates the streetwise, ironic, and radically translingual vernacular Nuyorican sensibility, so much so that Juan Flores famously claimed it as a work of proto-Nuyorican literature and Carrero as a "transitional" figure into the Nuyorican era.[13] We might also consider *Jet neorriqueño = Neo-Rican Jetliner* as anticipating the graphic innovations of later Carrero works such as *Notes of Nuyorican Seminar* (1972), whose comic-book sensibility and panel structure prefigure the increasing visibility of Nuyorican and Diasporican comic and graphic books, and a work that, in Patricia Herrera's words, innovates by "comically illustrating how Puerto Ricans in New York negotiate living between two cultures and languages."[14]

In contextualizing Carrero's articulation of a Nuyorican poetics at the experimental intersection of text and graphics, we could also go back to the work of poets Clemente Soto Vélez and Graciany Miranda Archilla, key figures in Puerto Rico's avant-garde movement atalayismo, which fused a vanguardist commitment to verbal and visual innovation with an irreverent revolutionary sensibility (the collective's original name, Atalaya de los Dioses, or Watchtower of the Gods, evokes the anarchic Romanticism of Friedrich Nietzsche). Both poets would establish themselves as key literary and cultural figures in postwar Puerto Rican New York City, in Soto Vélez's case due to his being prohibited from returning to Puerto Rico after being imprisoned in Pennsylvania on charges of sedition stemming from his militance with the Puerto Rican Nationalist Party. The atalayista combination of eccentric revolutionary art and poetry with revolutionary anti-colonial politics foreshadows the work of poets such as Pedro Pietri and Joey De Jesus.

The cover art of Miranda Archilla's 1930 atalayista landmark *Responso a mis poemas náufragos* (Requiem for my shipwrecked poems), by Afro–Puerto Rican poet, artist, and fellow Atalayista René Golman Trujillo, features a skeleton head looking off to one side over ocean waters, flanked by white clouds behind it and what look like beams of light underneath it, as if it were emerging from or descending into the water. Golman Trujillo's

art, together with the irreverent vitalism of Miranda Archilla's poetry, reads as a performative critique of a colonial necropolitics, where the sea is a site of death and for the exercise of power.[15] Later Miranda Archilla works—such as the self-translated English-language chapbook *Hungry Dust* (1988), featuring a rustic green cover with cursive lettering—expand on his search for poetry's vitalistic, quasi-mystical resonances against the trope of colonial bodies turned to dust.

Before the rise of the Nuyorican Poets Café in the mid-1970s, New York Puerto Rican poets were active participants in what has been dubbed the "mimeograph revolution": the emergence—facilitated by but not limited to the affordability of mimeograph publishing and connected to a culture of poetry readings and performances—of a wide range of independent poetry books and magazines between 1960 and 1980, strongly associated with the Lower East Side but with national and indeed hemispheric and global resonances.[16] At seventeen, the Puerto Rico–born and Lower East Side–raised Victor Hernández Cruz self-published his first book, *Papo Got His Gun! And Other Poems* (1966), on a mimeograph machine. Poems from the book were published in the prestigious, counterculturally aligned *Evergreen Review*, and the book provides important context for his work with the largely African American Umbra Poets Workshop as well as for the typographic and linguistic experiments that have made him one of the most celebrated living Puerto Rican poets.

The experimental use of the typewriter is key to the work of New York Puerto Rican poets emerging in the 1960s in conversation with or as part of the mimeograph revolution, including Hernández Cruz, Pedro Pietri, and Jesús Papoleto Meléndez. As a teenager, Meléndez began exploring a poetics of "cascadance," which involves laying out the poem on the page so that it appears to jump around or dance across it, its movements on the page echoing the cadences of the street vernacular that animates Meléndez's poems.[17] Meléndez's cascadence (like some of the more experimental works by Hernández Cruz) could be considered variants of what has been called "typewriter art," but it has a specific relationship to his performance practice, including his reading poems from scrolls that he proceeds to unfurl and that have been installed in art spaces such as Taller Boricua.[18] In these Meléndez works and in many other works of book art by Nuyorican poets of the 1960s and 1970s, the poem on the page functions as what Lorenzo Thomas calls, in the Black Arts poetry context, a score for a future performance.[19]

Unique in this context is the case of Frank Lima's first book, *Inventory*, published in 1964 by the Tibor de Nagy Gallery in Midtown Manhattan,

known for promoting key figures in midcentury New York art but also for publishing the work of the New York School of poets, of which Lima (1939–2013), raised in East Harlem of Puerto Rican and Mexican descent, was a part. Printed on yellow paper that evokes a composition notebook turned into an improvised ledger, *Inventory* is simple yet striking as an art object, heightening but also complicating the surrealist charge of Lima's raw urban dreamscapes. In the context of pop culture stereotypes such as *West Side Story*, it reads like a meditation on the impossibility of producing a proper inventory of New York Puerto Rican life in the mid-1960s.

The rise of the Nuyorican Poets Café would bring with it the 1975 publication of Miguel Algarín and Miguel Piñero's foundational anthology *Nuyorican Poetry* and of Piñero's celebrated play *Short Eyes*, both with major New York publishers. Still, the Nuyorican Poets Café would go on to establish its own press; its first published title, Algarín's defining poetry collection *Mongo Affair* (1978), featured illustrations by poet and visual artist Sandra María Esteves, a key Nuyorican figure whose import remains sorely underappreciated in Nuyorican art criticism despite her rich corpus of work and her many contributions to both the early Nuyorican Poets Café and the nearby New Rican Village, her long association with the Taller Boricua artists, and her earlier history of reading and organizing with the Young Lords, whose mimeograph-published newspaper *Palante* and assorted book and booklet publications should not be overlooked in histories of the mimeograph era.

Esteves's illustrations for *Mongo Affair* anticipate the poetics of Afro-Taino recovery of her seminal debut, *Yerba Buena: Dibujos y poemas* (Yerba Buena: Drawings and poems; 1980), which I have elsewhere discussed in the context of Yasmin Ramirez's important analysis of the work of the late Taller Boricua artist Jorge Soto Sánchez.[20] With their cultural syncretism, their play with shadows, and their elegant and vital depiction of female bodies, Esteves's black-and-white drawings in *Mongo Affair* and especially in *Yerba Buena* provide an important counter to the masculinist abjection of Algarín's early work and that of so many other male poets in the *Nuyorican Poetry* anthology. Patricia Herrera undertakes what is so far the most important and comprehensive project of archival restoration of Esteves's work across media, sourcing images and relevant history directly from Esteves to reconstruct key aspects of her pioneering work from an Afro-Nuyorican feminist perspective.[21]

What remains largely critically unremarked is Esteves's move toward self-publication of all her books of poetry following the 1990 release of her

Bluestown Mockingbird Mambo by Arte Público, a press at the forefront of Latina/o/x canon formation. While it was her first and only nationally distributed book and is the only physical book of hers still in print, Esteves was frustrated by the experience of publishing *Bluestown Mockingbird Mambo*, a book that did not showcase her visual art the way *Yerba Buena* had and that was saddled with a cover that infamously featured an image of a woman with her head cut off and wearing a frilly dress that shows off her legs.[22] As Esteves made clear to me, her choice to make and self-publish all her later books had to do partly with realigning her publishing process with her aesthetic and political principles and with allowing herself control over her work, including the freedom to showcase her art.[23] These later works, all self-published under the imprint No Frills Publications, live up to the "no frills" moniker with their modest word-processor design and short chapbook format, except for *Contrapunto in the Open Field* (1998), which is full-length and spiral-bound. With the informal, sketchbook feel of its spiral binding, its digital cover image of multicolored plants, and its poems about identity, nature, music, and healing, *Contrapunto* builds upon *Yerba Buena*'s Afro-feminist poetics and serves as a counterpoint to largely Anglo, white, and male institutional genealogies of experimental art and expanded field poetics.

Nuyorican poetry was also key to iconic photographer and artist Adál's imagining of abstractionist and conceptual aesthetics far removed from the Third World Marxist-inflected aesthetics and politics of Afro-Taino recovery we see in the early Esteves works. In his introduction to Adál's 1975 artist book of Surrealist, conceptual photographs *The Evidence of Things Not Seen*, Victor Hernández Cruz associates the power of art with "the turning inside out of the mind," evoking something akin to what Wilson Valentín-Escobar calls Adál's "bodega Surrealism" but also Hernández Cruz's own poetics of barrio phenomenology in his 1968 debut poetry collection, *Snaps*, with its snapshots of a surrealistically perceived urban reality as a mode of liberation from the burden of political and aesthetic representation.[24] The performance of a strategically blurred visibility links Hernández Cruz's famously abstract and experimental 1970s poetry to the conceptualism of *The Evidence of Things Not Seen* and of Adál's short-lived yet groundbreaking Foto Gallery in SoHo: both men left New York as teenagers for the Bay Area, where they collaborated with innovative Chicano artists and writers, and both developed sui generis aesthetics that blurred the boundary between street and avant-garde sensibilities. The fact that Hernández Cruz's introduction is presented in flowing cursive handwriting conveys

the phenomenological energy of this "turning inside out of the mind" while evoking Surrealist automatic writing as well as spiritualist traditions. Poetry and experimental writing were crucial to Adál's photographic practice, from his early images for Royal Chicano Air Force cofounder José Montoya's 1972 poetry book *El Sol y los de Abajo and Other R.C.A.F. Poems* to Adál's own 1981 "foto novela" (or photographic novel) *Falling Eyelids* and his Surrealist and processual text works.

Adál famously collaborated with poet Pedro Pietri, who also experimented with a barrio conceptualism in his homemade books, chapbooks, pamphlets, and book objects. Pietri's *Invisible Poetry* (1979)—a book of blank pages with a deliberately inaccurate author bio on the back that states Pietri is a native New Yorker born in Ponce, Puerto Rico, in 1898 and that *Invisible Poetry* took him ten years to write—recasts the fetishized first edition of a book into an either necropoetic or utopian "last edition" that costs seven dollars, a fortune in the 1970s for a book of stapled blank pages.[25] *Invisible Poetry* works as a Nuyorican readymade that challenges the institutionalization of Nuyorican literature and culture and that, in the spirit of Carrión, forces us to interrogate the very idea of a book through a confrontation with how and what we read in space and time. As I have argued elsewhere, *Invisible Poetry* has a blankness as its center point that, as Craig Dworkin puts it, can "reveal the field of poetic communication and textual information, overexposed."[26] However, while it shares with the works by John Cage, Carl Andre, and others that Dworkin analyzes a spirit of institutional critique in the manner of the avant-gardes, Pietri's book engages with historical and political contexts of the sort that formalist readings such as Dworkin's typically elide. By listing his birth year as 1898 instead of 1944, Pietri foregrounds Puerto Rico's history as booty in the Spanish American War but also evokes what he will call, in the manifesto that frames the original website for his El Puerto Rican Embassy multimedia collaboration with Adál, "a new 1898" where another sovereignty (of the imagination) is possible.[27] (Still, the historical record is not clear, as I found another edition of *Invisible Poetry* online that lacks the performative back cover bio and that appears to be inscribed and dated by Pietri on New Year's Day 1977.)

Even more radical is the massive, undated book-object *Public Execution*, which contains work dated from 1960 to the mid-1980s, and which the finding aid to the Pedro Pietri papers at the Center for Puerto Rican Studies archives describes as a text that "experimented with symbols and composition as a means to create alternative poetic forms."[28] In hundreds of pages that veer between typewriter art, asemic writing, translingual experiments,

14.1 Pedro Pietri, *Public Execution*, undated. Paper, plastic, and metal thumbtacks, 10 × 11½ in. Center for Puerto Rican Studies, Hunter College, CUNY, New York. Photo by Urayoán Noel.

Nuyorican performance text, found text from the New York City subway, and the permutations of conceptual writing, Pietri tests the reader's patience and the limits of legibility. Unforgettably, the oversize *Public Execution* features a spiky black cover that evokes bondage or torture gear, and the inside cover is full of metallic thumbtacks that extend the torture of the reading experience (see figure 14.1).[29] With its references to everything and everyone from the US invasion of Grenada to Pietri's mentor the oral poet or *declamador* Jorge "El Coco que habla" Brandon, *Public Execution* articulates a decolonial imaginary, yet it also challenges an instrumentalized poetics of protest or resistance through its overexposure (to use Dworkin's metaphor) of language on the page, as it fails to mean as we would want it to do. *Public Execution* embodies Carrión's suggestion that the new art

of making books is not relational in some facile, politically expedient way: as readers, we could get conned, offended, and even physically hurt as we navigate its massive tangle of spikes and thumbtacks.

The critical silence around *Public Execution*, and around Pietri's art of making books more generally, reflects the siloed nature of Puerto Rican and Latina/o/x literary and art criticism but also the way Pietri's reception has been overdetermined by the stature of his "Puerto Rican Obituary" as the poetic anthem of the Young Lords Party and by extension of the Puerto Rican movement of the 1960s and 1970s, even as the utopian necropoetics of the "Obituary" can and should be understood as part of a long exploration of colonial death and life-in-death. This exploration ranges from Pietri's earliest Vietnam poems through his Rent-a-Coffin performances and up to his late manifesto "Get the Fuck Out of Vieques" (2001), which was published as part of the Los Panfleteros poetry pamphlet series he coedited with Jesús Papoleto Meléndez and is intimately linked to their joint organizing of Nuyorican poets in solidarity with the struggle against US military occupation of the Puerto Rican island of Vieques. The unabashedly engagé politics of "Get the Fuck Out of Vieques" is of a piece with a *panfletero* (or pamphleteering) politics, ironically embracing the colloquial Puerto Rican use of *panfletero* (in lieu of the standard Spanish *panfletario* or propagandist) to refer pejoratively to someone with dogmatic (often Marxist) politics.

Pietri's art of making books reflects a punk-DIY sensibility in all its irreverent messiness. The cheeseburger-shaped object-poem "I Never Promised You a Cheeseburger," undated yet also issued as a Los Panfleteros pamphlet in 1997, is at times tear-inducingly funny and at times profound in its anthropophagous poetics of eating both reader and master, to my mind echoing the myth of Caliban and the decolonial vanguard politics of Oswald de Andrade's "Cannibalist Manifesto" (in the opening pages, Pietri urges the reader to eat the book's blank pages). Still, at other times, "I Never Promised You a Cheeseburger" feels like an artifact of an earlier time, full of fat jokes and gendered sexual humor that are begging for a rigorous feminist (and fat-studies) critique. A more politically sophisticated Pietri emerges in another homemade book, *Platonic Fucking for the 90s*, published with an attached condom and featuring performatively ugly, punctuation-less text in all-uppercase font that reads like one long scream about the violence of the AIDS crisis and the ongoing attempt to deny colonized bodies their desiring freedom.[30] Still, Pietri makes room for "MOMENTS OF ABSOLUTE SILENCE MINUS VIOLENCE" in what can also

be read as a manifesto of mourning where the deadly ravages of AIDS become sedimented onto the dead of colonial capitalism in a diasporic hall of mirrors.[31] With its attached condom, *Platonic Fucking for the 90s* also functions as performance documentation, given that throwing condoms into the audience was a trademark of Pietri's performances during this era. Significant in this context is Pietri's chapbook *Condom Poems 4 Sale One Size Fits All*, edited by Rojo Robles and produced as part of Lost and Found: The City University of New York (CUNY) Poetics Document Initiative. Per the publisher's website, this edition collects previously unpublished pieces from "a series of object-poems typed onto manila envelopes, each with a condom tucked inside called, 'Telephone Booth'" that Pietri gave away on the street and that serve as an "entry point into Pietri's boundless production" and his sex activism in particular.[32]

Beyond the collaboration with Meléndez on the Los Panfleteros series, Pietri also made books informally with others, including with poet and playwright Nancy Mercado, with whom he lived at one point. Mercado's early solo works include the self-published poetry collection *Illusions for Jubilance*, whose cover consists solely of a reflective plastic protector sheet. With its spare reflective cover complementing the spare vernacular of her poems and a "Table of Conscience" in lieu of a table of contents, Mercado echoes Pietri in using the metaliterary question of what makes a book to make us ask the broader question of what we think is real and why, given the false consciousness of capitalist society.[33] Mercado would go on to publish the book of poetry *It Concerns the Madness* and to publish younger generations of Nuyorican poets/performers, including Mariposa Fernández and Edwin Torres, as editor of the influential neo-Beat journal *Long Shot*. She earned a PhD from SUNY Binghamton and received the 2017 American Book Award for Lifetime Achievement.

The Nuyorican poetry scene of the early 1980s can be understood in a downtown context where the Lower East Side mimeograph revolution of the 1960s and 1970s gave way to the rise of a Loisaida/East Village zine culture tied to the flourishing of post-punk and hip-hop culture. An unheralded yet key figure in this Loisaida poetry scene is Manny (or M.D.) Lezcano, a Cuban American artist, musician, and independent publisher who knew Mercado from their days at Rutgers University, where both studied with Miguel Algarín (the two men lived together at one point). Lezcano edited a short, limited-edition chapbook credited to "Miguelito Piñero" and titled *Excerpted Journals Early Eighties* (1986?), featuring text

by Piñero (as transcribed and edited by Lezcano) and ten illustrations by noted graffiti artist Chris "Freedom" Pape, a longtime associate of Lezcano's (both were involved with the New York City graffiti scene).[34] Karen Jaime discusses the 1985 edition of this chapbook, published by a then-closed Nuyorican Poets Café and titled *Miguelito Piñero's Random Thoughts and Walking Poetry*, in her important recent study *The Queer Nuyorican*. Here, Jaime recovers Piñero's practice of walking the streets of Loisaida as a mode of queer performance that "marks and claims racial-sexual space."[35] The intimacy that Jaime finds in Piñero's walking poetry is at once amplified and complicated by the choice to credit Piñero as "Miguelito"—an affect-loaded diminutive that would be used informally by friends and that argu-ably frames the homoerotic intimacies of Piñero's journals entries/poems within the broader homosocial camaraderie of the downtown and Loisaida scenes—instead of as the usual Miguel.

Lezcano's edition of Piñero's text with Pape's illustrations also reflects a distinctive underground comic-book sensibility and a familiarity with the work of figures such as cult illustrator and cartoonist Vaughn Bodē, whom Lezcano had already written about in the 1970s, while Pape's flowing pen-and-ink drawings and stylized, all-uppercase block lettering embody the era's graffiti aesthetic.[36] Although neither Lezcano nor Pape is Puerto Rican, this Piñero publication is important in highlighting the influence of hip-hop culture and underground graphics in 1980s Loisaida, influences that curators and scholars working on Latina/o/x New York City often minimize or overlook entirely.

Facilitated by the increasing affordability of photocopying and word-processing technologies, self-published chapbooks were important to the rebirth of the Nuyorican Poets Café during the 1990s rise of poetry slams, as they allowed performers to monetize and promote their work. Edwin Torres's debut 1991 chapbook, *I Hear Things People Haven't Really Said*, introduced his innovative verbivocovisual style, influenced by graphic design (his longtime profession), global avant-garde traditions (especially Futurist graphics), and downtown post-punk and Nuyorican sensibilities, including the work of Pietri. Still, for Torres, politics is more about a quirky intersubjectivity—what his manifesto "Ugilante" calls "non communistic platanos"—than about any political program.[37]

Poems from this early collection appear, with some of my Spanish translations, in a recent handbound letterpress edition of Torres's work published by Massachusetts-based Indiana Puerto Rican artist Adrian Tió Díaz, which features the latter's silkscreen illustrations.[38] Those same

translations of Torres had previously appeared in a *cartonera* edition published in Puerto Rico by Atarraya Cartonera, the first *cartonera* publisher in the Caribbean.[39] In the 2000s, Atarraya cofounder Nicole Cecilia Delgado had lived in New York, where she connected with Latin American poetry and activist communities in, around, and beyond the Nuyorican Poets Café. She later moved to Mexico, where she became involved with various feminist and underground poetry collectives and learned to make *cartonera* editions. Upon moving back to Puerto Rico, Delgado and poet Xavier Valcárcel established Atarraya Cartonera, which functioned as a critical intervention in the context of Puerto Rico's austerity crisis. (The *cartonera* movement—where poets made books communally from recycled cardboard—was born in Argentina during its early 2000s financial crisis.) In 2016, Delgado and Amanda Hernández established the Risograph publishing project La Impresora, which has gone on to publish several Diasporican poets, including Aurora Levins Morales and Roque Raquel Salas Rivera, collaborating with important artists and collectives in Puerto Rico, including Beta-Local and its cofounder Beatriz Santiago Muñoz (caveat: I have been published by La Impresora and recently published a translation of two artist books by Delgado). Thus, the remediation of Nuyorican poetry across time and space allows for a networked relational book practice as imagined by Carrión, one that links Boricua geographies from New York and Puerto Rico to Indiana, Massachusetts, Mexico, and beyond.

Delgado had begun making books by hand while living in New York, inspired by New York–born Puerto Rican writer and artist Tanya Torres, whose Galería Mixta in El Barrio connected the creation and circulation of handmade books to a broader journey of personal and communal healing.[40] Ediciones Mixta published Yarisa Colón Torres, a New York-based collaborator of Delgado's raised between Puerto Rico and New York and celebrated for her ongoing practice of making poetry books by hand. Mixta also published Nuyorican poet, performer, and musician Sandra García Rivera's artist book *That Kiss*, part of a performance project that included a kissing booth and that approached the artist book as a space for feminist erotics, in conversation with poets and performers such as Mariposa (Fernández). In fact, what appears to be the only copy of *That Kiss* in an institutional archive was donated to the Bronx County Historical Society's digital archive by Mariposa, to whom the copy is inscribed.[41] With its small size (approximately 2½ × 3¼ inches), its fiber-art aesthetic, and its yellow bookmark ribbon complementing the red-and-yellow cover image

of a woman's body, the physical object of *That Kiss* embodies the at-once bold and delicate aspects of García Rivera's poetics, with the elaborately handmade aesthetic evoking the complexities of embodiment in a Nuyorican feminist aesthetic (see figure 14.2).

These networks of community bookmaking, performance, and activism are especially important for Nuyorican feminist poetics, all the way back to the work of 1970s poets such as Esteves and Lorraine Sutton, whose radically experimental, Black Arts–feminist inflected *SAYcred LAYdy* (1975) deserves much wider attention. For instance, despite her stature, Mariposa has never published a full-length, traditionally distributed book, so that the two editions of her chapbook *Born Bronxeña* (1999 and 2001), published with assistance from the Bronx Council on the Arts' Bronx Writers Center, were key to the circulation of her now canonical poem "Ode to the Diasporican" and her lesser-known poems that engaged difficult subjects such as militarism and mental health. While "Ode to the Diasporican" is ubiquitous in print and performance, *Born Bronxeña* and other self-published books and chapbooks remain neglected by scholars, thus eliding the complex histories of remediation that have shaped Nuyorican poetry on and off the page as well as the visual and graphic dimensions of these poetics.

The expanded field practice of Nuyorican poets making books could be further expanded to include younger poets who are culturally Nuyorican but working largely outside the Nuyorican Poets Café tradition. One such poet is the gender-queer, Bronx-raised, and Queens-based Joey De Jesus, whose work boldly cuts across visual art, performance, sound art, conceptual writing, and activism and is creatively amplified through social media (especially their Instagram @dejesussaves). Their chapbook *NOCT* (2019) incorporates erasures of an old black magic book to imagine the erasure and survival of oppressed bodies, while the limited artist edition *HOAX* (2022), which builds on their earlier virtual exhibition at BRIC, enacts a procedural and interactive "living book" (including a tarot deck, text scrolls, and digital components) that attempts to erase and suspend the "anti-Otherness" of colonial reason and its violence against queer and Black bodies (see figure 14.3).[42] While outside the Nuyorican Poets Café tradition, De Jesus's work extends and complicates a neglected but vital history of New York Puerto Rican poetry that reembodies the book beyond the institution in the name of a more relational politics of radical becoming.

14.2 Sandra García Rivera, *That Kiss*, 2004. Paper, cloth, metal, lace, thread, and glue, 2½ × 3¼ in. Photo courtesy Urayoán Noel.

14.3 Joey De Jesus, *HOAX*, 2022. Paper and plastic, 8 × 11 in. (sealed). Photo courtesy Urayoán Noel.

1 Krauss, "Sculpture in the Expanded Field."

2 Noel, *In Visible Movement.*

3 Dávila, *Latinos, Inc.*, 130; Dávila, *Latinx Art.*

4 See Drucker, *Century of Artists' Books*; and Flores, *From Bomba to Hip-Hop*, for an example of these respective views.

5 Krauss, "Sculpture in the Expanded Field."

6 Carrión, "El arte nuevo de hacer libros," 35.

7 Carrión, "El arte nuevo de hacer libros," 35.

8 MAPR (Museo de Arte de Puerto Rico), "Jaime Carrero," accessed December 1, 2022, https://www.mapr.org/en/museum/proa/artist/carrero-jaime.

9 On verbivocovisual, see de Campos, Pignatari and de Campos, "Plano-pilôto para poesia concreta."

10 Kane, *All Poets Welcome.*

11 MAPR, "Jaime Carrero." I elaborate on this archival history in Noel, "In Search of a Nuyorican Sixties."

12 For more on the institutional politics of Brazilian concrete poetry, see Aguilar, *La poesía concreta brasileña.*

13 Flores, *Divided Borders*, 143.

14 Herrera, *Nuyorican Feminist Performance*, 35.

15 Mbembe, *Necropolitics*, 15.

16 I approach the "mimeograph revolution" in conversation with Clay and Phillips, "Little History of the Mimeograph Revolution."

17 Meléndez, "Cascade of Words."

18 I use the term *typewriter art* in conversation with Tullett, *Typewriter Art.*

19 Thomas, "Neon Griot."

20 Noel, *In Visible Movement*; Ramirez, "Nuyorican Visionary."

21 Herrera, *Nuyorican Feminist Performance.*

22 Noel, *In Visible Movement.*

23 Noel, *In Visible Movement.*

24 Hernández Cruz, introduction to Adál, *The Evidence of Things Not Seen*, n.p.; Valentín-Escobar, "Bodega Surrealism," 3.

25 Pietri, *Invisible Poetry.* The phrase "last edition" appears on the front cover.

26 Noel, "In Search of a Nuyorican Sixties"; Dworkin, *No Medium*, 9.

27 Pietri, "El Manifesto." I write about Pietri's "new 1898" poetics and politics in Noel, *In Visible Movement*, 94.

28 Guide to the Pedro Pietri Papers, n.d., p. 40, Center for Puerto Rican Studies, Hunter College, CUNY.

29 My comments on *Public Execution* refer to the copy in box 58, file 6 of the Pedro Pietri Papers, Center for Puerto Rican Studies, Hunter College, CUNY (no publisher or date is given). Although *Public Execution* seems like a book-object that defies conventional reproducibility, I have heard from folks who knew Pietri that other copies may exist. At the very least, we can surmise that *Public Execution*, like so many of Pietri's homemade/handmade books, was meant for informal underground circulation among those personally connected to the author.

30 While I refer specifically to my personal copy of *Platonic Fucking for the 90s*, which I purchased online, my comments also generally apply to the handful of versions of the text I have seen over the years, including in the Pedro Pietri Papers, box 20, file 3, Center for Puerto Rican Studies, Hunter College, CUNY.

31 Pedro Pietri, "I Never Promised You a Cheeseburger," unpublished, undated typescript, Pedro Pietri Papers, box 58 file 6, Center for Puerto Rican Studies, Hunter College, CUNY.

32 Center for the Humanities, "Pedro Pietri: Condom Poems 4 Sale One Size Fits All," accessed December 1, 2022, https://centerforthehumanities.org/lost-and-found/publications/pedro-pietri-condom-poems-4-sale-one-size-fits-all.

33 Mercado, *Illusions for Jubilance*, n.p.

34 The context I provide here is based on my examination of a Lezcano archive found and held by a couple of private collectors and on conversations I had with these collectors and with Mercado. The bulk of the collection I saw comprised materials related to 1980s downtown hip-hop culture (especially graffiti), in addition to materials related to Algarín and Piñero. I debated whether to include Lezcano here, given the highly unusual way I came upon his materials and the many uncomfortable and still unanswered questions I was left with upon doing so, including his whereabouts and the exact circumstance under which his materials were acquired. Ultimately, I decided to include him, along with some of the context I was able to glean, given his work's historical significance, and in the hope that doing so will lead to some answers.

I was subsequently able to purchase from an online seller a copy of the chapbook in question, which is what I am referencing here. The chapbook does not list a publisher, but on Google Arts & Culture, the 1985 edition is listed as printed by the Nuyorican Poets Café. Even though the Café had closed in the early 1980s and reopened only in the wake of Piñero's passing in 1988, it remained a hub for innovative and underground art and culture through publications like this one. See the introduction and first chapter of Jaime's book, where she develops an important argument along these lines while inserting Piñero into an expansive and largely overlooked queer genealogy. For the 1985 edition, see https://artsandculture.google.com/asset/miguelito-pinero%E2%80%99s-random-thoughts-and-walking-poetry/gQHpRRj1nM8QMg?hl=en.

35 Jaime, *Queer Nuyorican*, 20.

36 Lezcano, *Rocket's Blast Comicollector*.

37 E. Torres, *I Hear Things People Haven't Really Said*, n.p.

38 E. Torres, *Illusions to Awakening*.

39 E. Torres, *ILUSOS*.

40 See Tanya Torres, personal website, accessed December 1, 2022. https://www.artbytanyatorres.com/about.

41 I accessed this inscribed copy of *That Kiss* on December 1, 2022 via the Bronx County Historical Society website using a link that no longer seems to work. I was able to access the webpage (https://digital.bchslibrary.org/items/show/561) via the Wayback Machine as this book was going to press, but I could no longer see the electronic copy of the book itself. The photo provided here is of my personal copy of the second edition, which I purchased from the author in 2004 (if I recall correctly, at a book launch for the second edition, where Rivera performed).

42 See "Joey De Jesus: HOAX," BRIC, accessed December 1, 2022, https://www.bricartsmedia.org/joey-de-jesus-hoax.

BIBLIOGRAPHY

Adál [Adál Alberto Maldonado]. *The Evidence of Things Not Seen*. Introduced by Victor Hernández Cruz. New York: Da Capo Press, 1975.

Adál. [Adál Alberto Maldonado]. *Falling Eyelids: A Foto Novela*. New York: Foto-Graphic Editions, 1981.

Aguilar, Gonzalo. *La poesía concreta brasileña: Las vanguardias en la encrucijada modernista*. Rosario: Beatriz Viterbo, 2003.

Algarín, Miguel. *Mongo Affair*. Illustrated by Sandra María Esteves. New York: Nuyorican Press, 1978.

Algarín, Miguel, and Miguel Piñero, eds. *Nuyorican Poetry: An Anthology of Puerto Rican Words and Feelings*. New York: Morrow, 1975.

Carrero, Jaime. *Jet neorriqueño = Neo-Rican Jetliner*. San Germán: Universidad Interamericana, 1964.

Carrión, Ulises. "El arte nuevo de hacer libros." *Plural* 5 (February 1975): 33–38.

Clay, Steven, and Rodney Phillips. "A Little History of the Mimeograph Revolution." In *A Secret Location on the Lower East Side: Adventures in Writing, 1960–1980*, 12–54. New York: New York Public Library/Granary Books, 1998.

Dávila, Arlene. *Latinos, Inc.: The Marketing and Making of a People*. 2nd ed. Berkeley: University of California Press, 2012.

Dávila, Arlene. *Latinx Art: Artists, Markets, and Politics*. Durham, NC: Duke University Press, 2020.

de Andrade, Oswald. "Cannibalist Manifesto." Translated by Leslie Bary. *Latin American Literary Review* 19, no. 38 (July–Dec., 1991): 38–47.

de Campos, Augusto, Décio Pignatari, and Haroldo de Campos. "Plano-pilôto para poesia concreta." *Noigandres*, no. 4 (1958). http://tropicalia.com.br/leituras-complementares/plano-piloto-para-poesia-concreta.

De Jesus, Joey. *HOAX*. Brooklyn, NY: The Operating System, 2022.

De Jesus, Joey. *NOCT: The Threshold of Madness*. Madison, WI: TAR Chapbook Series, 2019.

Drucker, Johanna. *The Century of Artists' Books*. New York: Granary Books, 1995.

Dworkin, Craig. *No Medium*. Cambridge, MA: MIT Press, 2015.

Esteves, Sandra María. *Bluestown Mockingbird Mambo*. Houston: Arte Público, 1990.

Esteves, Sandra María. *Contrapunto in the Open Field*. New York: No Frills Publications, 1998.

Esteves, Sandra María. *Yerba Buena: Dibujos y poemas*. Greenfield Center, NY: Greenfield Review Press, 1980.

Flores, Juan. *Divided Borders: Essays on Puerto Rican Identity*. Houston: Arte Público, 1993.

Flores, Juan. *From Bomba to Hip-Hop: Puerto Rican Culture and Latino Identity*. New York: Columbia University Press, 2000.

García Rivera, Sandra. *That Kiss*. 2nd ed. New York: Ediciones Mixta, 2004. First published 2000.

Hernández Cruz, Victor. *Papo Got His Gun! And Other Poems*. New York: Calle Once Publications, 1966.

Herrera, Patricia. *Nuyorican Feminist Performance: From the Café to Hip Hop Theater*. Ann Arbor: University of Michigan Press, 2020.

Jaime, Karen. *The Queer Nuyorican: Racialized Sexualities and Aesthetics in Loisaida*. New York: New York University Press, 2021.

Kane, Daniel. *All Poets Welcome: The Lower East Side Poetry Scene in the 1960s*. Berkeley: University of California Press, 2003.

Krauss, Rosalind. "Sculpture in the Expanded Field." *October* 8 (Spring 1979): 30–44.

Lezcano, Manny. *The Rocket's Blast Comicollector*, no. 121 (September 1975): n.p.

Lima, Frank. *Inventory*. New York: Tibor de Nagy Editions, 1964.

Mariposa [Fernández]. *Born Bronxeña: Poems on Identity, Survival, Love and Freedom*. Bronx, NY: Bronx Writers Center, 2001.

Mbembe, Achille. *Necropolitics*. Translated by Steve Corcoran. Durham, NC: Duke University Press, 2019.

Meléndez, Jesús Papoleto. "A Cascade of Words: Jesus Papoleto Melendez." Museum of Contemporary Art San Diego, October 25, 1996. https://www.uctv.tv/shows/A-Cascade-Of-Words-Jesus-Papoleto-Melendez-2645.

Mercado, Nancy. *Illusions for Jubilance*. New York: n.p., n.d.

Mercado, Nancy. *It Concerns the Madness*. Hoboken, NJ: Long Shot, 2000.

Montoya, José. *El sol y los de abajo and Other R.C.A.F. Poems*. San Francisco: Ediciones Pocho Che, 1972.

Noel, Urayoán. "In Search of a Nuyorican Sixties: Reading the Pedro Pietri and Jack Agüeros Archives." *Journal of Foreign Languages and Cultures* 2, no. 2 (December 2018): 61–71.

Noel, Urayoán. *In Visible Movement: Nuyorican Poetry from the Sixties to Slam.* Iowa City: University of Iowa Press, 2014.

Pietri, Pedro. *Condom Poems 4 Sale One Size Fits All.* Edited by Rojo Robles. The CUNY Poetics Document Initiative. New York: Lost and Found, 2019.

Pietri, Pedro. "El Manifesto: Notes on El Puerto Rican Embassy." El Puerto Rican Embassy, 1994. https://elpuertoricanembassy.msa-x.org/index.html.

Pietri, Pedro. *Invisible Poetry.* New York: Downtown Train, 1979.

Pietri, Pedro. *Public Execution.* N.p.: n.d. B58 F6. Pedro Pietri Papers, Center for Puerto Rican Studies, Hunter College, City University of New York.

Piñero, Miguel. *Short Eyes.* New York: Hill and Wang, 1975.

Piñero, Miguelito (Miguel Piñero). *Excerpted Journals Early Eighties.* N.p: n.p, n.d. Signed and numbered edition dated 1986.

Ramirez, Yasmin. "Nuyorican Visionary: Jorge Soto and the Evolution of an Afro-Taíno Aesthetic at Taller Boricua." *CENTRO Journal* 17, no. 2 (Fall 2005): 22–41.

Thomas, Lorenzo. "Neon Griot: The Functional Role at Poetry Readings in the Black Arts Movement." In *Close Listening: Poetry and the Performed Word*, edited by Charles Bernstein, 300–323. New York: Oxford University Press, 1998.

Torres, Edwin. *I Hear Things People Haven't Really Said.* N.p.: n.p., 1991.

Torres, Edwin. *Illusions to Awakening.* Illustrated by Adrián Tió Díaz. Translated by Adrian Tió Díaz, Urayoán Noel, and Iraida Díaz Tió. New Bedford, MA: Hare of the Dog, 2022.

Torres, Edwin. *ILUSOS.* Translated by Urayoán Noel. San Juan: Atarraya Cartonera, 2010.

Tullett, Barrie, ed. *Typewriter Art: A Modern Anthology.* London: Laurence King, 2014.

Valentín-Escobar, Wilson. "Bodega Surrealism: The Emergence of Latin@ Artivists in New York City, 1976–Present." PhD diss., University of Michigan, 2011.

Visual Artists, Surrealist Communions

Lois Elaine Griffith and Jorge Soto Sánchez at the Nuyorican Poets Café

Joseph Anthony Cáceres

I Searched from the color of the sky
I dreamed behind my eyes
I saw my reflection there
down in the subway.
I read the news on the walls:
Samo is a cure for the bla-bashee blues.
The trains come fast
Flame Dog
Jazzy
Mad One

risks his life to paint his name
for all to see he is alive
on a welfare check tagged at the edge
where the brain creases
folds in half
on the line separating him from me.

I remember all the times
I thought azur was a place I might be stepping into
or stopping over sometime for a look-see.
Still searching now
for a color of my own
a more subtle grade
like hothouse madness.
I am an underground root
deshabillée before a mirror in hothouse madness.
I stripped down one night
and found myself naked
in a sky of fuchsia suave.

Lois Elaine Griffith, "Speaking from the Underground"

Lois Elaine Griffith's poem "Speaking from the Underground," published in El Museo del Barrio's 1990 exhibition catalog celebrating twenty years of Taller Boricua's cultural contributions, is a conduit that connects the surrealism coming out of the Nuyorican Poets Café to the visual arts.[1] Griffith is one of the last surviving founders of the Nuyorican Poets Café. The allusions in her poem to graffiti on the subway walls, the recording of the graffiti artists' names on the subway cars, along with Griffith's thoughts that "azur was a place [she] might be stepping into /or stopping over sometime for a look-see" and the image of herself as she "stripped down one night / and found [herself] naked / in a sky of fuchsia suave," reflect that part of the Café's aesthetic invested in recording the daily dealings of people and communities of Latinx, Caribbean, and African descent in the Americas. These aspects of her writing also reflect and record the Surrealism found in many of the Café founders' poetry that was in dialogue with the Surrealist visual artwork created and exhibited throughout the Lower East Side and New York City's public sphere in the 1980s and 1990s.

In speaking about the cultural commitments and principles of Nuyorican art spaces, like the New Rican Village and Adál Maldonaldo's Puerto

Rican Embassy, which saw a fusion between folkloric images and rituals and the avant-garde that molded a new Latinx diasporic cultural aesthetic, Wilson Valentín-Escobar writes in "Bodega Surrealism" that everyday lived experiences were central to the Surrealism artists associated with these spaces deployed in their work. In making a connection between the values that overlapped with these Nuyorican artists' visions, Valentín-Escobar quotes American artist Tristan Meinecke, who speaks about how Surrealism's democratic principles

> open the doors of real creativity for all, and therefore undermine the stifling domination of established critics, gallery proprietors, and museum directions. . . . [In this vein,] Surrealism is much more than Art. . . . [It is also] a way of looking at things, a way of life . . . giv[ing] us truly living myths . . . that transform every aspect of everyday life . . . offer[ing] a real hope beyond the ordinary limitations of human existence, [which can be] transcended by the mind, and . . . overcome [through] free creative activity.[2]

Like these Nuyorican art spaces, the Surrealism found in the poetry of artists associated with the Nuyorican Poets Café depicts the everyday lived experiences of colonial subjects in America, which reflects their liminal position—a position that can be described as surreal, as it is marked by the intense (ir)rational, racist reality of the American Dream. Thus, engaging with an anti-war European art movement that formed in the aftermath of World War I was attractive to post–Civil Rights artists of the Afro-Caribbean diaspora, especially Nuyorican artists who served and/ or protested the US involvement in Vietnam with work that critiqued the colonial violence of the war while tying it to the imperial legacy of the Spanish-American War.[3] In that way, Surrealism offered artists at the Café a means to expose, challenge, and resist the limitation imposed on them by oppressive racist, colonial forces.

In learning about the Café, its founders, their work, and their aesthetic, I've come to understand much of the poetry coming out of the Café between 1973 and the late 1990s as elegies.[4] Poetics, in this sense, becomes the conservator, as Patrick Chamoiseau states, of *re*membering what remains of the silences caused by history.[5] A close reading of Griffith's poem, then, becomes an act of time travel; of tracing her memories, her *memorias*, to see the connections history is intent on eliding.

Griffith's poem is also a bridge that connects the Nuyorican Poets Café to the visual arts and allows us to expand how we traditionally understand the Café and its legacy since, in the common, cultural parlance, it has become synonymous with spoken word, slam poetry, the literary and performing arts. No serious connections have been made to the visual artists whose work was nourished within and/or exhibited on the walls of the Café, especially since many of its founding and canonical artists, like Griffith and Sandra María Esteves, are renowned for their literary and visual artworks. Thus, by focusing on Surrealism as these artists' aesthetic mode, I underscore the very important, yet severely understudied, cultural *and* dialogic exchanges that took place at the Nuyorican Poets Café, specifically exchanges between Afro-Caribbean visual artists invested in exploring shared cultural legacies, such as Yoruba, in the creation of a liberatory project through communing, collaborating, and collectively crafting, sharpening, and fostering an anti-colonial aesthetic.

The impetus for this chapter began after I became involved with the Nuyorican Poets Café Founders Archive Project (NPCFAP) in the weeks following the death of the Café's founding father, poet Miguel Algarín, on November 30, 2020. For nineteen months, I helped Griffith curate essays, poems, visual artworks, and memories to commemorate the life and work of Algarín for *Memorias de Miguel*, an anthology that was published by the Hemispheric Institute at New York University (NYU) on October 8, 2022.

Curating works for anthologies, conducting oral histories from people involved with the Café's inception, and organizing community, cultural, and academic events that preserve the legacy of the Café's founders is the NPCFAP's mission. Griffith founded the NPCFAP circa 2015, in the years after she and Algarín were ousted from their lifetime positions as trustees of the Café's board in the early 2000s. Griffith said she was not only angered, frustrated, and disappointed by the occurrence; she was also concerned that the cultural work she and Algarín produced over three decades would at best, be diminished, and at worst, dismantled and destroyed. Thus, the NPCFAP was born out of a fear of necessity to preserve the work done by the mostly Caribbean, Latinx, and African American artists involved in formulating the globally recognized cultural institution the Café grew to become.

When Griffith and I first collaborated, it was during the pre-vaccine part of the COVID-19 pandemic, so our initial meetings were held on Zoom and via telephone calls, text messages, and emails, before our now regular tequila and taco dinners and sessions in her Brooklyn home. It is in

Griffith's home where a significant portion of the Nuyorican Poets Café archive is held.

Griffith is known as the keeper of the Nuyorican Poets Café archive. A great portion of that collection is made up of a few dozen banker's boxes that occupy the living room of the ground floor of her home. It consists of posters, schedule books, diaries, CDs, cassette and VHS tapes, scripts, scrapbooks, unpublished manuscripts, visual artwork, and other ephemera archiving almost five decades of the Café's history. During the first few months of meeting in person with Griffith, I did not venture into her archive. Instead, it presided over our time together and framed our discussions. And I sat with Griffith listening to, and recording (with her insistence), the casual history lessons she gifted me about her time at the Café, the three decades she spent running its day-to-day operations, and her thoughts on its aesthetics.

It is through Griffith that I learned of Miguel Algarín's generosity of spirit when it came to supporting artists of any medium at the Nuyorican Poets Café. The early iterations of the Café are renowned for bringing poetry from the streets to the stage. But it was Algarín, Griffith told me, who offered the Café for her first art exhibition: "There's a picture of Miguel and Lucky [Cienfuegos]. . . . It's a famous *New York Times* picture. They're sitting at a table in the old Café [when it was located on Sixth street between Avenues B & C]. And the pictures that are behind them, those are my pictures! And even some of the videos the Hemi [NYU's Hemispheric Institute] has . . . people dancing. . . . In those years, those pictures on the walls, those are my pictures."[6] I hear the urgency in Griffith's voice when she tells me this, and it reflects the ethos of the NPCFAP's mission. Griffith has strong opinions on the extant scholarship on the Lower East Side during the latter part of the twentieth century, particularly revisionist scholarship that whitewashes and displaces the contributions of ethnic cultural sites, like the Nuyorican Poets Café, a site where artists from the Beat, Umbra, Black Mountain, Black Arts, and Nuyorican arts movements came to share and sharpen their work, ideas, and aesthetic practices.

Despite Griffith being a founding member of the Nuyorican Poets Café, to date, there is no existing scholarship seriously exploring her contributions to the Café and her artistic relationships with artists of the Nuyorican arts movement. The memories and work of Griffith, as a founding member, are not only equally important in her mission of preserving the Café's history but are necessary in expanding the field of Nuyorican/ Diasporican art.

Evidence to support this claim lies not only in Griffith's memories but in her archive, which holds the materials that record and document the relationships between many artists of diverse disciplines as well as diverse racial, ethnic, and cultural backgrounds who frequented and communed at the Nuyorican Poets Café. It was during my first encounter within Griffith's archive that I came across a hand-sketched ink print by Jorge Soto Sánchez, a Nuyorican visual artist and one of the founders of the Boricua visual art space and cultural center Taller Boricua. The ink print was tucked in the pages of a notebook Griffith used for her sketches in 1979. I quickly discovered the print was the front of an invitation for the opening reception of Soto Sánchez's work at El Museo del Barrio (see figure 15.1).

When I stumbled upon this invitation, I brought it to Griffith's attention. "That's Jorge's work," she told me, before nonchalantly stating, "You know, he used to come by the Café and he and I would draw together. That's how we 'talked.'"[7]

This connection was further solidified and documented in El Museo del Barrio's 1990 exhibition catalog celebrating twenty years of Taller Boricua in which Griffith dedicates her poem "Speaking from the Underground" to Soto Sánchez. In a brief passage that prefaces her poem, Griffith writes, "This poem is from a series of poems *Bajan Fantasies* that I wrote in the late '70s, early '80s, when the Nuyorican Poets Café was on East 6th Street and I used to hang out with Jorge Soto, Fernando Salicrup and the fellas from Taller Boricua."[8]

Jorge Soto Sánchez was born in El Barrio in 1947. His formative years were spent in the South Bronx, where his family moved in the 1950s. A self-taught artist, in the 1970s and 1980s Soto Sánchez was involved with Taller Boricua and other New York City Boricua art scenes where Surrealist and Afro-Indigenous cultural practices were central. During that time, Soto Sánchez began to deploy Yoruba iconography to cultivate a Surrealist, deconstructionist aesthetic that confronted and communed with those Afro-Indigenous traces silenced by history.

As Yasmin Ramirez notes, the deployment of Yoruba iconography in Soto Sánchez's work "went beyond formal appreciation. . . . He studied, if not practiced the rituals and mythology of the Yoruba and other enslaved African and Native American people."[9] Soto Sánchez's drawings, Ramirez continues, "can also be understood as an allegory of the Puerto Rican migration to New York and the birth of 'Afro-Taino' consciousness among his fellow artists at the Taller."[10]

This is exemplified in Soto Sánchez's 1974 renowned painting *El Velorio de Oller en Nueva York*, which is a revision of nineteenth-century Puerto Rican Impressionist painter Francisco Oller's *El Velorio* (1893; see figure I.1). The critical and aesthetic lens of Soto Sánchez's painting is guided and shaped by his experience as a Nuyorican. As an allegory of Puerto Rican migration to New York, Soto Sánchez's *Velorio* participates in an ongoing dialogue at the time revolving around Puerto Rican authenticity.[11] In his revision, Soto Sánchez employs an Afro-Taino purview that *reframes el baquiné*, which is central to his and Oller's painting.[12] In his Afrocentric reframing, Soto Sánchez embraces the subaltern position that critics have said Oller vilified in his Eurocentric depiction of this ceremony. In that way, Soto Sánchez addresses and critiques an engagement with a nineteenth-century Puerto Rican Hispano-philia that Puerto Rican *letrados* (creole elites) at the time employed through their art in their creation of a sycophantic European national identity that deployed a racist ideology of Black deviance in the creation of a subaltern Afro–Puerto Rican Other.[13] Thus, Soto Sánchez's use of Afro-Taino and Yoruba iconography in his revision is a project that recovers Afro-cultural (hi)stories elided and silenced by egregious acts committed by Oller and his contemporaries. It also offers a counternarrative to resist the oppressive legacies that body of work reproduced.[14] Yoruba and Afro-Taino iconography allowed Soto Sánchez to reclaim our signs, symbols, and language to help us, in the diaspora, understand our present by reimagining a conventional understanding of our past. It also allowed him to commune with the African, Indigenous, and other non-European aspects of his Nuyorican identity. I find that the multicultural, pluralistic aspects of Yoruba would seem attractive to an artist like Soto Sánchez, whose biography also reveals the cultural exchanges responsible for shaping his aesthetics, and whose career Ramirez's "Nuyorican Visionary" depicts as being involved in spaces where artistic collaboration was central.

So, when Griffith told me she used to draw with Soto Sánchez, the breadth of knowledge of Soto Sánchez's investment in collaborative art spaces was expanded. This connection was further solidified and documented by the works of art I discovered in Griffith's notebooks in her archive—the actual drawings Griffith did while she and Soto Sánchez were at the Café (see figure 15.2).

This, of course, was the second iteration of the Café that first opened its doors on October 31, 1974, located on East Sixth Street between Avenues B and C. At the time, Griffith was a recent master of fine arts (MFA) graduate from the Pratt Institute when she met Miguel Algarín in the early 1970s.

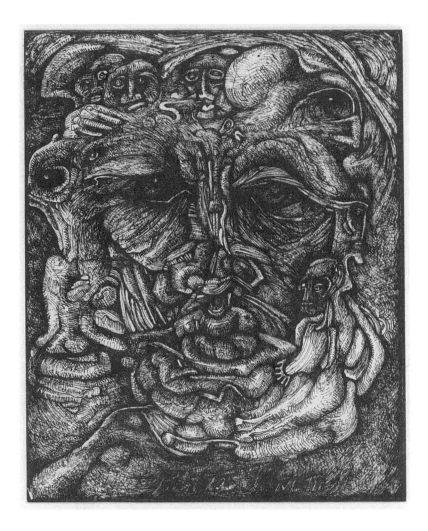

15.1 Front of hand-printed invitation to El Museo del Barrio that features a Surrealist Afro-Taino image by Jorge Soto Sánchez, 1979. Courtesy of Lois Elaine Griffith.

Back then, Griffith experimented with writing literature but primarily identified as a visual artist—not the prolific poet, playwright, novelist, and visual artist as she is now known.

Pratt Institute, Griffith told me, is where she learned the skills and techniques to become a visual artist. Through a study-abroad program, Griffith traveled to Pietrasanta and studied under Italian sculptor Licio Isolani. While there, she was also exposed to and taught by other influ-

15.2 Lois Elaine Griffith, *Untitled*, 1979. Courtesy of the artist.

ential and world-renowned twentieth-century sculptors, such as Isamu Noguchi and Jacques Lipchitz. It was the training she received from Pratt Institute instructor Salvador Montano, however, that Griffith credits with learning the basis of drawing.

> Salvador Montano. He was a man who said look at the human body, look at animal bodies. Draw your connections. He would . . . put

things together in class for us to draw like . . . what's the connection between a horse and a human body? You know. Okay, we're all vertebrates here, and mammals. But then, look at the fish. Those are vertebrates too. . . . And he would give us assignments, like what connections can you make . . . birds have wings, we have arms. Look at the bats! How their arms are legs are fingers. . . . And that's how I started making that kind of connection. . . . Then, of course, he took us to Columbia Presbyterian every week to see cadavers and drew from them.[15]

Deploying the skills she learned and sharpened at Pratt, Griffith described the work she created in the early 1970s as her way of trying to find her artistic voice. Born in Brooklyn on July 20, 1947, to West Indian parents who migrated to New York after World War II from Barbados, Griffith often told me that her Caribbean background left her feeling alienated from the African American community in Brooklyn. She shared a similar sentiment in a 2019 interview when she recounted why she was initially attracted to the Nuyorican Poets Café: "Hearing what Latino, Puerto Rican poets, artists, *declamadores* were doing made me value my own culture, my West Indian culture, that I had always kind of shoved to the back, wanting to be just like all the other Blacks here, no one to single me out. But it does make a difference. Feeling aligned with that, knowing things about the Caribbean and having those things in common that they knew, that my parents had taught me and immersed me in."[16] The commonality Griffith realized with the Puerto Rican founders of the Café was a spiritual alignment she defines as Afrocentric—a spirituality grounded in Yoruba religious practices that also shaped her and the Café's aesthetic, one whose legacy of syncretism in the Americas provides modes of survival while promoting discursivity, is tied to the collective, looks at the past in forging a path in the present and toward the future, and is invested in paying homage to the ancestors.[17] Griffith explains,

> Here in the States, we don't pay too much homage to our ancestors. And at the Cafe we were always very conscious that we don't come from nothing. There's something in Latin American culture and Native American culture—and Caribbean culture too—we have no problems in conversing with the dead. We have no problem in talking about the ancestors and the blood in conversation. . . . You

have Santería, you have Candomblé, you have Obeah. I used to see my mother and my grandmother practice. They would go to people for guidance, for readings, for blessings. My mother used to have a little altar that she kept for the saints. And I never really thought anything of it, although I never really talked about it with people outside of my culture. And when I came to the Cafe back in 1974, I recognized the celebration of Santería. And I said, "Damn, this is the same thing I've been growing up with all these years!" . . . The Nuyorican was a spiritual place when we opened on 6th Street. Almost every night we were there we had drummers, we had chanting. We understood the African call and response method of singing and making poetry. In so many ways, that is its root.[18]

My intent in focusing on the Afrocentricity of Griffith's and the Café's aesthetic is important in understanding the Surrealism coming out of the Café in the 1970s and early 1980s—this is her entry point into dialogues about her work and the work of the artists associated with the Café. The collective spirit embedded within Yoruba religious practices offer Griffith, and many other artists involved in the Nuyorican arts movement, the ability to create art invested in conserving *and* recovering the lives and cultures history is intent on erasing. In that way, the Café's aesthetic also offers us narratives to counter the ahistorical culture reproduced by American ideals of progress.

The collective spirit of the Café's aesthetic also helped Griffith shape her artistic voice by focusing on her everyday lived experiences as an Afro-Caribbean colonial subject living in a white supremacist American culture. Her drawings from the early 1970s, then, can be seen as renderings from that lens: from the position of those members of a modern society pushed into the edges of the empire.

In Griffith's early drawings, bodies—human, terrestrial, aquatic, and celestial—meld into archetypal, mythological Surrealist figures (see figure 15.3). These images are representative of the Surrealism, as Amiri Baraka states in his essay "Aimé Césaire," that reflected the deconstructionist ways that Black artists, like Césaire and Léopold Sédar Senghor, for example, expressed their disillusionment with Western humanism: through images and art that retell the violence of coloniality.

During one of our sessions, Griffith told me how she never thought of her work, back then, as being in the Surrealist vein. It is only recently,

15.3 Lois Elaine Griffith, *Untitled*, 1974. Courtesy of the artist.

after reading and studying the work of Suzanne Césaire and her husband, Aimé, people who were involved in a Caribbean Surrealist movement, that she came to think of the work she and the others did at the Café as part of a tradition of Caribbean Surrealism. In the early days of the Café, Griffith shared with me, Surrealism *might* have been something many were experimenting with—since collaboration was the nature of the Café's aesthetic. Artists might influence one another, but, Griffith stated, for her it wasn't intentional. She felt she was making art that reflected how she viewed the world as an Afro-Caribbean woman.

Griffith's current sentiment on Surrealism in relation to her aesthetic is reminiscent of Afro-Cuban artist Wifredo Lam's deployment of the medium. As Julia P. Herzberg writes, Lam's work subverted Surrealism's traditional theories by placing the Santería that was part of his upbringing center stage in his art. In doing so, Lam redefined "the empirical world in terms of the spiritual world. While the Surrealist held that the spiritual world was part of the unconscious, to the Afro-Cuban, the spiritual world was part of everyday reality."[19]

This definition of Surrealism, the artist's creative process, and the lived experiences that are unique to colonial subjects is something that Soto Sánchez iterates in an interview with Patricia L. Wilson Cryer. Soto Sánchez states,

> I'm saying that my conception of the world has been written for and molded by culture . . . by my mother, by family, by my experiences. . . . I think that my art deals with my experiences that are unique to what I am. . . . Basically the main images in my work deal with MAN, human beings, distorted bodies, twisted faces, and tortured souls. You and I being victims of this so-called democratic society we live in. My images offer no escape but a repulsive mirror we refuse to look into because it is too painful and disturbing.[20]

Since Soto Sánchez's death in 1987, we, who do this work in the wake of an ancestor's passing, are left with the traces in the archive that allow us to pull back the veil between the living and the dead in our attempt to broaden our understanding of a severely understudied moment in our history.[21] There, we discover the extant writing and scholarship on Surrealism coming out of Taller Boricua, El Museo del Barrio, and the New Rican Village—the art spaces where it is well documented that Soto Sánchez was a founding member of, participated in, and/or circulated within them. We discover the interviews he did at the height of the Nuyorican arts movement where he provides information on his artistic instruction and training. We discover how Soto Sánchez subscribed to *Art in America*; purchased a pocketbook called *Enjoying Modern Art*, John Berger's book on Pablo Picasso, and a "book on the Surrealist"; and "credit[ed] the French Surrealists and the British Expressionist painter, Francis Bacon," as influencing his early work.[22] We discover that Soto Sánchez also went to museums and galleries to develop himself as an artist, but he received little to no formal artistic training. We discover he quit school, quit the army, and what he knew was mostly self-taught, along with the lessons he learned working with other artists in these primarily Boricua cultural spaces. In that regard, Soto Sánchez is rightfully described as an organic intellectual.

In fusing the assemblages of Soto Sánchez's life, through his art we discover his connection to the Nuyorican Poets Café and the work he produced around the time he visited and drew with Griffith—work that exemplified and defined the collaborative and communal spirit of the Nuyorican arts spaces at the time (see figure 15.4).

15.4 Jorge Soto Sánchez, *El Nacimiento de mi hijo: Jorge y yo como figura mitológica/The Birth of My Son: Jorge and I as a Mythological Figure*, ca. 1978. Pen and ink on paper, 20 × 29 in. Collection of El Museo del Barrio.

In discussing her "communion" with Soto Sánchez as well as with the artists of Taller Boricua, Griffith further highlights the importance of spirituality.

> Jorge [Soto Sánchez] and Fernando Salicrup and Marcos Dimas and Nitza Tufiño—later—we did not talk about "surrealism" or any of those big-time artists of the day except for the bochinche. For me the drawing was about tapping into the energía del momento—wherever I was—the line drawing is a kind of calligraphy—picture/poem. The line drawing—the India ink on paper is like writing. I write the pictures - the pictures are a place to put the energy. The line runs and twists and shapes around what there is to see in what there is to see. I can say this now about the line but we visual artists weren't talking like that about our lines. There were moments of music—the drum— the dance—dancing was everything in those days—the body thinks in the drum sounding—calling Spirit to be present—calling to join the present Spirit—and Spirit enters body and you can draw and you can dance and let it flow in and out of you to feed you in a spiritual way.[23]

The significance of describing this relationship with these artists from Taller Boricua in spiritual terms underscores an engagement with a sense of communion defined by a legacy of syncretic Yoruba cultural practices in the diaspora. That is, the communion Griffith describes subverts the principles of its Christian counterpart, specifically the Christian sacrament, which symbolizes the union between communicants and the body (and blood) of Christ. For the consummation Griffith describes is not one with the body and blood of a deity. The union here is a dialogue with the community, and collectively, collaboratively "tapping into the energía del momento," similar to the way the Spirit, or the Orishas, are called at a tambor to possess and work/act through one's body. Drawing then becomes the medium through which these artists embody their physical, mental, and cultural environs to create images that "offer no escape but a repulsive mirror we refuse to look into because it is too painful and disturbing." The other body, here, are the texts, or the aesthetic objects, that are created in the space where these artists gather to draw/commune together.

The spirituality Griffith speaks about as she describes the drawings she did with Soto Sánchez at the Café also reflects the Surrealist philosophy and ideology of the New Rican Village, a Boricua cultural center in Loisaida where artists communed during the Nuyorican arts movement. Quoting the New Rican Village founder, Eddie Figueroa, from Ed Morales's *Living in Spanish*, Valentín-Escobar notes, "'New Rican is an open-ended idea to unify our identity. . . . Our culture is the culture of the future. . . . Life doesn't proceed in fuckin' straight lines, you know.'"[24] As Valentín-Escobar concludes, "Figueroa's spiritual influences assume a Hegelian-like formation that also synthesizes the dialectical intersections between dream and reality."[25]

And what such spirituality reveals, especially in the relationship between Griffith and Soto Sánchez, is the cultural and dialogic exchanges that took place at Nuyorican/Diasporican art spaces between (visual) artists at the height of the Nuyorican arts movement. Griffith and Soto Sánchez's relationship exemplifies the ethos behind the notion of Surrealism becoming an activity. In talking with Griffith and learning about the artists of the Nuyorican arts movement, I find that they embody the principles of their aesthetic projects intent on recovering the (hi)stories silenced by a Western culture. I find that they moved and created in ways reflective of a time before 1492 where the islands in the archipelago of what is now called the Caribbean were part of a larger network of Indigenous cultural and dialogic exchanges (i.e., languages, goods, cultures, animosities, etc.), a network thought *completely* disrupted and disremembered because of European colonization. Despite this historical reality, I am arguing

that looking at Griffith and Soto Sánchez's relationship also exemplifies how we in the diaspora commune in ways that reflect the legacy of our Indigenous and African ancestors. Griffith and Soto Sánchez's relationship and the relationship of the artists who gathered at the Café and other Nuyorican cultural sites exemplify cultural and dialogic exchanges that can perhaps offer models for liberatory projects. I underscore the call for further study to explore such connections that are absent from current scholarship.

NOTES

1 El Museo del Barrio, *Taller Boricua Alma*, 79. The Taller Boricua is a cultural space that was founded in 1969 by Puerto Rican artists to promote Puerto Rican arts and culture throughout Spanish Harlem and to offer a platform for artists from underrepresented and marginalized groups.

2 Valentín-Escobar, "Bodega Surrealism," 204.

3 Here I am thinking of Nuyorican poet Pedro Pietri's excoriation of the Spanish-American War and its colonial legacy that defined part of the anti-war and anti-colonial Surrealist aesthetic of his oeuvre. In an oral history Griffith and I conducted with Marcos Dimas, one of Taller Boricua's founders, on May 11, 2023, Dimas spoke about Pietri and his role in the Young Lords and Pietri's influence on the artists of Taller Boricua. Dimas summoned Pietri's name before sharing how Taller Boricua in the late 1960s, along with the Art Workers' Coalition, protested a Surrealist exhibition at the Museum of Modern Art because Taller Boricua "felt they were co-opting the [Surrealist] movement. . . . The Surrealist movement was actually an anti-war movement in Europe. . . . And since we were an anti-war movement we said we had to demonstrate." Marcos Dimas, interview by Lois Elaine Griffith and Joseph Cáceres, May 11, 2023.

4 Griffith, Jaime, and Cáceres, *Memorias de Miguel*, 33.

5 Chamoiseau, *French Guiana*, 28.

6 Conversation with Griffith on November 25, 2022. Paraphrased statements attributed to Griffith throughout this chapter are based on conversations we have had since I began working with the NPCFAP in March 2021.

7 Conversation with Griffith on March 15, 2022.

8 El Museo del Barrio, *Taller Boricua Alma*, 79.

9 Ramirez, "Nuyorican Visionary," 29.

10 Ramirez, "Nuyorican Visionary," 30.

11 I am thinking of Algarín's account of how he and Miguel Piñero reclaimed Nuyorican, a derogatory term that island Puerto Ricans use to refer to Puerto

Ricans who migrated to the mainland and settled in New York. Hernández, "Miguel Algarín," 33–37.

12 Referencing Marta Moreno Vega's and Federico de Onís's scholarship, which establishes connections between West African and Afro-Puerto Rican religious practices, Jill S. Kuhnheim provides a definition of the baquiné as a transcultural ceremony that combines Spanish and Kikongo wake traditions that sometimes "[celebrate] the death of a child, who becomes an angel" ("Performing Poetry, Race, and the Caribbean," 140).

13 As Jason Cortés notes in "Wounding Materiality," nineteenth-century Puerto Rican *letrados* attributed the existence of the Afro–Puerto Rican population on the island as the reason Puerto Ricans (or, more specifically, the creole elites) could not progress on the world stage. As such, they used art to create a deviant Afro–Puerto Rican subaltern as the site of this so-called national trauma, or the trauma resulting from colonial emasculation.

14 Cortés also notes in "Wounding Materiality" that the Puerto Rican writers of the generation of the 1930s, like Antonio S. Pedreira and René Marqués, were influenced by Oller and his contemporaries. I would argue that the nationalism found in poet Luis Lloréns Torres's "El Patito Feo" (1940), for example, also engages in a project similar to Oller's and these writers of the 1930s in that it delineates Puerto Rican abject "bodies" as those severed from a Eurocentric, masculinist genealogy. In that regard, Soto Sánchez's paintings and drawings respond to the racist legacies of these artists' works by offering a counternarrative that broadens the narrow purview of a Western Weltanschauung. Soto Sánchez states, as quoted by Ramirez ("Nuyorican Visionary," 30): "I felt [at the Taller] like the ugly duckling who returned to its pond and realized he was a beautiful swan. . . . I found out that my roots stretched from Borinquen through the Caribbean into the Americas, Latin America, Native North America, the continent of Africa, through Asia into Oceania and back to Méjico and to Borinquen."

15 Conversation with Griffith on December 9, 2022.

16 Roberson, "Home at the Nuyorican."

17 Griffith is an astute pupil of Miguel Algarín's teachings. In that regard, Griffith's aesthetic aligns with Algarín's definition of the Nuyorican Poets Café's aesthetic found in his 1981 article, "Nuyorican Literature." That is, it is an aesthetic rooted in "a mixture of Catholicism and African religions, and most importantly [the way] we carry on the oral tradition—the tradition of expressing the self in front of the tribe, in front of the family" (90). Algarín concludes that the three parts of the Café's aesthetic are rooted in these African religious traditions.

18 Roberson, "Home at the Nuyorican."

19 Herzberg, "Rereading Lam," 151.

20 Wilson Cryer, "Puerto Rican Art in New York," 130.

21 Sharpe, *In the Wake.*

22 Wilson Cryer, "Puerto Rican Art in New York," 129; Ramirez, "Nuyorican Visionary," 26.

23 Lois Elaine Griffith, email to the author, December 12, 2022.

24 Valentín-Escobar, "Bodega Surrealism," 84–85.

25 Valentín-Escobar, "Bodega Surrealism," 85.

BIBLIOGRAPHY

Algarín, Miguel. "Nuyorican Literature." *MELUS* 108, no. 2 (1981): 89–92.

Baraka, Amiri. "Aimé Césaire." In *The Leroi Jones/Amiri Baraka Reader*, edited by William J. Harris in collaboration with Amiri Baraka, 322–32. New York: Thunder's Mouth Press, 2000.

Chamoiseau, Patrick. *French Guiana: Memory Traces of the Penal Colony.* Photographs by Rodolphe Hammadi. Translated by Matt Reeck. Middletown, CT: Wesleyan University Press, 2020.

Cortés, Jason. "Wounding Materiality: Oller's *El velorio* and the Trauma of Subaltern Visibility." *Revista Hispánica Moderna* 65, no. 2 (December 2012): 165–80.

El Museo del Barrio. *Taller Boricua Alma, 1969–1989: Reflecting on Twenty Years of the Puerto Rican Workshop.* New York: El Museo del Barrio, 1990. Exhibition catalog.

Griffith, Lois Elaine, Karen Jaime, and Joseph Cáceres. *Memorias de Miguel: The Hard Work of Love.* New York: NYU Hemispheric Institute, 2022.

Hernández, Carmen Dolores. "Miguel Algarín." In *Puerto Rican Voices in English: Interviews with Writers*, 33–47. Westport, CT: Praeger, 1997.

Herzberg, Julia P. "Rereading Lam." In *Santería Aesthetics in Contemporary Latin American Art*, edited by Arturo Lindsay, 149–69. Washington, DC: Smithsonian Institution Press, 1996.

Kuhnheim, Jill S. "Performing Poetry, Race, and the Caribbean: Eusebia Cosme and Luis Palés Matos." *Revista Hispánica Moderna* 61, no. 2 (December 2008): 135–47

Morales, Ed. *Living in Spanglish: The Search for Latino Identity in America.* New York: St. Martin's Griffin, 2002.

Ramirez, Yasmin. 2005. "Nuyorican Visionary: Jorge Soto and the Evolution of an Afro-Taíno Aesthetic at Taller Boricua." *CENTRO Journal* 17, no. 2 (Fall 2005): 22–41.

Roberson, Jehan. "A Home at the Nuyorican: An Interview with Lois Elaine Griffith." *Teachers and Writers Magazine*, April 18, 2019.

Sharpe, Christina. *In the Wake: On Blackness and Being.* Durham, NC: Duke University Press, 2016.

Valentín-Escobar, Wilson. "Bodega Surrealism: The Emergence of Latin@ Artivists in New York City, 1976–Present." PhD diss., University of Michigan, 2011.

Wilson Cryer, Patricia L. "Puerto Rican Art in New York: The Aesthetic Analysis of Eleven Painters and Their Work." PhD diss., New York University, 1984.

16

"SAMO©...AS AN EPIC POEM WITH FLAMES"

Al Díaz's Poetics of Disruption

Rojo Robles

SAMO© (1978–80) was a poetic satire criticizing the corporatization of arts and life in the late twentieth century.[1] It was initially conceived by Jean-Michel Basquiat and Al Díaz, artists of Puerto Rican descent. They presented SAMO© as both a poetic tag and a corporate entity. The messages of SAMO©, spray-painted on Manhattan walls, employed cryptic and ironic tones, questioning society's reliance on products and artificial, brainwashed lifestyles. Basquiat left the collaborative project in 1980 to pursue painting and achieved widespread fame. While Díaz is primarily known as Basquiat's early collaborator, Díaz's career in music and street arts spans five decades. In the 1980s, he was active in the downtown art

and music scene in New York City, playing percussion and creating audio recordings. After that period, Díaz mainly worked as a foreman and lead carpenter in the New York building industry, while refining his artistic language. In the past decade, he has returned to the spotlight, participating in documentaries about Basquiat and undertaking new subway and street art projects and gallery shows. In 2016, Díaz revived SAMO©, maintaining its original purpose of providing a sarcastic and brutal commentary on artificial life imposed by capitalist forces. This chapter engages with recent Black, Puerto Rican, and Latinx scholarship to position Basquiat and Díaz within a creative, poetic, and theoretical ecosystem. By exploring their Black, Caribbean, and inner city cultural contexts, language, and iconographies, I contextualize SAMO© as a product of Díaz's, Basquiat's, and a Black–Puerto Rican hive mind. While critical writings on Basquiat abound, I emphasize Díaz's unique contribution and his recent reengagement with SAMO©.[2] I examine how Díaz has given new life to the conceptual project by addressing current sociopolitical issues. Through a polished ideographic practice, he has developed an acidic poetic of dissent that remains in dialogue with his late friend and a Nuyorican lineage.

Al Díaz's History of New York City Graffiti

By the late 1960s, a first generation of graffiti writers emerged from NYC's neglected neighborhoods. These early graffiti writers were gangs of teens of Black–Caribbean–Puerto Rican descent who roamed the inner city and made their marks in public spaces. Writing their names on walls and buildings became a way to mark territory and assert their presence within the neighborhood. The typical template consisted of a name and a number, carrying personal meaning for the writers. This art form, created by teenagers aged twelve to sixteen, stemmed from their social needs and unfiltered imaginations.

In the introduction to *NY City of Kings*, Díaz characterizes the early examples of graffiti as cruder, immediate, and unpretentious. He says that over time, graffiti evolved into more sophisticated forms that were often indecipherable or perfectly blended and orchestrated. Graffiti developed its unique slang, codes, rules, clothing style, heroes, villains, and folklore. Graffiti writers established a code of respect encompassing principles such as not defacing or writing over each other's names, avoiding plagiarism of other writers' styles, and promoting originality and transformation through respectful homage. Additionally, the behavioral code included racking up

or shoplifting art tools instead of purchasing them. While the initial wave of graffiti was mostly male, young women soon joined the ranks, contributing to the growing movement.

Initially, graffiti was predominantly found in parks, in schoolyards, and on walls. However, the real explosion of graffiti occurred when it expanded onto mobile platforms such as trucks, buses, subways, and trains. This shift allowed the art to traverse boroughs, infiltrating broader socioeconomic circles. Consequently, graffiti transformed into a counterculture and underworld that experienced a complex narrative: being criminalized, shamed, celebrated, and eventually recognized as a legitimate art form.[3]

To contextualize SAMO© within this concise history, it is vital to highlight several key aspects. The debut of SAMO© took place in January 1978, introducing a matchless artistic expression characterized by a "pure concept with zero frills." SAMO©'s distinctiveness stemmed from its anonymous nature. What made SAMO© significant within this period was the intrigue it generated through its ad-infused off-beat texts. As people encountered these arousing messages, they began to anticipate and speculate about the identity of the author(s). This intentional air of mystery surrounding SAMO© added to its allure.[4]

SAMO© ... AS A REALIZATION PROCESS

In the late fall of 1979, after three years of creating songs, rhymes, poems, writings, and drawings for our friends, a school newspaper we helped launch, laughing, crying, sharing food, money, girlfriends, drugs, booze, wild antics, and every bad habit known to man, Jean-Michel Basquiat and I parted ways.

Al Díaz, SAMO© ... SINCE 1978 ...

Díaz and Basquiat first met as students at an alternative public high school called "City-As-School" in the late 1970s.[5] With a shared Puerto Rican/ Caribbean cultural heritage (Basquiat was also of Haitian descent) and a mutual aspiration to explore their multilingual writing abilities innovatively, they became classmates, *panitas*, or, as they sometimes referred to themselves, "walas." Living, coexisting, and conversing on the streets of NYC, they chronicled their escapades through SAMO©. In a recent interview, Díaz revealed that SAMO© was initially a nickname they gave to a friend's parents who used to smoke weed with them but who ultimately became tiresome.[6] However, SAMO© did not refer to those individuals lost in a haze. It represented a close friendship that allowed them to develop an evolving poetic

16.1 Al Díaz, *Ghost Painting*, 2020. Gel transfer, paper, acrylic, 21 × 30 in. Photo by the artist.

expression. From a school play to a short story (centered around a man seeking a new religion) published in their school newspaper, *The Basement Blue Press*, SAMO© continued to grow, eventually making its way onto walls in New York City and worldwide (see figure 16.1).[7] Shedding light on this transformative journey, Mariah Fox, an associate professor of media arts and editor of Díaz's book *SAMO© . . . SINCE 1978 . . .* , emphasizes that there was something exceptional, pivotal, and largely unspoken that occurred when Díaz and Basquiat engaged in their playful antics. It was a viewpoint that went beyond mere silliness, possessing a remarkable sophistication that manifested whether their words were written on a wall or not.[8]

Fox highlights the shared language and private communication between them, a synergy that fueled their banter and led to the development of sardonic and unconventional word combinations, sounds, and phrases. These linguistic creations rejected the mundane and predictable aspects of everyday life. Fox examines their bond, revealing that it revolved around creating a "humorous attitude" that often probed profound concepts.[9] Díaz, a former graffiti writer known as Bomb 1, explains that he and Basquiat knew that SAMO© offered something distinct from the name-and-number graffiti prevalent in the 1970s.[10] It was a departure that provided

an exhilarating rush: "We aimed for our phrases to sound as if they 'might' or 'could' be part of a cult or belief system. . . . We wanted to sound slick, like we were saying, beware of that nonsense, we are observing you."[11] They even crafted a comic book featuring characters testifying to the marvels of SAMO©. According to these fictional individuals, SAMO© astonishes, changes perspectives, boosts confidence in romantic pursuits, surpasses the significance of Black revolutionary politics, and supplants the need for substances.[12] Their tag was not just a personal graffiti endeavor. It encompassed a public poetic venture that demanded attention to raw aesthetics, letterform development, and a somewhat open conceptualization that involved recognizing what SAMO© was not or would not endorse (as imitators were abundant).

The early graffito of this period read: "SAMO© . . . AS AN END TO MASS-PRODUCED INDIVIDUALITY & MEDIA-CONTROLLED FADS . . . THINK"; "SAMO© . . . AS AN END TO BOOSH-WAH-ZEE PRINCIPLES . . . THINK"; "SAMO© . . . AS AN END TO MINDWASH RELIGION, NOWHERE POLITICS, AND BOGUS PHILOSOPHY"; "SAMO© . . . AS AN END TO THE POLICE"; "SAMO© AS AN END 2 NINE-2-FIVE NONSENSE WASTIN YOUR LIFE 2 MAKE ENDS MEET . . . TO GO HOME AT NIGHT TO YOUR COLOR T.V."; "SAMO© AS AN ALTERNATIVE TO BULLSHIT FAKE HIPPY WHACK CHEER"; "SAMO© AS AN ALTERNATIVE 2 "PLAYING ART" WITH THE RADICAL CHIC SECT ON DADDY$ FUNDS . . . 4.U"; "SAMO© . . . 4 THE SO-CALLED AVANT-GARDE"; "SAMO© AS AN END 2 CONFINING ART TERMS"; "SAMO© . . . AS A NEO ART FORM"; "SAMO© . . . FOR THE SOCIALIZED AVANT GARDE"; or "SAMO© . . . SAVES IDIOTS AND GONZOIDS."[13] SAMO© emerged as an entity or a discursive power that actively challenged the exclusionary nature, often imbued with racism, prevalent in art publications and gatherings. It critically questioned the alleged provocative elements of the avant-garde movement, particularly when its symbolic frameworks and objectives remained confined within Eurocentric aesthetic ideals and bourgeois dominance. Rooted in both resentment and enthusiasm, SAMO© aimed at the ideological foundations of late modernity and the discourses that perpetuated cultural elitism and socioeconomic class hierarchies within the urban context.[14]

As I do here, in his "The Shadows" essay, Caribbean poet and critic Christian Campbell urges us to approach SAMO©'s writing seriously.[15] He characterizes SAMO© as a collective of enigmatic and thought-provoking tricksters who operate in the shadows, capable of assuming various forms. Campbell explores how SAMO© constantly defines and redefines itself,

giving rise to an ars poetica. He describes it as poetry expressed through elusive speech. By critically examining SAMO©, Campbell argues that an alternative art history emerges, presenting an imaginary archive that captures a city undergoing tumultuous transformation and encapsulating the friendship between Díaz and Basquiat. Campbell interprets their work as a bustling activity space, akin to a hive, representing an evolving progression.[16] He explains, "Each SAMO © graffito was, for the most part, carefully and collectively planned but individually executed. Al and Jean developed a chirography that was unlike the flamboyant ciphers of most graffiti at the time; there was no Technicolor flair. They went for a minimalist style of mainly black block lettering drawn with Magic Marker or spray paint. It is obvious that they intended this 'experiment in hype' to be read closely and not only experienced visually."[17]

While SAMO©'s verses were promoted as a miraculous creation, Díaz emphasizes that the graffiti was frequently tailored to specific sites. Their messages were directed toward the denizens of Downtown Manhattan's bars, galleries, and boutiques, often satirizing their lifestyles, trivialities, and consumer-driven fancies. In this regard, SAMO© shared common objectives with train writers.[18] As the cultural critic Greg Tate reminds us, "the prime directive among the subway writers [was] to 'bomb all lines'—meaning not only to target every car running the tracks of the Big Apple's number- and color-coded system, but also to intellectually blow up the established art-world order with cantankerous metaphorical, mystical, and metaphysical content and savvy. To bomb all the lines that ran beyond the literal train system meant detonating the linear thought constructs of Western art legitimacy."[19]

Like Campbell, Tate contextualizes Basquiat's and Díaz's artistic endeavors within the framework of "hip-hop's Afrofuturistic hive mind." He highlights how subway writers coexisted within the same neighborhoods, communities, and recreational spaces as their multitalented musical peers. The early days of hip-hop culture allowed an avenue for writers to explore and express their multidisciplinary aspirations and inspirations. Basquiat, Díaz, and their contemporaries formed a network of creators, engaging in fulgurous nightlife scenes at clubs and independent art spaces. These regular encounters served as platforms for them to articulate their oppositional intentions and theories, just as SAMO© did. Díaz, Basquiat, and the early hip-hop generation harnessed their "racial alienation and sense of ethnic difference from the white world as ideological and ideographic

rocket fuel."[20] SAMO© was propelled by a desire to create seemingly spontaneous, intentionally unprofessional, and disruptive written landscapes that defied conventional notions of ownership and propriety. SAMO© crafted a haven for excess and irrationality within these disrupted artistic sites, deftly channeling words that connected intimately to their racialized bodies, artistic tools, and even random products. SAMO© effectively conveyed the intricate relationship between the self and the commodified art world through this unconventional manipulation of language. As Tate writes, "suddenly Gotham's most disenfranchised, harassed, over-policed, and invisibilized citizenry—its wise-assed tactical bombing youth—were impossible to ignore or to stop from dropping their wildstyle bombs."[21]

SAMO© . . . AS BOMBA NUYORICAN

The practice of Nuyorican graffiti employed by SAMO© allows for examining how coloniality controls and adjusts definitions of Puerto Rican, Caribbean, and Nuyorican identities. This approach uncovers the intricate understandings of freedom and unfreedom that emerge from these ethnic heritages.[22] SAMO© challenges the preconceived notions surrounding Puerto Rican and Nuyorican working-class culture through their subversive acts, highlighting the complexities and nuances inherent within these identities.

In their essay exploring the concept of artistic sovereignty, scholars Frances Negrón-Muntaner and Yasmin Ramirez argue that Basquiat and the work of SAMO© are focused on visualizing the connection between capitalism, modernity, colonialism, racism, and Western sovereignty using fluid and unstable words. They analyze Basquiat and Díaz as writers and theorists who examined how words gain and maintain authority and power. They also place their generation in the context of the syncretic Caribbean creolization of New York City: "This generation was also the first to read black and Puerto Rican history comic books and other 'alternative' popular reading materials. In addition, they actively participated in the creation of Nuyorican poetry, Afro-diasporic spoken word, and hip-hop, cultural forms that critiqued racism and coloniality and were themselves grounded in notions of empowerment via 'the word.'"[23]

SAMO© comes from and participates in a Nuyorican field of enunciation, negotiating the terms and parameters by which art practices are discussed and made legible. By doing so, they challenge existing power structures and offer alternative art perspectives. SAMO©'s artistic expression embodies a

Black Nuyorican aesthetic, offering new points of departure and maps of invention within an otherwise enclosed elitist art world.

Miguel Algarín's introduction to *Nuyorican Poetry: An Anthology of Puerto Rican Words and Feelings*, published in 1975, allows us to see the connections between the work of Díaz and Basquiat and the Nuyorican movement. Algarín describes Nuyorican poets as skillful word jugglers who take risks, presenting themselves as rulers of the urban environment. Algarín suggests poetry is a force in the streets, providing visions of the future. He emphasizes that innovation is not about conforming but often about disruption and chaos. According to Algarín, the raw poetics of urban chaos reflect a dynamic and erratic bilingual linguistic experience without boundaries, characterized by unruly, tense, and informal communication.[24]

Algarín expands on his previous text in his essay "Nuyorican Literature," highlighting three principles of the Nuyorican aesthetic. The first is bilingual orality, which communicates the Puerto Rican condition in psychological, economic, and historical terms. The second tenet is to establish protection and mutual assistance systems, proposing a language and a constitution for surviving in the city. His final point is creating spaces where people can unite and share their writing. Even though SAMO©'s work is highly distinctive, it exhibits a bilingual orality and a bold ludic critique that directly carves out writing spaces for marginalized youth. Since its inception, SAMO© has recognized that public discourse involves challenging and dismantling racialized borders and displacements perpetuated by the wealthy. Just like Algarín proposes, SAMO©'s public poems document survival conditions and emphasize social presence's importance.[25]

Nuyorican poetics also defy disciplinary and genre boundaries, as seen in Algarín's comparison of Nuyorican poetry to bomba, an Afro-diasporic musical genre originating in Puerto Rico as a rebellious art form of the enslaved. The poems document the realities of street life with themes ranging from encounters with law enforcement to drug-related experiences and expressions of abhorrence. However, poets deliver these complaints in a new rhythm, analogous to the bomba rhythm, featuring varying pitches and bold stress. The vocabulary combines English and Spanish to create a language pulsating with fast rhythms, reflecting the relentless strain experienced by Nuyoricans.[26]

Algarín's concept of Nuyorican poetry as bomba is significant because it aligns with graffiti's explosive and disruptive nature in urban spaces. Like graffiti writers, the *bomberos* (practitioners of bomba) claim spaces through *bombazos*, gatherings of dancers, singers, and drummers. Bomba

sessions give voice to and mobilize the Black history of the community. Scholar Sarah Bruno, who specializes in Black feminism, music, and performance, describes bomba as a system of mutual relief that serves as a model for repairing structural damage. Bruno emphasizes that bomba is not solely a genre of music and dance but also a lifestyle and practice that acknowledges, repurposes, and releases the effects of colonial trauma.[27] By connecting bomba to Afro–Puerto Rican culture, I am not suggesting that Díaz and Basquiat participated in *bombazos* or bomba groups. However, their musical verses and use of Black Puerto Rican slang freely navigate abstract sound, intonation, and layered meanings, drawing political and anti-colonial inspiration from bomba chants.

Díaz and Basquiat engaged with the Nuyorican intention of establishing solidarity with transnational and diasporic movements using historically marginalized symbols of strength, defiance, and resistance. Central to SAMO©'s philosophy is putting forth a critical perspective regarding the notion of a consensual art world. By dismantling the prevailing faith in a harmonious downtown art order or any coherent social cohesion, SAMO© enters debates that question established art discourses and canonical epistemologies. It emerges as a disruptive force, a bomba, refusing to conform to existing norms and instead interrupting or redirecting the energies within an international art world.

SAMO© . . . 4 THE CREATIVELY DEFIANT

In his book *SAMO© . . . SINCE 1978 . . .* , Al Díaz describes how enraged he was after Donald Trump was elected president of the United States in 2016. In that pivotal year in recent US politics, he returned "WITH A VENGEANCE," refuting an early Basquiat graffiti, and claiming "SAMO© . . . NOT DEAD."[28] He resurrected SAMO© publicly as a "WAKE-UP CALL 4 A SNOOZZZING NATION."[29] Privately, he honed his SAMO©'s verses for many years, developing an unrestrained political critique that holds no punches. It was the right time, he felt. There was a double intention going on. On the one hand, he was reacting to the political course the United States has taken. On the other hand, he was getting back on Basquiat, who briefly took over the SAMO© abstract entity and turned it into his early art-world persona, writing ambiguous cut-up-style poems—a misconception, in Díaz's view. It is important to remember here that one of the reasons Díaz and Basquiat parted ways was because, for a brief period between 1979 and 1980, Basquiat used SAMO© as his alias, taking advantage of its newly gained

popularity in the downtown art scene. Díaz complains that "this only served to confuse the story," making him bitter. Díaz claims that SAMO© had always been a "product" and was never intended to be a person and less so a celebrity.[30]

Hence, when giving new life to the project, Díaz brought it back home by centering on social critique for an "EMPIRE IN DECLINE," a "DROWNING CIVILIZATION," a "FLACCID SOCIETY," and a "TURBULENT PLANET" in "DEVOLUTION."[31] He wanted to use SAMO© ubiquitously "AS A PUBLIC SCOLDING," as a tool to mock political and media authorities, mindless digital rituals, obedience to "BRAND NAME CRAP," and formal discourses that enclose prejudices, elitism, and ignorance.[32]

Primarily from 2016 to 2018, Díaz wrote multiple SAMO© graffiti in NYC train stations, but SAMO©'s verses popped up in other states and cities of the world, some of them in translation (see figures 16.2 and 16.3). He continually documented his return on Instagram and eventually in his book. In graffiti of late 2016, Díaz attacked Trump's anti-migrant rhetoric and underlined his documented sexual abuses: "SAMO© . . . 4 ALL NASTY WOMEN & BAD HOMBRES," "SAMO© . . . 4 ALL GENITAL GRABBING OLIGARCHS," and "SAMO© . . . 4 AMERIGO VESPUCCI & 'THE NEW WORLD' MIGRATION."[33] In tune with the polarized times, SAMO© reemerged as a champion of political critique proposing a denaturalization of European migration to (and colonization of) the Americas. Looking beyond Trump, in one of the graffiti around nationalism and migration, he asks readers in Spanish to choose "CUAL ES MAS AMERICANO."[34] What/who is more American? He gives John Wayne, apple pie, baseball, or SAMO© as options. Díaz puts the reader in the situation of confronting John Wayne, an embodiment of manifest destiny, Indigenous genocide, and white mediatic power, with SAMO©—a multicultural poetic entity that challenges authority and has roots in the Caribbean. By asking the question in Spanish, Díaz is centering SAMO© over the other signifiers of US American identity. Hence, SAMO©'s notion of US Americanness is borderless and pluricultural. He adds value to the Caribbean as a germinal site to comprehend US American identities. He rejects white Anglo supremacy while understanding SAMO© as a diasporic creation that also proceeds from a US context.

Díaz also proposed that the mainstream political realignment toward corporate leaders represents another expression of the war machine and the search for nuclear power. He points this out through two graffiti: "SAMO© . . . BECAUSE 'WAR' IS SIMPLY A 3 LETTERED WORD 4 'BUSINESS AS USUAL,'" and in a rhymed stanza:

WATCH THE YELLOW LINE
BE CAREFUL NOT 2 SNEEZE
THOSE ARE BILLION DOLLAR WARHEADS
GOVERNMENT ISSUED CHEESE
50 GALLON DRUMS OF A FATAL DISEASE
4 RADIOACTIVE SNEAKERS 4 ALL THE
REFUGEES![35]

Spitting bars, Díaz considers the links between the welfare state and the military-industrial complex. He asks the reader to analyze the ways the government allocates funds. The "cheese" represents the typical austerity of the US social programs. However, there are no budget constraints to developing weapons of mass destruction. In this poem, systemic-induced poverty kills like warheads. But consumerist desires (the sneakers) hide this reality. Díaz also commented on the political strategy of promoting ideological division as a form of domination rooted in imperialism and enslavement: "SAMO© . . . 4 THE MASSES WHO, ONCE DIVIDED, WILL MOST CERTAINLY BE CONQUERED."[36]

As with his commentary on war, SAMO© also targeted the Unites States as a nation-state organized around surveillance, policing, and the prison-industrial complex: "SAMO© . . . 4 THOSE WHO EMBRACE THE 'POLICE STATE' MODEL."[37] Díaz informally participated in abolition activism by drawing attention to the US approach to policing and incarceration, as described by abolitionist geographer Ruth Wilson Gilmore. Gilmore noted in 2008 that the United States holds the top position regarding military power, wealth, war involvement, murder, and incarceration rates. When Gilmore wrote her essay, approximately 1 percent of US adults were imprisoned, with an additional 2 percent directly supervised by the criminal justice system. Although most individuals in custody had not committed acts of murder or violence, the prevalence of violence in all aspects of US American society helps explain the interconnectedness between law enforcement, prisons, and warfare.[38]

Díaz, who grew up in a project on the Lower East Side, knew firsthand the violence of police profiling and repression. He recalls multiple disturbing interactions with the NYPD. The police harassed him as early as when he was five years old after witnessing a presumptive murder in his building. At ten, the cops took him to the precinct because he entered with friends into the boiler rooms of his tenement. Approximately at the same age, he was in the middle of a full-scale community insurgency

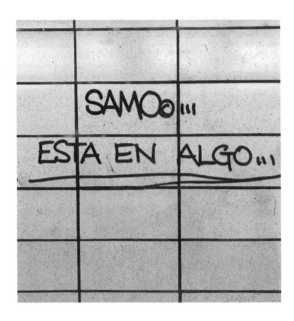

16.2 SAMO©..., NYC subway station graffiti, ca. 2017. Photo by Al Díaz.

after the police tried to pull into their car a neighbor doing a "Three Card Monty" game outside a pizza place. He also experienced police brutality, a beating, when the police caught him doing intravenous drugs (Díaz has been open about his struggles overcoming heroin addiction).[39] Through his concise graffiti work, Díaz sheds light on how, as Gilmore discusses, the expansion of criminalization is explained away by referencing a rise in violent activity but never the shift of infrastructural investment from schools and hospitals to jails and prisons.[40] In recurrent public verses, Díaz amplifies the notion that we live constantly surveilled by the police state: "SAMO© . . . 4 THOSE TWO COPS," pointing to their camera devices, "SAMO© . . . 4 ALL THE SURVEILLANCE CAMERAS PRESENTLY OBSERVING THIS," or "SAMO© . . . 4 BIG BROTHER & ALL HIS LITTLE HELPERS."[41] Using the literary notion of Big Brother, the omnipresent eye from the dystopian novel *1984* by George Orwell, Díaz argues that surveillance is imposed on us by the state, but it requires and feeds from compliance. Surveillance is inherent to racial and ethnic hierarchies. Policing maintains the status quo.

An aspect to remember here is that modern surveillance has its roots in racial capitalism. As scholar Simone Brown suggests, "understanding

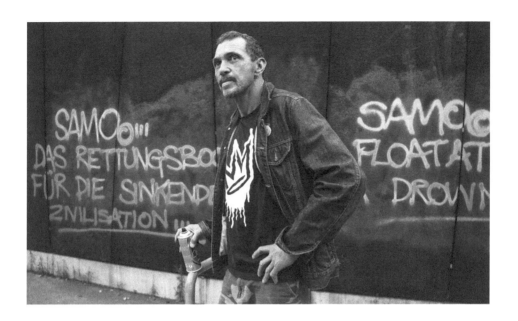

16.3 SAMO©..., Basel, Switzerland, 2018. Photo by Raphael Rapior.

the ontological conditions of blackness is integral to developing a general theory of surveillance."[42] Taking readers back to the slave ship, Browne argues that "enactments of surveillance reify boundaries along racial lines, thereby reifying race, and where the outcome of this is often discriminatory and violent treatment."[43] Like Browne, Díaz comments on how his racialized generation of Puerto Rican, Caribbean, and Black artists still experiences criminalization and persecution.

Díaz traces how, with policing and media misrepresentation as a by-product of camera surveillance, comes co-optation, mimicry, and, ultimately, displacement. Díaz constantly pinpoints the commodification and banalization of hip-hop and street culture. We can read these considerations in wall poems like "BRAZILIAN IMPLANTS, GUCCI SLIPPERS, ST. LAURENT TATTOO A DEGREE IN HIP-HOP YOGA THAT SHE EARNED AT NYU SAMO© . . . 4 TODAY'S DEBUTANTE," "SAMO© . . . 4 THE BOUTIQUE THUGS & RUN-WAY GANGSTAS," and "SAMO© . . . 4 THOSE INDIVIDUALS INTENT ON CO-OPTING CURIOUS LIFESTYLES & CHARMING LOCATIONS."[44] As the title of his book says, since 1978 SAMO© has been calling out the forces of urban and cultural gentrification on the Lower East Side and elsewhere.

Díaz queries the very real dislocation that comes with the simplification, misunderstandings, and fakeness that emerge from a "NOSTALGIC HIPSTER" media that romanticizes and whitewashes artistic movements from the past: "SAMO© . . . 4 THE STUNTED MINDS THAT WILL NOT MOVE AHEAD TRYING TO RELIEVE HISTORY THEY'VE BORROWED FROM THE DEAD."[45] As that poem connotes, with the increasing monetization of Basquiat's work, Díaz is conscious that SAMO© does not escape these dynamics. The market drafted him a long time ago. A generous speaker ready to share his anecdotes, Díaz is also critical of academic events and panels ("SAMO© . . . AS AN ALTERNATIVE 2 SYMPOSIUMS PANEL DISCUSSIONS & LECTURES ON SAMO© . . ."), especially when none of the surviving people involved in art movements are invited to share their knowledge.[46] He believes academics tend to co-opt street movements to gain undeserved cultural credibility.

Consistently, Díaz highlights how hip-hop is appropriated and inaccurately analyzed within academia. Nevertheless, this does not imply that he lacks dedication to historicizing and providing pedagogical tools for the study of graffiti and street art. Instead, he approaches this goal on his terms and those of his peers. In collaboration with cocurators Eric Felisbert, an author and former graffiti artist, and Mariah Fox, his collaborator in editing SAMO©'s works, Díaz curated an exhibition and compiled a corresponding book titled *NY City of Kings: A History of New York City Graffiti* in 2022–23. This groundbreaking project, the first of its kind, successfully opened at the Lower East Side Gallery Howl! in November 2022 (see figure 16.4). The research and conception of the project involved direct engagement with the NYC graffiti community and supporters. It involved tasks such as tracking down images and conducting interviews, fact-checking, and researching with the help of volunteers. In the introduction, Díaz clarifies that the exhibition and book present in a chronological timeline the perspectives of the actual participants in the graffiti scenes throughout the decades. Díaz discusses how NYC graffiti artists have historically been underrepresented and how gallerists, art historians, collectors, and academics have misinterpreted or distorted their narratives. Díaz also comments on the irony that the birthplace of graffiti culture lacks a dedicated museum, unlike cities such as Miami, Amsterdam, and Berlin. The exhibition and book aim to fill this void, even if only temporarily, and hopefully catalyze more significant investment in ethically documenting this fifty-year movement.[47] *NY City of Kings* exemplifies Díaz's ongoing critique of how the work of young artists, starting from the early days of SAMO©, is monetized and distorted by unscrupulous art institutions that

dismiss the artists' direct voices, frameworks, and creative processes. In a vastly Nuyorican move, he grounds the imperative of resisting disinformation by controlling the narrative and the spaces where it is displayed.

As with the exhibition, Díaz understands SAMO©'s project as a tradition inserted within the history of graffiti in NYC. Díaz conceives of its poetry as a product "4 THE MISINFORMED, UNDERINFORMED & PURVEYORS OF DUBIOUS INFO," "THE EXASPERATED POPULACE," "THE PARTIALLY & COMPLETELY CONFUSED."[48] SAMO© is a contrast "2 AN OTHERWISE DRAB, UNINSPIRED EXISTENCE" and a dose against the "INDIFFERENT ACUTELY BORED" capitalist order.[49] As in the early days, SAMO© continued to target consumerism and media manipulation. Díaz principally focuses on what he names "MASS PRODUCED INDIVIDUALITY."[50] In other words, he discusses how our society encourages uniqueness and constant trend-setting acts ("SAMO© . . . NOW TRENDING").[51] However, in this public quest, people create a uniform vision of supposed nonconformity. In some verses, he focuses on phones and social media dependency ("SAMO© . . . 4 THOSE OF YOU, NOT PRESENTLY STARING IN 2 YOUR PHONES WHO CAN ACTUALLY READ THIS"), instant gratification, and the alteration of reality through apps ("SAMO© . . . AS AN ALTERNATIVE 2 FACE FILTER APPS & 'TWERKING' EMOJIS").[52] In other graffiti, he looked at fetishized products such as "FOOTWEAR" or "A CUPPA CAW-FEE."[53] Others pick a fight with a "STANDING ARMY OF POSERS," "WANNABE & THE NEVERWUZ."[54] He has also maintained a critical distance and perspective vis-à-vis the art world and its players, which he conceived of as pimps playing tricks. To express these points, he uses Basquiat's case as a cautionary tale:

TO SAMO © . . .
YOU'VE BECOME SOMEWHAT OF
A "BIC MAC" DOWN HERE,
I HOPE YOUR SOUL IS JOYRIDING,
"CARE FREE" THRU' THE UNIVERSE . . .
—FROM SAMO©

Since he worked on the sidelines, he observed the irony of Basquiat's posthumous success with high bidders, mainly since his oeuvre centers a reconsideration of Black cultural value apropos the history of racial capitalism in the United States, the Caribbean, and Latin America.[55] Díaz also implies that, like a mass-produced hamburger, Basquiat has been processed by the cultural industries after his death. They have turned him into an

16.4 *NY City of Kings: A History of New York City Graffiti* timeline installation at Howl! Happening, New York, 2022. Photo by Jake Couri for Howl! Inc.

easily consumable commodity, erasing his heritage, complexities, and contradictions as a person, artist, and theoretician of Black life.

While this chapter cannot delve into it extensively, it is crucial to mention that alongside SAMO©'s revival, Díaz concurrently engages in another text-based art project, *Wet Paint*. This initiative involves displaying similar critical signs throughout New York City's MTA subway system. As an Instagram user (albert_diaz1), Díaz widely shares these satirical images to this day (as of April 2024), consistently sparking a transnational conversation. Díaz skillfully extracts individual letters from MTA public announcements in his lettered collages, reformulating them into "clever-sounding, surreal, and poignant anagrams."[56] Much like SAMO©, *Wet Paint* fosters a critical perspective on a society deemed a "RECURRING DISASTER" perpetuated by a "FRENZIED PACE" in need of "A FEW SMALL MIRACLES" for survival.[57] Within *Wet Paint*, Díaz confronts herd mentality and mindless consumerist "PILGRIMAGES" to the "STRIP MALL." Complementing those signed by SAMO©, in one of his most impactful graffiti pieces, Díaz exposes how consumer and media rituals, alongside imperial power masquerading as militarism, effectively conceal profound levels of socioeconomic inequality:

AS I WITNESSED 2 DESPERATE MEN
BATTLING 4 A PISSED STAINED
MATTRESS AND A FEW RANCID
MEAT SCRAPS IT BECAME CLEAR
ALL WAR IS IN BAD TASTE[58]

In a recent artwork posted on July 4, 2023, but made in 2019, Díaz symbolically transformed the stars on the US flag into skulls, serving as a metaphor for a necropolitical empire driven by war and gun violence. Questioning the nature of the celebration, he asserts that the United States is steered by the motives of "BIG BIZNIS SPREADING DISEASE, PAIN, AND PROPAGANDA." Díaz characterizes the United States as an imperial force that "CAPTURES, SEPARATES, INTIMIDATES, DETAINS, CAUSES SUFFERING, INSTILLS FEAR, TWISTS FACTS, TELLS BLATANT LIES [and] ABUSES."[59] In a counterpropaganda gesture, these fragmented artworks, at times dripping with deep sarcasm and at others delivering direct combative messages, explore how individuals become intermediated by beliefs, behaviors, or attitudes promoted by the state, corporate groups, and industrial complexes, often at the expense of their history, ethical judgment, and moral compass.

Joywriting

"ETERNALLY FREE, ETERNALLY YOUNG" embodies Díaz's portrayal of his friend Basquiat and their collaborative project SAMO©.[60] As demonstrated by the graffiti presented in this chapter, Díaz disregards Basquiat's value in the art market or the transformation of Jean-Michel into the epitome of contemporary art commodification (the Big Mac of art). Instead, Díaz's focus lies in the task of "FREEING SAMO© [and Basquiat]," which entails comprehending SAMO© as a critical and poetic expression of freedom (joyriding/joywriting) and defiance.[61] This comprehension of language in a radical and interconnected manner aligns with Christian Campbell's notion of shadow work and trickster work. Basquiat's and Díaz's writings explore the disruption of urban spaces by the multilingual youth in the streets, an aspect celebrated by Miguel Algarín. Building upon Algarín's influence, Frances Negrón-Muntaner and Yasmin Ramirez perceive Basquiat and Díaz's intervention as Puerto Rican decolonial poetics, centralizing their critique of Western sovereignty.

SAMO©'s poetics embody an "ALIEN CUBISM"—explosive, perpetually fragmented, acidic, fluid, and occasionally elegantly indecipherable.[62] During its initial phase, SAMO© endured for merely two years. Through their synergy and wild escapades, classmates Jean-Michel Basquiat and Albert Díaz left a lasting impact—a resounding "BOOM, FOR REAL," as famously expressed by Basquiat.[63] Díaz resurrected the project in 2016, transforming SAMO© into "AN EPIC POEM WITH FLAMES . . . AS AN END 2 THE NEON FANTASY CALLED LIFE."[64] Remaining faithful to their original youthful endeavor and his new multimedia project *Wet Paint*, Díaz opted to revisit a critique of consumerism, technology as a means of social control, and political apathy. Additionally, he incorporated a self-aware layer that explores the co-optation strategies, media influence, and academic snares. Díaz extends an invitation to readers and fellow enthusiasts, urging them to seize control and establish an authentic street practice that disregards "ALL RULES, REGULATIONS, LAWS, EDICTS, CODES, COMMANDS, AND DIRECTIVES."[65]

NOTES

1 The title of this chapter comes from a piece of Díaz's graffiti that reads: "SAMO© . . . / AS AN EPIC POEM, / WITH FLAMES, PIN-STRIPES / & LOTS OF CHROME." Díaz, *SAMO© . . . SINCE 1978 . . .* , 107.

2 Infamously, criticism on Jean-Michel Basquiat's art and persona was predominantly white, Eurocentric, racist, biased, and an example of the coloniality of art criticism. This affected Basquiat profoundly during his lifetime as he was seen as a primitive prodigy. He rebelled against white journalists and critics by rejecting most interviews or assuming an aloof personality with them (see the 2010 documentary directed by Tamra Davis, *Jean-Michel Basquiat: The Radiant Child*, and the interview section of Saggese, *Jean-Michel Basquiat Reader*). Notwithstanding, since the late 1980s seminal Black scholars and critics like bell hooks, Greg Tate, and Robert Farris Thompson started to develop an Afrocentric critique on his life and works that has shed light on his Black diasporic signifiers, practices, and concepts. Black scholarship on Basquiat has increased exponentially. A case in point is the 2014 book *Reading Basquiat* by Jordana Moore Saggese and her edited 2021 anthology *The Jean-Michel Basquiat Reader*. Caribbean and Latin American scholars and theorists like José Esteban Muñoz, Frances Negrón-Muntaner, and Yasmin Ramirez have provided essential discussion on his oeuvre from a queer Caribbean decolonial perspective. Recent exhibitions like *Basquiat Boom for Real* (also a documentary, 2017), *Basquiat's Defacement: The Untold Story*

(2019), *Writing the Future: Basquiat and the Hip Hop Generation* (2021), and *King Pleasure* (2022), to name a few, have offered significant contributions and expanded the reading of his work vis-à-vis Blackness and Afro-Boricua-Haitian and Latinx street cultures in NYC and elsewhere. These exhibitions, social media interventions, and audiovisual pieces look at his art and his explorations of multifaceted cultural phenomena, including music, pop culture, film, Black sports figures, poetics, and psycho-affective geographies, providing insight into the late artist's creative life and collaborations. They offer needed context regarding the multicultural communities he navigated.

3 Díaz, "Introduction," xvi–xvii.

4 See Fox, "Timeline: 1967–Today," 21.

5 Examining the trajectory of SAMO©, Díaz understands their writings as a transdisciplinary practice intertwined with teenage "wild abandon." Writing is a by-product of the "spirit of youth" of being "estar en algo loco, loco, loco, loco," as Basquiat elaborated in a painting/gift to Díaz in 1986. "Estar en algo loco" is a polysemic Puerto Rican phrase. It implies being under the influence of mind-altering substances. It also signifies being on the path of free uncensored expression. Díaz, "Dedication," n.p.; Díaz, "Epilogue," 195–97.

6 Cherokee Street Gallery St Louis, "Al Díaz Drops Truth," 16:35–20:30.

7 In the short story, Basquiat describes SAMO© as a "cosmiconcept" and as a "guilt-free religion and beyond." The protagonist goes shopping for a "practical" religion that fits his lifestyle and finds a character named Quasimodo Jones who introduces or rather sells SAMO© to him. "'Samo,' began Jones, 'is the belief of mercy in which we do all we want here on earth and then rely totally on the mercy of God on the pretense that we didn't know. That's the basis of it all. We didn't know. Once a week we attend services where the Samo priest places a piece of yarn on our eyebrows symbolic of the wool over our eyes. I fumbled for my checkbook. 'Make that payable to Relig-o-mat, the religion supermarket son,' said Jones beaming. Music swells. Title rise. The end. Life goes on." Basquiat, "SAMO," 58.

8 Fox, "Al Díaz and the Counterculture Legend of SAMO© . . . ," 18, 20.

9 Fox, "Alien Cubism," 75.

10 "It was my cousin Gil, he lived in Washington Heights . . . I was exposed to it up there, through him & the boys he rolled with. . . . I was Bomb 1, that was my tag, & then there was Snake 3, MANMAKER and MR DEATH. . . . We were the first four in all the projects in the LES . . . around 71 or 72 or so. . . . We sought each other out because there weren't any other really. . . . About a year after we started, you started seeing more names and I guess it [graffiti] was getting bigger & bigger, but for around a good year our names were the only ones that were visible, which was cool for us. . . . We were the Elite." Díaz, quoted in Louison, "Stuff Nightmares Are Made Of."

11 Díaz, "Foreword," in *SAMO© . . . SINCE 1978 . . .* , 5.

12 Basquiat and Díaz, "Experience SAMO," 2–3.

13 Basquiat and Díaz, quoted in Louison, "Stuff Nightmares Are Made Of"; Basquiat, Díaz, and Flynt, "SAMO© Graffiti Portfolio," 33–43.

14 Basquiat and Díaz were "similarly consumed by the challenge of disrupting Eurocentric knowledge and institutions that delegitimize and marginalize African, Afro-diasporic, and indigenous epistemologies and imagination. . . . Through various aesthetic means, including collage, repetition, improvisation, copying, scaling, designing, and color, Basquiat generated a dense sensorial archive that revised, related, and recontextualized black, Caribbean, indigenous, and other knowledges, affects, and memories." Negrón-Muntaner and Ramirez, "King of the Line," 338–39.

15 Like other contemporary critics, he goes against Basquiat himself, who dismissed the collaborative project as something childish without future relevance. See Miller, "Interview."

16 Campbell, "Shadows," 31–32.

17 Campbell, "Shadows," 31.

18 Díaz clarifies that although aware of the movement, Basquiat was never part of any train writers' group: "Jean was never involved in the name/number graffiti culture of the 1970s like I was. He may have been somewhat sheltered from 'street culture' during his pre-teen years. I remember he made an illustration for *The CAS Basement Blues Press* (the school paper that we founded together) and drew an interior of a subway car covered with graffiti. He added his own tag: Jean the bohemian, revealing to me that he did not quite get the whole graffiti vibe." Díaz, "Foreword," in *SAMO© . . . SINCE 1978 . . .* , 4.

19 Tate, "Hip-Hop's Afrofuturistic Hive Mind."

20 Tate, "Hip-Hop's Afrofuturistic Hive Mind."

21 Tate, "Hip-Hop's Afrofuturistic Hive Mind."

22 For a detailed account of Díaz's Nuyorican upbringing, see McVey, "Al Diaz."

23 Negrón-Muntaner and Ramirez, "King of the Line," 349.

24 Algarín, "Introduction," 11, 18, 19.

25 Algarín, "Nuyorican Literature," 91.

26 Algarín, "Introduction," 15–16.

27 Bruno, "'Yo la bomba no la bailé,'" 93.

28 Díaz, *SAMO© . . . SINCE 1978 . . .* , 16. The section title is from Díaz, *SAMO© . . . SINCE 1978 . . .* , 64.

29 Díaz, *SAMO© . . . SINCE 1978 . . .* , 27.

30 Díaz, *SAMO© . . . SINCE 1978 . . .* , 196.

31 Díaz, *SAMO© . . . SINCE 1978 . . .* , 92, 175, 53, 188, 120.

32 Díaz, *SAMO© . . . SINCE 1978 . . .* , 49, 46.

33 Díaz, *SAMO© . . . SINCE 1978 . . .* , 24, 38, 22.

34 Díaz, *SAMO©... SINCE 1978...*, 30.

35 Díaz, *SAMO©... SINCE 1978...*, 32, 37.

36 Díaz, *SAMO©... SINCE 1978...*, 27.

37 Díaz, *SAMO©... SINCE 1978...*, 35.

38 Gilmore, "Race, Prisons, and War," 141.

39 Louison, "Stuff Nightmares Are Made Of"; McVey, "Al Diaz."

40 Gilmore, "Race, Prisons, and War," 149.

41 Díaz, *SAMO©... SINCE 1978...*, 66, 67, 39.

42 Browne, "Introduction, and Other Dark Matters," 8.

43 Browne, "Introduction, and Other Dark Matters," 8.

44 Díaz, *SAMO©... SINCE 1978...*, 100, 135, 145.

45 Díaz, *SAMO©... SINCE 1978...*, 132, 102.

46 Díaz, *SAMO©... SINCE 1978...*, 140.

47 Díaz, "Introduction," ix, xvii.

48 Díaz, *SAMO©... SINCE 1978...*, 40, 61, 72.

49 Díaz, *SAMO©... SINCE 1978...*, 47, 126.

50 Díaz, *SAMO©... SINCE 1978...*, 171.

51 Díaz, *SAMO©... SINCE 1978...*, 156.

52 Díaz, *SAMO©... SINCE 1978...*, 154, 155.

53 Díaz, *SAMO©... SINCE 1978...*, 130, 147.

54 Díaz, *SAMO©... SINCE 1978...*, 112, 134.

55 Díaz's grafitti quoted in Schulz, "New Yorker Spotlight."

56 Díaz, "Wet Paint," accessed April 16, 2024, https://al-diaz.com/category/wet-paint/.

57 Díaz, "Wet Paint."

58 Díaz, "Wet Paint."

59 Díaz, "Go ahead. Celebrate the 4th of July. Just don't blow yourself up or cause any fire!!," Instagram, @albert_diaz1, July 4, 2023, https://www.instagram.com/p/CuSM5aAufek/?img_index=1.

60 Díaz, *SAMO©... SINCE 1978...*, 77. Díaz sampled this phrase from a Steely Dan song.

61 Díaz, *SAMO©... SINCE 1978...*, 164–65.

62 Díaz, *SAMO©... SINCE 1978...*, 84.

63 This phrase appears in many of Basquiat's paintings and recently has become a frame for a series of critical, audiovisual, and curatorial work on Basquiat's early creative environments.

64 Díaz, *SAMO©... SINCE 1978...*, 107; Basquiat, Díaz, and Flynt, "*SAMO©* Graffiti Portfolio," 41.

65 Díaz, *SAMO©... SINCE 1978...*, 31.

Algarín, Miguel. "Introduction: Nuyorican Language." In *Nuyorican Poetry: An Anthology of Puerto Rican Words and Feelings*, edited by Miguel Algarín and Miguel Piñero, 9–19. New York: William Morrow, 1975.

Algarín, Miguel. "Nuyorican Literature." MELUS 8, no. 2 (Summer 1981): 89–92.

Basquiat, Jean-Michel. "SAMO." In *Basquiat: Boom for Real*, edited by Dieter Buchhart, Eleanor Nairne, and Lotte Johnson, 58. New York: Barbican, 2017.

Basquiat, Jean-Michel, and Al Díaz. "Experience SAMO." In *SAMO© . . . SINCE 1978 . . .* , edited by Mariah Fox, 2–3. Santa Fe, NM: Irie Books, 2018.

Basquiat, Jean Michel, Al Díaz, and Henry Flynt. "The *SAMO*© Graffiti Portfolio, 1979–91." In *Basquiat: Boom for Real*, edited by Dieter Buchhart, Eleanor Nairne, and Lotte Johnson, 33–43. New York: Barbican, 2017.

Browne, Simone. "Introduction, and Other Dark Matters." In *Dark Matters: On the Surveillance of Blackness*, 1–29. Durham, NC: Duke University Press, 2015.

Bruno, Sarah. "*'Yo la bomba no la bailé, la bomba yo la viví*' (I Didn't Just Dance Bomba, I Lived It): The Pedagogy of Daily Puerto Rican Life, Black Feminist Praxis, and the Batey." *Transforming Anthropology* 30, no. 2 (2022): 93–106.

Campbell, Christian. "The Shadows." In *Basquiat: Boom for Real*, edited by Dieter Buchhart, Eleanor Nairne, and Lotte Johnson, 30–32. New York: Barbican, 2017.

Cherokee Street Gallery St Louis. "Al Diaz Drops Truth on NYC, Graffiti, Basquiat and SAMO© . . ." YouTube, September 13, 2018. https://youtu.be/Rs96pyRokoU.

Davis, Tamra, dir. *Jean-Michel Basquiat: The Radiant Child*. Curiously Bright Entertainment; LM Media GmbH; Fortissimo Films, 2010. 1 hour, 28 min. https://youtu.be/1chdCPR83Ns.

Díaz, Al. Introduction to *NY City of Kings: A History of New York City Graffiti*, compiled by Al Díaz, Eric Felisbert, and Mariah Fox, xvi–xvii. Santa Fe, NM: Irie Books, 2023.

Díaz, Al. *SAMO© . . . SINCE 1978* Edited by Mariah Fox. Santa Fe, NM: Irie Books, 2018.

Driver, Sara. *Boom for Real: The Late Teenage Years of Jean-Michel Basquiat*. Hells Kitten Production and Magnolia Pictures, 2017. 1 hour, 18 min. https://youtu.be/55pYmStOrhw.

Fox, Mariah. "Al Díaz and the Counterculture Legend of SAMO©" In *SAMO© . . . SINCE 1978 . . .* , edited by Mariah Fox, 17–20. Santa Fe, NM Irie Books, 2018.

Fox, Mariah. "Alien Cubism." In *SAMO© . . . SINCE 1978 . . .* , edited by Mariah Fox, 75. Santa Fe, NM: Irie Books, 2018.

Fox, Mariah. "Timeline: 1967–Today." In *NY City of Kings: A History of New York City Graffiti*, compiled by Al Díaz, Eric Felisbert, and Mariah Fox, 21. Santa Fe, NM: Irie Books, 2023.

Gilmore, Ruth Wilson. "Race, Prisons, and War: Scenes from the History of US Violence." In *Abolition Geography: Essays Towards Liberation*, edited by Brenna Bhandar and Alberto Toscano, 141–57. Brooklyn, NY: Verso Trade, 2021.

Louison, Evan. "The Stuff Nightmares Are Made Of." *1985*. Accessed July 7, 2023. http://www.1985artists.com/artist/al-diaz.

McVey, Kurt. "Al Diaz: 4 the Creatively Defiant." Upmag, 2020. https://upmag .com/al-diaz-4-the-creatively-defiant/.

Miller, Marc H. "Interview by Marc H. Miller." In *The Jean-Michel Basquiat Reader: Writings, Interviews, and Critical Responses*, edited by Jordana Moore Saggese, 17–31. Berkeley: University of California Press, 2021.

Negrón-Muntaner, Frances, and Yasmin Ramirez. "King of the Line: The Sovereign Acts of Jean-Michel Basquiat." In *Sovereign Acts: Contesting Colonialism across Indigenous Nations and Latinx America*, edited by Frances Negrón-Muntaner, 336–71. Tucson: University of Arizona Press, 2017.

Saggese, Jordana Moore, ed. *The Jean-Michel Basquiat Reader: Writings, Interviews, and Critical Responses*. Berkeley: University of California Press, 2021.

Saggese, Jordana Moore. *Reading Basquiat: Exploring Ambivalence in American Art*. Berkeley: University of California Press, 2014.

Schulz, Dana. "New Yorker Spotlight: Al Diaz on NYC Street Art and Working with Jean-Michel Basquiat." *6sqft*, June 12, 2015. https://www.6sqft.com /new-yorker-spotlight-al-diaz-on-nyc-street-art-and-working-with-jean -michel-basquiat/.

Tate, Greg. "Hip-Hop's Afrofuturistic Hive Mind." Hyperallergic, October 11, 2020. http://hyperallergic.com/589757/hip-hops-afrofuturistic-hive-mind -basquiat/.

17

¡No te luzcas!

Nuyorican Performance and Spectacularity in the Visual Art of Adál, David Antonio Cruz, and Luis Carle

Arnaldo M. Cruz-Malavé

Puerto Ricans are a performative people, most Americans think, whether condemning such performativity as rowdy, garish, or violent, or envying it for its devil-may-care, seductively affirmative force. Yet for a considerable period of their history, Puerto Ricans have striven to present themselves before the judging eyes of the US public as respectable, properly scrubbed social subjects, devoid of such tropical élan. We can now safely confirm that those days are gone—that they have been swept away with the promises of development in the island archipelago that would be realized if only its colonial subjects behaved, if only they renounced Indigenous traditions, adopted US hegemonic cultural norms, and believed in what the poet

Pedro Pietri called in his celebrated, sardonically amusing dirge to Puerto Rican respectability, "Puerto Rican Obituary," "these dreams, these empty dreams," these self-annihilating "empty dreams."[1]

But not too long ago, during the street-inflected, tumultuously loud yet more respectful years of the late 1960s and early 1970s in which the Spanglish term *Nuyorican* was being forged and New York Puerto Rican art institutions, such as El Museo del Barrio, were being founded, the Spanish verb *lucirse* could still strike fear in people's hearts. A very positive term in most of the Spanish-speaking world, a call to shine, to show oneself in the best light—*luz* or light being the root of the verb—when representing oneself, this verb was most often deployed in Puerto Rico as a negative command: an order not to show oneself, not to stand out, not to inject oneself in ongoing activities or events, lest one disrupt them and ruin them by making a spectacle of oneself.

"*¡No te luzcas!*" was the stern imperative with which most Puerto Rican parents began every family outing as a warning to their children to behave, to stand still, not to stick out, not to speak unless spoken to, not to intervene in adult conversations, not to volunteer information to others about family matters, lest they be suddenly and unexpectedly greeted by the silencing force of what my grandmother would simply call a *tapabocas*, literally a mouth covering yet—believe me—not just another Spanish-language term for a *mascarilla* or facial mask.

It is in this context of socially enforced respectability that the term *Nuyorican* would first make its appearance—significantly, not in New York but in the island archipelago. And it is there that the term would grow from a sign that named the purported cultural distance between those who had stayed and the adult children of those who had left and were joyfully returning to acquaint themselves with their family roots to become a marker not just of cultural difference but of a faulty, deficient, contaminated, and unruly type of colonial national subject—the self we had all been warned against: a spectacularized ethnic subject, or in local parlance, *un lucío* or *una lucía*, someone like the self I must have looked like when, in the early 1970s, I returned to Puerto Rico, after suffering through four years of a Long Island high school education, with a huge curly Afro, cranberry platform shoes, wearing a retro Hawaiian tropical shirt, and dancing salsa.[2]

This is the Nuyorican epithet with which the poets and cofounders of the Nuyorican Poets Café Miguel Algarín and Miguel Piñero were accosted in 1974 upon landing in Puerto Rico in search of what Piñero would call in his aptly titled poem, "This Is Not the Place Where I Was Born," "spiritual

identity."³ Instead of the anticipated union with the spiritual foundations of Puerto Rican home culture, we know from their poems that Algarín and Piñero would encounter the abject spectacularized self that a proper, respectable sense of national belonging would project onto them, and it was this spectacularized self-turned-Other and named *Nuyorican* that they would bring back with them and redeploy as the inspiration or impulse that would propel their New York Puerto Rican or Nuyorican artistic project.⁴

For Algarín, that encounter with the expelled spectacularized self that was the Nuyorican would lead him to focus not on ideal or spiritual being but on fugitive material practices, on what he called in the introduction to their first edited anthology, *Nuyorican Poetry*, "outlaw" practices: practices that "hustle" and "juggle" between visibility and invisibility, legality and illegality, in the hope of building someday through them a unified grass-roots communal governance and language.⁵ For Piñero, it would become a stubborn unyielding resistance to normalization, a refusal to reduce and smooth out the rough edges of what Jacques Lacan has called the traumatic, unprocessed, and inarticulable hard kernel of the "real." Either way, whether juggling or refusing meaning, Algarín's and Piñero's embrace and redeployment of the abject and spectacularized figure of the Nuyorican would become in their work more than an act of defiance; as Urayoán Noel and Karen Jaime have argued, it was a virtuosic multilingual, multimedia performance of creative empowerment.⁶

Ever since then—one might suggest—New York Puerto Rican visual artistic expression has been caught between the hypervisibility of sensationalized representation (whose counterpart is the invisibility of social abjection) and the respectable imperatives of colonial ethnonational representation, haunted as they are by the spectacular marginalized figure of the *lucío/lucía*, whose visual aesthetics and performative style are closer to what Jillian Hernández has termed a Latinx aesthetics of excess and Martin Manalansan the "fabulosity of the marginalized."⁷

It is true that painfully aware of the notoriously sensationalized negative representations of Puerto Ricans in the US media, an important and influential current of New York Puerto Rican visual arts has set out not only to document underreported historical events in the community but also to lovingly portray the singular, intimate moment that neither indexical realism nor exuberant tropicalism can represent. Consciously working against the media's sensationalizing hypervisible lens, artists like the Young Lords in-house photographer Hiram Maristany produced images that showed a community organized to take action in response to oppressive living conditions

in historic demonstrations such as the Lords' Garbage Offensive of 1969 or the funeral march to protest the death of fellow Lords member Julio Roldán, who died while in police custody after being arrested and falsely charged. But in works like *Kite Flying on Rooftop* (1964) and *Hydrant in the Air* (1963), Maristany also captured the sublime beauty and extraordinariness of everyday life in El Barrio in the almost invisible or seldom-acknowledged actions of a young boy on a rooftop flying a kite or children joyfully playing under a hydrant's water arc that jets out perfectly like a stream of light.[8]

In his stark, black-and-white prints, *New York Times* photographer and journalist David Gonzalez has similarly sought to counter sensationalized views of the burning South Bronx of the late 1970s and 1980s by delicately depicting the simple everyday activities that sustained its residents' sense of community and hope during these devastating years. In one of his most emblematic photos, *The Dancers* (1979), a Black Latinx couple dressed to the nines tenderly hold each other as they make a stylish salsa turn. Dancing in the middle of what appears to be a desolate, empty street in the fire-ravaged neighborhood, the anonymous dancers seem to sustain each other as they are in turn sustained, as Gonzalez notes, by the ephemeral richness and grace of this cultural form.[9]

Yet there is another current, equally prominent and influential, which, despite its presence in the New York cultural scene since the 1960s and the fame of some of its exponents, is seldom acknowledged when theorizing about what constitutes Nuyorican culture and art and which may even be said to have not yet acquired the necessary cultural capital to define what counts as "Nuyorican." It is a current that we might call, following on the innovative avant-garde photographer, videographer, performer, and thinker Adál Maldonado's definition of his art, "conceptual" (rather than "documentary"): it does not focus on proper representability before the sensationalizing gaze of the colonizing other but deploys instead what Jillian Hernández, among others, has called a Latinx aesthetics of excess that draws attention to fabulous marginalized subjects that make a spectacle of the self, dislocating it, dislodging it, and displacing it onto "out-of-focus," ghostly, blurred, and unhomely zones in order to engage in a different sort of politics—one that dislocates the self as a way of opening it up to multiple forms of agency and radically alternative speculative worlds for times that might often be considered, as we shall see, "postrevolutionary."[10]

Looking at New York Puerto Rican art from this radically alternative perspective—as an art whose subject is not just about performance but whose very methods, principles, and practices are performative as well—a

powerful and influential lineage of Nuyorican art comes into view: it includes the work of one of the most transformative fashion illustrators of contemporary times, Antonio Lopez, who brought the over-the-top attitude and swagger of the streets of El Barrio into high fashion;[11] the blurred, Surrealistic, and gestural work of Adál, whose performative subjects are not just dislocated but find empowering ways to remake themselves and their environments through such dislocations;[12] the expressionistic, neo-Afro-Taino, baroque, personal, and collective (self-)portraits of Jorge Soto Sánchez;[13] the neo-baroque trompe-l'oeil theatricality of Angel Rodríguez-Díaz's affirmative HIV-positive (self-)portraits;[14] the hip-hop religiously inflected *acrollage* assemblages of self in Rodríguez Calero's multiethnic, multiracial, intersectional subjects;[15] the out-of-frame figures of David Antonio Cruz, whose queer subjects' performative pose can't "sit" still, can't be contained or controlled;[16] and the incessantly proliferating migratory queer translocal portraits of Luis Carle's drag photography in NYC streets. And while Nuyorican artist Raphael Montañez Ortiz's celebrated aesthetics of "performative destructivism" might not qualify as spectacularized visions of self, it is nevertheless symptomatic of this other performatively conceptual lineage in Nuyorican art that, as Montañez Ortiz was first realizing his ritual acts of destruction of discarded objects found on empty lots in inner-city streets, he was also founding what would become in 1969 the first New York Puerto Rican museum, El Museo del Barrio.[17] After all, one could ask, underscoring thus the significance of performance for the constitution of a specifically Nuyorican aesthetics, what other diasporic, anti-colonial ethnonational visual-art tradition may be said to begin with the performance of destruction as a founding act?

Instead of positing this Nuyorican performative aesthetics of mostly second-generation New York Puerto Rican artists as a response to Puerto Rican hypervisibility in the US media or its counterpart, abject social invisibility, we could trace it to a broader affective response on the part of the diaspora to an ethnonational politics of respectability that became prevalent on the island archipelago and that demonized migrant Puerto Ricans as defective, inauthentic, and extravagant representatives of Puerto Rican identity and culture.[18] This condition, which would eventually become consolidated in the then-pejorative term hurled at Algarín and Piñero in their 1974 return to the homeland—Nuyorican—had by then a long history. Ever since the late 1950s, local Puerto Rican media had become awash with images of New York Puerto Rican gangs, *jíbara* peasant women whose traditional morality had supposedly lapsed, and deteriorated migrant neighborhoods,

and a general sense of what Frances Negrón-Muntaner has called "national shame" had not only overtaken "elite" discourse, as Negrón-Muntaner asserts, but also pervaded popular culture forms on the island archipelago.[19]

A retrospective look at Nuyorican cultural production would confirm that, like Algarín and Piñero, New York Puerto Rican artists did not respond to this demonization with bowed heads. Instead, artists such as the in-your-face scandalous, sexually suggestive lesbian *guarachera* Myrta Silva;[20] the Bronx gangster-styled salsa composer, singer, and orchestra leader Willie Colón;[21] and the queer underground drag performers Mario Montez and Holly Woodland,[22] among others, had countered such a shaming trend by becoming even more performative, more outrageous, and louder. By the mid-1970s, this other more fabulously personal and irreverent, unapologetically ludic and spectacular aesthetics that recycled the abject diasporic figure of the Nuyorican had gained considerable ground, becoming in important ways an alternative center of gravity of artistic creativity not only in New York Puerto Rican communities but on the island archipelago, where the transnational "counterstreams" of what the sociologist Juan Flores has called diasporic "cultural remittances" incited young Puerto Ricans in the archipelago to follow the Nuyorican example.[23]

While the emergence of this alternatively conceptual, performatively spectacular aesthetics may be traced to the diaspora's complex and fraught relationship to the island archipelago's hegemonic notions of national identity and culture about who may represent this culture and how it may be represented, its development and consolidation may be said to be promoted and shaped by a more internal historical shift in local New York Puerto Rican cultural politics. In the mid-1970s, the dissolution of the radical and charismatically popular Young Lords Party (YLP) brought about the demise of its revolutionary socialist utopian goals of attaining national independence and sovereignty for Puerto Rico and control of community resources for US Puerto Rican diasporic people and other "internal colonials." And in its wake, a former YLP member and activist named Eddie Figueroa would set out to reimagine the Lords' utopian aspirations of community engagement and empowerment and how to achieve them under the new cultural and political circumstances of failed socialist sovereignty and community control.

As recounted by the cultural critic Ed Morales in an article for *CENTRO Voices*, the online journal of the Center for Puerto Rican Studies, based on his last interview with Figueroa in 1990, shortly before his death in 1991, Figueroa would reimagine the Lords' utopian aspirations by shifting from the more rigidly centralized collective structure of the YLP to a

looser, free-floating concept of community that focused on the power of individual creativity and the role of culture to shape potential and always evolving forms of community or what he called in Spanglish El Spirit Republic de Puerto Rico. Disillusioned with what he considered the merely instrumental way the Lords had deployed culture as a means of achieving and supporting their intended political goals of attaining national sovereignty and community control, Figueroa set about creating a looser gathering place or institution, the New Rican Village, where artists could achieve collective goals through culturally decolonizing the self and thus expanding their and their audiences' abilities to radically imagine alternative forms of community and utopian futures.[24]

We might call Figueroa's vision for his New Rican Village a radical utopian revolutionary blueprint for postrevolutionary times, for a time when the Lords' revolutionary project of community control and national sovereignty no longer seemed to be viable and generative of personal and community empowerment and agency and needed revision. It is in this context of a foreclosed dream of community control and sovereignty as a political future to which many young Puerto Rican artists and activists had subscribed that the Nuyorican conceptual, performative aesthetics of self that we have been discussing would not only grow but would become the viable and generative alternative center of gravity of Nuyorican creativity that would rescue and transform the Lords' project of community empowerment and sense of future.

And, indeed, what we have been calling Adál's performative, conceptual, Surrealistic, and excessive aesthetics of self so perfectly aligns with Figueroa's vision of constructing alternative collective realities and futures through an emphasis on individual creativity and cultural decolonization that in 1994, a few years after Figueroa's death, Adál would join the avant-garde Puerto Rican Surrealist poet Pedro Pietri to realize Figueroa's vision of a Spirit Republic de Puerto Rico by establishing an imaginary El Puerto Rican Embassy that would issue creatively designed and conceived passports, a national anthem, currency, and maps, in order to incite its "citizens" to build "sovereignty" not as a physical or geographic space but, as Pietri famously put it in his "Manifesto: Notes on El Puerto Rican Embassy," "a state of mind."[25]

As Adál explained to critic and poet Urayoán Noel and critic and curator Yasmin Ramirez during the opening of his 2009 exhibition *Blueprints for a Nation* at the Center for Puerto Rican Studies, his photographic oeuvre had undergone a similar evolution to the one he now advocated for the Nuyorican community's El Spirit Republic. His art had grown from his early self-

reflexive work in books like *Evidence of Things Not Seen* (1975) and *Falling Eyelids: A Foto Novela* (1981), which tended to absorb him or immerse him into the very fiction he was creating, to affirming through this paradoxically immersive self-reflexive approach alternative speculative communal formations and visions.[26] Like the postmodern narratives analyzed by Linda Hutcheon in *Narcissistic Narrative: The Metafictional Paradox,* one could propose, Adál's self-reflexive photography showed not an evasion of the collective and communal but a rejection of the world as we know it, of the exhausted paradigms from which we commonly understand it and view it, suggesting thus, like contemporary Afrofuturism, other possibilities of action for the self and for dislocated, marginalized, and spectacularized subjects that could open up their limited perspective to multiple other speculative imaginings.

Throughout the rest of his work—in series like *Out-of-Focus Nuyoricans* (2004), *Puerto Ricans Underwater (Los ahogados)* (2017), and *Los dormidos* (2018)—Adál would continue to engage in this self-reflexive approach to collective worldmaking by immersing his subjects in blurred, ghostly, uncannily "out-of-focus" environments that dislocated them, forcing them to create alternative forms of individual agency and collective empowerment. This is nowhere clearest than in his stunning late masterwork *Puerto Ricans Underwater (Los ahogados* [The drowned]*),* where Adál invited a diverse group of artists, friends, and strangers to be photographed while they lay submerged in a tub of water as if they were drowning (see figure 17.1).[27] Begun in 2016—the year the US Congress imposed on the local colonial government of Puerto Rico the Financial Oversight and Management Board (FOMB) or La Junta, as it is commonly known on the island archipelago—this series addresses, as Adál has explained, the death and devastation that are wreaked on people's lives by colonial control.[28] Yet the photographed participants, who collaborated by adding their own props (flowers, plantains, machetes, guns, books, horns, goggles, glasses, and masks), do not seem here to be merely dying or enduring the devastation of colonial control. They also appear seriously engaged in reflecting, smoking, reading, shooting, laughing, and transforming themselves and their underwater world. Caught by Adál's camera in the middle of this transformative process, they may be seen as striking a pose, as offering the viewer their by-turns scandalously, seductively, defiantly mournful, angry, haughty, and joyous gestures as interruptions to the expected, prescribed teleological ending of *ahogo*, or drowning, and thus opening up the field of vision, like the gestures promoted by queer theorists José Esteban Muñoz and Juana María Rodríguez, to alternative speculative actions and readings. They

17.1 Adál, *Puerto Ricans Underwater (Los ahogados):
Andrea del Pilar*, 2016. Inkjet print. Courtesy of the
Estate of Adál Maldonado and Roberto Paradise.

are, as Sandra Ruiz has eloquently proposed, enduring colonial oppression while at the same time offering alternative personal and collective forms of respiration.[29]

It is this spectacularly defiant, excessive, gestural language that is also captured by queer artists like David Antonio Cruz and Luis Carle. Recalling his childhood in Philadelphia, Cruz remembers how as a young man his corporal movements were consistently monitored and surveilled by his Puerto Rican family and neighbors, and how he reacted then—to their

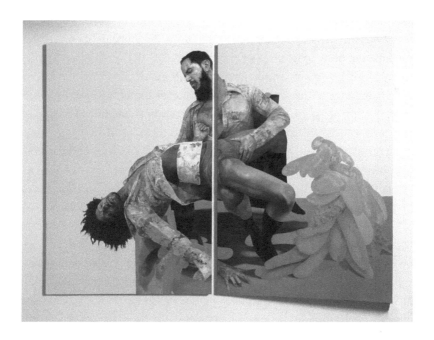

17.2 David Antonio Cruz, *soletthemeatasylumpink, thosedamnboys*, 2016. Oil and enamel on wood panel, 72 × 96 × 10 in. Courtesy of the artist and Monique Meloche Gallery.

shock and shame—by scandalously dressing up and even cross-dressing.[30] In much of his work, Cruz returns—against the grain of his family's aesthetics of respectability and ethics—to this surveilled and suppressed body of his childhood to joyously exhibit it, show it off, and liberate it, offering excessive, sexualized, and indeed queer baroque renderings of his Puerto Rican family's peasant roots in massive, vibrantly colored, tropical portraits, such as in his daringly erotic and tender *Jíbaro* series (2004–6).

In more recent work, the artist focuses instead on queer bodies and alternative families. In series like *returnofthedirtyboys/girls* (2016–18), he attempts to portray the movement and drama of the gender-fluid body in space and of alternative family formations without fixing them into a set pose, without capturing them.[31] Instead of pinning down the perfect moment that defines the queer subject and its alternative family relations, the artist captures the moment when the pose fails as the sitting body falls or exceeds the frame (see figure 17.2). Like Jack Halberstam's art of failure, Cruz's art succeeds in failing.[32] By refusing to control, pin down, or reduce

the queer subject and its alternative family relations to a predetermined linear narrative of movement or a static frame, he ends up liberating the gender-fluid body to its utopian potential.

Inspired by LGBTQ and AIDS activism, Luis Carle—who arrived in NYC from Puerto Rico in the early 1980s and, as founding director of the Organization of Puerto Rican Artists (OPArt), would become in the 1990s and early 2000s a major promoter of Puerto Rican art exhibitions—is a recognized documentary photographer of LGBTQ marches and demonstrations; of legendary activists of the queer and trans movements, such as Sylvia Rivera and Christina Hayworth. Carle's celebrated portrait *Trans Respect* (2000) is currently in the collection of the National Gallery; and of famous drag stage performers such as Joey Arias, Lady Bunny, Amanda Lapore, Antonio Pantojas, Barbra Herr, and Kevin Aviance.

There is, however, another Carle: the photographer of street performance and drag spectacularity who, as he narrates in his recent photographic essay in *Small Axe*, the Caribbean studies journal, began shooting street gender performers in 1984 in the East Village when the neighborhood was still not gentrified and Wigstock, the drag performance festival that took place there annually in Tompkins Square, was not so much a staged show as part of the neighborhood's yearly takeover by the progressive forces of gender fluidity and gender/sexual/racial creativity and diversity.[33] Since then, Carle has photographed many a well-known professional artist and performer, but it is the gender performers who transform on the street in front of our eyes, often daring to make a spectacle of themselves, and who valiantly and radically transform in the process our sense of the street and its everyday life, that I believe is most compelling in his work.

This is the other less glossy, less commodified story that is captured by Carle's lens in his moving photographs of New York's gender performers, many of them, like Oswaldo Gómez, doubly vulnerable, both refugee and trans, who migrated to the city to escape persecution in war-torn areas of the world. Known in her Jackson Heights, Queens, neighborhood as Ms. Colombia and La Paisa, Gómez fled Medellín during the outbreak of drug-trafficking violence in the mid-1970s and arrived in the economically distressed, racially and class segregated, post-Stonewall New York whose young people nevertheless came together on the streets, the dance floors, and the beach under the sign of a new popular ethos of sexual freedom and love.[34]

In the ensuing decades, as the city became increasingly gentrified, Gómez would develop a street performative practice that she qualified as

"desinhibida y a la carrera," uninhibited and on the run.[35] It was a practice that turned the streets into a kind of backstage dressing room where she would quickly change outfits as she dialogued and jested with passersby, fostering a relaxed, nonviolent atmosphere of gender fluidity, inquiry, and freedom that she called "carnivalesque."[36] Combining *pollera*-like dresses with silver lamé rebozos, schoolgirl pocketbooks with rainbow-colored gay bear beards, multicolored Afros and flowers with Hasidic, Catholic Orthodox, and Rastafarian headdresses, or simply, as Carle captures her, by herself with the ever-present Miranda-esque parrot on the head, Gómez would end up producing a style that mixed Colombian folk imagery with the culturally heterogenous accessories found in multiethnic New York to create an effect that she described as "cosmic," hybrid yet not a fusion, dialogically engaged yet also "fuera de serie," or as the archivist Dani Stompor has wittily called it, "fuera de serio," humorously out-of-sync, unique (see figure 17.3).[37]

While Carle has been recognized for his portraits of LGBTQ activists and performers, his focus on these other trans migrants' migrating street performances underscores his attempt to foreground and promote what the critic Lawrence La Fountain-Stokes has called the "translocal," rather than global, gender performances of NYC street artists. These are performances that refuse to reduce the difference of local, or indeed *loca*, ethnic queer vernaculars to appeal to a more homogenized and commodified trans world by depicting what Carle's recent exhibition called the "magic of everyday life" of NYC streets.[38]

Indeed, Carle's critique of gentrification and commodification is spectacularly front and center in his series *Dirty Martini Delivers Gender Justice* (Wigstock, 2019). Facing a homogeneously gentrified Manhattan skyline from the refurbished upscale margins of the East River's Pier 17, where the new Wigstock Festival has been relocated after a fourteen-year hiatus, drag burlesque performer Dirty Martini delivers in this series, as Carle states, "a mordantly joyful" gender performance that parodies the nation's symbols of justice and the city's neoliberal development that has forced so many trans people to leave New York (see figure 17.4). And, as she does so, she at the same time affirms, with her "excessively voluptuous, baroque, and hard-to-manage-and-mainstream body," drag performance's original utopian aspiration: to take over the city and install in it gender freedom and fluidity and gender/sexual/racial creativity and diversity.[39]

Nuyorican visual art has been much recognized for its corrective to sensationalist media images and its dignified representative depictions of

17.3 Luis Carle, *Ms. Colombia, The Cosmic Paisa* (People's Beach, Jacob Riis Park, Queens, New York), 2014. Digital print. Courtesy of the artist.

New York Puerto Rican community life. Yet there is another current of Nuyorican visual art, which dialogues with this documentary trend: a current that is irreverent, discomforting, polemical, and jarring; that exhibits and dislocates the self, even making a spectacle of it, to promote by other means an expansion and reimagining of the possibilities of an individual and collective future. It is this other fabulously conceptual, unapologetically ludic, scandalous, and indeed spectacular current to which artists like Antonio Lopez, Jorge Soto Sánchez, Adál, Angel Rodríguez-Díaz, Rodríguez Calero, David Antonio Cruz, and Luis Carle, among others, belong:

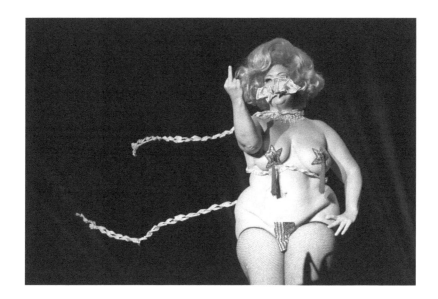

17.4 Luis Carle, *Dirty Martini Delivers Gender Justice* (Wigstock), 2019. Digital print. Courtesy of the artist.

a current that does not summon an already predetermined future but one whose radical out-of-the-frame, out-of-the-colonial-loop baroque excessiveness we hope for but cannot yet foresee.

NOTES

Acknowledgments: I'd like to thank the Fordham University Dean's Office for its Research Assistant Fellowship for summer 2022 and my extraordinary student Victoria Carmenate for her impeccable research.

1 Pietri, "Puerto Rican Obituary," in *Puerto Rican Obituary*, 4.

2 For a sharp and moving reflection on the aesthetics of "unruly" diasporic subjects, see Gopinath, *Unruly Visions. Lucido* and *lucida* are past participles of the verb *lucir* used as masculine and feminine nouns, respectively, with an elided "d" or syncope, as is common in colloquial Castilian and Caribbean Spanish.

3 Piñero, "This Is Not the Place Where I Was Born," in *La Bodega Sold Dreams*, 14.

4 See Piñero, "This Is Not the Place Where I Was Born," 13–14; Algarín, "Mongo Affair," in *Nuyorican Poetry*, 52–57.

5 Algarín, "Introduction: Nuyorican Language," in *Nuyorican Poetry*, 9–19.

6 See Noel, *In Visible Movement*, 41–82; Jaime, *Queer Nuyorican*, 27–55. On the figure of abjection in Algarín and Piñero, see also Cruz-Malave, "What a Tangled Web," 137–42.

7 J. Hernández, *Aesthetics of Excess*; Manalansan, "Queer Dwellings."

8 On Maristany's work, see Durón, "Hiram Maristany."

9 See School of Visual Arts, "David Gonzalez," for Gonzalez's lecture. For his discussion of the photograph *The Dancers* (black-and-white inkjet print, 1979), watch section 1:00:41–1:03:48.

10 On Adál, see Garrido Castellano, "De claves," 181.

11 See Padilha and Padilha, *Antonio*, 40. See also Bill Cunningham's comments— in James Crump's film *Antonio Lopez 1970: Sex Fashion and Disco*, based on Padilha and Padilha's book—on how dance and the street informed Lopez's illustrations. For images of Lopez's work and a review of his exhibition at El Museo del Barrio, *Antonio Lopez: Future Funk Fashion*, consonant with this analysis of Nuyorican spectacularity as an influential current in New York Puerto Rican visual art, see Cotter, "Nuyorican Artist's Career Survey."

12 For images of Adál's work, see Jackson, "Powerful Photo Series"; Durón, "Adál."

13 See Ramirez, "Nuyorican Visionary."

14 See Cordova, *Angel Rodríguez-Díaz*. For images of Rodríguez-Díaz's self-portraits, see Rubin, "Angel Rodríguez-Díaz's Spiritual Evolution."

15 See Torres de Veneciano, "Hip Hop and Metaphysics." For images of Rodríguez Calero's art, see https://www.rodriguezcalero.com/.

16 See David Antonio Cruz's comments on his painting *thosebutterflyboys* in the exhibition *A Place for Me: Figurative Painting Now*, Institute of Contemporary Art, Boston, March 31–September 5, 2022, https://www.icaboston. org/multimedia/david-antonio-cruz-thosebutterflyboys/.

17 See Carle, "Dirty Martini Delivers Gender Justice"; Aranda-Alvarado, *Unmaking*, 5–13; Ramirez, "Interview with the Destructive Artist."

18 As Arlene Dávila has proposed in *Latinx Art: Artists, Markets, and Politics*, despite the internationalization of art, Latin American art markets continue to tether their claims of authenticity, purity, universality, and creative freedom to nation-centered definitions that occlude colonial histories of race and class, and, I would add, migration, gender, and sexuality. In her view, because of its border and marginalized condition vis-à-vis national definitions, its excessiveness, its "x," Latinx art has the capacity of making those occluded histories visible. The performative spectacularized current in Nuyorican art that I analyze is proof of that.

19 Negrón-Muntaner, *Boricua Pop*, especially chapter 3, "Feeling Pretty: *West Side Story* and U.S. Puerto Rican Identity" (58–84); and chapter 4, "From Puerto Rico with *Trash*: Holly Woodlawn's *A Low Life in High Heels*" (87–114).

20 On Silva's scandalous musical performances, see Fiol-Matta, "Getting Off . . . the Nation," in *Great Woman Singer*, 16–66. See the image on the cover of her 1961 album *Camina como Chencha* as proof of the scandalous over-the-top personality that she assumed in this title song about the lapsed morality of a migrant woman in New York: https://www.ansoniarecords.com/post/new -release-myrta-silva-camina-como-chencha-1961.

21 See the cover of Colón's 1969 album *La Cosa Nuestra*, with its gangster Mafia-inspired image: https://fania.com/record/cosa-nuestra/.

22 See Mario Montez in Andy Warhol's short film *Mario Banana*, where he plays with a banana, suggesting fellatio: https://www.youtube.com/watch?v =1Ku9sGT2Ugg. On Montez's performances, see Cruz-Malavé, "Between Irony and Belief." On Montez and shame, see Cruz-Malavé, *Queer Latino Testimonio*; and La Fountain-Stokes, "Gay Shame Latina-Latino Style." On Woodland, see Negrón-Muntaner, *Boricua Pop*, 87–114; and La Fountain-Stokes, *Translocas*, especially chapter 3, "Diasporic Welfare Queens and the Translocas Drag of Poverty" (70–101).

23 Flores, *Diaspora Strikes Back*, especially chapter 2, "Of Remigrants and Remittances" (33–49), and chapter 3, "Caribeño Counterstream" (51–72).

24 Morales, "Places in the Puerto Rican Heart."

25 See the portal designed by Adál for El Puerto Rican Embassy of El Spirit Republic de Puerto Rico, which contains the "blueprints," passport, anthem, head of state, and its "coconaut" space program. Pietri, "El Manifesto."

26 Basilio, "Blueprints for a Nation."

27 Adál, *Puerto Ricans Underwater (Los ahogados)*.

28 Jackson, "Powerful Photo Series."

29 Muñoz, *Cruising Utopia*, 80–81, 90–91; Rodríguez, *Sexual Futures*, 5–7; Ruiz, *Ricanness*, 5.

30 On Cruz's upbringing in a religiously conservative Puerto Rican migrant jíbaro or peasant family in Philadelphia and the way he responded by queering that jíbaro tradition in his art, see his videotaped talk at the University of Wisconsin Milwaukee, especially mins. 2:00–6:00: https://vimeo.com/625455061.

31 For an eloquent description of Cruz's methodology in portraying the fluidity of the queer body and queer relationships, see his videotaped talk at the University of Wisconsin Milwaukee, especially mins. 20:30–21:15, and his comments on the painting *thosebutterflyboys* for the exhibition *A Place for Me: Figurative Painting Now* at the ICA Boston: https://www.icaboston.org /multimedia/david-antonio-cruz-thosebutterflyboys/.

32 Halberstam, "Queer Art of Failure."

33 Carle, "Dirty Martini."

34 On Gómez's biography, see the video by Nicholas Heller, *No Your City 2*, episode 4, "Miss Colombia," https://www.youtube.com/watch?v =qUBPrZ8INBU&t–13s.

35 López, "La Vida Loca."

36 See Tijeras, *La Paisa Documentary*. On the carnivalesque atmosphere that Gómez promoted through her visual and verbal wit, see Avery, "What I Learned."

37 For Gómez's discussion of her "cosmic" style, see López, "La Vida Loca"; and Stompor, "Into the Archive."

38 See Cruz-Malavé, *Magic of Everyday Life*; the online catalog of Carle's latest solo exhibition, https://luiscarle.com/; and the review by Robb Hernández, "The Magician and His Wardrobe." For more images of Carle's work, see https://luiscarle.com/ and https://visualaids.org/artists/luis-carle.

39 Carle, "Dirty Martini," 132.

BIBLIOGRAPHY

Adál (Adál Alberto Maldonado). *Evidence of Things Not Seen*. New York: Da Capo Press, 1975.

Adál (Adál Alberto Maldonado). *Falling Eyelids: A Foto Novela*. New York: Foto-Graphic Editions, 1981.

Adál (Adál Alberto Maldonado). *Out-of-Focus Nuyoricans*. Cambridge, MA: Harvard University Press, 2004.

Adál (Adál Alberto Maldonado). *Puerto Ricans Underwater (Los ahogados)*. Designed by Joshua Camacho Sánchez (Bold Destroy), with a prologue by Mercedes Trelles. San Juan: Strange Cargo, 2017.

Algarín, Miguel. *Nuyorican Poetry*. New York: William Morrow, 1975.

Aranda-Alvarado, Rocío. *Unmaking: The Work of Raphael Montañez Ortiz*. Jersey City: Jersey City Museum, 2007.

Avery, Dan. "What I Learned from the Fabulous Ms. Colombia." Logo, November 8, 2018. https://www.logotv.com/news/iwlqa7/ms-colombia.

Basilio, Miriam. "Blueprints for a Nation: An Installation by Adál." Video of panel discussion for *Blueprints for a Nation*, Center for Puerto Rican Studies, May 14, 2009. https://www.youtube.com/watch?v=fBwiC51xUJc&t=294s.

Carle, Luis. "Dirty Martini Delivers Gender Justice." *Small Axe* 69 (November 2022): 121–32.

Cordova, Ruben. *Angel Rodríguez-Díaz: A Retrospective*. San Antonio: Department of Arts and Culture, 2017.

Cotter, Holland. "A Nuyorican Artist's Career Survey: Loud, Proud and Timely." *New York Times*, June 16, 2016.

Crump, James, dir. *Antonio Lopez 1970: Sex Fashion and Disco*. Film Movement and Dogwoof, 2017. Documentary, 1 hour, 35 mins.

Cruz, David Antonio. "UWM Artist Now Talk: David Antonio Cruz," University of Wisconsin Milwaukee, October 6, 2021. https://vimeo.com/625455061.

Cruz-Malavé, Arnaldo M. "Between Irony and Belief: The Queer Diasporic Underground Aesthetics of José Rodríguez-Soltero and Mario Montez." *GLQ* 21, no. 4 (Fall 2015): 585–615.

Cruz-Malavé, Arnaldo M. *The Magic of Everyday Life: Luis Carle's Queer Translocal Photography*. Curated by Arnaldo M. Cruz-Malavé, with Gregory R. de Silva. Paul Robeson Gallery, Rutgers University, 2022.

Cruz-Malavé, Arnaldo M. *Queer Latino Testimonio, Keith Haring, and Juanito Xtravaganza: Hard Tails*. New York: Palgrave Macmillan, 2007.

Cruz-Malavé, Arnaldo M. "What a Tangled Web!: Masculinity, Abjection, and the Foundations of Puerto Rican Literature in the United States." *differences* 8, no. 1 (1996): 132–51.

Dávila, Arlene. *Latinx Art: Artists, Markets, and Politics*. Durham, NC: Duke University Press, 2020.

Durón, Maximiliano. "Adál: Key Photographer, Whose Work Imagined New Futures for Puerto Rico, Has Died at 72." *ARTnews*, December 11, 2020. https://www.artnews.com/art-news/news/adal-maldonado-dead -1234579063/.

Durón, Maximiliano. "Hiram Maristany, Young Lords Photographer Who Lovingly Turned His Lens on El Barrio, Dies at 76." *ARTnews*, March 11, 2022. https://www.artnews.com/art-news/news/hiram-maristany-photographer -dead-1234621738/.

Fiol-Matta, Licia. *The Great Woman Singer: Gender and Voice in Puerto Rican Music*. Durham, NC: Duke University Press, 2017.

Flores, Juan. *The Diaspora Strikes Back: Caribeño Tales of Learning and Turning*. New York: Routledge, 2009.

Garrido Castellano, Carlos. "De claves, enfoques y *heartbeats*: Entrevista con Adál Maldonado." *CENTRO Journal* 25, no. 3 (2013): 172–99.

Gopinath, Gayatri. *Unruly Visions: The Aesthetic Practices of Queer Diaspora*. Durham, NC: Duke University Press, 2018.

Halberstam, Jack. "The Queer Art of Failure." In *The Queer Art of Failure*, 87–121. Durham, NC: Duke University Press, 2011.

Hernández, Jillian. *Aesthetics of Excess: The Art and Politics of Black and Latina Embodiment*. Durham, NC: Duke University Press, 2020.

Hernández, Robb. "The Magician and His Wardrobe: Luis Carle's Queer Translocal Photography." Intervenxions, March 10, 2022. The Latinx Project. https:// www.latinxproject.nyu.edu/intervenxions/the-magician-and-his-wardrobe -luis-carles-queer-translocal-photography.

Hutcheon, Linda. *Narcissistic Narrative: The Metafictional Paradox*. Waterloo, Ontario: Wilfrid Laurier University Press, 1980.

Jackson, Jhoni. "Powerful Photo Series 'Puerto Ricans Underwater' Is a Biting Metaphor for an Island Drowning in Debt." Remezcla, November 28, 2016. https://remezcla.com/features/culture/puerto-ricans-underwater-photos -adal-maldonado.

Jaime, Karen. *The Queer Nuyorican: Racialized Sexualities and Aesthetics in Loisaida*. New York: New York University Press, 2021.

La Fountain-Stokes, Lawrence. "Gay Shame Latina-Latino Style: A Critique of White Performativity." In *Gay Latino Studies: A Critical Reader*, edited by Michael Hames-García and Ernesto Javier Martínez, 55–80. Durham, NC: Duke University Press, 2011.

La Fountain-Stokes, Lawrence. *Translocas: The Politics of Puerto Rican Drag and Trans Performance*. Ann Arbor: University of Michigan Press, 2021.

López, Alexandra. "La Vida Loca AKA 'The Miss Colombia Project.'" 2010. https://www.youtube.com/watch?v=NTPj-wFtYcI.

Manalansan, Martin, IV. "Queer Dwellings: Migrancy, Precarity and Fabulosity." Duke University Feminist Theory Workshop Keynote, March 12, 2013. https://www.youtube.com/watch?v=mdMUBO3ZvLc.

Morales, Ed. "Places in the Puerto Rican Heart: Eddie Figueroa and the Nuyorican Imaginary." *CENTRO Voices*, accessed May 20, 2024. https://edmorales.net/eddie-figueroa-and-the-puerto-rican-imaginary/.

Muñoz, José Esteban. *Cruising Utopia: The Then and There of Queer Futurity*. New York: New York University Press, 2009.

Negrón-Muntaner, Frances. *Boricua Pop: Puerto Ricans and the Latinization of American Culture*. New York: New York University Press, 2004.

Noel, Urayoán. *In Visible Movement: Nuyorican Poetry from the Sixties to Slam*. Iowa City: University of Iowa Press, 2014.

Padilha, Roger, and Mauricio Padilha. *Antonio: Fashion, Art, Sex and Disco*. New York: Rizzoli, 2012.

Pietri, Pedro. "El Manifesto: Notes on El Puerto Rican Embassy." El Puerto Rican Embassy, 1994. https://elpuertoricanembassy.msa-x.org/index.html.

Pietri, Pedro. *Puerto Rican Obituary*. New York: Monthly Review Press, 1973.

Piñero, Miguel. *La Bodega Sold Dreams*. Houston: Arte Público Press, 1985.

Ramirez, Yasmin. "An Interview with the Destructive Artist Raphael Montañez Ortiz." In *Unmaking: The Work of Raphael Montañez Ortiz*, by Rocío Aranda-Alvarado, 21–25. Jersey City: Jersey City Museum, 2007.

Ramirez, Yasmin. "Nuyorican Visionary: Jorge Soto and the Evolution of an Afro-Taino Aesthetic at Taller Boricua." *CENTRO Journal* 23, no. 2 (Fall 2005): 23–40.

Rodríguez, Juana María. *Sexual Futures, Queer Gestures, and Other Latina Longings*. New York: New York University Press, 2014.

Rubin, David S. "Angel Rodríguez-Díaz's Spiritual Evolution." *Glasstire {Texas visual art}*, July 14, 2015. https://glasstire.com/2015/04/14/angel-rodriguez-diazs-spiritual-evolution/.

Ruiz, Sandra. *Ricanness: Enduring Time in Anticolonial Performance*. New York: New York University Press, 2019.

School of Visual Arts. "David Gonzalez—Photographer and Co-Editor, Lens Blog." Masters in Digital Photography Lecture Series, School of Visual of Arts, April 18, 2017. https://www.youtube.com/watch?v=kiCmAD-GU6k.

Stompor, Dani. "Into the Archive." *Visual AIDS,* October 17, 2022. https://visualaids.org/blog/dani-stompor.

Tijeras, Pachanga. *La Paisa Documentary.* 2011. https://www.youtube.com/watch?v=lmRARoH49dA.

Torres de Veneciano, Jorge Daniel. "Hip Hop and Metaphysics: Introductory Notes on Rodríguez Calero." In *Rodríguez Calero: Urban Martyrs and Latter Day Santos,* 11–19. New York: El Museo del Barrio, 2015.

18

"Bridging Gaps and Building Communities"

Wanda Raimundi-Ortiz's *Ask Chuleta* and Afro-Latinx Identity beyond the "White Box"

Kerry Doran

From 2006 to 2013, not counting later spin-offs and cross-over appearances, Nuyorican artist Wanda Raimundi-Ortiz performed as the title character of the web series *Ask Chuleta*. Made for and posted on YouTube, *Ask Chuleta* comprises about twenty videos, each four to nine minutes in length, numbered in sequential order with various subtopics about contemporary art: "Biennials," "Collectors," "Appropriation," "Identity Art" (see figure 18.1). Like Raimundi-Ortiz, Chuleta is a young female artist from the Bronx. She starts recording confessional-style vlogs to explain the ins-and-outs of the art world to people like "me and yous."[1] In the first video, simply titled "Contemporary Art," Chuleta expresses her motivation:

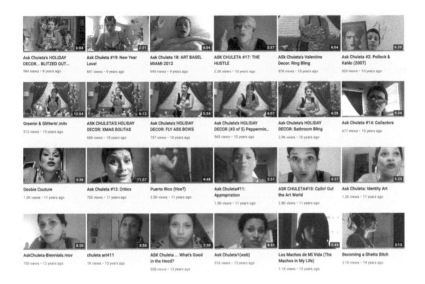

18.1 Screenshot of *Ask Chuleta* video thumbnails on YouTube, ca. 2021.

"People don't really be thinkin' about us like we be going to museums and stuff like that. They be underestimatin' us and whatnot."[2] Chuleta speaks freely, using bilingualisms and slang to address people whom the museum underestimates or altogether excludes. She has the expressed aim of "bridging gaps" and "building communities," phrases she often repeats in her videos. According to Chuleta, there is "the world like us," which she uses to refer to Latinx, Puerto Rican, Brown, and Black folks, and the "white box community," a play on the concept of the white cube that describes the whiteness of the mainstream art world. While Chuleta begins her project with enthusiasm at the prospect of connecting these worlds, the series becomes increasingly critical. She starts "calling out" and "coming for" the art world's hypocrisies and double standards, which apply to people based on race, gender, sexuality, class, ability—basically, anyone who does not fit into the white box of so-called normativity.

The phrases "bridging gaps" and "building communities" invoke the vanguard expressions of Puerto Rican artists within the New York alternative Art Space movement (1965–85). According to art historian Yasmin Ramirez, artists of Puerto Rican descent were at the forefront of this coalition-building movement. She writes that "artists of diverse backgrounds, races, and ethnicities founded not-for-profit alternative galleries

that stood in opposition to the Eurocentric, patriarchal, and market-driven values of the mainstream New York art world."[3] Furthermore, writes Ramirez, Puerto Rican alternative spaces could be summarized by the following two mottos: "(i) 'resistance (to U.S. hegemony) and affirmation (of Puerto Rican self-determination)' (ii) 'bridging gaps (between Puerto Ricans residing on the island and New York) and building community (between artists and local residents).'"[4] Coinciding with the civil rights movement, the women's liberation movement, and anti–Vietnam War organizing, the politics of the New York alternative art space movement aligned with these social justice movements, while also responding to targeted ethnoracial discrimination against Asian, Black, and Brown communities in New York City. Following Ramirez once more, Puerto Rican alternative spaces opened in working-class barrios, and, with their distinctly community-driven praxis, aimed to center artists, activists, and community members in New York's civic sphere.[5]

By invoking the language of Nuyorican artist-activists, Chuleta knowingly situates herself and her project within this legacy—a legacy, it must be noted, that is largely known through the contributions of male figures, such as Miguel Algarín, Hiram Maristany, and Raphael Montañez Ortiz, among many others. Chuleta is an Afro-Latinx woman who establishes herself within this lineage. While this gesture is radical in and of itself, so too is Chuleta's way of being and being in community: her mannerisms, appearance, and language are distinctively of an Afro-Boricua from the Bronx, and she posts her videos on YouTube. Both are forms of resisting the "Eurocentric, patriarchal, and market-driven values" of mainstream culture and the art world.[6]

Chuleta may remind you of a friend, a cousin, or even yourself. She wears big earrings, styles her hair in a doobie, and always keeps it real. She's friendly and unpretentious. She records her videos off the cuff while thoughts are fresh in her mind; sometimes she's sick in bed, sometimes she's drinking her morning *cafecito*. For Raimundi-Ortiz, the character of Chuleta was inspired by the "hood girls" she knew so well growing up—a kind of intimacy of knowing that comes from "watching all the things you're not supposed to do and cataloging them."[7] The artist's mother forbade her to dress, talk, or act like these women. Depreciation for these women and girls can be expressed in many ways; one denigrating word within the Spanish-speaking Latino/a/e-Caribbean world and its diaspora that might be used to label them is *chusma*.

Employing his own framework of disidentification to theorize this specific stereotype, José Esteban Muñoz identifies *chusma* characters

and *chusmería* behavior in Carmelita Tropicana's play *Chicas 2000* (first performed in 1997), summarizing the drama as "a tacky affair, a spectacle of Latina excess and gaudiness."[8] He then defines *chusmería* as "a form of behavior that refuses standards of bourgeois comportment."[9] Bourgeois comportment invariably links the concept to class, race, and sexuality. As Deborah L. Vargas aptly summarizes while elaborating her analytic, *lo sucio*—a visceral, sensual framework informed by Muñoz—*chusmería* "suggests that Latinos should not be too black, too poor, or too sexual, among other characteristics that exceed normativity."[10] The quality of exceeding normativity is also operative in Jillian Hernández's *Aesthetics of Excess*. She theorizes the "sexual-aesthetic excess" of Black and Latina women and girls, who are often considered "'too much': too sexy, too ethnic, too young, too cheap, too loud."[11] All three frameworks center embodied practices as modes of theorizing and a politics in themselves. Exceeding is a form of trespassing, writes Hernández, rejecting "neoliberal racial, class, gender, and sexual normativity."[12] For Vargas, smells, tastes, and sounds associated with *suciedad* (a Latino vernacular for dirty, nasty, and filthy) resist neoliberal hetero- and homonormative cleansing agendas. And for Muñoz, *chusma* identity contests "hegemonic models of citizenship."[13]

Excessiveness can only be perceived as such when measured against modernist and classical Western discourse, notes Hernández.[14] The ideologies and classificatory systems that extend therefrom regulate and censure people, material, senses, and sensualities that exist, and thrive, beyond such boundaries. I understand Chuleta's white box as representative of this white supremacist ideology and its biopolitical consequences. More specifically, she references two white boxes. For a series about contemporary art, the white box is obviously a play on the concept of the white cube (its history and alleged neutrality elaborated and critiqued by the late Brian O'Doherty).[15] By critiquing this white cube, I also see her as challenging the white box of the web browser, her exhibition venue.

Raimundi-Ortiz recorded the first episode of *Ask Chuleta* in 2006, the same year *Time* magazine chose "You" as its "Person of the Year." *Time*'s selection for "Person of the Year" celebrated the triumph of the "user" in the dawning era of Web 2.0. "Neocritics," as Alondra Nelson would call "analysts and boosters of technoculture" several years earlier, argued that "the information age ushered in a new era of subjectivity and insisted that in the future the body wouldn't bother us any longer"—a mythology that intensified as the social became lucrative.[16] Following the dot-com crash in

the early 2000s, Silicon Valley entrepreneurs learned that human connection, or extraction, would be more profitable than e-commerce. Websites and apps that emphasized the social would come to define Web 2.0, and social media companies disguised their extractive business models through the language of the "user." Corporations and neocritics would argue that people could speak back to power and organize through content creation, connection, and collaboration—precisely the mythology *Time*'s "Person of the Year" issue celebrated. The cover of the issue features a white iMac G5 monitor displaying YouTube's graphical user interface (GUI); above the playback bar, the gray, mirrorlike screen displays the word *You*.[17] As Richard Dyer has historicized, whiteness entails "being without properties, unmarked, universal, just human," epitomized by the *Time* cover with its generic, faceless "You."[18] Ultimately, the universal quality of the "user" suggested that racialized, gendered, and economic barriers to entry would be leveled with the democracy ushered by this new social web.

Essentially, Web 2.0 was a neoliberal software update of the early web (retroactively named Web 1.0) with its emphasis on the pull-yourself-up-by-your-bootstrap's user. Still, it is true that faster broadband speeds, greater capacity for image processing, and wider availability of mobile devices altered ways of creating and sharing content. And, to some extent, the level of access was unprecedented. Raimundi-Ortiz explained her early draw to YouTube as follows: "It was like a public-access channel. You didn't have to go to the Cablevision shop or the Spectrum sound stage. You could just set it up in your house. And there wasn't a big approval process. You had a page and you put stuff up."[19] Following this same logic, YouTube could also be an exhibition venue. Artwork did not need to be vetted by a commercial gallery—it could simply be uploaded. Although alternative art space Exit Art (founded by art historian Jeanette Ingberman and Nuyorican performance artist Papo Colo in 1982) would remain open until 2012, the 1990s and early 2000s were marked by the widespread implementation of neoliberal policies in New York City, particularly in neighborhoods with large Latine/a/o and Puerto Rican populations.[20] The opening of new alternative venues or the maintenance of preexisting ones would become increasingly difficult during these decades. YouTube, particularly for a Puerto Rican woman of color, was a viable channel of self-representation.

Working within the frame of the mainstream internet's whiteness, however, Raimundi-Ortiz would face a different reality when sharing her series online. *Ask Chuleta*'s raw, unedited style and tone matched much of the content on YouTube at that time. Raimundi-Ortiz's all-too-convincing

performance, without the context of an art gallery, led many viewers to experience Chuleta as real. Her videos ultimately elicited derogatory comments from people within and outside the Puerto Rican community—reactions Raimundi-Ortiz did not wholly anticipate when beginning her series. These responses track with Muñoz's writing on *chusmería* politics (though his framework is specific to Cuban culture): calling someone a *chusma* is a distancing technique, to separate middle class from working class, white from Black, immigrant from "American."[21] Yet even within an institutional context, the character of Chuleta was stereotyped by white art critics, described as a "sassy Latina" from "the projects" (she never identifies as such).[22] In both cases—the white box of the web browser and the white box of the white cube—Chuleta exceeds the frame of representation and is judged against it.

Although *Ask Chuleta* is a video performance series specifically made for YouTube, it developed out of Raimundi-Ortiz's interdisciplinary body of work, encompassing performance, illustrations, murals, prints, and works on paper, as well as video and internet art. The character of Chuleta was born out of a worldbuilding practice through these wide-ranging media, which I discuss later in this chapter. It must first be noted, however, that Raimundi-Ortiz's worldbuilding is not limited to this one character. *Las Reinas (The Queens)* (2013–15) is a series of performative self-portraits in which the artist transforms herself through elaborate costuming, makeup, poses, and settings into regal figures—the Bargain Basement Sovereign, GuerilleReina, PorcelaReina, and GringaReina—whose identities relate to yet positively reappropriate the artist's personal trauma. Forms of gendered and racialized violence, from intimate partner violence to Eurocentric beauty standards, become powerful affirmations of identity. In another recent body of work, *Wig Variants* (2020–present), Raimundi-Ortiz connects herself to the natural environment through her hair extensions (see figure 18.2). In both drawings and photographs elaborate, even sculptural, hair echoes and merges with the lush landscape in which she is pictured. Raimundi-Ortiz's hair—which the artist has elsewhere described as the Blackest part of herself, and thus a target of discrimination—is mobilized to find peace with her surroundings.[23] Across her practice, Raimundi-Ortiz honors the resilience of Afro-Latinx women and uplifts the beauty that is always already there, despite the specific intersection of racism and sexism that women of color endure in a white supremacist culture. The *Chuleta* series provides a significant lens for Raimundi-Ortiz's oeuvre in that it offers a form of disidentificatory *chusmería* that parodies the parody of white supremacy.

18.2 Wanda Raimundi-Ortiz, *Wig Variant #6, Sanctuary series, Nested,* 2021. Performance portrait, 30 × 40 in. Photo courtesy of the artist.

Chuleta first appears in *Wepa Woman* (2005–6), a series of comic-book-like works on paper and murals, both outdoors and in.[24] Wepa Woman is the heroine of this hero's journey, the "quintessential Puerto Rican bombshell who is approved and sanctioned," according to Raimundi-Ortiz, and "who looks nothing like me but holds all of my political beliefs."[25] With an hourglass figure revealed through skintight clothes, a thick, slicked-back ponytail, and perfectly applied eyebrows and lipstick, Wepa Woman is drawn to fit the stereotype of the Boricua bombshell. Like other bombas of Puerto Rican descent, such as Iris Chacón and Jennifer

Lopez, she is other enough to be racially and sexually objectified, but not "too black, too poor, or too sexual," recalling Vargas's words. Wepa Woman's skin is ambiguously colored in or not colored in at all, alluding to the ways in which the character might be aligning herself with whiteness despite being Black or Brown.

Wepa Woman can often come off as a person who would use the word *chusma* in a denigrating way. While her moral superiority at times produces positive effects, such as when she kicks *machistas* to the curb, she also comes for the "too much" Chuleta. In fact, Wepa Woman is Chuleta's nemesis. In one ink drawing, Chuleta is pictured at the bar, imaged as the antithesis of Wepa Woman: curly ponytail, Afro-descendant features, low-cut halter top, her fresh set of acrylics laid on the bar while loudly ordering another appletini. In contrast to Wepa Woman, Raimundi-Ortiz describes Chuleta as looking like her physically, but "totally hood ratchet," and everything her mother told her not to be.[26] Drawing the Wepa Woman series was a process of self-discovery for Raimundi-Ortiz. Alongside reading Adrian Nicole LeBlanc's *Random Family* (2003), she told me, Raimundi-Ortiz came to recognize Wepa Woman's actions as epitomizing a kind of self-loathing—namely, internalized white supremacy.[27] The artist therefore became more interested in the complexity of the antagonist, or the "anti"-heroine of the story, Chuleta.

Chuleta was born, or embodied in an act of self-acceptance, in Raimundi-Ortiz's endurance performance *Becoming a Ghetto Bitch*, presented at Exit Art in 2006. Alongside the exhibition *Wild Girls*, a group show that included selections from the *Wepa Woman* series, curator Papo Colo organized an evening of performances. Raimundi-Ortiz's began as gallery visitors mingled in the show.[28] Sitting in a simple black outfit, wearing no makeup and with natural hair, Raimundi-Ortiz stands up and approaches a mirror, which reflects her as well as a *Wepa Woman* drawing behind her. Slowly, she begins to transform herself: she applies winged eyeliner, lip liner, and lip gloss; she undresses, changing into a white singlet (the word *Bronx* emblazoned across the chest) and a studded denim miniskirt; she covers her curly hair with a dark-red wig, clipping it into a doobie; she returns to the chair, zipping up high-heeled metallic boots and drinking a beer. Then, she yells into the ambient crowd: "These right here? These shoes cost $400! . . . They did! Don't look at me like I'm fuckin' crazy. I'll show you the receipt!"[29]

An exasperated monologue begins, as if the woman is angrily venting to someone about a racist incident. She, along with her three kids and

partner, were passed over by a taxi, the driver picking up a presumably white woman instead: "But because she had to go to her fucking staff meeting, or her board meeting, or wherever the fuck she had to go. . . . She had places to go like I didn't have places to go. Because apparently, you know, I'm not doing shit with my life, so what's the fucking hurry."[30] Both women are wearing "badass shoes," the character says, but one pair is perceived as professional or classy, and the other as cheap or trashy. When the character is passed over for the cab, she is invisibilized—yet such invisibilization can only result from being *seen*. ("You can't see this? How do you not see this?" the woman hypothetically yells to the taxi driver.) The paradox of being simultaneously seen and unseen happens in the gallery too. The woman is hardly perceived—ignored, even—by gallery-goers at the beginning of the performance. As she starts voicing her rightful frustration, she draws attention to herself, albeit as someone who is complaining. As Sara Ahmed writes, "To be heard as complaining is not to be heard," rendering the figure invisible despite any focus on her.[31] In Raimundi-Ortiz's description of the piece, she writes that the work explores "the very stereotypes of my own culture" and allows "this character to voice her frustrations about being seen and unseen," themes that would also become significant in the *Ask Chuleta* series.[32] Becoming a "ghetto bitch" in this work means becoming a *chusma*, becoming *sucia*, becoming too much—becoming Chuleta.

We meet a version of Chuleta in the first webisode of her series *Ask Chuleta* (see figure 18.3). Although she has the same style, accent, and mannerisms as the character from *Becoming a Ghetto Bitch*, she now has her name and a different narrative. Chuleta is an aspiring young artist and art student, establishing a practice, attending critiques, learning art history, and visiting galleries and museums. Through these experiences, she identifies a disconnect between people like "me and yous," signifying Black and Brown folks, and "the white box community," or the mainstream contemporary art world. The implication, of course, is that there are no Black and Brown artists, curators, gallerists, or other art workers in the latter category. She therefore intends to carve out a space online to bridge gaps and build community, like Puerto Rican vanguards before her—especially significant given the gentrification of the neoliberal city and mainstream Web 2.0 culture.

Chuleta begins vlogging with genuine intentions to bridge gaps and build communities, an aspiration she maintains throughout the series. However, her tone and the subject matter shift as the series progresses.[33] She doesn't see herself reflected in the art world despite her efforts, the

18.3 Screenshot of Chuleta from the *Ask Chuleta* series, 2011.

ultimate proof of which comes when her work is "appropriated," or stolen, without due credit. In her videos about critics, collectors, and biennials, she critiques how those in power—upper-class white people—overlook, ignore, and misunderstand ontologies and epistemologies that operate beyond the "white box," which ultimately results in the invisibilization of these practices. In short, artists of color are both seen and unseen. For example, in Chuleta's response to the 2010 Whitney Biennial, she says: "A biennial is supposed to be a show that puts things together like it's supposed to be showing you what's hot, like what's really good and what's hot in this moment, like right then right there. . . . Like it fucks with me that . . . you know what I'm saying, I don't see me."[34] Or, when artists of color are included in white box exhibitions, their work is only viewed through the prism of identity and difference. In the same video, Chuleta describes how the artists of color are exhibited in one corner: "Maybe it's just me. . . . I don't know if anybody else has a problem with this shit. . . . It don't take no rocket scientist to see. Like they have all the artists of color, all the Black artists, in one corner, all smashed together, umm. . . . Since when do we put everybody in the same group together in the same spot like that, like

that's supposed to be cool. I don't know. . . . That seems like, segregation?"[35] Chuleta calls it like it is. Along with describing this curatorial decision as "segregation," she calls the art world a "hustle" and appropriation "stealing," both of which white artists get away with. It is in these moments of critique that racialized and gendered double standards come to bear.

"Ask Chuleta #11: Appropriation" (2011) is particularly illustrative of how these racist and sexist biases are enacted by art world institutions and ideologies. Chuleta begins her video by discussing Fred Wilson's *Mining the Museum* (1992–93), an artistic intervention at the Maryland Historical Society. Wilson's selection and reinstallation of objects from the institution's permanent collection challenged Eurocentric historical narratives as well as systemic racism in collecting and exhibitionary practices.[36] As Chuleta describes, one of Wilson's exhibition design decisions entailed changing the wording of object labels (or little *papelitos*, as Chuleta calls them) to read as "stolen" from rather than "appropriated" from Indigenous peoples of the African continent. Wilson's gesture aligns with the ethos of Chuleta's project: he removes the guise of highfalutin art-world jargon to call the action what it really is, in plain yet powerful language. Chuleta takes it a step further by embodying that language. "Can I appropriate twenty dollars from your wallet?" she asks, putting on a pretentious voice while stiffening her posture, as if performing the whiteness of the mainstream art world through her language and comportment.[37] She continues: "Say you see a stop sign or a 'Do Not Enter' sign from the street and you wanna use it in your work. . . . So, does that mean I can tell the cops that I didn't steal it, I'm appropriating it 'cause I got an art piece? Would I get away with that shit?"[38] Chuleta describes how racialization alters the perception of a gesture. Stealing and appropriating are the same, but the former is criminalized while the latter is sanctioned, at least for white artists. Through her lived experience, Chuleta arrives at what Ahmed theorizes as a "stopping device," or the racialized experience of phenomenological motility—the difference between "I can" and "I cannot."[39]

Ultimately, Chuleta's web series is a work of institutional critique, which, like Wilson's *Mining the Museum*, is a kind of critical race theory in praxis.[40] While she exposes the ideologies and power structures that determine how art is made, sold, displayed, and circulated, she does so by demonstrating how these very machinations are defined by and through race. Further underscoring this point, Chuleta does not benefit from the system she critiques, unlike white artists who practice institutional critique. Her series also differs from canonical institutional critique in that

she explicitly works beyond the walls of the museum and other cultural institutions by working online.

Chuleta's positionality as a Black woman elicited a specific form of online violence that Moya Bailey has defined as misogynoir.[41] A portmanteau of "misogyny" and "noir" (the French word for "black" that also references film noir), misogynoir identifies the anti-Black racist misogyny experienced by Black women, womxn, and femmes in US visual and digital culture. Bailey thus defines misogynoir as the "uniquely co-constitutive racialized and sexist violence that befalls Black women as a result of their simultaneous and interlocking oppression at the intersection of racial and gender marginalization."[42] The hateful comments posted on Chuleta's videos—so violent and numerous that Raimundi-Ortiz needed to turn off comments—are indicative of this precise form of violence. I would furthermore argue that it is not only Chuleta's subject position but her interest in art that engendered racist and sexist reactions. Chuleta is not the same as the character from *Becoming a Ghetto Bitch*; in fact, she's not even always perceptible as a character. While both women voice critiques of systemic racism, Chuleta's interest in art is at once a threat to her community, which may judge her interest in art as assimilating to whiteness, and the mainstream art world, whose racist ideologies and power structures she exposes.

Such responses tangentially relate to the experience of being "*ni de aquí, ni de allá*" (neither from here nor there). The expression is popular within the Latinx community because it speaks to the widely shared experience of diasporic (un)belonging, namely, the liminality of migration. However, while Latinx identity is forged through migration and border crossing, the construct of Latinidad (Latino is its cognate) simultaneously erases Black, Brown, and Asian experiences.[43] Raimundi-Ortiz's understanding of *ni de aquí, ni de allá* more precisely addresses what is at stake in the reception of her videos. In a conversation held at El Museo del Barrio in 2014, Raimundi-Ortiz described *ni de aquí, ni de allá* as "not light enough to be included in the mainstream of 'gringolandia,' or the Anglo world, and not dark enough to belong in the black community."[44] She thus describes the racial experience of being Afro-Latinx, and the two predominant responses to her videos are reflections thereof. In some of her videos, she anticipates critiques from her community members who are calling her a "wannabe white girl."[45] Meanwhile, to the white art world, she knows she is perceived as "just a little hood chick from 'round the way that don't know shit."[46] Even though Chuleta develops a distinctive art-critical language that is relatable, honest, and funny—unlike the opaque and intentionally

exclusionary jargon of the white box art world—her institutional critique will not be heard as such. When Ahmed writes on complaint, she quotes Patricia Hill Collins: "Black women who make claims of discrimination and who demand that policies and procedures may not be as fair as they seem can more easily be dismissed as complainers who want special, unearned favors," to which Ahmed adds, "Racism as such can be dismissed as a complaint."[47]

Raimundi-Ortiz's performative realness constructively elucidates the misogynoir-istic violence Chuleta and women like her experience on a more-than-daily basis. The artist works in a tradition defined by Moira Roth as "persona-play," which Cherise Smith elaborates in her study of Adrian Piper's *The Mythic Being* (1973–75).[48] Writes Smith: "Incorporating equal parts autobiography and mythology feminist persona-play artists dressed as and acted out characters that were thought to represent or embody gender types."[49] Piper's project blends aspects of her personal identity with that of a male alter ego, the Mythic Being, who she brought to life by wearing an Afro wig, mustache, sunglasses, and "working class" clothes, performing this identity on the street, and distributing his image through photographs, film, and *Village Voice* advertisements.[50] Piper, speaking of herself, writes: "By manipulating her (apparent) identity to produce reactions, she demonstrated the power and influence of stereotypes."[51] Smith, in the conclusion of her *Enacting Others*, discusses a new generation of contemporary female artists working in the tradition of feminist persona-play, Raimundi-Ortiz among them. Smith likens Raimundi-Ortiz's distribution of Chuleta's image and messages through YouTube as simultaneously akin to Piper's *Village Voice* ads and street performances.[52] YouTube is both a distribution channel and (digital) public sphere, and this guarantees that non-art-world audiences will experience the work as experience—a necessary condition to illustrate and interrogate the power of stereotypes.

Even as Chuleta has become known, thus changing that experience, Raimundi-Ortiz has continued to perform as the character in spin-offs, mostly recently in "Cessa and Chuleta Talk Gingo [*sic*] Lingo #AOC #AlexandriaOcasioCortez #CodeSwitching" (2019). Chuleta meets her friend Cessa LaPrincessa, played by SkittLeZ Ortiz, at a diner often frequented by US Representative Alexandria Ocasio-Cortez in hopes of catching the progressive politician's eye. Chuleta is dressed in her version of business casual—"business chic"—and lovingly reproaches her friend for their strictly chic outfit. Along with concern over their appearance, Chuleta tells Cessa about the importance of knowing "gringo lingo" to survive in

predominately white professional contexts, or spaces that are structured by white values and norms. She then challenges Cessa to give her any phrase to translate, claiming to be a "fluent gringo-ologist."[53] Cessa fabulously delivers phrases in slang with varying intonation and complexity, which Chuleta translates into stiff white-speak.[54] The verbal exchange between Chuleta and Cessa, as much as their dialogue about appropriate outfits, illustrates the strategy of code-switching (as the title of the work also makes clear). The comedic bit delivers a real message about the lived experiences and survival strategies of people of color in the United States and works to undo the very stereotypes that the video mobilizes to make its point.

However, to conclude this discussion, I want to return to the point raised by Smith in her comparison between Piper and Raimundi-Ortiz, namely, that Raimundi-Ortiz's performance on YouTube achieved an effect similar to Piper's performance, which was staged in the public sphere and distributing through media channels. With the rise of Web 2.0, a number of artists working online recognized the possibilities for persona-play performances with huge distribution potential beyond the art system, among them Petra Cortright, Ann Hirsch, Jayson Musson, Marisa Olson, and Amalia Ulman.[55] Like the persona-play artists considered in Smith's study, these artists blended aspects of their lived experiences with fiction, creating and performing characters that represented or embodied a type. Unlike persona-play artists from the 1970s, however, the practice of constructing identity was a more widespread cultural phenomenon in the 1990s and early 2000s, first through email, message boards, chat rooms, and MUDS (multiuser dungeon/domain) and MOOs (multiuser, object-oriented environment), and later with the rise of Web 2.0.[56] As Alice Marwick writes, social media platforms engender a remaking of subjectivity, allowing people to create and present carefully constructed images of themselves to online publics: individuals may develop a particular persona, a platform-specific identity, or augment or censor certain aspects of themselves.[57] A useful overview of Web 2.0 culture published in the midst of social media's rise to power, Marwick's assessment does not address how race and gender factor into the construction or reception of online identities. Raimundi-Ortiz's *Ask Chuleta* does, and furthermore, it is unique among artworks from this time period because of the artist's and character's intersectional subject position.

The importance of Raimundi-Ortiz's contribution to performative artistic practices during the Web 2.0 era is underscored when read through María Fernández's "Postcolonial Media Theory." In her now-classic text,

Fernández notes that media studies and postcolonial theory are concerned with similar themes but have developed in parallel. Discussing the theme of identity, Fernández writes that, while both areas challenge conventional understandings of identity as stable and singular, identity in postcolonial studies involves collective identities (ethnic, national, gender), whereas in media studies, identity relates to postmodern concepts of authorship (i.e., the death of the author, the birth of multiple subjectivities).[58] The multiplicity of identity in media studies is realized through individual acts of authorship across media that center on self-development. As an example of this, Fernández quotes Sherry Turkle describing identity as "several versions of a document open in a computer screen where the user is able to move between them at will."[59] Meanwhile, in postcolonial studies, the construction of identity is always rooted in history, collective politics, and bodily experience—all three of which we find in *Ask Chuleta*. The character from Raimundi-Ortiz's web series develops her project out of the legacy of the Puerto Rican alternative art movement, and she is intent on centering and uplifting herself, women like her, and her community. Her mode of theorizing derives both from academic study and embodied knowing. *Ask Chuleta*, like Raimundi-Ortiz's overall body of work, is a practice of placemaking that sees Brown and Black Latinx people on their own terms rather than through the prism of the white box.[60]

Ask Chuleta makes visible aspects of Afro-Latinx identity, as experienced by the series' protagonist. Through this visibility, it also becomes clear that there is a necessity to look at and historicize Latinx contributions to the field of internet art. In recent years, significant scholarship has been published on Black and Latin American internet art; however, the two subjectivities often do not overlap, and Latinx identity is often conflated with Latin American identity.[61] Furthermore, histories on Latin American internet art do not deal with the nuanced racial histories of Latin America and its diaspora.[62] Following Arlene Dávila, Latinx art is a "productive category especially for revealing how matters of class, race, and nationality are operationalized in contemporary art worlds."[63] Naming Latinx internet art as such enables us to honor distinctive epistemologies, historical genealogies, and lived experiences, and in the case of *Ask Chuleta*, the ongoing colonization of Puerto Rico must also be underscored..

The necessity of this kind of specificity—one that accounts for race, gender, immigration status, coloniality, and class—came through in a moment Wanda Raimundi-Ortiz shared with me during our interview for this chapter. When I asked her about her upbringing, she described spending

time with her mother, a woman who was not allowed to learn how to read while growing up on the main island. "Recognizing how difficult it must have been for her to navigate a world like that [as an immigrant in New York]," said Raimundi-Ortiz, "highlighted systems and power structures for me at a young age." She continued:

> Knowing that folks like my mom, folks like my dad, working-class poor Latino, Puerto Ricans, we weren't important enough to document—only the bad stuff. And once my mom and my dad die, that's it, they go in the ground and that's it. There's no legacy, there's nothing grand that happens. And we're just a forgotten people. We inhabit the space; people move around us. They move around us and through us to get to the island, to get to the palm trees, but they don't want to have to deal with us, deal with the complications of what it is to be a Puerto Rican, what it is to be colonized.[64]

To write about *Ask Chuleta*, then, is to document its contribution and take inventory of the specificity of being Afro–Puerto Rican online and off.

NOTES

Acknowledgments: A version of this chapter was presented at the Nuyorican/Diasporican Art Conference, organized by The Latinx Project at NYU on November 4, 2022. I would like to thank Yasmin Ramirez for her guidance and support. This work developed out of her seminar "Afro-Latinx Art and Activism" at the City College of New York CUNY during the spring semester of 2022. I also thank Wanda Raimundi-Ortiz for her practice, insights into which she generously shared through interview. Thanks to Cathryn Jijón and Suzanne Oppenheimer for reading versions of this chapter.

1 Raimundi-Ortiz, "Ask Chuleta1(web)."
2 Raimundi-Ortiz, "Ask Chuleta1(web)."
3 Y. Ramirez, "'. . . A Place for Us,'" 281–82.
4 Y. Ramirez, "'. . . A Place for Us,'" 283.
5 Y. Ramirez, "'. . . A Place for Us,'" 282.
6 Y. Ramirez, "'. . . A Place for Us,'" 281–82.
7 Wanda Raimundi-Ortiz, interview by the author, virtual, October 3, 2022.
8 Muñoz, *Disidentifications*, 182.
9 Muñoz, *Disidentifications*, 182.
10 Vargas, "Ruminations on Lo Sucio," 715.

11 Hernández, *Aesthetics of Excess*, 9.

12 Hernández, "'Miss, You Look like a Bratz Doll,'" quoted in Hernández, *Aesthetics of Excess*, 9.

13 Muñoz, *Disidentifications*, 185.

14 Hernández makes this point in reference the legacies of Adolf Loos and Le Corbusier, for example. Hernández, *Aesthetics of Excess*, 10.

15 O'Doherty, *Inside the White Cube*.

16 Nelson, "Introduction," 2.

17 The GUI is unbranded on the cover, but its red and gray color scheme is undeniably YouTube's. In 2006, the video-sharing platform was one of the fastest-growing websites, leading it to be acquired by Google by the end of the year.

18 Dryer, *White*, 38.

19 Raimundi-Ortiz, interview by the author, 2022.

20 Ramirez marks the opening of Exit Art as the denouement of the Puerto Rican alternative art movement. She also cites the closure of Cayman Gallery/Museum of Contemporary Hispanic Art (MoCHA) in 1991 as marking a general trend in downsizing of alternative spaces at the end of the eighties. Y. Ramirez, "'. . . A Place for Us,'" 291. For more on the neoliberalization of New York City during these years, see Dávila, *Barrio Dreams*.

21 Muñoz, *Disidentifications*, 182.

22 Genocchio, "Angry, Funny."

23 Gonzalez, "For Her Latest."

24 A helpful overview of *Wepa Woman* as well as of other series by Raimundi-Ortiz, is found in Corchado, "Artsy Girl from the Bronx."

25 Raimundi-Ortiz, interview by the author, 2022.

26 Raimundi-Ortiz, interview by the author, 2022.

27 Raimundi-Ortiz, interview by the author, 2022.

28 Of the nearly three-hour performance, there are approximately three minutes of documentation. Raimundi-Ortiz, "Becoming a Ghetto Bitch."

29 Raimundi-Ortiz, "Becoming a Ghetto Bitch."

30 Raimundi-Ortiz, "Becoming a Ghetto Bitch."

31 Ahmed, *Complaint!*, 1.

32 Ahmed, *Complaint!*, 1.

33 Raimundi-Ortiz, interview by the author, 2022.

34 Raimundi-Ortiz, "AskChuleta-Biennials.mov."

35 Raimundi-Ortiz, "AskChuleta-Biennials.mov."

36 As noted in the article by Fred Wilson and Howard Halle about the installation, "Wilson was responsible for all aspects of the exhibition, including arrangement of works, labeling, wall colors, graphics, film projections, and

audio recordings." Wilson and Halle, "Mining the Museum," 152. Wilson also sourced a selection of objects from the Maryland Commission on Indian Affairs, since the Maryland Historical Society did not have contemporary images of Indigenous peoples of the Americas in its permanent collection. Copeland, *Bound to Appear*, 39.

37 Raimundi-Ortiz, "Ask Chuleta #11."

38 Raimundi-Ortiz, "Ask Chuleta #11."

39 Ahmed, "Phenomenology of Whiteness," 161–63.

40 This is true of other works in Wilson's oeuvre that challenge and subvert the violence of Western institutional display mechanisms, beginning with his *Room with a View* series in the late eighties.

41 First coined in Bailey, "They Aren't Talking about Me . . ."

42 Bailey, *Misogynoir Transformed*, 1.

43 Flores, "'Latinidad Is Cancelled.'"

44 Aranda-Alvarado, "Conversation."

45 Raimundi-Ortiz, "Ask Chuleta #2."

46 Raimundi-Ortiz, "Ask Chuleta #11."

47 Collins, *Black Feminist Thought*, 279, quoted in Ahmed, *Complaint!*, 2.

48 Roth discussed in Smith, *Enacting Others*, 247n27.

49 Smith, *Enacting Others*, 37. Feminist persona-play artists include Linda Montano, Eleanor Antin, Lynn Hershman-Leeson, Suzanne Lacy, Howardena Pindell, and Lorraine O'Grady. Smith's chapter on Piper integrates her into this history.

50 Smith, "Re-member the Audience," 47.

51 Piper, *Out of Order, Out of Sight*.

52 Smith, *Enacting Others*, 275n15.

53 Raimundi-Ortiz and Ortiz, "Cessa and Chuleta."

54 For another discussion of this piece, see Flores, "'Latinidad Is Cancelled,'" 77.

55 Works by these artists—Olson's *American Idol Audition Training Blog* (2004–5), Cortright's *VVEBCAM* (2007), Hirsch's *Scandalishious* (2008–9), Jayson Musson's *Art Thoughtz* (2010–12), and Ulman's *Excellences and Perfections* (2014)—either appear in Rhizome's *Net Art Anthology* or have been presented online by Rhizome's institutional affiliate, the New Museum. Connor, Dean, and Espenschied, *Art Happens Here*; "Amalia Ulman: Excellences and Perfections," New Museum, October 2014, http://webenact.rhizome.org /excellences-and-perfections.

56 See Nakamura, *Digitizing Race*, for her discussion of racism, Orientalism, and cultural appropriation in MUDs and MOOs.

57 Marwick, *Status Update*.

58 Fernández, "Postcolonial Media Theory," 64.

59 Turkle, "Rethinking Identity," 121–22, quoted in Fernández, "Postcolonial Media Theory," 64.

60 *Ask Chuleta* could thus be understood as working in a similar tradition to Cafe Los Negroes, which McLean Greaves founded in 1995 to create Black and Brown self-determined virtual space. A. Ramirez, "NEW YORK ON LINE."

61 Dean, "Blackness in Circulation"; Pagola, "Netart Latino Database."

62 Pagola, "Netart Latino Database"; C. Taylor, *Place and Politics.*

63 Dávila, *Latinx Art,* 2.

64 Raimundi-Ortiz, interview by the author, 2022.

BIBLIOGRAPHY

Ahmed, Sara. *Complaint!* Durham, NC: Duke University Press, 2021.

Ahmed, Sara. "A Phenomenology of Whiteness." *Feminist Theory* 8, no. 2 (August 2007): 149–68.

Aranda-Alvarado, Rocío. "Conversation with Wanda Raimundi Ortiz and Ivan Monforte." *Seismopolite,* July 6, 2014. https://www.seismopolite.com/conversation-with-wanda-raimundi-ortiz-and-ivan-monforte.

Bailey, Moya. *Misogynoir Transformed: Black Women's Digital Resistance.* New York: New York University Press, 2021.

Bailey, Moya. "They Aren't Talking about Me . . ." Crunk Feminist Collective, March 14, 2010. https://www.crunkfeministcollective.com/2010/03/14/they-arent-talking-about-me/.

Collins, Patricia Hill. *Black Feminist Thought: Knowledge, Consciousness, and the Politics of Empowerment.* New York: Routledge, 2009.

Connor, Michael, Aria Dean, and Dragan Espenschied, eds. *The Art Happens Here: Net Art Anthology.* New York: Rhizome, 2019.

Copeland, Huey. *Bound to Appear: Art, Slavery, and the Site of Blackness in Multicultural America.* Chicago: University of Chicago Press, 2013.

Corchado, Carmen. "How an Artsy Girl from the Bronx Became a Transnational Reina." *CENTRO Voices,* May 8, 2015.

Dávila, Arlene. *Barrio Dreams: Puerto Ricans, Latinos, and the Neoliberal City.* Berkeley: University of California Press, 2004.

Dávila, Arlene. *Latinx Art: Artists, Markets, and Politics.* Durham, NC: Duke University Press, 2020.

Dean, Aria. "Blackness in Circulation: A History of Net Art." In *The Art Happens Here: Net Art Anthology,* edited by Michael Connor, Aria Dean, and Dragan Espenschied, 394–99. New York: Rhizome, 2019.

Dyer, Richard. *White.* New York: Routledge, 2017.

Fernández, María. "Postcolonial Media Theory." *Art Journal* 58, no. 3 (Autumn 1999): 58–73.

Flores, Tatiana. "'Latinidad Is Cancelled': Confronting an Anti-Black Construct." *Latin American and Latinx Visual Culture* 3, no. 3 (July 1, 2021): 58–79.

Genocchio, Benjamin. "Angry, Funny and Concerned about Identity." *New York Times*, February 13, 2009.

Gonzalez, Damaly. "For Her Latest Body of Work, Wanda Raimundi-Ortiz Renounces Presenting Her Pain as Art, Opting Instead to Show Moments of Joy." *ArtNEWS*, September 26, 2023. https://www.artnews.com/art-news/artists/wanda-raimundi-ortiz-profile-1234680368/.

Hernandez, Jillian. *Aesthetics of Excess: The Art and Politics of Black and Latina Embodiment*. Durham, NC: Duke University Press, 2020.

Hernández, Jillian. "'Miss, You Look like a Bratz Doll': On Chonga Girls and Sexual-Aesthetic Excess." *NWSA Journal* 21, no. 3 (2009): 63–90.

LeBlanc, Adrian Nicole. *Random Family: Love, Drugs, Trouble, and Coming of Age in the Bronx*. New York: Scribner, 2003.

Marwick, Alice E. *Status Update: Celebrity, Publicity, and Branding in the Age of Social Media*. New Haven, CT: Yale University Press, 2013.

Muñoz, José Esteban. *Disidentifications: Queers of Color and the Performance of Politics*. Minneapolis: University of Minnesota Press, 1999.

Nakamura, Lisa. *Digitizing Race: Visual Cultures of the Internet*. Minneapolis: University of Minnesota Press, 2008.

Nelson, Alondra. "Introduction: FUTURE TEXTS." *Social Text* 20, no. 2 (2002): 1–15.

O'Doherty, Brian. *Inside the White Cube: The Ideology of the Gallery Space*. Berkeley: University of California Press, 1999.

Pagola, Lila. "Netart Latino Database: The Inverted Map of Latin American Net Art." In *The Art Happens Here: Net Art Anthology*, edited by Michael Connor, Aria Dean, and Dragan Espenschied, 400–404. New York: Rhizome, 2019.

Piper, Adrian. *Out of Order, Out of Sight*. Vol. 1, *Selected Writings in Meta-Art, 1968–1992*. Cambridge, MA: MIT Press, 1996.

Raimundi-Ortiz, Wanda. "Ask Chuleta #11: Appropriation." YouTube, May 24, 2011. Video, 5:50 min. https://www.youtube.com/watch?v=dRANpRDJs2I.

Raimundi-Ortiz, Wanda. "Ask Chuleta #2: Pollock and Kahlo." YouTube, January 2, 2012. Video, 6:19 min. https://www.youtube.com/watch?v=8bOrERuqCRk.

Raimundi-Ortiz, Wanda. "Ask Chuleta #14: Collectors." YouTube, December 7, 2011. Video, 9:33 min. https://www.youtube.com/watch?v=ofofRfrg5dg&t.

Raimundi-Ortiz, Wanda. "Ask Chuleta1(web) ['Topic 1: Contemporary Art']." YouTube, January 5, 2009. Video, 8:50 min. https://www.youtube.com/watch?v=boSffRSywZE.

Raimundi-Ortiz, Wanda. "AskChuleta-Biennials.mov." YouTube, October 17, 2010. Video, 8:49 min. https://www.youtube.com/watch?v=SFflqO4GD3o&t.

Raimundi-Ortiz, Wanda. "Ask Chuleta: Identity Art." YouTube, May 22, 2011. Video, 5:25 min. https://www.youtube.com/watch?v=FpeGFOF1Wic&t.

Raimundi-Ortiz, Wanda. "Becoming a Ghetto Bitch." YouTube, February 14, 2008. Video, 3:13 min. https://www.youtube.com/watch?v=QLeP9EvHwaU.

Raimundi-Ortiz, Wanda, and SkittLeZ Ortiz. "Cessa and Chuleta Talk Gingo Lingo #AOC #AlexandriaOcasioCortez #CodeSwitching." YouTube, September 20, 2019. Video, 2:58 min. https://www.youtube.com/watch?v=U4MHNegp9tw.

Ramirez, Anthony. "NEW YORK ON LINE; Cafe los Negroes, Virtual Hangout." *New York Times*, November 16, 1997.

Ramirez, Yasmin. "'. . . A Place for Us': The Puerto Rican Alternative Art Space Movement in New York." In *A Companion to Modern and Contemporary Latin American and Latina/o Art*, edited by Alejandro Anreus, Robin Adèle Greeley, and Megan A. Sullivan, 281–95. Hoboken, NJ: Wiley-Blackwell, 2021.

Smith, Cherise. *Enacting Others: Politics of Identity in Eleanor Antin, Nikki S. Lee, Adrian Piper, and Anna Deavere Smith*. Durham, NC: Duke University Press, 2011.

Smith, Cherise. "Re-member the Audience: Adrian Piper's Mythic Being Advertisements." *Art Journal* 66, no. 1 (Spring 2007): 46–58.

Taylor, Claire. *Place and Politics in Latin American Digital Culture: Location and Latin American Net Art*. New York: Routledge, 2014.

Turkle, Sherry. "Rethinking Identity through Virtual Community." In *Clicking In: Hot Links to a Digital Culture*, edited by Lynn Hershman-Leeson, 121–22. Seattle: Bay Press, 1996.

Vargas, Deborah R. "Ruminations on Lo Sucio as a Latino Queer Analytic." *American Quarterly* 66, no. 3 (2014): 715–26.

Wilson, Fred, and Howard Halle. "Mining the Museum." *Grand Street* 44 (1993): 151–72.

19

A Modernist Nuyorican Casita and the Aesthetics of Gentrification

Johana Londoño

In 2014, an architectural rendering of a redeveloped casita in the Willis Avenue Community Garden in Mott Haven was displayed at the Bronx Museum of the Arts (see figure 19.1).[1] Casitas have long been an icon of Nuyorican landscapes, especially in the built environment of the South Bronx, reputedly the location of the first diasporic casita. Along with murals and low-riders, casitas make up most of the scholarship on urban Latinx material culture. In contrast to the negative views that city officials and media held of casitas, scholars have discussed the structures as forms of working-class resistance to uninviting and inhospitable, decaying urban environments and the midcentury modernist high-rise housing

19.1 Screenshot of a rendering of the redesigned casita by TEN Arquitectos, 2014. Bronx Museum of the Arts Facebook page.

19.2 Screenshot of an event at the original casita. Willis Avenue Community Garden Facebook page.

and transportation projects that cleared away Black and Latinx neighborhoods. Locals of the Willis Avenue Community Garden suggested that their original casita, an open light-blue structure with hanging flower baskets and Puerto Rican flags, served a similar purpose. It was a cultural landmark. Though sometimes in need of repair, the casita was a site for Puerto Rican community and artistic expression in one of the most maligned and disinvested areas of New York City (see figure 19.2). The new, redesigned casita on display at the Bronx Museum, however, did not reflect these descriptions. Not only was its streamlined structure built by a globally renowned

architectural firm and devoid of the colorful paint and decorations usually found in casitas, but the exhibit space that surrounded this casita also conveyed very different messages. Placed on a small wall near the more conspicuously promoted *Beyond the Super Square* exhibit on artistic responses to Latin American and Caribbean modernist architecture from the 1920s to 1960s, the casita was folded into institutional discourses on modernism in the creative fields.[2] Situated alongside this modernist history, the new version of the Willis Avenue casita at the Bronx Museum appeared less an artifact of resistance and more an aesthetic object worthy of professional appreciation. Architectural news and urban policy and planning websites announcing the new casita credited the New York Restoration Project (NYRP) and the Urban Air Foundation, the groups behind the redesign, for creating "casitas," with no mention of long-standing local community efforts.[3] In its new form, the casita was legitimized as a depoliticized and decontextualized product of art and design.

Nuyorican casitas had appeared in museums before, though with other cultural connotations. In 1991, a reproduction of a Nuyorican casita was mounted inside the halls of the Smithsonian's Arts and Industries building in Washington, DC.[4] Puerto Rican cultural studies scholar Juan Flores described opening day as "uncanny," with Nuyorican performers and casita regulars invited to attend and bring life to an exhibit hundreds of miles away from its original context.[5] Despite attempts to offer audiences a complete immersive experience, "a living installation," the exhibit received criticism in reviews such as one by anthropologist Carol Jopling, who declared: "The exhibition is weakened by its amateurish quality. As a whole, it lacks force because of the incoherence of its design and presentation, and thus raises several questions about its installation."[6] The casita simulacrum set a precedent for thinking about the casita as a malleable, creative object, open to artistic reinterpretation, recontextualization, and institutionalization, precisely the kind of treatment that the casita at the Willis Avenue Community Garden in Mott Haven experienced nearly twenty years later.

Since the 1980s, the casita has gone from a "counterspace," a term coined by Marxist philosopher Henri Lefebvre in the 1970s to describe spaces that resist a dominant organization of space, to an institutionalized object, curated for museum galleries.[7] As the Willis Avenue Community Garden in Mott Haven makes clear, the casita is now also a redesigned artifact for wider audiences, including those brought to the Bronx by gentrification.

This chapter builds on research gathered from six interviews performed between 2013 and 2017 with gardeners at the Willis Avenue Community Garden and urban designers working with the NYRP as well as on photographs and renderings to examine the trajectory of the Nuyorican casita. I argue that the Nuyorican casita has gone from a visible counterspace to a redesigned, stripped-down object intended to appeal to a diverse and gentrifying residential population. There has been an ongoing interest in abstracting from barrios to create built environments with minimal references to working-class landscapes.[8] Anthropologist Arlene Dávila's research on East Harlem in the early 2000s and the neoliberal workings of redevelopment that made sanitized Latinx culture appealing is particularly insightful.[9] By focusing on abstraction, I stress how the visual environment tells the story of urban change and its incorporation of Latinx ethnic culture, especially when the existence of Latinx culture and people are deemed to pose a threat to capitalist profit making, as is the case with ongoing gentrification in New York City.

The Casita as Antithetical to Modern Urbanism

Starting in the late 1970s, Puerto Ricans built casitas in NYC neighborhoods, such as the Lower East Side, East Harlem, and the South Bronx. Scholars widely agree that Nuyorican casitas are visually similar to rural houses found on the Puerto Rican countryside that combine European, Taino, and African architectural vernaculars.[10] According to architect Jorge Ortiz Colom, the casita—a "poor cousin" of the larger *casa criolla* that developed by the 1830s in Puerto Rico and related to *bohíos* or huts—reflected its residents' needs for transportable abodes and minimalist building.[11] The Diasporican casitas in NYC typically feature verandas, corrugated or pitched roofs, vibrant colors, and nationalist Puerto Rican decorations. Sometimes chickens roam the surrounding gardens.[12] Users improve the structures with recycled materials, and some add limited electricity and plumbing.[13] Despite their name—casita, which means house in Spanish—these casitas are not living quarters but rather social clubs or community centers.

Cultural historian Celeste Olalquiaga describes the casita's rural imagery as nostalgic longing for the homeland or a more sustainable lifestyle.[14] In this light, vacant lots were sites for reenacting the culture and social dynamics of peasants in the Puerto Rican countryside. The connection between Nuyorican life and culture and rural Puerto Rico has a long precedent, with both policymakers and analysts such as Clarence Senior explaining with condescension that the rural habits of Puerto Rican migrants

in the 1940s and 1950s made it difficult for them to adapt to modern life in New York City.[15]

More emphatically, perhaps, scholars describe casitas as a reaction to modernist urban development and its unequal effects on people of color. They argue that because casitas developed amid a bleak, deindustrialized context of disinvestment with largely untenable housing and abandoned city lots filled with rubble and damaged cars, they are spaces of cultural and social defiance. Folklorist Joseph Sciorra writes that "planting a garden and erecting a wood structure are often strategic attempts to force out car thieves and drug dealers who use abandoned lots for illegal activities."[16] Anthropologist Barbara Deutsch Lynch sees the casita gardens as a form of "rebellion" against the urban landscape.[17] Urban planner Luis Aponte-Pares has written the most about the resistant qualities of casitas. For him, casitas are "alternative landscapes on the devastated urban milieu" and examples of Lefebvre's counterspace.[18] Architectural historian Dolores Hayden agrees and, like Aponte-Pares, juxtaposes the casita with large-scale and homogeneous tenement buildings, to highlight the cultural attributes of the casita's vernacular architecture.[19]

These perspectives on the cultural significance and historical origins of the Nuyorican casita counter the damning narratives that emerged in the 1980s and continued through the 2000s. Public officials labeled casitas illegal dens for unhoused locals and drug users and traffickers. According to Sciorra, "everything about the casita world" was "considered illegal by the dominant culture."[20] By criminalizing casitas, city officials justified their demolishment and the selling of the land on which the casitas sat.[21]

The city's hostility resulted in some Nuyorican casitas falling under the purview of the NYRP, a nonprofit organization founded by the actor Bette Midler in 1995.[22] The organization describes itself as an "environmental justice nonprofit and citywide nature conservancy preserving community gardens and other green spaces."[23] In 1999, the NYRP bought 51 lots with community gardens throughout the five boroughs in response to then mayor of New York City Rudolph Giuliani's announcement that he was going to sell 112 community gardens to developers.[24] City officials claimed that the city lots on which the gardens sat needed to "be used for housing or economic development or put up for sale."[25] Mayor Giuliani delighted in telling community members their gardens were stuck in an era of "communism" and they needed to be ushered into a free-market era.[26] The NYRP's takeover of the casitas, insofar as it recognized the importance of public space and gardens in underresourced neighborhoods, seemed like a victory to gardeners

and public space activists who privileged community over profit. However, while the NYRP's deal with the city seemingly ensured that a pro-gardener agenda be maintained, stating that "if the properties are ever used for anything other than gardens, ownership will revert to the city," the spaces on which the gardens sit have changed.[27] While the lots still include gardens, the NYRP has begun to replace the original casitas with modular casitas that borrow from the original structure but look vastly different.

I suggest that for both the NYRP and city officials the original casitas are a deviation for a "public" in search of the new and profitable—in other words, a public hungry for the modern. For both the city and the NYRP, the casita's Nuyorican placemaking was at odds with the kind of space their notion of the public would enjoy. For city officials, the public use justified selling the lot to serve the financial interests of the city at large. For the NYRP, the potential for a larger public to use the casita justified redeveloping the garden. The working-class, Nuyorican aspects of the casitas were seen as the reason to sell lots or revitalize the gardens. In other words, the casita's Nuyorican placemaking was defined as continuously nonmodern and its long-term users as inconsistent with an idealized public. As such, the original casitas serve as an excuse for urban change, be it led by the city or the NYRP.

The Casita and the Modernist Alternative
"Kit of Parts"

In 2014, the NYRP decided that the light-blue Willis Community Garden casita with a partial enclosing wall on the back would be the first to be replaced with an unpainted wooden "modular casita" inspired by a "kit-of-parts" design approach. The casita's surrounding garden—a site for local gardeners to play dominoes; enjoy the adjacent mural depicting Puerto Rican dancers and the words *boricua* and musical *montuno*; roast *lechón*; and to plant, among other things, bell peppers, squash, cucumbers, tomatoes, strawberries, and cilantro—would also be razed to create a new garden with more functional drainage, permeable pavers, and a compost toilet placed on the location of the original casita. The garden's redevelopment would be a model for other NYRP-owned gardens, including gardens without Nuyorican-built casitas, a move that, as a NYRP staff member stated, has made them move "away from the term 'casita' because now it's going in a garden that has nowhere that reference doesn't really make sense, and we're just calling it a shade structure."[28] These new structures,

including the Willis Avenue casita, could one day include, as the NYRP staff member noted, solar panels, Wi-Fi, and USB ports. The designers, who had recently witnessed the devastations of Hurricane Sandy, wanted to equip the garden with technology that could be useful in an emergency.

The kit-of-parts approach used at Willis Avenue is a modernist design project with uncertain modernist origins. Citing architect Bernard Rudofsky, architect Carlo Carbone notes that the prefabrication process at the center of a kit-of-parts design approach has its origins in medieval construction methods and traditional Japanese construction.[29] Industrial mass production and colonial housing needs of the late nineteenth century greatly accelerated and streamlined the prefabrication process at the heart of this design theory. In the mid-twentieth century, internal controversies in the field of modernist architecture led some architects to claim that kit-of-parts modernist design was more user-friendly, flexible, and open to community engagement than beleaguered top-down modernist projects.[30]

Although the potential of a kit of parts to engender community-centered modernist design motivated the NYRP's redevelopment, it was not always received in this way by local gardeners. One gardener complained that the NYRP came and showed the gardeners the plans, but because the pieces were complicated to put together, "they sent people from Home Depot and students to make it."[31] At the NYRP, designers defended the new casita from critiques that the kit-of-parts approach strayed from the local community's design needs. The NYRP designers pointed out that the vertical posts of the wooden platform are reminiscent of those found in the original casita and that the simple-to-build frame could be put together by locals, echoing the communal roots of the original casita. Furthermore, and similar to the city's long-standing stigmatizing discourse, NYRP staff said that the preexisting gardens sometimes served unhoused people and illegal activities and the more open layout could prevent such activity. Ironically, the original casita had a more open layout than the typical Diasporican casita with windows and a door. Locals I spoke with did not comment on the openness of the original structure, but they did push back against claims of illegal activity happening therein. One gardener instead pointed out what they found to be the undesirable behavior outside the garden, such as cars playing loud music and people washing their cars, activities that they thought might attract drug users or other illegal activity. Despite these contradictions, the NYRP focused on the casitas as a problem. Seeing the preexisting casita as too exclusive, the NYRP claimed the new stagelike setting was an opportunity to open the casita to a larger

public. As an NYRP staff member stated: "I understand that there has been criticism from the community that this isn't like their old casita. They call it a stage, which for us isn't necessarily a bad thing. We were trying to find a middle ground, something that could serve as a hub for them and for them to occupy, but to also be welcoming and being a public structure. . . . We didn't want there to be any confusion whether or not something was a public space that people were welcomed into."[32] The NYRP's idea of the "public" would be used to explain the need for a universal, mainstreamed redesign of the casita.

In an interview with the designers of the casita, Ten Arquitectos, a global design firm headed by Mexican-born architect Enrique Norten, the project's universality and adaptability were further stressed: "Our casita project—the only Hispanic element that it has is the name. . . . It could just be any casita. . . . Never saw this as a Puerto Rican anything. . . . Anyone can appropriate it and bring its own personality."[33] For Ten Arquitectos, the standardization of the casita was not a big deal. In fact, the firm's design approach "felt that better than giving them [local Latinx residents] a representation of what [their] identity was, the real empowerment came from creating a kit of parts . . . [that they could] assemble themselves."[34]

Modernist Universality and the Gentrification of Mott Haven

The locals I spoke with did not feel empowered by the kit-of-parts design. When I visited, a local gardener shared photos of what the garden used to look like, as they mourned the loss of their chickens, their gardening plots, and their Puerto Rican flags, which they said they were only allowed to rehang after several discussions with the NYRP (see figure 19.3). According to the gardener, the NYRP had opposed having Puerto Rican flags in the garden, arguing that the garden should belong to everyone, not only Puerto Ricans.[35] This justification resonated with pro-gentrification practices found in NYRP projects elsewhere.

Indeed, while the casita in Mott Haven was the first modernist casita the NYRP built, it was not the first casita the organization remodeled in the context of growing gentrification. In 2010, the NYRP unveiled a newly redesigned Los Amigos Community Garden in East Harlem. Architect Richard Alomar consulted with local community members who "were able to interpret nuances in construction, use, and color to help design an alternative structure."[36] In other words, the community participated

19.3 The redesigned casita with flags, Bronx, NY, 2017. Photo by Johana Londoño.

in the abstraction of the long-standing casita. According to Alomar, the new casita, which was a framed structure without walls, "was not like a typical casita, but was seen as such by the residents thanks to their active and engaged participation in design, historic research, and discussions on materials."[37] In a review of how the redesign came about, Alomar suggests that gentrification was key in the transformation of the casita. He writes, "Under pressure for access and change by newer residents, this entangled condition converged the dynamics of ownership, stewardship, demographic change, and redesign (restoration)."[38]

Gentrification arrived later in the South Bronx than in "super-gentrified" areas of Brooklyn and Manhattan.[39] In part, this is because Mott Haven, a mostly Black and Latinx (Black and non-Black) area, has long been considered one of the poorest and most dangerous neighborhoods in the city. As historian Evelyn Gonzalez notes, this demographic profile was evident by 1960 when Puerto Rican and Black migrants poured into the South Bronx area and its white residents left for the suburbs. Whereas African Americans (presumably non-Latinx Black) residents settled in "central Morrisania, from Webster to Prospect Avenues and from 163rd Street to

just beyond Crotona Park South," Puerto Ricans settled around "the sub-way and elevated train routes into central Mott Haven, lower Morrisania, Claremont, and Hunts Point–Crotona Park East" sections.[40] The section's impoverishment was due to various factors, including redlining, a banking practice that, by denying loans to racialized areas of the city, ensured the South Bronx's worn housing stock would go unrepaired. The development of public housing that demanded lower rents compared to other public housing buildings in the South Bronx also contributed to the lower-income character of the section.[41]

Gentrifying developments have become more visible in Mott Haven since the 2010s.[42] In 2015, an article in the *New York Times* real estate section, a harbinger of gentrification, described "Mott Haven, the Bronx, in transition."[43] In 2016, the "Construction and Design" section of *Real Estate Weekly* called Mott Haven a "magnet for developers."[44] In this context, the abstraction of barrio culture seen in the transformation of the casita is a reminder of how aesthetics work together with political economic forces to displace marginalized people from coveted neighborhoods.

I argue that the cultural dilution of barrio imagery, what I have termed abstraction elsewhere, sets the ground for wealthier newcomers and professionals from other parts of the city to reappropriate urban space of the casita.[45] The original small blue casita structure that meant so much to locals is replaced with an unpainted wooden structure heralded by art museums, architecture journals, and major newspapers. It is now a "new" site worthy of tourism and aesthetic appreciation. I argue that while these aesthetic changes may seem insignificant—after all, gardening is still happening and community events are still taking place—they register a cultural appropriation that greases the wheel of for-profit urban change. Aesthetic change signals the neighborhood's readiness for a modern life that its Latinx, Black, and Puerto Rican residents and cultural production have been characterized as opposing. It signals the neighborhood's new appeal to recently arrived, privileged newcomers. However, in naming this aesthetic abstraction—the dilution of working-class culture to its bare bones, ridding it of its excess—I also flag how long-standing garden users remember the Nuyorican casita and try to re-create through physical means the feeling of belonging that memory produces. New communal growth—literally the continued growth that happens in the garden with community members planting their fruits, vegetables, and flowers—stands as a counter to the flattening that results from an aesthetic project of redevelopment. The

community's continued interaction in that space is a challenge of unknown permanency to gentrification-driven abstraction of place.

Ongoing community participation is a reminder that we must emphasize the value of everyday performances that make a casita a community space and not merely its look or its structure. It should not take gentrifying newcomers to the area, an art museum, architectural websites, or a globally renowned architect to put a positive spin on Nuyorican vernacular culture, especially when this attention focuses on seeing the casita as a depoliticized avant-garde structure. There are important community relations taking place on the site that ask that the redesigned casita be grounded in place histories of struggle and cultural recognition. Precisely, for the sake of memory of place and the continued struggles this memory may inspire, this chapter concludes that the casita, in whatever iteration, must be contextualized and made less "new."

NOTES

1 The Bronx Museum exhibited *Rethinking the Garden Casita* from May 1, 2014–January 11, 2015. According to the museum's Facebook post, "The New York Restoration Project (NYRP), in partnership with the Urban Air Foundation, enlisted TEN Arquitectos and engineers at Buro Happold to rethink the traditional casita as a modular kit of parts." Bronx Museum of the Arts, Facebook, April 29, 2014, https://m.facebook.com/bronxmuseum/photos/a .10150699566405081/10152332979050081/?type=3.

2 Bessa, *Beyond the Supersquare.*

3 Frederick, "Ten Arquitectos"; "Accomplishments," Urban Air Foundation, accessed August 8, 2023, http://urbanair.org/accomplishments/.

4 The *Casitas: An Urban Cultural Alternative* (on display February 1, 1991, to June 30, 1991) exhibit was curated and produced by Betti-Sue Hertz and Bill Aguado, both former associates of the Bronx Council on the Arts (BCA). "Las Casitas Collection," Hostos Library Archives, accessed August 9, 2023, https://guides.hostos.cuny.edu/hostosarchives/collections/lascasitas#Las _Casitas_04_01.

5 Flores, *From Bomba to Hip-Hop*, 64.

6 Jopling, "Review Work," 502.

7 Lefebvre, *Production of Space.*

8 Londoño, *Abstract Barrios.* My understanding of abstraction in urban redevelopment is similar to the multiple definitions that circulate about abstraction in the visual arts, such as those Abdiel Segarra Ríos discusses in "Abstractions between Puerto Rico and Chicago" in this volume. In both urban design

and visual arts, abstraction's avoidance of direct representation can be inter-preted, on the one hand, as altogether rejecting political meaning or, on the other hand, as a way to complicate common representations and the political meanings associated with them. I argue that the definition that best applies to any given text—be it a piece of the built environment or a painting—ultimately depends on the audience and location of the abstracted creation. Unlike some visual art, which can be held in private and public spaces, the architecture I discuss in this chapter is located in public space. The meanings of a casita's architectural aesthetics cannot be divorced from its users or producers. Moreover, as a scholar trained in cultural studies, I hold onto the notion that socioeconomic contexts inform the political meanings of culture. In the case of the casita that is abstracted as its surrounding environment gentrifies, it is important to underscore how abstraction is mobilized as a tool for making sense of, resisting, and/or advancing gentrification.

9 Dávila, *Barrio Dreams*, 59.

10 Aponte-Pares, "Casitas."

11 Ortiz Colom, "Tradition," 60, 65.

12 Ortiz Colom, "Tradition," 60, 65; Sciorra and Cooper, "'I Feel Like.'"

13 Sciorra and Cooper, "'I Feel Like.'"

14 Olalquiaga, *Megalopolis*. Other scholars writing about Latinx rural imagery elsewhere make a similar argument. See Rinaldo, "Space of Resistance," 148; Smith, "Rural Place."

15 Londoño, *Abstract Barrios*, 28–29.

16 Sciorra and Cooper, "'I Feel Like,'" 158.

17 Lynch, "Garden and the Sea," 112.

18 Aponte-Pares, "Casitas," 8.

19 Hayden, *Power of Place*, 36.

20 Sciorra and Cooper, "'I Feel Like,'" 158.

21 Coleman and Gonzalez, "Sowing a Green Revolt"; Friedman, "Deflowering the Bronx."

22 New York Restoration Project, "Our Story," accessed February 11, 2023, https://www.nyrp.org/en/our-story/.

23 New York Restoration Project, "Our Story."

24 Another group, the Trust for Public Land, also bought parcels. Barry, "Bette Midler."

25 Barry, "Bette Midler."

26 Kifner, "Giuliani's Hunt for Red Menaces."

27 Barry, "Bette Midler."

28 Interview by the author, New York City, February 19, 2015.

29 Rudofsky, *Architecture without Architects*; Carbone, "Kit of Parts," 55.

30 Love, "Kit-of-Parts."

31 Interview by the author, New York City, June 11, 2017.

32 Interview by the author, New York City, February 19, 2015.

33 Interview by the author, New York City, June 26, 2015.

34 Interview by the author, New York City, June 26, 2015.

35 Interview by the author, New York City, June 3, 2017.

36 Alomar, "Invisible and Visible Lines," 100.

37 Alomar, "Invisible and Visible Lines," 100.

38 Alomar, "Invisible and Visible Lines," 101.

39 Lees, "Super-Gentrification."

40 Gonzalez, *Bronx*, 110.

41 Gonzalez, *Bronx*, 112.

42 Hughes, "Makeover in Mott Haven."

43 Hughes, "Mott Haven."

44 "Mott Haven a Magnet for Developers," *Real Estate Weekly*, March 2, 2016.

45 For more on abstraction, see Londoño, *Abstract Barrios*.

BIBLIOGRAPHY

Alomar, Richard. "Invisible and Visible Lines: Landscape Democracy and Land-scape Practice." In *Defining Landscape Democracy*, edited by Shelley Egoz, Karsten Jørgensen, and Deni Ruggeri, 96–105. Northampton, MA: Edward Elgar, 2018.

Aponte-Parés, Luis. "Casitas, Place, and Culture: Appropriating Place in Puerto Rican Barrios." *Places* 11, no. 1 (1997): 52–61.

Barry, Dan. "Bette Midler Chips in to Rescue Gardens." *New York Times*, May 13, 1999.

Bessa, Antonio Sergio. *Beyond the Supersquare: Art and Architecture in Latin America after Modernism*. New York: Fordham University Press, 2014.

Carbone, Carlo. "The Kit of Parts as Medium and Message for Developing Post-war Dwellings." *Histories of Postwar Architecture* 2, no. 4 (2020): 54–74.

Coleman, Chrisena, and Carolina Gonzalez. "Sowing a Green Revolt Rally to Save Urban Oases." *New York Daily News*, January 14, 1999.

Dávila, Arlene. *Barrio Dreams: Puerto Ricans, Latinos, and the Neoliberal City*. Berkeley: University of California Press, 2004.

Flores, Juan. *From Bomba to Hip-Hop: Puerto Rican Culture and Latino Identity*. New York: Columbia University Press, 2000.

Frederick, Shiloh. "Ten Arquitectos Develop All-Purpose 'Casitas' for Community Gardens around the City." *6sqft*, June 5, 2015.

Friedman, Andrew. "Deflowering the Bronx—Parks Department Paves Green Spaces Saved by Volunteers." *Village Voice*, May 8, 2001.

Gonzalez, Evelyn. *The Bronx.* New York: Columbia University Press, 2004.

Hayden, Dolores. *The Power of Place: Urban Landscapes as Public History.* Cambridge, MA: MIT Press, 1995.

Hughes, C. J. "A Makeover in Mott Haven." *New York Times*, April 17, 2011.

Hughes, C. J. "Mott Haven, the Bronx, in Transition." *New York Times*, March 25, 2015.

Jopling, Carol. "Review Work: Las Casitas: An Urban Cultural Alternative by Betti-Sue Hertz." *Journal of American Folklore* 104, no. 414 (Autumn 1991): 500–502.

Kensinger, Nathan. "Inside the Casitas of the South Bronx's Community Gardens." *Curbed NY*, October 1, 2015. https://ny.curbed.com/2015/10/1/9915402 /inside-the-casitas-of-the-south-bronxs-community-gardens.

Kifner, John. "Giuliani's Hunt for Red Menaces." *New York Times*, December 20, 1999.

Lees, Loretta. "Super-Gentrification: The Case of Brooklyn Heights, New York City." *Urban Studies* 40, no. 12 (2003): 2487–2509.

Lefebvre, Henri. *The Production of Space.* Translated by Donald Nicholson-Smith. Cambridge, MA: Blackwell, 2007.

Londoño, Johana. *Abstract Barrios: The Crises of Latinx Visibility in Cities.* Durham, NC: Duke University Press, 2020.

Love, Timothy. "Kit-of-Parts Conceptualism: Abstracting Architecture in the American Academy." *Harvard Design Magazine*, no. 19 (2003). https:// www.harvarddesignmagazine.org/issues/19/kit-of-parts-conceptualism -abstracting-architecture-in-the-american-academy.

Lynch, Barbara Deutsch. "The Garden and the Sea: U.S. Latino Environmental Discourse and Mainstream Environmentalism." *Social Problems* 40, no. 1 (1993): 108–24.

Olalquiaga, Celeste. *Megalopolis: Contemporary Cultural Sensibilities.* Minneapolis: University of Minnesota Press, 1992.

Ortiz Colom, J. "Tradition and Invention in Domestic Construction in the Caribbean Region: The Case of Southern Puerto Rico." In *History of Construction Cultures: Proceedings of the 7th International Congress on Construction History, July 12–16, 2021, Lisbon, Portugal*, 1:63–70. Boca Raton, FL: CRC Press, 2021.

Rinaldo, Rachel. "Space of Resistance: The Puerto Rican Cultural Center and Humboldt Park." *Cultural Critique*, no. 50 (Winter 2002): 135–74.

Rudofsky, Bernard. *Architecture without Architects: An Introduction to Nonpedigreed Architecture.* New York: Museum of Modern Art, 1964.

Sciorra, Joseph, and Martha Cooper. "'I Feel Like I'm in My Country': Puerto Rican Casitas in New York City." *TDR: The Drama Review* 34, no. 4 (1990): 156–68.

Smith, Jeffrey S. "Rural Place Attachment in Hispano Urban Centers." *Geographical Review* 92, no. 3 (July 2002): 432–51.

Conclusion

The Spatial Politics of Shellyne Rodriguez, Rigoberto Torres, Lee Quiñones, and Danielle De Jesus—With Some Concluding Comments

Arlene Dávila

On a Sunday morning in spring 2021, I received a surprise video call from artist Shellyne Rodriguez, delighted to share a bit of Nuyorican/Diasporican and Bronx art history in the works. She was being cast by artist Rigoberto Torres, who had come to the Bronx from his home in Kissimmee, Florida, to turn her into one of his well-known life-sized plaster and fiberglass sculptures. These sculptures have been the core of Torres's art practice for more than forty years, part of a collaboration with artist John Ahearn where Bronx residents and everyday people, family, and friends take center stage. Rodriguez was as excited to become memorialized as a sculpture as I was to witness the making of Diasporican art history.

Here is a collaboration of two Nuyorican/Diasporican artists spanning different generations whose works document and serve as placemaking archives for urban communities: Torres through life-sized casts of his neighbors in the Bronx and now in Kissimmee, Florida; and Rodriguez through drawings and ceramic reliefs of Bronx residents that communicate their subjects are important and matter. Rodriguez grew up admiring Ahearn/Torres's public art sculptures such as *Double Dutch* (1981–82) that decorated the walls of buildings all over the Bronx, and while Ahearn had wanted to cast Rodriguez years earlier, she was holding off until Torres could be involved. "He is half of the duo," she told me. "It was important for me to center him as a Nuyorican artist whose approach comes from his uncle and because of his claim to this place, from being from the Bronx."[1]

The finished sculpture features Rodriguez with a sleeveless T-shirt exposing her tattoo of the Taino goddess Atabey, holding a copy of Cedric Robinson's *Black Marxism* with one hand and a machete with the other, representing the artist's militant stance that informs her artwork, her teaching, and her activism (see figure C.1). The artist's braided white hair cascades to the side and powers the sculpture, following Torres's styling recommendation.

Placemaking and casting identity into space have been long-standing concerns in Nuyorican/Diasporican art. Whether it is by claiming space through murals and graffiti or by validating vernacular urban communities through art, as Torres and Rodriguez do, it is evident that spatial politics have long shaped and deeply concerned the work of Nuyorican/Diasporican artists. What follows explores how these issues are salient and recurrent in the works of several Nuyorican and Diasporican artists by threading the work of three interlocutors of Bronxrican artist Shellyne Rodriguez (b. 1977): the Orlando-based sculptor Rigoberto Torres (b. 1960), the master NYC graffiti artist Lee Quiñones (b. 1960), and the Bushwick painter Danielle De Jesus (b. 1987). I define interlocutors as artists who have influenced or admired each other's work, or who worked contemporarily even if they had not met personally for most of their artistic careers. My goal is to create an alternative archive following Pilar Tompkins Rivas's missive to reconstruct missing elements of art history by exploring linkages between artists who, as Quiñones once described for graffiti artists, "didn't necessarily have any art history to stand on [and who] were creating art history without a script in their hand."[2] With this approach I also seek to highlight the intellectual work of filling voids in the history of Latinx and American art that artists do, whenever they identify interlocutors and retell their stories.

C.1 John Ahearn and Rigoberto Torres, *Shellyne's Radical Education*, 2022. Acrylic on plaster, 34 × 24 × 9 in. Courtesy of Charlie James Gallery, Los Angeles.

Finally, I focus on Shellyne Rodriguez's interlocutors because her work is neatly grounded on issues of spatial precarity as well as the consolidation of neoliberalism, the displacement of Puerto Rican barrios, and the creation of multiethnic diasporas. Her work also anchors the centrality of hip-hop and popular culture that filled the lack of Nuyorican-specific art spaces at a time when key art institutions founded by Puerto Ricans in the late 1960s and 1970s began to transform into Latin American art institutions throughout the 1980s, leaving siloes and gaps for New York–based

Puerto Rican artists to meet and learn about each other. Rodriguez's ode to Buddy Esquare, popularly known as "King of the Flier" and a legend in hip-hop culture, which she terms the "last avant-garde art movement of our time and last slap back to power," is a good example. In her mixtape drawings, she uses Buddy Esquare's poster design as a frame to anchor and honor the legacy of hip-hop in the Bronx, and in what would be announcements of performers, Rodriguez inserts images of Bronx residents depicted as a diverse and multiethnic community that is living, working, thriving, surviving, and fighting back (see figure C.2). As she described, for Buddy, the neo Art Deco–inspired signs were an announcement to a party; for her, "it's an announcement of who's here." Rodriguez's work anchors the history of Puerto Ricans in the diaspora in the long story of capitalist development and displacement coinciding with the city's growth as a global financial epicenter from the 1970s onward, and as a laboratory for neoliberalism and real estate speculation from the 1990s to today. This interest draws her to Torres, an artist whose life and work bears the mark of this history.

Rigoberto Torres was nine years old when his parents fled agricultural work on the archipelago in search of a better life in New York as part of the large-scale Puerto Rican migration to New York City from the 1950s onward. The family settled in the Bronx, where Rigoberto was raised in a working-class family and learned how to mold and cast sculptures by working in his uncle Raul Arce's saint-making factory. Torres met Ahearn at Fashion Moda, an alternative space founded by Stefan Eins in the South Bronx that became a center for downtown artists as well as an incubator of graffiti arts. His collaboration and his forty-year-plus partnership with artist John Ahearn quickly followed, and while it is Ahearn who has received continued attention from the mainstream art world and who was first represented by Charlie James Gallery in Los Angeles, it was Torres who introduced Ahearn to the South Bronx, who encouraged him to move his studio from Fashion Moda to Walton Avenue in the South Bronx, to cast his Bronx neighbors and everyday people, and to set work in public sidewalks to make their process accessible to community members.[3] Both Ahearn and Torres also cast and paint figures on their own, and each boasts a unique style. Torres's sculptures are rich in narrative and stories and display brighter and more varied colors. These differences were evident in the recent retrospective at the Bronx Museum in 2022 as well as in critic Don Cameron's write-up for Torres's 1995 solo exhibition *Grace under Pressure* at Lehman College, where he states: "It is not so much that Torres's subjects are defined by what they do, but rather they are so engaged by their activity that they seem to

C.2 Shellyne Rodriguez, *BX Third World Liberation Mixtape
No. 1 (Wretched Freak to the Beat)*, 2021. Color pencil on
paper, 58 × 48½ in. Courtesy of Shellyne Rodriguez and
P · P · O · W, New York.

physically bond with their setting to form a single, complex unit."[4] Torres
told me it has been his life mission to represent and give value to everyday
people: "If they have a life-cast, they and their family and communities
can see that they matter."[5] When I spoke with him in the fall of 2022, he
was casting a group of Diasporican artists in Orlando, Florida—some who
migrated after Hurricane Maria, others longtime residents of Kissimmee
and Orlando, Florida.

Torres moved to Kissimmee, Florida, to recover from a life-threatening
asthmatic seizure attack in 1993 that left him with temporary vision and

C.3 Lee Quiñones, *Spit*, 2021. Acrylic, spray paint, and ink marker on panel, 36 × 24 in. Photo by Yubo Dong/ofstudio. Courtesy of Charlie James Gallery, Los Angeles.

memory loss, and in a state of overall disorientation captured in his sculpture *Split Self* s (1997–2000). There, he has been part of a growing community of Diasporicans that have made Orlando home—becoming a vivid example of how spatial politics have shaped the work of Nuyorican/Diasporican artists and communities.

As several chapters in this volume show, the large-scale migration of Puerto Ricans from the archipelago and from other states to Orlando has never been the product of individual choices as much as of the unequal economic development and spatial precarity that has pushed Puerto Rican

communities to find better opportunities in Orlando. Additionally, Torres's story highlights the health and environmental ramifications of housing precarity and social inequality guiding these migratory flows, as it was pollution that made the Bronx an untenable home for him after the seizure. In the history of "noxious New York," communities such as the Bronx have long served as dumping grounds for the placing of bus depots, toxic waste facilities, and roadways concentrating all types of environmental polluting agents.[5] Add to this the high levels of unemployment and the lack of public space and open air in the Bronx, and one can see the geographic and spatial politics of environmental racism at play in the borough's historically higher rates of asthma-related emergency hospital visits and hospitalizations, which according to the New York City Department of Health, stand at more than double the rate of all other NYC boroughs combined.[6]

Returning to New York, I turn to artist Lee Quiñones, whom Rodriguez had surprisingly never met when we originally spoke but whom she had long admired as a major representative of the graffiti art movement and as someone who is similarly engaged with issues of spatial precarity. After all, graffiti is all about stamping culture onto the place by literally painting and claiming the urban landscape (see figure C.3).

Quiñones grew up miles away from the Bronx, but in similar conditions of precarity produced by a history of infrastructural disinvestments in NYC's poorest neighborhoods. His milieu was the Lower East Side, more specifically the Lower Deck (which people also know as "the lower Lower East Side") and the housing projects closest to the East River surrounded by economic and infrastructural poverty. This experience shaped his assessment of graffiti's role as a global new art form responding to an urban crisis: "We knew New York city was burning down, and fucked up. For us graffiti was about creating a sense of strength and identity and an anchor in the neighborhood to reclaim it." In this context, naming and stamping names was utterly political, as he continues: "For kids who were pushed down, ignored, the power of a name was paramount, as in Stay High 149. Stay High is to stay above everyone who keeps you down. [Isn't] that a statement!"

Today, graffiti is acknowledged as a global art movement, with numerous volumes dedicated to documenting and examining its evolution. These volumes range from photographic archives of early graffiti, as seen in the classic *Subway Art* to contemporary works exploring its role in identity formation and its impact on urban spaces.[7] However, it is interesting that oftentimes, the focus on graffiti as a global medium has involved the recognition of New York City as the cradle of graffiti, but also the simultaneous

erasure of the creatives of color behind this movement. In part, this is due to the tagging that these creatives used to call out their names. It served to shout them out while also anonymizing them among those not in the know or within the immediate community of writers. In particular, within the graffiti literature, there is recognition of a distinctive New York style, but individual creatives of color and the racial dispossession that birthed the medium receive minimal acknowledgment.[8] As Yasmin Ramirez aptly expressed in one of our conversations, "The more global, the less Rican, or perhaps Rican style is international"—yet often unnamed.

This observation becomes evident in the reception of Lee Quiñones. Although he is acknowledged as a foundational figure in the history of NYC graffiti in exhibitions and scholarly works, one must carefully navigate through this literature to discover his Puerto Rican background, if mentioned at all.[9] This erasure of Lee's background may be more pronounced in the archipelago. Despite international recognition, Lee Quiñones has exhibited only once in Puerto Rico—in a solo show curated by African American curator Isolde Brielmaier at Candela Gallery at the Candela Arts and Music Festival in Old San Juan on October 19, 2006. In a personal conversation, Quiñones shared that he still holds on to his lifelong dream of being exhibited at El Museo de Ponce in Ponce, Puerto Rico, the city of his birth.

To understand why Nuyorican artists' role in the creation of this global art movement has not received necessary recognition, we must first center the racism and classism at play in the reception and evaluation of this cultural movement. Even when embraced by the art market, graffiti was still regarded as vandalism. It is also worth noting that graffiti artists have often been marginalized in the Nuyorican movement by mainstream scholarship, where the Young Lords, Taller Boricua, or the Nuyorican poetry movement take center stage. The work of graffiti artists was never collected by many mainstream art museums or even El Museo del Barrio, or embraced as art or even considered as valuable and politically important, and if it were not for the keen eye of artist Martin Wong's early appreciation, collection, and ultimate donation of his graffiti arts collection to the Museum of the City of New York, much of this work would have been summarily lost.

Raquel Z. Rivera's foundational volume, *New York Ricans from the Hip Hop Zone*, suggests that graffiti's association with hip-hop culture, and its reduction and commodification as a "Black" product separate from "Puerto Rican culture," is a key element for the erasure of the contribution of Puerto Rican artists to this movement. She documents and warns about the artificial boundaries imposed on urban cultural expressions such as hip-hop

and graffiti that are diverse, diffuse, and that showcase the greatest overlap between African American, West Indian, and other Nuyorican and Latinx artists. She attributes the homogenization of hip-hop as a Black cultural product to the racism and nationalism involved in branding and marketing musicians, to which we must add the class and cultural capital dimensions undergirding these distinctions. Moreover, while artists associated with Taller Boricua and the Nuyorican Poets Café, along with the Young Lords, developed a new aesthetic vocabulary and language that drew from marginalized yet more recognized Puerto Rican nationalist symbols, such as Taino and African heritage, graffiti artists like Lee Quiñones were mining commercial and popular culture symbols. It was Howard the Duck and commercial and popular culture that were pictured in Lee's work, while he was famously starring as Raymond Zoro in Charlie Ahearn's film *Wild Style* (1983) (widely regarded as the first hip-hop movie) and in Blondie's "Rapture" music video. In sum, graffiti's popular culture and commercial associations did not always fit the narrow nationalist confines or the anti-capitalist ethos of the dominant representation of Puerto Rican culture we associate with the Nuyorican art movement and/or the alternative art movement more generally.

Yet Nuyorican graffiti artists never doubted the impact and value of graffiti arts, and we owe them its recognition as art in the New York City art world as well as its continued preservation and evaluation. Graffiti artists were the pioneers in organizing exhibitions to present graffiti art as high art in New York City galleries, and they have persistently promoted this work, exemplified by the Graffiti Hall of Fame in East Harlem and other ventures, regardless of the highs and lows in popularity and recognition that graffiti artists have endured throughout the decades.

Specifically, Hugo Martinez, a junior at City College when he founded United Graffiti Artists in 1972, played a pivotal role. He organized exhibitions at the Razor Gallery as early as 1973 and at Artist Space in 1975, both of which received mainstream art world recognition. The Artists Space catalog for United Graffiti Artists includes an essay by Martinez that attributes the growth of graffiti to a group of "Puerto Rican adolescents" and features an essay by Peter Schjeldahl, who would later gain international status as an art critic.[10] In his piece, Schjeldahl reflects on "what type of art is studio graffiti?" as graffiti makes the transition from subway cars to canvas. This marks what is likely the first serious consideration of graffiti art by an art critic from a mainstream publication.[11] To date, Martinez continues to promote graffiti at his Martinez Gallery in Harlem.

For his part, Lee Quiñones served as a guide to Martin Wong's collection, directing him to up-and-coming artists he should collect. Meanwhile, the South Bronx gallery Wallworks, spearheaded by graffiti artist John "Crash" Matos, has been exhibiting and elevating graffiti artists through regular exhibitions alongside local and international contemporary artists.

Quiñones' work shows how politically informed the work of many graffiti artists is, even if these politics were different from the traditional activism we associate with Taller Boricua or the Young Lords of a decade earlier. Works like *Stop the Bomb*, which dealt with nuclear devastation, were deeply enmeshed with the larger political movement of the times, while in the famous *Howard the Duck* handball court mural, Lee makes a daring statement of reclamation and belonging. In particular, in leaving behind the furtive practice of painting at night Lee was among the first graffiti artists painting openly in daylight where everyone could see, a bold and open stance about artists' and communities' inalienable right to public space amid the never-ending criminalization of graffiti and privatization of space.

In sum, Lee's work highlights the social movements *within* social movements and the diversity of artists and actors who have been stamping identity onto space while contributing to one of the most globally recognized and foundational contemporary art movements. Today, within contemporary Nuyorican art, graffiti remains a paramount index of urban NYC culture as a sign of continuity, resilience, and survival. It is commonly present in Shellyne Rodriguez's drawings as well as in the paintings of Bushwick Rican Danielle De Jesus, another key interlocutor of Rodriguez, whom she met through their common activism against gentrification and displacement. They drew on this history when they participated in the two-artist exhibition *Siempre en la Calle*, at Calderón Gallery in the fall of 2021, one of the first commercial gallery exhibitions of their work, and a history-making event in a city where female Nuyorican artists are rarely seen in commercial galleries.[12] As a victim of gentrification from Bushwick, the community she grew up with, De Jesus stamps her paintings with graffiti to mark landscapes and distinguish the communities of Bushwick—archiving and recordkeeping the graffiti that marks these neighborhoods' walls, stoops, doors, and commercial metal fences before it succumbs to the area's rapid gentrification and commercialization. Her representations distinctively challenge the monotonized landscape of new developments and amplify and honor the dreams and aspirations of the communities of color that are being displaced—returning them to sceneries and backgrounds that index continuity and survival. In addition, De Jesus's paintings communicate a

C.4 Danielle De Jesus, *Loyalty like this doesn't exist anymore*, 2021. Oil on linen, 83 × 67 in. Courtesy of Calderón Gallery, New York.

decolonial urban aesthetic that validates and uplifts elements of everyday urban Latinx life that are usually devalued. De Jesus's tattooed arm in *Loyalty like this doesn't exist anymore* (2021) is a good example (see figure C.4). The painting brands Bushwick with the popular culture of ink and tattoos—stereotyped in some circles as a symbol of unrefined culture and taste—and with Puerto Rico, pictured in the scab on the subject's elbow. The work links the fates of Bushwick and Puerto Rico, both subject to real estate speculation, a process as devastating as colonial settlement practices have been around the world. Against this reality, the artist provides a proud and unapologetic image that says, in no uncertain terms, "my hood and surrounding culture are valuable and beautiful."

In sum, the politics of place link Shellyne Rodriguez, Rigoberto Torres, Lee Quiñones, and Danielle De Jesus, and so many more Nuyorican/Diasporican artists working amid the increasingly aggressive financial speculation in housing and space in contemporary cities. As we saw, their work is informed by these forces; how could it not be? These artists

were policed and criminalized, had to face toxic and debilitating effects of environmental racism and the pressures of gentrification and displacement, and all these forces guided their work and makes us aware of how much Nuyorican/Diasporican artists have been working against, alongside the push-and-pull forces of geographic displacement and unbridled capitalism-led gentrification. It comes as no surprise that we find creative and poetic critiques of capitalism in these works and visual vocabularies that insert communities and their culture into space. The result is work that is affirming for people of color facing spatial precarity and displacement everywhere, which is exactly what makes Nuyorican/Diasporican art so presciently important in contemporary art: because when we look carefully, we find these artists have been documenting and responding to the commodification of space and moving us to appreciate the grittiness of the streets and the vernacular landscapes that make up communities. Most importantly, they have been centering the everyday people that give meaning and life to our communities, offering alternative visions of fair/equitable use of space, where art, culture, and community—not real estate speculation—are centered.

I introduce the topic of space in this conclusion to highlight its prominent role and recurrent appearance throughout this volume. As we saw, the quest to expand space—figuratively and materially—has been at the heart of many Nuyorican/Diasporican artists and has equally informed several works in this volume. Indeed, concerns over spatial politics reverberated in Johana Londoño's discussion of casitas in the Bronx, in Wilson Valentín-Escobar's analysis of the creative effervescence of the New Rican Village in Loisaida, in Al Hoyos-Twomey's discussion of Maria Dominguez's anti-gentrification murals, in Joseph Anthony Cáceres's challenge to the whitewashing of Loisaida's history, and in most of the volume's chapters in one way or another. It is also evident in Yasmin Ramirez's discussion of the Nuyorican alternative space movement, showing the essential role that culturally specific institutions have played in amplifying the value of what is considered worthy of study, exhibition, and collection in the art canon and beyond. Indeed, the power of presence in physical institutions, and of accessing square footage dedicated to our artists, such as through the creation of alternative galleries and cultural institutions from New York City to Philadelphia, constitutes one of the key takeaways of this volume. This observation affirms that spatial politics are always intrinsically connected to issues of value in art and that Diasporican artists have been historically at the vanguard of these debates.

Furthermore, a key aspect of our volume is broadening of the definitions of art, aesthetics, and value while acknowledging the artistic and cultural contributions of Diasporican artists. This constitutes the principal and fundamental intervention that underlies all of these essays. Specifically, these chapters present challenges to narrow definitions of authenticity and of what Puerto Rican art should look like, which have historically undervalued Nuyorican/Diasporican artists, and particularly dismissed the contributions of the Nuyorican art movement from the late 1960s and beyond. In this regard, our volume makes a bold move about the evaluation of diaspora identities as a key contribution of the Nuyorican art movement. This is especially evident when considering the constraints and racism that Puerto Rican artists faced in NYC and on the archipelago, described by Melissa M. Ramos Borges—foreboding the in-between status that Nuyorican artists have since faced—in relation to the historical and ongoing challenges posed by Nuyorican artists, movements, and institutions to territorially bounded definitions of Puerto Rican identity. Chapters by Ramos Borges, Valentín-Escobar, Arnaldo M. Cruz-Malavé, Cáceres, and more—in fact, most chapters in this book—provide instances of artists' active rebuttal of narrow definitions of Puerto Rican art that prioritizes territorially and archipelago-based creativity over that of the diaspora. Altogether the chapters point to the diversity of aesthetics, moves, and decolonial practices through which artists assert creativity amid their ongoing racialization. They also advance and provide models for researchers intent on recovering and appreciating the diverse visual culture of the diaspora to bring about a fuller understanding of Puerto Rican, Latinx, and American art. In particular, our work is a statement of the value of interdisciplinary scholarship in advancing marginalized areas of research in the visual arts and in bringing about the necessary change across traditional disciplines.

Additionally, the chapters call for a greater appreciation of the diverse cultural and dialogic exchanges that fed, and were in turn nourished by, Nuyorican artists and spaces. Chapters by Taína Caragol and Néstor David Pastor document the Latin American and Latinx exchanges and connections between key Nuyorican artists and creators in places like MoCHA, and how Nuyorican creators were simultaneously foundational to the development of Latinx and Latin American art worlds. Likewise, Deborah Cullen-Morales chronicles the impact of African American artists in the development of many Nuyorican artists through the creative collaborations and artistic innovations generated at Robert Blackburn's Printmaking Workshop, while Cáceres sheds light on Lois Griffin's archives and her

role in preserving the work of the mostly Caribbean, Latinx, and African American contributors to the Nuyorican Poets Café. These essays indicate the need for centering Nuyorican/Diasporican art in the study of New York City contemporary art, as well as in the fields of Latin American and African American and "American" art more broadly.

Another lesson of these chapters is the diversity of movements, practices, and aesthetics that made up the Nuyorican art movement and the range of influences that enriched it, such as Urayoán Noel's call to appreciate book arts and the creative visual imagery of poetry, and the visual work of artists such as Sandra María Estevez, who have been known solely as poets, not as visual artists in their own right. Other chapters shed light on aesthetics that are not generally associated with Nuyorican/Diasporican art, such as abstraction and Surrealism, or "bodega Surrealism," as explored by Valentín-Escobar, Cáceres, and Abdiel D. Segarra Ríos.

Finally, other chapters introduce novel ways of looking at visual products and archives produced by Nuyorican artists. For instance, Yomaira C. Figueroa-Vásquez's analysis of Frank Espada's documentation of an Afro–Puerto Rican family in his Puerto Rican diaspora project follows Tina Campt's "listening to images" approach to rediscover marginalized Afro–Puerto Rican communities in Espada's work. Elizabeth Ferrer's analysis of Máximo Colón and Nuyorican photography examines the poetics of Colón's documentary photography and his careful attention to his subjects. This work reveals the poetics of documenting social movements and activism and the role that photography has played in expanding the political demands of Puerto Rican communities in New York. These chapters bring to the fore the artivism of many foundational Nuyorican and Diasporican artists, whether in documenting social struggles or creating alternative imaginaries and possibilities through their work. They also demand that we pay attention to the social demands, politics, and historical knowledge that are embedded and communicated in these artworks, while resisting the urge to aestheticize or discount the value of artists of color who purposefully use art to uplift social movements and struggles.

Other contributors introduce queer studies and performance studies perspectives to examine the "spectacularity" of many Nuyorican art practices. These chapters consider the racial, gender, sexual, and class critical dimensions of artworks that may be characterized within the rubrics of an "aesthetics of excess," using Jillian Hernandez's term, especially when seen against dominant racial tropes of proprietary and middle-class respect-

ability that downplay the fantastic and performative elements of Nuyorican and Latinx culture.[13] In essays by Kerry Doran and Cruz-Malavé, we point readers to the work of scholars such as Jillian Hernandez, Karen Jaime, and Sandra Ruiz, who unfortunately were not able to contribute to our volume but who have also been innovating analysis of visual culture with an emphasis on race, aesthetics, and decoloniality.

Finally, most chapters highlight the diversity of aesthetics involved in the Nuyorican movement that were being developed and generated in simultaneity—bringing light to the diversity of genres, forms, visual vocabularies, and curatorial perspectives that were being produced by Nuyorican and Diasporican artists. In sum, this collection shows that Nuyorican and Diasporican artists have always cultivated a larger range of aesthetics than the realist formats we generally associate with their work. This is another important contribution of this volume—by documenting artists producing graffiti and street arts alongside printmaking and abstraction side by side with realist works and learning about the practices of artists from Minneapolis to Orlando and Philadelphia, we can appreciate how much Diasporican artists have been saying out loud: we are here and we are artists creating valuable works, while begging for a more expansive consideration of Nuyorican/Diasporican art practices and movements.

In this regard, we saw distinct, alternative Diasporican art scenes operating independently from one another, even within one single city or location, often with little overlap or connection among their participants. We saw different institutions working with different curatorial approaches alongside each other, as is the case of NYC's MoCHA or Taller Boricua, and muralist artists working in all cities at the margin of more institutional efforts. This insight complicates any generalizations and warns us against the temptation to search for a single "Nuyorican" or "Diasporican" aesthetic that oversimplifies the complexity of diverse and coexisting alternative art scenes. In fact, modalities of Diasporican identities and art practices are also affected by the multiethnic intersections at play within distinct regional communities, as Teréz Iacovino discusses when examining the art practices of three different Diasporican artists located in different regions. She underscores the significance of regional differences in the racial and ethnic makeup of different communities where Diasporicans live and the specific context in which their work is situated to fully appreciate the social imaginaries that Diasporican artists outside New York City have been building. These writings show the expansiveness of Diasporican identities, bringing to mind the

globality of Nuyorican culture and the multiethnic context and histories that inform the work of these artists, past and present.

On this point, I return to the work of Shellyne Rodriguez with which I started the conclusion because her work evokes the expansiveness of Nuyorican/Diasporican identities. Rodriguez's work draws deeply from her Bronx community, a multiethnic and global community with an amalgam of ethnicities and cultures, languages and histories, hence the portrayal of Bangladeshi, Indigenous Mexican, and Arab communities and references in her mixtape drawings. This diversity and globality, however, is always mediated by points of encounter shaped by these groups' shared marginalization and struggles for liberation. I point to Rodriguez's drawing *The Common Denominator*, which was included in her first solo show at P · P · O · W in the spring of 2023 (see figure C.5). The drawing displays an old radiator: the type where the valve may no longer function or be under any individual tenant's control, meaning the tenant is at the mercy of the building's owners or administrators who set the temperature (if at all) to save costs. The radiator is depicted against a stark black backdrop, a common setting that the artist uses to heighten the visual impact of her subjects. By placing the radiator in this context, the artist confronts the viewer with the clear message that if there is no heating we are all affected, and we have no recourse but to come together in collective action. This powerful statement highlights the structural conditions that can only be overcome through collective organizing and struggle.

In this vein, we hope this book inspires scholars from all fields to learn in the spirit of community and liberation to uplift and appreciate the creativity of diaspora identities everywhere. In particular, we hope this book centers the possibilities for larger anti-racist collaborations, alliances, and projects like those that have been historically facilitated by Nuyorican/Diasporican artists. As we saw, Nuyorican/Diasporican artists have acted as a gateway for diverse communities, challenging racializing projects imposed on communities of color across place and time. As a result, artistic social movements have been formed, institutions established, and the boundaries of art worlds expanded to create more inclusive art worlds. These artists worked hard to challenge the exclusions associated with the New York City art establishment. They created alternative models for art making and community building that have contributed to enriching multidiverse communities of color in New York City and beyond. By centering their work, we embrace these same values, and expect this volume will contribute to building more diverse and expansive art worlds.

C.5 Shellyne Rodriguez, *The Common Denominator*, 2023. Color pencil on paper, 43¾ × 28¼ in. Photo by JSP Art Photography. Courtesy of Shellyne Rodriguez and P · P · O · W, New York.

1 Statements and citations by four artists discussed in this chapter—Shellyne Rodriguez, Rigoberto Torres, Lee Quiñones, and Danielle De Jesus—are drawn from personal interviews conducted throughout 2021 and 2023.

2 Tompkins Rivas, "You Belong Here"; Lee Quiñones quoted in Dwyer, "From Vandals to Artists."

3 See Cameron, *Grace under Pressure*.

4 Cameron, *Grace under Pressure*, 19.

5 Sze, *Noxious New York*.

6 NYC Health, "Disparities among Children with Asthma."

7 Chalfant and Cooper, *Subway Art*; Chalfant and Prigoff, *Spraycan Art*; Avramidis and Tsilimpoundid, *Graffiti and Street Art*.

8 Munsell, *Writing the Future*.

9 Deitch, Gastman, and Rose, *Art in the Streets*; Munsell and Tate, "*Writing the Future*."

10 Martinez, "Brief History of Graffiti," n.p.

11 Schjeldahl, "Notes on Studio Graffiti," n.p.

12 In "Two Latinx Artists Take on Gentrification," I reviewed the exhibition for *Hyperallergic*, highlighting the rarity of encountering exhibitions like this in commercial galleries. This achievement was made possible through the efforts of Puerto Rican gallerist Nicole Calderón.

13 Hernandez, *Aesthetics of Excess*.

BIBLIOGRAPHY

Avramidis, Konstantinos, and Myrto Tsilimpounidi. *Graffiti and Street Art: Reading, Writing and Representing the City.* Florence, Italy: Taylor and Francis, 2016.

Cameron, Dan. *Grace under Pressure: The Works of Rigoberto Torres.* Bronx, NY: Lehman College Art Gallery, 1995.

Chalfant, Henry, and Martha Cooper. *Subway Art.* New York: Thames and Hudson, 2016.

Chalfant, Henry, and James Prigoff. *Spraycan Art.* London: Thames and Hudson, 1987.

Dávila, Arlene. "Two Latinx Artists Take on Gentrification from the Perspective of Those Displaced." *Hyperallergic*, December 2, 2021.

Deitch, Jeffrey, Roger Gastman, and Aaron Rose. *Art in the Streets.* New York: Skira, 2011.

Dwyer, Jim. "From Vandals to Artists: Time Rouses More Appreciation for Graffiti." *New York Times*, May 14, 2014.

Hernandez, Jillian. *Aesthetics of Excess: The Art and Politics of Black and Latina Embodiment*. Durham, NC: Duke University Press, 2020.

Martinez, Hugo. "A Brief History of Graffiti." In *United Graffiti Artists 1975*, edited by United Graffiti Artists. New York: Artists Space, 1975. https://artistsspace.org/media/pages/exhibitions/united-graffiti-artist/4026758671-1639688455/fullcatalog_1975_unitedgraffitiartists.pdf.

Munsell, Liz, and Tate, Greg J., eds. *Writing the Future: Basquiat and the Hip-Hop Generation*. Boston: MFA Publications, Museum of Fine Arts, 2020. Exhibition catalog.

NYC Health. "Disparities among Children with Asthma." Epi Data Brief (126). New York City Department of Health and Mental Hygiene, September 2021.

Rivera, Raquel Z. *New York Ricans from the Hip Hop Zone*. New York: Palgrave Macmillan, 2006.

Schjeldahl, Peter. "Notes on Studio Graffiti." In *United Graffiti Artists 1975*, edited by United Graffiti Writers. New York: Artists Space, 1975. Exhibition catalog.

Sze, Julie. *Noxious New York: The Racial Politics of Urban Health and Environmental Justice*. Cambridge, MA: MIT Press, 2006.

Tompkins Rivas, Pilar. "You Belong Here." *Aperture*, Winter 2021, 20–25.

CONTRIBUTORS

Joseph Anthony Cáceres is a queer Puerto Rican writer from the South Bronx whose work has been published in *Slice* magazine, *Cosmonauts Avenue*, CURA, and *Emerge: 2019 Lambda Fellows Anthology*. An alumnus of the Yale Writers' Workshop, Cáceres is also the recipient of the Bronx Council of the Arts' Bronx Recognizes Its Own (BRIO) Grant for Fiction, and the LAMBDA Literary Writers Residency for Emerging LGBTQ Voices. As an English PhD candidate at the CUNY Graduate Center, Cáceres studies queer American artists of African and Caribbean descent.

Taína Caragol is curator of painting, sculpture, and Latinx art and history at the National Portrait Gallery. Her scholarship focuses on Latinx and Latin American art and its institutional and market validation as well as on the recovery of histories suppressed by colonialism. Her curated or cocurated exhibitions include *One Life: Dolores Huerta, UnSeen: Our Past in a New Light, Ken Gonzales-Day and Titus Kaphar,* and the landmark *1898: U.S. Imperial Visions and Revisions.* She is a coauthor of *1898: Visual Culture and U.S. Imperialism in the Caribbean and the Pacific* (2023). Caragol has a BA in modern languages from the University of Puerto Rico, an MA in French studies from Middlebury College, and a PhD in art history from the CUNY Graduate Center.

Arnaldo M. Cruz-Malavé is a professor of Spanish, comparative literature, and Latin American and Latinx studies at Fordham University. He is the author of *El primitivo implorante: El "sistema poético del mundo" de José Lezama Lima* (1994), *Queer Latino Testimonio, Keith Haring, and Juanito Xtravaganza: Hard Tails* (2007), and *Bailar en un encierro: Duelo, danza y activismo en las manifestaciones del Verano Boricua de 2019* (2023). He is the editor of the short stories of New York Puerto Rican queer writer Manuel Ramos Otero, *Cuentos (casi) completos* (2019) and *Cuentos "completos"* (2023); and a coeditor, with Martin Manalansan, of *Queer Globalization: Citizenship and the Afterlife of Colonialism* (2002). He curated, with Gregory de Silva, *The Magic of Everyday Life: The Queer Translocal Photography of Luis Carle* at Rutgers University's Paul Robeson Galleries in Newark, New Jersey (2021–22).

Deborah Cullen-Morales is a program officer for arts and culture at the Mellon Foundation, focused on the visual arts sector. Previously, she has served as executive director of the Bronx Museum of the Arts, director and chief curator of the Wallach Art Gallery at Columbia University, and director of curatorial programs at El Museo del Barrio. Cullen-Morales was curator of the print collection at the Robert Blackburn Printmaking Workshop and is a Trustee for Robert Blackburn. She focuses on Latinx, Caribbean, and African American modern and contemporary art and holds a PhD in art history from the CUNY Graduate Center.

Arlene Dávila is a professor of anthropology and American studies at New York University. She is the author of multiple books on Latinx cultural politics spanning the media, urban politics, museums, and contemporary art markets, including her latest, *Latinx Art: Artists, Markets and Politics* (Duke University Press, 2020). Dávila is also the founding director of The Latinx Project, an interdisciplinary space focusing on Latinx art and culture and hosting artists and curatorial projects at NYU.

Kerry Doran is a PhD Candidate at the Graduate Center, City University of New York (CUNY); a Graduate Teaching Fellow at Brooklyn College, CUNY; and a Curatorial Advisor for Web Commissions at M+ in Hong Kong. Their research focuses on decolonial histories of new media art throughout the hemispheric Americas.

Elizabeth Ferrer is an independent curator and writer specializing in Latinx and Mexican art and photography. She previously held positions as vice president and chief curator at BRIC, Brooklyn, and as Gallery Director of the Americas Society. Ferrer has curated major exhibitions that have appeared at venues such as the Center for Creative Photography, University of Arizona, Tucson; the Smithsonian Institution, Washington, DC; El Museo del Barrio, New York, and the Aperture Foundation Gallery, New York, among other institutions. She is author of *Louis Carlos Bernal: Retrospectiva* (2024), *Latinx Photography in the United States: A Visual History* (2020), and *Lola Álvarez Bravo* (2006).

Yomaira C. Figueroa-Vásquez is an Afro–Puerto Rican writer, teacher, and scholar. She is professor of Africana, Puerto Rican, and Latino Studies and the director of the Center for Puerto Rican Studies at CUNY Hunter. She is the author of the award-winning *Decolonizing Diasporas: Radical Mappings of Afro-Atlantic Literature* (2020). She is a founder of the MSU Womxn of Color Initiative, #ProyectoPalabrasPR, and the digital/material project Taller Electric Marronage. Figueroa-Vásquez was a Duke University SITPA fellow, a Ford Foundation postdoctoral fellow, and Cornell University Society for the Humanities fellow. She is the PI and codirector of the $2 million Mellon Foundation Higher Learning grant for the collaborative project "Diasporas Solidarities Lab."

Al Hoyos-Twomey is a PhD student in art history at Newcastle University in the UK. His research explores Nuyorican art and activist spaces on New York's Lower East Side between the mid-1970s and the late 1980s, with an emphasis on the work of CHARAS and El Bohío.

Teréz Iacovino is an artist, educator, and the assistant curator of the Katherine E. Nash Gallery at the University of Minnesota in Minneapolis. Her creative practice has been supported by the Jerome Foundation, the Imagining America Foundation, and the UMN Institute for Advanced Study and Institute on the Environment. She is the recipient of a curatorial research fellowship from The Andy Warhol Foundation for the Visual Arts in support of a collaborative investigation, with independent curator José López Serra, on twenty-first-century Puerto Rican artistic practices spanning Archipelagic and Diasporican perspectives.

Johnny Irizarry retired as the director of the Center for Hispanic Excellence: La Casa Latina, at the University of Pennsylvania, in 2020. Before working at Penn, Irizarry served as CEO of the Lighthouse, a multiservice community-based center; he also served as executive director of Taller Puertorriqueño. Irizarry worked as a teacher and as a program specialist for Puerto Rican and Latino studies for the School District of Philadelphia's Office of Curriculum Support. He received his BFA from Philadelphia College of Art and his MA in urban education from Temple University School of Education. He is currently teaching part-time at the University of Pennsylvania, creating art, exhibiting, and writing.

Johana Londoño is an associate professor of Latino and Caribbean studies at Rutgers University, New Brunswick. She is the author of *Abstract Barrios: The Crises of Latinx Visibility in Cities* (Duke University Press, 2020), which received the Best Book Award from the LASA Latino Studies section. Her research focuses on Latinx urban culture and spaces. She received a BFA from the Cooper Union School of Art and a PhD in American Studies at NYU. She has been awarded various fellowships, including from the Ford Foundation and the Smithsonian Latino Museum Studies Program, and she received a Princeton-Mellon Foundation Fellowship in Architecture, Urbanism, and Humanities.

Gabriel Magraner is a cultural worker based in New York City by way of Diasporican Texas. Currently he is the associate director of The Latinx Project. He is a former director of programs at the National Association of Latino Arts and Cultures in San Antonio, Texas. His research interests include Latinx arts, politics, and culture. He is a past Fulbright ETA grantee to Brazil and holds an MA in Latin American and Caribbean studies from NYU.

Nikki Myers is an NYC-based Dominican-American arts scholar, writer, and curator originally from Ocala, Florida. She has a BA from NYU Gallatin with a concentration in Latin American Women and Visual Culture, and she is currently pursuing an MA at Parsons School of Design in the history of design and curatorial studies. Her research includes Latinx art, queer art, female Caribbean/Latin American artists, and Latina iconicity in popular culture. She has volunteered with several migrant justice organizations and has assisted in various film and book projects centering Latin American and Latinx artists and designers.

Urayoán Noel is the author or translator of a dozen books, including *Transversal* (2021), a New York Public Library Book of the Year; *In Visible Movement: Nuyorican Poetry from the Sixties to Slam* (2014), a winner of the LASA Latino Studies Book Award; and Nicole Cecilia Delgado's *islas adyacentes/ adjacent islands* (2022). His international performances include Poesiefestival Berlin, Barcelona Poesia, and the Toronto Biennial of Art, and his work has been exhibited at the Museum of the City of New York and the Museo de Arte de Puerto Rico. Originally from Río Piedras, Puerto Rico, Noel lives in the Bronx and teaches at NYU, where he serves on the board of The Latinx Project and as editor-in-chief of its online publication *Intervenxions.* He is also a board member of the Clemente Soto Vélez Cultural and Educational Center.

Néstor David Pastor is a writer, editor, translator, independent researcher, and organizer from Queens, New York. As former managing editor of *Intervenxions*, an arts and culture publication he helped launch for The Latinx Project in 2019, he oversaw the production of *Latinx Politics— Resistance, Disruption, and Power* and *Intervenxions*, vols. 1 and 2. He is also a cofounder of *Huellas*, a bilingual magazine of longform writing by emerging Latin American and Latine writers. Additional past editorial work includes CENTRO *Voices*, a digital publication of the Center for Puerto Rican Studies, and the award-winning NACLA Report. Most recently, he participated in NALAC's 2023 cohort for its National Leadership Institute. He is a graduate of SUNY Binghamton and holds an MA in Spanish from Queens College, CUNY.

Yasmin Ramirez is an art worker and adjunct professor of art at the City University of New York. Born in Brooklyn, Ramirez was active in the downtown art scene of the early 1980s as a club kid and art critic for the *East Village Eye*. Currently an independent curator, Ramirez has collaborated on curatorial projects with the Bronx Museum, El Museo del Barrio, the New Museum, the Loisaida Center, the Studio Museum in Harlem, Franklin Furnace, and Taller Boricua. Her recent critically acclaimed exhibitions include *Pasado y Presente: Art after the Young Lords, 1969–2019* (2019); *Home, Memory, and Future* (2016); *Martin Wong: Human Instamatic* (2015); and *¡Presente! The Young Lords in New York* (2015). She holds a PhD in art history from the Graduate Center, CUNY.

Melissa M. Ramos Borges is an art historian with a predilection for the (re)vision of the art historical narrative in Puerto Rico. She obtained her

doctorate from the Programa de Estudios Artísticos, Literarios y Culturales, with a specialty in art history at the Universidad Autónoma de Madrid, where she presented the first comprehensive study of avant-garde art produced between 1960 and 1980 in Puerto Rico. She is a professor in the Art History and Theory programs at the University of Puerto Rico, Mayagüez. In addition, she is an independent researcher and curator who has published and presented her exhibitions and articles in various international platforms. She organized and curated SUZI FERRER, the first retrospective exhibition of the groundbreaking Puerto Rican feminist avant-garde artist.

Raquel Reichard is an Orlando-based award-winning journalist and editor with an editorial objective to engage, educate, and empower. As a writer, she centers her reporting on body politics and Puerto Rican culture. Currently, she's the deputy director at *Somos*, Refinery29's multiplatform subbrand by and for Latines. She has a BA in journalism from the University of Central Florida and an MA in Latine media studies from New York University. A proud Nuyoflorican, Reichard was born in Far Rockaway, Queens, New York, spent her childhood in her parents' enchanting homeland of Puerto Rico, and was raised in Orlando.

Rojo Robles is a writer, filmmaker, cultural critic, and professor born and raised in Puerto Rico. He graduated from the University of Puerto Rico, Río Piedras, with a BA in theater and an MA in comparative literature. He completed his MPhil and PhD degrees in Latin American, Iberian, and Latino cultures at CUNY's Graduate Center. He is an assistant professor of Black and Latino studies at Baruch College, CUNY, where his research and courses are focused on Latin American, Latina/o/e, and Afro-diasporic literature, film, and cultures, with an emphasis on Puerto Rico. He is currently at work on a book project about maroon poetics in Afro–Puerto Rican diasporas.

Abdiel D. Segarra Ríos is a PhD student in the Program of Artistic, Literary and Cultural Studies at the Universidad Autónoma de Madrid. He works as an associate curator at the Museo de Arte Contemporáneo de Puerto Rico. His research focuses on the effects of nationalist ideological agendas on official narratives of the history of art in Puerto Rico. He holds a BFA from the Escuela de Artes Plásticas de San Juan (2008), an MA in cultural management and administration from the University of Puerto Rico (2013), and an MA in contemporary art history and visual culture from the Uni-

versidad Autónoma de Madrid. He directed the Visual Arts Program of the Institute of Puerto Rican Culture and the 4th edition of the San Juan Poly/Graphic Triennial.

Wilson Valentín-Escobar is on the faculty at The New School in New York City. He is a scholar, professor, curator, and activist who hails from pre-gentrified Brooklyn. His scholarship, teaching, and curatorial work live at the nexus of social justice and varied art-making modalities that aim to showcase the liberatory artistic practices of wrongfully maligned and marginalized groups. An American Studies scholar trained in the critical ethnic studies tradition, he has long been committed to community-engaged pedagogy and collaborative, transdisciplinary, public-facing scholarship that fosters praxis-oriented intellectual inquiry. Valentín-Escobar is the author of the forthcoming book *Bodega Surrealism: Latinx Artivists in New York City.*

INDEX

Note: page numbers followed by *f* refer to figures.

ABC No Rio, 58

abstraction, 10, 18, 274, 283, 396, 405n45, 420–21; casitas and, 401–2; decolonial, 273; diaspora and, 15; hard edge, 42n27, 46–47; language of, 205; Puerto Ricanness and, 271; Soto's work and, 281; in urban development, 403–4n8

Acevedo-Yates, Carla, 15, 273, 286n22

activism, 78, 11–16, 47, 54, 109, 134, 150, 200, 221–22, 224, 291, 358, 408, 416, 420; abolition, 339; arts, 4 (*see also* artivism); AWC, 50; bookmaking and, 293, 304; Casa Culture and, 264; civic, 109; community, 48, 131, 142, 145, 151, 235–36; decolonial, 107; HIV/AIDS, 218, 362; independence movement, 93; LGBTQ, 363; Nuyorican, 132; political, 110, 255; public space, 398; Puerto Rican alternative spaces and, 374; Puerto Rican, 7, 15, 47; queer and trans, 362; sex, 301; social, 70, 107, 109;

sociopolitical, 4; Taller Puertorriqueño and, 214

Adál, 2, 55, 105–7, 109, 111, 116–22, 124n11, 126n34, 298, 355–56, 358–59, 364, 366n10, 366n12; autoportrait illustrations and, 127n42; *Blueprints for a Nation*, 126n29, 127n42, 220, 358; *Coconautas in Space*, 126n30, 220; *Evidence of Things Not Seen*, 297, 359; Latine Cultural Left and, 125n21; New Rican Village and, 124n5; Nuyorican poetry and, 297; *Out of Focus*, 121*f*, 127n46; *Puerto Ricans Underwater (Los ahogados)*, 359, 360*f*; Spirit Republic and, 126n34. *See also* New Rican Village (NRV); Pietri, Pedro; El Puerto Rican Embassy (El Embassy); El Spirit Republic

aesthetics, 107, 204, 227, 297, 361, 365n1, 402, 419–21; Afro-Boricua, 17; Afro-Taino, 2, 86n21; architectural, 404n8; collage, 125n24;

aesthetics (continued)
cultural, 116; decolonial, 4, 6; diasporic, 18, 71; Griffith's, 315; Latinx, 354–55; Montañez Ortiz's, 356; national, 274; Nuyorican, 356, 358; of the Nuyorican movement, 21n7; parallel, 149–52, 157, 161; radical, 6; SAMO©'s, 333; Soto Sánchez's, 317; spectacular, 357; Surrealist, 120; surrealistic, 111; tropical, 114; Vega's, 277; visual, 354; working-class, 108

African Americans, 46, 73, 81, 94, 125n28; atrocities committed against, 91; in South Bronx, 401; working-class, 92

Afro–Puerto Rican communities, 238, 420

Afro-Taino iconography, 11, 18, 317

Aguado, Bill, 64, 403n4

Agüeros, Jack, 59–60, 62, 151, 152f, 156, 162n8, 293

Aguirre, George, 150–51, 152f, 162n7

AHA. See Association of Hispanic Arts

Ahearn, Charlie, 58, 415

Ahearn, John, 407–10

Alberty, Roberto "El Boquio," 28–29, 40n3, 40n7

Albizu, Olga, 42, 275, 285n6

Alegría, Ricardo, 42n29, 74, 86n17, 86n19, 182n26

Algarín, Miguel, 56–58, 314–15, 326n11, 345, 353–54, 356–57, 374; abjection and, 366n6; Association for Hispanic Arts (AHA) and, 62; Griffith and, 317, 327n17; Latine Cultural Left and, 125n21; Lezcano and, 301, 307n34; "Mongo Affair," 78, 87n29; Mongo Affair, 296; Nuyorican Poetry (Piñero), 8, 56, 78–79, 82, 87n29, 296, 336, 354

Alicea, José, 42n29, 216

alternative art movement, 2, 9, 415; Puerto Rican, 60, 63–64, 386, 388n20

alternative art spaces, 7, 12–13, 46, 110, 125n18, 158, 373–74, 376; Puerto Rican, 8–9, 12–13, 46,

54–56, 59–60, 64–65. See also The Alternative Museum; Exit Art; Museum of Contemporary Hispanic Art (MoCHA)

Alternative Museum, The, 8, 58–59, 146n34

Alvarez, Candida, 141, 158, 167–69, 180n8, 181n14, 272, 281, 286n22

Andrade, Oswald, 59, 300

Andre, Carl, 47, 298

Araiza, Juana Alicia, 201–2

architecture, 4, 18–19, 404n8; 1930s, 33; journals, 402; modernist, 395, 399; Puerto Rican, 282; vernacular, 18, 283, 397

archives, 5–7, 17, 238; Center for Puerto Rican Studies, 298; of early graffiti, 413; Latinx art and, 3; of Nuyorican artists, 420; placemaking, 408

Archives of American Art (Smithsonian), 6, 36

art criticism, 28, 292, 300; coloniality of, 346n2; Nuyorican, 296

Artforum, 33, 64, 197

art history, 2, 5–6, 20, 251, 293, 380, 408; alternative, 17, 334; canon, 4; Diasporican, 20, 28, 407; Latinx art and, 3; New York, 5, 64; Nuyorican, 20, 407; US, 63, 65

Art in America (journal), 33, 35f, 323

artists of color, 9, 47, 70, 95, 113, 137, 141–42, 144, 220, 253, 256–57, 266, 273, 381, 420; emerging, 13; queer, 58; young, 169

Artist Space, 56, 415

artivism, 4, 6, 123n2, 208n47, 420

art making, 28, 223; alternative models for, 422; community-based, 114; culturally interlocked approach to, 226

art market, 28, 142, 292; Basquiat's value in, 345; global contemporary, 20n1; graffiti and, 414; Latin American, 366n18

Art of Collab, 256, 260

art scenes, 27–28, 36, 253, 256; Boricua, 316; Diasporican, 421

Art Workers' Coalition (AWC), 47, 50–51, 66n14, 81, 326n3. *See also* Black and Puerto Rican Art Workers' Coalition

art world, 2, 9, 79; alternative, 11–12; alternative art spaces and, 64; contemporary, 160, 380; Diasporican artists and, 4; Díaz and, 343; of El Embassy and El Spirit Republic, 117; equality in, 81; graffiti artists and, 55–56, 334, 415; imaginary postracial, 141; institutional, 144; international, 1, 337; Latin American/Caribbean, 178; mainstream, 13, 113, 152, 382–83, 374, 380, 410; Peraza and, 150, 161; Raimundi-Ortiz and, 17, 372–74, 380, 382–84; roles in, 142; SAMO© and, 335–37; Vega and, 275. *See also* New York art world

Asociación de Músicos Latino Americanos (AMLA), 214, 217

ASPIRA, 29–30, 40n9; of Pennsylvania, 214

Association of Hispanic Arts (AHA), 8, 62, 159, 164n40. *See also* Moreno Vega, Marta

avant-garde, 28, 31, 36, 38–39, 40n2, 41n10, 294, 313; art, 28, 31, 36, 38, 41n15, 42n18; artists, 28–30, 36, 40n4, 42n31, 112–13, 118; casitas as, 403; collage aesthetics and, 125n24; communities, 120; Diasporican, 29–30; hip-hop culture as, 410; institutional critique and, 298; New Rican Village and, 106, 109; otherness and, 141; SAMO© and, 333; sensibilities, 297; theories of, 107; traditions, 302

Báez, Myrna, 216, 257

Ballester, Diógenes, 84–85n2, 175–79, 181n14, 183n33

Baraka, Amiri, 294, 321

Barnet, Will, 170, 181n16

Barraza, Santa, 167–68, 179n1

Barreto, Elí, 31, 41n13, 41n15

Basement Workshop, 58, 146n34

Basquiat, Jean-Michel, 56, 346–47n2, 347n5, 348n14, 349n63; graffiti culture and, 348n18; SAMO© and, 17, 329–32, 334–37, 342–43, 345–46, 347n7, 348n15. *See also* Díaz, Al (Bomb1)

Bey, Dawoud, 167, 169

Bhabha, Homi K., 71–73

Biasiny-Rivera, Charles, 55, 66n19, 93–94

bilingualism, 56, 373

Black and Puerto Rican Art Workers' Coalition, 7, 47, 50

Black artists, 137, 170, 273, 321, 341, 381. *See also* Ringgold, Faith

Blackburn, Robert, 13, 168–73, 180n8, 180nn11–12, 181n16, 183n32; Ballester and, 175–76, 178–79; Escobar and, 182n26; Khalil and, 182n29. *See also* Robert Blackburn Printmaking Workshop (RBPMW)

Black Emergency Cultural Coalition (BECC), 46–47, 50

Black Panthers, 48–49, 92, 17

Black Puerto Ricans, 15, 238

Blades, Rubén, 98, 192

bodegas, 107–8, 111, 119, 124n13, 127n41, 213

bomba, 62, 133–34, 136, 140, 213, 251, 266, 336–37; drummers, 258. *See also* plena

bookmaking, 292–93, 300, 303–4

Boricua College, 233, 235

Borilando, 251–52; visual art culture in, 266–67; visual arts scene in, 260

Boza, Juan, 164n37, 168

Bronx, 43n33, 100, 159, 189, 304, 357, 372, 374, 379, 407–8, 422; art history, 407; casitas in, 418; Galería 22, 41n13; gentrification in, 395; hip-hop and, 410; Lincoln Hospital, 50; Mott Haven, 393, 395, 400–402; pollution in, 413. *See also* South Bronx

Bronx Museum of the Arts, 9, 60, 62, 101, 162n12, 393–95, 403n1, 410

Brooklyn, 18, 314, 320, 401; Brownsville, 91; Bushwick, 142, 408, 416–17; Clinton Hill, 169. *See also* gentrification

Brooklyn Museum, 42n31, 46–47, 180n8

Brull, Pedro, 256–57

Buján, Juan Carrera, 153–56

Cáceres, Joseph Anthony, 5, 17, 418–20

Campbell, Christian, 333–34, 345

capitalism: Bodega Surrealism and, 119; colonial, 301; extractive, 106; gentrification and, 418; racial, 340, 343; SAMO© and, 335, 340; Surrealism and, 108

Caragol, Taína, 10–11, 13, 158, 162n8, 162n12, 165n47, 419

Carbonell, Gisela, 257–58

Caribbean, the, 14, 72, 79, 161, 175, 303, 320, 325, 327n14; racial capitalism in, 343; SAMO©'s roots in, 338; in the States, 197

Caribbean Cultural Center, 8, 53, 102n16

Carle, Luis, 17, 356, 360, 362–64, 368n38; *Dirty Martini Delivers Gender Justice*, 363, 364f-65f

Carrero, Jaime, 293-

Carrión, Ulises, 292–93, 298–99, 303

Casa Culture, 264–66

Casitas, 18, 393–406, 394f, 401f, 418

Cayman Gallery, 8, 40n1, 53, 59–60, 62, 146n34, 149, 151–54, 164n40, 169; Alvarez solo exhibition at, 180n8; closure of, 388n20; legacy of, 161. *See also* Museum of Contemporary Hispanic Art (MoCHA); Torruella Leval, Susana

Center for Puerto Rican Studies, 101; *Blueprints for a Nation* (Adál) at, 358; CENTRO *Voices*, 357; Library and Archive, 6, 298

Central Florida, 250, 252–57, 260, 264, 267; migration to, 16, 252–53, 261, 265–66; Orange County, 253, 260; Puerto Rican art scene in, 266; University of Central Florida, 253–55, 258; WestART Walls, 261. *See also* Kissimmee; Orlando

CHARAS/El Bohío, 8–9, 13, 21n8, 55, 57, 132, 136, 139–40, 143–44; La Galería en El Bohío, 140, 142. *See also* García, Carlos "Chino"

Chicago, 5, 14, 19, 239–43, 248n4, 254, 270, 272, 274; Diasporicans in, 16, 267; Humboldt Park, 260; Puerto Rican communities in, 6, 15, 278; Puerto Rican cultural activism in, 15; Puerto Rican diaspora in, 285n1; Puerto Rican neighborhoods in, 251; Puerto Ricans in, 234, 239, 245, 275, 277–78, 280–81, 283–84. *See also* Espada, Frank

chusma, 374–75, 377, 379–80

chusmería, 375, 377

Cinque Gallery, 50, 169, 173

Cintrón Goitía, Sandra, 29, 40n7

Cityarts Workshop, 132–33, 145n8

City College of New York, 47, 235, 415; graffiti art show at, 55, 66n20

civil rights, 109; Art Workers' Coalition and, 47; era, 14; movement, 91, 174, 374; Puerto Rican, 46, 70; struggles, 7

class, 11–12, 126n40, 238–39, 373, 386, 415; *chusmería* and, 375; colonial histories of, 366n18; hierarchies, 3, 333; segregation and, 362

Clemente, Roberto, 262, 264f

Close, Chuck, 88n30, 171

code-switching, 192, 385

collectors, 64, 141, 238, 307n34, 342, 381

Colo, Papo, 5, 51, 60, 61f, 65, 146n34, 376, 379. *See also* Exit Art

Colón, Máximo Rafael, 55, 90–101, 102n7, 420; *Grito de Lares, Plaza Borinquen*, 96, 97f; *Operation Move-In Demonstration*, 96, 97f

Colón, Miriam, 62; Latine Cultural Left and, 125n21. *See also* Puerto Rican Traveling Theater

Colón, Willie, 357; *La Cosa Nuestra*, 367n21

colonialism, 14, 60, 78–79, 106, 119–20, 248; decolonial abstraction and, 273; relief under, 257;

resistance to, 102n17, 134, 271; SAMO© on, 335; Spanish, 234; US, 116

Columbus, Christopher, 14, 74, 86n19

El Comité, 7, 92–93

Conceptual art, 17, 28, 63. *See also* SAMO©; Soto, Edra

conceptualism, 4; barrio, 298; of *The Evidence of Things Not Seen* (Adál), 297

Congreso de Latinos Unidos, 214, 223

Cooper Union, 46, 175, 181n16, 183n31

Cortijo, Nestor, 134–36

critics, 9–10, 64–65, 141, 313, 317; Basquiat and, 346n2, 348n15; Chuleta and, 381; conservative, 63; cultural, 248; Latinx studies, 292; neo-critics, 375–76; in Puerto Rican newspapers, 28; white, 346n2, 377; Young Lords and, 48

Cruz, David Antonio, 17, 220, 356, 360–61, 364, 366n16, 367nn30–31

Cruz Azaceta, Luis, 158, 163n20

Cruz-Malavé, Arnaldo M., 17, 366n6, 367n22, 419, 421

El cuarto del Quenepón, 178, 183n35

Cullen-Morales, Deborah, 7, 13, 419

cultural assimilation, 38, 72–73, 78

curators, 2–3, 9, 11–13, 59, 64, 157, 266, 302, 380; non-Latinx, 141

Damast, Elba, 160, 164n34

Davalos, Karen Mary, 191, 196, 200

Dávila, Arlene, 4, 18, 85n4, 163n28, 271–72; on art market, 20n1; Latinx art and, 366n18, 386; on nationalist privilege, 157; on neoliberalization of New York City, 388n20, 396; placemaking and, 191; on Society of Friends of Puerto Rico, 162n6; on whiteness, 141–42

dealers, 9, 64, 100, 141

decolonization, 93, 107, 117; cultural, 358

deindustrialization, 106, 112

De Jesus, Danielle, 18, 408, 416–17, 424n1

De Jesus, Joey, 294, 304, 305*f*

De Leon, Perla, 55, 95

De Mater O'Neill, María, 181n14, 183n35. See also *El cuarto del Quenepón*

design, 4; of *Baile Bomba* (Dominguez), 136–37; casitas and, 395, 398–401; *Defend, Grow, Nurture Phillips* (Levins Holden) and, 202; of El Embassy passport, 126n33; Esteves and, 297; experimental, 19; graphic, 254–55, 302; history, 18; *PLAY, LAY, AYE* (Gonzalez) and, 199; Taino, 12; urban, 403n8

diaspora, 5, 14–16, 39, 85n7, 144, 205, 250, 253; African, 170; Afro-Caribbean, 313; artistic forebears of, 71; artists and, 51, 112, 178; Chicago and, 270; *chusma* and, 374; identities, 419, 422; Latin American, 386; multiethnic, 409; politics of respectability and, 356; Soto Sánchez and, 317, 325; Yoruba cultural practices in, 324–25. *See also* Puerto Rican diaspora

Diasporican artists, 1–4, 6, 10, 16, 19–20, 29–30, 190–91, 271, 408, 418–22; gentrification and, 417–18; in Orlando, 411–12

Diasporicans, 16, 72–73, 75, 85n4, 190, 267, 412, 421

Díaz, Al (Bomb1), 17, 56, 329–32, 334–46, 347n10, 348n14, 348n22, 349n60; on Basquiat and graffiti movement, 348n18; on graffiti writing, 347n5; *NY City of Kings* (Díaz), 330, 342, 344*f*; on Trump, 337–38; *Wet Paint*, 344, 346. *See also* SAMO©

Diaz, Carmelo, 132, 141–42, 143*f*

Dimas, Marcos, 11, 50–51, 71, 73–74, 77, 84, 87n23, 88n30, 171, 181n14; Griffith and, 324; Latine Cultural Left and, 125n21; *Pariah*, 79–82; Pietri and, 326n3; *Self Portrait as an Invisible Man*, 47; SVA and, 181n18. *See also* Close, Chuck; Taller Boricua

discrimination, 7, 13, 133, 238, 243, 245, 374; Black community and, 203; Black women and, 384; Irizarry and, 38; Raimundi-Ortiz and, 377

disinvestment, 106, 131, 134, 397; gentrification and, 132; infrastructural, 413; in Latinx art, 3

displacement, 2, 14, 36, 72–73, 82–84, 134, 145, 251, 261, 418; exile and, 72; Lincoln Center and, 92; in the Lower East Side, 132, 139–40, 142; Rodriguez and, 409–10, 416; SAMO© and, 336, 341; violence of, 144. See also gentrification

dispossession, 85n10, 134, 236, 238, 248; racial, 414. See also gentrification

Dominguez, Maria, 2, 55, 131–33, 140–41, 144–45, 418; *Baile Bomba*, 132–37, 139–40, 145n8; *Contemporaneos*, 132, 140, 142–43; *Gentrification*, 132, 137–40; Latine Cultural Left and, 125n21

Don Rimx, 16, 256, 266–67

Doran, Kerry, 17, 421

Dos Mundos: Worlds of the Puerto Rican, 54–55, 58, 94–95, 100, 102n7

D'Oyen, Dina, 109, 124n5

Duany, Jorge, 85n4, 86n19, 190

Dworkin, Craig, 298–99

East Harlem/El Barrio, 29, 46–47, 66n10, 81, 94, 100, 142, 157, 260, 267, 296, 316; Los Amigos Community Garden, 400; art spaces in, 8, 11, 50, 59; casitas in, 396; children in, 93–94; everyday life in, 355; fashion and, 356; Fiestas de Santiago and, 102n16; Galería Mixta, 303; Graffiti Hall of Fame, 415; El Museo del Barrio and, 51, 54, 173; Power Street Theatre Company, 229; School of Visual Art (SVA) and, 171; schools, 176; Taller Boricua and, 53, 171; Young Lords and, 48–50

elitism, 9, 17–18, 338; cultural, 333

En Foco, 8, 55, 62, 66n19, 102n7

Escobar, Elizam, 220, 286n22

Espada, Frank, 15, 91, 233–38, 249n13, 286n22, 420; Collazo family and, 239–46, 247f, 248n4, 249n14; Latine Cultural Left and, 125n21

Esteves, Sandra María, 51, 105–7, 109, 111–16, 119, 122, 124n5, 304, 314; *Bluestown Mockingbird Mambo*, 297; Latine Cultural Left and, 125n21; Pratt Institute and, 124n11; *Yerba Buena: Dibujos y poemas*, 296–97. See also New Rican Village (NRV); El Puerto Rican Embassy (El Embassy)

ethnicity, 2, 11–12, 58, 189

Eventos: Space for Living Art, 8, 51

exhibitions, 10, 15, 18, 36–38, 46, 162n8; Alternative Museum and, 58–59; Alvarez and, 180n8; Basquiat and, 346–47n2; Buján and, 154; Carbonell and, 257; Cayman Gallery and, 59; Colón and, 101; De Leon and, 95; En Foco and, 55; La Galería and, 143; graffiti and, 414–16, 424n12; Latin American art boom and, 141; El Museo del Barrio and, 54, 65; nationalist biases and, 20; of New York avant-gardes, 41n10, 42n19; OLLANTAY Gallery and, 151–52; in Orlando, 251; Pepón Osorio and, 223; Peraza and, 157, 160; La Plaza Cultural and, 57; Puerto Rican art, 362; Puerto Rican artists and, 2; Puerto Rican diaspora documentary project and, 236; Taller Boricua and, 52, 65; Taller Puertorriqueño and, 216, 220; Torruella Leval and, 156; white box, 381

exiles, 72; queer, 197

Exit Art, 8, 13, 60, 146n34, 169, 376, 379; Alvarez and, 180n8; archives, 5; opening of, 388n20; Sánchez and, 183n30. See also Colo, Papo; Ingberman, Jeanette

expressivity: Afro-diasporic, 6; Black, 9

Fajardo-Hill, Cecilia, 273–74, 280, 283
fashion, 4; illustrators, 356 (*see also* Lopez, Antonio)
Febo San Miguel, Carmen, 219–20
Fernandez, Benedict J., 55, 93
Fernández, María Teresa "Mariposa," 14, 126n30, 189, 301, 303, 385–86
Ferré, Luis A., 38, 42n29
Ferrer, Elizabeth, 11, 13, 101n6, 239, 420
Ferrer, Rafael, 28, 40nn3–4, 181n14, 223, 286n22
Ferrer, Suzi, 38, 42n29
Figueroa, Eduardo "Eddie," 57, 105–7, 110, 122, 123–24n5, 124n11, 125n29, 325, 357–58; Latine Cultural Left and, 125n21. *See also* El Spirit Republic
Figueroa-Vásquez, Yomaira C., 15, 420
Flores, Juan, 294, 357, 395
Flores, Vanessa, 16, 261; *Locura Lucida*, 261, 263*f*
Flores-Gonzalez, Nilda, 15
Foto Gallery, 8, 297
Fox, Mariah, 332, 342
Fragoso, Adrian, 261, 262*f*
Franco, Ángel, 55, 93–95

Galería Campeche, 39n1, 40n7
Galería El Morro, 29, 40n7
Galería Morivíví, 8, 62
Galería 36, 30–31, 32*f*, 41n13
galleries, 9, 50, 59, 151, 168; alternative, 7–8, 11–13, 46, 62, 64, 373, 418; artist-run, 12, 41n13, 62, 65; in Central Florida, 266; Chuleta (Raimundi-Ortiz) and, 380; commercial, 424n12; in the East Village, 140–42; El Embassy and, 116; female Nuyorican artists and, 416; graffiti and, 415; mainstream, 38; in Orlando, 251, 256, 260; in Puerto Rico, 42n29; SAMO© and, 334; in SoHo, 46; Soto Sánchez and, 323; Suave and, 217; white cube, 139. *See also* Artist Space; Cayman Gallery; Cinque Gal-
lery; Galería Campeche; Galería Morivíví; Galería El Morro; Galería 36; Hundred Acre Gallery; Just Above Midtown; OLLANTAY Gallery; Razor Gallery; Tibor de Nagy Gallery
Garcia, Adrian, 47, 51, 54, 66n4, 84n2, 171
García, Carlos "Chino," 132, 139–40, 142
García, Domingo, 31, 36, 39n1, 40n7, 42n29, 59, 152*f*; *Felicidades-El Museo del Barrio*, 10*f*; Latine Cultural Left and, 125n21
García Rivera, Sandra, 303–4; *That Kiss*, 303–4, 305*f*, 308n41
gender, 11–12, 58–59, 123n1, 197, 366n18, 373, 384–86, 420; binary, 199; discrimination, 7; equality, 201; fluidity, 362–63; hierarchies of, 3; logics, 238; marginalization, 383; normativity, 375; performers, 362
Generación del 50, 28–29, 36–39, 40n5
genocide: colonial, 11; Indigenous, 338; Taino, 79
gentrification, 14, 58, 60, 106, 136, 197, 213, 252, 396, 418; activism against, 416; aesthetics of, 18; Bronx and, 395; of Bushwick, 416; Carle's critique of, 363; casitas and, 400–403, 404n8; city-sponsored, 92; on the Lower East Side/Loisaida, 131–34, 137, 139–41, 144, 341; of the neoliberal city, 380; Taller Puertorriqueño and, 220
Gilmore, Ruth Wilson, 339–40
Giuliani, Rudolph, 136, 397
Glissant, Édouard, 272, 274
Gómez, Oswaldo, 362–63, 367n34, 368nn36–37
Gonzalez, David, 55, 355, 366n9
Gonzalez, GeoVanna, 190–91, 196–200, 204–6; *PLAY, LAY, AYE: Navigating queerness, where space is always in flux | Act I*, 197–200
Gonzalez, Juan, 66n10, 71, 158, 164n34

graffiti, 6, 17–18, 55, 58, 226, 228–29, 302, 307n34, 330–34, 342–45, 347n10, 413–16, 421; artists, 2, 55–56, 302, 312, 342, 408, 414–16; art show, 66n20; Basquiat and, 348n18; bubble, 267; culture, 342, 348n18; Fashion Moda and, 410; Nuyorican, 335; spatial politics and, 408; wild-style, 62; writers, 330, 332, 334–36, 348n18, 414. *See also* Ahearn, Charlie; Díaz, Al (Bomb1); Quiñones, Lee; SAMO©; United Graffiti Artists (UGA)

Great Migration, 7, 91, 190

Griffith, Lois Elaine, 17, 312, 314–26, 327n17; "Speaking from the Underground," 312, 314, 316. *See also* Nuyorican Poets Café

Haiman-Marrero, Samí, 264–66

happenings, 9, 28, 41n10

hard edge, 10, 28, 30–31, 33, 39, 42n27, 46

Harlem Renaissance, 170, 201, 260; artists, 13, 40n2

Hernández, Jillian, 354–55, 375, 388n14, 420–21

Hernández Cruz, Luis, 33–34, 36, 41n15, 41n19, 42n29

Hernández Cruz, Victor, 295, 297

Herrera, Carmen, 274–75

Herrera, Patricia, 294, 296

Herzberg, Julia P., 163n30, 165n47, 322

hip-hop, 62, 334, 342, 356, 414–15; cultural forms, 335; culture, 17, 301–2, 307n34, 334, 341, 409–10, 414; dancers, 58; social commentary, 226

Hispanic Association of Contractors and Enterprises (HACE), 194, 214

HIV/AIDS, 62, 218, 235, 300–301; activism, 362

Homar, Lorenzo, 31, 37–38, 42n29

Hostos College, 6, 159, 161

Hoyos-Twomey, Al, 5, 9, 11, 13, 418

Hundred Acre Gallery, 38, 42n27

Hurricane Irma, 16, 261

Hurricane Maria, 14, 16, 252, 257, 261, 265, 411

Hussain, Maqbool Fida ("M. F."), 168, 179n1

Iacovino, Teréz, 16, 421

iconography, 79, 116; Afro-Taino, 11, 18, 317; neo-Taino, 175; of New Rican Village (NRV), 112; pre-Columbian, 173; Taino, 75, 86n17, 87n23; Yoruba, 316–17

identity, 82, 109–10, 194, 272–75, 279, 283–84, 297, 377, 381, 384–86, 400, 408; art based on, 13, 169; artivism and, 208n47; Boricua, 98, 106, 123n5; *chusma*, 375; cultural, 28–29, 84, 132, 134, 139–40, 155, 292; curatorial practices based on, 58; diaspora, 419, 422; Diasporican, 16, 73, 80–81, 421–22; diasporic subjectivity and, 11; ethnic, 30; graffiti and, 413, 416; Latine, 106; Latinx, 192, 383, 386; mixed racial, 79; national, 29, 57, 73, 120, 271, 277, 279–80, 284, 317, 357; nationality and, 17; neighborhood, 285n18; New Rican Village and, 325; Nuyorican, 134, 139–40, 317, 335; performance of, 98; politics, 59, 157; Puerto Rican, 8, 15–16, 18, 28, 39, 59, 74, 84, 280, 335, 356, 419; queer, 4; spiritual, 353–54; transnational, 60, 120; tropical desirability and, 119; US American, 338

Indigenous people, 75, 86n18, 160, 382

Ingberman, Jeanette, 60, 146n34, 376

installation, 10, 28, 38, 109, 137, 221, 223–26, 285n18; sound, 191. *See also* Adál: *Blueprints for a Nation*; Gonzalez, GeoVanna: *PLAY, LAY, AYE*; Osorio, Pepón; El Puerto Rican Embassy (El Embassy); *re-Form*; Romero, Raúl: *Onomonopoetics of a Puerto Rican Landscape*

Institute of Contemporary Hispanic Art, 8, 102n7

Instituto de Cultura Puertorriqueña (ICP), 33, 42n19, 42n29, 160, 164n43, 178; *ICP* magazine, 285n6
invisibility, 140, 273, 277, 283, 354; Nuyorican art, 2; of Puerto Rican alternative art, 9, 63; silence and, 113; social, 356
Irizarry, Carlos, 10–11, 27, 30–33, 36–39, 41n10, 41n13, 42n27, 42n29, 43n33
Irizarry, Marcos, 42n29, 181n14

Jaar, Alfredo, 59, 157
Jacobs, Jay, 10, 27, 36, 39n1, 42n24
Jaime, Karen, 302, 307n34, 354, 421
Jiménez, Ivelisse, 273–74
journalists, 94; Basquiat and, 346n2
Just Above Midtown, 146n34, 169

Kenkeleba House/Gallery, 58, 116, 126n33, 132, 137, 142
Kissimmee, 16, 250–51, 253, 260, 267, 407–8, 411
Koch, Edward, 154, 156*f*

Lam, Wifredo, 107, 322
Latin American art, 2, 152–53, 162n12; boom, 141; institutions, 409; markets, 366n18; world, 419
Latin American artists, 7, 59, 149, 151–52, 154, 159, 161
Latinx art, 3, 5, 7, 85n4, 366n18, 386; world, 419
Latinx Project, The, 3–4, 7
Latinx/Latine artists, 4, 7, 16, 20n1, 85n4, 104–5, 108, 124n7, 152, 158, 161, 415; Casa Culture and, 264; Cayman Gallery and, 154; *Contemporaneos*, 132, 140–41, 143; in diaspora, 112; difficulties of, 2; diversity of, 5; hostility toward, 113, 116; International Painting Biennial and, 157; *Puerto Rican Panorama* and, 229
Lefebvre, Henri, 145, 395, 397
Lester Properties Inc., 38, 43n36
Levins Holden, Olivia, 190–91, 200–206, 208n48; *Defend, Grow, Nurture Phillips*, 202–4

Lezcano, Manny (M. D.), 301–2, 307n34
liberation, 48–49, 17, 117, 120, 228, 297, 326, 422; women's, 374
Lieberman, Bill, 37, 42n31, 183n34
Lind-Ramos, Daniel, 179, 257, 281
Lippard, Lucy, 47, 66n14
Liss, Jesse, 31, 41n15
Loisaida/Lower East Side, 8, 46, 56–59, 107, 111–12, 144; casitas in, 396; Colón's photography and, 100; Díaz and, 339; Dominguez and, 131, 133, 137, 139, 142, 145; Fiestas de Santiago and, 102n16; Figueroa and, 105; gentrification and, 133–34, 138, 341; history of, 418; Levitt's photography and, 94; Member's photography and, 137, 140; Nuyorican, 131–34, 136; Piñero and, 302; La Plaza Cultural, 136; poetry and, 293, 295, 301; Quiñones and, 413; resistance in, 67n27; scholarship on, 315; School of Visual Arts (SVA) and, 171; El Spirit Republic, 117; Surrealism and, 124n7, 126n34, 312; YLP offices in, 49; zine culture in, 301. *See also* CHARAS/El Bohío; Kenkeleba House/Gallery; New Rican Village (NRV); Tibor de Nagy Gallery
Londoño, Johana, 18, 140, 418
Longwood Arts Project, 8, 64
Lopez, Antonio, 356, 364, 366n11
López de Victoria, Domingo, 10–11, 27, 29–31, 33–34, 36, 38–39, 41n10
La Lucha Continua (Artmakers Inc.), 144, 147n46
Lugo, Roberto, 226; *Put Yourself in the Picture*, 217*f*

Malave, George, 55, 94
Maldonado, Adál. *See* Adál
Manhattan, 17, 36, 101, 150, 190, 329; alternative art spaces in, 60; Central Park, 91, 98, 102n15, 136; Chelsea, 60, 169–70; Chinatown, 58, 146n34; diasporic avant-gardes

Manhattan (continued)
in, 29; Downtown, 5, 50, 334; East
Village, 57–58, 105, 112, 132, 134,
140–42, 144, 362; gentrification
and, 363, 401; Harlem, 81, 93, 170,
181n15, 415 (see also Studio Mu-
seum in Harlem); Lower, 8, 46,
56–57, 149; Midtown, 146n34, 295;
SoHo, 8, 46, 56, 58–60, 146n34,
150–52, 158, 160, 297; Tribeca, 58,
146n34; Upper, 55, 95; Upper West
Side, 91–92; West Harlem, 47.
See also East Harlem/El Barrio;
Loisaida/Lower East Side
Maristany, Hiram, 50, 54, 66n10,
94–95, 354–55, 366n8, 374; Latine
Cultural Left and, 125n21
Márquez, Laura, 153–56, 162n13
Martinez, Hugo, 55–56, 415. See also
United Graffiti Artists (UGA)
Martorell, Antonio, 216, 257; A/RESTOS,
220
Matos, John "Crash," 56, 216, 416
Matta-Clark, Gordon, 57
Meléndez, Jesús Papoleto, 51, 124n5,
295, 300–301
Mendoza, Jorge, 29–30, 40n7
Mercado, Joaquín, 29–30, 38, 39n1,
41n10, 42n29
Mercado, Nancy, 301, 307n34
mestizaje, 81, 238; Puerto Rican, 51
Metropolitan Museum of Art, 42n27,
50–51, 79; Harlem on My Mind,
46–47
Miami, 16, 190–91, 197, 199, 204, 256;
Bass Museum of Art, 197–99; graf-
fiti museum, 342
migrants, 71, 100, 255; Black, 401;
Puerto Rican, 212, 215, 251–52, 255,
271, 274, 396, 401; trans, 363
migration, 22, 70–72, 85n7, 190, 197,
234, 236–38, 240, 286, 366n18;
to Central Florida, 252; cultural
identity and, 73; European, 338;
forced, 72, 234, 258; to Greater
Orlando Area, 251–52, 412; justice
work, 255; liminality of, 383; mass,
70, 72, 251–52, 266; to New York,

7, 316–17, 410; outmigration, 14;
postwar, 7; stories of, 248. See also
Great Migration
Millán, Neysa, 262–63, 264f
Minneapolis, 16, 190–91, 200–201,
203–4, 421; Studio Thalo, 200,
208n48
Miranda Archilla, Graciany,
294–95
Mirzoeff, Nicholas, 132–33, 143
modernism, 59, 109, 395
Momber, Marlis, 137–38, 140, 142
Montañez Ortiz, Raphael, 47, 356, 374;
Archeological Find # 22: The After-
math, 3f; Latine Cultural Left and,
125n21
Montez, Mario, 357, 367n22
Moreno Vega, Marta, 9, 54, 62,
164n40, 327n12; Latine Cultural
Left and, 125n21
multiculturalism, 63, 157, 169
Muñoz, José Esteban, 197, 200, 346n2,
359, 374–75, 377
muralism, 4, 6, 55, 201
muralists, 55, 257, 263; Mexican, 28
Museo de Arte de Ponce, 42n29,
163n28, 179
El Museo del Barrio, 8–9, 11, 18, 47,
49, 51, 53–54, 59–60, 62, 65, 154,
156, 169, 180n11, 353; Agüeros and,
151, 293; Antonio Lopez: Future
Funk Fashion, 366n11; Associa-
tion for Hispanic Arts (AHA) and,
164n40; challenges faced by, 161;
Confrontation, Ambiente y Es-
pacio, 180n8; graffiti and, 414;
Montañez Ortiz and, 356; Mujeres
9, 95; ¡Presente! The Young Lords
in New York, and, 101; Raimundi-
Ortiz and, 383; Soto Sánchez and,
82, 88n36, 316; Surrealism and,
323; Taller Boricua exhibition, 312,
316; Tufiño and, 173. See also
Torruella Leval, Susana
Museum of the City of New York, 101,
414
Museum of Contemporary Art
Chicago, 15, 286n22

Museum of Contemporary Hispanic Art (MoCHA), 5–6, 8, 13, 18, 53, 62, 146n34, 149–50, 154–61, 164n45, 419, 421; artist studios at, 163n20; closure of, 388n20; *Immersion (Piss Christ)* (Serrano) and, 164n32; inauguration of, 156*f*, 163n19; Peraza and, 155. *See also* Exit Art; Hostos College; Torruella Leval, Susana

Museum of Fine Arts Houston, 6, 85

Museum of Modern Art (MoMA), 42n31, 51, 183n34; *Artist as Adversary*, 38; *East 100th Street* (Davidson) at, 100; Surrealist exhibition at, 326n3; Takis and, 46

museums, 17, 65, 100, 175; AWC and, 47, 50; Black Emergency Cultural Coalition (BECC) and, 46–47; Chuleta (Raimundi-Ortiz) and, 373, 380; community-based, 62; Dominguez and, 104; Espada and, 236–37; graffiti artists and, 414; Latinx art and, 3; Nuyorican casitas in, 395, 402; Nuyorican and Diasporican art in, 71; in Orlando, 255, 260; Puerto Rican art and, 42n31, 85n4; Puerto Rican artists and, 2, 54; Puerto Rican visual culture and, 6; Soto Sánchez and, 323. *See also* Alternative Museum, The; Bronx Museum of the Arts; Brooklyn Museum; Metropolitan Museum of Art; Orlando: Rollins Museum of Art; Studio Museum in Harlem; Whitney Museum of American Art

music, 29, 57, 106, 133, 200, 347n2; in Central Florida, 264; De Jesús and, 229; Díaz and, 329; Esteves and, 297; Griffith and, 324; Latinx, 228–29; making, 98, 102n15; Nuyorican movement and, 4; Ojibwe people and, 203; Puerto Rican, 213, 220, 228, 258; New York scene, 98, 330; in Orlando, 253, 267; Romero and, 192; visual arts and, 6. *See also* bomba; hip-hop

National Endowment for the Arts (NEA), 60, 62, 164n32

national identification, 2, 189, 272

nationality, 17, 386

National Portrait Gallery, 85n4, 101

national privilege, 27, 38

Negrón-Muntaner, Frances, 218, 335, 345, 346n2, 357, 367n22

neo-Taino movement, 174, 182n28

New Jersey, 16, 85n9, 196, 267

New Rican Village (NRV), 8–9, 13, 21n8, 51, 57–58, 105–14, 116–17, 122, 123n3, 123–24nn5–6, 296, 312, 358, 418; Surrealism and, 124n7, 323, 325; Taller Boricua and, 53. *See also* Esteves, Sandra María; Figueroa, Eduardo "Eddie"; Meléndez, Jesús Papoleto; Pietri, Pedro; El Puerto Rican Embassy (El Embassy)

New York art world, 46–47, 51, 141, 150; alternative art spaces and, 7, 9, 12, 64, 110, 374; Art Workers' Coalition and, 81; Exit Art and, 60; graffiti artists and, 415

New York City: African artists in, 182–83n29; alternative art spaces in, 12–13, 46, 110, 373–74, 418; art establishment, 18, 422; art history, 5; art scenes, 27–28, 29, 37–38, 113, 316, 329–30; avant-gardes in, 40n2; Ballester and, 176; Caribbean Creolization of, 335; Carrero and, 293; Chinatown, 58, 146n34; Colón and, 91–92; contemporary art, 420; critics, 9–10; cultural scene, 355; Delgado and, 303; Department of Health, 413; displacement in, 73; Espada and, 235, 247; exhibitions in, 10; Fiestas de Santiago in, 102n16; Fire Department, 164n32; gentrification and, 16, 106, 136, 396; graffiti and, 413–15; graffiti scene, 302; Grito de Lares in, 102n14; Irizarry and, 30, 36–39, 42n27, 43n33; Latin American art circuit in, 152, 162n12; Latin American artists in,

New York City (continued)
151; Latinization of, 4; Mendoza
and, 40n7; Mercado and, 41n10;
migration to, 2, 7, 16, 72, 272,
316–17, 320, 326n11, 387, 388n20,
396–97, 410; neoliberalization
of, 363, 376; Peraza and, 150, 153,
157, 159–61; Police Department
(NYPD), 136, 339; Puerto Rican art
institutions in, 353; Puerto Rican
artists in, 7–8, 11, 14–15, 29–31,
60, 65, 170, 356–57, 409–10;
Puerto Rican art movement in, 1,
7, 42n31, 46 (see also Nuyorican
[art] movement); Puerto Rican
communities in, 30, 38, 40n9,
81, 90, 93, 150, 357, 364, 420;
Puerto Rican diaspora and, 14,
70, 85n7, 85n10, 90, 190, 252, 284;
Puerto Rican neighborhoods in,
251; Puerto Rican photographers
in, 54–55, 93–94; Puerto Rican
poets in, 295–96; Puerto Rican
renaissance in, 54; Puerto Ricans
in, 55, 81–82, 84, 100, 105, 133,
294, 374, 402; Puerto Rican youth
in, 48; Puerto Rico's printmaking
tradition in, 53, 172; Rockefeller
Foundation in, 158; SAMO© and,
332, 344; subway, 299, 344; Sur-
realism and, 312; vanguardist
movements and, 6. See also alter-
native art movement; Bronx;
Brooklyn; Manhattan; Queens
New York Restoration Project (NYRP),
395–400, 403n1
New York State Council on the Arts,
173, 175, 183n30
Nieves, Nora Maité, 272–78, 286n22;
Transitional Land, 275, 276f
Noel, Urayoán, 16, 67n28, 354, 358,
420
Norris Square Senior Center, 214, 218
NRV. See New Rican Village
La nueva abstracción, 31, 34f-35f
La nueva plástica, 31, 41n15
Nuyorican artists, 2–4, 6, 11, 13, 17–18,
20, 81, 178, 408, 415, 417–22;

alternative art space movement
and 65; Black, 179; female, 416;
graffiti and, 414; in Orlando, 267;
RBPMW and, 170; spaces, 62; Sur-
realism and, 313
Nuyorican (art) movement, 1, 8–9,
46, 70, 73, 84n1, 94, 131, 336,
415, 419–21; Blackburn and, 170;
bomba and, 133; community infra-
structure and, 39; graffiti artists
and, 414; queer aesthetics of, 21n7;
visual aesthetic of, 6
Nuyorican poetry, 17, 52, 56–57, 65,
292, 304, 335, 414; Adál and, 297;
art and, 293; bomba and, 336;
scene, 111, 301
Nuyorican Poets Café, 8, 9, 13, 17,
21n8, 51, 57–58, 62, 291, 293, 295–96,
314–17, 320, 326, 353, 420; aes-
thetic of, 327n17; artists associated
with, 415; Association of Hispanic
Arts and, 164n40; chapbooks and,
302, 307n34; Delgado and, 303;
history of, 67n28, 315; Nuyorican
book making and, 304; Soto Sán-
chez and, 323, 325; Surrealism and,
312–13, 321–22. See also Algarín,
Miguel; Esteves, Sandra María;
Griffith, Lois Elaine; Meléndez,
Jesús Papoleto; Pietri, Pedro; Pi-
ñero, Miguel
Nuyorican Poets Café Founders Ar-
chive Project (NPCFAP), 314–15,
326n6

Ojibwe people, 203, 209n62
OLLANTAY Gallery, 152, 158
Oller, Francisco, 317, 327n14
Op art, 28, 30–31
oral histories, 7, 17, 106, 124n6,
124n11, 215, 238, 314, 326n3
Orlando, 5, 15–16, 19, 250–67, 413,
421; East Orlando, 250, 256–57,
260–62, 264f; Puerto Rican com-
munity in, 6, 261; Puerto Ricans
in, 250–53, 256–58, 260–61; Rol-
lins Museum of Art, 255, 257–58;
Torres and, 408, 411–12; West

Orlando, 253, 255, 260. *See also* Art of Collab; Borilando

Ortiz-Pagán, José, 226–28

Osorio, Carlos, 51, 84n2

Osorio, Pepón, 64, 223–26; *reForm*, 224–25

Otero, Manuel "Neco," 50–51, 54, 84n2

Otero Rodriguez, Néstor, 51, 124n5, 126n33, 181n14. *See also* Eventos: Space for Living Art

painting, 4, 6, 183n34; Basquiat and, 329; Carrero and, 293; Gonzalez and, 196; identity in, 84; Quiñones and, 416; Salicrup and, 171; style, 39

Pastor, Néstor David, 4–5, 9, 11, 13, 127n40, 164n37, 419

Pellot, Josué, 272–73, 277–81

Peraza, Nilda, 59, 146n34, 149–61, 163n15, 164n43. *See also* Museum of Contemporary Hispanic Art (MoCHA) and

performance art, 2, 4, 6, 11, 13, 105, 117, 355; Black, 337; bookmaking and, 293, 304; García Rivera and, 303; Gonzalez and, 197; Meléndez and, 295; Nuyorican aesthetics and, 356; Pietri and, 301; Piper and, 59, 385; poetic practice and, 291; Puerto Rican diaspora and, 17, 190; queer, 302; Raimundi-Oritiz and, 377, 379–80, 385, 388n28; Romero and, 193; scene, 47; street, 111, 362

performance studies, 4, 17, 420

Philadelphia, 6, 14–16, 19, 190–94, 220–21, 251, 253, 418, 421; Cruz and, 360, 367n30; Diasporicans in, 16; institution building in, 15, 213; North Philadelphia, 222, 226, 229; Puerto Rican community in, 6, 212–13, 223–24, 226, 228–29; Puerto Rican neighborhoods in, 251; Puerto Ricans in, 214, 225, 227–28, 230; Romero and 190, 193, 204–5. *See also* Asociación de Músicos Latino Americanos

(AMLA); Congreso de Latinos Unidos; Norris Square Senior Center; Taller Puertorriqueño

photography, 4, 11, 55, 121, 264; Adál and, 119–20, 122, 124n11, 359; black and white, 248; Colón and, 91–93, 420; drag, 356; enthusiasts, 238; Espada and, 235–36, 245; laser, 150; NRV and, 106; Nuyorican art movement and, 6; Rosado and, 16; Sánchez and, 175; street, 90, 94; Young Lords and, 54, 66n10. *See also* En Foco

Pietri, Pedro, 51, 57, 106, 116–17, 121–22, 125n29, 294–95, 301–2, 358; *Blueprints for a Nation*, 126n29; Bodega Surrealism and, 125n16; *Invisible Poetry*, 298; New Rican Village and, 124n5; *Platonic Fucking for the 90s*, 300, 307n30; *Public Execution*, 298–300, 307n29; "Puerto Rican Obituary," 353; Spanish-American War and, 306n27, 326n3; Young Lords and, 66n10, 326n3. *See also* Adál; El Puerto Rican Embassy (El Embassy); El Spirit Republic; Nuyorican Poets Café

Piñero, Miguel, 58, 301–2, 307n34, 326n11, 353–54, 356–57; abjection in, 366n6; "The Book of Genesis According to Saint Miguelito," 82–83; *Nuyorican Poetry*, 8, 82–83, 296

Piper, Adrian, 59, 384–85, 389n50

placemaking, 16, 109, 191, 194, 196, 204–5, 224, 386, 408; Nuyorican, 398

La Plaza Cultural, 57, 136

plena, 133, 136, 213, 251

poetics, 300, 304, 306n27; Afrofeminist, 297; of Afro-Taino recovery, 296; Basquiat's, 347n2; of cascadance, 295; of Colón's documentary photography, 420; decolonial, 345; Nuyorican, 294, 336; of protest, 299; of Puerto Rican diasporic experience, 247; SAMO©'s, 346; of survival, 237–38

poetry, 4–6, 8, 9, 11, 300–303, 315, 321, 336, 420; concrete, 294, 306n12; magazines, 293; NRV and, 106; performance, 291; readings, 53, 295; SAMO© and, 334, 343; self-empowerment and, 200; slam, 302, 314; Surrealism and, 312–13; Young Lords and, 54. *See also* Algarín, Miguel; Carrero, Jaime; Esteves, Sandra María; Hernández Cruz, Victor; Mercado, Nancy; Miranda Archilla, Graciany; Nuyorican poetry; Pietri, Pedro; Piñero, Miguel; Torres, Edwin

political prisoners, 14, 49, 160

Pop art, 10, 28, 38, 42n27, 47, 63

posters, 48–49, 53, 66n10, 218; agit prop, 11; Esteves and, 105, 111, 114; Nuyorican Poets Café, 315; "Se Vende Pasteles," 267

poverty, 94, 100, 134, 245, 252, 413; culture of, 110; generational, 106; systemic, 52, 339

Pratt Institute, 46, 124n11, 293, 317–20

printmakers, 49, 168

printmaking, 4, 11, 13, 168–72, 183n31, 421; Ballester and, 176; history of, 178–79; Nuyorican, 6, 170; Puerto Rican, 49, 53, 172, 182n26; Sánchez and, 175. *See also* Blackburn, Robert; Robert Blackburn Printmaking Workshop (RBPMW); Taller Boricua

PS1 Contemporary Arts Center, 169, 108n8

Pueblo Nuevo, 132, 136, 139, 142

Puente, Tito, 136, 192–93

Puerto Rican art, 42n29, 42n31, 46, 51, 190, 285n18, 419; abstraction and, 271; in Central Florida, 266; in Chicago, 272; exhibitions, 362; historiography, 28; initiatives, 2; institutions, 353; movement, 1, 7; El Museo del Barrio and, 156; New York, 355; organizations, 263; political, 140; printmaking and, 170; professionals, 251; spaces, 58; Taller Boricua and, 52; as transnational, 85n4

Puerto Rican artists, 1–2, 4, 6–11, 15, 37, 40n2, 63–64, 112, 116, 216, 220, 358, 419; abstract art and, 271; alternative art spaces and, 46, 65, 373; avant-garde, 38, 40n4; Black, 6, 10; Blackburn and, 170; Cayman Gallery and, 154; cultural equity and, 54; in East Harlem, 50; foundational, 18; Friends of Puerto Rico (FoPR) and, 150, 162n8; Galería El Morro and, 29; graffiti and, 414; *mestizaje* and, 81; New York, 14, 30, 60, 356–57, 409–10; in Orlando, 251, 256–57, 266; in Philadelphia, 229–30; photography and, 54; queer, 6; RBPMW and, 181n14; School of Visual Arts (SVA) and, 171; visibility of, 47. *See also* Taller Boricua

Puerto Rican community/communities, 14, 47, 194, 377, 420; casitas and, 394; in Chicago, 6, 278; diasporic, 27; Gonzalez and, 196; Metropolitan Museum of Art liaison to, 50; in New York City, 30, 38, 40n9, 90, 93, 150, 357, 364; in Orlando, 6, 261; in Philadelphia, 212–13, 223–24, 226, 228–29; postnational visions of, 120; Rodriguez and, 58; Romero and, 191; survival of, 83; in the United States, 233. *See also* Afro–Puerto Rican communities; East Harlem/El Barrio

Puerto Rican culture, 48, 79, 160, 271, 415; African- and Indigenous-derived elements of, 162n6; Afro–Puerto Rican culture, 136, 337; Black expressivity in, 9; graffiti and, 414; in New York City, 8

Puerto Rican diaspora, 17, 72, 179, 226, 271–72, 275, 357, 410; African contributions to, 283; artists of, 74; in Central Florida, 252; Central Park and, 98; Chicago and, 285n1; communities, 124n13, 127n40; East Harlem and, 11, 48; expansion and decentralization of, 6; history of,

174; mobility in, 241, 243; New York and, 70, 85n7, 85n10, 90, 190, 284; NRV and, 106; Nuyorican and, 14; Orlando and, 261; Pellot and, 278; project, 234–38, 247–48, 249n13, 249n15, 420; Soto and, 281; El Spirit Republic and, 117

El Puerto Rican Embassy (El Embassy), 105–6, 109, 116–18, 120, 122, 125–26nn29–30, 126nn32–33, 312–13; manifesto (Pietri), 298, 358; portal, 367n25. *See also* New Rican Village (NRV)

Puerto Rican history, 11, 51, 237, 241, 335; classes, 217

Puerto Rican independence, 60, 144, 271, 278, 357; activists, 93; avant-garde styles and, 38; El Comité and, 92; posters, 53

Puerto Ricanness, 3, 74, 205, 271–72, 280–81

Puerto Ricans, 2, 30, 36, 59, 82–84, 93–95, 105, 150, 174, 241, 352; African Americans and, 81; Afro–Puerto Ricans, 234, 238, 327n13; on AHA Board of Trustees, 62; "American," 1; art institutions founded by, 409; Black, 15, 238; in the Bronx, 189; Cayman Gallery and, 162n8; in Central Florida, 251–52, 257, 260, 266; in Chicago, 245; *Contemporary Puerto Rican Artists* and, 46; diasporic, 14, 39, 70, 72, 243, 291; discrimination and, 7, 38, 133, 245; disempowerment of, 78, 81; En Foco and, 55; in Espada's work, 234, 238; island, 326n11; malt beverages and, 280; migrant, 356; migration of, 7, 16, 70, 72, 91, 251, 326n11, 412; military service and, 78; in Minnesota, 190; El Museo del Barrio and, 151; negative representations of, 100, 354; in New York City, 55, 81–82, 84, 100, 105, 133, 294, 374, 402; New York–born, 48; in Orlando, 250–53, 256–58, 260–61; in Philadelphia, 212–14, 229–30; political

change for, 248n4; Rodriguez's work and, 410; School of the Art Institute of Chicago and, 272; signification and, 112; as subalternized population, 283; Taino culture and, 74; in the United States, 71–73, 85n7, 236–37, 274; working-class, 92, 387; young, 357; Young Lords and, 48

Puerto Rican traditions, 98, 213, 217, 250

Puerto Rican Traveling Theater, 62, 164n40

Puerto Rico, 27, 31, 40n2, 40n7, 51, 83, 213, 240–41, 284, 298, 303, 353, 357; Afro-Indigenous roots of, 174; art circuit in, 278; artists from, 30, 39, 215, 272; art scenes and, 36; avant-gardes in, 28–29, 38, 294; Black and Brown marginality in, 80; Blackburn and, 176; Boricua and, 123n5; Bushwick and, 417; Carrero and, 293; Central Florida and, 260; Chicago and, 272, 274; *chinchorro*, 207n29; Colo and, 60; Colón and, 91, 101; colonialism in, 116, 134; colonial history of, 14, 75; colonial status of, 2, 79, 275; coqui and, 193–94; cultural condition of, 273; cultural establishment in, 33; Diasporicans and, 73, 75, 190; Espada and, 233, 235, 237; history of art in, 271; Hurricane Maria and, 258; Indigenous culture of, 79; Irizarry and, 10, 30, 38–39, 43n33; Lares, 102n14; Loíza, 98, 102n16, 179, 183n36, 216, 228, 265; Mercado and, 41n10; migration and, 71; national identity in, 29; natural disasters and, 2, 252 (*see also* Hurricane Maria); Nuyorican and, 57; Orlando and, 250, 253; Ortiz-Pagán and, 226; Peraza and, 157, 160; Ponce, 175, 179, 183n37, 216, 298, 414; printmakers from, 49; printmaking in, 53, 172, 179; Quiñones and, 414; race and, 238; return migration to, 234, 243;

Puerto Rico (continued)
Romero and, 196, 205; slavery and, 133; Soto and, 281–83; sugar industry in, 199; Taino culture and, 74, 86nn16–17, 87n23; Taller Boricua and, 84, 216–17, 219; *theARTmagazine* issue on, 36, 42n29; Torres and, 229; Traba and, 43n37; Tufiño and, 172; United States and, 40n5, 78, 116–17, 275, 359. *See also* bomba; casitas; San Juan

Queens, 152, 159, 304; Jackson Heights, 151, 362
queer studies, 17, 420
Quero Chiesa, Luis, 40n2, 43n33
Quiñones, Lee, 2, 18, 56, 58, 408, 412–17

race, 11–12, 58, 142, 181n16, 238–39, 341; art world and, 373, 382; *chusmería* and, 375; colonial histories of, 366n18; hierarchies of, 3; Latinx art and, 386; logics, 238; online identities and, 385; politics of, 7, 46; representation and, 169; visual culture and, 421
racism, 60, 213, 236, 274, 278, 384; of the art world, 17, 333; Black Puerto Ricans and, 15; environmental, 243, 413, 418; graffiti and, 414; hip-hop and, 415; institutional, 52, 72; in MUDS and MOOS, 389n56; of New York City art establishment, 18; Puerto Rican artists and, 419; Puerto Ricans and, 2, 238; SAMO© and, 333, 335; systemic, 382–83; women of color and, 377; YLP's opposition to, 48
Raimundi-Ortiz, Wanda, 2, 17, 257, 374–80, 383–87; *Ask Chuleta*, 372–77, 380–82, 385–87, 389n60; *Becoming a Ghetto Bitch*, 379–80, 383, 388n28; *Exodus/Pilgrimage*, 258, 259f; *Wepa Woman*, 378–79, 388n24. See also *chusma*; *chusmería*
Ramirez, Yasmin, 4–5, 8–9, 11, 13, 151, 178, 182n28, 414; on Adál, 358;

on artistic sovereignty, 335; on Basquiat, 335, 345, 346n2; Taller Boricua and, 84n2, 86n21, 172, 180n11; on closing of MoCHA, 158; on New York Alternative Art Space Movement, 110, 373–74, 388n20, 418; on Nuyorican art movement, 84n1, 85n4; on Soto Sánchez, 296, 316–17, 327n14
Ramos Borges, Melissa M., 10–11, 419
Razor Gallery, 56, 415
RBPMW. See Robert Blackburn Printmaking Workshop
Real Great Society Uptown Urban Planning Institute (RGS/UPI), 8, 50–51
Ringgold, Faith, 47, 137, 167–68
Rivas, Bimbo, 57, 132, 142
Rivera, Sophie, 18, 19f, 55, 95
Rivera Santana, Carlos, 273–74
Robert Blackburn Printmaking Workshop (RBPMW), 167–73, 175–78, 179nn2–3, 180n11, 180n12, 181n14, 182n26, 183n29, 183n32
Robles, Rojo, 17–18, 301
Rodríguez, Freddy, 155f, 164n37, 165n47
Rodriguez, Geno, 51, 54–55, 58–59, 93–95, 102n7, 146n34; Latine Cultural Left and, 125n21. *See also* Alternative Museum, The; *Dos Mundos: Worlds of the Puerto Rican*; Jaar, Alfredo; Piper, Adrian
Rodriguez, Jorge Luis, 18, 164n34, 181n14
Rodriguez, Ricky, 16, 255
Rodríguez, Shellyne, 18, 181n14, 407–10, 413, 416–17, 422, 424n1; *BX Third World Liberation The Common Denominator*, 423f; *Mixtape No. 1 (Wretched Freak to the Beat)*, 411f
Rodríguez Calero, Gloria (RoCa), 126n33, 181n14, 356, 364, 366n15
Rodríguez-Díaz, Angel, 356, 364, 366n14
Román, Mariah, 16, 253, 256, 261

Romero, Raúl, 190–96, 204–6, 220; *Onomonopoetics of a Puerto Rican Landscape*, 193–96

Rubio, Martin, 47, 51, 66n4

Ruiz, Nathaly, 253, 256, 260

Ruiz, Sandra, 16, 360, 421

Said, Edward, 71–73

Salicrup, Fernando, 73, 75–77, 84, 178, 181n14; El Taller Boricua and, 11, 71, 171, 316, 324; *Una vez más, Colón*, 75, 76f

salsa, 62, 353, 355; musicians, 98. *See also* Blades, Rubén; Colón, Willie

SAMO©, 17, 329–46, 347n5, 347n7

Sánchez, Juan, 13, 18, 51, 140–41, 143–44, 158, 175, 181n14, 216; *Once We Were Warriors*, 52f; *Sol y Flor para Liora*, 178; *Un Sueño Libre*, 176f

Sánchez, Zilia, 274–75, 285n6

San Juan, 41n10, 98, 150, 160, 183n36; art circuit in, 274; art scene, 28; avant-gardes and, 31, 36; La Casa del Arte, 41n19; La Casa del Libro, 173; Old San Juan, 30, 267, 414; Printmaking Biennial, 13, 42n31, 176, 178–79. *See also* Galería 63

Santería, 79, 168, 321–22

Santiago Muñoz, Beatriz, 286n22, 303

Schjeldahl, Peter, 56, 415. *See also* graffiti

School of the Art Institute of Chicago (SAIS), 272, 275, 278, 281, 284

School of Visual Arts (SVA), 46; Blackburn and, 171; Colón and, 95; Dimas and, 88n30, 171, 181n18; Dominguez and, 133, 140; Mercado and, 41n10

Segarra Ríos, Abdiel D., 15, 403n8, 420

Seidel, Michael, 71–74

self-determination, 48, 238, 277, 374

sexuality, 3, 197, 366n18, 373, 375

sexual orientation, 11–12, 58

shaped canvas, 28, 30–31, 33, 39

Silva, Myrta, 357, 367n20

Smith, Cherise, 384–85, 389n50

social practice art, 6, 54

social realism, 28–29, 115, 120

Society of the Friends of Puerto Rico (FoPR), 62, 150, 152f, 156f, 162n6, 162n8, 163n19, 164n40; Cultural Center, 47, 51, 59. *See also* Cayman Gallery

solidarity, 204; with Chile Committee for Human Rights, 152; El Comité and, 92; in Espada's work, 234; with Indigenous communities, 123n5, 203; Latinx Project and, 4; pan-Latino, 98; Panther 21 and, 92; public, 112; between Puerto Rican and Black communities, 81; SAMO© and, 337; Taller Boricua and, 74; Vieques and, 300

Soto, Armando, 12f, 47, 51, 66n4, 84n2, 171; Latine Cultural Left and, 125n21

Soto, Edra, 272–73, 277–78, 281–83, 286n22; The Franklin, 15; *GRAFT*, 281–82, 285n18

Soto Sánchez, Jorge, 2, 11, 17, 51, 71, 73, 77, 84, 86n21, 296, 316–17, 318f, 327n14, 356, 364; *Anonymous Americans*, 81–83, 88n36; Griffith and, 317, 323–26; Nuyorican Poets Café and, 316, 323; *El Velorio de Oller en Nueva York*, 53f, 317. *See also* Taller Boricua

South Bronx, 95–96, 107, 142, 316; art spaces in, 8; burning, 355; casitas in, 393, 396; Fashion Moda, 410; En Foco and, 55; gentrification in, 401; housing in, 402; Longwood Arts Center, 64; School District 7, 150; Wallworks, 416; Young Lords and, 49

Spain, 221; colonization of Puerto Rico, 75; Columbus and, 86n19; people of, 74; Puerto Rican nationalist paradigms and, 85n4; Santiago Apostól and, 102n16; *vejigantes* and, 261

Spanish-American War (War of 1898), 75, 87n25, 313, 326n3

Spanish language, 31, 33, 49, 56, 81, 151, 162n8, 205, 267, 353, 365n2, 374; Association for Hispanic Arts (AHA) and, 62; in Nuyorican poetry, 52, 87n29, 302, 336; *Onomonopoetics of a Puerto Rican Landscape* and, 194; Rollins Museum of Art and, 257–58; SAMO© and, 338

Spanish-language press, 57, 183n35, 229

El Spirit Republic, 109, 117–20, 122, 125–26n29, 126n34, 358, 367n25

street art, 2, 4, 16, 18, 261, 329–30, 342, 421. *See also* Díaz, Al; graffiti; SAMO©

street culture, 341, 347n2, 348n18

Studio Museum in Harlem, 157, 161, 169, 173

Suave podcast, 217, 230n6

Surrealism, 46, 106–8, 118–20, 124n6, 322–23, 325, 420; Bodega, 105, 108, 115, 119, 125n16, 297, 420; the everyday and, 125n14; Latinx artists and, 124n7; Nuyorican artists and, 17; Nuyorican Poets Café and, 312–14, 321–22; social, 109; working-class, 118–19

Taino culture, 74–75, 79, 87n23

Taino heritage, 51, 415

Taino iconography, 75, 86n17, 87n23, 317; Afro-Taino iconography, 11, 18, 317; neo-Taino iconography, 175

Taino imagery, 174–75

Taino people, 11, 75, 79, 86n18, 174

Taino petroglyphs, 77, 87n23, 173–74, 193

Taino roots, 81, 83

Tainos, 74–75, 86n16, 86n19, 179

Taller Boricua, 8, 11–13, 49, 51–55, 62, 71, 73, 170–72, 326n1, 326n3, 414, 421; activism and, 416; artists of, 72, 84, 86n21, 175, 296, 324, 415; Association of Hispanic Arts (AHA) and, 164n40; Ballester and, 176; Blackburn and, 170, 180n12;

exhibitions at, 65; Meléndez and, 295; El Museo del Barrio and, 312, 316; *New Work, New Visions*, 180n11; Pérez and, 93; Print Workshop, 20n4; Surrealism and, 323; Taino culture and, 74, 174. *See also* Dimas, Marcos; Garcia, Adrian; Griffith, Lois Elaine; Salicrup, Fernando; Sánchez, Juan; Soto Sánchez, Jorge

Taller Puertorriqueño, 15, 193, 214, 215f, 219f, 220; Eugenio Maria de Hostos Resource Center, 216, 219; Julia de Burgos Bookstore, 216, 219–20

Tate, Greg, 334–35, 346n2

theARTgallery Magazine, 33, 36, 39n1

Tibor de Nagy Gallery, 31, 295

Torres, Edwin, 301–3

Torres, Rigoberto, 18, 256, 407–11, 413, 417, 424n1

Torres Martinó, José Antonio, 28, 41n17

Torruella Leval, Susana, 60, 154–56, 163n30, 164n32, 165n47

Tufiño, Nitza, 11, 13, 18, 31, 51, 54–55, 71, 73, 84, 164n34, 171–74, 181n14, 216, 34; *Cemis*, 173, 182n25; Latine Cultural Left and, 125n21; *The Neo-Boriquen No. 4*, 174f; *Pareja Taína*, 75, 77f, 78–79, 81; Taino culture and, 87n23. *See also* Taller Boricua

Tufiño, Rafael, 42n29, 51, 84n2, 87n21, 171–73, 216; *El café*, 173, 182n26

United Graffiti Artists (UGA), 8, 55–56, 415

Urban Air Foundation, 395, 403n1

US Latinx Art Forum, 7, 85n4

Valentín-Escobar, Wilson, 9, 11, 13, 123n2, 297, 313, 325, 418–20

vanguardism, 63–64

Vargas, Deborah L., 375, 379

Vega, Manny, 54–55, 181n14

Vega, Rafael, 272–73, 275, 277–78; *Untitled*, 279f

vejigantes, 98, 102n17, 134, 216, 261, 263f

Vieques, 92, 300; movement, 14

Vietnam War, 77, 171; protest against, 91, 313, 374

visual culture, 4, 106, 253, 421; of the diaspora, 419; New York's, 11; Nuyorican, 234; Puerto Rican, 6

visuality, 108, 132–33; countervisuality, 144

way-out group, 27, 36

whiteness, 141–42, 373, 376, 379, 382–83

Whitney Museum of American Art, 85n4, 281, 285n18; Biennial, 157, 226, 381

Wild Style (Ahearn), 58, 415

Wilson, Fred, 64, 67n39, 389n40; *Mining the Museum*, 382, 388n36

Wilson Avenue Community Garden, 393–96, 399

Wilson Cryer, Patricia L., 154, 162n8, 323

women, 222, 386; Afro-Latinx, 377; artists, 6–7, 18, 47, 157, 221, 374; Black, 375, 383–84; of color, 16, 257, 377; domestic work and, 85n9;

equality for, 48; graffiti artists, 331; Indigenous, 203; *jíbara* peasant, 356; Latina, 375; photographers, 95; Puerto Rican, 279

Wong, Martin, 58, 414, 416

Woodland, Holly, 357, 367n22

WPA, 170, 172, 181n15

YLO. *See* Young Lords Organization.

Young Lords Organization (YLO), 7, 9, 15, 48, 50–51, 93, 174, 296, 414–16; decolonial activism of, 107; Garbage Offensive, 48, 355; *Palante*, 54, 66n10, 296; sociopolitical goals of, 111. *See also* Taller Boricua

Young Lords Party, 49f, 50, 105, 214, 300, 357. *See also* Maristany, Hiram

youth, 16, 216–17, 265; Borilando, 266; educational programing, 214–15; graffiti and, 335–36, 347n5; impact of HIV/AIDS on, 235; magazines, 218; multilingual, 345; Puerto Rican, 48; Tufiño and, 172–73

YouTube, 374, 376–77, 384–85, 388n17

Zavala, Adriana, 5, 20n1